Poussin and France

Poussin and France

Painting, Humanism, and the Politics of Style

TODD P. OLSON

YALE UNIVERSITY PRESS
New Haven & London

Designed by Elizabeth McWilliams

Printed in China

Library of Congress Cataloging-in-Publication Data

Olson, Todd, 1957–
Poussin and France : painting, humanism, and the politics of style /
Todd P. Olson.
p. cm.
Includes bibliographical references and index.
ISBN 0-300-09338-1
1. Poussin, Nicolas, 1594?–1665 – Criticism and interpretation.
2. Fronde. 3. Art – Political aspects – France – 17th century. I. Title.
ND553.P8 O48 2002
759.4 – dc21
2001005713

A catalogue record for this book is available from
The British Library

Frontispiece: detail of fig. 79.
Front endpaper: detail of fig. 5.
Back endpaper: detail of fig. 116.

For Darcy Grimaldo Grigsby

Contents

Facing page *Bronze Lamp* (*Lucerne de Bronze antique*), in Guillaume Du Choul's *Discours de la religion des Ancients Romains*, Lyon, 1556, p. 151 (Paris, Bibliothèque Nationale) (see fig. 15a).

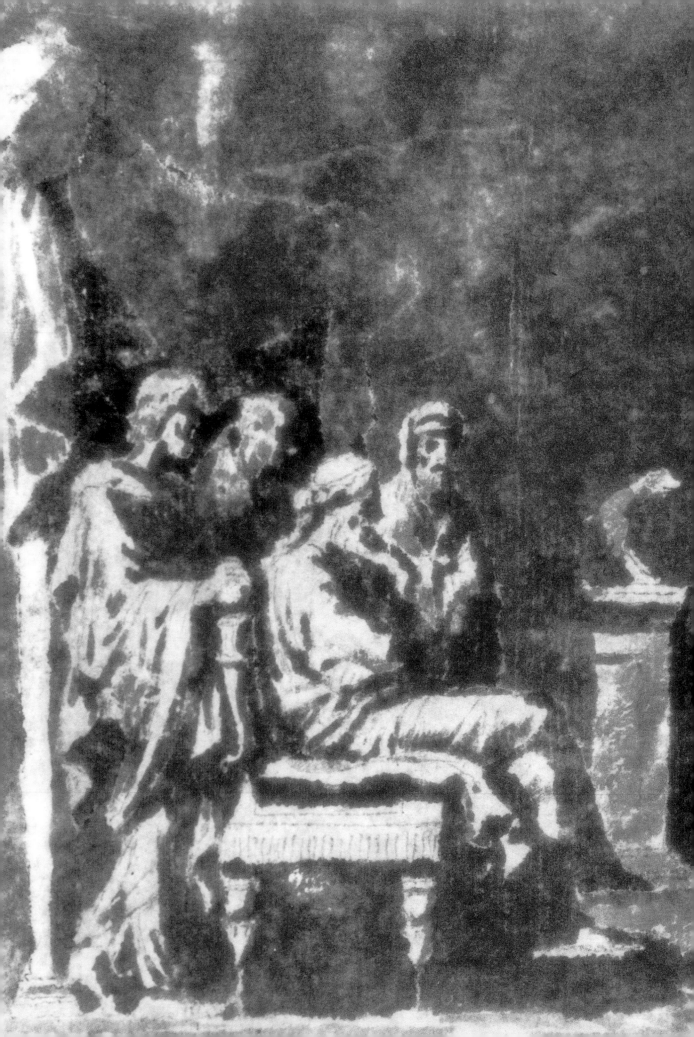

Acknowledgments

By working on an artist such as Poussin, I have had the privilege of relying upon a community of scholars who have debated for quite some time attributions and chronologies and have supplied documentation. My notes cannot fully acknowledge the scholarship of a number of people living and dead who have cared about Poussin. I have accumulated numerous personal and institutional debts that in themselves trace the complicated temporal and geographical boundaries, the accumulative experience of friendship, loss, exile, and belonging that have shaped this project. Many individuals have as a result taken on the obligation of reading this book. In my first graduate seminar, Svetlana Alpers motivated me to be an art historian and the accident of not having learnt Dutch led me to a paper on a French topic and a master's thesis on Poussin. Michael Baxandall taught me that there was more than one way to be an art historian. I would like to thank the faculty and students at the University of Michigan who made it both an intellectually fertile and humane place. Seminars with William Sewell, Jr., Domna C. Stanton, and Ross Chambers have shaped the ways I understand the discipline of art history. My exceptional dissertation advisors at the University of Michigan, Thomas Crow and Patricia Simons, and my readers Domna C. Stanton and Celeste Brusati gave me permission to conceive of that research as this book. Without the pressures of Tom's scholarship, this book would not have taken the form it did. His intervention in the field of art history has been immensely productive, at once enabling a collective conversation concerning a vital set of problems and providing this book with a community of readers. I would also like to thank Pat for helping me to bring shared intellectual and political commitments to this book that have been ignored in Poussin studies. Her close reading, unfailing critical insight, skeptical optimism, and continued support, encouragement, humor, and friendship have persevered through the long haul.

The doctoral research that led to the completion of this book was made possible by a Fulbright Full Grant, France, 1990–91, a Walter Read Hovey Memorial Award from The Pittsburgh Foundation, 1991, my tenure as The Florence J. Gould Tocqueville Fellow in Art History, 1991–92 (awarded by the International Doctoral Research Fellowship Program for Western Europe of the American Council of Learned Societies and the Social Science Research Council; funds provided by the French American Foundation and the Andrew Mellon Foundation). My bibliography and picture credits acknowledge that a number of public research institutions in France contributed to this project. In particular, I would like to thank the oldest public library, the Bibliothèque Mazarine, and its staff, who look after the orginal holdings of Giulio Mazarini's library as well as a rich collection of *Mazarinades*. Although they were not always convinced by my conclusions, I respectfully acknowledge the conversations I had with MM. Alain Mérot, Pierre Rosen-

Facing page Detail of fig. 66.

berg, and Antoine Schnapper. I must also acknowledge the generosity of Tom and Carol Rose, who allowed Louvignon to be an intimate part of the geography constituted by my writing. Completion of my dissertation was made possible as a Haakon Fellow in the Meadows School of the Arts at Southern Methodist University, Dallas, 1992–94, through the generosity of the Haakon Foundation, my colleagues, and students during my residence, as well as Michael Miller and the Three Teardrops Tavern. The book was written while teaching at a number of institutions. Thanks go to James Rubin in the Art Department, State University of New York at Stonybrook and a special group of graduate students. Thanks also go to my colleagues and students at San Francisco State University, University of California, Berkeley, Mills College, and the University of California, Santa Cruz. Special thanks go to the supportive staff, students, and faculty at Mills College. Catherine Soussloff as a colleague and friend sustained me in what seemed at the time to be a wilderness. Discussion that followed papers delivered at Emory University, the Courtauld Institute, the University of California, Berkeley, and the J. Paul Getty Museum have also shaped the outcome of my argument. Thanks go to one unsympathetic reader who led me to suspect that this book would have some effect and another anonymous reader who gave constructive criticism and led me to believe that there might be a more extended community for the book. My thanks to Katie Scott who made me understand the book better as she gave me encouragement. I should also like to thank the University of Southern California for allowing me to take a leave of absence and accept the Mellon Postdoctoral Research Fellowship at the American Academy in Rome, 1998–99, during the final phase of this project. I am indebted to my colleagues, students, and the staff at the University of Southern California for their encouragement and support. I acknowledge and thank Katherine Ibbett for her suggestions regarding translation, and Katharine Ridler for editing the manuscript. Thanks go to Gillian Malpass at Yale University Press for her sustained efforts and belief in this book. I wish to thank Elizabeth McWilliams, also at Yale University Press, for believing that a book on Poussin can be beautiful. In a book about imagined communities it is hard to acknowledge fully the contribution of those friendships that have survived the duration of this project: Michelle Amrich, Maureen Beck, Kyle Coleman, Michael Fahy, Roger Hankins, Jan Leigh, Patricia Reed, Francesca Rose, Jack Rosenberg, Stephen Schachter, David Sheidlower, and Lynne Standfill.

While my acknowledgments trace a curriculum vitae, in many ways this book is also a memento mori. The theme of absence and loss that traverses it is inseparable from several deaths: my father, Peter Carl Olson, to whose memory my dissertation is dedicated, Nora Esmeria Grimaldo Walters, who included us in her love of the present, Adelaide Dion, who gave me books, and Stefan Germer, who did not live to read this book. Distance from friends and family, especially my mother who suffered the loss of my father, inflected the passages on exile and *nostalgie* in this book. However, this book is also about the capacity to sustain practice. Its writing was possible because of my daughter Gregoria. I hope that the book somehow matches her intelligence and complexity, although it will never measure up to her sense of humor. Gregoria and my son, Wilgens Pierre, both inherit this book, its history, and my love. Finally, the completion of this book is a testament to years of collaboration, joy, shared difficulties, love, and sustained conversation with one woman, proving Montaigne to be wrong. I dedicate this book to her.

Preface

Nicolas Poussin (1594–1665) occupies a unique position in the history of French art. Generations of French artists have been burdened by his presence. Considered the progenitor of painting in France, he was eulogized by Delacroix and Cézanne. His works were copied by Géricault and Degas. Poussin's painting served David's pre-Revolutionary artistic vocabulary. Eventually Poussin's work was offered as evidence of a transcendent (albeit largely nationalistic) French classicism. Poussin's mythic position is complicated however by the fact that he spent most of his adult life away from the country of his birth. Surprisingly the French turned to an outsider as the embodiment of a patriotic culture. Yet, even as the exile crated and shipped his work across the Alps, he was becoming central to the French patrimony. The expatriate artist in Rome was recognized as the "French Raphael" by his contemporary supporters in France. Besides identifying the artist with one of the ultimate objects of emulation in European art, the epithet located this French-man outside France. At the same time, Poussin had virtually no impact on the development of Italian art. In this book I have attempted to explain a common yet underdescribed observation: at a significant moment in Poussin's career, the artist's production of easel pictures in Rome was almost exclusively destined for a select body of clients in France. This book's title is meant to suggest that exploring this peculiar relationship between Poussin and France (as distinct from "Poussin in Rome" or "Poussin in France") is important for understanding his art.

By turning my gaze to France, I was intrigued by the fact that Poussin's production of a body of works identified with pictorial and thematic severity coincided with a period of major historical transformation and political unrest. Mid-century France was famously dominated by a civil war known as the Fronde (1648–53). I rely on the term "coincide" to flag a problem central to anyone concerned with the relationship between artistic forms and other social formations. Even at the risk of making the error of homology, I have been occupied with the interrelation between historical and formal description. How might I explain the transformation of art into something beautiful yet difficult, severe, and ungenerous during a period in which an artist's clientele was faced with a social and political crisis? To speak of Poussin in these terms of course puts the interpreter at risk: in Anthony Blunt's early seminal essay on the "heroic landscapes," he importantly considered the impact of address and ideology on the artist's decisions in the studio, even as he sought to identify compositional order with social order.[1] Blunt's essay, if we can call it a work of social art history, points to the necessity of specifying the most immediate points of contact between a work of art and its audience. In another important early study, Sir Denis Mahon recognized that an artist such as Guercino had to negotiate the pressures of reception.[2] Indeed, the audience's critical dispositions were part of the artist's

material. However, unlike Mahon's consideration of the impact of art criticism upon Guercino's pictorial decisions, my research on the reception of Poussin in France takes as its premise that such pressures are not always articulated in artistic theory. Because the incipient viewers of paintings in France had not yet developed a vigorous, distinct genre of artistic criticism, other improvised and borrowed forms of cultural discourse had to be reconstituted and studied.[3]

In shifting the reader's attention to France for the understanding of a body of works by Poussin I shall not be ignoring important scholarship that has been concerned with the development and reception of his art in Italy.[4] Indeed, I hope my focus on France can be set in relief by those inquiries. If I am accused of attempting to make Poussin "more French," I am not alone. Anthony Blunt and Sheila McTighe have asked related questions that have informed my work. Blunt attempted to relate patterns of artistic support, class-motivated political interests and pictorial composition. McTighe has brought questions of Reception Theory to the table and, like Blunt, wondered about the motivated readings (or failed readings) of Poussin's paintings.[5] Other scholars, most notably Elizabeth Cropper and Charles Dempsey, have stressed the importance of Michel de Montaigne.[6] Richard Beresford, Marcel-Jean Massat, Claude Mignot, Jacques Thuillier, and Antoine Schnapper have made important contributions by documenting the contacts between Poussin and individual French clients as well as providing the bases for studies of the critical fortune of Poussin in France.[7] To investigate Poussin's French audience is not to perpetuate anachronistic nationalistic categories. Instead, it illuminates how post-Renaissance humanist culture was articulated differently by various societies as a result of the specific pressures of their distinct political systems. I hope to sustain the work of French scholars of the nineteenth century, such as Quatremère de Quincy and Henri Chardon, who were sensitive to the relationships between Poussin's art and politics.

If the reader concludes after reading my book that Poussin was "political" and "French," I shall not disagree. I believe those were significant categories largely invented by his audience in France. If the reader is at all persuaded that easel pictures were significant because they tell us something about how art can be both "social" and "historical," then I shall have achieved some measure of success. The burden of my study has been to question the characterization of Poussin's art as signifying exactly the opposite: the asocial and the ahistorical. Poussin has been haunted by two contradictory myths that have served to explain his recourse to a severe pictorial order in the representation of antiquity. According to one explanation fostered by early biographers, Poussin's classicism has its origin in his personal temperament. The individual predilection for order determined artistic decisions. The artist was a *peintre-philosophe* whose primary allegiance was to his studio as a site for meditating on the remains of antiquity. By contrast, another discourse, seemingly in tension with this individualist account, describes Poussin's achievement as his capacity to empty painting of personal reference and other signs of temporal contingency. In this scheme borrowed from nationalist literary studies, French classicism is synchronic and universal.

Recent scholarship has complicated our view of the artist by describing the ways that forms of intellectual and cultural sociability, whether modeled on individual friendship or the Republic of Letters, placed the artist's production within a meaningful community.[8] Sometimes such communities were mediated by texts, such as Montaigne's *Essays*, or by antiquities, such as the collection of archeological drawings in Cassiano dal Pozzo's so-called paper museum. One purpose of this book is to make a similar contribution, with a particular focus on the artist's importance in France. As in the work of Bätschmann, Blunt, and McTighe among others, my emphasis should not be taken as a mere geographic shift. Poussin's address to a French audience in the mid-seventeenth century is also a question

of a particular cultural and historical response to the representation of antiquity. While the study of the international and fluid character of the exchange of classical erudition is an important feature of recent Poussin scholarship, it must also be stressed that different demands were put upon humanist erudition by Roman clerics and by French state officials, by Louis XIV and later by the cultures of the French Revolution. The humanist's vocabulary and grammar were subject to political as well as historical contingencies. Again, this is not to contradict other scholars. Sheila McTighe relates Poussin's painting to the cultural politics of mid-seventeenth-century France. Elizabeth Cropper has pointed out that Roman classicism had an ethical and "even political" foundation insofar as it was an epistemological project that considered the relationship between individual action and the transmission of (classical) authority.[9] These lines of inquiry have necessarily focused on the intellectual exchanges among the members of a relatively small group. In McTighe's case, meaning resided in the restricted social phenomenon known as libertinage. For her, the painter's French clients largely dissociated their politics from the paintings Poussin made for them.[10] In Cropper's important study of Roman classicism, we encounter the group in Rome that staked its identity on its distance from the crowd.[11] In the work of Cropper and Charles Dempsey, affiliation between viewer and artist, artist and painting, was modeled on intimate friendship. These scholarly interpretations are important for considering the historical formation of Poussin's art, his immediate reception in Rome, and the personal character of his associations. Where my book differs from these works is in its emphasis on the circulation of antique referents in an expanded and conflicting field of material and visual cultural practices, one that developed in proximity to the emergent modern state in France and the Fronde. This book describes the particular community for whom Poussin painted a configuration of themes and styles representing Greco-Roman antiquity and the ways the exchange between artist and clients was shaped by specific historical and social pressures. Painting helped constitute an extensive community by articulating (one might say belatedly) the cultural and political values of a masculine, patriotic class.

Richard Verdi among others has identified Poussin with a philosophical orientation.[12] My stress is that the philosophical position of Poussin and his clientele was situated within a politics, that is within a sociability under the pressure of history. Poussin's much repeated expression of an aversion to confusion was not solely a personal predilection but a bid for a shared practice. His paintings circulated among the members of a group that read the sixteenth-century political theorist Guillaume du Vair's prescription for cultural identity in the face of a political crisis such as the Fronde: "One of these days you will be astonished to see the laws turned on their heads, the government changed, all will be put in confusion. Those who govern will do so with the intention of destroying both themselves and their country. Good men will not be permitted to open their mouths and give good and salutary advice. Remember that you are men and that you are French."[13]

This book attempts to explain why a social group that found literature quite suitable as a means of fashioning its identity would turn to easel pictures. The purchase and exchange of works by Poussin was a nascent expression of a concentrated interest in paintings. This is all the more astonishing given that the deployment of language to articulate the perception of a painting was fairly rudimentary in France. The kinds of artistic discourse available in the public Salon of the late eighteenth century had not yet been invented. In order to express verbally an interest in paintings, viewers had to turn to other rhetorical forms and literary genres attentive to visual and material culture. Attention to the particular material conditions offered by pictures was the precondition for the reception of Poussin's art.

Several scholars have noted the neglect of Poussin as a painter.[14] Few other artists have had to require proof that they were above all the makers of pictures. Today's alleged disciplinary divide between erudition and formal description has put art historians in a defensive position. This book attempts to reconstitute the meaningfulness of the material traces Poussin left on a series of canvases for a particular historical community. It also addresses Poussin's contribution to the history of the easel picture, which emerged in the seventeenth century as a distinct and important object. While Poussin produced pictures in Rome, where portable pictures were fostered by an international market and prominent local private collections, his peculiar relation to a distant clientele had notable consequences for the history of art. The specific and modest material conditions of easel paintings assumed a symbolic burden, both socially and politically.

* * *

This is not a short book. It attempts to reconstitute a long humanist tradition and a complex political situation. Taking as a point of departure Poussin's major decorative commission for the Grande Galerie of the Louvre, Chapters One and Two situate Poussin's representation of antiquity in relation to the formation of humanism in France. I describe the emergence of an educated class alongside the developing early modern state. Ancient literature and material culture had a particular efficacy for this class, which included Poussin's clientele. Chapter Three describes the importance of French humanist political culture for understanding collectors' interest in Poussin's art. Poussin's two versions of *Camillus and the Schoolmaster of Falerii* (Norton Simon Foundation and the Louvre), both painted in the mid-1630s, articulated a well-rehearsed cultural vocabulary through which a group had constituted itself. The fourth chapter discusses the collection and circulation of a religious painting depicting an episode in the life of Moses among the members of a socially and politically defined group. Having established the ground for Poussin's intensive production for a clientele in France, Chapter Five describes the active participation of a network of clients in the crisis of the Fronde. The chapter attempts to show how a broad description of social and cultural behaviors can illuminate issues of patronage. Chapter Six traces the contours of early modern cultural and political criticism and the salience of ancient Greco-Roman references largely through a study of the pamphlet literature known as the *mazarinades*. This prepares the way for a description in Chapter Seven of the emergence of artistic discourse during a period of political crisis. The chapter describes the formation of aesthetic discourse prior to its institutionalization in the Académie and the Salon. Chapter Eight turns to the problem of the artist's intervention in a structural system of relations. Drawings became the site of rule-bound experimentation as well as profitable inadvertent actions and effects. Chapter Nine is an extended discussion of *The Testament of Eudamidas*, a painting that thematizes through topic and material effects the terms of its own reception. Chapter Ten is a rescripting of the institutional history of the Académie Royale de Peinture et de Sculpture by considering its formation at a time of political instability. The final chapter directly addresses the importance of Poussin's landscapes painted around the period of the Fronde. At the same time that Poussin struggled to secure a consistent production of figurative compositions, he seems deliberately to have investigated a distinctly different genre. Landscape provided the means for a sustained practice that claimed its distance from history painting but not from classical culture or politics. Such a practice was imaginable because Poussin was able to draw upon a depth of rhetorical and poetic traditions readily available to his audience. As in the *Testament of Eudamidas*, an easel picture, the *Landscape with Diogenes*, thematized the terms and situation for its own reception.

This closing chapter on landscape brings to the fore an overriding problem I have faced in writing this book. In art historical writing, the act of reconstituting the perceptions of past viewers coexists in tension with the formal description of the work. The evocation of the present condition of the painting, its presence, and the description of the gesture of the artist in the present tense, is of course ideologically fraught, collapsing diachrony into synchrony. Yet recourse to the consistent use of the past tense, while serving to remind us of the incommensurability of historical experience, renders suspect any attempt to describe form. The description of landscape, and the fictional placement of the self in the situation of the landscapist, brings the tension between past and present to the foreground. This is painting's special gift and strange condition. It is what makes it such a powerful object of exchange and a living site of contention.

1. Poussin (after Villamena), *Relief of Trajan's Column,* based on engravings in Chacon, *Historia utriusque belli Dacici a Traiano Aesare gesti, ex simulachris quae in columna eiusdeni Romae visuntur collecta,* Rome, 1576, plates 77, 87, and 126, brown ink and brown wash on paper (Chantilly, Musée Condé, inv. AI 206, NI 250), 316 × 216 mm.

Chapter One

French Humanism and Patriotic Visual Culture

I knew about the affairs of Rome long before those of my family; I knew of the Capitol and its site long before I knew of the Louvre, and of the Tiber before the Seine. My head was full of the characters and fortunes of Lucullus, Metellus and Scipio rather than of any of our own men.

Montaigne, *On Vanity*[1]

In December 1640, aged forty-six, Nicolas Poussin returned to Paris in triumph after some sixteen years in Rome. Following negotiations with representatives of Cardinal Richelieu and Louis XIII, the painter was appointed to oversee all royal commissions in art and architecture. He entered the city and was received by Richelieu "with embraces proportionate to the grandeur of merit and reputation he had acquired in his art."[2] The return of the artist anticipated one of the foundational myths in Western art: the narrative of a French artist's voyage to Italy in search of experience and training became a familiar one largely through Poussin's example.

As first painter to the king, Poussin was charged with designing and executing the renovation project for the Grande Galerie of the Louvre. The task was daunting not only because of the monumental dimensions of the barrel-vaulted corridor (it measured 20 feet in width by some 1400 feet in length), but also because of the symbolic significance of the site. The great wing on the bustling River Seine that stretched from the original square fortress to the Tuileries palace was the most explicit sign of royal patronage left on the urban topography by Henry IV.[3] The Bourbon king's entrance into Paris in 1594 after bloody civil war had marked an attempt to consolidate power in the divided city. This succession of authority needed the ballast that could be achieved by ambitious architectural projects such as the completion of the Pont-Neuf, the Place des Vosges, the Place Dauphine, the Place de France, and the Grande Galerie. Although the great corridor provided a convenient means of escape outside the city walls should the occasion arise, the facade proclaimed the permanent presence of the court in a capital city. This major reorientation of Paris from an amalgamation of medieval *quartiers* and parishes to a centralized representation of monarchical authority was fully realized with the termination of the Place Dauphine project by the erection of a statue of the late king (fig. 2). From this vantage, the facade of the Louvre offered a perspectival view that integrated the Bourbon urban projects with the horizon. More than just a monumental facade, the extension from the old Louvre and its corresponding interior corridor, the Grande Galerie, was a manifest symbol of Bourbon authority (fig. 3).

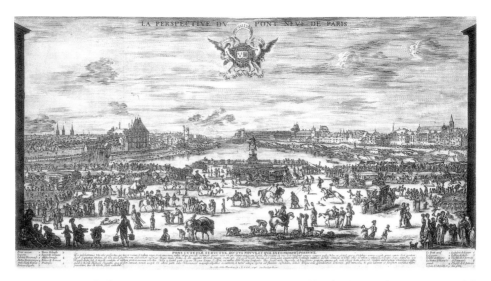

2. Stefano della Bella, *View of the Louvre from the Place Dauphine (La Perspective du Pont Neuf de Paris)*, 1646, engraving (Paris, Bibliothèque Nationale).

The monarchy's dependence on the symbolic authority of a visual culture marked a shift in the direction of political power and a redefinition (or redistribution) of feudal institutions. Henry IV's genealogical basis for power was tenuous and he had undercut the powers of the bellicose nobility, thereby undermining his feudal ties to legitimate rule.[4] He therefore required the consent of disparate regions, cities, and factions: the king sought the support and authority of educated lawyers, merchants, and members of the *noblesse de robe* who could not rely on feudal claims to power but had knowledge and rhetoric at their disposal. French humanism thus became central to monarchical power and complex state formation.

The mastermind behind the plan for the gallery's decorative elaboration was a major official in Richelieu's regime, the Secretary of State responsible for War, François Sublet de Noyers. Sublet was born into a *noblesse de robe* family. Like his father, one of the officers in the sovereign courts (the *Chambre des comptes*), Sublet was trained to serve the monarch. Soon after his appointment as chief administrator of the arts for the crown in September 1638, Sublet became actively engaged in the renovation of the king's buildings and pursued the matter of Poussin's return to France.[5] He was an efficient administrator who sought practical solutions to political problems, which included the cultural buttressing of the monarchy.[6] In addition to his renovation of the dilapidated château at Fontainebleau, which underlined the symbolic affiliation of the reign of Louis XIII to that of Francis I, the arts administrator sought to invest the Louvre with renewed authority by making it a center of royal cultural production.[7] Under his direction, the Louvre continued to be the residence for a number of artists (the *brevetaires*) who were protected by the king and were allowed to operate studios independently of the guilds.[8] A royal press and mint were also founded and installed in the palace. The state-sponsored press represented a significant intervention by Richelieu to control the means of literary production that was complementary to his foundation of the Académie Royale. The mint was central to a patriotic economic policy: the imprinted king's image gave the coinage a symbolic value attributable to the Bourbons. The standardized impression prevented the shaving of the coin for gold, thereby allaying fears that precious metals were crossing borders and draining the wealth of France.[9] Richelieu's consolidation of these institutions within the Louvre demonstrated that French culture, as defined by the royal official, was an emanation of the crown.[10]

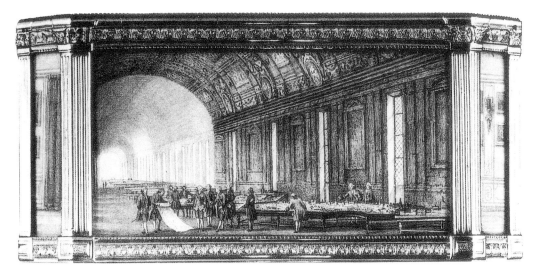

3. Louis van Barenberghe, *View of the Grande Galerie of the Louvre*, 18th century, snuffbox (Private Collection).

The power of the Grande Galerie of the Louvre as a synecdoche of the Bourbon monarchy was therefore not restricted to its facade: the Galerie was a performative space that produced material culture and provided the framework for the ceremonial life of the French court and state visits. While public access to the gallery was famously exploited by the king for the annual demonstration of his sacred, curative touch, it must be stressed that the sacralized body was bolstered by the institutional authority provided by the king's officers.[11] The Louvre was a symbolic site for Richelieu's strategies of cultural intervention and political centralization, which progressively displaced the customary authority of the traditional aristocracy. As the feudal topography was being challenged, the noble lands were becoming the provinces. The ambitious decorative project symbolically elaborated the internal function of an edifice that sought to secure Paris as a capital city. This was Poussin's task. He was contributing to the unification of French culture and, as Sublet put it when he recruited him, he was serving both *patrie* and *nation*.

The decorative project resists description because it was never completed and no part of it survives. We enjoy a partial view of the gallery drawn from an eighteenth-century snuffbox (see fig. 3) as well as fragmentary contemporary descriptions. From Poussin's sketches and its individual motifs, as well as the drawings executed by assistants, scholars have been able to reconstruct the decorative program. The Grande Galerie represented a collaborative effort on the part of the royal administration and the artist.[12] Sublet de Noyers modified Henry IV's original plan for a series of "portraits" of various towns in the realm, paid by the respective municipalities.[13] This earlier ideological construction of France as a unified kingdom constituted by several towns that independently acknowledged Bourbon rule was subordinated to a more ambitious iconographic project offering a mythological and historical panegyric. Responding in part to the triumphal arch and niches with antique statues erected shortly before Henry IV's death, Poussin introduced grisaille bas-reliefs that referred to the virtuous Roman emperor Trajan.[14] The imperial imagery was to be coordinated with both feigned medallions and rectangular friezes that represented the life and labors of Hercules.[15] In the tradition of the hall of princely virtues, the glory of Roman imperial history and the abstract virtues of the self-made demigod Hercules were implicitly mirrored by Louis XIII.

The generalized theme contrasted with the Petite Galerie, an adjoining room that began the grand ceremonial sequence. Henry IV had decorated the ante-chamber to the more

monumental processional space with a portrait gallery that insisted upon a customary and genealogical basis for Bourbon power.[16] The portraits were buttressed by a decorative scheme with mythological scenes, such as Medusa slayed by Perseus, who bore an uncanny likeness to Henry IV. Unlike the Petite Galerie, where resemblance bolstered the king's authority, the Grande Galerie associated the French monarchy with a structural imperative. Poussin conceived the gallery's barrel vault as an orderly repository for casts of antique reliefs whose disposition was structured by painted elements.[17] Rather than a continuous, illusionistic painting, Poussin's Grande Galerie project was organized by a modular composition. The vault was divided into discrete units by transverse ribs. Each of these units was decorated by a series of three panels, one above each cornice and one at the crown of the vault. The corridor was further punctuated above each window by a pair of grisaille terms supporting a gold medallion with painted reliefs (fig. 4). This rigorous compositional solution was Poussin's response to the demand by Sublet to incorporate seventy casts from the reliefs on Trajan's Column, two tondi from the Arch of Constantine (believed to have originated from a Trajanic monument), and copies of other ancient Roman works.[18] The arrangement of the Trajanic cycle, determined by the conception of the gallery as a repository of antique reliefs, was complemented by Poussin's inventions for a grisaille cycle dedicated to Hercules: representations of Roman imperial history were interpolated with the life and labors of Hercules (fig. 5; see figs. 63 and 64). Clearly, the complex layering and interpenetration of antique references and cast objects, inset, stuccoed, and painted over several square miles of colossal vault, was a great conceptual and physical challenge.

What made Poussin qualified to execute a project of such unprecedented ambition in France? His early biography hardly represents an heroic ascension.[19] He was raised near Rouen where he attended secondary school (a *collège*) and then trained with an itinerant artist and was therefore not integrated into an artistic community. At the age of eighteen he made his first trip to Paris. There he lacked financial support and enjoyed no significant attachment either to the crown or to the monopolistic painters' guild. His limited artistic horizons can be measured by an early composition, *Saint Denis Frightening his*

4 *(left).* Workshop of Nicolas Poussin, *Study for the Grande Galerie of the Louvre,* Ignudi and Medallion, c. 1640–43, pen and brown ink on paper (Vienna, Graphische Sammlung Albertina), 440 × 281 mm.

5 *(right).* Poussin, *Studies of Two Circular Panels and Four Rectangular Panels Depicting Episodes from the Life and Labors of Hercules for the Grande Galerie of the Louvre,* c. 1640, pen and brown ink on paper (Bayonne, Musée Bonnat, AI 1673, NI 48), 186 × 303 mm.

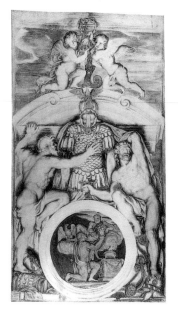
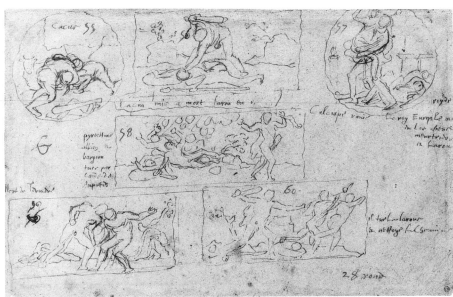

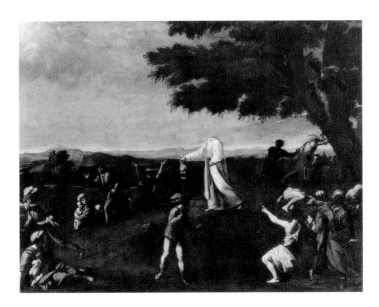

6. After Poussin, *Saint Denis Frightening his Executioners with his Head*, 1620s, oil on canvas (Rouen, Musée des Beaux-Arts, inv. 373.12), 640 × 835 mm.

Executioners with his Head (fig. 6), featuring an awkwardly additive assemblage of figures in a landscape.[20] The young artist attempted to display his skill at depicting a variety of individual centrifugal gestures and expressive responses to the ambulatory decapitated French martyr in the center. If in hindsight we can recognize in germinal form the compositional and expressive interests of the later *Gathering of the Manna* (see fig. 37), at the time the painting won him little support.

After drifting around the country, Poussin finally attracted an important protector when he completed a set of summarily executed paintings for temporary religious decorations in Paris.[21] He was invited to stay in the household of the Neapolitan poet Gian-Battista Marino, who was part of Marie de' Medici's entourage in Paris. The episode is important because it reveals how quickly the artist shifted from the broadly painted banners for a

7. Poussin, *Polyphemus, Acis, and Galatea*, 1623, pen, gray-brown wash, traces of black chalk on paper (Windsor Castle, The Royal Collection, Royal Library, no. 11940), 182 × 323 mm.

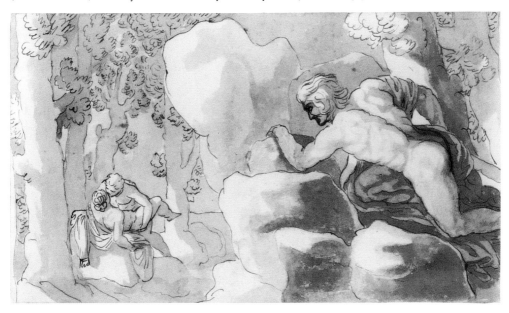

religious festival to a series of small drawings based on classical mythology and ancient history.[22] Among numerous intimate pen and wash evocations of Ovidian metamorphoses is a drawing of Polyphemus spying upon Galatea and her lover (fig. 7). The vertiginous effect of the massive figure in the foreground enhances the violence of the voyeuristic theme reminiscent of pornographic prints.[23] The drawing suggests the patron's desire for provisional, even awkward, adaptations of ancient myth.

Marino's patronage of the artist was fugitive. Upon the completion of his masterwork, the *Adone*, the exiled courtier-poet returned to Italy to receive his accolades. The Norman painter's brief episode in a courtly Italianate culture in Paris came to an end. Although Poussin received a few subsequent commissions in France, they were apparently not sufficient to detain him.[24] Marino provided the vehicle for Poussin's ambitions – a letter of introduction to a member of the Barberini circle in Rome soon after the coronation of Maffeo Barberini as Pope Urban VIII. And so the painter left France to seek his fortune and avenues of support unavailable to him in his native land.

Poussin spent sixteen years in Rome. When he returned to France, he presumably brought back with him a set of desirable skills. Yet he was ill-prepared either to serve the court as a portraitist or to run a large workshop. Poussin is famous for his lack of monumental commissions in Rome. Although Francesco Barberini arranged a commission for the *Martyrdom of St. Erasmus* for a chapel in St. Peter's, Poussin's paintings for members of the Barberini circle were characteristically modest in scale. Many of these early canvases, however, depicted ambitious themes. Roman history had provided the topic for one of Poussin's first paintings in Barberini's collection, *The Death of Germanicus* (fig. 8). The tale of imperial intrigue, death, and promised retribution is keyed to individual expression and displays of painterly virtuosity. Soldiers rally to the bedside of the dying hero, the taut muscularity of the central declamatory pose is mitigated by summary passages of impasto

8. Poussin, *The Death of Germanicus*, 1626–28, oil on canvas (Minneapolis, The Minneapolis Institute of Arts, The William Hood Dunwoody Fund), 1480 × 1980 mm.

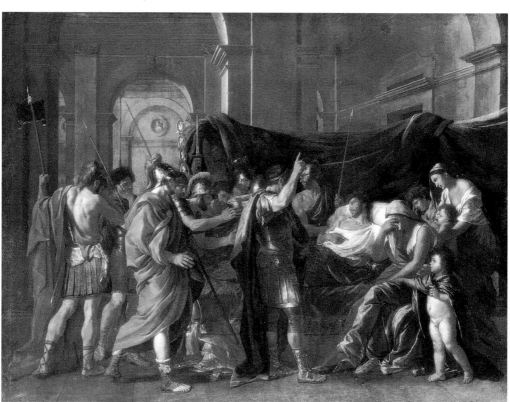

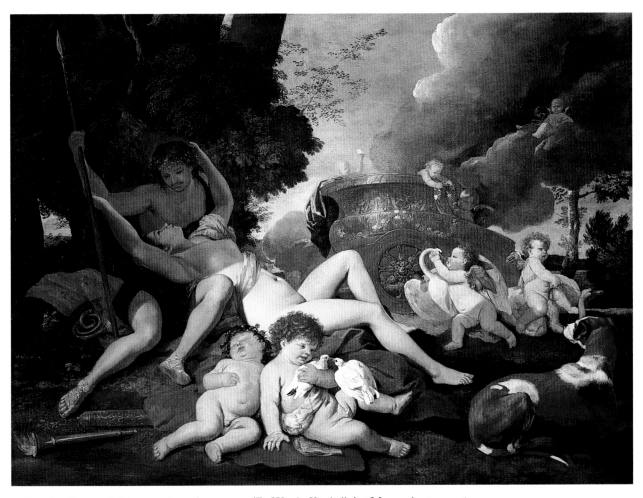

9. Poussin, *Venus and Adonis*, c. 1627, oil on canvas (Ft. Worth, Kimbell Art Museum), 985 × 1346 mm.

10. Poussin, *The Rape of the Sabines*, c. 1635, oil on canvas (New York, Metropolitan Museum of Art, Harris Brisbane Dick Fund, 1946, 46.160), 1546 × 2069 mm.

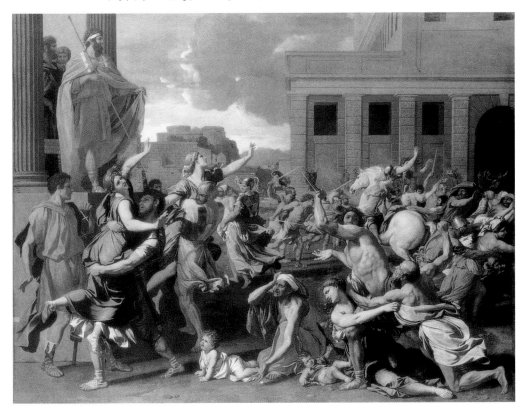

making up flamboyant helmets, flowing drapery, and lustrous armor. The separate module of women and children bear the burden of expression, echoing Roman funerary statuary. The severity of the frieze-like compression of the group, similarly an index of the painter's affiliation to antiquity, is compromised by dispersed attention to the vibrant hues and modulated tones of the drapery.

In addition to multiple-figure pictures based on grand narratives, Poussin also supplied pictures that demanded even more sensual pictorial effects. Emulating the theme and composition of Titian in his *Venus and Adonis*, Poussin managed chiaroscuro to enhance erotic attachment to the reclining female nude (fig. 9).[25] Shadow is achieved by a thin application of paint over red-brown underpainting that is contrasted with passages of greater viscosity and intensity of hue signifying illuminated bodies. The underdescribed passage is abruptly transformed below the breasts of Venus. This truncation, mitigated only by a swath of gold drapery, draws attention to the carefully modeled belly, genitalia, and legs. The erotic subject is subvened by coordinating the tension between impasto and understated effects.

The small paintings based on Roman history that found their way into French collections through diplomatic exchange drew upon a similar conception of scale if not sensual attraction.[26] *The Rape of the Sabines* (fig. 10) is a battle scene bursting with figures and incidents. Like several of Poussin's early paintings, it reduces the grand theater of history to intimate vignettes emphasizing personal relations and modes of expression.[27] In the foundational myth of a state predicated on sexual violence and patriarchal succession, familial drama is represented in a number of set pieces: a suspended woman struggles in the arms of her assailant, a pursuant baby cries, an elderly mother entreats, and a bearded father joins his daughter to form the base of a pyramidal group whose apex is a murderous dagger-wielding thug. While the seductions of gradated tonal variation are restricted, Poussin characteristically invites close visual engagement with a field of tightly syncopated discrete hues.

In light of the modestly gauged effects of these paintings, why did Richelieu chose Poussin for a monumental project that would have challenged the artistic and organizational skills of even the most experienced artist? The cardinal seemed to have ample talent already available to him. He had, after all, commissioned Simon Vouet and Philippe de Champaigne to execute a major gallery commemorating illustrious exemplars from French history in the Palais Cardinal. Vouet used the experience he had himself gained in Rome, an adroit ability to adapt his style to occasion and audience. He took on Richelieu's project for a series of virtuous historical figures that effectively displaced aristocratic genealogy with models for practical action. Large portraits of the "heroes who by their counsel or their courage have preserved the crown" were surrounded by busts, small narrative pictures, and emblems that were pointedly didactic.[28] Having to assume the role of a French Plutarch in paint, however, risked creating static portrayals of individuals whose likenesses were not even established. In his most successful picture, Vouet turned the erect body of a thirteenth-century royal official dynamically about face and characteristically exploited the opportunity for the display of drapery (fig. 11). Gaucher de Châtillon's scabbard, plate armor, and pike are subordinated to an aristocratic deportment accented by a dynamic flourish of his cape. In his weakest moments, Vouet disguised his lack of command over anatomy through his evocations of textiles. At his best, his nearly obsessive studies of the endless possibilities of folded cloth offered surrogates for noble bearing and an expressive body (fig. 12). Vouet rightly valued drapery for the active surface effects and compositional movements so effectively transferred to monumental altarpieces and ambitious programmatic painting.

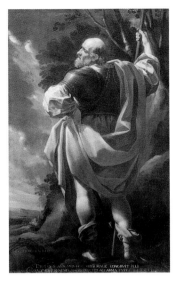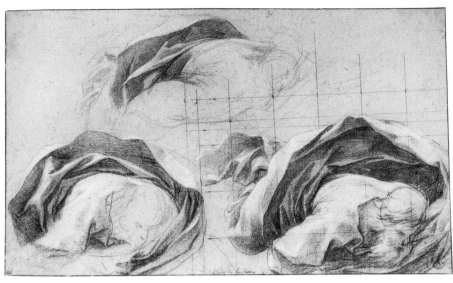

11 *(left).* Simon Vouet, *Portrait of Gaucher de Châtillon, (1250–1328) connétable de France,* c. 1633–34, oil on canvas (Paris, Musée du Louvre, inv. 1937.119), 2180 × 1370 mm.

12 *(right).* Simon Vouet, *Study for God the Father,* 1635–38, black graphite with white highlights on beige paper (Paris, Musée du Louvre, inv. RF 34516), 236 × 408 mm.

Compared to Vouet's bravura, Poussin lacked facility with a broad brush. He never achieved the kind of masterful fluidity that would have allowed Vouet effortlessly to block in an entire vault. When Poussin's brush was applied to large canvases, it did not always produce favorable results. This was presumably the reason why the painter, after having achieved one major commission (the *Martyrdom of St. Erasmus* in the Vatican), did not execute any other altarpieces in Rome. Poussin was a painter of tableaux, modestly scaled easel pictures. His paintings demanded the close concerted attention appropriate to nuanced expressive effects. What a tremendous handicap to a painter responsible for all the royal buildings including, and foremost, the decoration of the Grande Galerie of the Louvre! Although researched paintings can reveal a measure of ambition, unless knowledge could be deployed in broad gestures, erudition was detrimental for a would-be courtier. But Poussin was neither Rubens nor Tiepolo. Poussin's talent was far from the sweeping sumptuous effects that bolstered a powerful ruler. Later in the century, Charles Le Brun had radically to translate Poussin's artistic authority in order to satisfy the requirements for monumentality and magnificence at Versailles.

Poussin's lack of fit with the demands of art in the service of the state is a familiar tale.[29] In short, he returned to Rome and the project was never completed. When perceived as a failure, this episode of state-scale patronage has supported the argument that he was an independent artist whose temperament led him to flee from the pressures of court life. In Anthony Blunt's words, "he was made First painter to Louis XIII, but threw away this opportunity in order to go back to freedom in Rome."[30] For some, Poussin has epitomized the artist at a distance from state politics.

In drawing attention to Poussin's limitations and his predilection for easel paintings as he entered Paris in 1640, I risk being misunderstood. The modest scale of easel pictures is all too easily confused with private experience, or a studio practice removed from politics. To say that Poussin was better suited to paint small pictures is to use hindsight and to ignore the position he struggled to create for himself. Poussin was cutting out his own

niche by inventing a particular kind of easel picture. He was in the process of making the small, portable canvas an important site of artistic ambition and political signification. After Poussin, the large decorative project was no longer the obligatory sign of artistic achievement in France. Political meanings need not reside in the elaborate program, such as the Marie de' Medici series. Aside from the later episode at Versailles, ceiling paintings seldom assumed a major place in French political culture. The prince's gallery was supplanted by the easel picture and the exhibition. This book is about that transformation.

The Grande Galerie was never finished. For well over a century after it had been begun, Poussin's decorative project was left incomplete and became increasingly dilapidated. The testament to Poussin's failure to produce a monument was finally painted over in the eighteenth century, thereby securing his reputation as an easel painter. We could conclude that the royal administration miscalculated when they commissioned Poussin to perform the tasks of a major decorative project of great political import. But this is not a satisfactory explanation. Even if we were persuaded that Poussin's predilection for easel painting led to the ultimate failure of the project, it would be more productive to consider why Poussin's deficits were clearly overlooked in 1640. Might they even have been viewed as assets?

Here was a large-scale decorative cycle perfectly suited to Poussin's skills, talents, and limitations. The project included none of the broad areas of illusionistic painting then popular in Rome. Rather, the modular conception permitted the artist to create a series of simple tableaux that could be prepared in drawings and delegated to assistants. The grisaille friezes and tondi complementing the casts of actual reliefs were in themselves vignettes, simple oppositions of figures: Hercules making an offering to his father, Zeus (fig. 4), Hercules wrestling Cacus, Hercules clubbing a centaur (see figs. 5 and 64). The exceptionally complex tondo depicting the battle of Hercules and the Amazons respects the anachronistic compression of depth (see fig. 63). The artist solved the problem of spatial relations by merely enforcing contours with abrupt tonal shifts. The choice of feigned monochrome reliefs, intended to recall antique medals, avoided the problems of hue on a large scale. Similarly, the artist did not have to contend with the complications entailed in representing anatomically articulated bodies in complex narrative situations. Poussin relied upon simple oppositions of proximate figures. Indeed, the demand to represent antique statuary permitted him to subordinate painterly invention on a large scale for other displays of skills.

Rather than fluid painterly effects, the overall structural logic, selection of themes, and disposition of reliefs privileged facility of a different order. Poussin was counted upon to handle antique themes and objects, the textual and material artifacts of Roman mythology and history. Much scholarship has shown us the importance of Poussin's training in Rome and his familiarity with antiquarian resources, such as Cassiano dal Pozzo's drawing collection, the so-called *museo cartaceo* (or paper museum), and the important collection of sculptures in the Galeria Giustiniani, which prepared him for his obligations in Paris.[31] Poussin's archeological project was therefore a major asset in his bid for *premier peintre*. Indeed, he brought these skills to France after a long apprenticeship at the site of Roman antiquity.

Poussin's productive contact with the antiquarian resources in Rome was to be fully realized on a monumental scale under the direction of Richelieu's administration. The project's ambition was a testimony not only to the king's power and prestige but also to the painter's skills of acquisition and organization. With effort, Poussin acquired the rights to copy and export works from Rome. His acquaintance with the papal policies regarding the protection of Roman antiquities and his association with the Barberini and the civic administration in Rome qualified him for this task.[32]

Rome in Fragments

When Poussin exported casts after antiquities to Paris for the Grande Galerie project, he was displacing fragments from the capitol of Montaigne's historical imagination. The French painter was in an excellent position to satisfy a demand for the artifacts of ancient Rome in Paris. In addition to providing Sublet de Noyers with "the casts of the most beautiful reliefs in Rome," he offered objects that demonstrated his immediate contact with the remnants of antiquity (see fig. 1).[33] His drawing after Trajan's Column reveals a thorough familiarity with the profiles, dress, shield, and altar recorded on the spiral relief. Poussin's conspicuous commitment imaginatively to restore the ancient carving betrays an experiential knowledge of the actual artifact. In the drawing, the raking light emphasizes the broad effects of the deep incisions in the worn and degraded stone. The artist registered the passage of time, deterioration, and ruin.

The overall composition is not the result of observing a single artifact. The seeming archaisms of an ancient relief, the cellular composition and discontinuous narratives, are the cumulative effect of separate sessions of drawing discrepant objects. The drawing encourages a confusion between the compositional conventions of the sculpted sequential narrative units and the juxtapositions resulting from the accumulation of studies on a single sheet. Adjacent plastic forms joined in unlikely combinations appear to occupy a continuous space because areas of wash suggest shadows cast by a single light source. The seemingly accidental compression of figures and the truncation of their members gave the drawing an immediacy and the rhetorical gestures a sense of urgency. This tension between archaistic spatial convention and the accretion of separate drawing incidents over time locates the object at the nexus of antiquity and the artist's practice. The drawing represents the presence of the draftsman at the site of Montaigne's capitol. It is a relic of a collaboration of eye and hand that retraced the marks left by Trajan and accident.

Poussin served as a participatory informant, but this was largely a fiction. Ironically, like the cast copies intended for the Louvre, the representation so vividly conjuring the artist's presence is in fact mediated by a reproductive practice. Poussin's drawing was based on three plates in a sixteenth-century portfolio of engravings produced from drawings done by an artist in a basket suspended from the top of the column.[34] The knowledge conveyed in a drawing without the distortions of foreshortening could only have been made available from this otherwise imaginary point of view. It was entirely characteristic of Poussin

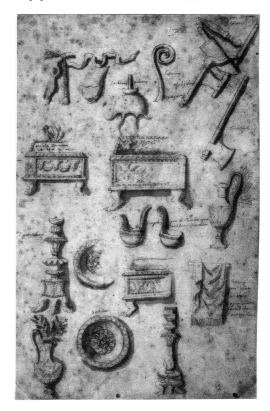

13. Poussin, *Sacrificial Instruments,* drawing after a sixteenth-century engraving by Nicolas Beatrizet of a relief from a temple dedicated to Neptune in the Roman Forum, 1624–c. 1640s, pen and brown wash on paper (Paris, Ecole des beaux-arts), 348 × 228 mm.

to turn to published sources despite his proximity to more immediate material examples. Indeed, Poussin's habitual pattern of supplementing his ink drawings with a wash on the right of depicted projections is a translation of the conventions of engraving, as can be seen by his annotated series of ritual implements derived from a well-known compendium of ancient Roman artifacts (fig. 13).[35]

Secondary appropriation in the seventeenth century (whether textual or pictorial) was not merely a convenience or a result of a lack of imagination.[36] Poussin's studies after engravings show that far from being an experimental archeologist, he was an artist engaged with the visual resources of his immediate audience. Rather than discovering hitherto unknown objects and contributing by increments to a cataloguing of knowledge, the artist turned to a readily available and recognizable, shared currency. As Elizabeth Cropper and Charles Dempsey have argued, Poussin organized and experienced antiquity in the performative space of the architectural gallery as well as in its cognate, the galley sheet: the graphic reproduction of the Giustiniani collection provided a series of discrete objects available for convenient comparison.[37] Poussin culled representations of antiquities from authoritative compendia, imbedding them within readable historical fictions. The placement of the already known object in a shared conceptual field registered an affiliation between the artist in Rome and a community in France with common interests.

Much scholarship has related the collection of antiques and antiquarian knowledge to the broader phenomenon of a Republic of Letters.[38] Poussin's Roman patron Cassiano dal Pozzo was in contact with European intellectuals known to one another through correspondence. Pozzo's cabinet of curiosities and *museo cartaceo* provided part of the vocabulary and grammar for Poussin's early representations of material history. The collector's pictorial interests ranged from the selection of examples of antique statuary to an experimental epistemology founded on specimens. His collection bridged his scientific, ethnographic, and archeological commitments. The artifact, the fossil, Artemisia Gentileschi's self-portrait, the depicted heron, the frog in amber, and the sculpted ancient god became collected samples for classification.[39] Thus when Poussin was enlisted to collect and organize antiquities for the Grande Galerie, the monarch was obtaining not the profuse spolia of imperial conquest but rather the means to claim antiquarian authority. Rather than being innovative, this investment in antiquity articulated the existing interests of Poussin's immediate audience.

Published Sources

The publication of representations after ancient art, like the printing of humanist texts, enabled the interest in antiquity to traverse national borders. Engravings allowed the French reader of Montaigne's essay "On Vanity" to visualize more precisely the fragmentary artifacts of a geographically and temporally distant Rome. At the same time that Poussin was being solicited for the post of *premier peintre*, a fellow French artist and acquaintance in Rome, François Perrier, was publishing a set of engravings that helped prepare the way for Poussin's reception in France.[40] In 1638, Perrier offered an organized lexicon of famous antique statues to the French. In addition to serving a pedagogical function, the set of one hundred plates was a recipe book for artists. Figures were indexed and organized by gender and anatomical position. Sculptures were represented from different points of view: the Apollo Belvedere was represented from the front and back; the Vatican's *Nile* was pictured from three vantage points in a landscape (figs. 14a, b, and c). This formal

14a, b, and c. François Perrier, The Vatican's *Nile* (after 2nd century BCE), engravings in *Icones et segmenta nobilium signorum et statuarum . . .* , Rome, 1638, plates 93, 94, and 95 (Los Angeles, Library, Getty Research Institute).

15a and b. Poussin, Sheet of drawings based on engravings in Guillaume du Choul's *Discours de la religion des Anciens Romains*, 1556, recto and verso, pen and brown ink on paper (Chantilly, Musée Condé), 412 × 273 mm.

and functional organization facilitated the use and recognition of antique sculptures as models for contemporary painting. For artists, this emphasis on the figure as an active body in space encouraged its deployment in pictorial narratives. For those interested in antiquity, the engravings included information normally available only to the visitor to Rome.[41] Perrier's studies permitted an intimacy with these Italian artifacts arranged in the calm of one's library and experienced in the comfort of one's own linguistic community.

Perrier's second series of engravings, the *Tabularum* published in 1645, made an even more direct appeal to research into the historical and literary sources of ancient representations.[42] The textual identification of themes from ancient reliefs begins with a number of bacchic dances and culminates in triumphal and imperial imagery.[43] Several works that were to be included as casts in the Grande Galerie were represented in Perrier's volume.[44] Rather than treating Perrier's engraving merely as a source for Poussin and a guide for French viewers, I mean to stress that the affinities between their enterprises reveal a common visual culture in France. Like Perrier, Poussin's direct contact with antiquities helped him address and foster his audience's extant interest in antique objects.[45]

Both Poussin and Perrier were articulating a humanist cultural vocabulary that had its foundation in French scholarship of the previous century. Poussin, for example, based a number of sheets of drawings of antique artifacts on Guillaume du Choul's *Discours de la religion des anciens Romains* (1556; figs. 15a and b).[46] Du Choul was one of a number of antiquarians in Lyon dedicated to the study and publication of indigenous antiquities. Furthermore, he published in French rather than exclusively in Latin, and as a *conseiller du roi*, derived much of his patronage from the French monarchy.[47] Du Choul fashioned himself as a learned royal servant. His illustrated publications were therefore largely

addressed to a French audience. It is necessary to remember that antiquities were not arti-
facts from a distant historical civilization for Frenchmen like du Choul.

Along with many of his Lyonnais contemporaries, du Choul drew upon his local knowl-
edge. His discussion of ancient religious history was informed by the recent discovery of
Gallo-Roman objects. Du Choul based his historical ethnography on the ancient artifacts
where textual references were lacking. A bronze lamp found in 1525 was entered as evi-
dence to support a point on ritual objects (see fig. 15a, center-right and page vi). An ancient
coin representing a sacrifice before the temple of Diana helped reconstruct the *mise en
scène* of ritual slaughter, placing Bull, Augur, and a branch-bearing crowd in a ceremony.
Du Choul was one of the founders of an archeological method that flourished in Lyon
and other provincial cities in France.[48]

Art historical literature has laid stress on the relationship between Poussin's anti-
quarian project and the development of comparative archeology in seventeenth-century
Rome.[49] Indeed, the international character of the Pozzo–Barberini circle was a fertile
ground for Poussin's own research. Yet, as Elizabeth Cropper has stated, this circle, while
pursuing an ideal that was ethical and even political in its foundations, was largely a closed
academic society.[50] In order for an audience in Paris to be receptive to Poussin's paintings,
his antiquarian objects and methods required intelligibility, but Parisians did not need to
rely on Italian erudition and antiquarianism to illuminate those visual citations. Instead,
a readily available tradition of French humanist research would have prepared viewers for
Poussin's archeological references in his depictions of early Christian scenes as well as clas-
sical subjects. In fact, Poussin's practice was consistent with the comparative method in
du Choul's published texts. For example, du Choul took the image of a little vase from a
marble relief and compared it to the "little portable vessel for holy water, like that which
is still found in our churches today."[51] He then made a further comparison to a Jewish
ritual vessel for washing feet and hands (see fig. 15b, center-right). The stress on the con-
tinuity of pagan and Judeo-Christian practices was consistent with Poussin's methods in
the two series depicting the seven sacraments (see figs. 70 and 71). It is worth noting that
the second series was commissioned by Sublet's agent and nephew Paul Fréart de
Chantelou. Poussin's correspondence with his French client regarding archeological fea-
tures such as the table for the Last Supper or the appropriate lamp overhead echoes Du
Choul's analysis of Gallo-Roman finds.[52] The comparative religion and syncretism man-
ifested in Rome in the seventeenth century had its antecedents in sixteenth-century
French practices.[53]

I am not merely arguing for the priority of French sources for Poussin's project; I am
attempting to trace the motivations underlying a Frenchman's interest in antiquity and
how the viewing of its monumental organization would have been desirable. Attention to
Greco-Roman antiquity was an international phenomenon yet it enjoyed particular local
manifestations. From the Florentine city state to papal Rome and the Kingdom of Naples,
humanist resources responded to particular historical and institutional pressures.[54] While
dal Pozzo's scientific interests were finely tuned to the intellectual debates of seicento papal
Rome, Poussin's French audience had developed a humanist culture engaged in the
formation of the early modern state. The materials of the Grande Galerie were a case in
point. The series of parallels between the monarch and Trajan were of interest to a French
audience because engravings after drawings of the reliefs of Trajan's Column were in
circulation as early as the sixteenth century in France.[55] On his mission to acquire origi-
nals and casts after antique sculptures for Francis I, Primaticcio had made molds of sec-
tions of the column as well as the equestrian sculpture of Marcus Aurelius that had been
recently installed on the Capitoline Hill in Rome (Montaigne's Capitol).[56] Over one
hundred years later, as Sublet de Noyers restored Fontainebleau to the glory it had enjoyed

under Francis I, the acquisition of casts for the Louvre would have borne comparison to
the cultural ambitions of the early sixteenth-century monarch.[57]

Since painting had not yet attained the importance in France that it had in Italy,
seventeenth-century French artists like Poussin depended upon the skills of an audience
trained in a culture based on other visual materials. It is possible that Poussin's French
audience opened up a compendium such as Natale Conti's guide to the labors of Hercules
to comprehend the program.[58] Even though Poussin certainly used the illlustrated source,
as early as the sixteenth century the imported learned manual was not necessary for the
reception of a program such as that planned for the Grande Galerie. There were other
avenues that made the series of narratives and antiquarian sources legible to a wide spec-
trum of society in a public space.

Encomia and Entrances

As a hall of princely virtues, the Grande Galerie was intelligible within French material
and performative traditions founded in the previous century. The general pattern of
ideological buttressing through encomiastic mythological portraiture and allegorical pan-
egyric had been standard fare for prints, medals, poems, and triumphal processions since
the Renaissance. Henry IV encouraged the development of a virtual machine for the pro-
duction of classical references to history and myth.[59] Poussin's use of Hercules and Trajan
as implicit parallels to the French monarch in the Grande Galerie was consistent with the
currency of antiquity in seventeenth-century French political imagery. Put succinctly,
French antiquarianism was at the service of the state.

The figure of Hercules, central to the program of the Grande Galerie, was one of the
most frequent mythological references in French royal encomiastic literature and prints.[60]
In addition to being the exemplary individual who heroically overcame a number of obs-
tacles through his brawn, Hercules was an ideal example because he embodied several
abstract virtues as a founder of laws, arts, and civilization.[61] His particular importance in
France stems from the development of a myth of a Gallic Hercules who became the medi-
ator between French history and Greco-Roman mythology.[62] The imaginative progenitor
of princely lines in Gaul emitted golden chains of eloquence that linked the tongue of the
ruler-orator to the ears of his subjects.[63] The mythological figure lent a cogent symbolic
authority to the tenuous claims of the Bourbon line. In the aftermath of bloody civil war,
the gilded force of rhetorical persuasion promulgated an ideology of speech over arms and
consent over coercion.

The parallel of Henry to Hercules was useful for finding a symbolic equivalent for the
resolution of the civil wars. Hercules dragging the imprisoned Cerberus embodied the
victory of a just sovereign over the rebellious spirit of his subjects.[64] The image of
Hercules bludgeoning the fanatical, heretical hydra of Lerna continued to be used after
the surrender of Paris and Lyon.[65] The various struggles of Hercules, from smashing cen-
taurs to crushing Antaeus, were central to Henry IV's prolific production of prints and
medals.[66] Poussin's gallery exploited this serviceable mythology that reverberated with
allusions to the progenitor of the Bourbon dynasty. Louis XIII and Henry IV, son and
father, were linked to one another by their mutual appropriation of the figure of the Gallic
Hercules (see fig. 49). This symbolic authority and constructed dynastic continuity was
further substantiated by drawing from the historical materials of the Trajanic reliefs: Trajan
was an exemplar of the kingly virtues of wisdom, justice, and liberality.[67]

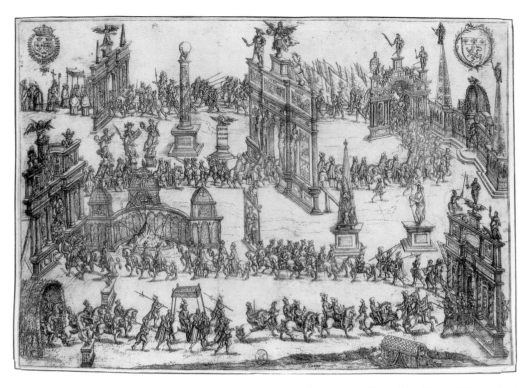

16. Anon., *Plan for Henry IV's Royal Entrance into Lyon*, 1595, illustration in Pierre Matthieu's *L'Entrée de très grand et victorieux prince Henry IIII, en sa bonne ville de Lyon, le IIII sept 1595* (Paris, Bibliothèque Nationale).

The ephemeral print, the inscribed exchange object, and the iconographic program were actively circulated as part of public rituals performed in France from the mid-sixteenth century, in settings designed by local elites and royal officials intending to evoke the triumphal entries of Roman antiquity.[68] The French monarch's ceremonial entrance or *entrée* into a city proceeded through temporary arches and other provisional monuments replete with inscriptions, sculpture, and paintings that honored the crown (fig. 16). This learned structure of literary and historical reference was also addressed to a reading public in the form of printed pamphlets, thereby underscoring the crown's desire for legitimacy by public consent and the extensive public currency of these antique referents. The ephemeral ceremony was a sustained iconographic program in a linear sequence that would have prepared Poussin's audience for the Grande Galerie. In fact, the gallery, like the Roman triumphal arch, gave concrete form to a provisional set of cultural practices.

The triumphal entrance was vivid in the memory of Poussin's contemporaries when he attended a *collège* in Rouen as a young boy. Poussin's family may have been among those people from the surrounding countryside and small towns who came to witness the newly crowned Henry IV's entrance into the city in 1596 (two years after the painter's birth). In that year, Rouen prided itself on its spectacular reception of the monarch, which recalled one of the first ceremonial entries in France to be systematically based on the ancient Roman prototype. The program for Henry II's entry into Rouen in 1550 had been equipped with a chariot modeled after woodcuts of Mantegna's *Triumph of Caesar* (see fig. 30). This prototype for all subsequent entries had combined a learned iconography with the more spectacular entertainments of gladiators, triumphal chariots, faux-elephants, sea battles, and colonized Brazilians.[69]

17. Anon., *Ruined Arch for Henry IV's Royal Entrance into Rouen,* 1596, illustration in Pierre Matthieu's *Discours de la ioyeuse et triomphante entrée . . .* , Rouen, 1599 (Paris, Bibliothèque Nationale).

In the last years of the sixteenth century, the *entrée* continued to be conceived as scenography, a series of backdrops for the monarch's political *tableau vivant*. Significantly, the booklet commemorating Henry IV's entrance into Rouen in 1596 was offered to the reader as a painting: the historian was a new Apelles.[70] The historian assumed the authority of Alexander's painter. However, while the pictorial effects of Henry IV's *entrée* referred to Roman imperial sources, the king's triumph was not an unambivalent celebration of bellicose values.[71] A series of temporary backdrops mixed allegory and ancient history to represent the destruction and poverty resulting from the civil wars. Rather than a complete triumphal arch, Henry passed through a ruin undergoing restoration (fig. 17). Atop the crumbling edifice, masons worked to the tune of a musician king, Amphion the restorer of Thebes. Henry IV would similarly heal France through his prudence, liberality, and other nonmartial (cultural) virtues.[72] Indeed, the royal entries for Henry IV prescribed limits to his imperial ambitions.[73] The potentially bellicose image of "Gallic Hercules, vanquisher with his club of his enemies abroad" was effectively displaced by a

restrained ruler who, by privileging domestic policy, triumphed over opposition in France "with his caduceus of clemency and virtue."[74] The *noblesse de robe* portrayed the king in a highly qualified triumph. Antoine Loisel (Parisian lawyer and progenitor of an owner of paintings by Poussin) similarly compared Henry IV's entry into Paris in 1594 to "a very glorious triumph" for returning Roman emperors and conquering generals.[75] However, the French monarch's victory was greater than that achieved by the successful deployment of arms: "he has vanquished and won by his prudence, temperance, and clemency, not only the hearts of the inhabitants of the town, but also the subjects of all other towns who had spoken of a kindness and gentleness so great and magnanimous."[76] In processional iconography and speech the message to the king was clear. Domestic policy had to use different methods from those of foreign military intervention – Mercury's wand (caduceus) not the brutal weapon of Hercules. The domestic implications of *imperium* had to be checked by highly qualified encomium. The praise of selective virtues by consenting subjects could assume the form of admonition.

Visual culture and rhetoric joined forces in the *entrée* in order to prescribe the relationship between crown and royal subject. The monarch advanced through a series of triumphal arches, proceeding through a dense symbolic topography of visual and verbal panegyrics, layers of speech, spectacle, and commemorative space. In a well-rehearsed pattern, the procession made its way through a carefully calculated series of sites, inscribed with captions, costumes, and hierarchical protocols. The royal historiographer Pierre Matthieu painted with care the twelve white faux-marble columns replete with "capitals, architraves, friezes, and gilded cornices" that made up the monumental triumphal arch in Rouen in 1596.[77] The architectural vocabulary addressed the reader's interest and visual capacities. Rather than sumptuous display, encomium was expressed as an enumeration of a lexicon that rehearsed a community's knowledge of architectural forms. This tectonic framework structured the city's claims to the learning and political rights of the Parlement of Rouen.

Henry, on horseback, played the triumphant Roman. Canopied, and accompanied by bare-headed civic leaders, he passed by another spectacular site – an obelisk with a vertical register of scenes from the labors of Hercules, a "work of such perfection that it seemed to be made of bronze" (fig. 18).[78] The cycle of labors was intended as an explicit comparison between the deeds of Henry IV and his ancient prototype.[79] Henry contemplated "this magnificent work, true hieroglyph of his virtues," then turned to his left and proceeded according to schedule.[80]

The historian painted a triumph. But it was also a picture of the king, physically constrained by local elites, following a

18. Anon., *Obelisk with the Labors of Hercules for Henry IV's Royal Entrance into Rouen*, 1596, illustration in Pierre Matthieu's *Discours de la ioyeuse et triomphante entrée . . .* , Rouen, 1599 (Paris, Bibliothèque Nationale).

highly prescribed spatial, iconographic, performative, and linguistic discipline. Although the king was patterned after Hercules and the triumphant Roman heroes, it was a pattern supplied by the political authorities of Rouen and enacted on the commemorative fabric of the urban topography. The king enjoyed a privileged position of knowledge of the city, but it was a perspective obstructed by local sites of historical memory that exceeded the monarch's mastery.[81] Royal power was mapped but it did not follow the absolutist contours of Versailles. Although the *entrée* recognized the power of the king and the obedience of his subjects, it also registered the authority of local educated elites. The spectacular ceremonial entry provided a demonstration of the humanist resources of an educated class and their integration within an evolving political system. The ceremony not only recognized the prestige of civic sites but also the important personages who linked local power to the royal government. The king, after all, had to participate and take his place in the rank and file pageant designed for him by members of local institutions. The pageantry ritually marked the exchange of displaced feudal fidelity for institutional loyalties.

The historical representation of the *entrée* articulated encomiastic humanist materials within a complex clientage system. Matthieu compared his contemporary account of the entry of Henry IV into Lyon to a medal of the king as a French Alexander or an allegorical tapestry depicting royal magnanimity and clemency.[82] Again, the historian was a visual artist. Nostalgic for a Lyon that had founded its great prestige early in the sixteenth century on the reputations of its poets and publishers as much as on its silk industry and international banking community, Matthieu valorized the contemporary local elites who inherited a vital humanist textual and visual culture.[83] Among those praised by Matthieu was Pomponne I de Bellièvre, Henry IV's *intendant*.[84] Bellièvre was a member of a prominent educated elite that bridged local power and royal administration, whose descendant Pomponne II owned a painting by Poussin. In addition to negotiating the surrender of Lyon to Henry IV, the elder Bellièvre was also instrumental in the design of the triumphal arches, accompanying iconography, and Latin inscriptions for the entrance of the new queen. Matthieu gave credit to Bellièvre for directly borrowing from the ancients and searching history for the forms that honored exemplary emperors.[85] In the pamphlet that accompanied Marie de' Medici's *entrée* of 1600, Matthieu stated that the city of Lyon was honored by Bellièvre, as Athens had its Phocion and Rome had its Cato.[86] Another local notable, Nicolas II de Langes, delivered a harangue that honored the Bourbon king in terms of the interests of his Lyonnais subjects.[87] A local political authority and collector of ancient medals, Langes drew on antiquity in order to describe the ideals of kingship. He contrasted dictatorial oppression and the tyranny of Roman emperors with the humility and reverence of a French monarch that produces the "repos public." In the description of the triumphal entry, Langes was also called "one of the Catos of France."[88] Antiquity validated not only the king but also those versed in it. The provincial elite who acted as an intermediary between local and centralized power was compared to the disinterested ancient political figure who maintained a critical relationship to factional interests.

Bellièvre's name recurs as a leitmotif in my argument. The fact that Pomponne's great-grandson and namesake acquired a painting by Poussin is significant insofar as Poussin's paintings were linked to important *noblesse de robe* families (see the following chapters). Pomponne's father Claude I, son, and great-grandson were also prominent office-holders. These recipients of Poussin's paintings and the Grande Galerie's immediate audience possessed a unique set of skills that were transmitted from father to son. The great *entrées* of the sixteenth century were carried on to represent ritually the bonds between the

Bourbon line and generations of office-holders. In the Grande Galerie the compositional and epistemological organization of antiquity echoed this performative tradition. The reproduction of these cultural resources was often more sound than genealogy. Institutional memory supplanted feudal sites.[89]

The monarch depended on an educated class to provide him with an imaginary pedigree drawn from ancient history that legitimated his dynastic succession. In the aftermath of devastating civil war, the lasting relics of an antique past served to bestow authority and authenticity on an invented historical continuity between ancient and Bourbon rule. In turn, facility with the interpretation of antiquity became the basis for group association and social validation that also provided the means for asserting political authority. Thus the vocabulary of Greco-Roman antiquity was deployed for the mutual validation of the French monarchy and an educated class that sought social legitimacy, the *noblesse de robe*. Poussin's antiquarian project for the Grande Galerie belonged to this exchange of ideological support for social and political prestige. The Grande Galerie was decorated in recognition of that pact.

Absolutism and Relational Power

The bourgeoisie and *noblesse de robe* of Paris, Lyon, and other cities secured their own interests as they lionized the monarch with eulogistic pomp and triumphal arches derived from antiquity. Praise for the prince was not necessarily a demonstration of servitude, fawning for favor with a flattering tongue. The humanist acquired strategic powers through knowledge. The gathering, translation, organization, and interpretation of ancient texts and material culture provided the historical lexicon, vocabulary, and techniques for the acquisition and maintenance of legal and political rights. While monarchical authority was largely based on abstract principles, royal officials had past registers in hand to back up their arguments and claims to privileges.[90] Those who could more effectively collect and retrieve information succeeded in the political system.[91] The archive, the register, and the collection were sources of authority. An educated class conserved, researched, cited, and applied examples. These were the resources at hand in the production and reception of the Grande Galerie. Rather than an arsenal for trophies, the Grande Galerie project was something of an archive.[92]

The stress on a symbolic power founded on historical referents that were subject to interpretation had important consequences for the monarchy and the robe nobility. Historical knowledge of the ancient past competed with or devalued a genealogical basis for power. History was constituted by ancient examples rather than the chronicles of bloodlines. The monarchy, and the newly formed Bourbon dynasty in particular, was therefore dependent on those articulate in the organization and the production of interpretations. The shift of authority into the hands of the *noblesse de robe* was less problematic than the struggle for military power among the ancient nobility. Yet it had its consequences.

Classical erudition constituted a strategic means of power when the interests of the crown and the officers conflicted. While the *noblesse's* admonition of imperial aspirations in the *entrée* qualified the praise for the triumphal king, references to ancient history also harbored more explicit criticism. If the crown infringed upon the interests of the officers, intellectual resources that buttressed the authority of the monarch were also used to modify their relationship to the crown. Encomium did not always display a state free of conflict and struggle.

In the midst of Matthieu's description of the entrance into Lyon, there is criticism of the two classical rulers Caesar and Alexander. Their statues in the niches of a triumphal arch provided an opportunity for excursus and comparison:

> And the the valor of Caesar and Alexander was a valor sharpened by the most violent ambition that ever seized a soul, the one to ruin his country, the other to have himself honored as a god in his own lifetime. But the King's valor was concerned only with the greatness of France, the defence of his subjects, and the conservation of the fundamental laws of the state. And to that end, God, the living God, not the Jupiter of Alexander or the Mars of Caesar, but the great King of Kings, the God of battles, miraculously called the King, and raised him up . . .[93]

The king was measured against the ambitions of his symbolic forebears. Caesar's reputation was blemished by dictatorial powers that destroyed him and his country. Alexander succumbed to an egoism that encouraged others to flatter him as a god. Although Henry was praised for being superior to Caesar and Alexander in this set of parallels, the potential of even the greatest leader to have limits, shortcomings, or even faults, was expressed. The subsequent gold effigy of the king, dousing destructive fire and bestowing olive branches to Lyon, was provisional insofar as dispraise reminded the king of the foibles of his symbolic predecessors. Henry IV was better than Caesar only as long as he maintained his virtues of clemency and magnanimity. In order to maintain his authority he must protect the laws of the state and worship a monarchical deity, not gods of vengeance and war. Henry was presented with a model of himself, as constructed by the Lyonnais, to be emulated. Humanism's science of the self was here used to define and modify the monarch. The fall that results from the abuses of absolute power was offered as a warning. As Plutarch's systematic comparison of positive and negative leaders was a pedagogical text, the misconduct of a ruler offered a valuable object lesson for educated provincial elites.[94]

Poussin had never accomplished a project of the magnitude of the ceremonial entry but his reputation in Rome was based on a similar critical evaluation of the Roman imperial past in a modestly scaled easel picture. *The Death of Germanicus* (see fig. 8), a painting that had attracted the attention of French clients, represents the death of an honored individual at the hands of Tiberius's favorite. The composition is famously structured, on the one hand, by the tensions between the rush of masculine armored figures taking an oath at the deathbed of the virtuous general and, on the other, by the collapsing expressivity of the feminine and infantile familial group. The highly influential heroic mode of the painting is checked, however, by the presence of the toddler Caligula, who grew up to avenge his father's death with further subterfuge and bloodshed.[95] The life of Caligula written by Suetonius provided one version of the narrative. The tone is anti-imperial, relying on the pathos of the family suffering to underscore the admonishing of imprudence and cruelty. Poussin also relied on another well-known and controversial source, the *Annals* of Tacitus.[96] Early in the previous century, Tacitus had been derided for his style in comparison to Cicero, who had been praised as a model for the art of writing. In the course of the century, Tacitus became celebrated for his use of historical evidence and his project of describing historical decline. While early sixteenth-century historians such as Guillaume Budé were Ciceronians who upheld ecclesiastical attacks on Tacitus because of his unabashed derision of the Christians, a later generation of scholars including Jean Bodin, Montaigne's friend La Boétie, François Hotman, and Rubens's mentor Justus Lipsius, overlooked what they considered was the unpolished style of Tacitus and found in his *Annals* a description of tyranny.[97] As a result of the Wars of Religion, the Roman historian was defended by some in preference to Cicero because the historical lessons of

Tacitus were more relevant to the troubles of Europe than a model of eloquence.[98] When Lipsius lectured on Tacitus he had no trouble comparing Tiberius to the Duke of Alba in the wake of the St. Bartholomew's Day Massacre.[99] Alternatively, a theoretical apologist for royal absolutism, such as Bodin, constructed a political philosophy by turning to Tacitus for examples of tyranny as counter-proposals.[100]

Indeed, the painting touched on political themes and an ancient historiography that were of great interest to Sublet de Noyers and other French officials. The ambivalence toward the encomiastic treatment of the Roman *Imperium* rehearsed in the tableau of Germanicus was further explored in the monumental corridor of the Louvre. If we return to Poussin's official project, we can see that the Grande Galerie would have stood like a permanent entry decoration. The mythological and historical apparatus similarly resembled the ancient Roman triumphal arch, which had also given permanent monumental form to the temporary furnishings of triumph. However, Poussin's process of appropriation and recombination of ancient artifacts did not stress imperial conquest (as later did Napoleon's artistic confiscations) but the procedures of acquisition practiced by scholars and amateurs: drawing, transcription of inscriptions, and serial disposition. Rather than the confiscation of the actual column, a facsimile of the column was dismembered and distributed in a gallery. Power was exercised by a demonstration of knowledge. The conception of a linear corridor privileged sequential viewing-as-reading over the gestalt of a totemic column. Like the engraved book, the gallery unfolded the narrative otherwise bound to the upwardly spiraling register of the column. Yet the physical limitations of the gallery did impose constraints on visual acuity, especially for those viewers ill-equipped to recall the themes and relate them to recognizable forms. Rather than amassing spoils, the composition favored considered selection.[101] The gallery was calling forth a level of erudition that may too easily conform to our expectations. Early modern studies in general and Poussin scholarship in particular may have accustomed the reader to erudition as a given. Furthermore, erudition is often assumed to have a limited currency. And yet, the peculiarity of the projected Grande Galerie, as well as its antecedent royal *entrée*, was its sheer monumentality and scope of address. The elaborate decorative program presupposed an audience that was conversant in antique topoi as well as ancient material objects. The following chapter describes how such a class of viewers was prepared by French cultural institutions.

MAE RERVM·...
EQVIDEMPRIMAMOM...VMIELAMCOGITATIONEMHOMINVMQVOM
MAXIMEPRIMAMOCCVRSVRAMMIHIPROVIDEODEPRECORNE
QVASINOVAMISTAMREMINTRODVCIEXHORRESCATISSEDILLA
POTIVSCOGITETISQVAMMVLTAINHACCIVITATENOVATASINT·
QVIDEMSTATIMABORIGINEVRBISNOSTRAEINQVODFORMAS
STATVSQVERESPNOSTRADIDVCTASIT
QVONDAMREGESHANCTENVEREVRBEMNECTAMENDOMESTICISSVCCE
SSORIBVSEAMTRADERECONTIGITSVPERVENEREALIENIETQVIDAMEXTERNI
NIVINVMAROMVLOSVCCESSERITEXSABINISVENIENSVICINVSQVI
DEMSEDTVNCEXTERNVSVFANCOMARCIOPRISCVSTARQVINIVS
PROPTERTEMERATVMSANGVINEMQVODPATREDEMARATHO
RINTHIONATVSERATETTARQVINIENSIMATREGENEROSASEDINOPI
VFOVAETALIMARITONECESSEHABVERITSVCCVMBERECVMDOMIRE
PELLERETVRA·GERENDISHONORIBVSPOSTQVAMROMAMMIGRAVIT
REGNVMADEPTVSESTHVICQVOQVEETFILIONEPOTIVEEIVSNAMET
HOCINTERAVCTORESDISCREPATINSERTVSSERVIVSTVLLIVSSINOSTROS
SEQVIMVRCAPTIVANATVSOCRESIA·SITVSCOSCAELIQVONDAMVT
VENNAESODALISFIDELISSIMVSOMNISQVEEIVSCASVSCOMES·POST
QVAMVARIAFORTVNAEXACTVSCVMOMNIBVSRELIQVISCAELIANI
EXERCITVSETRVRIAEXCESSITMONTEMCAELIVMOCCVPAVITETADVCESVO
CAELIOITAAPPELLITATVSMVTATOQVENOMINENAMTVSCEMASTARN
EINOMENERATITAAPPELLATVSESTVTDIXIETREGNVMSVMMACVMR EI
P·VTILITATEOPTINVITDEINDEPOSTQVAMTARQVINIISVPERBIMORES
VISICIVITATINOSTRAEESSECOEPERVNTQVAIPSIVSQVAFILIORVMR
NEMPEPERTAESVMESTMENTESREGNIETADCONSVLESANNVOSMAGI
TRATVSADMINISTRATIONEMTRANSLATAEST
QVIDNVNCCOMMEMOREMDICTATVRAEHOCIPSOCONSVLARIH
RIVVALENTIVSREPERTVMQVAPVDMAIORESNOSTROSQVOINA
PERIORIBVSBELLISAVTINCIVILIMOTVDIFFICILIOREVTERENTV
AVTINAVXILIVMPLEBISCREATOTRIBVNOSPLEBEIQVIDACONSV
LIBVEADDECEMVIROSTRANSLATVMIMPERIVM·SOLVTOQVEPOSTEA
DECEMVIRALIREGNOADCONSVLESRVRSVSREDITVM·QVIDIN
RISDISTRIBVTVMCONSVLAREIMPERIVMTRIBVNOSQVEMI
CONSVLARIIMPERIOAPPELLATOSQVISENIETSAEPEOCTONICREAREN
TVRQDCOMMVNICATOSPOSTREMOCVMPLEBEHONORESNONIMPERI
SOLVMSEDSACERDOTIORVMQVOQVEIAMSINARREMBELLAAQVIBVS
COEPERINTMAIORESNOSTRIETQVOPROCESSERIMVSVEREORNENIMO
INSOLENTIORESSEVIDEARETQVAESISSEIACTATIONEMGLORIAEPRO
LATIMPERIIVLTRAOCEANVM·SEDILLOCPOTIVSREVERTARCIVITATI

...EA SANE
...DIVV SA... ...EAPATRVSTI
CAESAROMVEXEMPLOREMVBIQVECOLONIARVMACMVNICIPIORVMBO
NORVMSCILICETVIRORVMEFLOCVPLETIVMINHACCVRIAEESSEVOLVI
QVIDERGONONITALICVSSENATORPROVINCIALIPOTIOREST·I IAM
VOBISCVMHANCPARTEMCENSVRAEMEAEADPROBARECOEPEROQVID
DELAPRESENTIAMRERVSOSTENDAM·SEDNEPROVINCIALESQVIDEM
SIMODOORNARECVRIAMPOTERINTREICIENDOSPVTO
ORNATISSIMAECCECOLONIAVALENTISSIMAQVEVIENNENSIVMQVAM
LONGOIAMTEMPORESENATORESHVICCVRIAECONFERTEXQVACOLO
NIAINTERPAVCOSEQVESTRISORDINISORNAMENTVMLVESTINVMLA
MILIARISSIMEDILLIGOETHODIEQVEFINIREBVSMEISDETINEOCVIVSLIBE
RIERVANTQVAESOPRIMOSAGERDOTIORVMGRADV·POSTMODOCVM
ANNISPROMOTVRIDIGNITATISSVAEINCREMENTA·VTDIRVMNOMENLA
TRONISTACEAMETODILLVDPALAESTRICVMPRODIGIVMQVODANTENDO
MVMCONSVLATVMINTVLITQVAMCOLONIAVASOLIDVMCIVITATISROMA
NAEBENIFICIVMCONSECVTAEST·IDEMDEFRATREEIVSPOSSVMDICERE
MISERABILIQVIDEMINDIGNISSIMOQVEHOCCASVVTVOBISVTILIS
SENATORESSENONPOSSIT
TEMPVSESTIAMTICAESARGERMANICEDETEGEREILEPATRIBVSCONSCRIPTIS
QVOTENDATORATIOTVAIAMENIMADEXTREMOSFINESGALLIAENAR
BONENSISVENISTI
TOTECCEINSIGNESIVVENESQVOTINTVEORNONMAGISSVNTPAENITENDI
SENATORESQVAMPAENITETPERSIGVMNOBILISSIMVMVIRVMAMI
CVMMEVMINTERIMAGINESMAIORVMSVORVMALLOBROGICINO
MENLEGERE·QVODSIHAECITAESSECONSENTITISQVIDVLTRADESIDERA
TISQVAMVTVOBISDIGITODEMONSTREMSOLVMIPSVMVLTRAFINES
PROVINCIAENARBONENSISIAMVOBISSENATORESMITTEREQVANDO
EXLVGVDVNOHABERENOSNOSTRIORDINISVIROSNONPAENITET
TIMIDEQVIDEMP·EGRESSVSADSVETOSFAMILIARESQVEVOBISPRO
VINCIARVMTERMINOSSVM·SEDDESTRICTEIAMCOMATAEGALLIAE
CAVSAAGENDAEST·INQVASIQVISHOCINTVETVRQVODBELLOPERDE
CEMANNOSEXERCVERVNTDIVOMIVLIVMIDEMOPPONATCENTVM
ANNORVMIMMOBILEMFIDEMOBSEQVIVMQVEMVLTISTREPIDISRE
BVSNOSTRISPLVSQVAMEXPERTVMILLIPATRIMEODRVSOGERMANIAM
SVBIGENTITVTAMQVIETESVA·SECVRAMQVEATERGOPACEMPRAES
TITERVNT·ETQVIDEMCVMADCENSVSNOVOTVMOPEREETINADSVE
TOGALLISADBELLVMAVOCATVSESSETQVODOPVS·QVAMAR
DVVMSITNOBISNVNCCVMMAXIMEQVAMVISNIHILVLTRAQVAM
VTPVBLICENOTAESINTFACVLTATESNOSTRAEEXQVIRATVR·NIMIS
MAGNOEXPERIMENTOCOGNOSCIMVS

19. Claudian tablet, 48 CE, bronze (Lyon, Musée de la Civilisation gallo-romaine) approx. 1370 × 1830 mm.

Chapter Two

Object Lessons

The Grande Galerie was conceived as an historical archive. Rather than the accumulation of spolia, the program emphasized an overriding structure that was an index of historical persons and events as models for action. As such the project had an affinity with Poussin's own records of the ancient imperial past. His drawing of the triumphal procession on the Arch of Titus (see fig. 20) is not intended to transport the viewer in imagination to ancient Rome. As in the drawing of Trajan's Column (see fig. 1), Poussin directs our attention to the worn stone, with its defaced figures, here emperor, winged victory (or Nike), and celebrants. The representation of ruin betrays the presence of a belated viewer situated in history. While the shining and pristine surface of a triumphal encomium would have emphasized an imaginary and ahistorical identification between ancient and contemporary ruler, the abraded fragment forces a looking back onto an irretrievable condition. The artifact in ruins is a vanitas. The Nike whispers in the victor's ear of his mortality. The object makes a general claim for the pathos of individual death or even the inevitability of cultural decline. But that looking back onto the ancient imperial object was also an act of historical consciousness. Poussin's drawing of an artifact claimed a purchase on past persons and regimes as historical examples to be measured against the present. He relied on an audience with a classical education accustomed to seeking exemplary objects in the past. And yet the drawing was also part of a larger social practice that far exceeded the material limits of ink and wash on paper. As in the Grande Galerie and the royal entrance, even this modest object, however erudite, potentially addressed a large constituency. Historical consciousness on the part of an extensive audience was the result of institutional developments in the century of Poussin's birth.

Education and Exemplarity

The *noblesse de robe*, those officers who designed the triumphal entries and ultimately recruited Poussin for the Grande Galerie and collected his pictures, were the product of an educational system largely developed in the previous century. Sixteenth-century France saw the great expansion of lay, municipal primary education for young males.[1] Provincial towns actively recruited lay scholars who were educated in Paris and insisted that local youth be instructed in the "Parisian style."[2] The municipal authorities of the early sixteenth century generally supplanted the cathedral schools by offering a free education to diverse social groups. The *collèges* trained a service elite, among them the Fréarts. This relatively uniform education provided an important link among towns scattered over Gaul

as well as between the provinces and the crown. A shared Greco-Roman repertory, founded in the *collèges* and expressed in contemporary correspondence, helped elide regional differences, allying diverse Parisian and provincial elites.[3]

The notion of an educational authority from outside the provincial city was articulated in the pedagogical structure and plan of studies. There were standardized levels within the humanist curriculum. Sixteenth-century contracts by local officials often specified authors for each level. Firstly, Cato, Cicero, Terence, Virgil, and Ovid were combined with the required translation of French and Latin. Later students learned rhetoric through the example of Cicero, Horace, Quintillian, Sallust, Livy, and Persius. The upper-level students might learn Greek as well.[4] Even as the phenomenal growth of lay education in France waned toward the end of the sixteenth century and the Jesuits assumed importance as educators, this tiered system and curriculum was largely left intact.[5] Sixteenth-century reforms in the curricula of *collèges* favored the reading of texts in the original as part of language instruction.[6] This shift not only had an impact on contemporary literature but also developed a receptive reading audience. The printing industry flourished, producing a number of pedagogical texts.[7]

In his memoirs, the fabulist Charles Perrault described the education he received at the *collège* de Beauvais in Paris from 1636, around the time Poussin began painting for French clients. Perrault read the books of Virgil, Horace, Tacitus, "and the greater part of all the classical writers."[8] He translated texts into French, while setting aside the more beautiful passages to be read in the original. This process of translation and extraction resulted in a store of fragments that he kept with him the rest of his life. The *collègien* often learned disengaged topoi in the form of citations and exemplars. Such rote practices made historical references or evocative portraits available to legal and judicial discourse.[9] Widely read and quoted, the apophthegm – an incident followed by a witty saying found in Plutarch's *Sayings of the Spartans* and *Sayings of Rulers and Commanders* – privileged the brief narrative anecdote as the core of a shared lexicon.[10]

The profusion of Latin phraseology and literary motifs was not always, however, a direct translation of silently studied text into official oral and documentary practice. When Poussin attended school as a boy, he was no doubt aware that the students in provincial *collèges* contributed directly to the iconographical embellishment of the royal ceremonial entries.[11] Students exhibited their command of Greek, Latin, and French poetry by attaching verse directly to the walls of the school as offerings to the processing monarch. Combining discipline and play, the schoolboys exercised their linguistic abilities as well as their future participation in a political community: as elders, like Bellièvre, recited harangues in verse and put up temporary triumphal architecture, the young male elite decorated their *collège* with the signs of their acquisition of social status. The students were learning to articulate the mythology that would be expected of them as *officiers*.

The transmission and practice of a classical lexicon also occurred through the dramatic recitation of the texts. For example, during the *entrée* of Louis XIII in 1622, students from the *collège* in Lyon put on a play entitled "l'Hercule Gaulois."[12] Theatrical performances also took place in the *collège* as part of the curriculum.[13] The plays drew upon a range of material from Latin tragedies to vernacular pastorals. Seventeenth-century French students reenacted Roman history and performed philosophical lessons. Julius Caesar was killed in the vernacular by schoolboys in Haute-Savoie.[14] The students at a Jesuit school performed "Diogène le Cynique cherchant un homme" ("The Cynic Diogenes Searching for a Man").[15] One imagines the stiff reading of Latin (inflected by a local accent) under the watchful eye of a Paris-educated scholar, while an adolescent held out a lantern and searched for one good man among schoolboys.

For aspiring jurists, provincial elites, or royal officials, plays in both Latin and French were useful oratory exercises as well as rehearsals for political life. Instead of relying on the written word, the students presented their declamatory authority and power of rhetorical gesture. This coordination of verbal and kinesthetic skills was an exercise in memorization, expressivity, and public discourse in the form of disciplined recreation. Matriculants vividly displayed their capacity to imagine antiquity and visually to recapitulate the figures and actions of the historical past.

While at times the world of the *collège* may have seemed to the student a world apart from extramural affairs, where disputes took place in Latin over the fixed material remains and vocabulary of dead cultures, the bright *collégien* found ways of integrating contemporary materials of a different order. The brothers Perrault, Charles and Claude, wrote at least two extended travesties of ancient epic poetry – a burlesque translation of the sixth book of the *Aeneid* and a homeric spoof, *The Walls of Troy, or the Origin of the Burlesque* (1653).[16] By writing a comic version of their *collège* texts, the young men were responding to a vogue in the literature and pamphlets during the civil unrest of the mid-century. In his memoirs, Charles Perrault explained the immediate references for the burlesque transformation of classical literature. According to his mythological literary history, Apollo invented the various genres of poetry based on different needs and social experience. While the god invented pastoral verse in order to seduce shepherdesses, burlesque arose from his laborious construction of the walls of Troy: "It was in the workshops of the masons and all sorts of workers that he learned all the trivial expressions that entered into the composition of the burlesque."[17] While bucolic verse was a masculine genre of sexual conquest, burlesque was the appropriation of the language of members of a lower social order. The acquisition of argot and its introduction to the classical lexicon was a conspicuous mixing of social registers. The burlesque is one demonstration of the active integration of classical and contemporary culture in Poussin's France. The culture of Rabelais was not entirely suppressed in the seventeenth century.

The literary exercises of the Perrault brothers were the result of a relatively uniform structure of education that simultaneously set local elites apart from social inferiors and provided a shared language that was transposed into various areas of social, commercial, and political experience on a national level. The matriculants in various provinces shared a common language and reservoir of experiences that set them off from their indigenous local cultures. In sixteenth-century Nîmes, for example, the speaking of Languedoc was forbidden in the *collège;* only Latin and French were permitted.[18] Various provincial elites identified more closely with similarly educated elites throughout France than with those versed only in local customs and language. (Hence Montaigne's identification with the Tiber rather that the Seine, or the local Garonne.) Yet the study of Latin did not entirely isolate the matriculant from social life and indigenous institutions.[19] Although humanist education transformed local practices, the *collège* was not cut off from daily experience. The student was trained to understand the quotidian event through its similarities to and differences from actions that preceded it in other places. The imaginative identification with the historical past was shared by students from different regions in France. An essentially bilingual education linked ancient Roman and contemporary French historical precedents with contemporary institutions. By reading *en face* translations of Cato, for example, the student integrated an acquired lexicon of rules of conduct with vernacular speech.

A shared education rather than blood or geography constituted the *habitus* of an emergent social and political group that attached particular importance to history.[20] The acquisition of a shared body of historical precedents and exempla was in part the result of a significant historical consciousness inherited from the response to the civil wars of

the sixteenth century. Because the authority of political transformation during the *ancien régime* was based on models of restoration, those who had a command of historical precedents enjoyed political power. Ancient historiography and rhetoric were necessary political tools.[21] Henry IV depended upon the humanist's topos of recuperation after a period of decadence. An educated elite was therefore integrated within the evolving nation state. The *noblesse de robe* felt at ease in the Grande Galerie; no doubt the uneducated noble of the sword felt less so.

Historical Skepticism and Material Culture

Part of the feudal noble's discomfort with the Grande Galerie was based on his relationship to the *entrée*. He probably had to bluff his way through the articulation of antiquity by urban elites. Like the *entrée's* imaginative scenography, Poussin's feigned reliefs were meant to evoke the Greco-Roman past in order to define the relations between king and subject in the emergent modern state. We can infer from the scattered remnants of Poussin's program the peculiarity of the project. The proposed gallery was a declaration of planned intelligibility that coexisted with an intimidating obscurity fostered by the sheer layering of iconography and compounded formal references. The difficulties of mentally ordering the program's overlapping fictive registers, Trajanic and Herculean imagery, faux embossed bronze and relief marble, was further complicated by their serving as a frame for casts of actual antiquities. The physical and conceptual organization of invented artifacts entailed skills that were also rehearsed in the handling of the actual remains of the historical past. These were talents shared by a group that clearly felt more comfortable holding Perrier's compendium of ancient sculpture than the reins of a horse during a stag hunt.

The collection and analysis of antique material objects was fostered by the *collège* as early as the sixteenth century.[22] As in the practices of the Republic of Letters, antiquities were used to express political as well as personal bonds.[23] Like literary references ancient objects embodied a shared repertory of themes. In addition, artifacts circulated within communities and thereby provided opportunities for distinct verbal, visual, and performative protocols. The physical exchange of ancient objects was a means of recognizing personal and political loyalties by registering a bond between royal agents and local elites. For example, the two officials involved in the royal entry into Lyon, Bellièvre and de Langes, were bound to each other by the ties of exchange: Langes recognized his friendship and alliance with Bellièvre by bequeathing his substantial collection of ancient medals to Bellièvre's son.[24]

For Poussin's patron Sublet de Noyers, who imagined the Grande Galerie as a repository of antique objects, antiquarian practice was not divorced from social and political considerations. His own austere Parisian *hôtel* had an ancient frieze set into a wall.[25] The fragment of Gallo-Roman sculpture, representing an imperial eagle, was the gift of a political client in Nîmes. The object recognized mutual education, dependence, and support. Consistent with this shared interest, Sublet's military dispatches included plans to document and restore antiquities in the region. Engraved architectural portraits of ruins in Orange were commissioned by the centralized state.[26] The architect Le Mercier was sent to Nîmes to document and restore the arena.[27] Ruins with significant symbolic value on a local level were simultaneously validated and brought into the culture of the *patrie*. The discourse of *patrimonie* was in the process of being invented.

The intensive acquisition of "the molds of the most beautiful bas-reliefs of Rome" for the Grande Galerie of the Louvre can be understood within this tradition of collecting and organizing artifacts in France. While the casts of Trajan's Column and tondi from the Arch of Constantine aggrandized the crown, they also demonstrated the capacities of the royal officials. As the encomiastic *entrée* was the site for negotiating power relations between monarch and subject, so too did political discourse surround the ancient Roman artifacts. Cast reliefs and the art of memory displaced spolia and the art of war.

Antique objects occupied an important place in the epistemology of seventeenth-century France. The primacy of the historical reliability of inscriptions and medals over literary sources has been described by some scholars as a development in late seventeenth-century historiography. But the investigation of ancient material culture in response to skepticism regarding textual evidence had its antecedents in the previous century.[28] This radical break with the *ars historica* of the Renaissance had been signaled in France by a profound theoretical debate over history. Humanism's interest in ancient history as a model for literary style gave way to an examination of the texts as evidence. In a shift from the art of writing to an art of reading, historians doubted the reliability of the sources and the objectivity of their authors. The authority of Greco-Roman historiography was called into question by those who criticized the lack of documentation and pointed out inconsistencies.[29] Early modern writers such as Cornelia Agrippa turned to the discrepancy between contemporary investigation and the knowledge of the ancients. For example, he compared the recent information obtained from European incursions in Africa and the Americas to the ancient false reports of "pygmies and troglodytes."[30] The sudden discovery of a world and peoples not accommodated by the epistemological and political organization of the Roman empire presented a crisis for the humanists of the sixteenth and seventeenth centuries.[31] When the French confessed to the Iroquois that they did not know anything about the native inhabitants before their encounter, one of the indigenous people replied "Then you don't know all things through books, and they didn't tell you everything."[32]

This epistemic shift in European intellectual and legal history points to a significant modification of the use of antiquity as a model for contemporary action. The French jurist Jean Bodin responded to attacks on the inherited system of Roman law as an anachronistic and historically relative set of practices written at a particular juncture in the development of the Roman empire.[33] In Bodin's jurisprudence, rather than choosing between the outright rejection of Roman law or accepting it as flawless synchronic justice, he treated it as a historically and customarily determined system that offered only a partial prescription for contemporary practice. In effect, the ancient written sources were recognized as a set of disparate, sometimes contradictory, authorities. Another French scholar of jurisprudence, François Baudouin, similarly responded to doubts about historical knowledge by putting the ancient authors in an expanded field of evidence. It was possible to recuperate historical veracity by turning to analogies in judicial practice and its use of evidence. For Baudouin, paintings, tapestries, and statues were entered as juridical exhibits for argument.[34]

The French historiographic debates of the sixteenth century had resulted in the conversion of the artifact from prestigious mirror into historical evidence. Rather than a theoretical debate restricted to French intellectual history, the treatment of archeological finds as historical evidence developed through the local acquisition of ancient material culture and its linguistic protocols. The commentary on Gallo-Roman architecture and archeological fragments, especially the Latin inscriptions on stone, treated the artifact as material proof of the validity of historical experience.

The Politics of the Antique Object

The emergence of archeology in France can be attributed in part to the fact that there were ample opportunities to integrate antiquarianism and early modern political institutions. As I have shown, humanist knowledge and its historical practices were absorbed into the developing French state. In addition to ancient literary culture and the deployment of an iconographic lexicon for political purposes, the research of antique objects joined the field of strategic power. The archeological reconstruction of antiquity by Poussin's French clientele was understood within this tradition: excavation, physical organization, verbal protocols, and textual enframement. Recently, scholars have described the ways in which the acquisition and exchange of knowledge about ancient artifacts and other objects constituted an important social practice among an elite associated with Poussin in Rome.[35] This was part of Poussin's training. In Rome his drawing of the triumphal frieze addressed a shared intellectual project (fig. 20). However, when his paintings representing classical antiquity made their way to France they enjoyed a different reception as a result of another set of social and political institutions. In French antiquarian practice, ancient artifacts, in addition to serving as a cement for patterns of sociability, were used to exert political power. Far from merely reproducing monarchical power, antiquarianism was a form of research by different groups for the practical assertion of rights and privileges derived from historical precedent.

Beginning as early as the sixteenth century, archeological expertise became part of organized political practice in France. One prominent provincial antiquarian was the great-great-grandfather of the famous president of the Parlement of Paris and owner of a painting by Poussin: Claude I de Bellièvre (born in 1487) was a magistrate trained in law at the University of Toulouse. He became a barrister for the king, one of the leaders of the civic government in Lyon, and then first president of the Parlement of Grenoble. When Claude's son Pomponne I de Bellièvre designed the triumphal program of the entry at Lyon, he was exercising his intellectual inheritance. The elder Bellièvre ranked with Guillaume du Choul as one of the major antiquarians in sixteenth-century Lyon. Chief among their preoccupations well into the eighteenth century was the collection, transcription, and discussion of the inscriptions left by the Roman colonists of Lugdenum.[36] Bellièvre's passion for the collection of Latin inscriptions from local Gallo-Roman fragments made his *jardin des antiques* overlooking the confluence of the Rhône and Saône a much frequented site made freely available to local and visiting antiquarians.[37] While this activity was an important part of his *otium* (studied leisure), it was also integrated with his active professional and political life.

In 1528 an important archeological discovery took place that exemplifies the engagement of antiquities with politics. A monumental bronze tablet inscribed with an official proclamation by Emperor Claudius was unearthed (see fig. 19). The find was significant because it provided physical evidence of the privileges the emperor had given to Lyon, previously known only from a text of Tacitus.[38] As it marked the official recognition of the speech delivered in the Senate in Rome, the inscribed metal was thought to be more faithful to the original speech. For Claude I de Bellièvre, magistrate and local political authority, the discovery of the bronze tablet counted for more than just erudition. Indeed, the material record of a Roman emperor's proclamation, like many other imperial artifacts found in Lyon, attested to Lyon's significant status under the Roman Empire, far exceeding that of the colonial outpost that became Paris. The object offered physical testimony to a known literary text in which the Roman emperor recognized Lyon's special privileges as a Roman colony. The Gauls were claiming the right not only of citizenship

20. Poussin, *The Triumph of Titus*, mid-1630s, pen and brown wash on paper (Stockholm, Nationalmuseum, NMH 1511/1875), 151 × 277 mm.

but entry into the Roman senate. According to Tacitus, the emperor's speech in favor of their election contradicted the arguments presented to him for the ethnic purity of the Senate. Claudius introduced his argument by stating that he would bring "excellence to Rome from whatever source."[39] He spoke of the historical precedent of the absorption of different cities into the empire, which reinvigorated the exhausted state:

> What proved fatal to Sparta and Athens, for all their military strength, was their segregation of conquered subjects as aliens. Our founder Romulus, on the other hand, had the wisdom – more than once – to transform whole enemy peoples into Roman citizens within the course of a single day.[40]

Bellièvre was responsive to the artifact's testimony to political integration as a later generation would turn to *The Rape of the Sabines* (see fig. 10). For Bellièvre the bronze artifact was especially significant because its inscription varied from the version published by Tacitus. The variation acknowledged that Lyon had rights to representation in the Senate.[41] Rather than pointing to the impossibility of belief in Tacitus, the material inscription offered a comparison of sources and opportunities for drawing inferences and conclusions based on the combined body of knowledge.

In addition to purchasing the tablet and translating the Latin inscription into French, Bellièvre installed it in the consul's quarters at the *hôtel de ville*.[42] Antiquity was not reserved for the private cabinet. Instead, it entered the civic forum. The artifact belonged to something akin to patrimony or the public domain. The political efficacy of Bellièvre's gesture was more substantial than a vague expression of civic pride. He brought to the object a lawyer's mind for historical precedent. Eight years later, he wove the story of the tablet into a petition to Francis I in order to obtain permission to found a Parlement in Lyon.[43] The text was useful: Claudius recognized that the Gauls had resisted Julius Caesar for ten years, yet when incorporated within the empire, their fidelity was inviolable. The tablet was a physical recognition of the privileges bestowed on a semi-autonomous

geographical and political entity in exchange for loyalty. It enlivened a discourse otherwise prone, in less adept hands, to feudal formulas of fidelity. Humanist erudition was put to political purpose. During the *ancien régime*, maintaining and pursuing privileges for individuals, corporate entities, cities, or provinces, relied on historical precedent, documentation, and argumentation. Bellièvre's legal and rhetorical skills took historical materials, including artifacts, and used them to argue for local prerogatives from royal authority.

The Claudian tablet continued to participate in the political symbolism of Lyon as part of what might be called institutional antiquarianism. Once Bellièvre had brought the artifact into public circulation, it continued to accrue symbolic associations for at least one hundred years. Value became contingent on shifting historical circumstances. Such a revaluation occurred during the decade that Poussin was working for clients in Paris and Lyon. The tablet was inserted in a new and significant framework in the 1640s: plans for the construction of a new *hôtel de ville* in Lyon coincided with the reassertion of local powers and the attempt to strengthen the local government after Richelieu's death. While there were open rebellions in Paris and Bordeaux during this period of civil war known as the Fronde, which will be discussed in Chapter Five, Lyon asserted the political authority of its indigenous institutions through the strategic representation of the city's special relationship to antiquity.[44]

The *hôtel de ville* was envisioned as a decorous display of the town's claims to participation in the *royaume*. The impressive architectural statement by the Lyonnais was intended to encourage patriotic zeal while at the same time inspiring one eulogist to compare it to the pyramids and causing him to exclaim "I dream the ancients."[45] The Claudian tablet was prominently displayed in this ideological and decorative framework: feigned ancient portrait medals depicting French royalty encrusted the facade of the building, attesting to the local practice of celebrating the French monarchs as ancient rulers.[46] Simultaneously, the ceiling was invested with allegorical representatives of the civic ruling body as nobles with local rights and privileges recognized by the crown.[47]

The Claudian tablet was not only imbedded in the conspicuous architectural symbol of local power, but also in the textual buttressing of the traditional civic authority, the *consulat*. The construction of the *hôtel de ville* and its symbolic embellishment with the Claudian tablet coincided with the civil war of the mid-seventeenth century. In the midst of the Fronde, as other provincial cities engaged in open rebellion, the Lyonnais *consulat* used their relative obedience to the crown to reassert their own prerogatives. A local printer was commissioned by the *consulat* to publish all extant archival documents of privileges given to the Lyonnais and their municipal ruling body.[48] Dedicated to the *consulat*, who was thanked for preserving "calm" in the midst of the "flood" and "tempest" of the Fronde, the *Recueil des privilèges* was a bid for institutional authority that used Seneca and the Claudian tablet as set pieces: the inherited local institutions derived their authority from the Roman Empire, only their names had been changed.[49] In addition to providing an object for rehearsing ancient etymologies in the tradition of du Choul, the tablet was also exploited to support claims made by the local elite that the civic authorities, like the colonial senators, had powers derived from the authority of a larger political system. By locating their authority in history prior to the French monarchy, an important distinction was made about the derivation of power. In exchange for voluntary submission without force or constraint, the king confirmed rather than granted privileges. Like the ancient senators, nobility was recognized in exchange for service and fidelity. By comparison to the bloodshed and prolific anti-regency propaganda of Bordeaux, Lyon was deceptively calm. If one looks to these traditional strategies for the assertion of political power, a picture evolves that shows the coordination of legal tactics and antiquarian cultural resources.

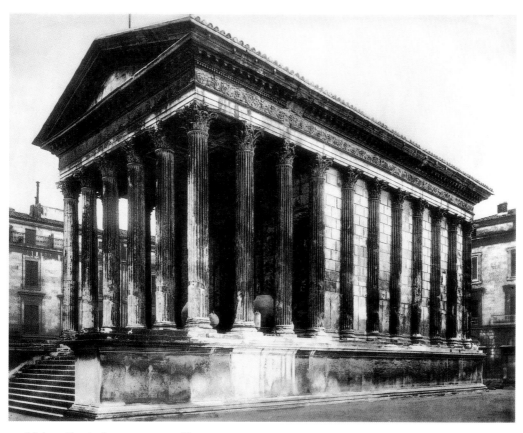

21. Maison Carrée, begun c. 19 BCE, Nîmes.

Montaigne's claim that he knew the Roman Capitoline before he knew the Louvre, giving priority to Latin literature and Roman archeology over the capital of modern France, has a particular valence when one considers his statement among the other provincial claims to inherit ancient Roman authority. Although antiquity has provided European elites with an abstract, imagined community, in Lyon the presence of Gallo-Roman ruins demonstrated that the city was historically part of the political institutions of the Roman Empire. For the Lyonnais, the ancient referent was not entirely geographically exterior or temporally discontinuous.[50] Rather, Roman antiquity served a strategic political purpose precisely because it was a valued term not identified with Paris. The Claudian tablet was a discrete artifact whose significance permutated in relation to its verbal and architectural setting. The combined legalistic and archeological strategies of Claude I de Bellièvre survived well into the seventeenth century.

The use of antiquities as vehicles for the assertion of local powers in relation to royal authority was not restricted to inscriptions. One sixteenth-century architectural historian and antiquarian, Jean Poldo, wrote an historical and formal analysis concerning antique buildings in Nîmes including the famous Maison Carrée (fig. 21).[51] His text methodically disproved earlier written accounts which stated that the building was an example of Gallo-Roman sacred architecture, a basilica built by Hadrian dedicated to his wife. He ruled this out on the grounds that its formal austerity would have been inappropriate for an imperial building. Instead, he argued, it was a "*Capitole*, or *consulat* house of the city." It had been used by public administrators of the town: there they had deliberated and issued edicts on public issues. The fact that for some four centuries the building had fallen into

private hands was for Poldo a sacrilege and an outrage "against the public." According to the historian's sense of precedence and continuity, the building that was the equivalent to the *hôtel de ville* and represented the consular form of elected government under the Roman Empire still belonged to the body politic: in no uncertain terms he stated in the present tense that "this house is public, sacred, and inalienable." He likened the possession of the Maison Carrée as private property to the occupation by "the barbarians of ancient Rome."[52]

Well into the seventeenth century, accounts of local antiquarian history and architectural forms were inseparable from the understanding of the customary privileges and liberties that belonged to provincial urban centers.[53] Identified as a capitol, the Maison Carrée stood for a history of the semi-autonomous relationship to imperial authority that preceded the relatively recent history of French rule since 1481.[54] The significance of this prestigious symbol of local privileges could not have escaped Colbert when he planned to number and dismantle its architectural members and transport it to Paris or Versailles.[55] As long as the building stood, it was subject to appropriation by interpretative communities.

Architectural history therefore belonged to the broadly defined field of antiquarian practice. The ruin, like the ephemeral furnishings of antique triumphal imagery or the bronze inscription, was a site in which elites, such as Poussin's French viewers, performed skills that had been inculcated in them as a social group in the *collège*. Historical example and ancient iconographic elements combined in the spectacular representation of reciprocal power relations in a culture that physically and conceptually handled the archeological remains of the Roman past. In sixteenth- and seventeenth-century France, antiquarianism was a discipline that developed in tandem with the emergent state. The unearthed, engraved tablet and architectural fragment were inserted into a political discourse that negotiated between centralized power and local rights and privileges. Archeology was a critical tool that had a bearing upon the production and reception of Poussin's art.

Classicism as Conflict

The system of myths and allegories shared by a social group and used to bolster itself and the monarch can seem to be an apology for the political order of the *ancien régime* and an absolute social solidarity. Yet the critical potential of antique referents in classical erudition may be better described by a less stable and more conflictual model of culture.[56] Despite Richelieu's attempts to regulate education and thereby control the political participation of elites, the curriculum in Latin and Greek letters continued to provide models of conduct that were potentially at variance with the maintenance of a centralized state.[57] Furthermore, as I have argued, assertions of local privileges were advanced by reference to customary liberties derived from a Gallo-Roman past. The education and skills of the *noblesse de robe*, as they represented their interests and those of the *roturiers* (nonnobles) in general, were deployed at the points of conflict in social and political organization. Conflict in the *ancien régime* was articulated in terms of tradition, customary rights, and privileges. The so-called legalism of the Parlement of Paris is only one important example of the ways in which justifications for social and political conflict were based on textual claims to traditional authority.[58] The conflict over artifacts also helps us to reconsider the immediate slippage between classical mythology and political reproduction.

The manipulation of local antiquarian resources was an integral part of the relationships defining civic ruling elites and the crown. One could read such an assertion of a "traditional, integrated local culture" as a reassertion of customary independence in response to "foreign" royal interventions in the increasingly centralized state (embodied, for example, in the person of the *intendant*). However, as historians have pointed out, the problem with this model of resistance to a repressive regime is that it forecloses the important collaboration between crown and ruling elites.[59] The *consulat* and other forms of local government had been for centuries part of a royal system with more or less autonomy.[60] The assertion of local powers and prerogatives was achieved through the same resources deployed to bestow power on the monarch. Strategic opposition occurred within a system of power relations articulated with a shared vocabulary, not from some imagined point outside power.

During the sixteenth and early seventeenth centuries, humanist materials and practices were negotiated in a period of crisis. Sometimes the sense of belatedness of humanist exemplarity resulted in a nostalgia for the authority of antiquity. This offers a partial explanation for the recuperation of humanist themes in Poussin's work. But nostalgia is not necessarily a complete denial of the conditions that precipitate loss. After the sack of Rome and the bloody religious wars of the sixteenth century, thinkers turned to the historians Tacitus and Flavius Josephus, who spoke of the tyranny and decay of the Roman world, the destruction of the universe of Moses, and the submission of the exemplar to the abuses of power and realpolitik.[61] Poussin's paintings trace a deep-seated ambivalence to the exemplarity of the pagan past expressed within the epistemology of humanism.

In 1641, the Grande Galerie project articulated a particular development of humanism in early modern France. As in Poussin's drawing from the Arch of Titus (see fig. 20), the *noblesse de robe* sought an oblique view onto the triumph. Far from seeking a fictional mirroring identification between historical example and contemporaneous prince, the ancient artifact served as a critical measure of royal institutions. Montaigne's imaginary conceptual center along the Tiber displaced Paris as administrative capital. Sublet de Noyers's cultural ambitions for the Grande Galerie, in turn, allowed the readers of Montaigne to superimpose the Tiber onto the Seine, the Capitoline onto the Louvre. When Sublet de Noyers acted on behalf of Louis XIII and directed the decoration of the Grande Galerie, he chose Nicolas Poussin to carry out that project. The artist's credentials included his physical proximity to Montaigne's imaginative geography as well as the requisite literacy in Greco-Roman materials. Sublet's anticipation of success was based not only on the physical evidence of pictures but also the fertile ground that existed in France for the reception of the antiquarian-artist as well as the support Poussin had already been able to solicit there. The following chapter will demonstrate how Poussin successfully obtained commissions and interested purchasers among powerful officials.

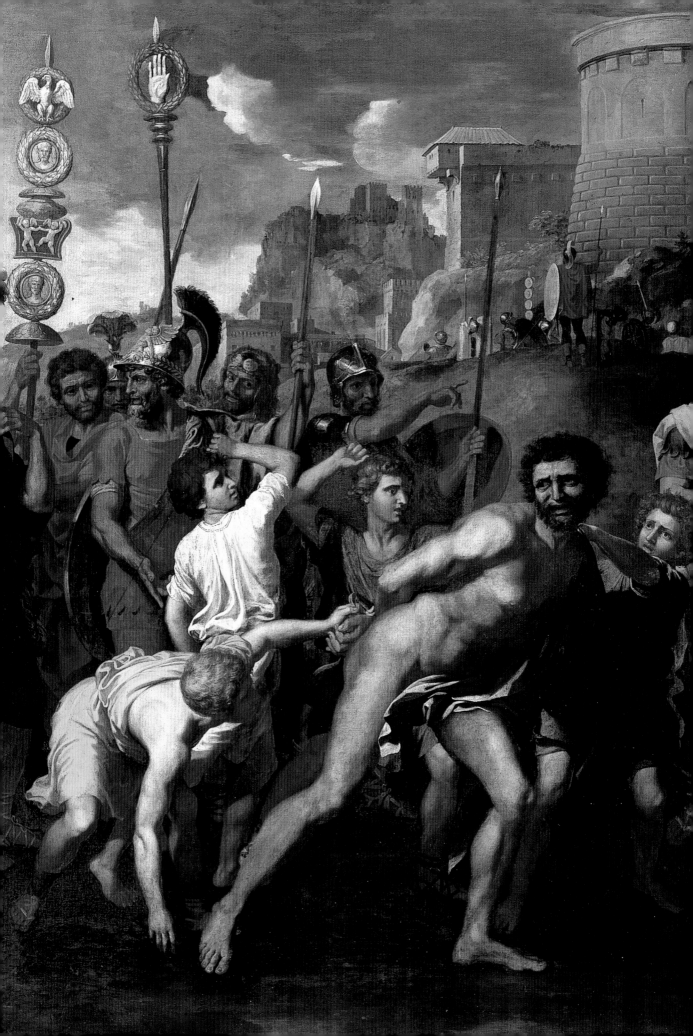

Chapter Three

Emergent Clients

Humart [Passart] wants to pass for a man
As knowledgeable as any seen in Rome.

Banquet des curieux.

A manuscript in the Bibliothèque de l'Arsenel in Paris offers a satirical glimpse of collectors and connoisseurs there in the late seventeenth century.[1] The generous satire *à la clef* describes one of Poussin's oldest and earliest supporters in France, Michel Passart, at a social gathering in the guise of "Humart." The ritual of sociability reminds us of similar convocations in Rome under the rubric of *accademie*.[2] That such gatherings occurred in Paris is attested by a dinner held in Poussin's honor during his stay.[3] A painting by Eustache Le Sueur representing just such a Parisian meeting (fig. 23) bears a resemblance to group portraits of civic elites, such as Philippe de Champaigne's *Echevins* (fig. 24). Both pictures make special claims for a space of male social intercourse. In Champaigne's group portrait of the leaders of the city of Paris, painted in 1648, conventional compositional regularity and labor-intensive veristic treatment of stiff piety plead for social continuity and political stability during a year of insurrection. By contrast the men in Le Sueur's painting demonstrate a selfconscious effort to evade official uniformity. They declare that identity can be fashioned outside of commercial and civic institutions. Unencumbered by the visual markers of station, these men assume an array of personifications. Le Sueur's depiction of a painter in this intimate group of recreating *honnêtes hommes* is significant and suggests that this artisanal practice was appreciated by Parisian cultural elites. The highly cultivated appreciation of paintings, however, was in the process of being invented in France during this period. By associating Passart with specialized forms of knowledge and expertise found only in Italy, the anonymous writer of the *Banquet* continued to pose Rome (rather than a French picture gallery) as the symbolic center of that pursuit.

A contemporary might state that Passart wished to pass for a Roman savant, and this identification with Rome was far from foreign to French elites. Rome had long signified the eternal city. The history as well as literary, archeological, and artistic cultures of Rome formed the capital for an imagined community: the reconstruction of a Latin phrase inscribed on damaged stone; the comparison of two Roman buildings in the former colonial outpost of Provence; erecting a makeshift triumphal arch with verse appended to the trompe l'oeil marble posts. These were only some of the ways antiquity was performed and experienced in the century of Poussin's birth. Broadly speaking, however, France had not yet invented for itself a culture that brought those practices to painting, and more

23. Eustache Le Sueur, *Réunion d'amis*, 1648, oil on canvas (Paris, Musée du Louvre, inv. 8063), 1360 × 1950 mm.

specifically the tableau. French easel painting eventually emerged as a significant object in a visual culture that initially privileged the materials of antiquity, and Poussin played no small role in this emergence. His call to Paris by Richelieu's regime in 1640 acknowledged the arrival of painting as an appropriate vehicle for a literary and visual culture that had until then been preoccupied with the study of plaster casts, epigraphic inscriptions, and buildings as well as the production of triumphal entrances.

Poussin's reputation had been established in the preceding years by a number of tableaux commissioned by members of the elite most conversant in these humanist practices, the *noblesse de robe*. Probably the earliest of these works was a painting executed for Passart that was explicitly dedicated to Roman history: *Camillus and the Schoolmaster of Falerii* (figs. 22 and 25). The importance of this theme is demonstrated by the fact that soon after its completion Poussin painted a larger version for another Parisian client (see fig. 34). Poussin was constructing a desire for painting that acknowledged special skills, which I described in the previous two chapters. It was Poussin's role as an artist to address Passart and permit him to recognize himself through the viewing of a painting as a man "as knowledgable as any seen in Rome." This chapter is about that act of interpellation.

Portraying Michel Passart

Michel Passart was born into a bourgeois family that had been successful in its bid for respect and a secure position in Parisian society. He was the descendent of a leather merchant who was able to purchase a fief in 1509.[4] Yet the Passart name had not accrued prestige solely from a fief or pedigree of marriage alliances but largely from its historical power and links to political clientage. Michel Passart's grandfather, Michel Passart le Gaucher,

24. Philippe de Champaigne, *The Prévot des marchands and the Echevins of the City of Paris,* 1648, oil on canvas (Paris, Musée du Louvre, MI 911), 2000 × 2710 mm.

had been rewarded for services rendered to Henry IV.[5] During the Bourbon campaign to control Paris, the elder Passart was the leader of an armed bourgeois militia. He was not above promenading on the quai Saint-Germain with his cronies, refusing the company of Calvinists and telling them to go to the devil.[6] But in the *quartier* by *quartier* campaign of allegiance during the final months of the Wars of Religion, Passart did not please the intransigent Catholic League, who controlled the city, because he was ultimately willing to reach a political compromise with the Huguenots and indeed became loyal to Henry IV. When Passart's grandfather was exiled by the Catholic League from Paris, he immediately joined Henry's army, which was laying siege to the city. The king was angered that Passart, a "true citizen" and his "good servant," had been hunted from Paris by *sots*.[7] As a result of this declaration of loyalty, the political fortunes of the Passart family soon changed when Henry made his triumphal entry into Paris a few months later, in 1594. The Passart name was effectively anchored to the Bourbon patronage of loyal bourgeoisie and the *noblesse de robe*.

Like the *parlementaire* and political theorist Guillaume du Vair, who suppressed resistance to the King's entry around the Sorbonne, the rewarded *bourgeois* Passart participated in the culture and politics embodied in the royal entries.[8] While Passart did not, in fact, have the education and administrative talents of du Vair, at least we can be sure that he deployed his financial resources and newly acquired political influence for the education of his children in order to insure their social advancement. In the pattern typical of its class, the Passart family obtained royal offices and formed alliances with other prominent families through marriage. Michel Le Gaucher's eldest son (the collector Michel's great-uncle) became a royal office-holder who also obtained noble patronage and saw to it that his sons entered the Parlement of Paris.[9] Because Michel's father Claude was not the eldest son of the veteran of the Paris siege, his passage to noble status was less immediate. Instead, Claude Passart became a prominent wine and fish merchant and a member of

the *consul des marchands*. In addition to this position in the civic government Claude purchased an office, *conseiller et secrétaire du Roi*, with funds from his business and the influence of a good name. No doubt his business sense also made him attractive to a noble house that enlisted his services as a treasurer.[10]

Poussin's Michel Passart was Claude's eldest son.[11] He was no doubt brought up to assume his position as patriarch within an aspiring Parisian *robe* family; he was educated in a *collège*[12] and had a comprehensive collection of law books and the requisite *Lives* of Plutarch.[13] Passart was versed in the textual culture that constituted Poussin's audience. The inventories of Michel's papers trace the other achievements of a successful bourgeois – inheritances, *rentes*, acquisition of properties, influential marriage alliances for himself and kin.[14] In addition to these records of financial transactions marking events in a substantial bourgeois life, there are other surviving patterns of affiliation and identity. Soon after he had acquired the Poussin *Camillus*, Passart gained individual political and social prominence with the purchase of one of the offices in the *Chambre des comptes* holding the title of *auditeur*, serving as an auditor and notary.[15] He acquired irrefutable respectability as a member of one of the prominent sovereign courts of Paris along with the Parlement. While his grandfather had policed the streets around the *hôtel de ville* with his militia and his father had accrued prestige as a prominent merchant, Michel Passart joined the honorable ranks of the nobles who milled around the Palace of Justice in their red robes, the so-called *robins*.[16] The simultaneous acquisition of an office and a painting points to an emergent pattern: the reciprocal relationship between collecting art and social and political advancement.

The Robin: *Prestige and Political Theory*

Michel Passart's ascendance in the social and political hierarchy of early modern France was not a repudiation of his class. Far from the stereotype of the *parvenus* who sought to disavow their *roturier* roots by becoming landed gentry, the bearers of the Passart name sought to imbed its prestige in the fabric of Parisian urban bourgeois society.[17] Furthermore, part of Passart's identification with his family name entailed an obligation further to aggrandize his social and political standing. When Michel Passart made his debut in the Chamber as an *auditeur*, the purchased office promised an income or *rente* and was the expected (and mandatory) initial office for those who had ambitions for the more prestigious ennobled office of *maître des comptes*.[18] In 1650, Michel assumed the title of *maître* in the *Chambre des comptes*,[19] his brother took over his position as *auditeur*, and before Michel's death in 1692, his son inherited his office.[20] Michel had the fortune of holding his office longer than any *maître* in the history of the *Chambre*.[21] While his son and brother sustained the Passart line within the *noblesse de robe*, his daughter married into a noble house, consolidating the family's prestige.[22]

This brief history suggests the associations evoked by the Passart name in mid-seventeenth-century Paris. Although the Passarts were often well-off, they were not members of the powerful financial elite. They were far from being considered *parvenus*. Disinterested service to the state and aristocratic distinction were not only based on an abstract ethical position, but were also predicated on distance from the conspicuous production of money. The Passarts achieved noble status through offices and perhaps *seigneuries*, yet chose to maintain their old Parisian name.[23] Despite their nobility, Michel and his family bore their coat of arms (a field of gold with three birds – *merlettes de fable*)

more lightly than the name itself. Rather than borrowing the entitled name of a purchased fief, Michel referred to himself as Passart, the name of his grandfather the bourgeois militiaman who struggled through the street politics of the League. To do so expressed a desire to identify himself with his family's honorable bourgeois ties and the prestige associated with the family name imbedded in the historical and social fabric of the streets of Paris rather than a distant country seat.[24] Historical associations overrode feudal values.

Michel Passart occupied a relatively secure position in the social hierarchy. This position was contingent, however, on the cultural resources at his disposal. He was a member of the educated elite whose deployment of literature and historical precedent traditionally insured participation in the affairs of the state and served to differentiate its members from the ancient nobility. However, at the same time that Richelieu centralized the state through French humanist culture, there was a perceived erosion of the authority and privileges of the office-holders. Acting on behalf of a royal treasury always on the brink of bankruptcy, the First Ministers Richelieu and Mazarin raised funds by creating more offices, thereby exacerbating a tension between the crown's interests and the traditional office-holders.[25] The increase in the number of *officiers* not only threatened the monetary value of these lucrative positions, but lessened their prestige and compromised their integrity. As fiscal pressures introduced *parvenus* into the ranks of the *noblesse de robe*, social categories were blurred. If distance from trade and financial speculation was a traditional measure of nobility, then the status of the royal offices was compromised. Fearing that the sovereign courts would be overrun by rich *financiers*, the *officiers* resisted the creation of offices and obtained some concessions from the crown.[26] The *robins* also attempted to maintain the integrity of their offices by screening office-holders and encouraging the election of people with solid credentials such as Passart, who purchased legitimate ancient offices.[27] For Passart, in addition to his solid *haut bourgeois* credentials and patrilineal status as a servant of the king, assuming an office created in 1483 provided an abstract genealogy, a family tree based not on blood but historical affiliation. In marked distinction to the *noblesse d'épée*, history was thicker than blood for the *noblesse de robe*. Lineage was based on service, shared duties, and other meritorious signs of social recognition.

The literature, history, and antiquarianism learned in the *collèges* had been a rehearsal for the daily political practices in sovereign courts such as the *Chambre des comptes*. As the *noblesse de robe* perceived that their actual power was being threatened, their cultural resources, inherited largely from the previous century, became increasingly symbolically central. The selfconscious and belated recuperation of sixteenth-century humanism has been discounted by some scholars as a form of nostalgia. But one cannot underestimate the authority that resulted from the recitation of historical memory and the claims for the continuity of cultural practice. This was the culture that affiliated the Passart name with the authority of Henry IV.

Power in the Archive

Trained as legal historians, the members of the sovereign courts were archivists who drew on historical precedents in order to pursue their interests. This was valuable knowledge in a society held together by a complex web of documents concerning genealogy, property, and privileges. In short, the *robins* were skillful lawyers who set a premium on historical interpretation.

Michel Passart was one such archivist. He was an active and talented member of the *Chambre des comptes*, which was directly responsible for the finances of the crown. First appointed as one of the auditors, he was carefully selected and overseen by the masters to exercise considerable fiscal responsibility and even had a deliberative voice in the Chamber.[28] After serving as an auditor for thirteen years, he was then received in the prestigious office of master and continued to be given a series of important duties.[29]

Passart's political power was not limited however to his contact with the king's purse, nor were his skills limited to computation. The *Chambre des comptes*, like the Parlement, was designated to approve the edicts presented to them by the king. By tradition, they had the power to present a "remonstrance," a formal speech or harangue that could amount to a form of resistance.[30] According to the political theory of the *noblesse de robe*, it was the duty of the sovereign courts to question the decisions of the temporal king in order to be loyal to the principle of kingship. Speaking in the Parlement of Paris, Omer Talon's famous harangue of July 31, 1648, sums up this position and thereby defines the *remonstrance*:

> The respectful resistance to which we sometimes have recourse in public affairs should not be interpreted as a mark of disobedience, but more as a necessary effect resulting from our duties and from the intention of those who have established the parlements, that is authorized by the public laws of the state and that was introduced by the consent of the kings, your predecessors . . .[31]

Talon articulated a political theory that attempted to separate the inalienable principle of kingship from its fallible embodiment in the temporal monarch.[32] Resistance was not to be confused with refusing to obey. In fact, by stating its objections to royal edicts, the Parlement thereby demonstrated its fidelity to the kings who had invested it with the power to remonstrate against the decisions of any given regime.

These rights were inflected with a greater or lesser degree of passive compliance to the royal will and of contentious assertion of critical autonomy. For example, in the name of the common good, the *Chambre des comptes* protested against the arbitrary creation of venal offices in 1636.[33] Soon after the successful registration of remonstrances, a deputation followed, which thanked Cardinal Richelieu for abolishing two of the newly created offices of *maître des comptes*.[34] Even though the *Chambre des comptes* and the other sovereign courts had to accept to a great extent the fiscal policies of Richelieu, in the give and take of legalistic procedure and compromise, there was an exercise of legislative rights and privileges.[35] While the *Chambre* often used such rights to serve its own interests, they had their basis in the charge from the monarchy itself to exercise "la résistance respecteuse" in the name of the collective principle of the public good.

Here a reader may pause and question whether or not these administrative skills and remonstrative powers, however important for the self-articulation of an elite, had direct consequences for viewing pictures. Verifying or resisting budgets in the Palais de Justice may seem to be an activity that had little bearing on the selection of a painting for Passart's house. Granted the illustration of Roman history provided an appropriate accouterment for the cabinet of an individual who also owned a beautifully bound set of Plutarch's *Lives*, but what were the specific demands put upon the object as a result of the skills and behaviors of the *officier*? In what ways did the viewing of an image, rather than reading a text or listening to oratory, constitute a group? How did the painting help position the accountant Michel Passart as a man imitating the savant at ease among the ruins of Rome?

Camillus and the Schoolmaster

Not a devotional image or decorative landscape or portrait, Poussin's *Camillus and the Schoolmaster of Falerii* (fig. 25) is a representation of Roman history. The story of Marcus Furius Camillus, derived from Livy, can be summarized as follows: around 390 BCE, the military tribune Camillus laid seige to the city of Falerii. After initial tactical successes, the siege became a protracted affair with the city having the advantages of ample supplies and strong fortifications. A scholar who instructed the sons of the best families of Falerii went on one of his accustomed walks outside the city walls, giving a lesson to his aristocratic charges. He distracted his young students with his oratory and led them into the Roman camp where he offered them to Camillus as hostages so that the Roman commander could negotiate a quick victory.

Poussin's painting represents Livy's version, which condemns the treasonable behavior of the schoolmaster as self-interested villainy despite his assistance to the Roman cause.[36] The schoolmaster is an unworthy subject, whose behavior is a negative lesson illuminated by the speech and actions of Camillus.[37] Poussin depicts Camillus's response to the offer:

25. Poussin, *Camillus and the Schoolmaster of Falerii*, c. 1635, oil on canvas (Pasadena, Norton Simon Museum), 810 × 1330 mm.

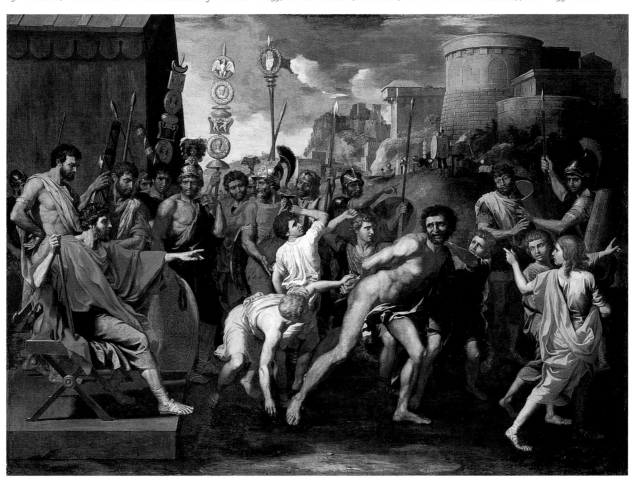

Neither my people, nor I, who command their army, happen to share your tastes. You are a scoundrel and your offer is worthy of you. As political entities, there is no bond of union between Rome and Falerii, but we are bound together none the less, and always shall be, by the bonds of [nature]. War has its laws as peace has, and we have learned to wage war with decency no less than with courage. We have drawn the sword not against children, who even in the sack of cities are spared, but against men, armed like ourselves, who without injury or provocation attacked us at Veii. Those men, your countrymen, you have done your best to humble by this vile and unprecedented act; but I shall bring them low, as I brought Veii low, by the Roman arts of courage, persistence and arms.[38]

The brief speech is followed by an active demonstration. Camillus has the schoolmaster stripped naked and his hands tied behind his back. He instructs the boys to escort their teacher home, supplying them with a rod with which to beat him.

In Poussin's paintings, Camillus is an example to his troops just as he is to the viewer. The paintings focus on the impact of Camillus's judgment upon the troops, who witness the effect it has on the would-be hostages. By contrast, a finished drawing by Poussin, probably intended for a collector, perhaps as a gift, emphasizes the young boys as immediate recipients of the lesson (fig. 26). Rather than stressing the event as a lesson for the troops, the drawing interprets the magnanimous gesture as something warranting a response from the boys of the besieged city. In the drawing the action of the children consists of two dominant gestures: the beating of the schoolmaster and a supplication addressed to Camillus. One gesture is a consequence of the commander's harsh condemnation of the schoolmaster. The other signifies a change in their attitude to the enemy: "you have given our freedom, we will honor you and consent to submission." The drawing, therefore, emphasizes the recognition by the recipients of the enemy ruler's generosity. Magnanimity rather than terror wins hearts and subjugates bodies.

In Poussin's painting for Passart, however, Camillus addresses the lesson to his own army. The bellicose frieze of faces and standards stresses their role as witnesses and constitutes a designated audience. The heads are studies of mature men's responsive expres-

26. Poussin, *Camillus and the Schoolmaster of Falerii* (drawing), 1630s, pen and brown wash on paper (London, British Museum), 336 × 495 mm.

sions, which mirror those of the violent boys. This role as responsive chorus is further established by the pair of soldiers to the right behind the fleeing schoolmaster. One soldier does not seem to comprehend and intends to intervene; another holds him back and thus seems to understand that the hostages should be given their freedom and allowed to do their just and violent act of vengeance. While this soldier might lament the lost opportunity for immediate victory, he respects his leader's virtue. The painting, therefore, stresses the moral influence of Camillus on his troops. The commander not only serves an exemplary function but literally delivers a statement on the protocol of siege warfare and the discipline of troops.

In Livy's account of Camillus, the demonstration of exemplary conduct has an inadvertent consequence. The feelings of the inhabitants of Falerii are reversed: "Where once [there was] fierce hatred and savage rage . . . there was now a unanimous demand for peace. In street and council chamber people talked of nothing but Roman honor and the justice of Camillus." By universal consent, representatives declared their surrender: "We shall live better lives under your government than under our own. From this war two things have emerged which humanity would do well to lay to heart: you preferred honor to an easy victory; we respond to that noble choice by an unforced submission." Camillus not only demonstrated his personal nobility but also proved that his justice and code of honor was representative of a superior form of government. The population submitted willingly to the paternalistic authority.

For Michel Passart, the painting of *Camillus* was resonant with a number of themes inherited from the culture of the *noblesse de robe* and inculcated in the *collège*. These can be summed up as follows: the topic demonstrates that exemplary actions should override force and violence. The leader is a model for his troops, who are the immediate depicted audience. Camillus's adherence to a set of self-imposed rules for conducting war persuades the Faleries where military force had not. Rather than superior might, nobility is registered by appropriate disinterested action which results in the consent of the adversary rather than forced submission to subject status. Hegemony is achieved by consent rather than by an iron fist.

Passart would have been equipped to compare the history of Camillus and the schoolmaster to similar themes. He could have recalled a series of historical topoi derived from texts and commentaries (or perhaps a piece of theater at school). Some years after his initial acquisition of the painting, he looked to an adjacent frame on his wall and compared it with a parallel incident in Roman history. Indeed, Passart sought and acquired another painting by Poussin representing a similar lesson, *The Continence of Scipio* (fig. 27). Although the painting was originally commissioned by the Roman cleric Roscioli by 1640, it was later acquired by Passart (perhaps as early as 1644).[39] The *Scipio* is almost identical in scale to Passart's *Camillus* and therefore functioned as a pendant to the earlier work. Again the enthroned commander demonstrates his magnanimity toward a subject people, serving as a model for his troops. Here, the rightful booty of the conqueror, the possession of the captured woman already promised to another man, is renounced and the Roman general not only releases her but offers a generous dowry to the grateful groom out of his own share of the spoils of war. The exchange of the woman is a demonstration of continence, the marshaling of sexual violence for the good of the state. It was a theme suitable for one of Montaigne's meditations on Scipio.

Persuasion through rhetoric and ethical value was familiar to an audience brought up on the royal *entrée*. Poussin offered Camillus as an historical exemplar or parallel to the ideal monarch. But that is not to say that the theme was cited and recited as praise of the ruling king. The ancient world was often a measure of what the modern state aspired to

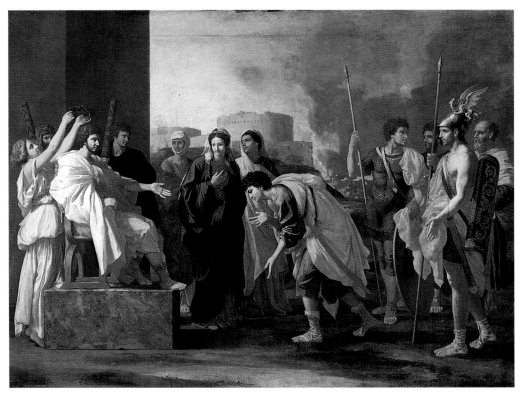

27. Poussin, *The Continence of Scipio*, 1640, oil on canvas (Moscow, Pushkin Museum), 1145 × 1635 mm.

but had currently lost. The ancient example was used not for encomium but to stress one's own shortcomings. Such were the critical strategy and aspirations of Omer Talon in his harangue for the model king. He searched the ancient forms, the language of his ancestors, for a retrospective example:

> [We] hope to reestablish in our own day the ancient language of our ancestors, which has been put out of usage by a bad and infamous adulation. While we speak to our sovereigns using the vocabulary of grandeur and majesty, [the ancients] used the words of clemency and gentleness. [Our current usage] speaks in the name of empire, authority, and absolute command, which represents to us a prince on horseback, baton in hand, surrounded by armies with victory marching before him. The other more ancient usage is an expression of love, of benevolence, and of humanity, one descended from the race of Saint Louis, and given to the grandson of Henry IV, who at his funeral was named "incomparable in magnanimity and clemency."[40]

Talon's etymological exercise contrasts different conceptions of kingship. His argument for linguistic archaism is a search for a purified language before it had degenerated. *Grandeur* and *majesté* are recently coined words linked to the image of an equestrian portrait of a bellicose leader. The orator evokes the imperial conqueror in order to counter it with its archaic, opposite term: the love, benevolence, humanity which constitute the French royal line in a state directed by the principles set forth by the *noblesse de robe*. The themes of magnanimity and clemency echo the appeals to Henry IV and then his grandson Louis XIV. Typically, through the celebration of the monarch's forebears, *robe* historical scholarship is both nostalgic and implicitly critical.

The use of the figure of Camillus by Poussin is similarly intended to refer to an exemplary code of behavior that is anachronistic. The painting, like Poussin's conception of the Grande Galerie, does not make a flattering reference to a contemporary ruler. Instead it offers a model. This is consistent with the use of the story of Camillus by Montaigne. In his *Essais*, the anecdote of the schoolmaster emphasizes a Roman code of honor: avoid treachery and seek honor (in contrast to Greek victories by "finesse" or ruse).[41] However, Montaigne puts little faith in a repetition of the event in contemporary French history. The Roman exemplum only underlines the difference between the Roman Empire and Montaigne's France;[42] the example is a measure of the depletion of contemporary mores and of the writer's experience of belatedness. No living ruler mirrors the Roman general – and yet the story is meant to be understood in contemporary terms. The Frenchman longs for a Rome of the imagination. Here, criticism verges on profound pessimism.

Conduct for Sieges

Montaigne's comparison of the actions of Camillus with contemporaneous behavior elicited a pessimistic response because of recent history in France. As in Montaigne's *Essais*, the historical examples of ancient Rome were inseparable in the minds of Poussin's audience from the ways in which military campaigns were conducted in contemporary France.[43] The discipline of *gens de guerre* was a topical subject: the quartering of troops resulted in appeals to the monarch by civic elites in a range of expressions from printed speeches to tax resistance and open rebellion. In a harangue addressed to the Regent by Talon during the crisis of 1648, the major complaint is rehearsed:

> [The] movement of troops and the insolence of the mercenaries have been the fruits of a weed that ravaged the farmlands, made the towns uninhabitable, and reduced the languishing kingdom to such a condition that the state was threatened by ruin.[44]

Undisciplined troops, underpaid and without rations, turned to plunder, destruction, and violence. Contemporary viewers of Poussin's paintings would have seen the Roman troops, Camillus's immediate audience, as learning from his example. Disciplined troops stand as students to a lesson.

Passart's later addition of the *Continence of Scipio* to his collection would have enhanced this reading. This second demonstration of appropriate rule was also understood in specifically contemporary terms. The excesses of royal armies, whether pillaging the countryside outside besieged towns or quartered in surrendered cities, were a constant refrain in the legal actions and oppositional propaganda of the seventeenth century. In particular, the sexual violation of nuns and other women in the countryside by mercenary troops was a major topos of seventeenth-century political discourse.[45]

A viewer who was critical of military abuses would have been especially appreciative of the value placed on a diplomatic solution. The painting served as a demonstration of the nonmartial values of a *robe* noble. Granted, in Livy's text Furius Camillus was not above the habitual practices of a military tribune and Roman general: he too plundered and burned the crops and farmhouses of the countryside.[46] Indeed, Camillus gained his fame from his fierce tactical warfare, and the conquered territory and plunder that he obtained for Rome.[47] However, in the particular story of the conquest of Falerii, "Camillus's fame now rested upon a finer achievement than when the team of white horses had drawn his triumphal chariot through the streets of Rome, for this time he entered the City in all the glory of a victory

won by justice and honour."[48] For Livy, the event exceeds the triumph of a bloody conquest and offers an alternative representation of glory to that of a triumphal entry. The town was not sacked and plundered and the Faleries merely had to give a tribute to cover the army's pay. The painting contrasts with depictions of a panoply of confiscated antiques, as in the relief of the spoils of Jerusalem on the Arch of Titus. A modest array of artifacts represents Camillus's discipline over the desire of his troops for spoils.[49] Military insignia, costume, tent, and gesture rather than booty are sufficient to signify Roman power.

The pairing of Camillus and Scipio in Passart's collection underscored the superiority of persuasion compared to coercion. The two topoi were in fact explicitly linked in sixteenth-century political theory. Arguing that the obedience of subjects was best achieved through admiration rather than fear of the monarch, Giovanni Botero's highly influential *Della Ragione de Stato* (*Reason of State*, 1589; first French translation 1599) cited as examples both Camillus's treatment of the schoolmaster and Scipio's return of the beautiful young bride unharmed to her husband.[50] The two complementary citations demonstrated that the preservation of the state resulted from the universal esteem obtained through the renunciation of violence.

Poussin focuses on the leader's command of words rather than troops. As in Livy, the seated general with the staff of rhetorical authority punctuates the occasion with a short speech, commands the boys, and oversees the punishment. The emphasis on oratory reminds Livy's readers of Camillus in a later episode during the sack of Rome by the Gauls. In one of his last forays into public life, the retired commander's lengthy oration persuaded the Romans not to abandon their ruined city. Without Camillus's command of language, the destiny of Rome would have been severed from its civic foundation. For the *noblesse de robe* the painting offered an opportunity to discuss the persuasive power of the orator in contrast to the thrashing sticks of the brutish boys.[51]

Disorder or Fleeing Confusion

This reading has so far neglected an important aspect of the painting – the violence at its center. The composition privileges the boys attacking the naked body of their schoolmaster yet does not offer any identification with figures who respond to the cruelty with either empathy or repugnance. The witnesses to the beating are joyful, bemused, curious, or contemplative. There is no expression of fear, repulsion, or sorrow.

If the painting is an exemplary image of discipline and honor, how does one account for the prominence of this humiliation and disorder? In the micro-social event of the battering of the schoolmaster, the terms of authority and discipline are inverted. The schoolmaster has forfeited his rights and privileges as a humanist whose duty entailed the preparation of an aristocratic elite for participation in society. The stripping of the adult by the children is a powerful breach of social authority. The mentor is humiliated not only by his nudity but as a result of the tools of corporal punishment that are turned against him. In the famed mid-seventeenth-century guidebook to Paris, Sauval's *Histoire et recherches d'antiquités de la ville de Paris* (c. 1652–55), the author encountered Poussin's other version of Camillus in a collection and saw the beating as an act of retaliation against contemporary pedagogical abuse:

> We notice the satisfaction that schoolboys must likely find in finally getting revenge on the shoulders of him who never spared them the rod and whip [*fouet*] that they so often received from him. Some admire the union of colors, others the choice of draperies; but

all [admire], the aspect of the head, the variety and movement of the passions, and the whole composition of this great history picture.[52]

The author initially sees the stick in the hand of the youth and recognizes one of the instruments of the humanist pedagogue, the *férule* or rod. Then, in conjunction with the schoolboy memory, the author exercises the incipient discourse of an *amateur* to demonstrate his critical competencies. The nuanced handling of paint and the management of contours is admired, but the author attributes this admiration to others. The author's own predilection is to turn back to the presentation of fortune's reversal in the figure of the abused teacher. This is shown by Poussin's command of expressivity. The artist demonstrates considered attention to a variety of gestures in response to the event. His acute observation of an individual is combined with his skill at conveying the complex and heterogeneous qualities of a crowd.

For Sauval, as well as contemporaries like Passart, the themes of antiquity were familiar, quotidian, and immersed in the experience of social institutions such as education. Sauval can therefore look at the painting and think of the classical narrative in terms of the very institution in which he learned this story, the *collège*. As pointed out, the *collège* was a major institution that formed and perpetuated what could be called a class. (It was similarly the practice of the Faleries to have their children educated in a group by an instructor rather than having them individually tutored.) This is also Poussin's point of reference: in addition to his early education in a *collège* in Rouen, in his twenties he boarded at the Collège de Laön in Paris and was commissioned by another *collège* to execute some pictures.[53] This background explains, in part, the peculiar disposition of the painting toward the description of the schoolboys' antics. We would not be faithful to Sauval's reading if we leveled the distinction between this painting and other depicted topoi of magnanimity and moral fortitude cast in an orderly mold. Sauval is more attracted to the discordance in the picture. He does not linger on the impervious countenance of the exemplary enthroned orator. His tastes and interests draw him to the spectacle of punishment and comic abuse.

The guidebook writer was not exceptional in his association of education and the whip. In Charles Perrault's description of the Paris Collège de Beauvais of his adolescence, there is a boastful reference to corporal punishment: "All my brothers and I took my studies there, without any one of us having had the whip."[54] The pedagogical instrument of corporal punishment is also conjured up in Molière's *Bourgeois gentilhomme*, when the social climber Monsieur Jourdain willingly calls for the humiliation of a whipping in order to achieve his belated entrance into learned society. The actor's line can be played for its pathos, its slapstick, or both. Jourdain's aside glosses the discordant effect of an adult nude male subjected to the schoolboy's discipline.

Sauval's comments draw our attention to the strangeness of the picture (see fig. 22). This is not a classical nude. It is a stripped man. There is a disjunction between head and body. A grimacing, particularized face is grafted onto a torso that recalls the idealizing strategies of antique sculpture. Yet the discordance of a face bearing the brunt of signifying pain and terror disrupts any archaic associations. The discrepancy of tone between dark gesticulating face and pale naked flesh stresses the ignobility of a body stripped of clothes. The figure is a study in humiliation. His hands have been purposefully tied behind his back in order to expose his genitals. He is debased and helpless. He is jeered at and physically assaulted by his pupils. The contrast between fair youth and naked bearded man suggests a sexualized distinction. In contrast to the inquisitive and reserved expressions of the camp followers under the command of the seated leader, the grimacing face of the schoolmaster responds to the sticks and stones of abuse as he is led back to his town where a gawking crowd and certain death await him.

The picture appears to move from sedate judgment to complete disorder. This contradiction, this tension between parts, is not entirely resolved in the Passart version. The unresolved composition is compounded by awkward passages: the schoolmaster's head is arbitrarily sutured to a classical nude body. The soldier to the right of the schoolmaster would intervene if a fellow soldier did not restrain him. But what does the soldier's grimace signify: dumbfoundedness or a smirk? Does he intend to stop the battering or join in? And what of Camillus? The purported site of valor, honor, and justice is weak, falls flat, before the gyrating, tortured bulk of a man driven by an orchestrated group of badgering boys. Depicted in a conventional seated pose, Camillus's rhetorical gesture and impassive expression have to carry much if the picture is to succeed. Indeed, the schoolmaster's turgid grimace and the gyrations in the cramped quarters of the foreground attract Sauval's attention. Is it right to see the object of the painting as a *tour de force* attempt to hold together, on one hand, calculated fortitude as represented by pictorial order (the regimented frieze of troops and statuesque Camillus) and on the other, chaos or pictorial disorder (the violent students and the bestial nude)? Does this latter category adequately describe the young students' violent "escort" of their schoolmaster? How do we explain this impious, sexually charged, disorderly realm of experience in the midst of a painting depicting the virtues of statecraft? What is the function of the spectacle of a rebellion before the stiff impassive ceremonial gesture and fixed gaze of the Roman leader?

Sauval recognized a logic of inversion. He identified the painting's field of reference as this reversal of authority, expressed in schoolboy terms. But the tension between the two groups, the leader and troops versus the schoolmaster and pupils, is nevertheless expressed in terms of social decorum. That is to say, even inversion relies on conventional rules, the appropriate behavior between social categories and deference to authority, articulated in gestures and speech. The *ancien régime* had its protocols that were enmeshed in the very fabric of social order and hierarchy. But its inverted double, the breaks in that order, were not just absences of rules, unselfconscious unmeditated acts. Where there is a fissure in the order, there is another order, a grammar that may represent the image of chaos, but a grammar nonetheless.

What rules of syntax would have been available to a contemporary viewer? In Passart's painting, the scene is replete with Roman insignia, troops at attention, and haranging ruler. Authority and military discipline emanate from the commanding figure. A naked man is escorted. Some boys take the rear. Others flank their (dis)honored guest. Some precede, not beating the flesh but pointing, talking, announcing. The mockery becomes pageantry in anticipation of the crowds that will form along the streets of Falerii. The spectacle follows the form of an official entry into the city. This processional aspect is even more evident in the finished drawing (see fig. 26). The frieze-like composition, the directionality, the prancing movements and prattle of the young boys, have much in common with *The Triumph of Bacchus* (1636; fig. 28) executed for Richelieu's country residence around the same time. The Roman soldier, like the schoolboy on the right in Passart's version, echoes the bacchic reveler whose forward movement is counterposed by the backward glance. At the center of the spectacle, a bridled, carnal, and drunken centaur replaces a grotesque political prisoner. Poussin's libidinal triumph, indebted to a Venetian palette and early Titian's juxtaposition of discrete hues to create a screenlike suspension of interlocking shapes, grants the theme of Roman military triumph some of its play on the erotics of violence.

The inverted triumph makes an appeal to what Mikhail Bahktin has called the carnivalesque in order to describe the depicted event.[55] The teacher turned object of abuse by his subordinates is a world turned upside down in a spectacle of brutality and excess. This brand of genital humiliation was familiar to the painter in Rome. A member of Cassiano

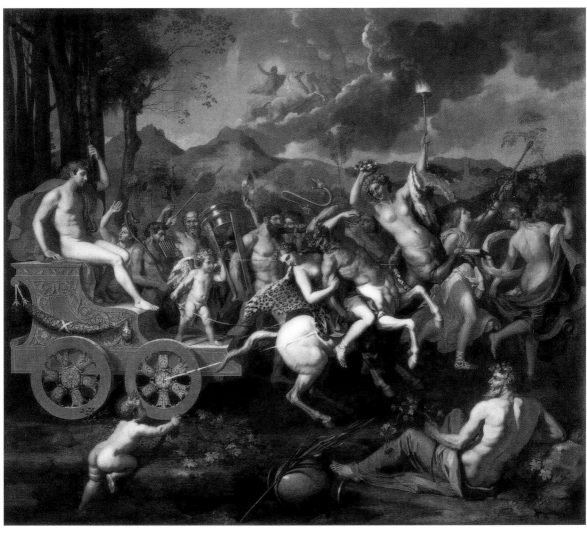

28. Poussin, *The Triumph of Bacchus,* 1636, oil on canvas (Kansas City, The Nelson-Atkins Museum of Art, purchase: Nelson Trust 31-94), 1283 × 1511 mm.

29. Collection of Cassiano dal Pozzo, *Foot Race in the Circus Maximus*, 1626–57, pen and wash on paper (Windsor Castle, The Royal Collection, Royal Library).

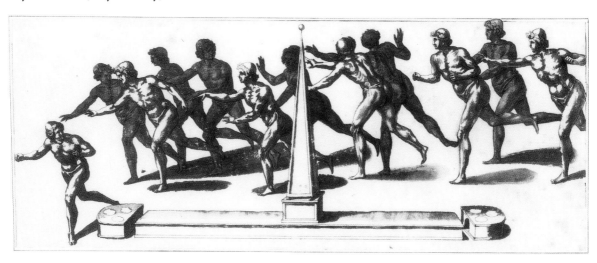

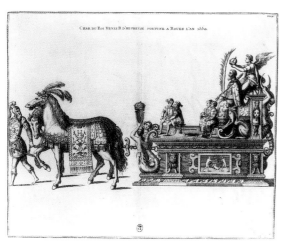

30 *(left)*. Anon., *Henri II's Entry into Rouen*, Rouen, 1550, engraving (Paris, Bibliothèque Nationale).

31 *(Right)*. Anon., "Float of the Abbé des Conards of Rouen" from *Les Triomphes de l'Abbaye des Conards, contenant les cries et procla-mations faites, depuis son advenement iusques à l'An present*, Rouen, 1587 (Cambridge, Mass., Houghton Library, Harvard University).

dal Pozzo's circle published a description of the carnival tradition of a foot race of young men of the Jewish ghetto (fig. 29). Stripped naked, the Jewish runners were encouraged by the unruly Roman crowd with verbal insults, bundles of twigs beaten against their thighs, and the carnival missile of choice, rotten oranges.[56] Franceso Barberini's secretary of Latin and correspondent of Cassiano dal Pozzo, the Frenchman Bouchard, also served as an informant (or rather a participant-observer) of the Roman carnival: he invited upon himself the festive humiliations of being pelted with eggs by masking alternately in exag-gerated male and female French national costume.[57]

But a Bahktinian gloss would lack historical specificity (and leans toward nostalgia). Instead, the most historically pertinent frame of reference in France was provided by the norms and conventions of mock entrances. The comic reversal of the mock entrance depended upon the importance of its double, the triumphal entry, for signification (fig. 30). I have already discussed in Chapter Two the importance of the royal entry for defin-ing monarch–subject relations and initiating young men into the political community of the robe nobility. In 1587, thirty-seven years after the triumphal entrance of Henry II into Rouen, the Abbé des Conards rambled through the streets on a ramshackle chariot pre-ceded by his heckling train of violent young men (fig. 31). The antique triumphal imagery in the crude print underscores the dependency of the mock entrance upon the humanist imagery of the legitimate *entrée*. The apparent disorder of the satirical double combined the alternative vocabulary of inverted encomium with the syntactical structure derived from the royal procession.

Poussin's depiction of the schoolmaster's parade drew upon the shared thematic, formal, and performative referents of the serious and mock entries. The procession was a significant formal mapping of social hierarchies, for example in the *lit de justice*, where the monarch formally imposed his will by entering the chambers of the Parlement of Paris.[58] The ceremonial entrance had its rules, protocols which were meant to represent the relations of power between subject and ruler. The reversal of these relations, the mockery of the object of praise, also followed a system of rules to political purpose. The mock entrance was therefore used as a representational strategy in political literature. While the king's triumphal entry was performed and commemorated in engravings and panegyric by the king's historiographer, a berating farcical attack against the king's enemies was performed in public rituals and represented in cheap prints and pamphlets. The famous assassination of Marie de' Medici's favorite Concino Concini, marquis d'Ancre, was still fresh in the memory of Poussin and his client Passart. Ordered by Louis

XIII himself, after a campaign of pamphlets against the Italian courtier, the homicide consolidated the succession of the young king and insured "la liberté publique." Concini's funeral was disrupted by a spontaneous usurpation of the ritual and the corpse of Concini by a disorderly crowd – but the abuse soon turned to structured, processional behavior. After the performance of ritual mayhem and castration, the body was paraded through the city streets, where rituals were enacted at a series of stations. Each interval marked a specific commemorative site: the Bastille, where Condé had been imprisoned; the sacrificial victim's sacked palace; and finally, the recently erected statue of Henry IV on the Pont-Neuf (see fig. 2). Before the image of the king, the people made a special burnt offering of the desecrated corpse.[59] The ritual followed the structure of the *entrée* and was similarly commemorated in a pamphlet.

The mock triumphal procession depended upon a display of grotesque pomp that mirrored by inversion the rituals of panegyric. In order to communicate the disgrace of the schoolmaster, the powerful punishment and humiliation of the traitor, Poussin similarly used the brutal humor of the reversal of authority. The "burlesque" aspects of the drawing and the painting suggest how Poussin drew upon these resources to invest the classical tale with the vitality of contemporary French life. At least at this point in Poussin's development, around 1635–37, there was no need to inscribe strict boundaries between a realm of experience that was subsequently constituted as the "popular" on the one hand and the "classical" on the other.[60] In the juvenile literature of the brothers Perrault as well as in the contemporaneous work of Paul Scarron, the burlesque travesty of Latin epic literature is one instance of this manipulation of social categories. Passart would have seen no incongruity between Roman history and the application of skills rehearsed in the bacchanals and erudite parody.

The schoolmaster is a site of burlesque violence managed by the composition. He stands as a figure of perversion, thereby constructing through a series of oppositions the social and formal order of the painting. The grimacing and bestial face, painstricken and gyrating body subjected to violation, is a foil to the designated site of valor and political authority: exemplary political behavior is figuratively represented by the rhetorical gesture of an enthroned idealized body with fixed countenance. In the structural logic of this particular painting, the indecorous display of transient and exaggerated gesticulations and the confrontational gaze of individuated particularity contrasts with the propriety of expression and immobile features of a generalized face in profile. The body of Camillus derives its authority, in part, by its reference to Roman imperial reliefs and medals. His countenance is mediated by the typological portrait in which a fixed set of commemorative features is eternally available for contemplation. The achieved contrast of men depends on both the antique referent and the carnivalesque representation of the felon, thereby articulating a discourse of class behaviors.

The age and rank of these two men mark them as the agents of political and pedagogical guardianship. However, they are differentiated by their respective relationships to the third term, the pre-adolescent male youths. The schoolmaster violates his paternal obligation to the youth of the ruling elite while Camillus restrains himself from illicitly holding the youths as hostages. Instead, he returns them to their guardians, thereby restoring the social order. Camillus occupies a superior moral position as a foil to the schoolmaster's abuse of his power over his dependent charges.

The social distinctions of the two men and the basis for their claim to power is also represented by different constructions of masculinity. The discipliner becomes the object of discipline, the recipient of the lesson of the rod, but he also becomes a naked sexualized body subject to the phallic violence of the boys. Retribution is exacted by reversing the power relations between the sexually mature man and the unanchored sexuality of the

32. Agostino Carracci, *Satyr Whipping Nymph*, from the series known as the *Lascivie*, c. 1590–95, engraving (London, British Museum).

pre-adolescent youths. The bound naked man is thereby related to the pictorial convention of a man subject to the whipping of a putto, driven by sexual desire.[61] But it also recalls the sadistic fantasy of whipping and the narratives of sexual submission and domination in Agostino Carracci's series of nymphs and satyrs, the *Lascivie* (fig. 32).[62] The normative hierarchical relations in a society organized by distinctions of age and gender are threatened by the inversion of the sexualized distinctions of dominance and passivity.

By representing antique referents, Poussin was not only articulating the cultural materials of the group of Frenchmen that he served, but he was also representing the anxieties in the formation of that pedagogical culture. The *noblesse de robe's* class formation and self-definition was tied specifically to the education and particular institutions depicted in the painting – the *collège*. As the nexus of the interdependent formation of gender and class, the relations of this all male society were therefore the object of great concern. As an extreme projection of inappropriate conduct, pedagogic pederasty was recognized as an abuse of the power relations regulating paternalistic relationships. This is perhaps suggested in Livy's text by Camillus's speech to the schoolmaster, where the commander is repulsed by the infraction against the law of nature. The appropriate male guardian, the commander in a masculine society who applies severe ethical standards to combat, was defined as the site of normative heterosexual masculinity. The politics of this homophobic subtext partook of the function and cultural forms of the *charivari*: the pantomime of genital humiliation and whipping of exposed buttocks policed appropriate sexual conduct. The theater of sexual excess produced discipline.

Poussin's painting represents sexual disorder in order to describe the failure of political relationships. The accusation of aberrant sexual behavior was a recurrent form of political criticism in early modern Europe. Tyranny was represented by the subjection of the ruled to anal sex.[63] Political disorder was understood to be a result of the disruption of "natural" paternalism and heterosexual conduct, in the process converting the male political client into a passive, feminized object of unbridled desire. During the sixteenth and seventeenth centuries, sodomy was repeatedly castigated as a sign of political corruption in France.[64] The pejorative, feminized term *mignons* continues to be the preferred euphemism used by critics of Henry III's regime. In the second decade of the century, Marie de' Medici's favorite Concini was the object of scores of libels attacking his purported sodomitical proclivities. During the Fronde, the "Italian vice" was used repeatedly in a xeno- and homophobic campaign to oust the First Minister, Jules Mazarin. Appropriate political conduct and patriotic identity were therefore defined by the enforcement of a particular construction of masculine sexuality.

In an early drawing from a series commissioned by the poet Marino, Poussin constructed an allegory of the regulation of same-sex relations (fig. 33). The composition is organized

into two opposing groups: on the right, a seated imperious figure is crowned by two men in ancient Roman military and civic dress. In its antithesis, on the left, a seated passive male nude is fed a cluster of grapes by a satyr with an erect penis. Although the allegory is not secured (surely the armored figure is similarly open to the accusation of passivity?), it does suggest a comparison with the Choice of Hercules, where the nude male hero was required to choose between female personifications of virtue and pleasure. While both allegories represent the path that diverges from virtue and exemplary masculine behavior, Poussin's castigation of inordinate sexuality is not achieved by the mediation of a female.[65] Instead, the lasciviousness and wantonness of bestial male–male carnal desire provides a significant foil to the regulated conduct of a group of men from antiquity.

Pederasty served as a negative example of same-sex relations within a more broadly defined political clientage system. This is precisely what motivated Montaigne's famous essay on *amitié* (roughly speaking "friendship"). Poussin's painting like Montaigne's essay is a meditation on the bonds between men. Montaigne excludes women and pederasts from the ideal union that he defines. He considers and eliminates relations between man and woman, pederast and boy from his definition because of the disparities produced by domination and submission. In Montaigne, there is simultaneously a desire for the same and a repudiation of physical intimacy. Poussin similarly represents a masculine self premised on the suppression of erotic relations and the abuses of paternalism, while at the same time producing an image of brutal sexual humiliation. Significantly, brutality was a response to anxieties found at the formative site of the self-articulation of a class and gender – the boys school.

The pairing of the Camillus painting with *The Continence of Scipio* (see fig. 27) in Passart's cabinet also inflected the representation of sexuality as an organizing principle for a field of power relations. In addition to the juxtaposition of depictions of the renunciation of violence, the pendants offered another lesson in hegemony. The *Continence of Scipio* defines the political relation of ruler and subject through a sexual contract. The ruler abdicates his prerogatives as conqueror and restores the woman to her bride-

33. Poussin, *Allegorical Scene* (or *Choice between Virtue and Vice*), c. 1624, pen in brown, gray wash on paper, (Budapest, Szépmüvészeti Múzeum, no. 2880), 181 × 328 mm.

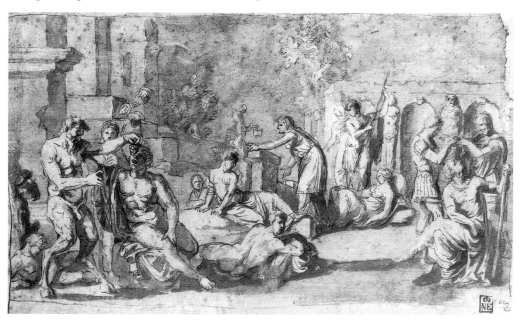

groom. The behavior of conqueror yields to the homosocial bond of ruler and subject. Incontinent sexuality is overcome and the social order is sufficiently restored to facilitate imperial authority. The sacrifice of heterosexual intercourse insures the ruler's bond with his male subjects. Similarly, Camillus's refusal to be complicitous in the base behavior of the pedagogue defines an appropriate paternalistic relationship. The subject people submit to the will of the continent male heterosexual.

Differential Readings

In 1637, Louis Phélypeaux de la Vrillière commissioned a second larger version of *Camillus and the Schoolmaster* to be included in a major ensemble of paintings in the large gallery of his *hôtel* (fig. 34).[66] Poussin's painting was not only included in a prestigious display of recent advanced Italian painting (Reni, Guercino, and Pietro da Cortona) but it also formed part of a series of canvases addressing historical themes from the rape of Helen to the intervention of the Sabine women, from the upbringing of Romulus to the death of Cato. Although not programmatic, the gallery was a hall of ancient histories that considered the formation of the state, its maintenance, and its dissolution.

Like Passart, Richelieu's secretary of state did not perceive the representation of humiliation and terror as incommensurate with a depiction of the political exemplarity of Camillus. In fact, the ethical superiority of the general depended upon an exchange of violent behavior rather than its renunciation. If the two paintings sought to regulate the sexual distinctions in the representation of an all male social order, they did so with a violence whose overdetermination highlighted its political significance. While the representation of the regulation of natural law was understood as a lesson for the maintenance of the monarchical state, it did not necessarily follow that the two recipients of the painting, with their respective relationships to the crown, had complete agreement over its inter-

34 *(right)*. Poussin, *Camillus and the Schoolmaster of Falerii*, c. 1637, oil on canvas (Paris, Musée du Louvre, inv. 7291), 2520 × 2680 mm.

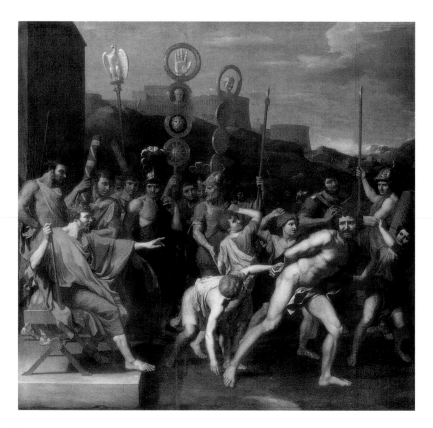

35 *(facing page)*. Jacques Callot, "Fructus Belli", from *Les Grandes Misères de la Guerre*, 1633, engraving (Paris, Bibliothèque Nationale).

pretation. For Passart and la Vrillière, the brutal comic effects signified very different things. As we have seen, Passart's prestige and values were identified with his father's fidelity to the king and the pacification of the city of Paris. Passart sided with the superior demonstration of law and political institutions. These were the powers with which he and his family were invested as royal office-holders.

Although la Vrillière shared the same education and cultural resources as Passart, as a member of the royal Council of State, his interests were more immediately concerned with the maintenance of royal authority in the relations between crown and the provinces. Humiliation, intimidation, and terror were characteristic of French political society during Richelieu's administration of France: these tactics were deployed when the ordinarily effective system of political clientage wore thin. Some of the most famous representations of the brutalities of the early modern state in response to provincial recalcitrance were inspired by Richelieu's policies in Lorraine (fig. 35). More typically, political resistance and retaliation occurred on a largely symbolic scale. A representative of the king was subject to the violence of local factions when the channels of political influence failed. Tax collectors were accused of pestilence, quarantined, then driven out of town (much in the fashion of the ritual abuse of the schoolmaster).[67] In response, royal authorities exacted penalties on the populace for its misconduct and infidelities.

In 1639, two years after commissioning the painting, la Vrillière experienced royal justice at first hand. He helped to implement royal authority in Poussin's own Normandy following the revolt of the *nu pieds*.[68] After the so-called barefoot revolt was put down, the crown turned to the customary practice of introducing a provisional court of law from the outside – an itinerant *parlement* called the Grands Jours. The punishment inflicted by the crown that resulted from these judicial proceedings was among the most brutal applications of coercive power against a province during Richelieu's regime.[69] Significantly, it was the local *noblesse de robe*, the provincial Parlement of Rouen, and other royal officials, who "suffered humiliation, divestiture, and execution."[70] La Vrillière was more closely aligned with the interests of Richelieu's centralized state than the customary rights of the *noblesse de robe*.

Royal justice was severe in the years when la Vrillière commissioned and installed his version of *Camillus* in 1637. Indeed, the punishments against rebellious subjects exacted by the justices of the Grands Jours included execution without trial and the razing of houses to the foundations, thereby obliterating symbolic, historic identities.[71] But the improvised abuses of the occupying troops were also punished by violent means. The delinquent agents of the crown were held accountable for their actions. In fact, the royal authorities reserved the most severe punishments for their retinue who abused the rules of conduct during an occupation.[72] Justice had to appear to be above self-interest and individual appetite. As in the representation of Camillus, the severe punishment meted out to someone dedicated to the cause of the occupier demonstrated self-discipline.

The officials that made their way to Normandy from Paris during the Grands Jours also demonstrated that they had strategies for royal hegemony other than violent coercion. La Vrillière attended dinner parties and visited with local elites in order to consolidate alliances and clients.[73] Cultural reciprocity helped consolidate the ties between Paris and Rouen. The royal authorities were soliciting the loyalty (and the revenues) of the Normans. While demonstrations of violent coercion had tactical purposes, la Vrillière and others had to use various means of persuasion. They were competing with local nobles for the support of the population.

The crown too had to contend with local fidelity to powerful nobles. If the monarchy had poor relations with these elites, it could lead to rebellion. For example, in Normandy, the popular support of the governing duc de Longueville was based on consent. In the oration at his funeral, he was praised for "the art of winning by love, the obedience and respect of the people." He was effective at bending the will of his subjects and exacting service from them because the chain of love that bound them was so strong and pleasant that they "no longer felt its weight, and took pleasure in bearing it."[74] This recipe for hegemony was contrasted with an imperial foil: "it was not by pomp, arrogance, empire, and terror, it was his extraordinary gentleness, his unparalleled benevolence, a unique affability, which ravished all hearts."[75] Sweetness and power were combined to seduce and ravish the subjects in contrast to conspicuous pride and the terroristic organization of the state. Consent was necessary for rule by the provincial aristocracy as well as by the crown.

For la Vrillière, therefore, the painting of *Camillus* addressed the royal representative and his council. It stated that coercion was inferior to the exercise of a higher ethical code of behavior. This resulted in the consent of towns and subjects to the central authority.[76] The painting served as a warning to royal officials in the provinces who acted as representatives of the central authority. It demonstrated that royal justice punished those who abused its powers. The subject people were thereby offered the consolation that abusive representatives would be punished. The occasional abuses of local representatives were separated from the justice and benevolence of the central authority.

This was a direct appropriation of the message of Passart's *Camillus*. La Vrillière, through his acknowledgment of his shared interest with Passart, demonstrated his identification with an audience that was represented by a member of the sovereign courts. La Vrillière was claiming participation in the culture of Passart. He was, after all, choosing to commission a near copy of another man's painting. He was not bothered by a lack of originality. In fact, he went out of his way to obtain a clearly designated variant. The repetition offered evidence to la Vrillière's visitors that their host had come to some agreement with Passart in order to have a variation made of his painting.[77] La Vrillière's painting was not only a declaration of belonging to a particular social group, the *robe* nobility, it was also an acknowledgment of the crown's dependence upon the obedience of that group. Ownership of the painting was akin to the social calls la Vrillière made on the houses of local elites during the Grand Jours in Rouen. A shared lexicon of valued terms was rehearsed by a commu-

nity that transcended regional boundaries. But a royal guest supported by a judicial and police apparatus was able to back these cultural resources with greater material power. And likewise, a painting of humiliation, terror, and siege warfare in the gallery of one of Richelieu's administrators may have elicited very carefully worded responses.

La Vrillière was insisting on a theme that was of interest to Passart. He commissioned the artist greatly to increase the scale while reducing the relative width of the composition so that it could be better coordinated with a series of square easel paintings selected for his gallery of Greek and Roman histories. The resonance of the particular theme of the traitorous schoolmaster would have been different for the eyes of the guests in la Vrillière's grandiose reception hall from those in Passart's relatively modest and less programmatic *Grand cabinet*. The visitors to the gallery in the Hôtel de la Vrillière realized that within the same tableau the ostensible theme of consent to a ruler who demonstrates restraint competed with the image of humiliation, punishment, and violent coercion. Poussin's picture offered an image of a punished traitor, a false agent of authority subjected to the disorder of mob violence. La Vrillière's visitors would have seen the cool restraint of the commander of the siege, but could not ignore the fact that he was backed by powerful troops. His rhetorical gesture at once conveyed restraint and his potential cruelty; his power was demonstrated by his capacity to survey the schoolmaster's humiliated body.

Irrespective of the differential readings suggested by the contrasting contexts of the two paintings, receptivity to such themes presupposed a fully developed and competent audience. Indeed, one of Poussin's principal talents was his capacity to address such viewers. But I have not attempted to make Poussin's production conform to a uniform conception of such a receptive culture. His paintings were not unmediated images of unchallenged myths stereotypically reproducing a system of political power. In the model of culture I have been describing, the shared resources at the disposal of the artist and the *noblesse de robe* were subject to the tensions inherent in sixteenth- and seventeenth-century political culture and theory. The antique referents, literary and antiquarian, validated a centralized authority but at the same time defined the limitations of power. The representation of Camillus contained the contradictions of coercion and diplomacy, siege warfare and conciliatory behavior. History did not provide an unblemished mirror for praise of a single institution or figure, but a field of demonstrations of power as a system of relations and possibilities.

I have been arguing that this representation of a relational field of power was produced from a variety of cultural resources. In Poussin's *Camillus*, the use of Roman history was inflected by the circulation of antique references in diverse social and political practices. These were not the obscure tools of an exclusive few. The *collège* education in ancient languages, literature, and history equipped painting's appropriate viewers as a social group. Antiquity had a situational value, as in Montaigne's *Essais*. The names and events of the Greco-Roman world jostled with any number of contemporary allusions and quotidian materials. Political, social, and economic crisis resulted in the use of antiquity as a vehicle for social articulation and negotiation. The perception that there were radical fissures in the cultural field of seventeenth-century France (between, for example, the "classical" and the "popular") has had its odd assortment of defenders: Mikhail Bahktin and Michel Foucault join ranks with Voltaire's *grand siècle* as well as nineteenth-century French nationalist historiographers and cultural historians.[78] Although Bahktin's study of Rabelais attached a different set of values to the respective categories of the popular and the classical literary canon, by hypostasizing the category of the popular, it maintained (even insisted upon) the divisions. Foucault similarly reinscribed a historical division between modernity and an alienated cultural past. At this juncture in Poussin's career, however, there was no need to draw a strict line between antique and contemporary sources.

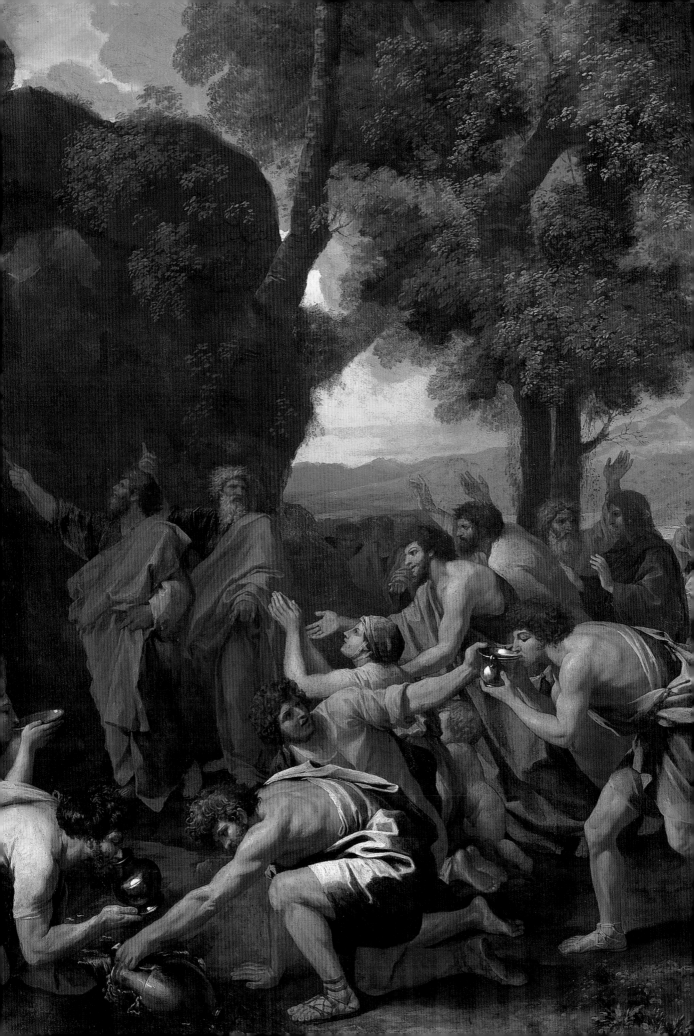

Chapter Four

Antique Moses

Poussin's *Moses Striking the Rock* (fig. 36) reached Paris sometime in the mid- to late 1630s along with the two versions of *Camillus and the Schoolmaster of Falerii*. Its composition too is predicated on the study of a variety of transient gestures in relation to a staid heroic core. In the foreground, the man stepping forth who brings glistening metal to his own lips is pressed into a pyramidal mass of figures at the center of the picture. The group can be explicated as a chain of figures and a narrative sequence, one drawing water out of a stream, another passing it on to yet another figure who drinks. The water has reached its destination. Another set of figures forms the apex of the pyramid. The group of bearded men coalesce as a narrative unit, reacting and interacting. But in response to what? A red-robed man with stick in hand reaching toward a boulder? Another man pointing upward? As in *Camillus and the Schoolmaster*, the declamatory act or gesture makes for little pictorial interest and offers little in the way of semantic clarity. Narrative exposition depends upon those who react. We search for causes in the most incidental of effects and the most banal of activities, drinking water. Several people attempt to quench their thirst simultaneously, suggesting that there was suddenly a fortuitous opportunity. Water has appeared in a desert. The stream runs from its source, a rock. A bearded and robed patriarch had struck the rock with a rod. Moses. Another bearded figure gestures upward. Aaron points to God.

The pictorial subordination of the divine prophet and leader to the incidental responsive gestures of the multitude stresses the narrative function of the picture and thereby displaces any possible reading of the painting as a devotional image. While the pictorial structure does have an affinity with certain Netherlandish disavowals of idol worship, its stress on expressive response is more in keeping with the narrative strategies and functions of Poussin's secular paintings. Like many of Poussin's religious paintings, *Moses Striking the Rock* was largely intended for display in a picture gallery rather than in the sacred context of an altar.[1] Poussin's biblical narratives were viewed along with his Roman histories, where prayer was displaced by conversation. *Moses Striking the Rock* and the *Gathering of the Manna* (fig. 37) share with *The Rape of the Sabines* a complex multiple figure composition that represents a multitude responding to an event. A variety of figure groups encourage the examination of different psychological states in response to violence and deliverance. Poussin's religious works were also suitable for the picture cabinet because they depicted biblical antiquity. His representation of the material culture and historical figures of the Old Testament was consistent with the historical method of the French sixteenth-century antiquarian Guillaume du Choul who, as I showed in Chapter One, sought a reconciliation of pagan historiography and Christianity. The first and second series of the Seven Sacraments are Poussin's most famous examples of an intensive

36. Detail of fig. 88.

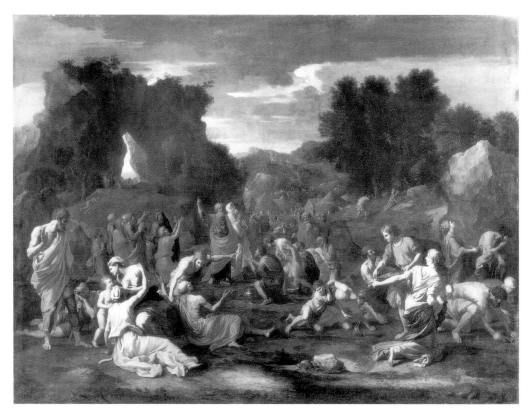

37. Poussin, *Gathering of the Manna*, 1639, oil on canvas (Paris, Musée du Louvre, inv. 7275), 1490 × 2000 mm.

38. Poussin, *The Rest on the Flight into Egypt*, 1655–57, oil on canvas (St. Petersburg, Hermitage), 1050 × 1450 mm.

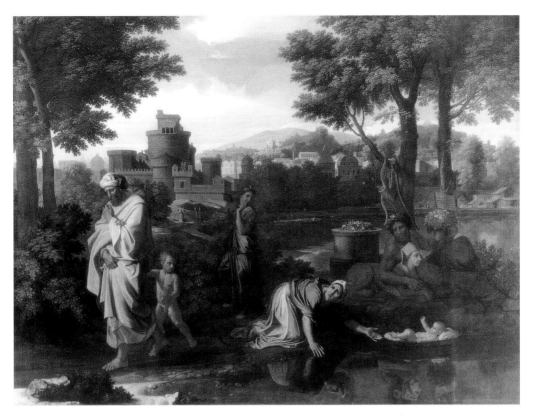

39. Poussin, *Exposition of Moses*, 1654, oil on canvas (Oxford, Ashmoleon Museum), 1500 × 204 mm.

investigation of the continuities of Jewish, pagan, and early Christian ceremony and material culture (see figs. 70 and 71). Similarly, *The Rest on the Flight into Egypt* (fig. 38) gave Poussin further opportunities to investigate the relationships between pagan and Christian ceremonial and religious archeology – Félibien and presumably other French viewers were trained to recognize the Egyptian processional ritual honoring the deity Serapis in the background.[2]

Poussin imagined Moses in the context of a picture cabinet alongside subjects such as Camillus. In his numerous representations of the life of Moses, the multiple archeological layers of Judeo-Christian and pagan antiquity were represented by the sculptural remains of the Roman imperial past. François Perrier's engravings insured the recognition of several motifs in Poussin's paintings that traced Egypt's inclusion in the Roman Empire. The Nile river god, cast for Francis I and engraved by Perrier (see fig. 14), appears in no less than five of Poussin's paintings depicting either the release or rescue of the infant Moses along the banks of the Nile (fig. 39).[3] The Roman allegory of the fertile, paternal source of water and its profusion of infantile tributaries symbolically bears the infant who became a Jewish prophet and leader. Poussin thereby used the sculpture in the Belvedere statue court to link the Roman and Judaic worlds. If Rome was an imaginary capital for Montaigne and Passart because of its ancient foundations, it was also a city central to the French historical imagination because of its several archeological layers linking Romulus, Brutus, Titus, and Caligula to St. Peter and Constantine.

The humanist education of Poussin and his clients inflected their religious beliefs. Secular and sacred history were mutually informing in the curricula of the *collège*. Biblical

figures were listed with pagan Roman heroes in the tallies of illustrative personages. This particular kind of historical consciousness permitted the sixteenth-century political essayist Pierre Charron to put Moses next to Socrates.[4] Poussin's own work investigated Solomon as well as Phocion, Moses as well as Diogenes. Indeed, in Poussin's *Moses Striking the Rock*, Moses and Aaron echo the pairing of Aristotle and Plato in Raphael's *School of Athens* (see fig. 36).

Flavius Josephus

One ancient historian provided Poussin with an important link between Judeo-Christian and Greco-Roman historiography. Flavius Josephus in the first century CE was best known for his eyewitness account of the destruction of the Temple of Jerusalem (a subject Poussin had twice depicted).[5] A Jewish intellectual and Roman imperial administrator who wrote the famous *History of the Jewish War* and *Antiquities of the Jews*, Josephus defended the historical validity of biblical texts disparaged by the critics of Judaism, specifically Greek historians. He therefore performed an important mediating role between religious and secular histories for Christian humanists.

The writings of Josephus had a direct impact upon Poussin's art, which depicted themes that were rare or unique to Josephus.[6] In addition to drawing upon the singular eyewitness account of the destruction of the Temple of Jerusalem by Titus, Poussin also represented Josephus's apocryphal story of the infant Moses trampling the crown of Pharaoh (see fig. 68).[7] When Poussin included several narrative details in his paintings that were derived exclusively from textual variants found in the works of Josephus rather than the Bible, he relied on his audience's familiarity with the Jewish historian.[8] In fact, the histories of Josephus were readily available to Poussin's clientele in France. Translated into French from 1558, there were several editions in the seventeenth century.[9] Josephus was known to Montaigne who imbedded the historian's name in the *Essais* along with other classical authorities.[10] The historical works of Josephus were valued for their passionate evocation of antiquity and their capacity to transport the French reader to the ancient world.[11] Like du Choul, Josephus offered yet another means for the artist to underline the material and textual continuities of Roman and Judeo-Christian antiquity. In particular, Poussin and his clientele were responsive to the ways in which Josephus provided a reading of biblical history from the vantage point of the erudition of the Roman Empire, a literature otherwise silent or vitriolic toward the Jews and Christians.[12] Josephus integrated the historical traditions of Judaism and humanism. In the preface to the *Antiquités*, he states that the object of the book is to correct the false chronicles of the war between the Jews and Romans – or rather, the war "our Jewish nation made against the Romans." Josephus was therefore engaged in the integration of Jewish and Roman imperial history (as Plutarch had sought to reconcile Greek and Roman history from the perspective of a colonized Greek). The Jews were but one of the peoples conquered and assimilated by the Romans.

In addition to his histories of the Jews, Flavius Josephus wrote defenses against the critics of his own work. Throughout his historical project, Josephus was acutely aware that historians were far from disinterested and objective commentators. Much of his work was a critical response to the motivated falsehoods of anti-Jewish historians of Egypt and Phoenicia. For example, some historians considered the story of Moses and the bullrushes a Jewish fabrication. According to these historians, Moses was in fact an Egyptian.[13]

Although Josephus was an apologist for the historical tradition of the Torah and its commentaries, he interpreted this sacred history within the historiography of Greco-Roman literature.

Moses the lawgiver had been assimilated into the canon of exemplary political leaders by many French and Italian humanists.[14] France's evolving state provided a particularly fertile ground for the political reading of Mosaic history. The name of Moses figures in lists of secular historical heroes in the rhetoric of the *parlementaires*.[15] In the sixteenth-century jurist Jean Bodin's attempt to write a general theory of law, Moses was a key figure in his projected universal history.[16] Roman and Mosaic law became part of a systematic comparative study of jurisprudence in seventeenth-century France: in his translation of Josephus, the Jansenist educator Robert Arnauld d'Andilly drew upon his own training in law: "Josephus makes one see how this admirable Legislator surpassed all others, and that no laws have ever been so sacred or so religiously observed than those that he established."[17] The superiority of Moses over all other progenitors of legal systems was made visible. Having received the education of a *robe* noble, Arnauld sought in Moses an exemplary life, like those found in Plutarch.[18] In his plan of studies, Arnauld recommended devoting as much time to reading Josephus as studying the Bible.[19] Josephus considered Moses "an excellent captain, a very wise leader and an incomparable protector."[20] The French legislators found in Josephus a concept of law and legal vocabulary consistent with their theory concerning the legislative functions of the *parlement* and the monarchy:

> I say thus that those who by their love of the public good have established some laws for the regulation of mores are much more estimable than those who live without order and discipline. The work of a Legislator consists in making laws that are as just as they are useful to those who carry them out. And the people's duty is to never wander from that, be it in good or bad fortune. Our Legislator was a forerunner of others in antiquity.[21]

Arnauld's evocation of *le bien public* and *utilité* in his translation of Josephus was consistent with the usages of the Parlement. As a legislator, Moses anticipated the jurisprudence of Greece and Rome, Lycurgus and Solon. In a letter, Poussin similarly described the leader of the Jewish people in the *Gathering of the Manna* as "son Législateur."[22] Arnauld and Poussin were following the traditional emulation of Moses by the *noblesse de robe*. Like the famous French jurists before them, who had to rehabilitate jurisprudence in the wake of civil war, Poussin's clients would have thought that Moses was greater than the Council of Ten Men who had drawn up the Twelve Tables of Roman Law.[23] Although the *robin* judged the Judeo-Christian law superior to that of ancient Rome, comparative jurisprudence nevertheless demanded a thorough knowledge of the different traditions.

Josephus provided a significant biographical description of the biblical hero's leadership skills as legislator and orator, thereby inserting the biblical personage within the Greco-Roman biographical and literary tradition. Similarly, Poussin's representations of Moses constituted a humanist "life" with its assessment of the political importance of the portrayed figure. Flavius Josephus depicted Moses as an individual rather than as an instrument of God. The historian and political commentator underlined the native charisma of this leader. The transport of Moses in and out of the water, which was depicted repeatedly by Poussin, stressed that the gifts of Moses were not inherited by birthright but were his individual traits.[24] According to Josephus, the beauty of Moses astonished people. They turned their heads in the streets. They stopped their business to contemplate him. The sight of him, his great and native grace, ravished the spectator. An elite seeking to articulate a notion of a nongenealogical aristocracy based on individual exemplarity sought in

Moses a model for a persuasive orator. This helps us understand why Richelieu had the hubris to compare himself to Moses and why one of Poussin's most important commissions for the Cardinal during the painter's stay in Paris was *Moses and the Burning Bush* (1641).[25]

What made the life of Moses by Josephus so compelling to the *robe* nobility was, in part, its examination of the conduct of a leader, legislator, and orator during a historical and political crisis. Poussin represented Moses and his struggles with the Pharaoh on behalf of the Israelites in several works. The *Gathering of the Manna* and *Moses Striking the Rock* (see figs. 37 and 88) are based on related episodes during the critical time in which Moses had to check the violent public opinion that threatened his leadership. Josephus described the grueling thirty-day march in the desert, with only poisonous water to drink. The Israelites became angry with Moses, and a mob was ready to stone him "as if he were the author of the calamity." Moses boldly walked into an angry throng of people bearing stones in their hands:

> Moses was visibly a personage of very fine grace, and having speech appropriate to per-
> suade a multitude, he began to appease their wrath by exhorting them that by only
> remembering the difficulties of the present, they had forgotten past benefits; and that
> the suffering that they had endured thus, must not chase from thought, the graces
> and great goods that they had received from God . . . For help cannot come too late,
> especially if it comes suddenly, and before any difficulty has arisen. Thus, he appeased
> them and restrained the fury that would have led them to stone him.[26]

The late sixteenth-century French translator stressed the visible presence of the *orateur*, his natural grace, and his capacity to persuade a crowd through the "sweetness" of his oratory. He is able to argue for the benefits received in the past, constructing a history, lest the people forget. Under the threat of mob violence, he convinces them that the difficulty they experience is only a trial. The multitude is persuaded, repents, and Moses implores God "to forgive that which the people had done out of necessity."[27] It was a sympathetic, psychologically perceptive response to the event. Moses understood that their behavior was motivated by base needs and that their natural impulses and impatience interfered with their capacity to reason and act properly.

The persuasion of a political body, a theme central to Josephus's Moses, informs Poussin's handling of the narrative. Rather than depicting the miracle as a moment of thanksgiving bereft of tension, Poussin's *Manna* is informed by the psychological acuity of Josephus and his recognition of the political effects of starvation.[28] The multiplicity of figures and expressions makes a strong contrast with the individual leader. While some respond with acts of charity, mob violence threatens to erupt in the struggle over food. A man on the left, a viewer by proxy for Chantelou the royal official, gathers evidence.

The evidence of the Greco-Roman visual tradition further supported Poussin's case for the exemplarity of Moses. As Charles le Brun later pointed out, the painting is a virtual compendium of famous ancient statues.[29] The arrangement of vignettes based on sculptural groups, from the Niobe ensemble to the Medici wrestlers, resembles Perrier's own contemporary project of famous statues embedded in landscapes. By echoing the Niobe group's bodies wracked with pain from arrows of divine retribution, Poussin deepened the poignancy of the scene of rescue from imminent catastrophe.

The episode of the manna only temporarily resolved the predicament of Moses. He soon had to face "popular fury" once again due to severe thirst. Again the crisis was resolved by the persuasion of Moses through words and miracles. Poussin depicts the moment when Moses strikes a rock and abundant water comes forth. The people respond: the very

sight of the water stops their thirst. Seeing that Moses was honored by God, they held Moses "in very great admiration." Even Tacitus, whose antisemitic and anti-Christian position tested the humanists, tacitly admired the story as a lesson in real-politik (though he believed the cunning Moses feigned divine intervention when he secretly deduced that a source of water was present by following some wild asses to some tufts of grass).[30]

According to Josephus, Moses recovered his authority as a leader. The persuasion of a multitude through the *admiration* for their *législateur* was precisely how Poussin verbally articulated the importance of his representation of the *Gathering of the Manna*. Poussin called Moses "législateur" and stressed the expressive and diverse "natural attitudes" of the Jewish people in his painting:

> The admiration with which [the Jewish people] were touched, the respect and rever-ence that they had for their Legislator, with a melange of women, children, men of dif-ferent ages and temperaments, things, as I believe, which will not displease those who know how to read them well.[31]

Admiration, respect, and reverence are qualities derived not from the honor God bestows on Moses but from the nobility of his appearance and the power of his rhetoric that can move "un peuple." These movements can be "read" on their bodies. Political behavior is legible to the leader and the competent viewer.

The themes of both Camillus and Moses represented the relationship between a leader and his subjects. But rather than presenting that relationship as soundly hierarchical and secure, Poussin's narratives demonstrated the crises that can occur in that relationship and the attempts to resolve them. The representation of crises in the ruling of the Israelites offered valuable object lessons and opportunities for discussion by a political elite. Poussin's paintings were the pictorial legacy of the sixteenth-century project for a comparative jurisprudence and universal history.

Poussin's paintings of Camillus and Moses culled the ancient world for models of expression not simply to catalogue these examples but to examine them, since they were subject to the pressures of demographic catastrophe and political crisis. The representa-tion of crisis was central to Poussin's enterprise, from the threat of violence in the *Gath-ering of the Manna* to the violent inversion of authority in *Camillus and the Schoolmaster*. In the *Manna*, violence is a set piece, two boys grappling in the dirt. The breakdown of social order is not entirely placated. There is a concomitant thematization of that disorder in compositional discordance. Or rather, disorder must be represented so that it can be organized in the larger compositional order. The thrashing of the naked schoolmaster registered a similar commitment to the use of painting's expressive materials in conjunc-tion with the antiquarian and textual competencies of its immediate audience.

While the artist thematized political crisis in painting it was understood within the rhetorical tradition of exemplarity. But such examples of conduct diverged from the pan-egyric and instead stressed the admonition of inappropriate conduct. The schoolmaster dominates the composition and the struggle for food in the foreground of the *Gathering of the Manna* upstages the diminutive figure of Moses. Poussin's paintings were one response to the transformation of humanist exemplarity in post-Renaissance European culture. The pictures offered opportunities for discussion and improvised exegesis, thereby exercising the values and providing models for the practical action of a political elite. The humanist lexicon of ancient texts constituted a universal history whose abstractness was diminished in the face of actual political crisis. In the 1630s, siege warfare and the treat-ment of subject towns was a pressing concern as Richelieu's organization of a centralized

state infringed on the customary rights and privileges of ruling nobles and urban elites. The story of Moses, as told by the colonized Jew Josephus, and the Roman histories served to mediate these cultural and political relationships – negotiating tensions, acknowledging reciprocity, and providing ballast. This was the brief for the Grande Galerie given to Poussin by Richelieu and the elite who began to collect his paintings. By mid-century, Poussin's compendia of archeological materials and vivid evocations of the turmoil of a distant historical past became even more severely inflected by political crisis and historical transformation.

Exchanging Moses

Poussin's *Moses Striking the Rock* was a vehicle for the cultural exchange of humanist elites. The placement of a painting in a picture cabinet or a gallery provided an occasion to rehearse skills acquired in the *collège* and in the halls of the Palais de Justice. We might imagine the conversations of a group who gathered around a painting by Poussin and solicited him to direct the Grande Galerie project. We might also imagine another arrangement of an object that constituted a community in France. Like antiquities, the tableau's portability facilitated sociability and interpretation through changes in ownership. Félibien listed the names of those who exchanged the painting ("Gillier, de l'Isle Sourdière, Président de Bellièvre et Dreux") as if to stress that provenance traced a homogeneous social formation.[32] The owners of Poussin's *Moses Striking the Rock* during his own lifetime reveals that a class was defined by its relationship to the work of art as an object of material and social exchange.

If we tease out the dry texture of provenance research, a pattern emerges. The first owner of *Moses Striking the Rock* was a prominent and wealthy member of the *noblesse de robe*, Melchior de Gilliers, seigneur de Lagny (1589–1669).[33] He insisted upon identification as royal officeholder when he published a broadside of his family tree, reminding readers that his ancestor Philippe Giller was *intendant des bâtiments* for Philip V in the fourteenth century.[34] Gilliers also obtained prestige by serving as a major *officier* and cultural advisor for the duc de Créquy during his ambassadorship to Rome.[35] In Italy, Gilliers acquired Poussin's *Rape of the Sabines* (see fig. 10) for Créquy's collection and *Moses Striking the Rock* for his own.[36] The latter painting subsequently passed into the collection of "Président de Bellièvre," Nicolas Pomponne II de Bellièvre (1606–57), whose ancestors in Lyon, as I said before, were linked to the Claudian tablet and the triumphal entry.[37] He was rewarded with the office of Chancellor of France and the Bellièvres formed marriage alliances with prominent *noblesse de robe* families.[38] Pomponne II held several royal offices, including a diplomatic post in Rome where he may have met Poussin during Créquy's ambassadorship.[39] Like his father before him, Pomponne II was elected first President of the Parlement of Paris.[40] Poussin's painting found itself at the heart of the traditional *noblesse de robe*.

Although the family moved from Lyon to Paris, it maintained familial and cultural ties to the ancestral home. In recognition of his father's devotion to Gallo-Roman inscriptions and with commensurate humanist eloquence, Pomponne II's grandfather wrote a Latin inscription for his father's tombstone in Lyon.[41] Several generations of political service, the books and speeches, royal entries, and epigraphic translations constituted the ground for the painting's reception. Since Bellièvre died without an heir, his considerable fortune was bequeathed to charity, but the painting continued to circulate among the *robe*

nobility. It passed directly into the hands of a prominent member of the *Chambre des comptes*, Guillaume de Dreux, who would have known Michel Passart.[42]

The provenance suggests an economy of reception beyond the immediate control of the artist. It therefore allows us to extend the patterns of individual obligation from his direct patrons to a description of a larger audience. The list sketches a social description of Poussin's most immediate audience before his return to Paris. The restricted pattern of reception was not accidental. These collectors, like Passart, who belonged to the *noblesse de robe*, shared a comparable education and had a similar investment in historical evidence, specifically from a shared reservoir of antiquity. Bellièvre was the product of several generations of accumulated experience in the management of the objects and texts of the Roman past. His great-grandfather's *jardin des antiquités* on the Lyonnais hillside still remained in the family.[43] When his grandfather rehearsed his Latin on the tomb of his own father in honor of their shared knowledge, he did not fail to call his father a senator. Invoking the Roman Senate in a church was commensurate with displaying a picture of Moses in the official residence of the President of the Parlement of Paris. My stress is not on the facile handling of erudition for its own sake. Instead, for Poussin and his emergent clientele a depth of historical and antiquarian knowledge had the potential of assuming a public dimension, as in the decorative scheme of the Grande Galerie. Such erudition was always available to be exercised in the arena of state politics. In 1648, erudition was deployed in response to political crisis.

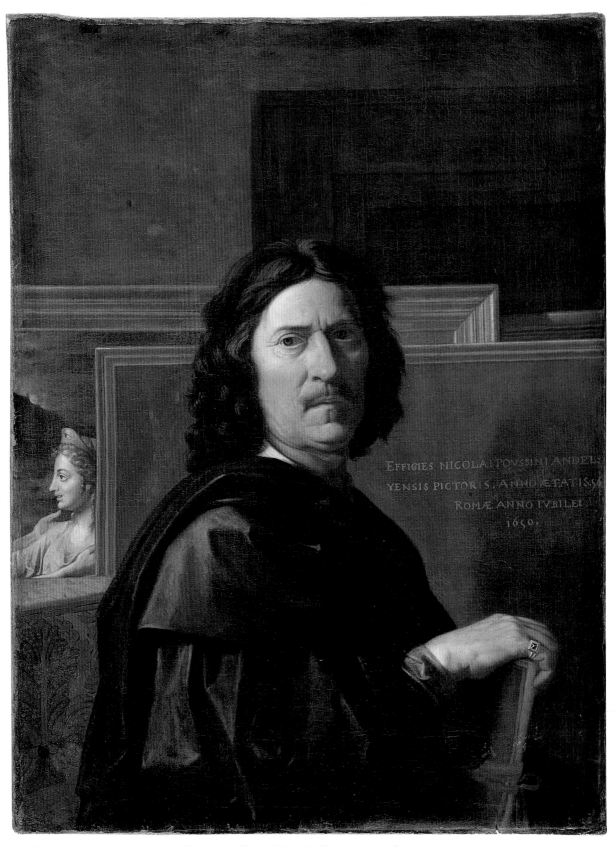

EFFIGIES NICOLAI POVSSINI ANDEL:
YENSIS PICTORIS. ANNO ÆTATIS 56
ROMÆ ANNO IVBILEI
1650.

40. Poussin, *Self-Portrait*, 1649–50, oil on canvas (Paris, Musée du Louvre, inv. 743), 980 × 740 mm.

The Fronde, Poussin, and his French Clients

A decade after Poussin's sojourn in Paris he painted two self-portraits in Rome (figs. 40 and 41). Both paintings bear inscriptions that commemorate his status and birthplace as well as the date and place of execution of the pictures. One (fig. 42) announces the Roman academician and first painter to King Louis XIII, thereby recalling the achievements of the previous decade by the man from Les Andelys who had served the late king. The other (fig. 40), painted a year later, simply stresses the French provincial origins of the painter and, like the other, locates the production of the likeness in Rome, now in the Jubilee year of 1650. The highly formal pose and immovable seriousness of these rare self-presentations bespeak well-considered purpose. One might even say that the pictures are manifestos.

The pair can be read as the culminating gesture of an artistic biography in the heroic mode: an artist exceeded the limits of his provincial origins and gradually arrived at a respected position as a result of his dedication and perseverance. He removed himself from his place of birth in search of training, experience, and fortune and after some success was received back into the bosom of the motherland. When Poussin returned to Paris in 1640 to begin the Grande Galerie project, he was seized upon by the French as one of their own. If the heroic tale had ended in 1640, it would have told of the artist's success in France. But the longer narrative took a turn. After a brief period in France as first painter to the king, Poussin returned to Italy. The inscriptions on the two self-portraits stress that the painter lived in Rome, at a distance from France.

Literally inscribed in the two self-portraits, Poussin's exile has been central to his biography and the interpretation of his work. The explanation given by his early biographers for the second and final exile goes something like this: Poussin found the political and meteorological climate in Paris unbearable. He preferred the more temperate conditions of Rome, far from the intrigues of jealous painters (principally Simon Vouet) and the overwhelming administrative duties attendant on conducting ambitious artistic projects. Poussin backed away from direct negotiation with his French patrons, wishing to keep his distance, serving from afar, keeping in touch by pictures and letters. That he did so has been viewed positively because Poussin's temperament was said to have been better suited to paint cabinet pictures that were intimate, researched, and well considered. Far from the glamor of the court, restrained in his mode of living, and distant from the agitation of political society, Poussin was free to create. The two self-portraits sent to Paris in 1650 seem to support this conclusion. With an intensity of concentration on the most modest of means, far from institutional concerns, Poussin represented himself as a singular artist, with chalk, folio, and framed easel pictures as his attributes.

41. Poussin, *Self-Portrait*, 1649, oil on canvas (Berlin, Staatliche Museen), 780 × 650 mm.

42. Charles Errard, Poussin's *Self-Portrait*, 1649 (Berlin), illustration in Bellori, *Vite*, Rome, 1674 (Berkeley, The Bancroft Library, University of California).

This explanation for Poussin's return to Rome has had its effects on the interpretation and assessment of his art. One tends to think of the French episode as an aberration in his career; an ill fit between his native talents and the demands put upon a court painter. Poussin was not the cosmopolitan courtly interloper Rubens, but a *peintre-philosophe*, distant, detached, and disengaged. His early biographers portrayed his art as personal theoretical speculation. Poussin's self-portraits have been used to support these claims. The pressure to represent him as a *peintre-philosophe* has been most dramatically brought to our attention by the restoration of the Berlin *Self-Portrait*.[1] Restorers discovered that the painting had been altered by another hand: the words painted on the book ("De lumine et colore") were a later addition, making an artist's drawing folio into a theoretical treatise. The biographer Bellori similarly replaced the mechanical artist with a wordsmith in his appropriation of Poussin's own likeness for his *Lives* of 1672 (fig. 42). In the engraving after the Louvre self-portrait, the appended abbreviated title ("De lvm[en] et vmb[ra]") on the portfolio turned book serves as a caption, implicating the sitter in theoretical speculation on the issues of light and shadow. More radically, the traces of Poussin's studio practice have been amputated. Without a chalk-bearing hand, an artist's folio is transformed from an instrument of observation. Painting is replaced by reading.

Elizabeth Cropper and Charles Dempsey have interpreted Poussin's *Self-Portrait* in the Louvre as a testament to Poussin's commitment to practice and community. They emphasize that the love of painting is based on Montaigne's model of friendship.[2] Art is engaged

in a larger social world. I am sympathetic to this view but I should like to consider further the invention of the isolated painter-philosopher. At the very least, the emergence of a myth surrounding an artist is useful for the historian. Myth illuminates the role constructed for the artist during his or her lifetime. Indeed, Poussin's expatriation continued for many years to have an important symbolic function for artistic and critical practice. From Fragonard to Chateaubriand, Poussin's Rome represented a large independent studio. For these Frenchmen, the expatriate was free from the constraints of state ambitions, free to wander in a countryside of atmospheric effects and ruins, free to behold the great works of the Western tradition, free to respond to internal demands. In this version, the heroism of this individual creator resides in the disengagement of his art from extra-aesthetic concerns. The work retains its power in an eternal present because of its universality. Ironically, Poussin can better serve Cézanne and French patrimony, modernism and nationalism, from his Roman outpost.

Do the self-portraits in fact convince us that Poussin's removal from France represented a resignation from French culture as well as the post of *premier peintre*? Were these works effectively removed from the circulation of meanings discussed so far? It is relevant that the two works were heatedly sought by two of Poussin's most active collectors, Jean Pointel and Paul Fréart de Chantelou. Indeed, Poussin's production and audience after his return to Rome reveal an intensification of his relationship to France. Despite his withdrawal, Poussin steadily exported works to France and continued to consolidate a dependable French clientele. Soon after his departure from Paris, he agreed to paint an ambitious project for Sublet de Noyer's agent and nephew Chantelou, who already owned the *Gathering of the Manna*. Chantelou's desire for a repetition of the series of paintings depicting the Seven Sacraments painted for Cassiano dal Pozzo resulted in a variation. Beginning soon after his return to Rome, Poussin sent the canvases one at a time to his patron, promising to abstain from other projects.

Yet before satisfying this obligation over the course of a few years, Poussin began to produce pictures for a number of other French buyers. Clearly, despite his absence, he not only sustained but expanded his artistic practice in France, producing a multitude of paintings despite the fact that conditions were adverse to the commerce of art. Throughout the 1640s, the political climate and economic conditions in France were volatile. Poussin's most prolific period, by his own admission, was contemporaneous with the explosion of the civil war known as the Fronde,[3] when he continued to supply paintings almost exclusively for a demanding French clientele. Under conditions that threatened the artist's concentrated production, under the shadow of ruined fortunes, political disgrace, and military violence, Poussin continued to paint and export his pictures to France.

Some readers may say that this is entirely consistent with Poussin's geographic and psychological distance. After all, his art is the quintessential expression of private demands. Why should he have been encumbered by the pressures of history? He was also abroad. In response, it must be pointed out that he was intimately tied to the situation in his homeland because of his sustained contact with the French clientele he had developed in the 1630s before his return to France as well as during his year in Paris.[4] During the 1640s Poussin's active correspondence and steady exportation of pictures to France was a performance of the bonds between artist and client, over both distance and time. The Seven Sacraments crossed the Alps in a series of shipments like epistolary installments that formed a whole only in Chantelou's cabinet (see figs. 70 and 71). Like Poussin's letters, which were bound by his correspondent, the series of paintings not only provided an opportunity to rehearse an antiquarian culture but also stood in for the artist himself.

The *Self-Portrait* sent to Chantelou in 1650 (see fig. 40) was a similar communicative act stressing that the recipient was a worthy addressee. The phatic gesture was repeated for his other client Pointel (see fig. 41). As Cropper and Dempsey have stressed, each self-portrait was defined by its part in an exchange, like an epistle, constituting the personal relationship between artist and patron.[5] The portrait was Poussin by proxy. The Self was a transactional object, one modeled on the gift or letter, not the commodity. At the same time that Poussin was diminishing the importance of the strictly commercial relationship between artisan and buyer, he was developing a social relationship based on the expression of common interests. Central to letter writing was the sending of news of events that exceeded the confines of the studio and the decisions on canvas. Sociability under the pressure of events that threatened the bonds of friendship became political behavior. This chapter attempts to offer a portrait of a painter, his clients, and the civil war that shaped their friendships and their politics.

Letters from Abroad

The letters by Poussin to his correspondents in France trace the relationship between a painter and his clients, friendship and artistic production. Poussin's correspondence can be likened to others among the Republic of Letters.[6] Relatively free from censorship, the discussion of antiquities and books was punctuated by candid observations on current events and politics.[7] Indeed, Poussin did not segregate contemporary realities from his discussion of art.[8] The evidence of the letters diminishes the mythic distance between the artist and the political history of France.[9] In fact, Poussin's letters written after his return to Rome, and in particular between 1648 and 1652, trace his response to the momentous course of events in Paris and the provinces.[10] What emerges from the letters is an historical account of the period leading up to and including the Fronde from the vantage point of an artist interested in its direct consequences for his clients.

The Fronde has been characterized variously as the last tragicomic grasp for power by the ancient nobility as well as the legitimate and incremental resistance of the *noblesse de robe*, most notably the *parlementaires*, to an encroaching absolute monarchy.[11] Scholars have interpreted the civil war either as a series of spontaneous rebellions consistent with the demographics of the period or as a political revolution; either conservative or innovative; it either ushered in the absolutism of the Sun King or kept tyranny at bay. Only one shared picture of the Fronde emerges: although the conflict changed from day to day as individuals and alliances shifted positions and strategies, there was often consensus on opposition to the First Minister Cardinal Jules Mazarin.

The roots of the opposition to Mazarin can be partially traced to the time of Poussin's ostensibly temporary return to Rome and the subsequent deaths of Richelieu and Louis XIII. In a pattern typical of *ancien régime* France, the monarchy's desire to form marriage alliances with foreign families and states led to a precarious political situation when the king died and left his son Louis XIV in his minority. Because of the salic law's prohibition against rule by a queen, the regency of Anne of Austria and her foreign minister Cardinal Jules Mazarin was subject increasingly to challenges by various interests. The years 1643–48 were marked by a mounting resistance to the regency.

<p style="text-align:center">* * *</p>

Disgrace

Even before the precarious minority of Louis XIV, Mazarin's creation of political enemies had a direct impact upon Poussin and his clientele. The death of Richelieu resulted in a redistribution of power shortly before the king's own death. Mazarin was blamed for the political disgrace of Poussin's chief patron in France, Sublet de Noyers, and the termination of his system of patronage. The fall from political favor of Sublet and those loyal to him, including Poussin's friend and patron Chantelou and his brothers Jean Fréart and Roland Fréart de Chambray, helps explain the particular acridity of the artist's opinion of the First Minister.[12] Poussin's personal identification with the disgrace of Sublet de Noyers opposed him politically to Cardinal Mazarin even before the outbreak of civil war. Furthermore, the disgrace of this network of clients helps explain how artistic culture came to provide a position from which political opposition could be articulated.

Whichever terms are used – retirement, retreat, fall, or disgrace – Sublet de Noyers suffered from Mazarin's political ascendancy.[13] Mazarin had tactfully announced that Sublet had asked permission to retire, which had been granted by Louis XIII on April 10, 1643.[14] Despite this polite euphemism for the taint of courtly disgrace, the memoirs of the period consistently describe Sublet as the victim of Mazarin's intrigues.[15] Having sought Sublet's favor while Richelieu was alive, Mazarin turned against him immediately after the cardinal's death.[16] Since Sublet had been responsible for the honors Poussin had received from the French crown, the absence of Sublet from court had a direct bearing on the painter's decision to remain in Italy.[17]

Poussin's letters from Rome provide evidence of his engagement in these affairs of state in the mid-1640s.[18] He closely followed news of Chantelou's political fortunes. He also reacted violently to Sublet's enemies at court who attempted to usurp his power, calling for one *intendant* to be hung by his testicles.[19] The rarity of such a direct verbal attack in the letters offers a measure of his feelings. More typically, Poussin relied on metaphor and myth to express his joy, anger, and despair over the events surrounding Sublet's disgrace. He compared Sublet's plight to that of Aeneas, wandering in exile, buffeted by the high winds, the fury of Scylla, steering for Latium and a quiet home.[20] When he chose to frame his thoughts in a language commensurate with the Grande Galerie, he did not withhold his vitriol. The painter used Herculean allegory to praise the efforts of Chantelou: "You work like the other virtuous Hercules to purge the world of tyrants, thieves, and hideous monsters, which horribly infect our poor France."[21] Poussin thereby associated both Chantelou and Sublet with the ideal of active disinterested patriotic service. His dismay over their retirement far exceeded personal loyalty.

The enmity Poussin felt for the regency was brought to a head when the artist was dealt a financial blow and an affront to his honor as part of a political attack on Sublet de Noyers. While other *brevetaires* were housed in the Louvre, Poussin as first painter had enjoyed the distinction of a garden property in the aristocratic Tuileries, not far from Sublet's own house. The confiscation of this house, besides causing personal loss, had a deeply political resonance. The artist had asked Sublet to intercede on his behalf in order to protect this valuable property. In an explicit affront to the authority of Sublet, the house was taken away from Poussin during the regency and given to Samson Lepage.[22] The decision was justified by hearsay evidence that Poussin had no intention of returning to Paris. According to Poussin, this argument was based on the false testimony of an agent of Mazarin who had interviewed him, the French ambassador to Rome. The ambassador then circumvented Sublet's authority by dealing directly with the secretary of state,

Brienne.[23] One of the *brevets* that awarded the house to Lepage explicitly stated that Sublet de Noyers must honor the *brevet* and insure that the new inhabitant not be troubled.[24] The regency anticipated Sublet's harassment of the tenant.

In a letter to Chantelou Poussin expressed resignation at his own persecution but asked for assistance because the seizure of his property constituted an affront to their patron Sublet:

> I do not have weapons strong enough to repair the nasty blows of envy and anger delivered by our Frenchmen except by suffering and being patient. It's true my happiness does not depend upon [the property], it is better founded; however, I beg of you to make some effort to resolve this matter because it concerns [Sublet].[25]

Poussin painted his fidelity to Sublet against the ground of Mazarin's vice-ridden regime.

The following June, in 1645, Poussin continued to interpret this affront to his person and to that of Sublet as the subjection of a disinterested service elite to hostile factions. He still maintained that he intended to return to France and that any statement to the contrary was a false invention. He expressed his sense of being persecuted: the late king had given him the house for life. A license had been obtained from the queen to throw Poussin out. False letters were drawn up to state that Poussin never intended to return to France. By these falsehoods the queen committed an injustice. Poussin lamented that he was being exiled from his place of birth:

> Now that I long to return and enjoy the sweetness of the land [*patrie*] where each of us desires finally to die, I see myself chased out . . . Is it possible that there is not one person who wishes to defend my rights? who wishes to stand up against the insolence of a vile man, a lackey? Is it possible that there is no one to defend my estate? Do the French have so little feeling for their nurslings who honor their country and fatherland [*leur pais et leur patrie*] by their virtue? Will we allow a man such as Sanson [sic] to throw a celebrated man of virtue known throughout Europe out of his own house? Furthermore, this is a matter of public interest.[26]

Poussin invoked the recurrent theme of the virtuous native who honors *pays* and *patrie* by giving fame to it, yet is mistreated, left to die far from the fatherland.[27] He was outraged by the regency's disrespect for the memory of Louis XIII, who had awarded him the property. He interpreted this as an affront to his person but also to himself as a public figure and a servant of the crown. The appropriation of his estate was, therefore, also an attack on the broader political concept of the *bien public*. The questionable legality of these politically motivated moves against Poussin provided a basis for criticism of the first minister's government.

In accordance with the rhetorical patterns of French humanist practice, Poussin argued from an assumed position of disinterestedness. His own persecution was voiced in general terms that echoed the plight of Sublet de Noyers. The attack on Sublet was a symptom of the general condition of envy injurious to the *patrie*. Poussin had already conceptualized his hopes for the imminent return of Sublet from exile as a matter of patriotism: he had written that France was happy because "she recognized those who alone are able to enhance her name and her glory."[28] Any evidence of an attack on Sublet was therefore a threat to the glory of France, the fatherland, and the grandeur of "our Nation" and its position in history.[29] As Sublet had appealed to Poussin's duty to crown and country, any infringement of his ability to return to France was a sign of ingratitude.

The affair of Poussin's house in the Tuileries is significant because it sheds light not only on the personal motivations for Poussin's animosity toward the agents of the regency, but also on the way his reputation as an artist entered into political discourse. Poussin's

anger at his treatment in Paris has long been taken to be a response to the jealousy and bickering resulting from artistic rivalries. The traditional account of Vouet's attempt to drive Poussin out of France is an exaggeration, as Jacques Thuillier has pointed out.[30] In Poussin's own words, the regency treated him "comme un exilé ou bani." Because Poussin and his French clients conceived of him as a royal servant banished by the regency, this early injury to *la patrie* accrued value as opposition to the regime mounted.

The Fronde

The situation came to a head. The crown was threatened by bankruptcy, so Mazarin and his administration increased taxation and created more venal offices. In order to expedite matters, he bypassed the traditional financial checks of the courts and therefore ignored the legal authority of the *noblesse de robe* to challenge these measures. On January 15, 1648, the regency attempted to pass edicts in spite of the remonstrances of the sovereign courts. A *lit de justice* by a king in his minority had dubious legality. The financiers who kept the strained royal finances from collapsing lost confidence in the government. The regency was threatened by legal crisis and financial ruin.

In the period known as the Parliamentary Fronde (1648–49), all the sovereign courts made a legal bid for fiscal and political reforms.[31] Representatives of the Parlement of Paris, the *Chambre des comptes*, and the *Cour des aides* met as a single body for a month.[32] This first phase of the Fronde marked an unusual consensus and alliance among factions within and outside the ranks of the *noblesse de robe* in Paris and the provinces. Reports of the proceedings in Paris were published and distributed in the provinces and news of the much desired elimination of the tax *intendants* as well as rumors of tax cuts ran rampant. Popular demonstrations by merchants, artisans, and peasants became a regular feature of Paris life through the summer of 1648.[33] In the face of growing opposition, Mazarin hastily called for financial reforms.[34] His concessions were inadequate and resistance intensified. For Poussin, exile afforded a vantage point from which to witness the mounting opposition to Mazarin, and the civil war that ensued. Poussin responded to Chantelou's account of the legal and extra-legal political resistance of the summer of 1648 in the following way:

> Truly, like any good Frenchman, I am not so indifferent to recent events in Paris that I desire [the government] to continue being conducted as poorly as it has been for several years. And if, as often happens, this great disorder might bring about some good reform, I personally would be extremely delighted. I imagine that every *homme de bien* shares my sentiment. But I fear the malignancy of the century. Virtue, conscience, religion are banished [*banir*] from among men. Only vice, deceit, and self-interest reign [*regner*]. All is lost – I despair of goodness – All is overcome by unhappiness. The current remedies are not strong enough to remove the evil. If we do not get rid of the Cause, we are wasting our time. What's the point in cutting off the finger if the arm is rotten? The fall of this villain . . . does not soothe me at all because I impatiently await that which must follow.[35]

For Poussin, the "good reform" justified the "great disorder." He identified himself with a position that he assumed was taken by "every man" and all "good Frenchmen." His joy was however undercut by a profound pessimism and sense of belatedness.[36] The voice is that of a late humanist reader of Tacitus.

Nevertheless, Poussin, like any "good Frenchman," brought this generalized lament and political reflection back to the particularity of daily politics. The verbs *regner* and *banir* are overdetermined here, implying the specific conditions of disgrace under the regency. Manichean oppositions of good and evil are grounded in contemporary political commentary by the reference to "the fall of this villain." It is likely that Poussin was referring to the fall of the finance minister Particelli d'Emery who had been strategically sacrificed by Mazarin.[37] But Poussin would not be persuaded by such expedient remedies until the "Cause" had been eliminated. For him, the removal of Particelli left the state as before, a body threatened by the putrefying deceit and self-interest of Mazarin. Poussin's antagonism toward Mazarin as the result of the disgrace of Sublet and his circle now found expression in the organized opposition to the regency and its vilification of the Italian cardinal. For Poussin, like many French people during the Fronde, the first minister became the principal object of derision and blame. He often served as the only common bond for a threadbare assemblage of factions and interest groups.[38]

Poussin's pessimism was timely. Despite the proposed reforms, the situation did not improve. A popular insurrection in August, known as the Day of the Barricades, resulted in the royal family's first flight from Paris. A settlement was reached, the regent returned, and again the crown reneged on the agreement. In early January, 1649, the royal family fled again and the royal armies, led by Condé, attempted to regain the city. The Parlement declared Mazarin an enemy of the people. Poussin responded to a Paris under siege: "May God by his grace preserve our France from that which menaces it."[39] Parisians were subject to the severe hardships of a blockade and the surrounding countryside was soon devastated by marauding troops.

Less than a month later, another letter from Poussin discussed what potential effect the civil war would have on the reception of his art and the decisions of collectors. He had already drawn up a composition for "a pleasant bacchic subject" for the burlesque novelist and *frondeur* poet Paul Scarron. However, he intimated that he would satisfy the obligation only if the turbulence in Paris did not make Scarron change his mind, adding: "God willing, may we see . . . peace in our poor country. When it happens we will be able to celebrate our joy with bonfires. But until then, we shall not be able to laugh heartily."[40] For Poussin, civil war threatened to banish the lighter mode of the bacchic subject and the deeply felt laugh. Political events infringed upon decisions in the studio. Typically, the first person plural possessive was attached to *pauvre patrie* as he reflected on an appropriate artistic response. He did eventually complete his obligation to Scarron by painting an *Ecstasy of St. Paul* that offered, as Charles Dempsey has pointed out, solace to the physically afflicted author.[41]

The "Parisian war" raised concerns for the safety of Chantelou. Not having heard a word from his correspondent, Poussin did not know if his friend was in his native Le Mans or trapped in "this destitute city."[42] He hoped that Chantelou's silence was merely the result of a preoccupation with concerns other than pictures.[43] However, within three weeks, Poussin again received word of the "affairs of our poor France" from Chantelou. The Treaty of Rueil had been signed. Poussin expressed his outrage at the temporary resolution of the conflict:

> What you have witnessed had been foreseen for some years even by the least intelligent of people. But what surprised everyone and foretells our total ruin is the accord that has been made. Better to have died instead . . . Certainly, we are the laughingstock of the entire world.[44]

Poussin's opposition to a peace treaty was not a renunciation of the Fronde.[45] While some members of the *noblesse de robe* considered the concessions granted by the regency an ade-

quate recognition of their authority, others were angered that the treaty's negotiators dropped their demand to exclude Mazarin from power.[46] It is this compromise that elicited Poussin's ire, and placed him among the ranks of the *mécontents* against the treaty, such as, according to one *frondeur* pamphlet, "painters, architects, sculptors, and engravers" who rioted in Paris after the document was signed.[47]

In order to express his immediate anxieties, Poussin drew upon an image from the *Odyssey*: "We think little of the future and yet, it is to be feared more than the present . . . Let us save ourselves, if we can, hidden under the sheepskin, dodging the bloody hands of the enraged and furious Cyclops."[48] The Homeric metaphor places Poussin and Chantelou in the roles of companions, scurrying out of the cave in the guise of sheep. In his personal epic of political fortunes, blind monstrous rage threatens to destroy the painter, but the ruse provides a way out. Poussin, like Odysseus, responded to the monster's "Who is there?" with "Nobody." Poussin evaded the monstrous force and irrational disorder. The image does in fact refer to the threat of explosive sexuality and violent shifts of scale in Poussin's early drawing of Polyphemus (see fig. 7). But in this case the monster is more specifically associated with the tyranny of a lawless-minded individual, Mazarin.[49]

A pattern of animosity toward Mazarin in the letters substantiates the allusion. Poussin's consistent venom toward Cardinal Mazarin is demonstrated by a letter in the fall of 1649. The court's return in August registered a confidence in popular support within the capital. After a flood of pamphlets celebrating the birthday of the king, there was a momentary calm that marked the end of the first Fronde. A month after the return of the court and Mazarin, Poussin described the situation from his position: "Here, everyone knows about the return of the king and his court to Paris and what transpired. But those who are familiar with the stupidity and inconstancy of the people are not in the least astonished by what they do."[50] Rather than negatively responding to popular violence, Poussin was perturbed by the passive acquiescence to Mazarin despite attempts to reform the regency.[51] One moment people are calling for exile, the next they give in to the resumption of power by Mazarin. Poussin was not alone in his frustration. The most radical *parlementaires* also regretted the lost opportunity for reform and the ousting of the first minister.[52] Mazarin's hold on the reins of power was assured at least for the moment.

However, Mazarin made some miscalculations that undermined the stability of the government. The perceived threat of the ambitious nobility led to Mazarin's incarceration of the Princes Condé and Beaufort at Vincennes along with the president of the *Chambre des comptes*, Jean Perrault.[53] This precipitated a provincial rebellion that enabled an alliance between the Parlement and the princes. After a period of uncertainty and bad news, by April of 1650 the situation in France had changed dramatically.[54] Then, with the liberation of the princes, Mazarin left Paris in February 1651, ousted from the government and banished from France. Poussin responded to Chantelou: "At last, Monsieur, your prophecies are accomplished. I pray to God that it will last forever. I fear the return."[55] Poussin and his clientele, especially those in the Sublet circle, celebrated this moment and, like many of the French, sought the cardinal's perpetual banishment.

There is an unexplained hiatus in Poussin's correspondence at this point so no evidence exists of his responses to an entire year of events. His epistolary voice reappears only after the triumphal return of the king to Paris in October 1652. The cardinal stayed safely in the wings until the following year when monarchical power was consolidated, amnesty was granted to most *frondeurs*, and some of the more recalcitrant figures were put away. Poussin wrote to Chantelou that the effects of over four years of civil unrest after a taxing period of foreign war could not be easily forgotten: "But too often we receive news of the desolation of our poor France. The universal chilling of curiosity for beautiful things had

made me think that you were busy with things other than some new painting . . ."[56] He ends on a defeated note regarding art and political change. As the editor Quatremère de Quincy noted (during the Bourbon Restoration), Poussin's extant letters after the Fronde cease to refer to politics, perhaps fearing interception once Mazarin's power had been reestablished.[57] In the wake of the war, the devastation of mercenary troops, the insecurity of factional divisions, and the inevitable recurrence of a similar distribution of power, Poussin expressed his belief that culture itself, the receptivity of the collector or viewer to beautiful objects, had frozen to a standstill.

What is striking is the fact that Poussin's remarks occur at the end of the civil unrest. Indeed, before 1652, during the war itself, Poussin's works had never been in greater demand, or his studio so productive. In the face of political upheaval culture had not ground to a halt. Even immediately after the blockade of Paris, during the tensions of the summer of 1649, Poussin confessed that his work was in steady demand.[58] Soon after, he admitted that his energies were taxed by his commitments to more than twenty "personnes de qualité."[59] The desire for his services among Frenchmen was also registered in Chantelou's lobbying on behalf of friends in competition with other collectors. Poussin's physical absence from the pressing demands of the court was apparently not distant enough to sustain an image of a contemplative, untaxed philosopher in his studio.

In spite of the difficulties, the paintings made their way from Rome to Lyon and Paris. Besieged cities, pillaging armies and quartered troops, economic crisis, and spontaneous violence did little to obstruct the satisfaction of a demand. Rather than maintaining a safe removal from politics and difficult conditions, a comfortable distance usually expected to be conducive to the acquisition of pictures, many collectors were in the thick of political upheaval. What might have been interpreted as a hindrance to the participation in artistic culture seems to have actually nurtured it. While Poussin's letters have attested to his full mental engagement in the course of events during the civil war in France, the story of the Fronde can be told in another way – from the position of Poussin's picture buyers.

Clients and Social Actors

Poussin was loyal to and shared interests with people whose lives were caught up in the political and economic turmoil of the Fronde. Although social proximity does not guarantee identical political positions, an intricate pattern of personal allegiances and loyalties constituted an important aspect of seventeenth-century political behavior and organization.[60] The very complexity of Poussin's network of relations is significant because it qualifies the myth of his isolation.

A number of collectors of Poussin's work can be linked to an institution at the heart of the Fronde's history, the Parlement of Paris. One of Poussin's earliest pictures executed after his sojourn in Paris was a Crucifixion commissioned by Jacques-Auguste II de Thou.[61] Poussin stated in a letter that he had been intimate with this *premier président* of one of the chambers of the Parlement of Paris for a very long time.[62] Because Richelieu had executed de Thou's brother for treason, along with the more famous favorite of Louis XIII, Cinq-Mars, in 1642, de Thou had a personal investment in the reformation of the monarchy in the wake of the cardinal's death. De Thou was a prominent and unrepentant radical in Parlement. His major offense was his conspicuous support of Gaston d'Orléans as head of state when the Parlement accused Mazarin of imprisoning the young king. As a consequence, he was exiled in 1652 when the king was restored to the throne.[63]

Another *parlementaire*, Pomponne II de Bellièvre, was actively opposing Mazarin at the same time that he acquired Poussin's *Moses Striking the Rock* (see fig. 88). Bellièvre has already been described as having inherited the dual tradition of classical erudition and judicial discourse from his great-grandfather. In speeches and actions, he took legal steps to exclude Mazarin from office.[64] In one of the speeches delivered in Parlement as president, he called upon the king to uphold the prohibition of Mazarin from the royal council and France, calling him the common enemy of all "good Frenchmen."[65] He reviled the tempests created by this self-interested foreigner, while great men of talent, born in France, languished at the margins of the monarchy. The zealous and loyal subjects were reduced to despair as the outlawed criminal defied the royal edict and entered France as if in a triumphal entry.[66] Such speeches certainly inflected the significance of the representation of Moses in the president's possession. In Moses Bellièvre found a model for a response to political crisis based on an art of persuasion founded in knowledge of law.

Bellièvre, like other *parlementaires*, also associated with aristocratic *frondeurs*. He made official visits to the Palais d'Orleans[67] and entertained *frondeurs* at his country house, the Château de Berny, among them the Duchesse de Chevreuse and his close friend, Charles de l'Aubespine, Marquis de Châteauneuf.[68] Châteauneuf, who may have owned Poussin's *Coriolanus Entreated by his Mother* (see fig. 54), was a key opposition figure throughout the Fronde.[69] He represents the traditional nobility who had made the transition to the early modern state by receiving a humanist education. Both a landed noble and a royal official, he acted as a *parlementaire* and ambassador during the reign of Henry IV.[70] As the product of the attempt to reform the *noblesse d'épée*, Châteauneuf was groomed for an appointment to the royal council under Richelieu's administration.[71] Three years later, in 1633, after having survived Richelieu's consolidation of power, Châteauneuf must have posed a threat. He went into disgrace until the cardinal's death.[72] Like many of those who fell as a result of Richelieu, Châteauneuf saw the regency as an opportunity to regain prestige and power, but his complete rehabilitation was frustrated by Mazarin. He was implicated in the conspiracy of the Importants to oust Mazarin in 1643 and was exiled again.[73] After his return, he was actively embroiled in the Fronde as an ally of the Parlement.[74] When he died in 1653, he chose President Bellièvre, the owner of *Moses Striking the Rock*, as his sole executor.[75]

The other possible initial owner of *Coriolanus*, Antoine III Loisel, was also a prominent member of the Parlement of Paris.[76] During the Fronde, he was entrusted with conducting the inquiry into the fraudulent business practices of Mazarin and his sequestrating of property before his flight from Paris. The careful tracing of silver, gems, and pearls by Loisel led to confiscations and sales.[77] This evidence was instrumental in the proceedings that resulted in Mazarin's banishment.[78] Loisel therefore stood for the judicial process of the Parlement that mounted legal opposition to the regency.

Passart and the Chambre des comptes

Several owners of paintings by Poussin contributed to the legitimate resistance of the Fronde. Much has been written on the prominent role of the Parlement of Paris during the civil war. Another sovereign court, the *Chambre des comptes*, similarly argued for its authority and duty to speak for the interests of the kingdom, the *Etat*, and the *bien public*. As an active member of the *Chambre des comptes*, Michel Passart was therefore not just a bookkeeper. After holding the post of auditor since 1635, he rose in prestige and respon-

sibility as a *maître des comptes* in the midst of the Fronde. Along with Passart, several other owners of compositions by Poussin – President Perrault,[79] Dreux,[80] and Mercier[81] – were directly associated with the chamber, as well as active members of the Parisian municipal government during the Fronde.[82]

The *Chambre des comptes* held the same deliberative and remonstrative rights as the Parlement. At the time that the sovereign courts formed a coalition, and met as the Chambre de St. Louis, Omer Talon gained public notoriety from his published *harangues* addressed to the monarchy during the *lits de justice* (see Chapter Three). The *remonstrances* of the *Chambre des comptes* also became part of the public record and entered the broad political discourse of the libels and broadsides.[83] These remonstrative powers were not restricted to the criticism of royal finances. The *Chambre* also responded to assaults on their authority and the abuse of the powers of the monarchy, such as the banishment of key members who were collectors of Poussin's paintings or related to them.[84] The resulting diplomatic negotiations, as well as mounting opposition, had a further impact upon the artist's clientele.[85]

The *Chambre des comptes* rallied together with various factions in common opposition to Mazarin. After the king's flight from Paris, the *Chambre* delivered a remonstrance for his return and the perpetual banishment of Mazarin.[86] The *Chambre* also protested in favour of Mazarin's exile from Paris on August 18, 1651. They expressed their "extreme displeasure" that nothing resulted from "so many ceremonies against the cardinal Mazarin."[87] In the *harangue*, the *Chambre* reiterated its position: "We declare afresh that we wish it to be understood that the Cardinal is forever excluded not only from our counsels but our kingdom."[88] In no uncertain terms, Passart's *Chambre* joined ranks against Mazarin.

During the Fronde, Michel Passart continued to exercise his traditional duties and institutional powers based on the ledger and the archive.[89] Like the Parlement, the *Chambre des comptes* asserted its institutional powers throughout the regency and the Fronde. One way to claim political power was for each institution to research its customary duties and describe how that institution was imbedded in the history of the French state. A treatise outlining the rights and privileges of the *Chambre des comptes* was part of this campaign.[90] Claude de Beaune's *Traicté de la chambre des comptes de Paris* (1647) described in detail the organization and functions of the chamber, providing legal evidence against the augmentation of offices and supporting the right formally to oppose the verification of royal documents.[91] The latter remonstrative procedure, which was one of the strategic powers of the sovereign courts during the Fronde, was subtly inserted into the dry, informative text of the treatise.

Beaune's document was an assertion of the chamber's autonomy published at the same time Passart entered the ranks of the *maîtres des comptes*. As part of his duties, Passart must have known the second part of the treatise by rote: a list of questions and responses. Examination insured the reproduction of this political body, through history, and as a result of a process of acquired knowledge and learned skills (not venality). As a legal body whose function was to verify *lettres patentes*, its duties went beyond those of numbered columns.[92]

In fact, during the Fronde, the chamber's powers had a direct bearing on the legality of Mazarin's claims to political power as a foreigner. One of the legal definitions that concerned the *Chambre des comptes* was the question of "nationality."[93] The chamber had to establish what constituted a foreigner, the procedure for naturalization, and the rights of a naturalized foreigner. The following catechism is instructive:

Question: What does the word "Aubain" signify?
Answer: It signifies foreigner, which is a man born outside of the kingdom . . .
Question: How many kinds of men are there in France?
Answer: There are two sorts: the true natural French born in the kingdom . . . And the other kind, the "Aubains", that is to say foreigners."[94]

As the definitions suggest, the naturalized *aubains* were never fully "vrais naturels François" but enjoyed a separate status from subjects of other kingdoms.[95] The power of the chamber to regulate the rights of foreigners, which might appear relatively inconsequential in the midst of the stacks of paperwork produced by the institution, became an important source of resistance to the powers of the regency. The *Traité* states the limitations of the political rights of foreigners: "By royal decree, foreigners are not able to obtain offices or benefices."[96] The office and benefices received by the naturalized Italian Mazarin as first minister and cardinal were in direct violation of the law.[97] During the Fronde, the decree of August 8, 1617, which forbade foreigners from the king's councils, was publicized in pamphlets and broadsides plastered on the walls and bridges of Paris.[98] Under public pressure, the law was upheld as a means of ousting Mazarin.

While the anonymous *libelle* or *mazarinade* cut to the quick, the linguistic ploys of the *noblesse de robe* were masterpieces of indirection. Beneath the even and incremental legalistic texture of Beaune's treatise were barbs against Mazarin. However, the plodding language could not be entirely sustained; the sober and disinterested tone sometimes broke to reveal something that might be described as an incipient nationalism and xenophobia: "It is considered odious to give either office or benefice to a foreigner."[99]

Indeed, as a sixteenth-century member of the *Chambre* protested, it would be "a heresy committed against history" to think of the institution as merely an accountant's office.[100] Here was the legal basis for challenging the government of the regency. These details of the powers of the *Chambre des comptes* yield some idea of the legalistic nature of Passart's resistance to the regency and his duties, but he would also have had first-hand experience of the more violent aspects of the rebellion. Like his grandfather and father, he participated in the political affairs of the city of Paris. He was present in the assembly at the Hôtel de Ville on the infamous day of July 4, 1652, when the building was torched by rioters. He was lucky on that occasion that as he left the deliberations he was not among the scores burned to death.[101]

Robins *for Nobles*

Another group of Poussin's clients shared the education, social position, and family alliances of the *noblesse de robe*, but they were not exclusively office-holders for the crown. Some were attached to noble households. This pattern of loyalty to the traditional "nobility of the sword" was in part the result of the difficulty of obtaining a limited number of expensive and inheritable royal offices. Indeed, the humanist ideal of access to the crown and integration with the affairs of state was not achieved by many matriculants of a system of education founded in the sixteenth century. The scarcity of offices left many in an awkward position, at once ignorant of commercial trade and fluent in a repertory of knowledge that had no practical application. The plaint of the (over)educated bourgeoisie was a recurrent theme. A lawyer at Caen demanded "Why aren't you in a shop, earning money? Might as well, there is no future here."[102] These withered "Greek and Roman flowers,"

having no native soil, were the forerunners of the later generation of disenfranchised educated men during the Enlightenment. Like their eighteenth-century counterparts, they provided their services as hack writers and libelists.[103] Nevertheless, the *homme de bien* at court, the ostensibly disinterested council charged with "the good of their country," continued to be upheld as an ideal during the first half of the seventeenth century even by those with little opportunity for advancement.[104]

The more successful social aspirants among the educated bourgeoisie, equipped for managing the affairs of the crown, performed similar duties for other noble households. Poussin's client Chantelou sought protection from Condé and other nobles once he lost royal patronage after the death of Richelieu in 1643.[105] Jean Perrault, an owner of a copy of the Seven Sacraments series, was also Condé's secretary and legal advisor.[106] He assumed the presidency of the *Chambre des comptes* in 1647. Poussin's client Melchior Gilliers, as detailed before, was attached to the Duc de Créquy, as was the poet Saint-Amant, who wrote a poem about a painting by Poussin in his cabinet.[107] Another owner of works by Poussin, Fromont de Veine,[108] acted as a powerful "shadow minister" in the cabinet of Gaston d'Orléans.[109] During the Fronde, while aristocratic clients maintained Gaston's troops, *robin* office-holders ran the affairs of state. Fromont was one of the trustworthy agents surrounding the prince whose cultural and political skills facilitated alliances with fellow *noblesse de robe* and made him an able negotiator and propagandist.[110] In this capacity, Fromont played an active part in the Fronde and a system of alliances and fidelities linking various social orders.[111]

Café de la Fronde

The fluid social intercourse between *robin* and noble during the Fronde was another way in which parties interested in Poussin's work knew one another. One of Poussin's acquaintances provided a venue for such social alliances. Poussin talks affectionately in his letters of Louis Renard, a royal officeholder whose house in the Tuileries became an important meeting place during the Fronde.[112] Poussin knew him as a neighbor during his stay in Paris.[113] Like Sublet and the Fréarts, Renard had been born in Le Mans and had aristocratic protection. Poussin considered Renard an "*honnête homme* and *amateur* of beautiful things."[114] He commissioned engravings after Raphael's frescoes in the Stanze of the Vatican during the 1640s,[115] and was sought by Mazarin for his expertise in tapestries.[116]

Just outside the walls of Paris, Renard's house was a meeting place frequented by *frondeur* nobles and *parlementaires* who came for the strong political ambiance as much as for refreshments.[117] Hence it was known as a café. Mazarin called these regular gatherings "le sabbat."[118] Fromont must have attended this "council chamber" where he no doubt met Passart since they exchanged letters.[119] Renard's house achieved a great deal of notoriety during the Fronde. The fashionable café was known not only as a place where political strategies were worked out but also as the setting for a "bacchanal."[120] Outside the strict social codes of Paris, it became a space where social roles and etiquette were modified. Renard cultivated the disregard for deportment as a sign of social distinction.[121] By enjoying rude familiarity with his prominent guests, Renard fostered a relaxation of etiquette that escalated into a battle of mock-epic proportions: the Duc de Beaufort, known as the Prince of Les Halles (the market) for his street oratory and his support by the lower classes of Paris, affronted a group of supporters of Mazarin by turning their dining table over onto them. The notorious event was celebrated in a burst of pamphlet literature and the

memoirs of the period.[122] After this the crown attempted to suppress the meeting place where politics and art were topics of conversation.[123] Poussin therefore regarded Renard as yet another *honnête homme* who was associated with antagonists of Mazarin.

The Brothers Fréart

As Poussin's correspondent and client, Paul Fréart de Chantelou had an extremely important role in Poussin's sustained attachment to France. His brothers Roland and Jean also maintained a special relationship with the painter throughout the period of the Fronde. In 1650, Roland Fréart de Chambray published his architectural treatise *Parallèle de l'architecture antique et de la moderne* (*A Parallel of Ancient and Modern Architecture*) as well as a French translation of Leonardo da Vinci's *Trattato della pittura*.[124] Poussin was involved with these books as a dedicatee, illustrator, reader, advisor, correspondent, and distributor.[125] The eldest brother Jean Fréart commissioned a Baptism of Christ from Poussin.[126] Jean had a keen interest in the artist's display of archeological accuracy; he was a friend of Jean Pointel (the owner of several of Poussin's paintings including the Berlin *Self-Portrait*), and was also intimate with Rémy Vuibert, who was in charge of the Grande Galerie after Poussin's return to Rome. Perhaps Jean was consulted on the project. It is telling that Poussin's only direct reference to the exiled Montaigne in his letters is in one of his well considered and selfconscious epistles to Jean.[127] They held the sixteenth-century author as a common term in their humanist practice during the Fronde.

Despite his conspicuous status as the addressee of most of Poussin's extant letters, Paul Fréart de Chantelou had a less direct role in the documented political confrontations of the period, although he seems to have retained his *curiosité* in spite of the upheavals. Yet Poussin still considered him a virtuous Hercules purging France of infectious monsters. As one of Sublet's chief clients, Chantelou had experienced an early fall from favor during the first years of the regency and later refused a position offered by Mazarin. By the time of the Fronde, Chantelou had been partially rehabilitated, assuming the royal office of *maître d'hôtel ordinaire du roy*.[128] However, Chantelou did not follow the court into exile but probably withdrew from the Parisian political landscape.[129]

The provinces, however, were far from tranquil, as attested by the activities of the other Fréart brothers. Whereas Chantelou's direct involvement is difficult to gauge, his brothers were active in politics. Jean and Roland, like their father Jean, sieur de Chantelou, were involved in the governing of the region around their native city Le Mans.[130] Like Chantelou, they were among the supporters and relatives of Sublet de Noyers who were disgraced after the death of Richelieu. However, like his brother Paul, Jean was rehabilitated by the late 1640s, maintaining a post as a *conseiller du roi* in the *élection du Mans*. As an *élu*, he served as a royal agent traveling between Le Mans and the capital.[131]

The political policies and responses to the fiscal pressures of the crown in the region of Maine followed a relatively common pattern in the years leading up to the Fronde. As in other regions, the financially pressed crown tried to exact taxes or quarter troops in order to sustain the army. The local authorities attempted to use their institutional powers to resist these obligations. While Maine rarely resorted to the open rebellion witnessed in other provinces, loyalty to the regency had deteriorated by the late 1640s. In 1648, a general assembly met in Le Mans in order to organize the placement of barricades.[132] In 1649, the magistrates went into rebellion and troops loyal to the Parlement of Paris were allowed to enter Le Mans, seven hundred strong.[133] The city was soon subjected to siege

by four regiments of infantry and cavalry loyal to the regency.[134] The local authorities, in response to the imminent confrontation with troops under Mazarin's command, appointed Jean and Roland Fréart as *commissaires* in charge of fortifications and munitions.[135] The Fréarts were royal officials dedicated to local loyalties within a monarchical system; their belief in the principle of kingship did not disallow conflict with the specific regime in power when they aligned themselves with the Parlement of Paris and local interests against Mazarin. As devotees of Sublet des Noyers, they transformed this capacity to resist the regency into active opposition.

Poussin would have known of the travails of these elites since he communicated with them and served them as a painter. His strong personal loyalties to the Fréarts would have influenced his own opinions. The effective resistance by the people of Le Mans against the military interventions of troops loyal to a regency with questionable legitimacy would have been understood by him as traditional provincial political behavior. Perhaps this inflects Poussin's assertion of his birthplace Les Andelys in his *Self-Portrait* destined for Paul Fréart de Chantelou (see fig. 40).

Outside Institutions

It is more difficult to reconstruct the opinions and actions of those clients who did not enjoy direct political power or institutional positions of authority capable of bearing directly upon chronicled historical events. It has been observed that several of Poussin's clients were merchants and many were from Lyon.[136] In addition to the two years the artist spent in this city along the trade route between Rome and Paris, his continued association with Lyon can be explained by the active integration of these Lyonnais with his other clients in Paris.[137] Jean Pointel was a silk merchant with family ties to Lyon who spent much of his life in Paris where he had a major collection of Poussin's paintings,[138] but he also associated with other provincials; he befriended Jean Fréart of Le Mans as well as Nicolas Poussin of Les Andelys. Pointel's business associate, Jacques Sérizier, was also a Lyonnais silk merchant, who lived in both Paris and Lyon.[139] Sérizier's major collection was visited by Bernini who praised the Phocion landscapes. Marc Antoine Lumague, the owner of a *Landscape with Diogenes* (see fig. 119) was one of the many successful naturalized Frenchmen of Italian origin in Lyon who had important business relations with Richelieu[140] and close ties with Michel Passart.[141] Sylvio Reynon was also a silk manufacturer and merchant who left a cultural legacy in Lyon and was one of a number of other collectors of Poussin's work in that city.[142]

The class status of these clients has resulted in some incorrect inferences.[143] To call Pointel, Sérizier, Lumague, and Reynon bourgeois lacks precision, for in the absence of a powerful feudal nobility, the merchants in the cosmopolitan and relatively socially permeable city of Lyon enjoyed a special social status. In fact, banking and commerce were not incompatible with the local definition of nobility.[144] The absence of precision in historical description has resulted in the assumption that this elite acted as a single class and followed stereotyped behavior. According to Anthony Blunt's construction of Poussin, the temperamental artist found in the bourgeoisie an ally in his discomfort with popular violence. Blunt assumed that a merchant would have refrained from direct political confrontation and served his own interests by siding with the policing of civil disorder. As a consequence, the subject of the Phocion landscapes Poussin painted for the silk merchant Sérizier during the Fronde has been aligned with political order.[145] However, merchants

were not always in favor of the status quo and were not always willing to support Mazarin. In fact, throughout the 1640s and at the height of the Fronde, the cardinal was considered a threat to the financial interests of the merchants.[146] One *mazarinade* argued incessantly that Mazarin had interfered with France's economy. Through the voice of a woman silk merchant, the author blamed Mazarin for France's pervasive poverty. The minister was accused of stealing all the kingdom's gold under the pretext of war. According to the pamphlet, formerly flourishing cities such as Lyon, Bordeaux, and Tours were bankrupt because of taxes imposed on goods, thus stifling international trade. Merchants in the major cities claimed that weeks went by with no sight of goods or customers and boutiques went bankrupt. Only Mazarin turned a profit.[147]

One of the most well-known and respected political pamphlets of the Fronde, *Lettre d'un religieux*, made the same point.[148] The author accused the cardinal of trafficking in luxury goods and "curiosities," despite the fact that he was "engorged by goods and almost suffocating under all the riches of state."[149] Mazarin caused distress to a number of bourgeois families: "This miser through infamous commerce takes away the livelihood of fifty Parisian families, who legitimately gain from the things that they furnish to the court, each according to his rank."[150] Luxury trade itself was not questioned. It was an honest activity for those assigned to it in the social order. The bourgeoisie supplied the necessary signs of social decorum regulated by sumptuary codes. However, Mazarin was considered a foreign *parvenu* who breached French social distinctions; he abused the privileges of his clerical and diplomatic status by his commercial activities. While legitimate merchants served the public and *pays* by selling luxury items, Mazarin's own excessive desire for foreign goods made him refuse French products.[151] The Italian entrepreneur thereby defeated the patriotic economic policies associated with Henry IV (such as the cultivation of mulberry trees for silk manufacture).

Precisely how the merchants responded to the events of the Fronde and the threat to their interests is important for comprehending the reception of Poussin's art. Understanding their extra-aesthetic practices not only illuminates their biographies, but it questions or complicates some assumptions about the reception of his work by a "bourgeois" clientele. Moreover, the sociology of Poussin's clients has a direct bearing on the formal description of the paintings. Blunt's early interpretation of Poussin has continued to have an impact on the critical fortune of the artist. While Blunt as a mature scholar portrayed the artist as a *peintre-philosophe* who involved himself with his studio and a restricted social sphere, he had earlier characterized Poussin as a bourgeois artist who shared his clients' class-based fears of popular disorder.[152] According to Blunt's early formulation, Poussin and the bourgeoisie more generally equated the Fronde with mob rule. Blunt slipped into the present tense in order to describe this universal bourgeois who drifts in the political winds seeking protection from any faction powerful enough to thwart violence whenever the "people get out of hand."[153] This vision of an ahistorical bourgeoisie fleeing violent social inferiors, searching blindly for alliances with parties equipped with police powers, caused Blunt to read the compositional structure of Poussin's paintings, in particular the Phocion landscapes, as formal homologies of order.[154] Indeed, the political connotations of the overdetermined categories of order and disorder are part of the critical vocabulary of much of Western art. But to suggest that if someone commands orderly pictures they want political order is to oversimplify motivations. It also neglects the strategic representational effects of disorder (as in the representations of Camillus).

Blunt's description of Poussin and his clientele is inflected by the mythology of a "middle class." If one means by bourgeois, individuals who derived their wealth and social prestige from commerce, its knowledge, skills, and financial benefits, then a number of

43. Anon., *The Veritable Portrait of Broussel as Father of the People with sonnets by Le Pelletier (Le vray portraict du père du peuple)*, Paris, Claude Morlot, 1648, broadside (Paris, Bibliothèque Nationale).

44. Charles Errard, *Portrait of François Sublet de Noyers*, 1642–45, red chalk on beige paper (Albi, Musée Toulouse-Lautrec), 251 × 195 mm.

Poussin's clients fit this description.[155] However, Blunt's transhistorical characterization of the political behavior of the bourgeoisie suffers from a lack of local description. Recent historians of the Fronde have attempted to dismantle the stereotype of a law-abiding, fiercely royalist Parisian bourgeoisie fearful of resistance to taxation because it might foment violence against themselves and their property.[156] Even the wealthiest merchants, who it seems came closest to the stereotype, were far from being unswerving royalists.[157] Furthermore, not only economic motives need have dictated political expression.[158] At times, the hatred of Mazarin exceeded self interest.[159] Prominent members of the bourgeoisie were swept into the disorder of the Day of the Barricades, set off by the arrest of the distinguished octogenarian *parlementaire* Broussel, known as the "Father of the People" (fig. 43). While marketwomen in Les Halles may have intimidated some *bons bourgeois* into demonstrating against the regency, spontaneous insurrection nevertheless crossed class lines. Merchants took the lead in their stronghold on the Cité by erecting barricades near Broussel's home.[160] Corporate bodies also used the force of their numbers to make their opinions known.[161] During the Fronde, when collective action was strategically deployed even by the Parlement, a mob might be described as "bourgeois of all classes."[162]

Portraits, Retreat, and Recalcitrance

So far, the evidence of Poussin's correspondence and the biographical sketches of his clientele make it difficult to maintain the notion of Poussin's distance from the politics of France. However, the political engagements of both artist and client do not necessarily support any claim for an art *engagé*. After all, political action and collecting art are not a single practice nor does one passively reflect the other. A reader unsympathetic to the relationship between art and politics might even ask: what does owning a *Baptism of Christ* have to do with setting up fortifications? This is my question also.

Poussin returned to Paris again in the midst of civil unrest – but this time as a pair of self-portraits (see figs. 40 and 41). We can now begin to appreciate the significance of the demand for Poussin's pictures as well as his own interest in sending his proxy to his *patrie*. The painting of Poussin on the wall of Chantelou's cabinet complemented the tableaux produced by him: the *Gathering of the Manna* and the now complete series of Seven Sacraments were given a special place for presentation. The pair or series offered a way to control the reception of portable works, buffering them from comparison to pictures by other artists in a collection, bestowing an internal coherence based on authorship.[163] The retrospective exhibition and the likeness underscored both Poussin's absence and France's lack. The portrait is always a marker of absences, a momento mori, a commemorative relic, which explores the inadequacy of the present. Montaigne drew his portrait of Camillus in order to evoke his belatedness and invoke lost opportunities; the sixteenth-century Frenchman measured the distance between his own time and the antiquity of the great exemplar. This critical nostalgia was central to Montaigne's biographical project. Poussin's portraits of himself similarly stressed this dissociation of "Poussin the *premier peintre* of the great projects of the reign of Louis XIII" from the fortunes of the present. Both portraits inscribe the year, stressing their historical import. In one, the depicted funerary monument with laurel wreaths represents the absence of the painter's body from its country as if to repeat Poussin's complaint in a letter: "I long again to possess the sweetness of the land [*patrie*] where each of us desires finally to die, I see myself chased out." The painted presence itself signified loss. The portable pictures in France underscored the exiled position of the artist, his dislocation and absence. The other self-portrait hung in Paris bearing the inscription "Poussin of Les Andelys painted in Rome," thereby also conveying the ways in which location and absence were organized according to a patriotic distinction. The artist once in charge of the Grande Galerie was now in Rome making tableaux, stacked against the wall. The physical realization of *amitié* between fellow countrymen was thwarted by political circumstance. If Poussin closely identified with Montaigne, as it has been claimed, then the portrait of the artist in absentia is consonant with Montaigne's famous retreat to his library in Bordeaux just as it evokes the disgrace of the abused public servant Sublet de Noyers. The proxy looks out from his foreign funerary monument or his studio of propped stretcher bars, underscoring not individual death but distance and the impossibility of an embrace.

While Poussin's return to Rome has been understood as a response to the dictates of his own artistic temperament, in his own lifetime this removal resonated with exile and disgrace.[164] Poussin was not the only one to invest geographic displacement with the connotations of retreat derived from literature and politics. As I have shown, Sublet's disgrace had a profound effect on the artist's immediate critical fortune.[165]

The self-portraits represented a politics of removal, the traces of a dislocation from a center, which was Paris, to that imaginary center, Montaigne's Rome, and ultimately that

studio hemmed in by canvases. For Poussin this retreat was strongly identified with the
persecution of Sublet de Noyers. Collecting a picture by Poussin had the potential of sym-
bolically identifying the collector with these positions. The self-portraits for Pointel and
Chantelou entered Paris in the same year that Fréart de Chambray published a book ded-
icated to Sublet. The architectural treatise, which Poussin called a "portrait" of Sublet de
Noyers, contained an engraving based on a line drawing by Poussin's colleague Charles
Errard (figs. 44 and 45). The oval portrait, conceived in the tradition of the *homme illus-*
tre, was probably executed in Sublet's country retreat at Dangu. But the humanist por-
trait cannot stand in isolation. The multiple editions of Amyot's sixteenth-century
translation of Plutarch with its engraved likenesses had insisted that the portrait was
understood in a series of parallels. By portraying himself, Poussin offered a parallel to the
contem-poraneous published engraving of Sublet. His self-portrait was inflected by this
other act of portraiture drawn at the margins of French political life. If Sublet's portrait
in the architectural treatise asks us to contemplate the politics of Poussin's practice it does
so by insisting not only upon an examination of the character of Sublet but also the cul-
tural practices that went into the making of that personage. The peculiar nature of Sublet's
retreat resulted in its strategic symbolic value for opponents of Mazarin and the regency.

Sublet's Portrait

Sublet had earned a reputation for his obstinate integrity. Although a creature of Riche-
lieu, he escaped being associated with the taint of tyranny linked with that name in the
period after the demise of the cardinal. Sublet succeeded in this partly because he did not
fit the mold of an aristocratic courtier: he had never cultivated a close personal bond with
the monarch. One account of the disgrace, albeit from a hostile witness, stressed Sublet's
stubborn independence, even insubordination. After a number of disputes between Sublet
and Louis XIII, "the king told him that it seemed that he saw contradicting him as part
of his task. Monsieur des Noyers replied that since his service was not agreeable to him,
he asked to be allowed to withdraw."[166] Sublet was willing to hold his ground as a royal
counselor. True to the beliefs of the *noblesse de robe*, his primary loyalty was to the prin-
ciple of kingship rather than to the king himself.

In Paris, Sublet's house was known for its simplicity, even decorative neglect.[167] He
seems to have been as honest in his dealings with royal finances as he was frugal in his
personal habits. Although he was in a position to make great monetary gains, as did many
financiers investing in the costly Thirty Years War, Sublet abstained. He inherited his
father's fiscal integrity – like Passart, Sublet's father had been a *maître* in the *Chambre des*
comptes. The son also befriended other officials and diplomats, such as Pomponne II de
Bellièvre, through the shared duties and culture of the *noblesse de robe*, including a common
interest in books and Poussin's art.[168] Indeed, Sublet exemplified the ideal of the disin-
terested French royal official who shunned the courtier. When he retired, he sought the
"repose and tranquility one rarely finds at court."[169]

During the regency, those set on dismantling Richelieu's legacy saw in Mazarin the
reincarnation of the worst of the late cardinal. They found in Sublet a forceful counter-
example.[170] President Molé, as a voice of the Parlement (its most conservative monarchist
wing), sought the reinvestiture of royal authority in the hands of the exemplary minister
Sublet, who had suffered the courtly intrigues of the envious Mazarin. Sublet's recalci-
trance was admired (he initially refused to relinquish his office of secretary of state to

45. Georges Tournier (after Charles Errard), Frontispiece of *Parallèle de l'architecture antique avec la moderne*, 1650 (Los Angeles, Library, Getty Research Institute).

46. Jean Daret (after Charles Errard), *Portrait of Sublet de Noyers*, 1652, engraving (Paris, Bibliothèque Nationale).

one of Mazarin's protegés.)[171] As a symbol of disinterestedness, integrity, and cultural authority, Sublet drew different groups together, from *parlementaires* to rebel nobles.[172]

Sublet's authority was enlisted in the first major attempt to check Mazarin's power, the would-be coup of the Importants. Such unlikely figures as Beaufort (Prince of Les Halles), President Molé, Châteauneuf, Jesuits, and courtiers found a common cause in the person of Sublet. A precursor of the Fronde, the conspiracy failed to remove Mazarin from office. Instead, Mazarin exiled most of Richelieu's client system as well as Richelieu's opposition, thereby consolidating and confirming his power.[173] Sublet remained in retreat.

After his death in 1645, Sublet continued to function as a symbolic foil to Mazarin. The contrast between the two figures was accentuated during the Fronde in the literature of opposition to Mazarin. Sublet's nephew Roland Fréart wrote in the dedicatory preface of the *Parallèle de l'architecture* (1650), accompanied by the engraved portrait of Sublet, a eulogy for the *officier* who spent his last days "in the countryside like an exile":

I confess . . . that I find the retreat of the disgraced (provided that they are *gens de bien*) infinitely preferable to their being in favor. If [only] merit and substantial services were

able to establish and affirm a man at court forever, if [only] they were able to offer a defense against envy and jealousy, which are immortal enemies and the plagues of virtue, which reign unhappily in that place.[174]

The plaintive refrain is repeated in Poussin's letters and the memoirs of the period: the virtuous and meritorious *homme de bien* is forced out by the machinations at court. Here, Fréart's text is both specific in its references and published for a public during the Fronde. The court, dominated by Mazarin, is opposed to the virtuous exile.

Sublet was similarly lionized in written eulogies in the memoirs of the Fronde as well as a separately published engraving based on Errard's portrait. In 1652, Jean Daret appropriated the engraving after Errard's drawing of the late secretary of state for his famous collection of illustrious figures (fig. 46). Daret added an inscription explicitly stating that Sublet was the victim of envy.[175] By contrast, the curt notice attached to Mazarin's portrait in Daret's portfolio is the shortest entry in the series and leaves an awkward and embarrassing caesura.

It is necessary to stress that the disgrace of Sublet became an important element of political discourse during the Fronde. At least one political pamphlet made an explicit reference to Mazarin's responsibility for Sublet's fall. Some thirty pages into a topical political discussion held by women next to the bed of a mother soon after childbirth, one of the women recapitulates the heated proceedings:

> On the very first day that [Mazarin] was called to office after the death of the late Cardinal Richelieu, author of his greatness, [Mazarin] had le sieur des Noyers, secretary of state by whom the late Cardinal had been served with much satisfaction in the greatest affairs of state, hunted from the council.[176]

During the Fronde, Sublet was represented as an early victim of Mazarin. The exemplary consul at court was chased out by the insolent minister who subjected France to his ambition, cruelty, tyranny, vindictiveness, and larceny.[177]

Upon Sublet's retirement, his exemplary status as a symbolic foil to Mazarin was not entirely retrospective: he did in fact maintain a singular position of influence in the court and the administration of the regency until his death in 1645. Although he was ultimately forced to withdraw from the office of secretary of state, he continued to be the *surintendant des bâtiments* (chief royal administrator of the arts).[178] Despite the exercise of pressure by Mazarin, Sublet was able to continue his duties in the royal buildings, with the support of the Parlement; he applied himself to the arts "with no less pain or pleasure than if they were great affairs of State."[179]

Mazarin seems to have concentrated his efforts on ousting Sublet from his position of *secrétaire d'Etat*, but neglected to strip him of the position of *surintendant des bâtiments*. The cardinal may have believed that the office was a marginal concession and tolerated Sublet's continued presence as a patronizing gesture. This judgment was in part due to Mazarin's miscalculation as an outsider. Sublet was credited with having excelled in the post of *surintendant des bâtiments*. The initial news of his disgrace in 1643 was immediately interpreted as a blow to the arts in France. As one inside observer put it: "The mercenaries are pleased by his disgrace but the virtuosi, printmakers, painters, sculptors, and decorators regret it."[180] Sublet had secured his reputation as administrator and patron of the arts. In the eulogy to him inscribed for Daret's engraving, he was honored for having fostered the arts in spite of the constraints of war: "In the midst of his administration of the affairs of war, the arts of peace were made to reign as a result of his fostering beautiful works of painting, engraving, architecture, and printing."[181] Daret offered this praise

in order to explain why Sublet was subjected to the envy of the court. By being permitted to retain this office, he continued to foster his reputation and exert political influence.

The recorded traces of Sublet's actions during the disgrace are relatively humble, restricted to the field of art, architecture, and landscaping. They register his detailed attention to the administration of the royal buildings. Nearly two months after the collapse of hopes for a coup, Sublet was working on the Grand Canal at Fontainebleau and supervising the garden.[182] Decoration and gardening seem to be marginal activities for a senior diplomat but they accrued a symbolic and strategic value. The position of administrator of the arts was a way to maintain influence in the court. Sublet continued to serve a powerful symbolic function as a recalcitrant figure who survived the political fortunes at the edges of political power despite the antagonism of Mazarin.[183] Despite the disgrace, it was known that architectural projects and cultural institutions which Sublet had fostered under Louis XIII, including the royal press and mint, would continue to function.[184] Sublet was largely responsible for the restoration and renovation of Fontainebleau, a monument to Francis I.[185]

In particular, President Molé had negotiated to ensure that the decoration of the Grande Galerie of the Louvre would continue under the direction of Sublet. In Poussin's initial written response to Sublet's disgrace, which had occurred shortly after Poussin had returned to Rome, the artist lamented "the difficulties and disgraces" that had befallen his patron. However, Poussin assured Chantelou that "the things that we have started will be able to be continued."[186] Despite the disgrace of Sublet and the exile of Poussin, there was an attempt to maintain some continuity in their shared cultural ambitions, in particular the Grande Galerie project. In a letter to Molé from his "Solitude," Sublet made explicit his intention to erect a tomb to Louis XIII and carry out Poussin's designs for the Louvre: "Three lines from the queen would make me take up the trowel and go to execute her noble plans for the tomb of the late king and the continuation of the Louvre project . . ."[187] Poussin continued to be involved in the production of drawings for the Louvre, as well as arranging the transport of antiquities to Paris.[188] Several months after Sublet's disgrace, an assistant was directing the work and soliciting drawings from Poussin.[189] Sublet was actively renovating Fontainebleau and maintaining other royal buildings.[190] His signature was necessary for the approval of numerous projects. Significantly, he also issued a series of *brevets*, granting privileges to artists. He still supported and installed artists in the Louvre that were loyal to him, such as Charles Errard. As *surintendant des bâtiments*, Sublet maintained a loyal clientele and political authority within the sphere of culture even in political disgrace. Several of his official acts were signed "à Dangu" as if to emphasize the place of his exile.[191]

The significance of Sublet's exercise of cultural authority was articulated by the writer of an architectural treatise who was protected by him.[192] François Derand's treatise on vaulting was dedicated to Sublet and included his titles as secretary of state and official in charge of the arts. The author of *L'Architecture des voutes* pointed out the official patronage for the text: "I undertake, Sir, under the protection of your authority, and being employed by you to work for the State, this work."[193] Rather than recognizing a personal indebtedness, the author stressed his obligation to Sublet as a man of state. Significantly, the book was approved for publication twenty days after Sublet's disgrace when his official functions had ceased.[194] This indicates one of the ways in which his authority was maintained. The dedication, with its conspicuous inclusion of his contested position as secretary of state among the list of offices and titles, also celebrated his preeminence as an arts administrator.[195] Derand's dedication is important for its stress on the significance

of the *surintendant des bâtiments* position. For Derand, the state of the official patronage of arts and the protection of the royal buildings was likened to the larger political system. As a *surintendant des finances*, then secretary of war, Sublet had effectively marshaled material and human resources. In the dedication, Derand drew a significant parallel between the requisite skills for administering the political state and the state of the arts: in both spheres, Sublet reviewed sites in the kingdom, intervened in order to "repair the faults," thereby ennobling and protecting them. Here Derand invested the *surintendant des bâtiments* position with a significant symbolic authority; the surveillance and protection of France's buildings were comparable to repairing the faults in the maintenance of political order and the cracks in the edifice of royal authority. The allegorical investment of political authority in the administration of the arts constructed a set of terms in the early years of the regency that acquired an increasingly important oppositional significance in the years directly preceding the Fronde. On Sublet's death, Mazarin assumed the position for himself, a move which only heightened the potential comparison between the two men.[196] His assumption of the office of *surintendant* was a sign of conquest over an influential insider. Perhaps Mazarin had also by then learned something about French political life and the symbolic significance of a post in the arts.

Sublet died in disgrace. The memory of his suffering under the humiliations of Mazarin and the ultimate abortion of his grand cultural projects enhanced the value of his recalcitrant position as a disinterested servant of the crown. Herein lay the significance of Fréart's memorialization of Sublet in his *Parallèle*. The dedicatory preface indicates how Sublet privileged utility and the good of the state in his execution of architectural projects. Fréart praised the construction of defenses for their functionalism. He applied the same values to his assessment of the Grande Galerie: expeditious and cost-efficient architectural solutions were designed not to anger a realm suffering from the financial duress caused by war. Fréart did not, however, paint Sublet as a pragmatic functionary with little patience for art. Instead, he was represented as a genius who loved the arts "with knowledge, cultivated them, and despised his own interest in order to conserve that of the state and the public."[197] Sublet was a patriotic *amateur*.

By the time Fréart wrote his treatise, Sublet was dead and Mazarin had already appointed himself as the *surintendant des bâtiments*. For Fréart, Sublet's efficient cultural administration was a foil to the dereliction of Mazarin, who was only briefly in charge of the arts. Although shortlived, his administration was perceived as neglectful. The crown's possessions and the *bien public* fell into disrepair. Instead, according to Mazarin's critics, only selfish accumulation prospered. Freart's *Parallèle* was published in the midst of the Fronde, soon after the author's own participation in militant resistance to the regent's troops. The book's critique of the regency from the vantage of artistic discourse was pointed out by the nineteenth-century literary historian Henri Chardon. In a passage largely neglected by scholars of Fréart's theoretical work, Chardon called the book a manifestation of the artistic Fronde.[198] Fréart's preface lamented the impoverishment of the arts that resulted from the exclusion of Sublet from authority and the abandonment of the Louvre and other artistic projects. According to Fréart, France experienced a revolution with the triple loss of Richelieu, Louis XIII, and Sublet. The death of the king and the first minister, coupled with the retreat of Sublet, left France with no effective administration. Because the regency no longer had the requisite knowledge and talents, official culture was at a standstill.

Just as Sublet's political power during his disgrace derived solely from the office of *surintendant des bâtiments*, so too did Fréart's book similarly articulate its criticism of the current regime through the arts. The seemingly powerless architectural theory measures

unrealized contemporary projects against symbolic exemplars from antiquity. In Fréart's book, the architectural portraits were comparable to human exemplars. The treatise, like a gallery of illustrative individuals, underlined the lack of contemporary rivals for a position in posterity. Indeed, Poussin described the book as a memorial portrait of Sublet.[199] He was in part referring to the title page and preface with its description of the deceased, but the theoretical project that follows the dedicatory epistle also portrayed the man by representing the unfulfilled ambitions that resulted from his fall. According to Fréart, the book was a transcription of conversations held by Sublet with his fellow exiles in his country estate at Dangu. As an academy in retreat, the constituent materials for monumental, public architectural projects were assembled in language. Fréart's illustration of Trajan's Column could not have been discussed without reference to the lost opportunities of the Grande Galerie (see fig. 85). Because of the fortunes of the court, Fréart's privileged jewel of antiquity would not be encased in the palace of the monarch. The interests and tools of a learned culture that could have served the state and the *bien public* were instead rehearsed only in the conversations of exiles and realized solely on paper. Theory is often articulated, at least initially, by those divested of material power.

The book as well as the man were positioned within the topos of exile. Public forms of address were articulated from a position of retreat. Sublet's political practice had been sustained in the precinct of humanist culture. The book represented the results of that retreat, the withdrawal from political intrigue, *otium*, and the exercised erudition of a small circle of friends. The vision of exile in the *Parallèle* was consistent with the cultural practices of the *robe* nobility that represented group interests and maintained social affiliation. The book spoke from the site of exile, Le Mans, as Montaigne had spoken from his library.

As François Derand had suggested, the administration of art required the same skills as political action. Sublet invested this cultural activity with an importance that was in part derived from its capacity to highlight Mazarin's lack of competence. As the *surintendant* in charge of the arts, Sublet was a shadow minister, serving as an oppositional double to Mazarin. In that capacity, Sublet had been the "flame of Virtue" and "the greatest minister, the most disinterested, the most diligent, the most effective, of such an extraordinary and proven probity."[200] But this office was not solely symbolic. Like a shadow minister, Sublet had fostered an extended system of French clients (among them Poussin) while the Italian cardinal was understood by his enemies to have practiced nepotism that favored foreigners. Sublet had striven to conserve and enhance the royal buildings while Mazarin was accused of selling off royal domaines.[201] Sublet had founded a mint that sought to standardize French currency and maintain its monetary value while Mazarin was accused of exporting the wealth of the French nation.

Seeking to restore and protect what would now be called the French patrimony, Sublet was supporting a patriotic culture.[202] As I have shown in Chapter Two, he directed the documentation and planned the restoration of Gallo-Roman buildings in Provence. In recognition, he obtained gifts of antiquities from Nîmois elites.[203] Sublet had established provincial clienteles and consolidated the support of local authorities by appealing to this shared imagined community. Fréart's dedication of his translation of Leonardo's *Trattato* to Poussin explicitly linked the French artist to Sublet's patriotic cultural mission.[204] Poussin, like Leonardo, was the "restorer of painting and the ornament of his century." Both Leonardo and Poussin were called to France in order to foster the arts. Sublet was therefore compared to the patriotic patron of the arts Francis I. The emerging claim that Mazarin was antipathetic to French *patrie* was substantiated by the disgrace of Sublet, the incapacity to support artists such as Poussin and the resulting impoverishment of the arts.[205]

Roland Fréart's understanding of Sublet's disgrace hinged on the tradition of retreat. Sublet had inscribed himself within a topos that resonated not only with the famous retreats of the Greco-Roman literary tradition and the Christian hermitages, but also with those in French history, notably Montaigne.[206] The topos of exile had been enunciated by Sublet himself. He wrote to Molé from his provincial retreat at Dangu: "Sir, permit me to render services to you as well in the desert as in the crowd and tumult of the cities."[207] Far from urban disorder, Sublet was not idle. His solitude permitted him to see more clearly and to understand the passions of others. His capacity to exercise political power was not only possible within the frame of exile, because of the apparent lack of threat to actual authority, but the position of exile itself imbued his person with profound symbolic authority.

Strategic Power and Relative Autonomy

The preceding chapters have described how "culture" was a significant arena for politics. That is to say, a learned repertory of historical referents and behaviors provided a common discourse for active political affiliation. The royal *entrée*, for example, brought rhetoric, historical analysis, and visual forms in useful juxtaposition for the assertion of social and political rights and privileges. The culture exercised by the *noblesse de robe* was the active rehearsal of symbolic forms in artistic, social, and political practice. This performative culture was not excluded from ostensibly direct forms of rhetorical persuasion and political action. The ceremony signified the assertion of the political ordering of society. The *lit de justice* and its ceremonial counter-demonstration provided an ordering of behavior and the legitimization of responses.

It would be inappropriate, however, to suggest that power was evenly distributed among *entrées*, royal edicts, judicial process, gardening, and the critical evaluation of pictures. I do not want to confuse the effects of power acted on the human body with those enacted on the canvas. Nor can I make equivalent the respective discourses of *lèse majesté* and the conversation in a picture gallery. However, to acknowledge the uneven distribution of power in various cultural practices is not to diminish the importance of the tools available in the more marginal fields, even the seemingly inconsequential effects of a brush on canvas. Indeed, that which is tolerated as harmless evades the concentrated effects of coercion. The evacuation, as it were, of the threat of repression designated a relatively autonomous area where social identification and self-articulation could occur. Strategies were rehearsed and thereby made available to other areas of organized experience. The organization of cultural resources by a disenfranchised group provided a laboratory of sorts for other social practices.[208]

The example of Sublet shows how a relatively autonomous area of cultural practice, the administration of the arts, was a position from which political meanings were produced. Roland Fréart de Chambray's vision of exile among a circle of learned friends who discussed architectural theory and engaged in the formal description of architectural supports provided a strategic model. He portrayed Sublet assuming the role of the exile and Sublet identified himself with the tradition of *otium*. This positionality was not original but garnered its power from its participation in broader meanings, established codes, and traditions. What is innovative, however, is this group's particular emphasis on the visual arts as part of the constituent elements of exile.

In disgrace or exile during the *ancien régime*, the individual posited her or himself in relation to a tradition that accommodated the seemingly contradictory aspects of withdrawal and political action. Exile enjoyed an important role in the cultivation of aristocratic culture throughout the seventeenth century. The immensely popular novel *Astrée* became one model for a disaffected *noblesse d'épée* that articulated their own sense of belatedness and loss. Montaigne's withdrawal to his library, on the other hand, represents a famous retreat from *negotia* that continued to be engaged in an investigation of knowledge offered to an extended reading public. *Otium*, therefore, was a figure put into circulation by the printed word. After Montaigne, retreat was a topos of private life that circulated in a public sphere.[209]

The possession of Montaigne's *Essais* or Fréart's *Parallèle* permitted the reader access to *otium*, or its figure, while remaining in the world of affairs. Sublet's provisional academy in retreat gave him an authority and integrity based on the disinterested acquisition of knowledge and the discussion and exchange of ideas. But these discourses were not entirely cut off from *negotia*. The productivity of the provincial architectural seminar underlined the vacuum in the state sponsorship of the arts. For most of those disgraced from court, the topos of *otium* provided a model of behavior and an enunciatory position. Le Sueur's painting of the gathering of friends might be one pictorial corollary of a form of sociability that accrued significance during the Fronde. But better examples might be found in Poussin's own work. The inscribed self-portrait as well as several portable pictures sent to Paris at the height of the Fronde point to how friendship was freighted by politics.

<p style="text-align:center">* * *</p>

Poussin's physical removal to Rome gained a particular significance in the years leading up to and including the Fronde. His production was supported by a group of French clients who perceived themselves as a community supporting that project in exile. In his studio, Poussin's practice maintained a culture in reserve. Like Sublet's disgrace, Poussin's retreat did not remove him and his art from the concerns of French political life. Instead, symbolic detachment provided opportunities for articulating authority. Retreat was a central topos of early modern political culture: the exemplar of disinterested virtue was victimized by self-serving factional interests detrimental to the *bien public*, the monarch, and *la patrie*. The sacrificed hero removed himself from the court. However, in the political and literary tradition from Montaigne to the Jansenist Arnauld, retirement was not a complete renunciation of political thought and power. Direct political action was exchanged for a less constrained critical position. This partially explains why clients in France, who had a direct stake in *frondeur* politics, were attracted to an artist at a distance.

In the course of the 1640s and throughout the Fronde, Poussin's increasing fame and critical fortune in exile underlined the failure of the French state to foster French art and the *gloire* of the *patrie*. This further enhanced the criticism of Mazarin's general failure to patronize French culture, which will be discussed in the following chapters. Poussin's absence and the fragmentary execution of the Grande Galerie project stood for the dearth of royal support for the visual arts. His drawings for the project continued to circulate in Paris. Their presence in Parisian collections along with canvases testified to the value of Poussin's art as a talisman. The importation of his paintings by individual clients further underlined the lost opportunities for patronage by the regency. While Sublet's disgrace represented a breach between loyal servants and an unappreciative crown because of the

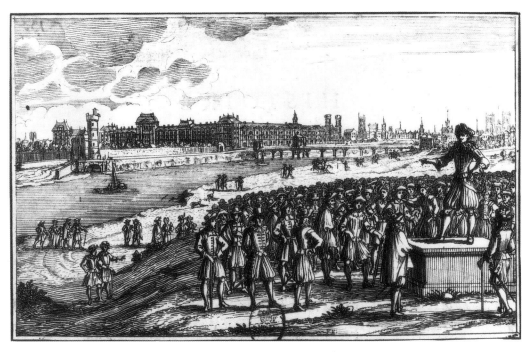

47. Anon., *View of the Louvre from the Left Bank with Frondeur Orator* (*Avis que donne un frondeur aux Parisiens contre Mazarin, 6 janvier 1649*), 1649, engraving (Paris, Bibliothèque Nationale).

provisional politics of the regency, Poussin's exile in Rome occupied a similar symbolic position. Sublet and Poussin represented the *gloire* of France and were the best executors of a significant project such as the Grande Galerie. According to Fréart the Louvre was to be no less than "the center of the arts" and the "most noble and most superb building in the world."[210] Art and the monarchy would be celebrated as one in the completed decoration. The undoing of the Louvre project was the undoing of France.

Across the river from the palace of the Louvre, just outside the jurisdiction of the Parisian authorities, crowds gathered around soapbox orators. In a *frondeur* print (fig. 47), the image of improvised political insurrection with the Grande Galerie as a backdrop marked a shift in the potential significance of the Louvre in the year of Fréart's publication. The engraving offers a contrast to an earlier print's perspective from the Place Dauphine, which commemorated the grand projects of Henry IV. With the late king's equestrian statue as a symbolic center, the material culture emanating from the monarchy was coordinated with the orderly procession of royal authority (see fig. 2). This performance of the political order organized around the facade of the Louvre was radically reoriented in the *frondeur* print. Instead of asserting the ordering of political relations from the vantage of the place Dauphine, the oblique view from St.-Germain demonstrated that the monument to the Bourbon monarchy was subject to appropriation by the rhetorical claims of marginalized voices at a remove from Paris. The culture of the Fronde was welding a bond between *le bien public* and visual objects.

Poussin's framed pictures – self-portrait, sacrament, Roman history – entered Paris as objects subject to symbolic appropriation, talismans defining the contours of a group. As in all cultures, exchange, whether of artifacts or pictures, is a primary constitutive practice of social identity. But as I have already asserted, archeological materials were more specifically deployed in the field of political practice in the emergent French state.

The collecting of paintings as a related form of sociability began to accrue political significance when events and language exerted pressures on the reception of its objects. The following chapter rehearses those pressures and their relevance for the production of pictures.

Chapter Six

Mazarinades *and Cultural Resistance during the Fronde*

While significant traces remain of the institutional affiliations, personal allegiances, political positions, and collective actions of Poussin's clientele, much has been left unrecorded. As in the print of the *frondeur* orator (see fig. 47), we can make only limited deductions about spoken language from gestures and situations. Yet, against this caesura in attributable utterances, from our historical distance we can perceive a pantomime of political rhetoric. Inferences about Poussin's clientele can be drawn from a rich body of largely anonymous texts. Between 1648 and 1653, there was an avalanche of brochures: more than five thousand pamphlets are collectively known as *mazarinades* because the majority, like the poem with that title by Paul Scarron, were libels against Cardinal Mazarin. They articulate the positions of various oppositional constituencies during the Fronde. The large quantities printed, the multiple editions in a short period of time, the continual references to other pamphlets, the heated debate over the latest brochures and placards in the correspondence and memoirs of the period, all suggest that the *mazarinades* were a significant locus of public opinion and persuasion. They addressed a reading public as a body politic. The strongest testimony to the power of this literature is the fact that Mazarin's librarian Gabriel Naudé wrote and published a 718-page dialogue that attempted to edit, interpret, and thereby control the significance of the *mazarinades*.[1]

The *mazarinades* represent one of the most complete bodies of cultural, social, and political criticism of a regime prior to the French Revolution.[2] In a political climate where written tracts were inundating daily life (averaging over two publications every day of the Fronde), various areas of French culture were being culled for rhetorical persuasion. This chapter will describe how the humanist culture of Poussin's clientele, as a lexicon of terms and set of interpretive skills, played a central role in political discourse during the Fronde. Historical and political crisis insured the expansion of those cultural resources into a public domain.

The term *mazarinade* encompasses the more spectacular, comic, and obscene libels as well as legitimate forms of political discourse and official edicts. Judicial procedure during the *ancien régime* was largely prohibited from being witnessed by a public in its immediate chambers, but it found a deliberative voice in print.[3] The Parlement's resistance to the edicts of the monarch was articulated in the verbal *harangues* or *remonstrances*, which were immediately published and distributed in the streets of Paris. The speeches delivered at the *lits de justice*, the ceremonial imposition of royal prerogative, were in great demand by a public eager to read the latest act of *la résistance respectueuse*.[4]

The categories of official and illicit political discourse were fluid. The legitimate resistance of the Parlement of Paris was published in pamphlets that competed with or complemented other factional claims for public recognition and support.[5] Clandestine and official pamphlets shared common methods of distribution. Texts made the rounds at social gatherings and in cafés. They were also circulated by itinerant vendors and were sold in the shops on the Pont-Neuf (see fig. 2). Although the libels were often printed by clandestine presses, the unofficial literature did not have clearly demarcated rhetorical boundaries that separated it from the legal rhetoric of the Parlement. Both official and illegal literatures had authors of similar rank and education who addressed comparable audiences. Parliamentary leaders with legitimate venues for the articulation of their authority also hired propagandists or wrote their own uninhibited diatribes under a pseudonym. The deployment of a given writer for these different projects therefore registered the alliances and minglings of various individuals and groups during the Fronde.[6] The overlapping of officially published political discourse, illegal pamphlet, and public speeches marked collaborations between *robins* and princes and revealed shared rhetorical strategies and frames of reference.

Antiquity: The Language of Contemporary Politics

Given the *collège* education of these *robe* nobles and authors it is not surprising that ancient forms and themes were pervasive in political discourse during the period of the Fronde. In response to economic and political crisis, the circulation of classical referents exponentially increased in oral and published form, from broadside sonnets to books on ancient and modern triumphal entries.[7] Indeed, during this political upheaval, the representation of antiquity was considered more rather than less relevant to contemporary experience. The humanist culture and erudition exemplified by Poussin's two representations of Camillus, his representations of Moses, and the decorative project of the Grande Galerie continued to provide a counter-balance to the contingencies of French politics.

Antiquity was endemic to criticism during the Fronde. One pamphleteer was horrified by the abuse of citations from Latin primers stuffed into serious political discourse.[8] References to Cicero, Horace, and Cato were running rampant. Published Latin plays, such as "Le Virgile Mazarin," echoed the pedagogical exercises of the *collège*. Other pamphlets were similarly pedantic, riddled with citations and Latin commentaries in the margins.[9] The political discourse of the *mazarinades* inherited the humanist culture that found its expression in Montaigne's *Essais*. As we have seen, Montaigne had offered the sixteenth-century learned individual the fluent integration of contemporary life with Greek and Latin letters. By the mid-seventeenth century, his writings still offered these values to Poussin and his intimate friends.[10] But reading Montaigne was also part of a wider social phenomenon. During the Fronde, there was a market for extracts of the sixteenth-century author fitted to the particular circumstances of daily politics.[11] Such flagrant textual borrowing of Montaigne in *mazarinades* was symptomatic of the variety of subjects and modes of expression derived from French humanist literary culture found in the pamphlets. Several pamphleteers wrote under the pseudonym of a Greek or Roman exemplary figure.[12] Some assumed the voice of a mythological character's statue.[13] Others rehearsed the ancient literary genre of the dialogue.[14] Still others wrote the animated repartee of mythological figures or dialogues of the sacrosanct dead of antiquity.[15] Indeed, Montaigne's imaginary center near the Tiber continued to orient

political discourse in mid-seventeenth-century France.

A Greco-Roman lexicon provided the metaphors for a language of praise during the Fronde. In an attempt to secure the authority of the king in his minority during the turbulent year 1649, Jean Valdor's *Les Triomphes de Louis le Juste* associated the dauphin with his Herculean father: the frontispiece represented the bust of Louis XIV near the late king, who appears in the guise of the nude heroic demigod (fig. 49).[16] Opponents of the regency also hailed their own representatives in the traditional mode of classical panegyric. However tenuous, the alliance among princely factions, Parisian parties, and the Parlement was expressed by a common pool of heroic exemplars. Playing classical references against ribald gestures, Poussin's client the burlesque writer Scarron hailed Gaston d'Orléans, the brother of Louis XIII, as "A wise Prince, a real Cato,/ In valor another Alexander the Great."[17] Paul Gondy, soon to become Cardinal de Retz, was called "this young Scipio";[18] he was also compared to Cicero, Demosthenes, Ambrose, Bernard, Martin, Moses, Samuel, and Alexander.[19] In a

49. Jean Valdor, *Louis XIII as the Gallic Hercules with a bust of Louis XIV*, from *Les Triomphes de Louis le Juste*, 1649 (Paris, Bibliothèque Nationale).

similar mélange of Judeo-Christian and Greco-Roman exemplars, the Duc de Beaufort (the "prince de Les Halles") was compared to Socrates and Solomon by the poet du Pelletier.[20] Drawing on the Roman imperial past, the princes Condé and Condi were praised as military commanders and called "les Césars françois."[21] Or Caesar would himself appear to provoke Condé into destroying Mazarin and protecting Paris.[22]

Significantly, the Parlement was cast repeatedly as "the most august Senate in the universe" with powers that exceeded even those of Hercules.[23] One of the most famous and well received *mazarinades* argued for the sovereign court's position as "the veritable image of the Roman Senate under the emperors."[24] The Roman institution, inscribed on the Claudian tablet (see fig. 19) and the elder Bellièvre's tomb, provided the model for a disinterested body which served *le bien du public* by keeping the despotic potential of monarchy in check. "Working only for glory and honor," it was sometimes necessary for this Senate to "combat the most powerful." In order to invoke this imaginary continuity with the antique past and to establish his own rhetorical power, the author cited Cicero's speech to Mark Antony.[25]

These tracts indicate how the rhetorical strategies of the humanist tradition were part of the public record during the Fronde. Classical references became part of daily political discourse, read and overheard in cafés, delivered in Parlement, or from makeshift podia on the outskirts of Paris (see fig. 47). Shared cultural practice was crucial for uniting in opposition the various factions with potentially divergent interests. The authority of the antique past offered a much needed common basis for legitimacy.

Of course Greco-Roman literature also provided countless negative comparisons for the burgeoning printing industry. It exploited the traditional Gallic Herculean imagery to show Mazarin as the defeated Italian Cacus to a French Hercules.[26] Or he had the burning ambition of Phaethon.[27] Poussin's own reference to Mazarin as the enraged and gory Polyphemus is consistent with the depth of classical imagery in contemporary pamphlets.[28]

The public recognition of classical protagonists and narrative situations also permitted the subversion of forms and techniques customarily used to bolster political authority; as discussed earlier, antique references were subject to semantic instability. Far from decorating a secure absolute monarchy, the humanist exemplum potentially pointed to the fallibility of political figures. As one *mazarinade* put it: "Every prince is only a man, and each man is subject to change. Nero was virtuous. Nero was detestable."[29] During the course of the Fronde, the legitimating discourse of the French monarchy was highly unstable and subject to appropriation by opposition factions. If Poussin's art has been associated with a classical order devoid of tension, the unstable and contested deployment of antiquity within a highly politicized society would call into question such a reading. At the time when the artist was most productive for a French clientele – the period usually designated as his greatest devotion to a resolute classicism – antiquity was neither securely assigned to its task as ballast for a state nor innocent of temporal contingencies. The cultural strategies of the *frondeurs* intimately linked the Greco-Roman past with a political expediency that helped define the peculiar character of seventeenth-century revolution.

Inversions

Simple reversals of hierarchies rendered antique referents unstable during the Fronde. If a classical repertory conventionally legitimated power, it could also undermine it by deploying the strategy of inversion. *Mazarinades* combined Greco-Roman cultural forms with popular modes of expression. As we have seen, the burlesque style of Scarron, or the Rabelaisian genre of a world-turned-upside-down, was compatible with the world of antiquity. Not surprisingly, mock triumphal imagery was a mainstay of opposition criticism of the regency during the political crisis. In a number of pamphlets, triumphal entries resembled carnival excess when the laureled victor was the chastised Mazarin. The written descriptions of imaginary triumphal entries referred not only to the debasement of ancient Roman prototypes but also the travesty of the reign of Henry IV.[30]

Inverting the conventional ceremonial form and placing Mazarin at the apex of a discredited hierarchy required the same cultural skills as the composition of monarchical pomp and *parlementaire* procedure. In one of the most complete parodies of encomiastic literature, *Le Triomphe du faquinisme* (The Triumph of Knavery), the anti-hero Mazarin was surrounded with hyperbolic praise.[31] He spared no expense for the "magnificence" of a spectacle where "the glory of the Romans" triumphed on the pont Notre-Dame.[32] When the Sicilian cardinal bought ancient Roman glory the crowd gathered "to be a spectator of such beautiful pomp."[33] The procession assembled on the place de Grève, where there was ample room for large crowds and spectacular, ritual executions. We are given glimpses of the ordering of society:

> The schoolboy is seen there, and the troops of nuns,
> Our gentlemen the lackeys,
> The washer women
> And all those who live in the kingdom of Les Halles.[34]

In this motley roll call, students, servants, washerwomen, and food market people were followed by financiers and businessmen. In the midst of the rabble, a recent hero, the *parlementaire* Broussel, attained immortal status as the invincible Gallic Hercules (see fig. 43).[35] However, behind him stood the Senate, the parlements of Paris, Aix, Bordeaux, and Cambray, surrounded by the images of Mazarin's "great projects": "a thousand paintings/ of these most beautiful accomplishments/ and maps of the cities he wished he had taken."[36] In a similar mock triumph, Mazarin displayed his painted attributes: a sodomitical cupid, tax collectors, and a gambling table.[37]

At last, the exiled first minister appears. Now the Herculean officers of the Parlement have their cue to act like the Roman Senate and judge Mazarin.[38] The cardinal is represented with his list of crimes as a one-eyed Sicilian monster with antique credentials: "Polyphemus the sign of tyranny."[39] The festive procession then turned into another ceremony with its own etiquette and similar interpretive demands for the viewer – the execution and mutilation of Mazarin. Reminiscent of the morbid mock entrance of another regime, the desecration of Concini's corpse is repeated: "It is time, spectators, for the pomp to end/ Direct your eyes and hearts toward the sacrifice."[40]

Unstable Signs

Simple inversion is only one example of the instability of humanist Greco-Roman referents customarily associated with panegyric literature. One of the most significant effects of the deployment of classical antiquity was the shifting of historical values due to the multivalency of seemingly fixed referents. Apparently stable signs, such as the identities of historical personages, were modified by contemporary circumstances.[41] If the tools of a classical education invested an historical figure with virtues in order to draw a parallel with a contemporary monarch, those same interpretive skills found parallel faults. Instead of making flattering comparisons between the regency and Greco-Roman mythology, a *mazarinade* culled the uncompromising stoic Cato from the collective memory of the *collège* as a voice of disinterested criticism. In response to Mazarin's set of engravings picturing himself as a second Aristotle guiding the new Alexander through his minority, another cheap pamphlet circulating in the streets of Paris blasted the cardinal for his incapacity to foster a new Athens to be created by starving French writers and philosophers.

As we have seen, under certain circumstances, the monarch depended upon flattering comparisons to imperial Rome to bolster his power. Epithets derived from the Caesars were tenable as long as one was assured that contemporary circumstances did not resemble the last moments of Julius Caesar's rule. The Roman triumphs that shored up Henry IV's tenuous position depended upon support from groups that perceived themselves as mirroring the constituent assemblies of ancient Rome. But if these groups saw their rights undermined, Roman history provided other terms for negative comparison. While the harmonious relationship between Parlement and Henry IV was likened to that of a benevolent emperor and the Roman Senate, Mazarin's power was compared to imperial despotism.

Apologists for Jules Mazarin made a play on his name and that of Julius Caesar,[42] but the comparison was not very stable. The coincidence of forenames was used to negative advantage by highlighting the dictatorial Caesar who was justifiably assassinated. In one pamphlet, the price put on Mazarin's head by the Parlement of Paris was compared to the virtuous expediencies of Brutus.[43] Another author admonished the queen for her acqui-

escence to Mazarin's greed: "You support Caesar and his fortune."[44] Caesar was a favorite
term of comparison in parallel lives. But unlike Plutarch's balanced comparative portraits,
Mazarin had all the vices but not one of the virtues of Caesar.[45] Setting out to attack
writers who dedicated their books to this "Jules moderne," the author of one famous pam-
phlet chose to emphasize the history of Caesar's conquest of the Gauls. The two con-
quering Italians ravaged the French countryside, stole money, and exported it to Rome.[46]
Another pamphlet claimed that Mazarin was planning a pompous triumphal entry into
the vanquished city of Bordeaux, again hailing himself as Caesar.[47] As "Julius" Mazarin
continued to seek validation by comparison to Caesar, he inadvertently undermined his
own position because he did not keep abreast of the changes in the value of the term.

Oppositional Historiography

Roman history provided not only an extensive repertory of historical topoi but also dif-
ferent modes of historical explanation. The writers of the unofficial histories of the Fronde
escaped the task of eulogistic flattery and drew upon Tacitus as a model for their own
craft. As we have seen, Tacitus was one of Poussin's sources for his own representation of
the consequences of political corruption in *The Death of Germanicus* (see fig. 8). Since the
Roman historian had been used by theoretical proponents of absolute monarchy such as
Jean Bodin, the writings of Tacitus had come to be recognized as a legitimate historical
discourse by the French monarchy. Yet, Tacitus's description of the corruption and infight-
ing of successive imperial regimes was subject to appropriation. For Achilles II de Harlay,
a lawyer seeking his position in the *noblesse de robe* during the 1640s, Tacitus was an exem-
plum of historical writing and quotidian political practice. Harlay's father harangued
Henry IV in the Parlement of Paris for the right to remonstrate against monarchical pre-
rogative; his son, Achilles III, also became a president of Parlement and the owner of a
painting by Poussin, *The Judgment of Solomon* (see fig. 75).[48] In the preface to his edition
of Tacitus's history, Harlay hoped that his translation of Tacitus would parallel the Roman
author's political conduct: it would neither be inflexible nor flatter.[49] Harlay hailed Tacitus
because the historian resisted being swayed by political coercion and the demands of
patrons. Far from a flattering eulogy of foreign wars and patriotic death, Tacitus responded
to the homicidal intrigues at the center of power as a "torrent of wasted bloodshed far
from active service [that] wearies, depresses, and paralyses the mind."[50] Tacitus's position
of uncompromising disinterestedness therefore offered an alternative to the panegyric
mode of praise. His integrity thus represented the values of the *noblesse de robe* who sought
to assert their own political autonomy.[51]

During the Fronde, references to Tacitus's history signified a critical evaluation of the
contemporary government.[52] The ancient historian provided a model of official conduct
for the man at court, steering the *homme de bien* between "perilous insubordination and
degrading servility."[53] But he also offered a monumental cast of historical personages who
provided warnings to those who abused their power. The themes of ambitious mothers,
corrupt favorites, and victimized sons provided ample opportunity for historical analogy.[54]
The decadent and despotic image of the usurper Nero served portraitists of Mazarin
during the Fronde.[55] Other pamphlets called Mazarin a second Lucius Aelius Sejanus,
infamous favorite of Tiberius.

The comparison of a contemporary political figure with the tyrants described by Tacitus
was hardly an original strategy in France. A parallel pamphlet campaign that drew upon

Sejanus as an analogy to a regent's favorite had occurred only forty years earlier during the regency of Marie de' Medici. Indeed, by linking the two regencies through a shared reference to Roman history, the *mazarinades* reminded the French people that the minority of Louis XIV and that of his father mirrored one another.[56] The assassination of Henry IV in 1610 left a foreign queen in power as the regent. Like her counterpart Anne of Austria, Marie de' Medici depended upon another foreigner as a counselor and intimate. The Italian Concini, the Maréchal d'Ancre, similarly became the brunt of a campaign of slanderous and xenophobic brochures. In a pamphlet campaign in the first decades of the seventeenth century we see the first rehearsal of themes that were later used against Mazarin. Ambition, greed, lowly and foreign birth, moral depravity and sexual perversity were the recurrent themes deployed to undermine both regencies.[57]

A civil war was avoided by the murder of Concini in 1619 and, soon afterwards, the exile of the queen mother. The assassination of the foreign usurper was the foundation for the official mythology of Louis XIII's reign. Pierre Matthieu, the historiographer who had bolstered Henry in his description of the triumphal entries (see Chapter One), deployed the same humanist references to justify Concini's murder and the defamation of his corpse in the name of the Bourbon monarchy.[58] Like the corpse of Sejanus, which was dragged around Rome for three days and then thrown into the Tiber, Concini's cadaver was torn apart and burned at different locations throughout Paris. Immediately after Concini's death, the coup d'état was justified "for the re-establishment of the authority of the king."[59] By forcing the majority of Louis XIII, the overthrow of Concini and Marie de' Medici was intended to save the French monarchy and France for the French (thereby constituting the French as such). According to Matthieu, "foreigners and their rabble-rousers usurp and take absolute possession of the government of the kingdom that they illegally employ and exercise with extreme tyranny and oppression."[60] In order to instill the sense that dynastic continuity had been achieved, Louis XIII took full responsibility for the coup as a beneficial bloodletting. At the king's death, the funeral orations praised the official purge of Concini: "Fire and iron were used to cut the root of evil so contagious that the very life of the kingdom was threatened by it; a punishment as sudden as the lightning of Jupiter fell on one head for the correction and example of many."[61] In 1649, Pierre Corneille similarly mythologized this act of violence that was the foundation of Louis XIII's power:

> From birth this conqueror
> Like [Hercules] got into fights
> And striking down dragons
> Was like child's play to him.[62]

Throughout the Fronde, the official account of Concini's assassination remained intact. This Bourbon mythology continued to be reiterated despite a historical parallel that incriminated the regency. If Concini was an evil root that had to be ripped out, or a dragon that had to be struck down by the legitimate monarch, it would logically follow that any other foreigner who had power over a queen regent had to be eliminated. Inadvertently, the history that legitimated the monarchy provided a readymade critical language and prescription for terminating the regency.

Critics, otherwise publishing under the threat of capital punishment, entered into legitimate political discourse by paraphrasing or repeating official historical accounts. Several legitimate brochures attacking Concini as a second Sejanus were merely reprinted with little or no modification. Repetition became allegory: Mazarin was a second Concini, yet another Sejanus. Resistant positions were voiced by a simple act of appropriation. For

50 *(right)*. Anon., *The Flight of Mazarin from Paris (Récit de ce qui c'est fait et passé à la marche mazarine, depuis sa sortie de Paris jusques à Sedan)*, 1651, engraving (Paris, Bibliothèque Nationale).

51 *(facing page, left)*. Jean Daret, *Mazarin, Louis XIV, and Anne of Austria as Minerva*, 1644, engraving (Paris, Bibliothèque Nationale).

52 *(facing page, right)*. Abraham Bosse, *David and Goliath*, 1651, engraving (Paris, Bibliothèque Nationale).

example, one night in June 1648, the walls along several Parisian streets and the Pont-Neuf were covered with posters announcing the official *arrêt* of July 8, 1617 against Concini, which had forbidden foreigners from high office.[63] A thirty-year-old edict, which had been at the heart of Louis XIII's reign, repeatedly legitimated opposition to the current foreigner in power.[64]

When Mazarin was exiled, the comparison made between him and his double Concini became more explicit. In one *mazarinade*, the shade of Concini welcomed Mazarin to the underworld and told him that a throne awaited him.[65] In a broadside, Mazarin was depicted fleeing on horseback with overflowing moneybags (fig. 50). His flight was only checked in the final frame by his overwhelming fear of Concini's bedeviled ghost.

To be haunted by Concini was also to be haunted by his antique prototype, Aelius Sejanus, in the "unflattering mirror" of the double portrait.[66] The author of *L'Ambitieux, ou le Portrait d'Oelius Séjanus en la personne du cardinal Mazarin* argued that as all good men sought out models, traitors similarly found their own masters to imitate.[67] Sejanus and Mazarin were both counselors who isolated their respective rulers and exiled noble and honorable families.[68] Mazarin repeated the crimes of Sejanus: sodomy, embezzlement, nepotism, and homicide. The poisoning of Germanicus was mirrored by the alleged murder of a president of the Parlement of Paris.[69] The parallel served not only as a thinly veiled reference but also an omen. If Sejanus poisoned Drusus the son of Tiberius for his

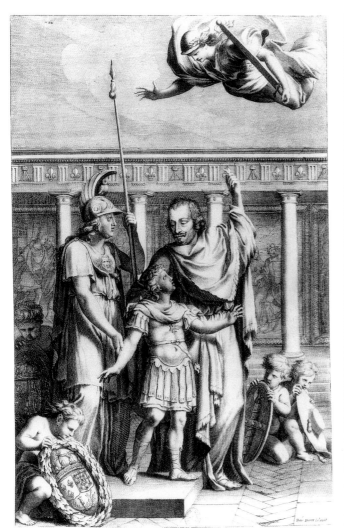

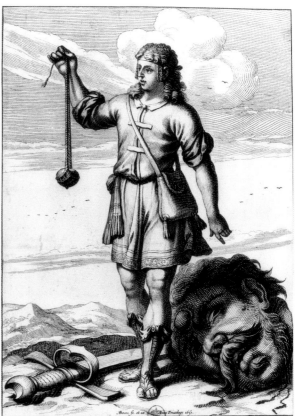

La Fronde en cet endroit fit vn coup Merueilleux,
Mais l'Esprit Eternel en conduisit la pierre,
Et luy donna du poids contre vn Front Orgueilleux,
Pour mettre en vn moment ce Colosse par terre,

Frondeurs de qui le bruit s'espend par tout le Monde,
Cet Exemple sacré vous a donné par Loix,
Vous pouuiez justement faire claquer la Fronde,
Pour la Cause du Ciel et pour celle des Rois.

own gain, the life of the king in his minority was similarly imperiled.[70] Once again, the pamphleteer cried: "Cruel tyrant, Sejanus, our common enemy . . . who loves confusion and disorder."[71]

As the antique referent "Jules" was unstable, so too were the official representations of Mazarin's relationship to his charge Louis XIV. While a classicizing representation of the pedagogue Mazarin guiding the Roman imperial Louis with the assistance of Anne of Austria as Minerva proposed a paternalistic relationship (fig. 51), critics were quick to exploit the anxieties regarding same-sex relations found in *Camillus*. In the libelous poem "La Mazarinade," Paul Scarron's underlining of Mazarin's duties as pedagogue for the king was inflected by sodomitical imagery: "Buggerer of sheep, buggerer of boys,/ Buggerer of all shapes and sizes."[72]

Political pamphlets enunciated a well-rehearsed French anti-Machiavellianism that collapsed xenophobic and homophobic discourses in the figure of the feminized and sodomitical Italianate courtier.[73] In a *frondeur* burlesque of the *Aeneid*, for example, courtiers were interviewed by the devil in order to be assigned an appropriate punishment:

> In the case of a French courtier
> He wants to know how many times
> He had committed the sin of Rome

(that's to say of Sodom).
But if it's an Italian,
He doesn't even bother to ask him anything.[74]

If accusations of sodomy had been a traditional mainstay of political commentary, the parallels between the sexuality of Mazarin and Sejanus had a direct bearing upon concerns about the cardinal's paternal relationship to the orphaned boy king. While the Parlement of Paris only hinted at the dangers of Mazarin's custodial relationship to the king at a highly impressionable age, the libels were more explicit in their denunciations, often relying on a parallel between contemporary and ancient pederastic initiation.[75] In one *mazarinade*, Louis XIV's father appears as a ghost in order to counsel his son. The wraith tells of Tiberius and his "inclinations and particular tenderness" for Sejanus.[76] The father's policing of his son's sexual conduct through the Tacitean lesson finds its corollary in Abraham Bosse's representation of David and Goliath. In the engraving (fig. 52), the triumphant Louis XIV as David wields his sling-shot (*fronde*) pointing to the decapitated head of Goliath/Mazarin. The superior force and overdetermined masculinity of the bearded monster is overturned by the adolescent youth. Bosse was exploiting the long-standing representation of inverted power relations based on a sexual distinction found in European art (from Donatello to Guido Reni). The schoolmaster got his just rewards.

If history repeats itself, so do the patterns of resistance. A dispassionate and disinterested commentator on Roman history was in a position to judge political tyranny and counsel the young king. The author of *Le Sésanus romain* addressed the king:

> Passion, Sir, certainly does not make me speak. I do not have any self-interest in these affairs, but truth guides my speech; never were Catelina Marius nor Silla, which the Roman History [by Tacitus] mentions, as pernicious to the Empire as this new Sejanus is to France. The triumvirate never did as much evil as this Sejanus.[77]

53. Antoine Caron, *Massacre of the Triumvirs*, 1566, oil on canvas (Paris, Musée du Louvre, RF 1939-28), 1160 × 1950 mm.

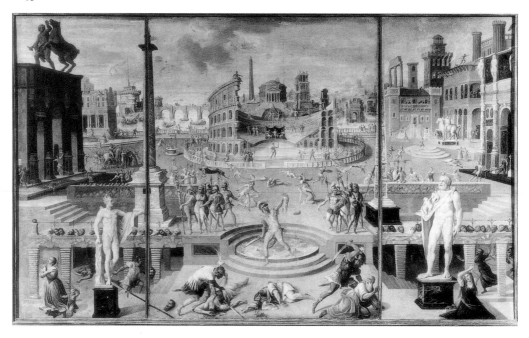

The triumvirate that Antoine Caron had painted as an allegory of the French civil war of the sixteenth century (fig. 53) returned in the political discourse of the Fronde. As in the parallel between Tacitean history and the massacre of Huguenots, the pamphlets reveal an educated audience's capacities. Historical commentary, central to the skills of the Parlement and its allies, argued that evils of Roman and recent French history were surpassed by the abuses of this new Sejanus. Likewise Mazarin's exiling of *parlementaires* was compared to Sejanus's campaign of terror and usurpation of authority. Like the Roman Senate, the "firm column of the crown" was threatened by extinction.[78] The pamphlet left no doubt as to the solution: all the evils of the reign of Tiberius had been stopped only by the death of Sejanus.[79] This writer versed in Roman history desired that history would repeat itself, albeit selectively.

It is important, at this point, to remember the distance from the intimate project of Cassiano dal Pozzo's *museo cartaceo* and Giustiniani's taste for things antique. The patterns of sociability in Roman antiquarian circles do not fully prepare us for the extent to which antiquity figured in a larger social movement in France. Rather than using the finely tuned and intimate instruments of erudite scholarship, groups during the Fronde relied on a range of historical and rhetorical tools, sometimes crude and improvised, in the public arena of factional politics. A painting such as *The Death of Germanicus*, had it been circulated in Paris ten years after its execution for the Barberini circle, would have been understood in quite radical terms by droves of *frondeur* pamphleteers. As an exiled Frenchman identified with the glory of a previous reign, Poussin represented classical antiquity for an audience who could perceive that such themes were immediately relevant to contemporary politics. Such was the vantage of Poussin's clients in France as his pictures made their way across the Alps.

Yet it does not necessarily follow that the depth of reference to the Greek and Roman past in French visual culture, however endemic to the period of the Fronde, would have necessitated a tableau. Although Caron's painting of 1566 serves as a measure of the long collaboration of antiquarianism and politics in France, the relative rarity of an easel painting accomplishing such a task suggests that in the sixteenth century, broadly speaking, France had not yet invented for itself a culture that brought those practices to painting. This was Poussin's project.

Reading Coriolanus

Poussin's painting *Coriolanus Entreated by his Mother* (fig. 54; see fig. 48) stands out as a direct response to the Fronde and would have been understood as such during its initial reception in France. The scene is from Roman history as recounted by Livy and Plutarch: Gaius Marcius Coriolanus is supplicated by his mother Volumnia, his wife, and other women of Rome not to wage against their homeland.[80] Modern art historians have not failed to interpret this story of civil war and siege as an allusion to the Fronde.[81] Painted around 1651, the painting is for some suggestive of the armed campaigns of the princes which occurred in 1649 and again after 1650.[82]

More than fifteen years after his *Scipio* and *Camillus* paintings, Poussin culled Roman history and his meditation on Montaigne for yet another representation of a siege. In *Camillus and the Schoolmaster of Falerii* (see figs. 25 and 34), the theme of siege was related to both the sixteenth-century essays of Montaigne and the more recent campaigns for the consolidation of state power under Richelieu. As I have argued, sieges had a particular

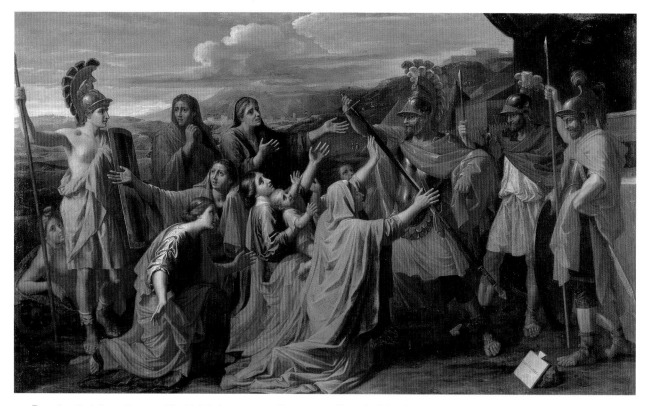

54. Poussin, *Coriolanus Entreated by his Mother,* c. 1650, oil on canvas (Les Andelys, Musée Nicolas Poussin), 1120 × 1985 mm.

significance in France during the first half of the seventeenth century because they were
the site of the conflict between local urban authorities and the increasingly concentrated
power of the centralized state (rather than a foreign power). When *Coriolanus* was painted,
siege was understood within the context of civil war. The blockade of Paris and the
surrender of outlying Charenton to the armies of Condé galvanized the *frondeurs* in the
early months of 1649. Numerous memoirs, letters, and pamphlets recount the hardships
of the people of Paris and the devastation and suffering in the city's environs (see Chapter
Eleven). Recall that in a letter to Chantelou, Poussin expressed his fear that his friend
was "trapped like the others in that miserable town" during the "Parisian war."[83] Other
sieges were well known during these years of conflict: the travails of various cities in the
realm – Bordeaux, Le Mans, Cambrai, Anger, Etampes – formed the basis for solidarity
against the regency. Pamphlets circulated between cities, often in the form of letters
addressed to the urban populace, comparing the hardships of their respective plights.[84]
During the period when Poussin was painting *Coriolanus*, the recurrence of widespread
and violent sieges was a symptom of the failure of the regency to represent a legitimate
monarchy. The regime had to resort to coercion.

To treat the *Coriolanus* as an admonition against siege is to resist the habit of perceiv-
ing the representation of ancient history as an *exemplum virtutis*. Of course, the powerful
protagonist commanding the composition could be mistaken for an object of admiration.
But the taut-muscled, sword-wielding general is held in check by the phalanx of women
led by his own mother. Indeed, Coriolanus did submit to his filial obligation, but only
after having proven his hubris and unyielding temper. For those viewers who perceived
the French people as victims of armies loyal to the regency, Coriolanus represented an
unsympathetic figure who waged war against his homeland. Clearly, the story of Cori-
olanus did not provide Poussin with an easily celebrated hero. Instead, as in the *mazari-
nades*, Roman history was used for its critical potential, dispraise not encomium. The

painter selectively appropriated the lessons of history, just as did Plutarch who praised exemplary behavior in his *Lives* but also described human faults.

Poussin's selection of a counter-example to exemplary political conduct from among the portraits written by Plutarch has been overlooked. If Poussin's depicted episode offered behavior to be emulated, it was not to be found in the rigid sword-bearing figure. Scipio's repression of individual sexual desire was a demonstration of the magnanimity and the continence of a conquering hero but Coriolanus's act could not have been. Plutarch instead had admonished Coriolanus for not yielding to the arguments of the ambassadors and the interests of Rome as a whole.

The heroic stature of Coriolanus is fraught with ambivalence in the texts by Livy and Plutarch. Coriolanus was no novice in siege warfare. In fact, Coriolanus was a courtesy title given to the Roman officer Gaius Marcius for his earlier capture of the city of Corioli. Plutarch praised the combatant's extraordinary individual skills as well as his subsequent aversion to pillaging. However, Livy was more critical of the warrior. In his *History*, Marcius seized a torch during the forced entry into Corioli and flung it among the houses just inside the city wall. "The cry which arose, and the shrieks of women and children in terror of death were, for the Roman troops, a heartening sound." In contrast to Plutarch, Livy states that Marcius "covered himself with glory" by erasing the distinctions between civilian and soldier in urban warfare, a leveling subject to harsh criticism. Livy's description therefore anticipates Coriolanus's cold-blooded siege of his native Rome, the subject represented by Plutarch, Livy, and Poussin.

If Coriolanus obtained an ambivalent reputation as a warrior, his skill as a statesman attracted even more criticism from his biographers. Coriolanus used his prominence as a soldier to become a persuasive representative of the patricians in Rome against the political advances of the plebeians. He took advantage of famine to reestablish the powers and privileges of his class, withholding food as ransom in order to obtain political concessions. As a consequence, Coriolanus angered the common people to the brink of violence. His dangerous politics alienated his own class and he was exiled.

We should not, however, mistake Coriolanus for a Phocion, an exemplary leader subject to the fortunes of the mob. According to Livy, Coriolanus's treatment of the plebeians had made him "little better than their executioner; he offered them the choice between death and slavery."[85] Plutarch also criticized Coriolanus's motives and held him in contempt, considering that Coriolanus was motivated solely by his arrogance and his anger. He was also a flawed leader because he did not have the essential qualities of a statesman: balance and sweetness, which are communicated by reason and education. His "nature", his "vehement temper and unswerving pertinacity", were the result of a lack of "culture" that would have provided the necessary discipline and moderation. Plutarch found a crowd-pleasing demagogue less reprehensible than a leader who treated the people with contempt. Although it was shameful to flatter the people in order to obtain power, it was both shameful and unjust to apply terror and oppression. Poussin had therefore selected a theme that invited the critical evaluation of a leader who lacked the political shrewdness to garner popular support.[86] While Phocion refused to bend to public opinion because of his steadfast principles, Coriolanus risked death or exile because of his arrogance.

The traitorous actions of Coriolanus, his recourse to "terror and oppression," were the particular object of criticism for the ancient writers. As an embittered exile, he was embraced by the enemies of Rome. He conspired with the leader of the Volscians Attius Tullius to move his subjects to war. The two tacticians used deceit and sacrilege to incite conflict. They manipulated the Roman consuls into banishing the Volscians from the Great Games at Rome by inspiring fear in the hearts of the Romans that their unruly

guests would riot. As the Volscians were ordered out of Rome without explanation, Tullius turned their collective sense of humiliation to rage against the Romans (this ruse can be contrasted with Camillus's refusal to use deceit). Coriolanus was elected by the Volscians to lead the war against Rome and quickly captured a series of recently acquired Roman territories. Then he marched on Rome, taking position outside its walls, laying siege, and commanding raiding parties to destroy farms and crops in the Roman campagna. This was the setting that formed the basis for Poussin's painting.

Diplomatic attempts by Roman envoys, even priests, were refused by the inflexible, vengeful commander. In response, Roman women flocked to the house of Coriolanus and entreated his mother and wife to go with his two young sons to the enemy lines and plead for peace.[87] "Men, it seemed, could not defend the city with their swords; women might better succeed with tears and entreaties."[88] Poussin responded to the challenge of depicting an episode from the events that followed. According to Livy, Coriolanus's first response to a delegation of women was a hardening of his resolution: he reacted in the same way as he had to the diplomatic initiatives. Then his resolve was crushed. In one instant, according to Livy, Coriolanus was moved by the sight of his mother and ran to embrace her, only to be admonished:

> "I would know," she said, "before I accept your kiss, whether I have come to an enemy or to a son, whether I am here as your mother or as a prisoner of war. Have my long life and unhappy old age brought me to this, that I should see you first an exile, then the enemy of your country? Had you the heart to ravage the earth which bore and bred you? When you set foot upon it, did not your anger fall away, however fierce your hatred and lust for revenge? When Rome was before your eyes, did not the thought come to you, 'within those walls is my home, with the gods that watch over it – and my mother and my wife and my children'? Ah, had I never borne a child, Rome would not now be menaced; if I had no son, I could have died free in a free country! But now there is nothing left for me to endure, nothing which can bring to me more pain, and to you a deeper dishonour, than this. I am indeed an unhappy woman – but it will not be for long; think of these others who, if you cannot relent, must hope for nothing but an untimely death or life-long slavery."[89]

Livy allocated a considerable portion of his text to the oratory of an angry woman. The mother's eloquence persuaded her son where the rhetoric of ambassadors had failed. In Livy's text, Coriolanus is embraced by wife and children, surrounded by a chorus of tears. He kisses his wife and two sons, sends them home and withdraws his army. His life ends in exile.

Poussin's painting similarly represents the failure of defense by sword and the imminent success of "tears and entreaties." Whereas Livy describes Coriolanus as initially moved by the sight of his mother, Poussin did not allow Coriolanus to display the affection of this filial bond. Instead, he stressed the suspenseful confrontation of the violent general and the entreaties of the women. They stand as the only defense between the sword-wielding warrior and the female personification of Rome. The story of the entreaty made to a political and military leader which results in a sympathetic response had already been rehearsed in the *Camillus* compositions and the painting of *The Continence of Scipio* (see fig. 27). Yet, Poussin's Coriolanus is caught in his relenting determination to put his pride before the demands of Rome. There is no glimpse of the scene of recognition and maternal embrace. Instead, he is impassively locked in his stiff pose, seemingly impervious to the compressed group of gesticulating figures. The effects of persuasion are possibly made visible only insofar as the hilt of the sword might retreat to the waiting scabbard.

55. Anon., *Financiers at the Wine-Press* (*Le Pressoir des partisans*), 1651, engraving (Paris, Bibliothèque Nationale).

Poussin's dispraise of the leader who undertakes a treasonous siege resonated with contemporaneous events. The theme paralleled the early propaganda against the Prince de Condé as he and his foreign mercenaries laid siege to Paris. Later, when Condé's troops were encamped in Paris in 1652, there was a broadening consensus that Condé held too much power. The practical politics of persuasion in Plutarch's reading is consistent with a famous man of letters' view of Condé's occupation of Paris. According to Guy Patin, Condé miscalculated the power of public opinion. The people, fatigued by his self-interestedness, turned to the king because the abuses of the *gens de guerre* could no longer be tolerated.

The figure of Coriolanus may also have been identified with Mazarin. The cardinal was blamed for leading mercenary troops ("les Mazarins" or "the audacious Mazarinistes") against French towns.[90] Opponents of Mazarin therefore fought troops loyal to the regency without being disloyal to the principle of monarchy (such as the brothers Fréart in Le Mans). Even in the siege of Paris, responsibility was diverted from Condé: the Parisians were blockaded by "a tyrannical and cardinalesque army."[91] Like Coriolanus, the alienated political leader Mazarin collaborated with foreigners for the ruin of the capital and the provincial towns. At Etampes, Mazarin was "a monster who strove to devour" the city.[92] The people of Angers feared the entry of the "abominable minister." A letter attributed to a woman from Bordeaux, read aloud at a fictional birthchamber conversation in Paris, derided the "fraudulent mind" of the cardinal: he did not plan to take the town by siege or assault, but rather by corrupting select officers in the civic regiment.[93] It was a crime Camillus would not have stooped to commit.

These readings were commensurate with the political alliances of the two possible initial owners, who were both committed in their opposition to Mazarin and Condé (see Chapter Five).[94] Poussin's depicted scene, however, cannot be overtly linked with a particular incident or historical actor. Given the shifting fortunes of the Fronde, how helpful would it be to anchor the representation to a particular episode? The broadside was quite adequate to this task. The political cartoon (for example, fig. 50) derived its authority from its urgency. In such ephemeral works, the crude hatchings of the burin were juxtaposed to a bit of dialogue sung to a popular tune blocking in a report of events. Or brutal allegory sought symbolic retribution by interested parties: Justice oversaw the gathering of money by laborers, nobility, and merchants while Peace, Time, and *le bien public* squeezed the tax collectors in a wine press (fig. 55). By contrast, the authority of the classical referent in

painting as in *frondeur* discourse resided precisely in its capacity to transcend specificity and ostensibly signify disinterestedness while maintaining its political potency and relevance as a precedent. It would have been of limited use to state that Coriolanus was Condé in the first months of 1649 or during his occupation of Paris in 1652. Nevertheless, it would have been difficult to miss the allusion. Rather than a strictly delimited allegory, the painting generalized the phenomenon of a siege in civil war. Characteristically, Poussin turned to the humanist exemplum as a compression of past and present rather than the substitution of one for the other as in allegory. This fluidity between ancient Rome and present-day Paris was consistent with the humanist integration of ancient history and contemporary political practice.

Female Agency

Unlike *The Continence of Scipio* (see fig. 27), Poussin's *Coriolanus Entreated by his Mother* does not represent the benefactions of the exemplary ruler but a drama of entreaty and supplication. The sword held by Coriolanus is suspended between acquiescence and violence. The delegation of women does not constitute a responsive chorus for the meritorious action of the military man. They do not yet thank him or honor him. Instead, they act upon him. They attempt to persuade him through their collective presence, through gesture, and according to Livy through rhetorical address. Unlike the woman in the *Continence of Scipio*, who is a mediating term, a passive token of exchange, in Poussin's *Coriolanus Entreated by his Mother*, the women are active agents.

 Given the painting's relation to contemporary history, a question arises: what would be the function of the action of the women in the context of the Fronde? What would be the benefit of selecting a theme that pits women against men? Rather than asking how Coriolanus conforms to the contemporary identification of the besieger as Condé or Mazarin, I believe a more compelling question is why Poussin feminized the besieged? Of course, history paintings have traditionally exploited the visual terms of the opposition of genders for the benefit of narrative legibility. Yet the question remains how the classical typologies of gender difference deployed by Poussin were inflected by the local manifestations of the humanist legacy. One answer may be sought by examining the representation of women in the political literature of the Fronde.

During the Fronde, women occupied important positions in political discourse. Several were even active agents. Mademoiselle de Montpensier, cousin of Louis XIII and daughter of Gaston d'Orléans, was the most prominent figure in the drama of civil war. While she was excluded from official council, she found ways of having an influence on events. Sometimes imposed constraints allowed very little room for maneuver by women. For example, as her father deliberated in the Hôtel de Ville, she promenaded in the streets, wearing her party's colors, followed by people shouting "Vivent le roi, les princes, et point de Mazarin!"[95] Or as her father was sworn in for emergency powers on July 20, 1652 she made candid observations from the audience.[96] But she is best known for her militancy at Orléans where she made an entry in order to insure the city's loyalty.[97] In a *frondeur* print (fig. 56), Mademoiselle assaults and immolates the supine Mazarin with her *fleur-de-lis* torch (the artist based the figure of Mazarin upon the Roman tax collector in Raphael's *Expulsion of Heliodorus by the Angels from the Temple of Jerusalem*). Throughout her life, Montpensier was painted with the residual attributes of armor and shield, assuming the allegorical role of Minerva and Amazon as well as actual warrior. Ironically, this led to the feminization of the Fronde in the historical literature.

Although women played important social parts in France when Poussin was painting the *Coriolanus*, representing women of antiquity was not a mere acknowledgment of such agency. Rather, the actions and words of contemporary as well as ancient women garnered a particular authority that might be assumed by different parties, including enfranchised males. Mademoiselle's entry into Orléans was represented in a number of *mazarinades*. While some accounts of it were reminiscent of antiquity, at least one, purportedly written by a chambermaid who overheard Mademoiselle's communication to her father, linked a woman's authority to specific historical and mythological precedents: both the power of the Amazons to overthrow an empire and remain in power for two hundred years and the just tyrannicide Thetis, who borrowed lightning bolts from her father Zeus, functioned as models for Mademoiselle's own militancy.[98]

The representation of the militant woman was not, however, restricted to the princess. Indeed, the image of the Amazon was pervasive in accounts of the Fronde. The women of besieged provincial towns helped to build fortifications for their defense. Women and girls marched on the battlements of Angers fearless of the muskets.[99] In Bordeaux, "bourgeois women and the most delicate" built defenses during the day and in the evening worked as seamstresses.[100] Indeed, this female militancy participated in the patriotic culture shared by both provincial cities and the capital. Women of Bordeaux called on

57 *(left).* Abraham Bosse, *Birthchamber Conversation (Cachet* [or *caquet*] *de l'accouchée),* c. 1635, engraving (Paris, Bibliothèque Nationale).

56 *(facing page).* Anon., *Mademoiselle as an Amazon at the Siege of Orléans (Vive le Roy point de Mazarin),* 1650, engraving (Paris, Bibliothèque Nationale).

women of Paris to defend "the liberty of our fatherland."[101] A pamphlet had the women of Paris answer in like fashion:

> Not only has the beauty of your charming faces been described to us, but also your valor, your generosity, and the greatness of your courage. Sometimes you have been shown busy toiling with your beautiful hands on the fortifications; sometimes repelling your enemies from the foot of your walls, and stirring your husbands to battle.[102]

Delicate hands dominating the battlements complemented the beauty of heroic virtues: valor, self-sacrifice, and courage.

The militancy of women was not only measured by building fortifications and bearing arms but also by expressing a wide range of rhetorical positions. Many women held highly vocal demonstrations in the streets.[103] The famous market woman Dame Anne was hired like other *criailleurs* and *criailleuses* by factions to shout libelous speeches.[104] Women also figured prominently in print. The exile of the court made the complaints of prostitutes a popular form.[105] The birthchamber conversation (the *entretien* or *caquet de l'accouchée*), a literary genre most famously represented in Bosse's engraving (fig. 57), was repeatedly used by *mazarinades* as an important source of news and commentary.[106] While some *mazarinades* were written and signed by actual women, other pamphlets claimed they published intercepted personal letters, or collective letters between the wives of *parlementaires*.[107] The epistolary form purportedly gave voice to the opinions of a wide spectrum of women, from Mademoiselle to the women of Les Halles.[108] The letters of Mère Angélique of Port-Royal described the atrocities of war from her position in the war-torn countryside and attempted to influence policy in Paris (see Chapter Eleven).

The speaking parts assigned women in Poussin's tableau as well as in the contemporary pamphlets suggest that women had a rhetorical authority on a symbolic level precisely because of the disinterestedness associated with their lack of material power. According to this ideological construction, because women were politically disenfranchised, they remained loyal to the natural ties of family not to the political interests of factions. In one pamphlet, women in the birth chamber called for an end to the devastation:

> When complaints are made to the Cardinal about the theft, sacrilege, impiety, and outrages performed by the soldiers of his army, he does not respond except to write it off as the effects of war, without confessing that he alone is responsible for these disorders and the war.[109]

Women at the bedside of the new mother were in agreement that Mazarin was to be blamed for the atrocities of the civil war throughout France.[110] The stress was on an expressive language shared by women in response to violence and material duress. Rather than the purported cackle of the *caquet*, this society of women exercised their "eloquence plus poli" to describe relevant current affairs.

In the *mazarinades*, women enjoyed a natural eloquence unavailable to men. In one pamphlet, Condé's mother wrote confidentially to Anne of Austria, princess to queen, woman to woman, mother to mother: "Listen to the voice of all the mothers and of nature herself."[111] The author appealed to the natural authority of motherhood. More precisely, women's alignment with nature posited their voice and gesture outside of artifice: "Weeping, the violence of my cries, on two knees."[112] What was particularly efficacious in the appeal made by the fictional Princesse de Condé was the figuration of physical gesture as a natural language. The woman's expressive body was a measure of truth, a natural sign.

The natural eloquence of woman was invoked by Madeleine de Scudéry in her fictional anthology of female oratory *Les femmes illustres ou les Harangues héroiques* (*Illustrious Women*

or Heroic Harangues; 1642).[113] In the epistle to women, writing under the pseudonym of her brother Georges, Scudéry cited the authority of antiquity in order to introduce her collection: "Among a thousand beautiful qualities that the ancients remarked in your sex, they always said that you possessed eloquence without artifice, without work and without effort."[114] Women's oratory attained a transparency of meaning that aligned it with true nobility: "The most delicate artifice consists in making it believed that there is none."[115] During her years in Paris, before completing her heroic novel that eulogized the Grand Condé in the midst of the Fronde, Madeleine de Scudéry turned to such heroines as Cleopatra, Berenice, Lucretia, and Sappho. In Lucretia's harangue to her husband, her justification for suicide as a response to her rape by the king Tarquin had an explicit political valence that foreshadowed the republican consequences of her act.[116] While the epistle made a claim for the natural eloquence of women, the oratory by Lucretia appealed to a reader who would have been sensitive to the discourse of anti-machiavellianism.

Scudéry's text has an affinity with the *mazarinades* in which women were "artless" enunciators of humanist rhetoric.[117] For example, the wives of *parlementaires* in Bordeaux shared with their Parisian counterparts references to antiquity.[118] In response, the voice of the Parisian women invoked the rumor of the pompous entry made by Mazarin at Bordeaux and described a parodic triumph: a superb triumphal chariot was pulled by four monkeys and four *malotiers* (the slang for tax collectors) as others bore the tableaux of the cardinal's infamous deeds, the imprisonment of Broussel, the sieges of Paris and Cambray, and the dishonorable peace of Munster.[119] Or the lamenting mother of Condé uttered "my dear Phaeton" to her bellicose son.[120] Indeed, these utterances can be related to the articulation of humanist culture by women writers and Scudéry's call to revive "this beautiful past century" and to emulate the "women of antiquity" in advance of the Enlightenment.[121]

In Poussin's painting, the mother of Coriolanus is wedged between her son and the personification of Rome. The armored woman, threatened by rape, partakes of both the identity of Amazon and victim. She is the fortified city willing to defend herself, but she is also the object of the violence of Coriolanus and his troops. The allegorical identification of the city as besieged woman permits the slippage between military and sexual conquest – indeed, allegorical figures of women always have this potential. In contemporary descriptions, the rhetorical opposition between men and women, soldier and besieged, was intensified by their evocation of actual sexual violence. In political discourse, metaphorical imagery regarding effects of power relied upon a description of violent sexual behavior.

When the city was allegorically figured as a woman, the pamphlet attacking the besieger participated in a sexual discourse. For example, a letter from the women of Bordeaux described the city as a woman subjected to the sexual violence of Mazarin. From his camp overlooking the city, Mazarin trained his spyglass on the features of the feminized town: "He threw his gaze onto the triumphal arches of her eyebrows, on the crystal windows of her eyes and on this sacred door of the palace that is her mouth, out of which exits the oracles of her justice against tyrants."[122] The city is a *blazon*, a series of architectural sites constituting the body of a woman. The significant historical places, such as the triumphal arches or the palace wherein the Parlement's sessions are held, are the eyes or mouth of this oracular woman. Away in his encampment, the voyeuristic Mazarin plots the attack. After committing specular violence, he forces his way in from behind: "he attacks us (Exuse the diction) 'in the Italian style.'"[123] The author's xenophobic reference to sodomy was consistent with the rumors and poetry dedicated to the unnatural sexual relationship between Mazarin and Anne of Austria (as well as the similar threat to the dauphin).[124] Sodomy was linked to the broader conceptualization of siege as rape.

Another *mazarinade*, purportedly in the voice of a woman, articulated the same metaphorical language of heterosexual sodomitical politics. In *Lettre de la petite Nichon*, a prostitute admonishes Condé for his aggression:

> Who would believe it, Mister, after so many exclamations of love, of services, and of fidelity, you've had so little of it for the French and for me? Why lay siege to a city where little Nichon is? The desire to take her by force? Oh, y'know, that I've never refused you entry [*entrée*]; I've never fortified the Square against your advances. And if you had had some munitions to make only one discharge, you merely had to train your cannon on a prominence near the moat.[125]

Granted, the bathetic conflation of military and sexual conquest was not innovative. Here, however, it was used to describe an unnecessary recourse to force, where wooing or money would have sufficed. By resorting to forced entry upon an unfortified object, not the welcome triumphal *entrée*, Condé revealed his impotence.

 * * *

A pictorial syntax based on sexual distinctions seems self-evident in classical representation because of its subsequent use by Poussin's emulators. It is as hard to imagine the structural opposition of active men and expressive women in David's *Oath of the Horatii* without Poussin's compositions as it is to imagine antiquity in French culture without Poussin. However, the successful naturalization of gender in painting after Poussin should not make us neglect the specific historical conditions and discourses in which the *Coriolanus* originally participated. Nor should the subsequent use of such a gendered typology in painting closely associated with state power make us collapse historical difference. Indeed, the fact that *Coriolanus* belonged to the specific culture and circumstances of the Fronde is attested by its differences from a painting executed by one of Poussin's followers in 1661, the year Louis XIV assumed personal rule.

In *The Tent of Darius* (fig. 58), Charles Le Brun's presentation piece for Louis XIV, the conqueror Alexander is assessed by his newly subjugated people, the Persians. The countenance of Alexander becomes a hermeneutic object that is not merely a problem of mistaken identification (which of the two entering conquerors is Alexander?), but rather the source of extreme anxiety for its represented audience. The responses of the women register their fear. They do not comprehend the behavior of the conqueror. To what violence will they be subjected? Will this conqueror behave in the accustomed manner, sexually appropriating the conquered, sending them off as slaves? In order to represent the unexpected benevolence, terror must be represented in the gestures of the women. Magnanimity is recovered only after the viewer is held hostage to the potential violence.

For Le Brun, the twin poles of terror and magnanimity served the purposes of Louis XIV. Power was represented in a sexual discourse: the expressive female face and responsive gesture bore the burden of signifying the representation of violence and physical coercion withheld. Alexander/Louis Bourbon triumphed through the simultaneous production of terror and magnanimity. The monarch was thereby instated as the site of masculine power and the female was the responsive and dependent satellite, personifying all royal subjects.

In Poussin's painting, however, the poles of action and reaction are reversed. Coriolanus's checked brutality is merely reactive like the women in the tent of Darius. The painting privileges the active gestures of female entreaty. As in Le Brun's painting, the women before Coriolanus display a variety of poses and expressions, but not as a responsive chorus:

58. Charles Le Brun, *The Tent of Darius*, 1661, oil on canvas (Paris, Châteaux de Versailles et de Trianon, MV 6165) 3060 × 4600 mm.

one woman kneels, entreating with extended arms, while another gestures toward Roma. A woman elevates a baby and the mother of Coriolanus speaks. The compressed movement from obeisance to rhetorical gesture and from display to demonstration forcefully commands the moral and ethical stage of action. Coriolanus cannot be offered as an unblemished sign of magnanimity because he does not act. Nor can he command the composition. Pictorial interest is organized around the tension between the variegated movements of the women and the compressed depth of the plane they occupy. Coriolanus garners interest only insofar as his arrested posture, capitulating to the compression of depth, may be read as the tragic consequence of his intransigence. If the painting is likened to one of the remonstrances addressed to the monarch demanding an end to brutal siege warfare, it similarly admitted the limits of speech and made its appeal through gesture:

> Neither words nor voice, nor even the unstudied accents of desolate France strike the ears of your Majesty any more. It is her tears, her suffering, her blood brought before your eyes, that have joined forces to fight this strict resolution to afflict the city of Paris with sacking and the disorder of Siege . . . This is the greatest beauty of the Kingdom . . . that kneels at your Majesty's feet, in order to implore the protection of your hand . . . These are the cloistered and the virgins . . . who beg pity.[126]

Le Brun's representation of magnanimity in 1661 marked his allegiance to the political and artistic culture exemplified by Poussin's Coriolanus and the *mazarinades*. However, Le Brun disavowed that culture's capacities for political transformation. Between 1648 and 1652, the production and reception of antique referents, whether in pamphlets or paintings, helped constitute a group identity for those who served the monarchy but resisted the regime in power. The handling of these materials by the *noblesse de robe* and the resulting patterns of sociability provided the tools for excluding Mazarin from political power. The next chapter will discuss how the mishandling of culture became a criterion for political illegitimacy.

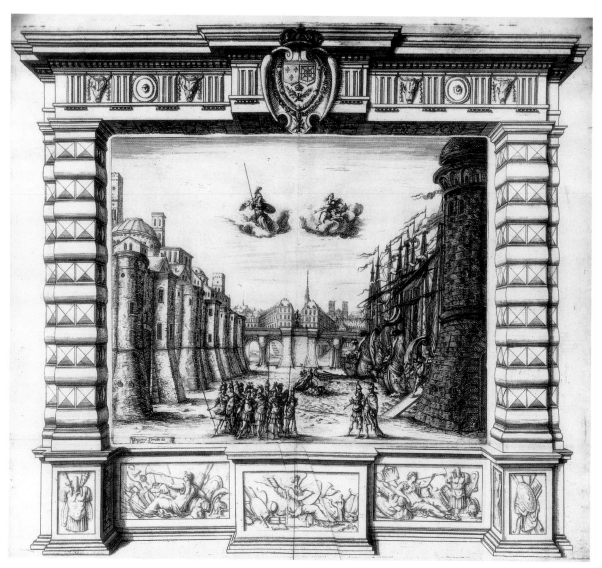

59. N. Cochin after Jacomo Torelli, "The Harbor at Scio", from the opera *La Finta pazza*, Paris, 1645, illustration to the libretto, *Feste Theatrali per la finta pazza drama del Sigr. Giulio Strozzi. Rappresantate nel piccolo Borbone in Parigi quest anno MDCXLV* (Cambridge, Mass., Houghton Library, Harvard University).

Chapter Seven

Frondeurs and Artistic Discourse

Who does not know at what cost he has had opera singers brought from Italy to France, among whom was an infamous female that [Mazarin] had debauched in Rome, and through the pimping of her, he insinuated himself into the good graces of Cardinal Antonio? All this during the war, when the people were forced to contribute to the upkeep of the armies, and the blood of the poor was used to make Cardinal Mazarin laugh, to the satisfaction of his desires.[1]

The writer of this famous *mazarinade* refers to Mazarin's importation of Antonio Barberini's Roman opera company, including the diva Anna Francesca Costa. Courtly decadence, prostitution, and musical spectacle proved to be among the major images in political discourse during the Fronde. Mazarin was not only blamed for the immigration of morally suspect foreigners, prostitutes and castrati, but he was also accused of supporting extravagant theatrical productions in order to extend his malevolent influence over a larger audience. Numerous *mazarinades* attacked him for his excessive disposal of money on gaudy spectacle. In one, Henry IV, the pragmatic patron of civic architecture, spoke through his statue on the Pont-Neuf and criticized Mazarin's enormous, frivolous expenditures on *fêtes*, ballets, and theatrical "machines."[2] These extravagant productions were compared to the circuses of decadent imperial Rome and the conspicuously wasteful expenditures of Sejanus.[3] In particular, Mazarin's spectacular 1647 production in Paris of Francesco Buti and Luigi Rossi's opera *Orféo* was so criticized that the crown was compelled to repress satires and imprison critics.[4]

For some, the operatic spectacles that lasted into the early morning at the Palais Royal were tedious despite the extravagant "machines" designed by Torelli.[5] Others measured the cardinal's excessive expenditure of the "people's money" against the hardships endured by the French.[6] While war was driving the royal finances into the ground, costly stagings enacted a fully fledged siege and attack on a city. Critics were incensed not only by the bread-and-circuses diversionary ploy of the foreign minister but also by the transparent hypocrisy of his erotic pastoral. How outrageous that an opera's brochure professed "that those who perfectly love virtue must detach themselves entirely from the pleasures of this world, awaiting compensation in the hereafter."[7] In the eyes of disgruntled Parisians, Mazarin hardly deserved compensation in the afterlife; he was wastefully indulging himself at the expense of the French people.[8]

The Italian machines that permitted quick scene changes made a vivid contrast with the imagery and techniques of a traditional form of political spectacle, the *entrée*. In Torelli's initial attempt to adapt his fantastic props from a Venetian production for the Parisian stage, a flattering acknowledgment of his royal host in one of the scene changes

resulted in a ludicrous symbolic remapping of the Bourbon topography: the facade of the Louvre and the statue of Henry IV on the Pont-Neuf only served as incidental backdrops for the Italian comedians, who were in turn upstaged by a ballet danced by four eunuchs, four bears, and four monkeys (fig. 59).[9] Clearly, Mazarin's indecorous revision of the Grande Galerie was a gross miscalculation. As this chapter will show, Mazarin's interventions in visual culture, from operatic scenography to the collecting of pictures, subjected him to charges of political illegitimacy. Legitimate cultural practices were in turn offered as counter-proposals.

During the Fronde, the memory of Torelli's brand of spectacle continued to be interpreted by Mazarin's critics as an affront to indigenous cultural forms and French humanist values. One *mazarinade* described a mock triumphal entry designed by Torelli in order to punctuate the cardinal's ill-fated siege of Cambray. According to the author, French triumphal imagery was perverted by Italian mechanized spectacle. Torelli's triumphal arches celebrated Mazarin's sexual debauchery, greed, and tyranny. One tableau represented Mazarin/Jason and his financier argonauts dividing up the golden fleece of France. The *mazarinade* concluded with the failure of the siege; the enraged Italian cardinal ate the words and images of Torelli's handiwork. In a final Rabelasian gesture, Mazarin vomited the triumphal imagery over his German mercenaries. The image of failed siege in *Coriolanus* had its repulsive carnivalesque double in luxuriant excess.[10]

The spectacle of *Orféo* provided ample opportunities for undermining the legitimacy of the regency. The attacks were not restricted to sumptuary criticism, in which the gaudy splash of wasted resources provided a backdrop for sexual and xenophobic anxieties. The perceived sexual threat to the queen mother and the dauphin by the "Sicilian sodomite" Mazarin was aggravated by his deployment of the operatic resources of the Barberini when Francesco and his brother Antonio had retreated to Paris after the death of Urban VIII.[11] While the librettist Buti and the composer Rossi were part of Antonio's household, Mazarin's chief prize in his effort to import Roman spectacle into Paris was the appearance of another member of the Barberini court in exile: the famous castrato Marc-Antonio Pasqualini. Antonio Barberini's favorite had been the subject of much gossip in Rome.[12] Playing both male and female roles in Roman sacred operas, Pasqualini was one of the castrated singers who were accused of passive sodomitical behavior or, alternatively, recalcitrant sexual potency. For French nationals in the papal city, the anxiety produced by the sexually ambivalent status of the neutered males manifested itself in public slander and fistfights.[13] Already subject in Paris to xenophobic constructions of sodomy ("la mode d'Italie" and Sejanus), Mazarin was further identified with illicit sexuality because of his patronage of the *castrati*.[14]

The French reacted violently to the appearance of the castrati in the production of *Orféo*. Cyrano de Bergerac compared their choreography to Marc-Antonio Raimondi's *Modi*, a collection of sexual positions set to Aretino's sonnets.[15] Indeed, the cast provided some uncomfortable juxtapositions of sexual identities for its Parisian audience. The lead role of Orpheus was played by the castrato Atto Melani. Pasqualini played Aristée, the son of Bacchus, who competed with Orpheus for Eurydice, played by Anna Francesca Costa, the only woman in the performance. The troop also included an aging castrato who played an old nurse, as well as three castrated "putti," who were thirteen to fourteen years old.[16] French audiences, unaccustomed to the recitative compositions and the pitch of the singers, witnessed a burlesque spectacle sometimes tragic and at other times confusing. In one scene, Pasqualini lamented with his piercing voice his unrequited love:

> To arms, my heart
> And against the hard

> miserly beauty
> Your force is deployed.[17]

The bathos of the bellicose metaphor for lovesickness is vulgarly emphasized by the sudden arrival of a clowning satyr and mime who accompanied the pining castrato with the vocalized sounds of trumpet and drum: "Tarara, Tappata." Pasqualini's song quickly deteriorated into onomatopoeic banter:

> Sù dunque sù, sù
> Guerra, guerra, ah, ah, ah!
> Serra, Serra.[18]

The verbal wit of Boti's satirical play on the conventions of romance was no doubt wasted on the French audience. They were more distracted by the mechanized entrances of Venus and flying castrati.[19]

Mazarin's patronage of Antonio Barberini's cast of castrati unleashed a torrent of homophobic anti-courtier discourse. The "bougre bouffon" Mazarin was the product of a system of patronage based on pederastic initiation inherited from antiquity.[20] As I have shown, Sejanus was conjured as a parallel to Mazarin in order to give a classical pedigree to the attacks upon the cardinal's perversion of patron–client relations. Like Sejanus, who as a boy was the favorite of a wealthy libertine and consented to "exécrables voluptez," Mazarin had been put in the service of Antonio Barberini, for whom he was "the administrator of some pleasures which are not strictly polite to say."[21] According to Cyrano's pamphlet, Mazarin's initiation to Sodom allowed him to become a participant and panderer:

> This abominable love that seeks only children . . . had been one of the first occupations of his life; he knew this vice when he was scarcely able to name it, and abandoned himself to it at an age that for most others is an age of innocence. In a business for which the laws have found fire to be the least punishment, he has since put the fable of Tiresias to the test, putting all abominations into practice. And in this way (the thought causes one to tremble) he was long the husband of those [men] for whom he had been the wife. This horrible gallantry brought him to several persons for whom he acted as both object and minister of outrageous voluptuousness, [as both] gallant and mistress; he then became their pimp, and was forced by all the favors [*brigues*] he received to procure for them that which he could no longer personally offer for sale. He was quite happy in this scandalous trade, he picked some fruit for himself from this embassy.[22]

Cyrano collapses pederasty, merchandise, diplomacy, venality, and sexual inversions. Sexual indeterminacy was symptomatic of the perverse social and political practices of the *parvenu* and the *financier*. Like Tiresias, Mazarin was put in the unique position of alternately playing the roles of both man and woman. Initiated as a boy when others experienced an "age of innocence," the cardinal in turn became a sodomite. Minister of outrageous pleasures, horrible *galante*, his commerce in sex allowed him to pluck the fruit of his labors, abandoning himself to pandering and pederasty. One pamphleteer had alluded to a pimping of "une infame," perhaps referring to the alleged prostitute playing Eurydice, but Cyrano made his denunciation of pederastic commerce explicit. The court was a world turned upside down, a copious and perverse pastoral. The series of reversals collapsed antiquity and the present. Sejanus and Tiresias were called forth to reveal the palimpsest of sodomitical and pederastic practices of ancient and modern Rome, imperium and the late pope's nephews (it is ironic that the collector of Poussin's *Death of Germanicus* became implicated in anti-imperial imagery). Antiquity provided a commentary

for France's worst unspoken fears: Louis XIV would be initiated by his foreign pederastic pedagogue and not only become a "bottom" for a "top" but also, as in the case of Henry III, be led away from procreation. By repeating antiquity and recent French history, the Bourbons had placed their lineage at risk.

The political pamphleteer was articulating the French humanist's contradictory attraction and revulsion toward antiquity. As Montaigne wrote in his essay on vanity, Rome contained and contains each political state, every fortune and misfortune, the desired republic and the repulsive tyranny.[23] Sexual identities, like political formations, were similarly juxtaposed or conflated in unseemly ways like a monstrous archeology.

Failed Patronage

The xenophobic criticism of Mazarin's presumed pederastic commerce and imported spectacular culture underlined a fundamental failure in political client–patron relations. The minister's consistent pattern of commissioning works by Italians, such as Torelli's *Orféo*, offered evidence that he was a foreigner whose chauvinism was diametrically opposed to the interests of France. Whereas legal bodies pointed out the interdiction of foreigners from royal office, cultural critics lambasted the monopolization of official artistic commissions by those not born in France. In *L'Enfer burlesque* of 1649 the author quoted a popular song of the time to underscore the nepotism and exclusionary practices of the cardinal: "If you are not Italian/ You will never see Orpheus."[24] Mazarin's inadequate patronage of French artists, historians, poets, and playwrights was symptomatic of his general failure to foster French political supporters.[25] Prefatory dedications to the cardinal in books by French literati fell on deaf ears. After the production of *Orféo* met with criticism, Corneille was hired to translate the libretto into French. The French playwright received only 2004 livres while Torelli was paid more than thirteen thousand for merely converting the sets for the new opera.[26] Pamphlets assailed the cardinal by denouncing the disparity between the vast sums received by the mechanic Torelli and the paltry support of French *gens de lettres*.

The debacle of *Orféo* was emblematic of Mazarin's failure to support French culture. Numerous French writers sought his patronage and were rejected. Disenfranchised, they turned against the first minister and sought patronage from opposition factions. The writers spoke for the lost opportunities of an entire generation of educated people who emulated the ideals born of French humanism's integration with the state during the reign of Henry IV.[27] The writers who lashed out at Mazarin form a notable list, some of whom were known to Poussin.[28] Paul Scarron, friend of Chantelou and client of Poussin, when snubbed by Mazarin turned his pen on him and invented the term "mazarinade" in the vitriolic and pornographic poem of that name.[29] Harnessing the anxiety of sexual inversion manifested in the *Orféo* criticism, Scarron libeled Mazarin as "Homme aux femmes, & femme aux hommes" whose sexual incontinence resulted in treasonous buggery: "Buggerer, both large & little,/ Buggerer, sodomizing the State."[30] In a later poem, "Epître chagrine" (1652), Scarron lamented the failure of Mazarin's patronage:

> The poor courtiers of the Muses
> Today are treated like imbeciles
> While in the past the late Richelieu
> Treated them like demigods.[31]

The writers, playwrights, and poets under the patronage of Richelieu, like their counterparts in the sixteenth century, enjoyed royal protection unavailable to Scarron's contemporaries: Pierre Corneille, Tristan l'Hermite, Saint Amant, and a significant list of other authors.[32] Saint Amant, who praised Poussin as the "king of painting" (rather than "painter of the king"), sought protection from one of Mazarin's adversaries and wrote *frondeur* verse.[33] A writer of an entirely different ilk, the Jansenist Arnauld d'Andilly, was a veteran exile of Richelieu's regime, who attempted to be rehabilitated during the regency. He solicited the queen regent to become the tutor for the king, but Mazarin was appointed *surintendant de l'education du Roi*.[34] The rejection of Arnauld led to his retreat to Port-Royal and resulted in two *mazarinades*. As in Sublet's reference to himself as a figure in disgrace, Arnauld signed one attack on Mazarin with the *nom de guerre* "le Solitaire," dated "du Désert."[35] Marin le Roy, Sieur de Gomberville, who also sought the same royal tutorial post, displayed his fluency in the cultural currency of the *robe* nobility by publishing a book on the education of the king, the *Doctrine des moeurs*. After this failed attempt to garner support, Gomberville became known as a "grand frondeur."[36] The historian Vulson de la Colombière was an educated and poor *gentilhomme* from Dauphiné who attempted to garner support from Mazarin by publishing a dedication to him in his lavish production of *Le Vrai théâtre d'honneur et de chevalrie* (1648). When he failed to obtain Mazarin's support, Vulson reviled him in a series of severe but reasoned pamphlets.[37] Others who had enjoyed the patronage of Sublet de Noyers's administration, left France for lack of patronage. Raphael Trichet du Fresne, who was responsible for the royal press and probably one of Poussin's clients, sought support from Christine of Sweden, as did Gabriel Naudé, Mazarin's devoted librarian and publicist.[38] Even before Naudé published his long apology for Mazarin in response to the *mazarinades*, the *Mascurat*, the librarian candidly complained to his friend Guy Patin of the avarice of his master and caused the correspondent to reflect on the neglect of yet another *honneste homme*.[39] This short list represents a culture that perceived itself in virtual exile, cut off from participation in the state.[40] As one *mazarinade* stated, French arts and letters were subject to the violence of the minister: the nine muses became "Nine poor desolate girls/ Sad, pale, disheveled" because Mazarin was a large ugly beast without a brain.[41]

Money for French visual artists was similarly scarce: Mazarin filled his palace in Paris with paintings acquired in Rome and had his gallery decorated by Pietro da Cortona's follower Romanelli.[42] The minister's support of an Italian opera impresario and a Roman ceiling painter was indicative of the disruption of the lines of patronage, political as well as cultural, that had formerly secured Richelieu's power.[43]

A pamphlet entitled *The Spirit of the Late Louis XIII to his Son Louis XIV* enlisted the Plutarchian tradition of parallel portraits to underscore Mazarin's failure to support French artists as well as literati.[44] In a set of parallels, the voice of the dead king is critical of both Richelieu and Mazarin as he gives advice to his son. Like Mazarin, Richelieu was accused of exacting money from the French in order to engorge his "magnificent palace" with riches. But Richelieu, like the emperor Vespasian, put the greatest part of the income to good use.[45] Unlike Mazarin, he supported native craftsmen, writers, and artists.

> Cardinal Richelieu was perfectly generous especially to gentlemen and to intellectuals, to whom Fortune showed herself to be miserly in nurturing; and Mazarin had always seemed the most treacherous and the most ungrateful of men, without having earned merit with any favor or recognition.[46]

This contrast of the two regimes and their respective relationships to merit and to the support of French talent resonates with the narrative of Sublet's exile, Poussin's own per-

ception of his country's ingratitude, and the position he represented as an exile. Some pamphlets claimed that after the death of Richelieu, poets, orators, and philosophers were incarcerated and died in hospitals for the poor: it becomes clear that the neglect of Poussin was not an isolated phenomenon.[47]

Roland Fréart's criticism of the devastation of the arts and the exile of Poussin in the *Parallèle* can be understood in the broader context of attacks against the regency (see Chapter Five). For Fréart, Poussin's art offered a foil to the degenerate state of French culture under Mazarin. The cardinal was not only a would-be Maecenas who failed French writers, he also neglected the French artistic culture exemplified by Poussin's enterprise.[48] Critics stressed that in addition to the cardinal's proclivity for Italian operatic spectacle, his inordinate desire for collectables distracted him from the French humanist culture embodied in Poussin's art. Mazarin's attraction to certain kinds of crafted objects was deemed consonant with the incontinent sexuality demonstrated in his patronage of *Orféo*. His collection, with its conspicuous absence of paintings by Poussin, served as a rallying point for the *frondeurs*.

Suspect Collections

Antagonism toward Mazarin's collecting practices was voiced in the first years of the 1640s by Poussin and the circle of Sublet de Noyers. Poussin's acquisition of antique originals and casts was impeded by Mazarin's agents. While the artist acted on behalf of the monarchy to obtain antiquities, Mazarin purportedly made two major private acquisitions by hiding them from the crown's view.[49] He was therefore accused of directly competing with the Grande Galerie project by Poussin's supporters and by the painter himself, who attacked the cardinal's display of Roman sculptures. In a letter, Poussin urged care in the acquisition and conservation of casts after the antique, such as the Farnese Hercules, in order to avoid making another heap of broken sculptures like those thrown into the open sewer in the courtyard of the Palais Mazarin.[50] Mazarin's alleged secretive hoarding and negligent treatment of ancient art were antithetical to the conception of a disinterested community constituted by the free circulation of drawings, artifacts, and books concerning antiquity.

During the Fronde, the hostility toward the regency's cultural failings can be measured by the voluminous attacks specifically against Mazarin's collection of art and the methods by which he obtained it. After his flight from Paris, which inaugurated the siege (January–February 1649), the cardinal was declared a public enemy by the Parlement. The Palais Mazarin was seized and the furnishings inventoried and confiscated.[51] After some months, a treaty was negotiated. Mazarin returned to Paris and retrieved his possessions. But when he was exiled a second time, in 1651, his property was seized once again by the Parlement and auctioned to underwrite the reward for his capture.[52]

Of course, as I have shown, criticism of the cardinal's conspicuous wealth and expenditure on luxury was a mainstay of attacks on the government's abuse of an impoverished people burdened by taxes. Rumors of accumulated wealth and hidden treasure led to the spontaneous pillaging of a house said to be holding the cache, even a ludicrous search for coins in fish.[53] But rumors also inspired more legitimate forms of political expression, such as the remonstrances of the nobility that complained of the deterioration of sumptuary laws and the resulting loss of gold to foreign countries.[54] Or, one of the *mazarinades* that purported to be Mazarin's testament juxtaposed the 30,000 hospitals direly needed for

those impoverished by the cardinal's economic policies to the queen's inheritance of a priceless ruby and giant oriental pearls.[55] Still others blamed the deterioration of fortifications along France's borders (including those built by Sublet) on the siphoning of state funds for theaters, galleries, and *cabinets des curiosités*. In this instance, collecting art was elided with spectacle and the tawdry jewelry worn by the wives of the financiers.[56]

Among the most virulent attacks on the legitimacy of Mazarin's ministry were those that criticized his personal collecting activities. Several *mazarinades* pointed to the cardinal's accumulation of diamonds and other precious stones, furniture, sculpture, and paintings. These *libelles* represent part of the social criticism that anticipated and followed the legal seizure and sale of the contents of the Palais Mazarin.[57] Rather than following the insurrectionary pattern of spontaneous looting and destruction, it was entirely characteristic of the *parlementaires* to turn to due process and the notary's inventory as a means of legitimizing the confiscation of the cardinal's property.[58] The actual cataloguing of Mazarin's collection provided the pamphlet writers with a vehicle for organizing criticism of the quality of objects displayed by the cardinal. One *mazarinade*, yet another pretending to be the last testament of the cardinal, bequeathed the excessive collection of jewels and gems mentioned in scores of pamphlets. Special attention was given to the cardinal's art collection. The pseudo-notary set aside a specific inventory of the paintings housed in "la Galanterie" (otherwise called the Venereal Palace). He noted a gallery named after Aretino's famous series of sexual positions; then he inscribed on his fictitious list a painting of the *Rape of the Sabines*. In Mazarin's gallery, the foundational myth of Rome became confused with pornography. Other paintings followed: the loves of Venus and of Cypris, the judgment of Paris, the abduction of Helen, the loves of Mark Anthony and Cleopatra, and the infamous promiscuity of Valeria Messalina. The most notable European artists were compromised by the venereal tone of the collection. More paintings revealed the homoerotic (even pederastic) desires of the collector: an entire cabinet of paintings was devoted to nudes, with at least as many men as women and as many boys as girls.[59] The pamphleteer laid emphasis on the patterns of selection that revealed the cardinal's prurient desires.

Another *mazarinade*, the *Inventaire des merveilles du monde rencontrées dans le palais du Cardinal Mazarin* (*Inventory of the Marvels of the World Encountered in Cardinal Mazarin's Palace*), stands out as the most complete description of Mazarin's collection that served to criticize the man and his aesthetic decisions.[60] This fictional inventory, like its official counterpart, offered a calculated written interpretation of the collection and a justification for its dispersal. It begins by arguing that beauty attracts the admiration and affection of humanity. But the author quickly outlined the risks of such an attraction. The artifice of the painter "allures the curious more than the subtleties and arguments of philosophers." Perceptual seduction and the snaring "charms of love" have a greater power over humanity than the school of the divine Plato. The inventory therefore does not catalogue a series of dismissed objects but rather argues for the efficacy of the collection to seduce.

The ambulatory guide identifies an object, a figure or table, which provides the opportunity for an excursus on the represented mythological imagery. But the opportunity is missed. Instead, each sentence slips into a description of the object's precious stone or other costly material. Even craftsmanship is ignored. The object's masterful carving, its bold conception, or subtle technical effects are not wrought into words. In its place, the viewer succumbs to sensation: "The variety of colors makes varied impressions upon the beholders and the pleasurable confusion of its richness confounds their sight and their minds."[61] Reason and distinct categories are supplanted by confusion. The direct com-

munication of thought through rhetoric is refracted by variety, variability, and indeterminacy. The object threatens to confound the viewer. This agreeable appeal to the senses results in confusion and our judgments falter. The integrity of a rational self is threatened by incoherence and dissolution before the seductive power of these myriad pigments and precious materials.[62]

The text's wandering eye does not rest in its search for further pleasure. We fly past rooms of sculptures that only catch our attention by their extraordinary expense (2,000 *écus* for one). The eye hesitates. Two ebony cabinets become the object of a quasi-sexual desire: black mirroring surfaces yield to our glances, encouraging complete access to every surface, revealing all their secrets.[63] The eye effortlessly pursues more surfaces, encrusted frames, rather than pictures of significant import. These luxury items do not represent moral exempla but only inspire the desire for other people's property. They ask to be stolen.

The reader passes with the guide into another room where antique statues are displayed. Instead of encouraging our contemplation of classical topoi and heroic bodies, our considerations are arrested by yet another marble table with inlaid flowers. We then move to more precious materials. The cardinal's famous collection of gems completely arrests our attention. The visual charm of jewels and the luster of diamonds eclipse the visible splendor of the palace of the Louvre and thereby blind the spectator to the monarchical state and the felicity of its people. Mazarin's luxury was a demonstration of his hubris.[64] If the contemporary architectural and monarchical institutions are overshadowed by ostentatious wealth, so too are the exemplary figures in history. Alexander, the conqueror often identified with the force of French kings in the royal entry, is merely porphyry in Mazarin's private chambers. The ancient hero is reduced to finery, delicacy, and preciousness.[65]

In the final passage, there is a shift in the tone of our guide. The author tagged on a moral that comments on the dangerous potential of *curiosité* to seduce a viewing public. The reader has temporarily risked seduction only to demonstrate the improper advances of Mazarin's art. The spectacular luxury of Mazarin and his financiers is dangerous because it can turn political subjects into spectators in search of sensual gratification. The narrative of the *Inventaire*'s guided tour was a trap set for an interested public. By appealing to the intended audience's attraction to art, the inventory enacted the overpowering persuasiveness of sensory delight. In order to demonstrate the corrupting powers of that which it condemned, the text strategically seduced the reader through its digressions. That is to say, the description of the objects was intended to induce the kind of debauched experience sought by Mazarin. Only at the end of the piece could the reader recoup a subjectivity appropriate to proper political conduct.

Other pamphlets concur: Mazarin's cabinet was compared to a palladium of Venus, an antique brothel, infested by perfumed slaves.[66] In another, Mazarin's financier lackeys "Seduce their spectators/ By the brilliance of their license/ At our expense/ They put disorder in our senses."[67] The *Inventaire* argues that this power of material objects over vision is politically dangerous because "the desire to see these beauties has made men scornful of all that is dear to them. It has forced them to commit their life to seachange and chance. Curiosity gave them contempt for their country [*pays*] and love for the Barbarians."[68] The foreign art in Mazarin's collection subjected the political order to chance, anti-patriotic sentiment and foreign infection (we are reminded of the discourse against *aubains*). Mazarin's desire for Italian furnishings, paintings, and knick-knacks opened the door to barbarity.[69]

This perverse love of visual objects, *curiosité*, by *les curieux* had potentially pejorative connotations in the seventeenth century.[70] Unqualified *curiosité* was understood as the

obsessional amassing of objects without any apparent systematic epistemological or aesthetic differentiation. For example, in *Les Caractères* (1691), La Bruyère gives the following definition: "Curiosity is not a love for that which is good or beautiful, but for that which is rare, unique, for that which one has, and that which others have not."[71] A contemporary writer, Brienne, who sought and purchased paintings by Poussin, described Mazarin in similar terms: "He was curious, yet without being well versed in beautiful things."[72] The *Inventaire* similarly defined *curiosité* in terms of rarity and pleasure, singularity and accumulation, rather than judgment, selection, organization, and circulation. Significantly, *curiosité* was also deemed antithetical to patriotism.

In numerous pamphlets, the political threat posed by Mazarin's curiosity was underlined by its association with imperial decadence.[73] Mazarin's perverse desire to collect was a negative attribute he shared with Julius Caesar, who was "the most curious in the world . . . Above all, Caesar loved jewels and gems, and all rich furnishings . . . In order to satisfy this passion, by which he was consumed (with a far greater craving than that of Caesar), Mazarin made a marvelous treasure trove for himself."[74] Mazarin was a political threat not only because he failed to be a disinterested civil servant, but also because his behavior served as a model for the dauphin. Because the minister was responsible for the education of the prince, his vanity and luxury were not mere character flaws but a danger to the nation: "[Mazarin] prostituted innocence through his luxuriant lifestyle and made its candor and majesty unholy by the disorder and malice of his conduct. Never has there been a man more attached only to the objects of the senses, nor more buried in pleasures and sensual delight."[75] Instead of a future king guided by Minerva (see fig. 51), the cardinal's mercenary character and the suffocating presence of his possessions would lead to nothing less than the corruption of the innocent prince.

Opposition to *curiosité* was not, however, an iconoclastic gesture. The negative criticism of material accumulation was understood in relation to a positive construction of the appropriate reception and appreciation of art. Mazarin's collection produced an opportunity for oppositional groups to develop their own definition of artistic patronage. In addition to the verbal harangue, the example of an appropriate gallery implicitly criticized the regency's failings as cultural patron and thereby undermined its political authority. The organization of a repertory of material objects is as capable of structuring the experience of social groups as texts. Art obtained its value through its conceptual and physical arrangement as well as the habits of speech that accompanied its display. In addition to the body of literary and historical knowledge acquired in the *collège*, a material lexicon of classical topoi, engraved portraits, and architectural forms contributed to a shared culture. The handling of archeological objects helped form a social group with a common discourse, shared protocols, and knowledge. These practices were understood as very distinct from the private collecting of precious things. The epistemological organization of paintings served as a culture counter to the accumulation of *luxe* or *curiosité*. Visual arts if made public did not have to be possessed in order to have value as objects. For example, an architectural discussion (such as Fréart's) did not entail material acquisition. Objects had the capacity to be ordered, repeated, transmitted, but did not have be owned. Similarly, a particular social group did not need to own precious art works in order to be defined by a common parlance and habits of attention to art. And as in ancient China or Renaissance Florence, the structural opposition to inappropriate visual protocols in mid-seventeenth-century France required something more productive than simple negation.

* * *

Appropriate Collections

During the 1640s, the appropriate kind of collection was set out in a history, a poem, and a series of engravings after paintings. Tristan l'Hermite and François Blanchard's *Eloges de tous les premiers présidents du parlement de Paris* (1645) recognized the collecting of art as a learned activity distinct from the accumulation of wealth. The verbal portrait of President Nicolas de Verdun (d. 1624) suggests the cultural preoccupations of a skillful orator, who could recall a range of citations from Greek authors with great facility to give his "doctes harangues" an authoritative texture.[76] This cultivation of knowledge was consistent with his collecting practices:

> Study was his ordinary occupation and the source of his greatest delight; thus he cherished only those who shared his activity. Never did the desire to accumulate [*amasser*] a fortune enter his mind, solely contenting himself with collecting [*assembler*] some excellent paintings and in particular some good books in order to be diverted by his innocent pleasures when he had some leisure.[77]

Thus, amassing riches is contrasted with assembling texts and pictures. The ownership of paintings and books is only valuable insofar as it facilitates the innocent pleasures of well-regulated *otium*.

A comparable set of visual and verbal practices was found in a poem of 1648 that praised a painting by Poussin within a collection: Tristan l'Hermite published a sonnet at the onset of the Fronde that addressed the notion of an appropriate collection. In the lodgings of his hermitage on the humble fifth floor the reader is invited to find "Paintings that are looked upon with astonishment/ Where savant brushes marked their excellence." In the poet's melancholic retreat, we find a painting by Poussin. Under the eaves of a rented flat, Tristan retires in the fashion of Montaigne, reading the actions of the wise ancients living in the histories. The paintings are not mixed with "rich tapestry, silk, and embroidery."[78] Instead, his austere digs are furnished with books that evoke for the poet the vivid verbal images of his companions Virgil, Horace, Lucian, Aristotle, Tasso, and Petrarch. The ten carefully selected tableaux in Tristan's collection are framed by his vivid verse portraits of these authors.

Tristan performed the paintings in poetry and embedded them in a humanist's setting. The poet invited the *homme de mérite* (Sébastian Bourdon, the follower of Poussin and founding member of the Académie) to see his paintings. In order to define the terms of the discourse suitable for his collection, he warned against the typical practice of "les gens du Cabinet" who only spoke *Lansquenet*. The term signified the argot of foreign card games, the accompanying idle gossip; here it metaphorically suggested gibberish or prattle as well as a frivolous pastime. (It should be noted that Mazarin was famous for inventing a card game that became a common target of derision in the *mazarinades*.) In contrast, conversation in Tristan's cabinet was restricted to "political topics." Poussin's painting belonged to a set of practices understood in contradistinction to *curiosité*. In the year of the barricades, painting was inflected by politics in a retreat on the upper floor.

As a final example, take Vulson de la Colombière's virulent *mazarinade* attacking any foreigner who occupied an office in the French state.[79] In 1649, having failed to secure patronage from Mazarin, Vulson published his rebuttal: "Foreigners introduce the mores and vices of their countries."[80] He argued (basing himself on Tacitus) that the instruction of the king in foreign cultural practices would lead to his downfall.[81] As a counterproposal to Mazarin's visual culture, Vulson dedicated a publication of the following year to Richelieu's gallery of historical portraits in the former Palais Cardinal, *Les Portraits des hommes illustres françois (Portraits of Illustrious Frenchmen).*[82] The series of engravings with accompanying text was a demonstration of an exemplary relationship to paintings. French

notables from Henry IV to Gaston d'Orléans, Abbé Suger to Gaucher de Châtillon, were virtuous company for the disenfranchised royal servant (fig. 60; see fig. 11). A writer of *mazarinades* selectively appropriated Richelieu's legacy in the midst of the Fronde. The later publication of the series of exemplary figures painted by French artists was enframed by the politics of the moment: the pedagogical and exemplary function of art that had belonged to the previous regime was left fallow by the regency; the engraved series was meant to meet the ongoing demands of *robe* culture.

Criticisms of Mazarin's cultural and political behavior led him to initiate reforms in order to recuperate some authority. A few months before the onset of the Fronde, Gabriel Naudé reported that Mazarin was acquiring paintings in Rome for the galleries of the Louvre, not his private collection.[83] As Mazarin's librarian, Naudé certainly knew what was needed in order to respond to the criticism. Naudé was also probably responsible for the opening of Mazarin's library to scholars at the height of the attacks against the cardinal, thereby asserting that the first minister recognized the *bien public*.[84] He publicly defended Mazarin's collection of art: "All the beautiful statues and all these excellent paintings" that Mazarin had shipped from Rome spared young French artists the inconveniences of the long voyage to Italy that was otherwise necessary for the perfection of

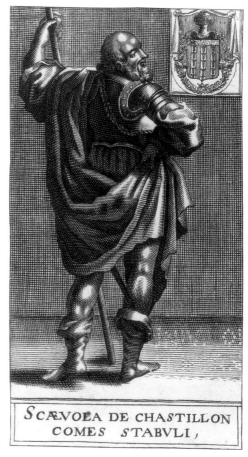

SCÆVOLA DE CHASTILLON COMES STABVLI,

60. Heince, Zacharie, and Bignon after Simon Vouet, *Portrait of Gaucher de Châtillon* (Paris, Musé du Louvre), engraving from *Les Portraits des hommes illustres*, 1650/1668 (Berkeley, The Bancroft Library, University of California).

their art.[85] It was he who converted the object of criticism, the private and foreign collection, into a pedagogical and patriotic institution. The regency attempted to dispel the criticism of Mazarin's *curiosité* and corrupting influence on the young king by incorporating exemplary art within an image of the regency guiding Louis XIV (see fig. 51). A colonnaded gallery of tableaux, presumably the cartoons for Raphael's *Acts of the Apostles*, provided a prestigious and edifying backdrop for pupil and pedagogue.[86]

The image of Mazarin standing in front of monumental paintings representative of the cultural ambitions of Poussin's clientele betrays an attempt by the cardinal to assimilate his artistic protocols to those persons who were by no means *curieux*. This circle did not belong to the financier class, nor did they tend to have collections to match the scale of Mazarin's. In general, they seem to have specialized in Poussin's tableaux and some may not have collected art at all except paintings by him. Poussin's clients were not therefore subject to criticism as consumers of luxury goods. In the case of a significant art collector such as Michel Passart, his collecting was understood as a counter-demonstration to Mazarin's example. Passart was highly selective in his acquisition of artworks by Italian artists – his inventory included Annibale Carracci and Domenichino (with whom Poussin had great sympathy).[87] Significantly, no gems were listed. Tapestries were restricted to

some biblical subjects and among the paintings there was a preponderance of landscapes. As I suggested earlier, the presence of the *Continence of Scipio* and the *Camillus* in Passart's *Grand cabinet* strongly identified him with the *noblesse de robe*. The acquisition of the *Scipio* (as early as the 1640s) underscored the fact that conversations around these paintings were weighted by politics. One other painting in Passart's possession that hung in the same room provided a commentary on the conceptual framework of the collection as a whole and directed conversation.[88]

The Orion *Landscape: Collecting Thematized*

Poussin's painting of blind Orion led by Cedalian toward the healing sun (fig. 61) is a simulation of an antique prototype described by Lucian in the house of an exemplary Roman collection.[89] In the ekphrasis of the ancient gallery, known as "The Hall," Lucian praised the placement of a wall painting of Orion next to a marble Athena, a painted rape of Athena, and a painting of Odysseus feigning madness. The Greek writer's description is not an ekphrasis of an individual work, as in Pliny's praise of artists. Instead, he was drawn to praising the collector and the assemblage of anonymous works. The emphasis on a programmatic display of works can be related, therefore, to Annibale Carracci's selection of themes from descriptions of antique paintings for the Farnese Gallery. As in Carracci's imaginative construction of an antique gallery, Passart's inclusion of the antique theme based on a lost ancient composition inflected the meaning and purpose of Poussin's other works.[90] The painting was less a reconstruction of a lost antique painting than an invocation of the verbal and physical context of its display. Poussin and his collector were drawing upon the antique precedent as a model for a seventeenth-century art collection and its accompanying protocols to inflect Passart's organized display of paintings.

The landscape was understood as a commentary on the function of collections and the obligation put upon the viewer to gloss the art object with speech. Importantly, the speaker Lucian opposed the painting of Diana and Orion to the stupefaction produced by an astounding building, a collection of wonders, and the fabled king's golden plane tree: "There was no craftsmanship or beauty or charm or symmetry or grace wrought into the gold or combined with it. The thing was barbarous, nothing but money, a source of envy to those who saw it, and of felicitation to those who owned it."[91] Indeed, "the barbarians are not beauty-lovers; they are money-lovers." The hall or gallery described by Lucian distinguishes the visual protocols of its intended viewers from the barbarous sensate practices of a corrupt elite audience seduced by the king's artificial tree. Unlike the dumbstruck viewer with his craning neck and awkward gesticulations toward paintings, the man of culture does not "harvest [the painting's] charm with his eyes alone."[92] In contrast to the excluded barbarian, the cultured man applied language to what he saw. Speech required the faculties of the mind and an ordered body.

Poussin's painting of Orion demanded the thought processes of a responsive speaker. The peculiar composition, with the radical disjunction of scale between colossal figure and attendant deities, at once declared pictorial archaism and literary erudition as impediments to an easily digested affective response. The viewer in Passart's picture cabinet was asked to repeat Lucian's performance. Poussin's use of Lucian to thematize the bridling of sensation by rhetoric was not original. As Elizabeth Cropper has pointed out, Lucian's oration had found readers among Roman classicists.[93] By shifting the object of that research for a particular viewing practice to Passart's cabinet, however, the painting became inflected by contemporary contention over reception in France. During the period of the Fronde, the

61. Poussin, *Landscape with Diana and Orion*, 1658, oil on canvas (New York, The Metropolitan Museum of Art, Fletcher Fund, 1924. 24.45.1), 1191 × 1829 mm.

social distinctions between viewers had a decidedly political valence. Lucian's opposition of barbarian to cultured man, eye to mind, money to beauty were significant oppositions in the cultural and political discourse that I have been describing. Parallels could be drawn between the golden tree and Mazarin's collection. Neither object could elicit speech ("charm or symmetry or grace"), but only dumbfoundedness and awe at gaudy effects. This was the disorderly behavior of the politically disenfranchised man, the barbarian.

<p style="text-align:center">* * *</p>

I have so far emphasized that the placement of pictures was a particularly contentious political arena. Mazarin's collection of art was a target for critics of the regime and a political discourse was attentive to the effects of art on its audience. Because the inventory of Mazarin's collection was offered as a sign of his political illegitimacy, different collecting practices represented the values of a legitimate culture. A collection of Poussin's paintings such as that of Michel Passart offered such a foil.

Nevertheless, Poussin's pictures were burdened by the suspicion that art corrupts. Or rather, there was an obligation for the paintings to differentiate themselves from visual objects that did so. In other words, it was insufficient for Poussin's canvases to function as symbolic markers of his status as an irreproachable, disinterested servant of the crown. Since the portable easel picture had to insist upon its own identity as a semi-autonomous object, the thematization of appropriate collecting offered one solution. The reference to Lucian in one picture situated in a collection of Poussin's paintings insisted upon select terms and protocols of reception. Poussin's *Orion* landscape represents one instance when the artist's materials approached theory. The simulation of the ancient painting challenged contemporaneous patterns of reception. The insistence on a particular context against others made the picture look different. But it still remains to be argued how an artist in the studio responded to the accusation that painting seduces. How did a painter with a palette in hand turn a distrust of sensory effects into pictorial decisions?

62. Poussin, *Self-Portrait*, mid-1630s, red chalk on papaer (London, British Museum), 375 × 250 mm.

Reception, Style, and Drawing

The period of the Fronde was marked by a crisis in signification. How could one signify one's own integrity, truthfulness, and proper clientage relations when political loyalties were corrupted by favoritism and subject to shifting alliances? The French responded in different ways to the anxiety of dissimulation and flattery. In the café run by Poussin's acquaintance Renard, a sociability divested of formulaic niceties prevailed. Renard's relaxation of the normative codes of etiquette was part of a larger pattern of social and political behavior. "Discourtesy" is the term used by the historian Orest Ranum to describe a pervasive breakdown of social decorum in Parisian society during the Fronde, wherein discourteous behavior refuted dissimulation.[1] "Vive le Roi, Foutre Mazarin" was the Duc de Beaufort's contribution to a highly unnuanced form of political expression. In literature, Scarron, Blot, and other writers made rule-breaking into a literary form, often turning their linguistic violence against the sexuality of the regent and her favorite Mazarin. But Scarron also used burlesque to undermine his own literary pretensions, turning upon himself as an object of derision. In a dedication addressed "To the Reader who never saw me," Scarron presented a deprecating self-portrait; he transformed his anomalous features into an assault upon the decorous flattering effects of an emergent form of aristocratic social intercourse, the verbal portrait.[2] Because his spine was deformed by disease he substituted his body for "the letter Z." He produced a burlesque blazon by enumerating his individual features, playing on the conventional comparison between a loved one's smile and a precious necklace ("My teeth, once so many square Pearls, are now of the color of wood and are quickly turning slate-colored, and I have lost one and a half on the left side, and two and a half on the right, and two are a little unstrung"). Poussin participated in this form of liberty-taking by uncharacteristically turning to the idiomatic in his critical response to Scarron's burlesque verse: according to Poussin, Scarron has a round asshole and shits square turds.[3]

Poussin's use of Scarron's scatology was one cultural response to a crisis of confidence in the capacity to interpret words and actions during the Fronde. Factional politics and sycophancy were running rampant, so obscenity served as a measure of truth. But nothing could be farther from Poussin's own pictorial practice in the late 1640s. Perhaps, Scarron's phallic violence and bedpan farce bear comparison to Poussin's earlier production, such as the *Camillus and the Schoolmaster*, where a patriarchal structure based on intergenerational sexual humiliation was inverted. Scarron's self-defamatory portrait of the writer in the preface to his mock epic resembles even more closely Poussin's own self-portrait drawing from the 1630s (fig. 62). Poussin posed himself as an artisan and like Scarron drew descriptive attention to his own infirmities: a bout of illness (perhaps syphilis) had left him bedridden.[4] In each representation of the diseased self, the function is not diaristic

but addressed to a recipient for specific ends. Both bodies are marked by the disfiguration of class and disease in order to mock self-importance and profess truthfulness. Poussin's grimace was an abbreviated affront to the conventions of deferential courtesy. The inversion of etiquette, understood as a promise of directness, was registered not only in the unkempt appearance of the sitter but also in the provisional marks of red chalk and wash. It is a sanguine face cut by raking light. The deep shadow in the depression at the base of the neck is a congealed red pool. Abruptly terminated chalk cross-hatching (also signifying shadow) merges with repetitive curved lines suggesting the texture of bristling chest-hair. Coarse and disheveled cloth is made up of a conspicuously careless outline, the traces of a quick movement of the hand, sudden shifts of direction without lifting the dulled tip of the chalk from the paper. A smudged patch unabashedly reveals its source in undulating line.

These formal strategies do not sit neatly with Poussin's subsequent painting (which has led some to attribute the drawing to an unknown artist).[5] Yet, despite the apparently insurmountable distance between Poussin's early self-portrait and his later self-fashioning (see figs. 40 and 41), the art of the 1640s and early 1650s can be understood as a continuous, albeit more consistent and prolonged, project of representing legitimate and direct forms of address. But rather than scatological reversal or slumming self-articulation, other performative metaphors to signify truthfulness became available to the artist from his own body of work.

In the midst of the Fronde, when Roland Fréart de Chambray turned to the discussion of the symbolically resonant Grande Galerie in his *Parallèle*, he addressed Poussin's formal decisions with an eye to their value for a community. The decorative project did not derive its worth solely from its iconography and narrative cycles (see figs. 3–5). Fréart identified a set of values intrinsic both to the art's production and to its formal characteristics. He emphasized the arrangement of the seventy bas-reliefs derived largely from Trajan's Column:

> Monsieur le Poussin introduced [the bas-reliefs] ingeniously and with much skill and consideration, in order to conform to the demands of the design put to him, not the most magnificent or the most superb that he was able to compose, but with an ornamentation promptly executed, and with moderate expense, in keeping with the times, and the impatient humor of our nation.[6]

Published in 1650, the last phrases pointedly addressed the criticisms leveled at the conspicuous consumption of the regency through the retrospective celebration of Poussin's efforts on the incomplete project. Fréart's emphasis on utility and severity in the ornamentation were clearly intended to be understood against the frivolous distractions and material excesses of Mazarin in the midst of fiscal oppression and prolonged warfare. The superior artist produces an *ornement* that is not just a reflection of social rank but also addresses the *nation* and the particular political circumstances of the times. Poussin recognized that magnificent ornamentation and splendor would have been valued less than expedient, skillful, and well-considered solutions. By Fréart's account, these values would continue to survive in the art of Poussin, the "honor of the French in his profession and the Raphael of our century."[7]

Significantly, Fréart's description of the values attached to Poussin's artistic practice and visual forms was retrospective. It took the terms of a debate about art that had occurred in the early years of the decade during Poussin's sojourn in Paris and transposed this criticism to the particular circumstances of the Fronde itself. According to Poussin's contemporary biographers, his work was attacked on stylistic grounds. Charles Perrault

remarked that during the artist's stay in Paris there was an aversion to his work by some because the paintings were deemed "hard, dry, and frozen."[8] The severity that has been associated with Poussin's mature art was deemed by these early hostile critics to have had less authority than enriched effects. According to Félibien, specific formal features of the plan for the Grande Galerie as well as Poussin's works in general had been criticized:

> As there are few people capable of judging the perfection of things, it wasn't difficult to make the ignorant believe that these works, considerable in their simplicity, were not even comparable to an infinity of others that the vulgar esteem because of their quantity and richness of ornament.[9]

Félibien clearly echoes Lucian's criticism of the vulgar gawkers searching for copious and costly decorative effects. As I have argued in the discussion of the *Landscape with Orion*, such social differentiation between viewers was politically fraught in the 1640s. For Roland Fréart in his writings during the Fronde, the utility and severity of the Grande Galerie project were the formal criteria against which he measured the failings of the contemporary regime. The argument concerning the Grande Galerie and the positive evaluation of a severe style had been based on Poussin's own earlier defense of his project.

Poussin's Argument

In a famous letter to his official patron Sublet de Noyers around 1641, Poussin defended the Grande Galerie project against criticism of its lack of richness.[10] He first offered an apology for the spare ornamentation by observing that a great multiplicity of forms would be lost in the monumental scale of the project.[11] Secondly, he argued that enrichment of the gallery was curtailed by a shortage of skilled craftsmen in Paris as well as by the consideration of time and money. Finally, he concluded that the architectural function of the "passage" did not necessarily justify rich ornamentation.

This last point is an important one. It introduced the notion of the relationship between ornamental decorum and political address. Although the specific ceremonial function of the architecture may not have required rich ornamentation relative to other parts of the palace, it was nevertheless an important royal space that demanded appropriate symbolic registration in architectonic forms. The stylistic categories of simplicity and richness entered into an architectural language that inscribed social and political hierarchies. Conventionally, architecture conformed to the rules of a society that regulated consumption and display in a variety of visual practices. The king and the merchant were both obligated to adhere (in theory) to sumptuary laws in order to clarify the structure of society. Such laws differentially marked the bodies of the monarch and his subjects by their dress, its materials, and the displayed investment of labor in the fabric. Intricate gold thread fashioned on a precious textile ground stood against the larger monochrome backdrop of society (see fig. 104). Language too was similarly constructed in terms of material plenitude and craft. The servants of the king who devised his mythology were compelled to address him in a decorous language that registered his difference (and their deference).

Why then did the Grande Galerie not require rich decoration? Poussin offered criteria other than ornament to signify his recognition of the king's authority. The artist claimed to make "a work more studied, more pleasing, more beautiful, better understood, better composed, more varied, in less time and with much less expense than that which had been started."[12] Through his concerted and practical effort to offer research and rhetorical

clarity, the artist served the king. The values of the *noblesse de robe* were imbedded here, not solely in the thematic exposition but in artistic practice. The artist's desire to bestow "honor upon the nation" was juxtaposed to the self-interest of his critics. His dedication to "industry" and to "study" attracted the envy of those whose reputation exceeded their merit.[13]

The formal decisions made by the artist in his studio were commensurate with the *noblesse de robe*'s service to the king. The studio argot of "distribution" and "variety" supplanted copiousness and luxury as signifiers of royal authority. In his letter, Poussin made an important substitution of politically and socially significant visual terms, rejecting ostentation as a legitimate recognition of authority and replacing it with other formal criteria to represent social hierarchies. He claimed that the traditional visual language of praise, as recommended by his critics, would have resulted in "confusion."[14] What Félibien called *simplicité*, Poussin characterized as the privileging of compositional values – distribution and variety – over material rarity and labor-intensive effects. Poussin and Félibien were of course echoing a leitmotif of European artistic theory and practice from at least the Renaissance.[15] In seventeenth-century France, this modification of the term *simplicité* into an elite value ran counter to traditional feudal codes of social distinction, based on the ostentatious display of material resources. Poussin's aesthetic was therefore closely aligned with the values of the *noblesse de robe* in contrast to the culture of the ancient nobility.

The question remains of how a series of apparent inversions of the visual terms of decorum served the king. Poussin's stylistic decisions were understood by his immediate audience within an available alternative representation of social hierarchy. He used a form of decorous address to the monarch that displaced ornamental language. This is illuminated by his own discussion of epistolary style. Toward the end of a subsequent letter to Sublet, Poussin apologized for his directness in the previous letter and excused himself for "his manner of expression."[16] He used the conventional excuse that as an artist he was best understood by his works and it was not his *métier* to know how to write well ("sçavoir bien écrire"). Poussin finished with a statement about his own language and manner of speaking. Félibien paraphrased the final lines as follows: "He had a good sense of what he was doing, without priding himself on it or even seeking favor for himself; instead, he always sought to render testimony to the truth and never to fall into flattery, which is incompatible with truth."[17] Poussin was apologizing for an infraction of the social rules that were imbedded in stylistic decorum. Customarily, the manner in which the artist addressed a patron registered their respective social positions and thereby recognized the latter's superior rank. The *robe* noble had authority over the artisan. Conventionally, indirection, praise, and deference were articulated by stylistic cues. By contrast, Poussin confessed his transgressions of the rules of speech marking his relationship with Sublet. The painter defended his position even at the risk of contradicting his patron's judgments. According to the letter, Poussin's outspoken criticism was neither boastful nor searching for favor. Truth and flattery were incompatible.

This, of course, was not a radical break in *ancien régime* etiquette. Poussin's argument echoed the anti-courtly discourse of the sixteenth and seventeenth centuries. Seeking to differentiate themselves from *courtiers*, the *noblesse de robe* often complained: "Oh, what a wretched country the court is . . . [The master] always has some laughing sycophants at his side."[18] Codified infractions of politeness in the name of integrity were encountered innumerable times. As one of the topoi of French humanism, apologies for impoliteness found their most common expression in the dedicatory epistles of historical works.[19] The rejection of polished fawning and the cultivation of awkwardness or brevity was the cul-

tural expression of the officials of the court responding to abhorrent behavior motivated by self-interest.

According to Poussin, he never fell into flattery. In a letter to Chantelou, he referred to his correspondence with Sublet as hardly "artificial but [instead] full of frankness and truth."[20] Poussin opposed artificiality to artlessness. Rhetorical ornaments that might politely mitigate the boldness of his defense were deliberately handled roughly by the artist.[21] As a social subordinate, the artist with a finely tuned brush and a clumsy pen was not held to the subtle indirectness of rhetorical art. He communicated with immediacy. Poussin was performing traditional forms of deference while at the same time modifying his social position within artistic discourse. His repeated efforts to distance his own writing from embellishment points to a pervasive suspicion regarding both the metaphorical and applied notions of craft. Significantly, these artisanal metaphors for epistolary style and address circulated in a culture otherwise ill equipped to discuss pictorial effects. An incipient artistic discourse, not yet a discipline, relied upon artisanal terms borrowed from rhetoric to describe an aversion to ornament in artistic forms. The rhetorician had first turned to the language of the workshop. Then the art critic turned to rhetoric and reclaimed pictorial metaphor. Metaphor returned to its source.

Poussin's defense of the Grande Galerie in a letter to Sublet is important. Rather than the improvised discussion of cabinet pictures with a friend, it selfconsciously defended art executed for a conspicuous public forum against its enemies. The artist contested criticisms circulating among factions and sought to influence the administrative decisions of the French monarchy. The artist was exercising a role in public life. His authority was based on his capacity to convince his correspondent that he was not merely trying to flatter out of self-interest. If Poussin was frank and truthful to his addressees, he demanded the same honesty in return when they criticized his work. In several letters to Chantelou, the artist requested his client's "true sentiments" regarding a picture.[22] He demanded a response to his art "without flattery."[23] In the same letter that spoke of his persecution by the envy and rage of those Frenchmen who deprived him of his house in the Tuileries, Poussin insisted on blunt artistic criticism from his friend. There was an implicit opposition between the attacks of an interested cabal and a relationship based on frankness and the willingness to address faults honestly. He disparaged any need for praise, especially from those quarters in France where it was not forthcoming.[24]

In speech as well as art, frankness (*franchise*) was signified by the elimination of ornament. Within artistic criticism it was also signified by an attention to faults. The rapport that developed between Poussin and Chantelou's brother Jean Fréart in a series of letters culminated in the client's frank assessment of Poussin's art. Poussin stated that Fréart's description of a painting he had commissioned was "a copy of the little tableau painted as well as the original."[25] The value of the verbal copy resided not in its flattery of the original but rather in its frank assessment of the strengths and weaknesses of the picture: "You have remarked well that which is there and that which is lacking." Poussin went on to frame the declaration of his own limitations in the form of a dedicatory epistle or foreword: "I only dedicated [the painting] to you, in the fashion of Michel de Montaigne, not because it is good, but it was that which I was able to make."[26] Identifying himself with the sixteenth-century humanist, Poussin declared his dedication to expediency and utility. Worth is derived from the execution of one's capacities regardless of critical judgments. For better or for worse, according to Montaigne, the text is himself.

The reduction of ornament and the frank acknowledgment of faults were the constituent materials of Poussin's criticism as well as the way in which his art was intended to be understood. In his handling of the Grande Galerie, restriction of ornament was

understood as the inscription of a set of values: truthfulness was not mediated by flattering effects. Matching this was the understanding between artist and addressee that there would have been an exchange of criticism. Their relationship was constituted by this frank assessment of assets and losses. There was no fiction that the object (like the personage) was flawless.

Poussin's letters suggest that he understood his own art in relation to a broader discourse current in early modern France concerning the capacity of style to signify a distantiation from flattery. Beginning in the sixteenth century, a rhetoric that conspicuously stressed the sources of speech (*inventio*) was deployed in opposition to the pleasing Ciceronian style practiced in the court.[27] The latter style attempted to avoid breaking the "smooth and shining surface" of speech (*elocutio*) with scholarly sources. For the *noblesse de robe* of the sixteenth century, Ciceronianism was associated with the court of Rome and the potential Machiavellianism in the French royal council that needed to be kept in check by the Parlement. As a result the two styles were understood in terms of antithetical characteristics: pleasantness, ignorance, and dissimulation were contrasted with rough strength, encyclopedic knowledge, and sincerity. The sixteenth-century political theorist du Vair, whose works were standard reading for Poussin and his clientele, perceived a major antithesis between Ciceronian *douceur* and another quality, *la force*. The evidence of this debate's conspicuous presence among the *robe* nobility is found in Montaigne's polemic against Cicero in the *Essais*. The Fronde unleashed a reassertion of deliberative Parlementary rhetoric in the tradition of the sixteenth century.[28] The *frondeurs* revived the opacity of rhetoric's sources and disrupted the "smooth and shiny surface" of speech.

Granted Poussin and other seventeenth-century French speakers made certain discriminations between rhetorical styles, it remains to be argued that this cultural activity would have had consequences for the production and reception of paintings. Rhetorical categories have, of course, served as organizing principles for European art criticism since the Quattrocento. A set of pictorial metaphors used to describe literary texts was in turn brought back to bear upon the description of paintings. Limited inferences regarding the production of an object have often directed visual attention to the most simplified of oppositions (copiousness versus structural severity and polished versus unfinished, for example). No matter how crude a binary might have been, it nevertheless has had its uses. Organized as such, these divisions served to differentiate one set of visual protocols from another, representing actual or imaginary differences between speakers. A sociability defined by differentiating aesthetic criteria under the pressure of history constituted a politics in mid-seventeenth-century Paris.

Bold, Rude, and Abbreviated Signs

A propensity for artistic metaphor occurred in the historical writing of a leading figure in Paris during the 1640s, Achilles II de Harlay. The Harlay family was not unfamiliar with the importance of rhetorical style. Achilles I had been a famous president of Parlement who held a firm ground against Henry IV in his famous remonstrances.[29] Nor were the Harlays insensitive to the significance of pictures. The family was intimately linked to members of *parlementaire* society that owned paintings by Poussin. The fact that the son of Achilles II possessed Poussin's *Judgment of Solomon* suggests that the family had taken an interest in collecting art. With a knowledge of his father's use of artistic metaphors, the son may have selfconsciously thought and expressed himself in these terms when he looked at the painting.[30]

Achilles II de Harlay brought his reflections on style, historical discourse, and painting together in his translation of the history of imperial Rome by Tacitus. Harlay's language in his preface reveals an habitual use of artistic metaphors consistent with the conception of the Roman historian as a vehicle for criticism of the regency during the Fronde. As I said earlier, the objectionable style of Tacitus was overlooked by sixteenth-century commentators in their search for historical authority. Rather than attaining a refined and elegant rhetoric, Tacitus's rough style was traditionally considered appropriate for his unflattering critical task. Significantly, Harlay did not apologize for the difficulties of Tacitus, he sought them out.

In his preface, Harlay initially drew upon martial metaphors to describe his attempt at faithfully translating Tacitean style into French. The historian resembled the general in combat who must use few words. Terse and precise commands were the efficient, albeit crude, models suitable for writing history. Elaborating on the historian's style, Harlay then shifted his field of reference from the battleground to the painting studio. He compared the historian to a painter:

> His work resembles those tableaux in which are recognized the robust strokes of some great painters' hands; and although they are a little rough [*rude*], their coarseness [*rudesse*] still has its beauty . . . All those who attentively read this author notice an ineffable obscurity, which nevertheless produces beautiful lights, as in a portrait where the darkest shadows often give to it a more vivid and more glittering daylight.[31]

Speaking studio parlance, Harlay described the effects of chiaroscuro to make a point about historical truth. Tacitus, like a great painter, built his historical tableau out of contrasts. His bold touch was often rough, but that crudeness was in turn beautiful. Severity provided a new criterion for grace. But painting was not used by Harlay as a metaphor of unmediated reality, the literary cliché of the mirror-like quality of visual representation that reveals truth and denies artifice. Instead, the metaphor is selective: the author insisted upon the conspicuous marks of a particular kind of painter who offered bold and contrasting effects. Rather than being immediately attracted to a refined and polished style, the careful and attentive reader of Tacitus found beauty in roughness. Rather than fluid clarity, obscurity matched the difficult path of thought.[32]

Harlay was only one among many voices. Artistic metaphor that stressed a distrust of ornament was pervasive among writers who discussed historical representation during the Fronde. The discussion of facture provided a tactile and visual metaphor for the "rough strength" of *robe* eloquence as it contributed to "la résistance respectueuse." The call for bluntness and brevity of effects was a common motif of historical prefaces, *mazarinades*, remonstrances, and various texts emanating from the *noblesse de robe*. For example, Tristan l'Hermite asserted that historical description should be fashioned in a blunt and unflattering style when faced with the task of writing a history of the presidents of the Parlement of Paris (1645). As in Harlay's preface to Tacitus, Tristan contended with the difficulty of praising a succession of powerful men while maintaining integrity (and credibility). He renounced ornament in order to signify truth: "In all this research I have sought to contribute no other ornament than the truth of a simple account, naked and without make-up."[33] The truthfulness of a decorous elegy for a *parlementaire* was asserted by using a style that declared its absence of seductive effects.[34]

At the onset of the Fronde, as I showed in the last chapter, Tristan had rehearsed pictorial metaphor in order to describe his own collection of paintings. His *Vers heroiques* sets out a serious conversation in the presence of a tableau by Poussin. In the usual vein of literary dedications, the epistle of his book asked forgiveness for the paltry level of achievement and lack of consummate skill that did not match his addressee. Tristan apologized

that he could not supply a magnificent sculpture as a decorous offering for his friend at the Temple of Glory, but instead he wrote a series of *tableaux*. The text's lack of material ambition and requisite finish as well as a conspicuous negligence were attributed to a necessary expediency in response to "bad fortune." Nonetheless, despite the limits of these pictures, they had a certain beauty that exceeded the more complete works of others. Tristan's imagined *tableaux* were valued "for the arrangement and the boldness of the brushstrokes."[35] The rigorous organization of the figures occupying the painted field as well as the vigorous facture constituted exemplary formal characteristics. Negligence was not a marker of spontaneity; rather, selective organization was wedded to a blunt and conspicuous painterly structure.

During the Fronde, pamphlets demonstrated a fluency in pictorial metaphor, where historical and political discourse rehearsed an attention to particular material chacteristics. A *mazarinade* entitled *Le Grand Miroir des financiers tiré du cabinet des curiosités du défunt Cardinal de Richelieu (The Large Mirror of the Financiers Taken from the Cabinet of Curiosities belonging to the late Cardinal Richelieu*, 1652) argued specifically about artistic style.[36] The essay contains many of the themes that had been developed in the pamphlet literature, including that of a perfect minister set in relief by attacks on luxury, foreigners, and spectacle. The ideal minister is not counted among the *curieux*. In contrast to the artificial gardens and fountains of the *financiers*, the garden of the ideal minister with its single tree and simplicity, even austerity, signifies the displacement of accumulation. Similarly, in the ideal minister's picture gallery there is a collection of select gifts from intimate friends. The author contributed pictures of "Amour Philosophique" and "Amour Divin" to this collection. One allegorical figure promotes heroism while the other directs all the virtues. In the imaginary space of the text, the gallery served other ends than unregulated *curiosité*. As the site of a gift exchange, the setting provided an occasion for the discussion of significant philosophical topoi and the consolidation of social bonds.

Within this ethos established by the ideal picture gallery, the author of *Le Grand Miroir* reflected on his own writing practice based on pictorial metaphor. He argued that the verbal portrait ought to be modeled after those of antiquity. The perfect portrait was brief and efficient. Brevity was valued above nuance. One must be content with lights and darks that are summarily blocked in. As in Harlay's description of chiaroscuro, the roughly modeled form was related to appropriate political practice. The seductive handling of paint was not suitable for the portrayal of the ideal minister's conduct. The author offered in its place an ideal descriptive language and style in conformity with the perfect minister:

> It would seem necessary . . . to speak . . . to them only in abbreviated signs, and using general expressions equal to those which are proper to pure minds. It would seem necessary, at the very least, that there be above all, as in China, a particular language designed to address [those minds]. And this language should also be like that of ancient Sparta, where harangues were made with two words, and letters with only a syllable.[37]

A speaker of such abbreviated signs could realize a political speech in two utterances. Epistles required only a sound. In contrast to the material plenitude and intricate effects valued by *curiosité*, this writer called for a semiology of reduction. Significant painting was not a mere elaboration of effects. Rather, superior style was defined by a radical repression of technical virtuosity. In contrast to the disorder of the senses found in Mazarin's collection, the desired effects of both political discourse and painting were achieved by the most restricted of means. Using an abbreviated language that eliminated excess, the speaker or painter celebrated terseness.[38]

Artfulness or polish was associated during the Fronde with the self-serving speaker or writer who sought to flatter and seduce. Pamphlets decried the shifting loyalties of political hacks, who sought the "reputation of polished writers more than that of good citizens." The weightless plume flew from one extreme position to another, "never stopping in the middle where *virtù* is."[39] *Polis* was therefore the style of the writer seeking favor and reputation rather than undertaking disinterested, patriotic service. The same writers who had formerly used their skill to blacken the actions of the Prince de Condé quickly changed loyalties and pursestrings, easily powdering over his imperfections (*blanchir*) and seducing by the application of gaudy make-up (*farder*).[40] The text registers a pervasive suspicion concerning the authenticity of a polished and effeminate style, opposing it to the exemplary masculine conduct (*virtù*) of an enfranchised male political elite, "les bons citoyens." Technical virtuosity was linked to self-interested writers who compromised themselves while disguising the equally transitory political behavior of the ambitious princes.

The pamphleteer's voice I have just quoted was sponsored by one of the names closely associated with Poussin's work, Châteauneuf.[41] It helps us further to appreciate the stylistic claims made by Harlay, Tristan l'Hermite, and the anonymous *frondeur*. Each of these authors registered different conceptualizations of painting in mid-seventeenth-century France. In contrast to the imaginary seductive force of luxurious effects and the effacement of both materials and effort, these authors offered robustness, conspicuous materiality, and reduction (*hardiesse, rudesse*, and *les signes abbregez*).

The borrowing of pictorial metaphors for a discussion of literary or historical writing was of course not in itself new. Often, such appeals to visual experience were too general to be useful or they were simply put to use in imprecise ways to evoke mimesis. And yet, I am interested that at this particular time, rather than merely appealing to painted verisimilitude as a metaphor for the transparency of their language, numerous authors drew attention to the mediation of paint, its opacity. The attention to the materiality of paint had a particular purpose. Painterliness had not yet been associated with improvised behavior as it was later in the history of French painting. Roughness did not signify spontaneity as resistance to constraint, but rather a well-considered brevity as a structured oppositional position. As the historian was likened to a great painter, so too did the painter serve as a model for communicative acts in general.

A rhetorical discourse based on the reciprocity of style and artistic material metaphor constituted a way, in turn, for artist and audience to talk about painting. If the painter provided such a lesson to the historian, poet, and *frondeur* pamphleteer, so too could the artist adopt this metaphorical language for studio practice. The transference of these discursive patterns of organizing pictorial reception according to material effects offers a way of understanding Poussin's production in the late 1640s. His art provided opportunities to inscribe social and political values in a style that was understood in relation to other artistic practices. Based on the kinds of textual evidence I have been discussing, Poussin's abbreviation of painting's constituent means was potentially understood in oppositional terms. Having proven his capacity to execute any number of skillful and luxuriant effects in his early work, by the 1640s Poussin rehearsed a calculated *rudesse* in opposition to material plenitude and technical virtuosity. The severity of the paintings of this period rejected the sensual immediacy associated with the culture of the regency. A brittle outline was understood in opposition to fluid brushwork. A discreet and uniform hue was seen against glistening pigments and transparent glazes.

My argument that pictorial metaphor was transposed from texts back into artistic practice might strike some as too facile. It implies that Poussin directly acted upon the avail-

able discourse. I need to stress that a set of formal characteristics spoken or in print is never immediately available to the studio practice of an artist. How were the metaphors derived from material observations brought back to studio practice? How was Poussin's audience prepared to understand these metaphors when adapted to the task of painting? In order to offer some responses to these questions it is useful to return to the Grande Galerie project.

Paper Gallery

In addition to gaining notoriety as a place available to visitors, the reputation of the partially completed Grande Galerie was also grounded in notations on paper.[42] Poussin's preparatory drawings were known to his clients and were included with his paintings in at least one collection.[43] By 1650, his drawings were already for sale with a prominent art dealer.[44] In order to understand the function of this collecting activity, it is important to stress that drawings had not yet become central to the French amateur's intimately scaled sociability (as in the case of the Crozat circle in the early eighteenth century). In mid-seventeenth-century France, organized attention to an artist's works on paper was only just beginning. Evidence of this comes from Poussin's own letters: he had been asked to review and compare for his patron Sublet de Noyers plans submitted by competing architects.[45] Poussin declared: "I will freely state my opinion."[46] The character of the architect or other personal considerations that would be important for the execution of the project did not come into play. Instead, disinterested comparison of two architectural solutions and their relative value was paramount for Poussin. The architectural plan was an exchange

63. Poussin, *Hercules and Theseus Fighting the Amazons*, c. 1640–43, drawing (Windsor Castle, The Royal Collection, Royal Library), 132 × 136 mm.

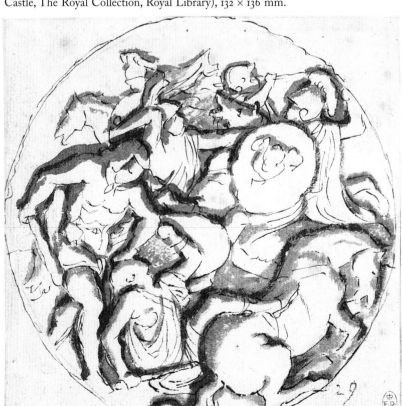

object facilitating a suspension of florid politeness and inviting criticism, recommendations, and other possible solutions.

The preparatory drawings for the Grande Galerie invited similar responses and a comparable critical discourse (fig. 63). The project was a rare instance of Poussin's delegation of artistic tasks to assistants. As a result the preparatory drawings were very different from his other works on paper. Intended for pragmatic studio practice, they were objects addressed to other artists. The drawings only inadvertently entered into broader circulation. It is obvious that once they were collected by a client these works were no longer possessed by their intended addressee (unlike, for instance, the presentation drawing of *Camillus*; see fig. 26). Rather, the collector who subsequently acquired a preparatory drawing became an eavesdropper on a conversation between Poussin and a fellow artist. The assistant was an artist interlocutor who received directions in the parlance of studio practice and responded with the more finished drawing (fig. 64). As an argot appropriated by the client collector, however, the generic identity of the drawing shifted from an enunciation addressed to a fellow mechanic to a collected object demanding the particular discursive engagement of learned viewers.

Poussin's drawings intended for his artisanal collaborator therefore bypassed the problem of an artist's self-interested address to a paying recipient: limited by the terms of expediency and utility, these drawings permitted a disregard for the decorum of social hierarchy. Although the preparatory drawings may have ultimately contributed to a decoration that addressed the king within the context of state architecture, the notations for that enunciation did not flatter because they did not represent a decorous address. They were visual counterparts to the argot of the studio.

The preparatory drawing was situated in a specific social nexus that suspended normative patterns of indirection and deference between artist and social superior. Despite the

64. Assistant of Poussin, *Hercules and the Centaurs at Pholoe*, c. 1640–43, pen and brown wash on paper (Windsor Castle, The Royal Collection, Royal Library), 262 mm diameter.

fact that the preparatory drawing was subservient to a particular task, it had a certain degree of autonomy. I hesitate to use the word "autonomy" because it has served as an ideologically fraught term signifying "freedom." I do not wish to suggest that the drawing occupied a position outside social structure. Rather, I am emphasizing in the first place that the preparatory drawing was produced at a relative distance from political power (that is, the material processes of the studio inherited from a craft tradition rather than the iconographic programs buttressing the state).[47] That is to say, the exercise of a graphic language between artisans seemed to have less at stake, socially and politically. Secondly, as a corollary to occupying this relatively unpoliced area of social practice, the preparatory drawing was the site of a slippage between the application of structural rules from one socially circumscribed enunciative position to another. In general, as a result of the uneven distribution of power among different cultural practices, there are greater opportunities for experimentation when rules from one formation are applied to another.[48]

Style registered a difference of address. The unfinished, the non-*poli*, was the language appropriate to the relationship between artist and colleague. Brevity signified a trust in the addressee's receptivity. In preparatory drawings shared among artists, the unsaid was understood. Physical description was subordinated to other demands. Rather than the subtle interaction of figure and ground by shifting gradations of light and shade, patches of unprepared paper were opposed to clumsy, emphatic layers of bounded wash (see fig. 63). The technique disrupted continuity, arrested movement, and asserted robust contours at the expense of plasticity. Poussin thereby maintained the abbreviated masses found in sketches yet avoided any casual effects – as can be seen in a similar medallion imbedded in a tectonic frame (see fig. 4). The drawings were developed through layers of washes that created contrasting textures and areas of opacity. Coarse edges reveal the passage of a dry emphatic brush. Rather than signifying the transitory fall of light by facile movements of brush against an unprepared surface, Poussin economically applied accretions of wash that he left to dry and then reworked. Wash assumed some of the accumulative formal properties of oil sketches, providing room for the viewer to infer the sequence of pictorial decisions from the traces. In contrast to his earlier works on paper, these drawings conveyed a more considered process without polished effects. The worked surface was not aligned with spontaneity and its concomitant social behaviors of aristocratic ease and casual deportment. The drawings were perfectly in keeping with Poussin's professed values: he made it clear to his clients in his letters that he valued effort (*soin*) and measured his own registration of graduated painterly traces against the paintings executed in twenty-four hours by the quick brushes of Paris.[49] Rather than fluid oscillation, the abrupt transitions between light and shade conveyed the ragged movement between things beheld and withheld.

Poussin's demonstration of artistic procedures far surpassed the requirements of Harlay's and Tristan's metaphoric language of hard and rude effects. The preparatory drawings addressed to a socially subordinate mechanic and their subsequent appropriation by an audience of a higher social position enabled these graphic marks to be understood by his immediate clients as authentically blunt and outspoken enunciations. While what I have been describing was an unintentional consequence of secondary reception, I would argue that these newly valued material effects were self-consciously repeated by the artist. Poussin's anomalous practice of making preparatory drawings and the particular symbolic resonance of the unfinished project provided him with a unique opportunity to apply these novel stylistic investigations to his broader studio practice during the 1640s. The initial burden of proof for this assertion resides in the subsequent drawings for his own use which shared distinctive features with those drawings he had developed for studio assistants.

Drawing upon Circumstance

Poussin's drawings for the feigned bas-relief cycles dedicated to Hercules and Trajan in the Grande Galerie were informed by his research into the casts from the actual reliefs of Trajan's Column and other antique monuments. Using antique friezes was not in itself new. Indeed, the lessons Poussin gained from the material remains of antiquity importantly contributed to the success he had already enjoyed in France. The early bacchanal series executed for Richelieu demonstrated the painter's willingness to impose limits upon his skillful articulation of a multitude of figures distributed within a systematic representation of depth (fig. 65; see fig. 28).[50] Yet, the handling of references to ancient friezes is significantly different in the works of the 1640s. The artist was less interested in the solution to the disposition of surface pattern imaginatively offered by monochromatic antique prototypes (the play, for instance, between discrete hues in the drapery of individual figures in the *Triumph of Pan*). Instead, Poussin's selective reference to an anachronistic treatment of space as well as his adoption of the physical limitations and consequent spatial grammar of ancient Roman bas-reliefs resulted in the simplification of masses and the suppression of movement in his drawings for the Grande Galerie. In *Hercules and Theseus Fighting the Amazons* (fig. 63), for example, the artist had been compelled to compress the figures within the medallion format. Hercules overcomes the fallen Amazon who is still partly mounted on her horse. The three figures are bound to each other, wedged into the same plane, their movements constrained by the border that circumscribes them.

In Poussin's drawing the masses are defined primarily by the coarse passages of wash. In an assistant's more finished rendering of a similar composition (see fig. 64), the contours suggest the gradual fall of shadow at the edge of the protruding stone. Poussin's technique, by contrast, more aggressively stresses a tension between figure and ground. The rough contour line is reinforced by a partially translucent wash that only approximates the initial definition of form. These coarse chiaroscuro effects are far from those refined passages found in earlier paintings of the late 1620s and early 1630s such as the *Venus and Adonis* (see fig. 9), where exquisite shadow bespeaks effortless understatement. In the early works, the painter casually suggested a series of areas that constituted a sufficient whole and encouraged an intuitive grasp of form and graceful movement. By contrast, the technique of the later Herculean figures declares itself in all its tense material relations.

Some of Poussin's drawings in the following years also deployed lessons learned in the Grande Galerie. Imitating the spatial effects of bas-reliefs, a drawing related to the painting of *Aaron's Rod changed into a Serpent* (fig. 66) distributed three compressed figure groups in a regular rhythm within a rectilinear format. The figures are surrounded by a wash that, by its opacity, suggests a neutral stone ground. The artist applied the same techniques in a depiction

65. Poussin, *The Triumph of Pan*, c. 1635, oil on canvas (London, National Gallery), 1340 × 1450 mm.

66. Poussin, *Aaron's Rod Changed into a Serpent*, c. 1638, pen and brown wash on paper (Paris, Cabinet des dessins, Musée du Louvre, RF 750), 158 × 261 mm.

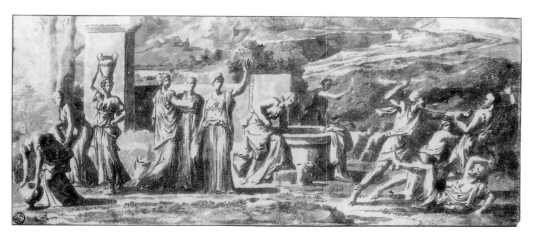

67. Poussin, *Moses Defending the Daughters of Jethro,* c. 1647–48, brown wash on paper (Paris, Cabinet des dessins, Musée du Louvre, inv. 32432), 173 × 434 mm.

of *Moses Defending the Daughters of Jethro* (fig. 67).[51] Made entirely from wash, the figures are disposed in a long rectangular format, grouped at regular intervals in a chain. The violence, structured and contained, recalls *Hercules and Theseus*. The drawing appears complete without being finished. The large scale also suggests a special function for the drawing, perhaps a *modello*. But it is more likely that, like the earlier drawing of *Camillus* (see fig. 26), the drawing of Moses was almost certainly an object addressed to a collector.[52] Poussin recognized a desire for certain kinds of technical effects that he had deployed in the drawings for the Grande Galerie. On the sheets designated for himself and a fellow artist, the provisional notations matched the rough ornaments sought by Tristan and Harlay.

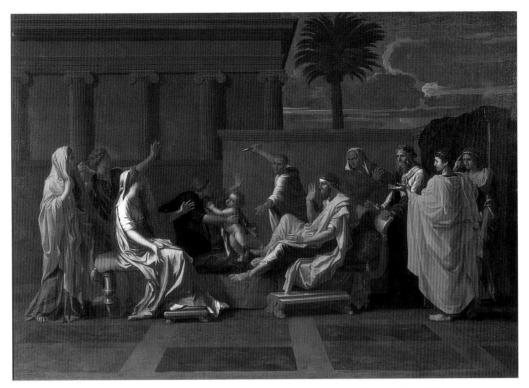

68. Poussin, *Moses Trampling on Pharaoh's Crown*, 1642–45, oil on canvas (Bedfordshire, Woburn Abbey, inv. 1180), 810 × 1330 mm.

From Ink and Wash to Oil

The lessons of this technical investigation on paper are found to great advantage in an oil painting, Poussin's first version of *Moses Trampling on Pharaoh's Crown*, the depiction of an event from Josephus (fig. 68). Painted for Jean Pointel between 1642 and 1645, while Poussin was executing the second Seven Sacrament series, the scene is constructed within the constraints of a shallow space limited by sparse walls. The relatively isocephalic composition (constituted in particular by the grouping of heads on the right) as well as the diminutive scale of the columns and the barren interpilasters echo one of Poussin's drawings after a famous ancient Roman relief.[53] The bracketing of the figures and the insistence on profiles emphasize their conception as a sculptural group occupying an imaginary rectangular block. This effect heightens the dramatic intensity of the foiled infanticide while making the figures inert. Clearly, this is a different pictorial world from that of the earlier *Rape of the Sabines* (1633–34; see fig. 10) or *Gathering of the Manna* (1637–39; see fig. 37).

As in other pictorial compositions of the 1640s, Poussin sacrificed both the number of figures and their placement in a sophisticated spatial system. The compression of a limited number of figures within a shallow plane not only stressed an affiliation with antique friezes but also represented a positive valuation of the reduction of figures. This is particularly significant given that the craft tradition still stressed the number of figures in contractual agreements. In early letters, Poussin quantified figures. To a fellow painter, he wrote that the *Manna* contained, without the landscape, thirty-six or forty figures and was, "between you and me," worth 500 *écus*.[54] However, in his correspondence of the 1640s, he distanced himself from the artisanal demand for payment per depiction of a human body. His request for more money from Chantelou for one painting was not due to the

increased number of figures: "I don't pay attention to so insignificant a thing." Rather, "all will be rich according to their subject."[55] He therefore simultaneously redefined his métier and the demands of his addressee: the client had criteria for "riches" other than a profusion of depicted objects and a physical proof of labor.

The restriction to a select range of skills in *Moses Trampling* signified the anachronistic technical procedures of antique reliefs as well as Poussin's own investigation of archaic effects in the Grande Galerie project. This reference to his own suppression of facility not only addressed the viewing predispositions of French antiquarians, it also signified the values inscribed in the style of the Grande Galerie – a style exercised in an ambitious effort begun during Louis XIII's regime but left fallow under the regency. The Grande Galerie project and its preparatory drawings symbolically embodied the denial of support by the regency.

The second series of the Seven Sacraments similarly represented the artist's loss of governmental support, as I said before. The suite of paintings had been executed during the retreat of Sublet's administration and exhibited in a disgraced client's cabinet. Poussin had agreed to dedicate all of his "study" and all the "force" of his talent to the project for Chantelou.[56] The artist was almost totally preoccupied with the execution of this series between 1644 and the outbreak of the Fronde. In contrast to a decorative wall, the suite offered a series of object lessons.[57] The second series provided an opportunity to repeat the theme while investigating his most recent formal innovations in the drawings for the Grande Galerie. The compositional strategies in those preparatory drawings were applied, for example, to the second version of the *Extreme Unction*.[58] In the first version, Poussin had placed a frieze-like composition of figures against an austere wall (fig. 70). With ample space between expressive figures, their movements are fluid, self-contained, and bathed in natural light. By contrast, the second version was based on a preparatory drawing that was indebted to the artist's investigations in wash for the Grande Galerie (fig. 69).[59] In the drawing,

69. Poussin, *Extreme Unction,* preparatory drawing for second series of the Seven Sacraments, c. 1644, pen, brown ink, and brown wash on paper (Paris, Cabinet des dessins, Musée du Louvre, inv. 32429), 217 × 331 mm.

70. Poussin, *Extreme Unction* from the first series of the Seven Sacraments, c. 1638–40, oil on canvas (Grantham, Belvoir Castle), 955 × 1210 mm.

71. Poussin, *Extreme Unction* from the second series of the Seven Sacraments, 1644, oil on canvas (Edinburgh, Duke of Sutherland Collection, on loan to The National Gallery of Scotland), 1170 × 1780 mm.

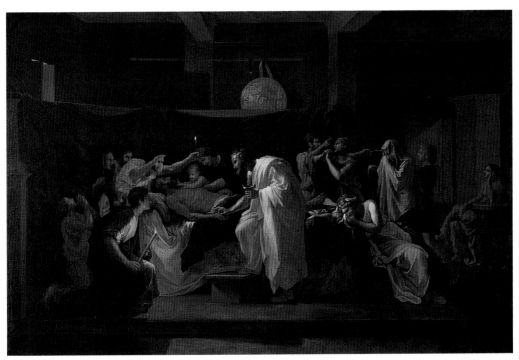

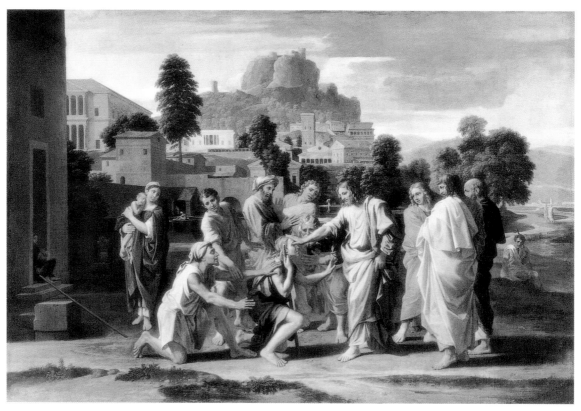

72. Poussin, *Christ Healing the Blind,* 1650, oil on canvas (Paris, Musée du Louvre, inv. 7281), 1190 × 1760 mm.

73. Poussin, *Christ and the Woman Taken in Adultery,* 1653, oil on canvas (Paris, Musée du Louvre), 1210 × 1950 mm.

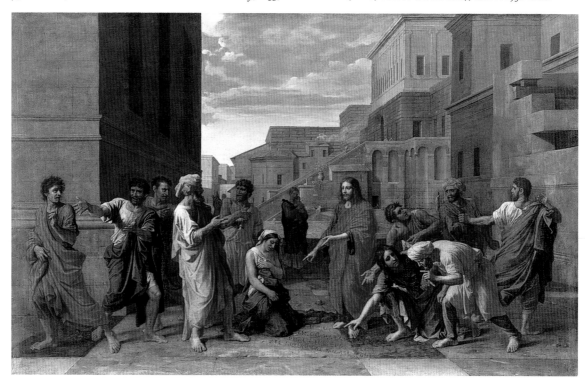

Poussin sacrificed facial features and anatomy was brutally simplified. The modulation between plasticity and void had been restricted. Dark wash was less intricately applied and compounded than the preparatory drawing. Yet spontaneity was nevertheless disavowed.

Based on the lessons of the Grande Galerie, the preparatory drawing for the second *Extreme Unction* enabled a departure from the earlier depiction of the Sacraments with its fluid exposition of a range of expressive gestures bathed in light. The resulting painting (fig. 71) relied on an even more dramatic use of artificial light. Figures actively reflect light and cast shadow and thereby threaten to cancel the discrete corporeal integrity of adjacent bodies. The pattern of light and shade constitutes a tense, interwoven single field. The dying man is constrained by the oppressive weight of the witnesses. In this later version, movement is more violent (the man with the candle or the crying woman at the foot of the bed) but it is centrifugal. In the first version, the expanse of linen covering the legs of the dying man and the subtle reliefs on the back wall seem like a void compared to the density and concentration of the later version.

Several of the paintings executed after the second Sacrament series attest to Poussin's insistence on the same approach. Consistency, even redundancy, was valued over the varied compositional solutions of his earlier work. The figure group in *Christ Healing the Blind* is confined to a rectilinear field in a single plane (fig. 72),[60] a pattern similar to that in the *Coriolanus* (see fig. 54). The two paintings parallel each other both in narrative and formal terms: the Roman general occupies the same position as Christ. Both are backed by their assistants (disciples/soldiers), both act on the kneeling figures before them (hand/sword, blind man/women) who have standing figures behind. Both compositions are bracketed on the left by a standing figure (mother and child/Rome). A similar structural logic is also

74. Poussin, *Death of Sapphira*, c. 1654–56, oil on canvas (Paris, Musée du Louvre, inv. 7286), 1220 × 1990 mm.

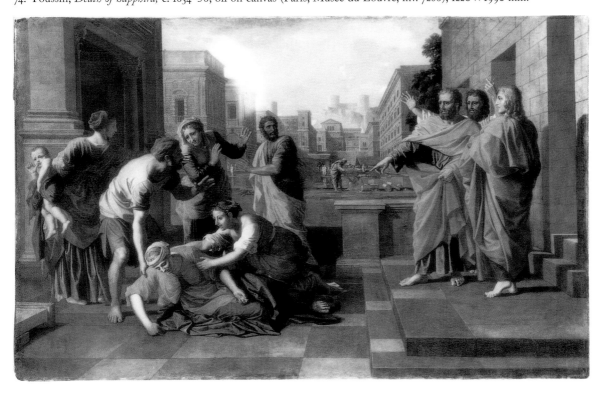

evident in two paintings executed in the immediate wake of the Fronde: the *Christ and the Woman Taken in Adultery* (1653; fig. 73) and the *Death of Sapphira* (c. 1654–56; fig. 74).[61] These paintings adapt the compositional pattern of the Seven Sacraments to a cityscape. In particular, the frieze of respondents to Christ's admonition exhibits the plodding syncopation characteristic of the works Poussin painted between 1649 and the mid-1650s in which figures occupy a relatively shallow frontal plane.

Poussin's restriction of a range of skills and his often brutal simplification of painterly effects during these years coincided with his increased production for French clients active in the politics of the Fronde. In the previous chapter, *Coriolanus* was discussed largely in terms of the articulation of the themes of Livy as applied to contemporary circumstance. However, Poussin's antiquarian project did not solely reside in the depicted artifacts and literary referents. Antiquity was signified not only by iconographic reference but also by formal resonance. Now we are in a better position to appreciate the formal severity of *Coriolanus* with its brittle drapery and static figures. Masses are juxtaposed rather than integrated. Poussin's discrete hues and hard-edged forms resemble abrupt and emphatic speech.

Pictorial composition conveyed the values attached to ancient art mediated by the Grande Galerie. This was by no means a new strategy in Poussin's work. The early chapters of this book have rehearsed the ways in which both thematic and formal references to antiquity were important for a French clientele early in his career. But stylistic references to antiquity could be various, from bacchanalian rhythms to military phalanx. What becomes increasingly evident from an examination of the works of this mature period is that one can use the term "style" to refer to repeated formal characteristics exercised to the exclusion of others.[62] This notion of style differs from the ways in which it had been used to signify decorum. As Poussin sought to restrict variety, attention was drawn to the internal coherence of his many works irrespective of their intended purpose. In his earlier work and correspondence, Poussin had displayed an understanding of style as a situational marker, a set of formal effects intended to signify a particular occasion or address. His style shifted from genre to genre, from one addressee to another. By contrast, in the mature figurative work, his oeuvre sustained its own internal formal logic. Consistency seemed to be valued over range. The pendant and the series marked a developmental stage in the artist's conception of his own work: the oeuvre contains its own self-reflexive semiotic system.[63] I am describing a radical condition in which decorum was dissociated from situation and address. Poussin was making his contribution to the history of the easel picture.

Archaism and Opacity

The replacement of high decorum with other formal values relied upon the identification of those material characteristics with similarly recognizable, overlapping, desired values outside the field of art. While triumphal imagery was associated with pomp, other archeological forms (such as the Maison Carré) acquired value as objects of study and discussion in sixteenth- and seventeenth-century France (see Chapter Two). In order for his own archeological project to be identified with the latter use of antiquity, Poussin inflected his withdrawal of ornament with technical anachronisms. The artist selfconsciously manipulated formal decisions to create researched, archaic effects. That Poussin

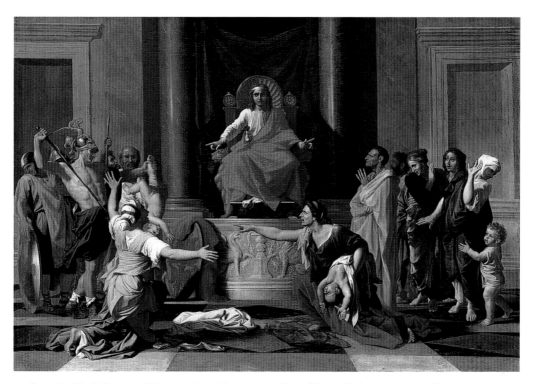

75. Poussin, *The Judgment of Solomon*, 1649, oil on canvas (Paris, Musée du Louvre, inv. 7277), 1000 × 1500 mm.

investigated anachronistic conceptions of spatial organization is attested by *The Judgment of Solomon*, a work executed for Jean Pointel in 1649 (fig. 75).[64] The composition as well as the figures are brittle. The enthroned Solomon is positioned between two columns; symmetry dictates the compositional logic. Two chains of figures flank the central figure on the dais. Depth is truncated by the wall to which the two groups of witnesses adhere. The plodding effect of these static and proximate bodies is relieved only by the relatively unplotted movement of anguished mothers. Solomon's imposing scale suggests a hieratic arrangement.[65] Poussin was deploying an anachronistic compositional vocabulary that combined different spatial systems: the two mothers play out their roles on a perspectival grid before a cast of witnesses organizing themselves into a bas-relief frieze. In addition, these two spatial systems hinge on the figure of Solomon whose privileged position is marked by iconic elevation, scale, and symmetry.[66]

Similar archaisms were investigated in a now lost painting, *The Rape of Europa*. Poussin conceived of the picture, known from a finished drawing (fig. 76), as a composition of relief figures in a shallow field.[67] At least two narratives are juxtaposed: figures representing the abduction by the bull butt up against a figure of Eurydice being bitten by the snake. The drawing adopts the visual grammar of ancient Roman reliefs, exploiting temporal discontinuities and spatial juxtapositions.

However, another cluster of paintings from this period (sometimes grouped as cityscapes) seems to contradict Poussin's quest to restrict depth. In *Christ Healing the Blind* (1650), *Death of Sapphira* (c. 1654–56), and *Christ and the Woman Taken in Adultery* (1653; see figs. 72, 74, 73), the deeply receding perspectival organization of depth disrupts the otherwise archaizing frieze-like composition of the figures. Unlike the

76. Poussin, *The Rape of Europa*, 1649, pen and brown wash on paper (Stockholm, Nationalmuseum, inv. NMH 68/1923), 262 × 590 mm.

development of figures in depth in Poussin's earlier works from the 1630s, such as the *Rape of the Sabines* and the *Manna* (see figs. 10 and 37), the later paintings repeat the compositional pattern established in the second Seven Sacrament series and juxtapose chains of figures in the shallow foreground to deep space. The figure group in the foreground reads as an intrinsic whole, but not as the rhythmic pattern of modulated hues characteristic of the early bacchanals such as the *Triumph of Pan* (see fig. 65). In works from the 1640s and early 1650s such as *Christ Healing the Blind Man*, there is a tension between an archaic frieze group and a convincing deep space.

In short, Poussin was producing unaccustomed effects. Whether in shallow reliefs or relief-like figure groups juxtaposed to deep space, he was willing to suppress a set of conventionally valued studio skills. In these paintings created during the Fronde, there is little display of the systematic adjustment of scale to a perspectival system, and little elaboration of narrative incidents: instead of the multiplicity of small groups or vignettes in the *Manna*, in the later paintings a single action demands a variety of responses from a restricted number of witnesses. The compositions withhold the various narrative threads produced by figures and vignettes interacting in depth. Instead, each agent tends to carry the same affective weight. Integrated compositionally into a mass (as in the second Sacrament series), the depicted figures are nevertheless a series of independent psychological entities, sometimes disengaged from one another, bearing an equal burden of expressivity in the narrative field.

Concomitant with the reduction of narrative plenitude, there was a restriction of the variety of brushstrokes. The drapery, for example, had become relatively uniform. These paintings do not reveal a subtle underpainting applied with a dry brush (as seen in the male figure on the right in the *Manna*). Nor is there a fluid repetition of discrete strokes suggesting the movement, buoyancy, and texture of cloth. The artist did not choose to highlight the creases of fabric in lively juxtaposition to darker tones (visible, for example, in his treatment of the right-hand woman's drapery in the *Manna*). Instead, a relatively uniform hue is occasionally disturbed by a darker tone representing the accidents of falling drapery or the interference of another juxtaposed body. Draped figures were subjected to severe simplification (see *Coriolanus*, figs. 48 and 54).[68] Flourishes of highlights on reflective surfaces were eliminated.

Understandably, several art historians have been less than enthusiastic about Poussin's later paintings and have deemed their repetitiveness formulaic.[69] A more sympathetic reading would see Poussin's formal consistency during this period as the result of a self-conscious and systematic restriction of technical competencies in favor of other values. This is not to say that the pictures are less complicated. Indeed, complexity arose from the restriction of pictorial problems by a highly constrained frequency of variation. Earlier accomplished effects and other pictorial concerns were displaced. Poussin was responding to pictorial metaphors in humanist discourse that were articulated in oppositional cultural criticism. Even at the risk of repetition, he chose to make his immediate audience perceive his paintings' internal coherence.[70]

<center>* * *</center>

A moment to pause and reflect is in order. We find ourselves caught in a tenuous set of relations between historical events of different orders and magnitude. Clusters of political discourse and action find themselves in proximity to less conspicuous activities: scratches on paper, the selection of brushes, stretching canvas, and the application of oil paint. Inferences drawn from the meanest of materials result in the barest scheme of historical transformation: causality, duration, and succession. A thin wash was applied and allowed to dry. Another thin layer of wash was applied. On the level of example, the Grande Galerie was understood by Poussin's contemporaries in relation to the cultural practices of Mazarin. The ambitious architectural project fostered a seemingly modest activity that proved to be highly significant: it required a delegation of labor that resulted in the preparatory drawings. Vestiges of this particular project later served to represent unrealized ambitions. These drawings not only constituted part of the diffusion of Poussin's work after his exile but also (as I shall show in the next chapter) informed his own artistic decisions in paintings of the following decade.

Poussin was successfully bringing the particular material resources of painting in productive relation to French humanist culture. His formal decisions were imbedded in a materially descriptive artistic discourse that played an important role in French politics. Fréart de Chambray's criticism of the regency drew attention to the regime's failure to sustain an artist who addressed the crown with an *ornement* that privileged brevity and economy. It was Fréart who stressed the organization of artistic forms rather than the registration of sumptuary codes. Poussin made pictorial decisions analogous to the purposeful infraction of social decorum. He thereby rehearsed an alternative tradition of appropriate social address that was actively performed in the political culture of the Fronde. Exemplary social and political behavior was not assimilated to the transparent sign of polished verisimilitude. Instead, for this constituency, conspicuous constructedness and the bluntness of material application were a measure of virtue.

Fréart's treatises were consistent with the writings of Tristan l'Hermite, Achilles II de Harlay, and anonymous pamphlet writers. They all point to a metaphoric tradition within humanist discourse that gave the studio performances of the painter a unique authority. Using the language of the painter's studio, historical statements and political acts were validated by the denunciation of seductive sensory effects deemed self-interested flattery. However, rather than celebrating the transparent sign, these participants in French humanist culture valorized the authority of other so-called opaque traces left by the mechanical acts of the painter. In these writings, effort was thematized as material pictorial effects. For Tristan, "the arrangement and boldness of the brushstrokes" were valued over completion and finish. For Harlay, the historian Tacitus was like a painter whose hard

77. Poussin, *Artist's Studio,* c. 1640, red chalk, pen, and bistre on paper, (Florence, Gabinetto Disegni e Stampe, Galleria degli Uffizi, 6121F) 119 × 190 mm.

and rude handling of bold and contrasting effects was exemplary. For the anonymous pamphleteer, the lack of subtlety in the abrupt transition of light and shade provided a metaphor for appropriate political conduct. This traditional set of metaphors had a particular critical function in the struggle for political authority during the crisis of the Fronde.

It is significant that authority for the artist was not derived from disclaiming practice in favor of abstract theory. Indeed, much recent scholarship has turned to Poussin's drawing of an atelier (fig. 77) as a testament to his identification with observation and experimental procedures, rather than theoretical speculation.[71] Poussin's studio was a site of work, a fact obscured by early biographers' attempts to overstate the artist's "nobility" (an artist without chalk holding a book). While Poussin's drawing of a studio may trace his experiential approach to theoretical concerns, as a diagram it also represents a site of directed labor and useful procedures, constructed out of a provisional system of lines and erasures that betray the schematic pragmatism of a *bricoleur.* The drawing represents what Poussin called *soin*: effort in the service of utility. Difficulty revealed. The painter as an artisan worker garnered a particular authority.

This chapter has already described Poussin's investment of effort in graphic work and its transposition to painting. Not merely drawing upon a homology between an extant artistic discourse and his own studio practices, the artist combined the humanist investigation of ancient material culture (such as French Gallo-Roman studies of the sixteenth century, discussed in Chapter Two) with a form of research into the properties of pictorial effects. It must be stressed again that the rhetorical style that best paralleled Poussin's material treatment of these drawings was largely a development of the sixteenth century that had been revived by a highly selfconscious group during the Fronde. Poussin's mature art paralleled the anti-Ciceronian rhetoric of French humanism in its conspicuous refer-

entiality, not only to antique themes and artifacts but also in its unabashed disclosure of its own constructedness. Pictorial severity was the citation of the already cited. The preparatory drawing was one instance in which obstructions in the ostensibly seamless texture of classical representation obtained a heightened significance. Rather than transparency, an opaque surface provided the material values for a social group. The next chapter describes a painting that constructed the terms of its own address through its opacity.

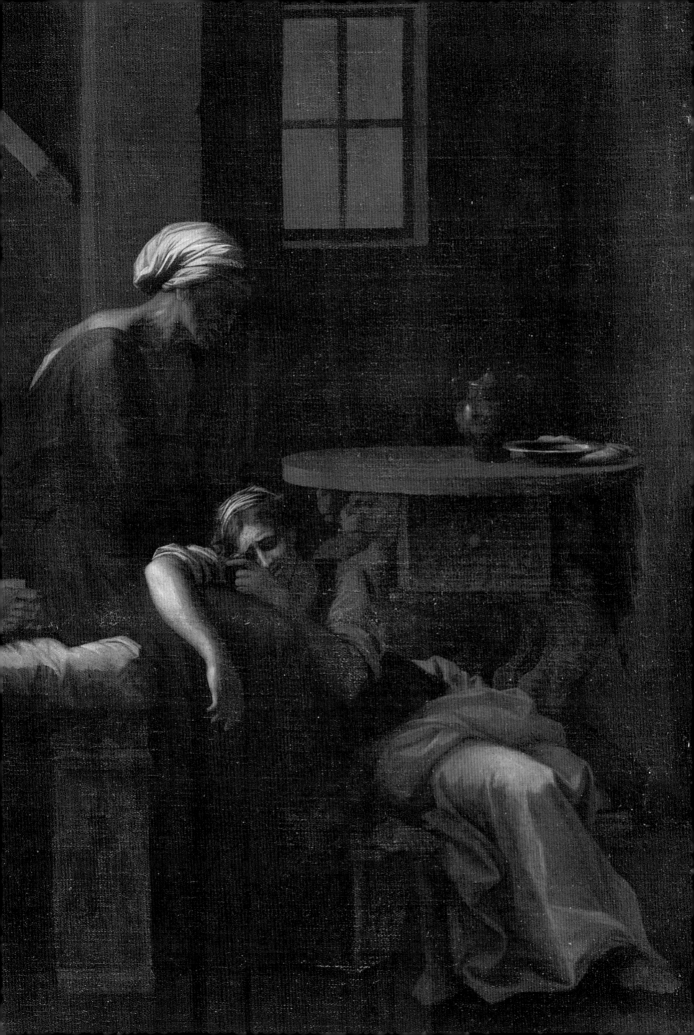

Chapter Nine

Interventions: Painting and Renunciation

I spoke with Monsieur Passart auditor of accounts and begged him to help
me conduct the present business deal. We spoke to Monsieur Lumague about
the delivery of the aforementioned [100] pistoles . . . He said he would have
the letter of credit sent to Rome at a rate of eight percent out of love for
Passart.

Poussin in a letter to Chantelou of June 1641[1]

The *Testament of Eudamidas* was painted sometime before 1650 for Michel Passart
(fig. 79).[2] The Corinthian Eudamidas is depicted on his deathbed dictating his last will
and testament to a notary. With no other property to bequeath, he gives the burden of
his surviving wife and daughter, who mourn at his feet, to his two closest friends. The
legatees accept the obligation. The themes of individual death, familial grief, and the
obligations of surviving friends invite deep meditation on the intimate bonds of family
and companionship. Indeed, the story of Eudamidas is one of a series of anecdotes offered
by the Greek author Lucian on the theme of friendship.[3] Montaigne's introduction of the
story to French readers in his essay on friendship ("De l'amitié"), with its dedication to
a late friend, seems to confirm the personal character of the choice of theme.[4] Yet, as I
have shown, the essay on *amitié* considered the social regulation of male relationships.
In keeping with Montaigne's *Essais*, the story of Eudamidas articulated even the
most intimate of bonds between men in economic terms. *Amitié* was founded on the dif-
ferentiation of men as active agents from women who were passive objects of exchange.
By representing the exchange of women as property in a legacy, Poussin's painting of
Eudamidas also depicted an important cultural and economic practice in homosocial
relationships – the last will and testament. As the contractual agreement brought the
private event into public discourse, so too did the painting represent an intimate range of
behaviors engaged in the production of a legal document.

The Early Modern Testament

The testament, which instated individual and social identity through the posthumous
transfer of possessions, was the most immediate term of reference for Poussin's closest
audience. Indeed, testamentary practice was important for Poussin's own self-definition:
he drew up no less than three during his lifetime, in one of which the executor was his

78. detail of fig. 79.

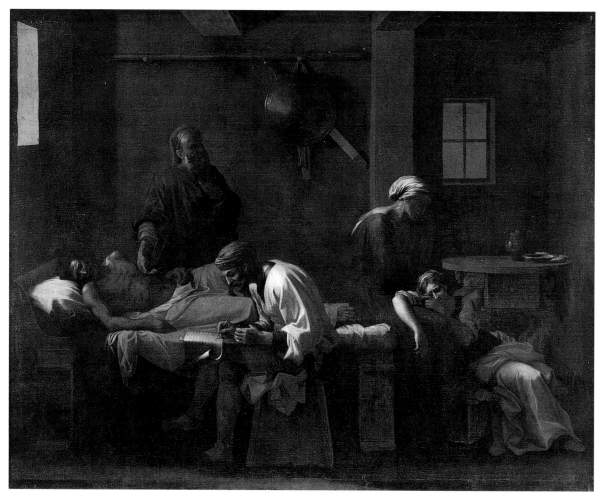

79. Poussin, *The Testament of Eudamidas,* 1645–50, oil on canvas (Copenhagen, Statens Museum for Kunst) 1105 × 1385 mm.

client Pointel.[5] The testament defined the self in terms of social bonds and also attempted to preserve that identity beyond the death of the individual, providing for Christian masses as well as transmitting movable property and the attributes of social rank (offices and titled fiefs). More generally, the testament also provided an important metaphor for historical transmission and reproduction, as in the case of Montaigne, who reflected upon his writings as his legacy to the reader in the absence of a male heir.[6]

The testament was often associated with the deathbed spectacle, known as the *beau morte*, which accounts for the stress on the behavior of Eudamidas in Poussin's painting. The document was a significant element in the dual performance of dying and writing. Emphasis was placed not on the text as a moribund document but, rather, on the ritualized practice which converted the last speech into exemplary artifact. In the majority of French seventeenth-century testaments, the notary described the legator as the "recumbent figure on the sick bed."[7]

As a textual practice that stressed social continuity and the conservation of economic and cultural resources, the testament was also a critical site of contention and transformation. Its public currency gave it a political significance. The politically charged nature of seventeenth-century French testaments is evident from the legal challenges to legacies, such as those that occurred after Richelieu's death.[8] The trials over disputed testaments were litigious spectacles that were avidly followed in print by a large public. As shown earlier, in the pamphlet war of the Fronde the testament permitted an assess-

ment of the integrity and social position of individuals. In Robert Arnauld d'Andilly's *mazarinade* entitled *La verité toute nue ... (The Naked Truth)*, the legacies of actual financiers under Richelieu are cited as evidence of their massive accumulation of money at the expense of the nation; after listing a few of the financial "monsters" and "harpies," the author stated that it would take too long to name those only known by the "sumptuousness of their banquets, the luxury of their way of life and of their furniture, and the magnificence of their buildings."[9] In another *mazarinade*, a fictitious testament attributed to Mazarin was used as a similar measure of the cardinal's avarice, providing yet another opportunity to issue an inventory of his lavish and lascivious objects.[10] The attentive description of his possessions lent veracity to the counterfeit document: the cardinal left a silver vase engraved with figures and encrusted with diamonds for a startling 50,000 livres (Poussin's largest paintings were valued at 1500 livres);[11] and again, he bequeathed to Condé a cupid raised on a column supported by two lions embraced by marine creatures. This grotesque fantasy laced with precious stones was valued at the same exorbitant price.[12]

The pamphleteer structured Mazarin's incriminating legacy in accordance with the rigid stylistic formula for testaments of the period.[13] The conventional compositional structure of the testament began with a preamble, proceeded to an invocation, which was followed by provisions for the funeral, the election of a burial site, and the request for subsequent masses. It concluded with a legacy that conventionally began with charitable donations. In the case of Mazarin's fictional testament, the religious sentiment was cursory and the donation was meager, leaving only 100 livres for twelve masses. Although the specifications for the funeral were left to the discretion of Anne of Austria, the demand for an excessive level of pomp was implied by the request for a sumptuous reliquary, enriched with stones, costing 80,000–100,000 livres.[14] There was a donation to the poor but, in return, forty-eight of these miserable souls were each obliged to bear a white torch in the pompous procession.[15]

Seventeenth-century readers would have been attentive to this combined avarice and ostentation. Not only would they have been sensitive to such issues in the context of the cultural criticism of theatrical spectacle and Mazarin's collection, but there was also a contemporaneous testamentary discourse that opposed ostentatious ceremony. Testaments emerged that laid stress on the preliminary spiritual clauses and diminished the importance of the burial rites.[16] At the very moment that the spectacular funeral cortege appeared on the cultural landscape, there emerged a counter-discourse that a modern historian has called "ostentatious humility."[17] While Mazarin's pseudo-testament recalled the procession of two thousand torches for Cardinal Richelieu, the austerity of the *Testament of Eudamidas* resembled oppositional cultural practices and testamentary discourse.

The conspicuous restriction of ostentation was a prominent testamentary practice expressive of a more personal mode of behavior – the holographic testament. Instead of using the intermediary of a notary, the legator wrote the testament in his or her own hand (health permitting) and the document was produced before an individual rather than the conventional set of witnesses and an official scribe. Such testaments emphasized individual obligation rather than communal ratification and display. They selfconsciously renounced pomp, sometimes going so far as to request burial in a pauper's ditch. Furthermore, although this type of document had its own conventions, it was written in the legator's own handwriting and permitted a less formulaic expression of spiritual and material desires.

This textual practice was exercised as a sign of devotion to the principles of humility by some members of the clergy. But the holographic testament was also an important

expression of the culture of the *noblesse de robe*. For example, the prominent art patron Nicolas Lambert in his holographic testament bequeathed the *hôtel* constructed by Mansart to his own brother. The possible owner of two of Poussin's paintings (and protector of the Académie), Châteauneuf entrusted his estate to another documented collector of the artist's work. Châteauneuf prepared his own brief testament and left the responsibility of execution largely to Pomponne de Bellièvre.[18] Most significantly, Michel Passart, the client who commissioned the *Testament of Eudamidas*, did not use the services of a notary in the execution of his own testament. Instead, he left his own handwritten instructions to his survivors. The text afforded an opportunity to express his spiritual needs and his disregard for ostentation. After some preliminary statements, he commenced his instructions with the following phrase: "First I recommend my soul to God imploring his infinite mercy for the forgiveness of my crimes."[19] In keeping with the emerging conventions of this testamentary form, Passart restricted the number of funerary candles to twelve and refused any *service solemnel* in the cursory instructions for his burial. He echoed the testament of his late wife, who on the date of her own death requested that she be buried with extreme "modesty and without ceremony."[20] Passart went on to argue explicitly for the renunciation of ostentation because pomp, according to him, satisfied the vanity of the living more than it offered any consolation for the dead. He therefore requested only the necessary number of masses for his soul.[21]

If we consider the *Testament of Eudamidas* in the light of the original owner's own holographic testament, the two artifacts are compatible despite the painting's inclusion of a notary. Both documents restrict luxuriant effects and spectacular ceremony and thereby give privilege to severity and a restricted social world. Poussin was once again handling available cultural materials and behaviors practiced by his clients. But it is also significant that decades after first commissioning the painting of a testament, Passart's own document sought some of the same effects as the painted counterpart. The picture may have exerted pressure upon the client's practice and not just the other way around. It is also important to stress that the holographic testament was not a dominant cultural form. Passart's and Châteauneuf's marks on parchment belong to only a small minority of those whose last will was not mediated by a scribe.[22] The painting similarly does not reflect a homogenous culture. It is the document of an elite.

Social Practice and Self-Reflexive Painting

The testamentary form also served Poussin as an analogue for the painting. The canvas, like the document, defined the relationship between the addresser and his client as recipient. Each exchanged object provided a narrative of instruction, interpretation, and obligation. The portable picture, divested of its fixed architectural support, depended upon its theme to situate its significance. In this way, Poussin's easel picture resembles those literary texts that attempt to ground their interpretation by situating the utterance in a self-reflexive narrative of storytelling (in the same way that the *Landscape with Diana and Orion* also situated itself within Passart's collection through Lucian's discursive frame).[23] In Poussin's *Testament of Eudamidas*, the social relationship constituted by a gift exchange thematized the transaction between painter and audience. In other words, the depiction of a practice that was concerned with the definition of social relations through material transaction provided a way to articulate processes of artistic production and reception.

80 *(left)*. Poussin, *Three Studies After the Antique: Eros and Demeter, Detail of the Base of a Column and Hercules Carrying a Tripod*, c. 1635, pen, brown ink, and brown wash (Bayonne, Musée Bonnat), 244 × 178 mm.

81 *(right)*. Poussin, preparatory drawing for *The Testament of Eudamidas*, c. 1643–45, pen, brown ink, and brown wash on paper (Hamburg, Hamburger Kunsthall, inv. 24035), 128 × 193 mm.

Poussin's painting is an inventory of received objects. Looking at the picture as a testamentary task, a notary of the seventeenth century would have made fast work of it. A pike, sword and shield, an old bed, some linen hardly worth mentioning, a table ornamented by carved legs with ceramic pot and metallic plate, a couple of stools. No tapestries, paintings, cabinets, or books are visible. Even the odd jewel bedecking the wife or daughter is absent. The women's simple clothes are devoid of ennobling detailed work in precious threads. The accouterments of the invited guests, the notary and the physician, act as foils to the decidedly impoverished household. Glancing at Eudamidas's possessions, the notary would assume the dying man's testament required only a brief general clause bequeathing all property to the heirs.

The material poverty of Eudamidas's personal property is homologous to the painting's depletion of thematic variety, narrative plenitude, and active handling of the painted surface. The painting encourages the observation of a series of perceived negations. Dramatic engagement and narrative elaboration are lacking. There is no shared visual engagement among the participants. No circuit of gazes conveys psychological states or social interactions.

By contrast, in several earlier paintings by Poussin, a series of actions emanates from a central event, offering different states of awareness and response. For example, in a complex figurative composition, such as the *Gathering of the Manna* (see fig. 37), the artist displayed his capacity to represent a multitude of expressions. Some fight out of hunger. Others admire the prophet. In some figures, the lack of awareness marks the prelude to knowledge of the event. The different stages of awareness of the event signify the passage of time. In the *Testament of Eudamidas*, by contrast, movement and temporality are hardly introduced. The recumbent Eudamidas makes his utterances. With his sloping back turned to the grieving women, the notary transcribes, attentive only to the page, the sound of the voice. The standing man holds his hand to his own chest, the other to the chest of the recumbent figure. Mother and daughter are cut off from the masculine group and their finely tuned gestures – the quill scratching scroll, the physician's surveillance of the dying flesh as he compares pulses. The women touch each other but there is

no other confirmation in speech or gaze of their shared yet different experiences. By comparison, even Poussin's drawings after antique reliefs seem multifarious and spontaneous (see fig. 1).

While other paintings by Poussin pass on the rich inheritance of classical antiquity, here the references are abbreviated. There is no staffage of river gods. Nor does an archeologically profuse topographical description of an antique city avail itself to us. Value does not reside in a profuse catalogue of artifacts, tools, or ritual implements. The inclusive compendium of ancient statuary one finds in *Gathering of the Manna* is abandoned for a field of selected fragments. The shield and pike on the wall as well as the leonine carving on the table leg were extracted from his sheets of ancient motifs. The compositional group of mother and daughter was based on a Roman altar type, recorded in a drawing (fig. 80). In a study for the finished painting, the reference to the antique sculpted representation of woman and child had been more explicit (fig. 81).[24] After making the figures conform to the text (the daughter is now a marriageable adult), the painting nevertheless repeats the structural relationship of the ancient formal typology, thereby distilling the composition of the antique referent. The carefully selected architectural member or implement represents only one object in a set of possible archeological fragments. The rigid structural imperative of the horizontal line of pike, circular shield, and finely tuned diagonal sword is an index to the epistemological and formal organization found in Poussin's antiquarian drawings. Reference to both source and archaic pictorial organization does not offer a seamless fiction of antiquity. Rather, stress is placed on a disciplined process of selection and elimination. If any excess can be designated within the pictorial field, it is reserved for the austere still life in the ancillary space. Free play is restricted to a limited set of impoverished objects.

Eudamidas utters his last testament. The viewer witnesses the document. The dying man's expression of his posthumous desires conforms to the formulaic constraints of a highly conventionalized genre, the last testament. But if the depicted testament's form is conventional, its content is not. Like all wills, it identifies the legacy, the legatees, and the executors. But in Eudamidas's equation, the normative heirs, his survivors, have become the property or legacy. According to Lucian's narrative, Eudamidas leaves his wife to one friend and his daughter to another. One friend will have to care for the mother, the other will supply the daughter with a dowry. The intimate friends are thereby both executors and inheritors. Eudamidas is articulating the conventional formula of testaments while breaking with normative expectations.

As in all testaments, an obligation is placed upon the legatees and the reader or viewer to interpret the last act of Eudamidas. The depicted document, the parchment on the scribe's slate, represents the participation of a larger interpretive community. Through the sustained customs of dictating a testament, a person's private speech enters the legal apparatus – the testament only acquires its meaning from its circulation and verification in that community. I must stress that normatively, the significance of a testament resides in its capacity to exclude multiple interpretations. Meaning is intended to be secured by the entrance of the private utterance into legal formula, by the integrity of the scribe, by the multiple witnesses, and by the surveillance of conventional ceremony. The notarized social document attempts to represent the closure of interpretability.[25]

According to the story, the testament dictated by Eudamidas was not, however, secure in a single interpretation. A larger community of readers of the legal document interpreted the will as a legalistic trick, which indeed it was, taken at face value, or rather monetary value. The dying man Eudamidas transferred property to the living but the legacy he bequeathed was a material deficit. The recipients of his bequest inherited the costly obligation of a mouth to feed and an expensive dowry to purchase.

The community of Corinth, laughing outside the confines of the depicted scene, interpreted Eudamidas's act in terms of accounting, assets and debits, strictly financial losses and gains. But Eudamidas's legatees, his friends who read the document, understood another system of value. For this intimate circle, the greatest gift to a friend was an obligation. The assumption of an obligation – the acceptance of a deficit – was an opportunity to perform the relationship, the friendship. As in paradigmatic kinship structures, the female provides a term to be exchanged between the men, thereby enacting and consolidating their bonds. For Lucian and Montaigne, Eudamidas is the greater friend for providing such an opportunity.

In his testament, Eudamidas has split his address between those close friends who understand and those others who misunderstand. Two audiences are therefore inscribed in the tale: the appropriate addressees and those excluded. Moreover, if Eudamidas had not initiated the process of misinterpretation within the larger community, there would not have been any occasion for interpretation. Indeed, "reading" is a socially constitutive activity. The appropriate or correct interpretation differentiates the friend/legatee from that larger body of individuals (the uninvited). The operation resembles irony as an enunciation split between two interpretive communities that is parasitically dependent on misinterpretation. The painting must be "read well," that is to say understood "otherwise" than what it immediately "says."[26]

The tale of Eudamidas was a self-referential theme for the painter and his audience. The stress on a bond based on an exchange was relevant to the relationship between artist and client. The imbedding of an act of interpretation within the painting provided the artist's immediate audience with a representation of their own viewing practice. Rather than a monetary transaction, a painting was offered to viewers who reciprocated in turn by accepting the burden of interpretation. The acceptance of the terms of the exchange differentiated one viewing audience or interpretive community from another. Those who misread Eudamidas's testament were like the critics of Poussin's paintings who only saw a lack of ornament (*simplicité*), or "hard, dry, and immobile" forms; only the appropriate audience valued the difficult terms of the exchange. The artist, in turn, was aggrandized by this inclusion in an economy that neither sought to flatter nor attempted to incur favor or monetary reward.

This bifurcation of interpretation was not unique to this painting in Poussin's oeuvre. In a number of other paintings, Poussin represented crises of interpretation. In *The Judgment of Solomon* (see fig. 75), painted for Jean Pointel in 1648, the king searches for the truth by telling a lie. He judges the claimants by telling the court that he will sever the baby in half and divide it between the two alleged mothers.[27] Poussin represented the horrified responses of the rigid series of attendant witnesses flanking the monarch; according to Josephus, the crowd was outraged by the irrational behavior of their prince. The court misinterpreted the gesture, but the wise ruler (and select advisors) understood the judicial value of the test. The true mother denied her own maternity in order to save the child; she returned the lie with another. The thematic and formal brutal severity of the painting, which seemingly appears to offer an unambiguous didactic message, ultimately investigates the anxiety over the interpretive act, its fallibility and the recovery of interpretive authority by the king. Even if meaning is inevitably secured, it is only after a crisis in the capacity to read visual signs and an encounter with discomfiting formal severity.

In at least one other painting by Poussin, there is a similar crisis in the capacity of the human body to signify. *The Saving of the Infant Pyrrhus* (fig. 82), painted in 1634, represents human gesture as an arbitrary rather than a legible sign. In the story of the flight of the child king, the protectors ran up against the obstacle of a river. Pursued by the enemy,

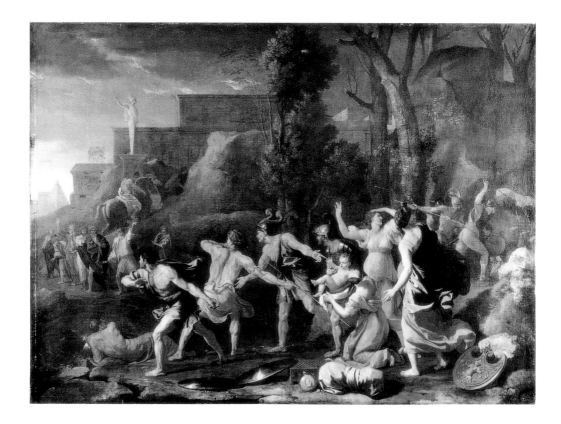

82 *(above)*. Poussin, *The Saving of the Infant Pyrrhus*, 1634, oil on canvas (Paris, Musée du Louvre, inv. 7292), 1160 × 1600 mm.

83 *(right)*. Charles Errard (after Poussin), "Figures Throwing Objects: a Javelin and a Stone," (based on a drawing, c. 1637, Milan, Biblioteca Ambrosiana) illustrated in Fréart's translation of Leonardo da Vinci's *Traité de la Peinture*, Paris, 1651 (Paris, Bibliothèque Nationale).

they sought the help of the astonished foreign crowd across the river, but the communication by voice was obscured by the noise of the torrent. The static produced by the roaring water forced the invention of other communicative acts. Waving and pointing had limited efficacy. The players resorted to writing. According to variant traditions, the urgent message was physically transmitted to its intended audience by either spear or rock. Poussin decided to provide visual representations of each of these textual alternatives; one man throws a javelin, another a stone. He thereby drew attention to the substitutive character of the narrative elements and the uncertainty of the truth of the textual variants. Alternative histories are held in suspension. Although the narrative function of the two figures is redundant, Poussin's repetition of the two men permitted a diagrammatic comparison of their respective anatomies. Poussin recognized the analytic function of these figures when he made drawings after them for Leonardo's *Trattato della pittura* (1651), where the actions of throwing stone and javelin were studied (fig. 83).[28] Engraved by Errard

and set in Fréart's translation of the *Trattato*, the isolated figures A and B are experiments in the study of movement extracted from narrative purpose. In the painting, however, the two armed men launching missiles offered other interpretive possibilities from the perspective of the crowd across the river. Do the recipients of the messages begin to grasp the entreaty or are they repelled by the sight of oncoming projectiles? The request for help takes on the appearance of an attack by stones and spears. From our vantage point, the crowd on the other shore is in disorder. Does that illegibility signify violence or uncertainty? Without the text in hand, distance and the static caused by the raging current obstruct the capacities of gesture and speech on both banks. The river divides a set of possible interpretations. The movement of the expressive human body is dissociated from one fixed signification. Noise is productive. It does not merely block communication but rather produces the conditions for interpretation.[29]

So too in Eudamidas. The gesture dictated by Eudamidas seems to be an insult and is taken to be ridiculous by a community. The apparent poverty of the bequest is misunderstood. In the painting, semantic uncertainty is impressed upon the viewer by a systematic obstruction of normative visual cues. As I have argued, in Poussin's ambitious figurative compositions of the 1620s and 1630s, the variety of gestures and glances of the protagonists were coordinated within a complex narrative. In the *Gathering of the Manna*, the series of vignettes offered Poussin a system for representing various states of looking, thereby providing the possibility of a depth of perspectives and temporality (see fig. 37). Each of these units constituted a subordinate narrative. Interrelated glances tied figures to the main theme, a spectacular miracle. The painting thereby offered a certain security or totalization of meaning. By contrast, I have argued that in the drawings and paintings of the 1640s and early 1650s, Poussin sought to restrict narrative plenitude. In a work such as the *Death of Sapphira*, the vignette was displaced by a chain of figures (see fig. 74), and responsive glances and expressive gestures are reduced. The painter achieved a careful simplification of the economy of represented vision, expression, and movement. In *Moses Trampling on Pharaoh's Crown*, the women's responses and entreaties in the face of infanticide are caught in a deadlock of self-effacing gesture (see fig. 68). But rather than semantic clarification, this process of elimination resulted in a disruption of the promise of legibility. The *Testament of Eudamidas* is Poussin's most radical articulation of this aggressive reduction of narrative devices and anecdote found in several paintings. In this picture Poussin systematically refuses to depict sight and movement. Fleeting glances are displaced by fixed stares with no object. The anecdotal potential of the deathbed scene (exploited a century later by Greuze) is frustrated.

Poussin's refusal to represent a responsive viewer is most evident in his representation of the mother and daughter (see fig. 78). In *The Death of Germanicus* (see fig. 8) and other scenes where women respond to a reclining male, they perform the role of tragic chorus. Such paintings participate in one of the primary expressive structures of the Western tradition – the gendered syntax of the beheld crucifixion and the pieta. In *The Death of Germanicus*, the mourning women and children occupy a distinct space apart from the active, oath-taking men. But in Eudamidas, the object of grief, the dying male, is not immediately beheld. Poussin has taken the female who weeps into a cloth at the end of the bed in both versions of the *Extreme Unction* (see figs. 70 and 71) and turned her away. The daughter collapses, taking on the burden of emotion. But the mother obstructs her daughter's view of the dying father.

There is, in fact, an insistence on the lack of involvement of the women, their extraction from a conspicuous economy of bequest and mourning. One might surmise that the women's lack of participation conformed to contemporary social codes excluding them from an active transmission of property. Indeed, the story stresses that the women are

passive objects of exchange among men. The abstention of the women as witnesses to their own transferal as property even seems to conform to contemporary legal practice. In Paris, women were not considered reliable witnesses for testaments because of their fragility and because they were "a mutable and inconstant sex."[30] According to customary law as it was understood by Passart, therefore, Eudamidas is alone in the room with one witness, the standing man. However, the passive role prescribed by text and image goes against the evidence of the actual behaviors of men and women in the seventeenth century. While women were in theory excluded from the role of witnesses, they were conspicuous as legators in testaments because they enjoyed power over heritable property. So, Poussin's insistence on their exclusion – the way the mother's sloping back appears to cut off social intercourse, the obstructing shadow on her face, the preponderant silence – cannot be deemed a simple reflection of social mores.

It is possible to interpret this insistence as a compensatory representation, seeking to manage certain social anxieties regarding the actual economic power of women. In seventeenth-century Paris, widows in particular had considerable economic power.[31] As early as the seventeenth century, Paris was becoming a city of women.[32] This is registered in testaments as well as other textual sites, such as the frequent inscription of *Chez Veuve* as the publisher on seventeenth-century titlepages. A random selection of notary records provides a regular rhythm of signatures belonging to women. Female heirs who married also asserted individual property rights in order to protect their family legacy.[33] As one *mazarinade* quipped, Paris was "heaven for women, purgatory for men and hell for horses." A contemporary satirical print similarly betrayed an anxiety over the economic power of women by depicting a topsy-turvy testament of Eudamidas. A motley group of witnesses surrounds a woman's disorderly leaving of "property": the obligation to take care of her cat and dog (fig. 84). By contrast, in Poussin's painting, power is solely invested in the male executors who become inheritors. The widow and daughter only inherit the protection of the male friends. They are effectively removed from the ritual transfer of property. Instead, as in the *Continence of Scipio*, which was also in Passart's collection, women are the commerce of men. The obligation, incurred through the custodial relationship to a passive subordinate, also echoed the theme of *Camillus and the Schoolmaster* in the same collection. According to Poussin's representation of homosocial bonds, as in Montaigne's essays, women (and children) were excluded from *amitié*.[34] However, such exclusion ultimately served to regulate the relations of men, which was a source of anxiety, as in the accusations of sodomy and pederasty against Mazarin. The exchange of a woman regulated male–male intimacy or, as in the *Self-Portrait* owned by Poussin's friend Chantelou, represented a displaced form of intimate contact (see fig. 40).[35] If the recipient of the embrace in the self-portrait personifies painting, then the painted object exchanged between men over distance was a testament to their *amitié*.

The *Testament of Eudamidas* also represents the displacement of women within another economy – the gendered economy of Poussin's paintings. If women conventionally functioned in pictorial representation as legible signs of expressivity, as necessary responsive terms that articulated the narrative, Poussin here obstructed this role. When women were assigned active roles in Poussin's numerous other pictures, it was as observed viewers. *The Rape of the Sabines* concerns the legibility of internal states of women as they respond to impending sexual violence (see fig. 10).[36] *The Judgment of Solomon* is the depiction of a man reading women as spectators in a theater of terror, where passionate expression betrays motherhood (see fig. 75). The *Death of Germanicus*, as well as the representations of the *Extreme Unction*, similarly represent this circuit of masculine display and female expressivity.

84. Anon., *Le Testament de Jeanne,* c. 1650, engraving (Paris, Bibliothèque Nationale).

In the *Testament of Eudamidas*, we do not witness the relationship between the woman's look and her responsive gesture. This is not to say that the women do not function as mourners. Indeed, the mother and daughter express grief while the men go about other tasks. But the normative visual interaction between exposed male body and the corresponding displayed gestural body of a depicted female observer is frustrated. The representation of the survivors of Eudamidas departs from the depiction of the expressive entourage in *Coriolanus Entreated by His Mother* (see fig. 54). I have already argued that the rhetorical structure of *Coriolanus* was based on active, emotive women, in conformity with current political discourse wherein women provided a figure for expressivity and disinterestedness. In the *Testament of Eudamidas*, Poussin reduced this available pictorial language and checked this source of narrative plenitude and metonymic elaboration.

If the two female relatives of Eudamidas can be described as divested of their actively responsive function, then what of their male counterparts? Poussin avoids representing the two heirs at the deathbed scene. The potentially dramatic interaction of friends is avoided (repeating the theme of displacement and the absence of physical contact in the Louvre *Self-Portrait*). The distant friends will have to rely on the document (the object that mediates) and the testimony of the available witnesses. Poussin puts in their place the doctor and the notary. The two deathbed technicians survey pulse and speech. One is making a prognosis, the other records words. The public scribe's sole response is the careful transcription of sounds, the repetition of language. These attendants – friends by proxy – appear detached and disinterested. As much as their tasks are clearly delimited by the brush, there is no disclosure of their interiority. The gestures are performative rather than expressive.

The efficacy of vision is not valorized. Moreover, observation is made difficult for viewers of the painting. In spite of compositional clarity, there are few visually apprehended certainties. The doctor stares off, concentrating on that comparative touch. The women are refused the sight of the body. The dying man's capacity to perceive his surroundings remains uncertain. That leaves us with the man with the quill (see frontispiece). With his eyes intent on each stroke of the pen, it is his occupation to be certain that the visual apprehension of his own codified calligraphic movements insures the reliability of

the language. It also assures us that his attention is sufficiently drawn to that testament so that he sees nothing but the ink on vellum. Only text seems to provide some degree of certainty. Knowledge avails itself to the reader. Yet according to Lucian and Montaigne, the text entered the interpretive community and divided its audience. Like the reader faced with the apparent transgression of the practice of inheritance, the viewer of bodies and gestures has little in the way of assured legibility.[37]

As in *The Saving of the Infant Pyrrhus* (see fig. 82), voices fail and the gestures are insufficient to communicate. In the earlier painting, the body requires a supplement – the text tagged to javelin or rock. Similarly in the *Testament of Eudamidas*, the surveillance of the expressive body yields little. Movement is negligible. When Le Brun later sought a model of physiognomic expressivity, he turned to Poussin's representations of the *Massacre of the Innocents*, his earlier investigations of female expression and the legibility of the terrified body.[38] By contrast, the *Testament of Eudamidas* resists immediate semantic availability.

This visual uncertainty and doubt relates to the depicted theme of interpretation. Eudamidas's testament is subject to radically different interpretations. His document is read by the community like the words of Solomon or the gestures of those figures on the opposite shore from the infant Pyrrhus. All of these paintings – the *Judgment of Solomon*, the *Saving of the Infant Pyrrhus*, and the *Testament of Eudamidas* – resist a single enunciation. Against certain expectations, Poussin's paintings are not simply "readerly" (in Roland Barthes's sense of a text advancing a single meaning). This is not to say, however, that interpretation loses its rigor. Crisis is not resolved through polyvalence or simple ambiguity. In the narratives of Solomon and Eudamidas, the temporary crisis is resolved by the identification of an appropriate reading and its corresponding audience. A crisis in interpretation ultimately results in the recuperation of a reading designated as correct, or at least limited in its scope. The *Testament of Eudamidas* performs the double function of enacting interpretation or readability as a socially constitutive practice and at the same time securing a reading for an elite.

The Painted Legacy and the Legacy of Paint

The stress on an exchange in the *Testament of Eudamidas* not only defined an audience but also proposed a reciprocal relation between artist and client. In exchange for support, the artist offered an obligation which was no easy task: to interpret the work. As in all of Poussin's pictures, the *Testament* invited the performance of cultural practices shared by painter and client: the viewer assumed the burden of recognizing the citation of Lucian and Montaigne. But there was another debt incurred in the offering. Poussin presented to his client a canvas that displayed its selective technical impoverishment and lack of narrative incident. The normative terms of value – the contracted number of figures, displays of skill, the pleasure of a fluency in painterly effects – was wanting. As a picture without such signs of painterly facility, the work was subject to criticism and the clients were potentially compromised. They had foolishly purchased objects that flaunted hardness, dryness, and immobility (these were the formal characteristics that Charles Perrault identified as those held against Poussin's work). However, by purchasing the pictures, the recipients acknowledged the value of taking on such an obligation: the work's difficulty. Difficulty here signifies both the semantic demands of the theme as well as the boldness, even crudeness, of the abbreviated forms (these were the terms used by Harlay and others during the Fronde). They were willing to risk being misunderstood by the larger community in

order to express the differing, often resistant, values they shared with the artist and among themselves as a select group.

I am arguing that Poussin's conspicuous set of refusals, the ways in which he displayed the deprivation of some of his skills, was part of a set of formal decisions made in response to the demands of his immediate clients and his identification with a particular culture. The aesthetic values demonstrated by Poussin's paintings obtained their significance against other values. If we understand the terms hard, dry, immobile within a structural set of oppositions, we might say that the painter sought to evacuate pliancy, fluidity, and movement from his compositions. Of course this structuralist conclusion risks arriving by a circuitous route at another way of describing universalizing Wölfflinian categories for the Baroque and its antithesis. In order to avoid merely recapitulating a formalist dialectic, I am stressing that Poussin's pictures were understood in opposition to other objects within a specific visual culture. The historical description of formal oppositions requires the use of the past tense and an insistence on the historical situatedness of real or imagined antithetical viewing practices.

In the *Testament of Eudamidas* Poussin depicted a tale of misunderstandings. The distance between the true friend and the excluded other was measured by who got the point. Similarly, an appropriate community of viewers was identified in contradistinction to an excluded viewer who misunderstood Poussin's formal criteria. The groundwork for the notion of an audience excluded from Poussin's painting – a repudiated third party outside the exchange of artist and client/addressee – has already been prepared in the discussion of the criticism of Mazarin's cultural activities. The reader/viewer risked dissolution by participating in the viewing practices defined in the fictional inventory of Mazarin's collection. The text thereby defined an appropriate practice by representing its contrary term (Mazarin). As in the case of the *curieux* subjected to the sensory disorder of Mazarin's collection, Poussin's excluded viewer constituted a social as well as a political category. Both rigorous viewing and the acceptance of difficulty were understood as participation in a discourse counter to luxury. While the beholder of Mazarin's collection sought material plenitude and an immediate apprehension of rich effects, the viewer who accepted the contract of the *Testament of Eudamidas* systematically refused these viewing practices.[39]

Poussin investigated in this painting how differential perceptual capacities and patterns of attention were constitutive of social distinctions. The production of a work of art that is highly self-reflexive about the terms of its own status as a perceptual object arises from particular pressures put upon it to make distinctions among its addressees. One would expect that this degree of self-reflexivity would have been reciprocated by the development of an artistic discourse that was similarly organized according to distinct perceptual behaviors. Indeed, if Poussin's *Testament of Eudamidas* was a demonstration of theory in practice, inviting the exercise of a critical language, there is also evidence that Poussin and his clientele selfconsciously articulated the problems of reception and the pressures put upon perception.

Duration and Attention

The Maison Carrée at Nîmes (see fig. 21) has already been explored as an example of the ways in which the description of Gallo-Roman archeology was put to political use. A sixteenth-century author was attentive to the style of the architectural structure in

order to arrive at an account of the building's historical function: the simplicity, relatively modest scale, and lack of imperial decorum identified the building as appropriate for civic, public architecture.

Poussin took up the topic of this building when in responding to one of Chantelou's letters he described revisiting the Maison Carrée:

> I am certain that what you say is true; this time you gathered with more pleasure the flower of the beautiful works that you had previously only seen in passing, without reading them closely. Things of perfection must not be seen with haste but with time, judgment, and intelligence. To judge them well requires the same means necessary to make them.[40]

He concurs with Chantelou that the beauty of the ancient columns in Nîmes is not immediately apparent but becomes evident upon reflection. He groups the columns into a larger category of visual objects in order to describe the processes of reception. He admits that some visual stimuli occur unnoticed, especially in the haste of perceptual life. Chantelou had initially passed the columns without giving them the requisite considered attention. But when time, judgment, and intelligence are applied to the same perceptions, the object is "read well." In the text, reading (*lire*) is a strategic metaphor. It does not signify the particular discursive properties of a referential image (for the columns are not textual in the sense of represented figures, emblems, and narratives). Instead, in Poussin's utterance, reading is an activity denoting the difference between sensation and perception.[41] In Poussin's usage, reading signifies vision regulated by cognition through duration.[42] In his discussion of the reception of antiquities, pleasure is derived from seizing the epitome of beautiful works previously merely glanced upon. Through the act of re-viewing, there is an obligation put upon the viewer to match the labor of the artist: "To judge them well requires the same means necessary to make them." Viewing is a difficult enterprise.

Part of this labor is the visual appropriation of the neglected object. According to Poussin, the Maison Carrée did not initially seem to warrant concerted attention. In fact, since the sixteenth century, the building had been understood to be a modest affair. Poussin by contrast recognized its value despite its sparse decoration and restrained effects.[43] By valuing the humbler architectural project, his theory of reception was bound to an appreciation of productions that did not boast high decorum. This is consistent with his own appraisal of the demands put upon him for the Louvre project. The renunciation of flattering forms and excessive ornament yields superior beauties based on other criteria.

Poussin renounced one kind of authority derived from antiquity – luxuriant decorum – and thereby did not accept a direct and necessary correspondence between hierarchical social positions and their corresponding visual signs inherited from sumptuary codes. By extension, painting did not have to accept this system of material values. Social elites were therefore capable of being defined and represented in different ways within the field of painting practice. Poussin cultivated other kinds of authority.

The value of architecture, for Poussin, ultimately resided in the judgment of the viewer, not in the building's function. Left to the immediate consideration of sensory effects, the building would exist in the periphery of experience. The columns would have been cast out of memory. Poussin mutually enforced the authority of both object and subject in a single gesture. He stressed that reception required a mental operation and this necessitated sustained engagement in the task of observation, consideration, and judgment of formal elements. The viewer had to match the painter's own dedication to effort (*soin*) and therefore had to avoid expedient effects (paintings made overnight).[44] The columns of the Maison Carrée were carefully evaluated and deemed exemplars for further observation and comparison by an interpretive community.

Although this pattern of reception was highly disciplined, pleasure ("the flower of beautiful works") was not denied. Ultimately, the columns were compared to other more immediate objects of desire: "I am certain that the beautiful girls that you have seen in Nîmes have not less delighted the mind through sight than the beautiful columns of the Maison carrée seeing that these [columns] here [in Paris] are only the old copies of those [in Nîmes]."[45] Duration enabled the delectation of the mind through vision. In the end, the pleasure derived from column-gazing was equivalent to that achieved by the sight of beautiful women. In the same sentence, priority was given to the Gallo-Roman architecture over the less authentic examples of Paris. The artist in the modern capital city longed for provincial women and primitive forms. Comparative archeology, patriotism, and male heterosexual desire were mutually inscribed. But again the postponement of gratification was given priority. As in the *Continence of Scipio*, woman was represented as an object of desire in order to be repudiated. The relationship among men/viewers was secured.

With Gallo-Roman columns as his immediate object of criticism, Poussin was mapping out a theory of reception. He described a viewer who refused ease, quick satisfaction, and sensory gratification. Instead, pleasure was obtained through an obligation to labored viewing that matched the effort of the painter. The viewer's relationship to the artist was thereby constituted through this difficulty. Poussin's valorization of one kind of viewing implicitly constructed its counterpoint, the undirected sensate viewing subject. Another spectator, who never brought the Maison Carrée into cognitive experience, was always already at the margins. This other viewer had more immediate demands.

The set of values inscribed in Poussin's theory of reception may be measured against the epistle to the spectator at Mazarin's production of *Orféo*: "Spectators will have much more pleasure if they are surprised by the theatrical machines and the play's rich variety of decorations and changes of scenery than if they know about these things before seeing it all."[46] Poussin's assertion of the practice of re-reading (to know in advance of seeing) offered a stark contrast to the values of immediate delight and the pleasures of the unknown. Surprise and spectacle were displaced by a mental operation and formal order.

Difficulty and Opacity

The cursory theory of reception as Poussin applied it to a column was taken up again more thoroughly at the end of the decade by Roland Fréart de Chambray in his *Parallèle* of 1650. In Chapter Five I considered Fréart's text as a portrait of Sublet des Noyers that invested Poussin's Grande Galerie with symbolic import during the Fronde. The *Parallèle* also derived its oppositional value from its theoretical differentiation of viewers and viewing practices.

Fréart discussed the Tuscan order and selected Trajan's Column as an exemplary model (fig. 85). The column's system of reliefs had been intended as the expeditious organizing principle of the decoration of the Grande Galerie, as described in Chapter One.[47] Therefore, Fréart's formal discourse concerning the column was inflected by his overriding eulogy for the administration in disgrace and the failure of Mazarin's government to sustain the culture of the members of the *noblesse de robe*, including the art of Poussin. That which distinguished the members of Fréart's political elite was their considered attention to specifically formal characteristics of the antique column. Fréart writes in his treatise:

If the Reader be intelligent, and [has] attentively viewed, with a masterly Eye, this rich and incomparable Piece which I describe, the Satisfaction he will derive from the accurate Observations I have made, and here present him, will be proportional to his Ability: For in these Particulars our Eyes see no farther than our Understanding [*entendement*] purges them; nor do their admirable Beauties reveal themselves at once, nor to all the World in general; they will be curiously observed and discovered with Industry. There are likewise several kinds which every one considers according to his wit, and as they conform to his *Genius*. Some there are who seek only the Grace and Neatness of Ornaments; others consider the Nobleness of the Work and Novelty of the *Invention*; the most knowing have regard to the Proportions chiefly, and the regularity of the Whole with its Parts, to the judicious Composition, the greatness and solidity of the Design, and such essential beauties as are only visible to the eyes of the most intelligent Archi-tects . . . However, there are more *Dunces* than *able Men*.[48]

85. Charles Errard, *Trajan's Column* in Fréart's *Parallèle de l'architecture antique avec la moderne*, Paris, 1650, engraving (Berkeley, The Bancroft Library, University of California).

In this extensive passage devoted to the reception of ancient artifacts, the superiority of an architectural member is evident only to the "most knowing" who attend to specifically formal concerns. The terms regularity, proportion, composition, and solid drawing con-tinued to be the vocabulary of serious critical discourse applied to architecture as well as painting by the discerning individual in France and England (this seventeenth-century translation by John Evelyn, who saw the Grande Galerie in 1650, had a hand in the trans-mission of Fréart's vocabulary into the English critical lexicon). Within the field of formal characteristics, Fréart privileged the most abstract and rigorous terms above graceful orna-ment and novel invention. Authoritative judgments could only be made by the qualified few against the ground of "dunces."

According to Fréart, that which distinguished a qualified elite and made artistic truths available to them, was their concerted attention. Understanding (*entendement*) was applied to the relentless observation and careful industry that resulted in discovery. *Entendement*, I must stress, was not applied to so-called discursive features; Fréart was not concerned here with the epistemological organization of iconographic materials into an historical narrative. According to him, the pure forms constituted a "rare kind of Language" where there was "no need to write 'This is an ox, a tree, a horse, a mountain, &c.'"[49] He applied a cognitive procedure to specifically formal characteristics, which constituted a field of knowledge. Representation was not transparent but instead asserted its materiality.

Fréart was mapping out a visual culture that was in the process of differentiating itself from other cultural definitions of elite status. He insisted upon the perception of visual

elements as a difficult enterprise, valuing effort and the systematic concentration of intellectual resources. Scholars of seventeenth-century Rome will recognize a parallel demand among theorists.[50] Yet Roman writers such as Bellori responded to specific local, historical pressures, such as the perception of the ills of an art market with its alleged premium on immediate gratification.[51] In France, the value placed on the difficulties of reception enjoyed a history that negotiated other social and political identities. The split between this behavior and its opposite, the promotion of immediate and improvised viewing practices was taken up in the late seventeenth century by Roger De Piles, who, in contrast to Fréart, valorized an ease of perception as a form of resistance to discipline (thus valuing surprise rather than re-reading). But this later division of viewing practices was the result of very different processes of signification in the late reign of Louis XIV. Until then, in the context of the culture of the Fronde, a rigorous practice of viewing was the constitutive behavior of an elite social and political formation.

It might strike some as surprising that I am calling Fréart a formalist but the term helps us understand Poussin and his clientele's specifically material enterprise. Fréart expressed a theory of the autonomy of artistic form several decades in advance of De Piles. But unlike De Piles, that autonomy was not predicated on the valorization of immediacy, surprise, and the *toute ensemble*. Instead, the materiality of art (what I have been calling its opacity) and architecture's constituent effects resisted transparency and foregrounded concerted effort. Fréart's theory of reception registered the values of the seventeenth-century *robe* nobility. While the social prestige and political power of this educated class had been traditionally derived from their monopoly over the acquisition, organization, and storage of textual and iconographic resources, Fréart and his circle laid claim to the perception of artistic forms and the description of those effects as a field of humanist knowledge. What is important to stress here is that Fréart was not describing the study of erudite narratives or allegories requiring recourse to the acquired literary vocabulary of the educated humanist. He was applying the same notions of expertise to a nonlinguistic object. In fact, he was not immediately concerned with the column's saturation with historical plenitude, as well as the potential pedagogical and ethical function of the sculptural program. Nor did the architectural member belong to the same epistemological system as the *cabinet de curiosité*. In Fréart's descriptive catalogue of architectural members, the column was not a sign of something outside itself, like the homologous morphologies of curiosities, but an example within a series of artifacts, each exhibiting qualitative differences. For Fréart, the historical example provided a model for prospective real or imagined projects.

I have already proposed that the values and interests of the *noblesse de robe* were demonstrated in the patterns of collection, arrangement, and discussion of archeological objects. In the context of Fréart's preface, prepared in exile and published during the Fronde, this activity was understood in opposition to the cultural practices of political opponents of Sublet de Noyers and, by extension, of the *noblesse de robe*. As a political exile, Fréart recognized the formal values of Trajan's Column and understood their appropriateness for the Grande Galerie. Meanwhile, the regency chose its own set of objects and left the Louvre project unrealized. The regime allegedly failed to recognize the value of the project as a repository of antiquity because it did not approach the object with the requisite rhetorical skills, knowledge, and understanding. Fréart's division between "dunces" (*sots*) and "able men" (*habiles gens*) was not exclusively social in its field of reference but capable also of describing political organization. Political competency was measured in cultural terms within the theoretical exposition of the exile.

Fréart's tactical social differentiation on the basis of mental operations and mastery over areas of knowledge was far from innovative. But the concerted application of this system

of thought to visual culture and, more specifically, to artistic form reveals the stakes for those participating in artistic practice. Viewing and the analysis of the perceptual activity of sensate subjects was emerging as a form of social distinction. Beginning in the seventeenth century, concerted attention and spontaneity were dialectical organizing principles for defining an elite.

In contrast to De Piles, the demand for prolonged cognitive reflection as a necessary part of artistic reception was taken up by Poussin's young contemporary André Félibien. Keenly aware of the social function of art, Félibien used his reading of a painting by Poussin to make this point: in the *Gathering of the Manna*, the man on the left who witnesses the nursing mother is taken to be an exemplary viewer (see fig. 37).[52] Félibien defines the viewer by conjuring his rhetorical opposite: the coarse and rustic gawker was moved by prurient desires, whereas the appropriate witness was marked by dress and deportment as belonging to a social station that decorously interprets the event, the act of charity by the nursing female. Félibien's reading reveals some anxieties about class and the role of artistic consumption as a means of social differentiation.

Indeed, the differentiation of social actors according to their viewing competencies has been a refrain in my argument. I have shown Lucian in the Roman Hall proclaiming the special prerogatives of the educated viewer, drawn to themes of significant import not to gaudy effects. During the Fronde, Tristan l'Hermite walked through his gallery and differentiated his own discourse from the prattle of cardplayers. Similar remarks were echoed in Poussin's own speech: the natural eye is contrasted with the attentive one. Like the anonymous writer of the *Inventory* who represented the dangers of unreflective viewing for the body politic, Roland Fréart stressed the role of *entendement* to describe the activity of an exceptional viewer who should fully participate in the monarchical state. For Fréart in 1650, the opposition between different viewing practices was understood politically. His theoretical discourse shared in the derogation of certain kinds of aesthetic experience noted in the *mazarinades*, such as the lambasting of the seduced viewer in the fictional inventory of Mazarin's collection. Both Fréart and the anonymous pamphleteer identified and excluded a category of viewer.

These textual operations parallel the thematized division of interpretive communities in the *Testament of Eudamidas* – the dying man's friends and the broader, misunderstanding community. Like the columns of the Maison Carrée, the represented objects (the ceramic vase and plate on the table, the leaden casement window, the clawlike hand of the dying man) were only so many visual stimuli – objects struck by the rays of the eye – without the organizing principle of understanding. The columns were only available to those appropriate viewers who valued study over immediacy. By reducing those features that merely attract and are immediately seen by the "natural" eye (to borrow Poussin's term), the artist constructed an object that addressed the exemplary viewing subject, and thus represented another kind of sensate viewer through his series of exclusions.

The *Testament of Eudamidas* thematized a politics of reception. The quick read was false, which was the point of the story as well: the immediate reading of the document produced a false interpretation. But this misreading provided a representation of an excluded community that was deemed incapable of judgment. The true friends were obliged to interpret the gesture. And the depicted obligation had its formal counterpart for the viewer. By restricting the range of available painterly effects, the painting offered a misreading: the picture displayed a negligence in the handling of gratifying pictorial effects, thereby breaking the conventional contractual obligation put upon painting to supply immediate pleasure. For the appropriate viewer, severity was taken on as a

necessary obligation. Clarity and uncertainty, legibility and doubt were sustained in the painting. A series of substantive negations revealed a productive set of pictorial complexities. The attention to ornament was displaced by an interest in an ordered pictorial problem-solving.

Perception and Political Theory in Practice

Poussin has been long associated with neo-Stoicism.[53] This philosophical tradition constituted part of the ethical and political thought of humanists who participated in the formation of the monarchical state after the Wars of Religion. The neo-Stoical writings of educated advocates of Henry IV's bid for the monarchy, such as Guillaume du Vair and Pierre Charron, continued to serve as staple reading for the *noblesse du robe* throughout the seventeenth century.[54] Du Vair provided a philosophical response to the disorder and violence of civil war from his personal experience of a besieged Paris, while Charron's *De la sagesse* (after 1595) borrowed freely from other writers, both ancient and modern, including the thoughts of his friend du Vair.[55] Both writers, following the example of Montaigne, have been identified with the synthesis of *robe* culture and the development of monarchical theory. Several scholars have recognized the importance of these writers for Poussin's thought.[56] In at least one instance, the artist repeated the words of Charron.[57] This referential field marks yet another instance of Poussin's allegiance to the humanists of the sixteenth century and to a philosophy grounded in politics.

I wish to focus on one particular aspect of the writings of du Vair and Charron that provides a link between the visual vocabulary of Fréart and political theory in seventeenth-century France. Both du Vair and Charron analyzed perceptual behavior as part of a political critique. Du Vair described the role of cognition in perception by using a metaphor modeled after the organization of the monarchical state. Man was compared to a republic wherein understanding (*entendement*) was enthroned in order to conduct and govern all life and every action. Under it, the faculty of sensory perception was regulated in order "to know and judge through the agreement of the senses the quality and condition of things which came to move our affections for the execution of judgments."[58] The metaphor of an enthroned understanding was later adopted by Charron in *De la sagesse* for discussing the passions.[59] Both texts echo the traditional corporeal models of the state based on a kingly head and, therefore, cerebral order. In their political theory there is a distrust of the senses, in advance of Descartes's skepticism. Although it is necessary to sense "the quality and erudition of things," perception must be bridled, sensations must be structured by the mind; otherwise reason can be led astray by this imperfect knowledge that results in false judgment or opinion.

In the writings of Charron and du Vair, political decisions and action are the result of two contrasting models. On the one hand, *opinion* is a spontaneous reaction and improvised operation associated with a disorganized social formation responding to the instant perception of an event. In other words, objects are perceived and produce discourse without the mediation of understanding (*entendement*). On the other hand, *judgment* is the result of the consideration by an organized body or institution. The two operations are understood in opposition.

Both du Vair and Charron represented the purely sensate viewer, the man who simply experiences, as a figure for disorder. Writing with the effects of siege in mind, du Vair described his suspicion of the senses:

The senses, true sentinels of the soul, located outside in order to observe all that is pre-
sented, are like a soft wax, on which is imprinted, not the true and the interior nature,
but only the exterior surface and form of things. They report these images to the soul
. . . according to what they find pleasant and enjoyable to themselves, and not accord-
ing to what is useful and necessary for the universal good of man: and in addition, they
introduce along with the images of things, the indiscreet judgment that the vulgar make
of these things. Out of all that, this rash Opinion is formed in our soul . . . [Opinion]
is certainly a dangerous guide, and a rash mistress.[60]

Charron similarly conceived of a masculine soul threatened by a reckless female guide.
He borrowed freely from du Vair adding that Opinion was dangerous because it was con-
ceived "without deference to discourse or understanding" and thereby subjected the soul
(and by extension the body politic) to the passions. Opinion was the result of the corrupt
senses, it was "false, vague, uncertain, contrary to nature, truth, reason [and] certitude."[61]
For Charron, dangerous femininity coexisted with a meteorological metaphor. Opinion
was a cavern where winds originated that created tempests in the soul. Looking back to
the *Inventaire*, Mazarin's collection can be understood as a similar vehicle for producing
a storm in the viewer's consciousness.

As a counter-demonstration to the production of opinion, Poussin offered the *Testa-
ment of Eudamidas*. The friends and heirs of Eudamidas, who applied judgment to the
document, were understood in opposition to the larger community that stood as a figure
for misreading and unfounded opinion. Within the pictorial field, the viewer was offered
a difficult object that resisted immediate sensory appropriation. The critical viewer of
Poussin's painting was described by Fréart around a decade after the Fronde. In the final
theoretical statement of his *Idée de la perfection de la peinture* (*Idea of the Perfection of Paint-
ing*, 1661), Fréart wished to model himself after the "savants who examined and judged
things in the manner of Geometers, in other words, with rigor, through pure demonstra-
tion, and through the analysis of their principles, without giving in to Opinion, or to Favor,
which are the plagues of Truth."[62] In a text usually associated with intransigent classical
art theory, Fréart conjoined *Opinion* and *Faveur* – pathological figures of disorder and the
infringement on the *bien public* that were commonplaces in the political rhetoric of the
Fronde. One referred to the chaotic discourse of the mob, hearsay (and the "cackle" of
women). The other reflected the interests of the debased courtier who spawned nepotism
and favoritism rather than a meritocracy. Even as Louis XIV began his personal rule,
the survivor of the Fronde and theoretician publishing in Le Mans defined aesthetic
judgment in terms of the class and appropriate political behavior of the *homme de bien*
attached to the state who emulated the rigors of geometric proofs.

* * *

In his paintings of the mid-seventeenth century, Poussin was managing a paradox. A
highly methodical approach to pictorial composition and carefully measured application
of paint signified an aversion to artifice. Poussin's paintings were participating in the anti-
luxury discourse of the Fronde. The artist assumed a potentially anti-materialist position.
Even as he asserted the material conditions of the canvas and his own practice, Poussin's
artlessness was potentially hostile to his own enterprise, the making of art. The renunci-
ation of *curiosité* risked producing iconoclastic gestures. The dispersal of Mazarin's col-
lection was an organized attack on the accumulation of certain categories of visual objects.
The political pamphlets and the actions against Mazarin's collection registered a distrust

of the senses. Significantly, Poussin was able to sustain his painting by representing that ambivalence toward artifice within a system of pictorial gestures. His figurative paintings of the late 1640s and early 1650s withdrew from the full range of painterly competencies available to the artist. The static, thick, and repetitive forms, the elimination of impasto, the effacement of facture, are the traces of acts of renunciation. Something as habitual to his early work as the contrasting play of impasto on a depicted metallic surface was suppressed. The conspicuous highlight was displaced by an even application of paint. At different moments in the history of art, a shift from a demand for material quantification to artistic skill registers a transformation in social values (most famously described by Michael Baxandall).[63] Poussin's mature work represents a different development in which the selective renunciation of a set of skills and the selective resistance to pleasure has a positive value for an elite, socially and politically.

Poussin rehearsed a discourse that was antithetical to artistic practice. He was managing the tension between art and artifice. To put it most strongly, anti-culture was a figure at the heart of culture. Ambivalence toward artifice provided a position of integrity, for the rhetorician as well as the painter. It was also the rhetorical strategy of the existentialist: "In order for the statue to be nude, beautiful speech must vanish."[64] In Camus's utterance, true art is a renunciatory act. Form is not an accretion but a reduction.

For Camus, as well as for Poussin, discipline signified freedom. The authenticity of the enunciation and the authority of the enunciator relied on a carefully articulated iconoclastic gesture. Artifice was perceived as an excess to be eliminated from art itself. The purveyance of spontaneous sensations was understood as flattery or seduction to be evacuated from the exchange of artist and client. Art as the intensive management of material, even at the expense of attraction and pleasure, became a criterion for truth. The artist's venality was displaced by the terms of obligation, difficulty, and analytical effort.

The alternation between spontaneity and analysis as organizing principles for painting describes a pattern in the history of art. Indeed, at different historical moments the attention to effortless improvisation yields to discipline. This is the way in which Cézanne's project has been understood in relation to Impressionist practice. His displacement of the expediency and virtuosity of the improvised mark by formal difficulty (awkwardness and doubt) was valued by humanist critics, such as Merleau-Ponty and Meyer Shapiro. The act of painting offered alternatively two heroic narratives: the recapitulation of the sensate subject's development and the modernist renunciation of the artificial construct of Renaissance perspective.[65]

By remarking on this recurrent phenomenon, I am not arguing that Poussin was a modernist *avant la lettre*. I am arguing, however, that under different historical conditions, the relative autonomy of artistic form paradoxically made the material properties of paint available to discourse. I have been claiming that Poussin and his clientele were constructing such a heroic narrative out of form. Poussin was not merely giving a visual form to the extant mythology of a literate class. The pictorial sign was carrying the burden of representing a culture to itself. The brushstroke was being organized as part of the repertory of humanist knowledge, making claims to represent social and political identities. At times, this discursive burden laid on artistic form approached allegory. In his monumental poem concerning painting, written around the time of the Fronde, Hilaire Pader envisioned Poussin as the Herculean painter combating Mannerist monsters with his powerful authenticity. Deviance was a painterly excess expelled by Poussin's severe handling of paint. Rather than the golden chains of eloquence and the coercive club of the ruler, this Gallic Hercules had brush in hand.[66]

As the brushstroke was ordered within a body of knowledge, painting produced a viewer attentive to formal opacity. Rather than the renunciation of the materiality of paint for a greater transparency to meaning, Poussin's paintings facilitated a formalist discourse. Yet, the painterly trace (and its effacement) was semantically burdened.[67] The practice of attention to the properties of paint was not invented by recalcitrant colorists of the late seventeenth century who resisted transparency.[68] In mid-seventeenth-century France, a critical discourse that attended to form was not emptying the painting of its utility. Instead, formalist discourse was born out of a demand for maximum discursivity. The painterly signifier in French art was effectively taken over by discourse within a relational system of styles.

In seventeenth-century France, the largely textually based practices of humanist elites and their discursive organization of artifacts was greatly augmented by the investment of intellectual and economic resources in painting. As a result, the brushstroke and the viewer became increasingly subject to a cultural order. A viewer was being produced who was attentive to pictorial effects and articulated differences in the application of paint to canvas. I showed how Fréart's column-gazing was the application of highly structured viewing to a nonlinguistic object. Form was increasingly laden with discourse.

This culture was not, however, monolithic and Poussin's painting insisted upon that point. The artist harnessed misinterpretation or "noise" to the machinery of painting.[69] By thematizing a split address, an elite community against a wider society which does not understand, the field of reception was being parceled out. But it was not linguistic competency or access to historical knowledge that were decisive in differentiating viewers: social and political distinctions were being organized according to differential acts of perception, not textual or historical knowledge.

Again I return to a modernist voice at the risk of conflating very different constructions of formalism. Poussin and Fréart de Chambray's reception theory should not be unfamiliar to readers of Clement Greenberg:

> Ultimately, it can be said that the cultivated spectator derives the same values from Picasso that the peasant gets from Repin, since what the latter enjoys is somehow art too, on however low a scale, and he is sent to look at pictures by the same instincts that send the cultivated spectator. But *the ultimate values which the cultivated spectator derives from Picasso are derived at a second remove, as the result of reflection upon the immediate impression left by the plastic values.* It is only then that the recognizable, the miraculous, and the sympathetic enter. They are not immediately or externally present in Picasso's painting, but must be projected into it by the spectator sensitive enough to react sufficiently to plastic qualities. They belong to the "reflected" effect. In Repin, on the other hand, the "reflected" effect has already been included in the picture, ready for the spectator's unreflective enjoyment. Where Picasso paints *cause*, Repin paints *effect*. Repin predigests art for the spectator and spares him effort, provides him with a short cut to the pleasure of art. Repin, or kitsch, is synthetic art.[70]

The affinity between Fréart and Greenberg tells us something about the longevity of social and political discourses predicated on perceptual theory. I have been trying to describe one historical incident in the invention of what Greenberg called a "spectator sensitive enough to react sufficiently to plastic qualities." That spectator's claim to "ultimate values" was based on his or her own capacities to defer those immediate impressions, to reflect upon the perception of plastic values. These capacities were understood by contrast with other competencies. Greenberg, like Poussin in discourse and in paint, had rhetorically to represent that other viewer.

Poussin's pictorial compositions made claims to inherit a culture that was integrated within the state. Nonetheless, such claims ultimately depended on anti-egalitarian strategies resembling those of Greenberg. Opposition to Mazarin was imagined through the alignment of the Italian minister with unreflective sensory perception rather than concerted attention to formal distinctions. Inviting easy consumption, Mazarin's collection threatened to dissolve the self in sensory excess. The *Inventaire* underlined the risks of perceiving such objects. Uncontrolled critical discourse or *opinion* was produced at the margins of judgment. That represented site of perceptual and intellectual disorder served to define by antithesis the operations of an elite. The postponement of pleasure by a concerted effort to marshal visual attention to specifically formal elements produced critical judgments. The authority of a political elite was represented in these visual competencies including the capacity to invest the painterly signifier with knowledge.

As much as I am emphasizing the ordering of painting's means, I am not however describing an aesthetics of absolutism. The formalist criticism of Fréart de Chambray was enunciated from the margins of political practice. As I have stated, this culture served those in exile. Authority was imagined through the formal projects of the analysis of columns and the severe representation of Lucian's tale of friendship. The evolution of the works in Passart's collection seems to have registered a shift from siege warfare to individual death, from which one might conclude that Poussin withdrew from more direct political concerns. However, I am arguing that the painting of Eudamidas was a demonstration of a continued engagement with the literary culture and visual rhetoric of French humanism on the part of Poussin and his clientele. The painting attempted to articulate French political culture on the scale of personal modes of cultural behavior: a series of canvases little more or less than a meter square were exchanged "pour l'amour dudit Passar." This is sustained practice on an intimate scale in relation to the broader scope of events during the Fronde. It is also what distinguishes Poussin from David. The finely tuned gestures and circuit of communication in the *Testament of Eudamidas*, which David later used for his grand public Salon entry *The Oath of the Horatii*, had initially represented a society in retreat and a culture in exile to itself. Yet David's intervention similarly depended upon the mythical transport of a portable painting from Rome to Paris. As a consequence of the retreat of Poussin's studio, the seemingly insignificant deployment of material resources, a suspension of oil and pigment applied to stretched canvas, was overdetermined.

The artist's ambivalence to the demonstrated painterly competencies of his early work was highly productive. Such self-imposed restrictions permitted the intensive investigation of a select range of pictorial problems. But such a strategy risked creating an impasse in his work, as discipline became an encumbrance, as restraint became an obstacle. This is a problem I shall address in the final chapter. In the next chapter, I shall consider how Poussin's enumeration of a redundant pictorial strategy constituted a style. Furthermore, a predictable set of formal relations was transmittable to other artists. Poussin's style was therefore subject to appropriation by others in ways that were both productive for the constitution of a culture and, paradoxically, bound to weaken its efficacy. Even in Poussin's own lifetime, exactly at the moment of the Fronde, he became identified with a pictorial style that served to bolster the authority of other artists. However, as throughout the history of French art, that identification was largely imaginary and often dissociated from the actual formal strategies of his art. Poussin became myth.

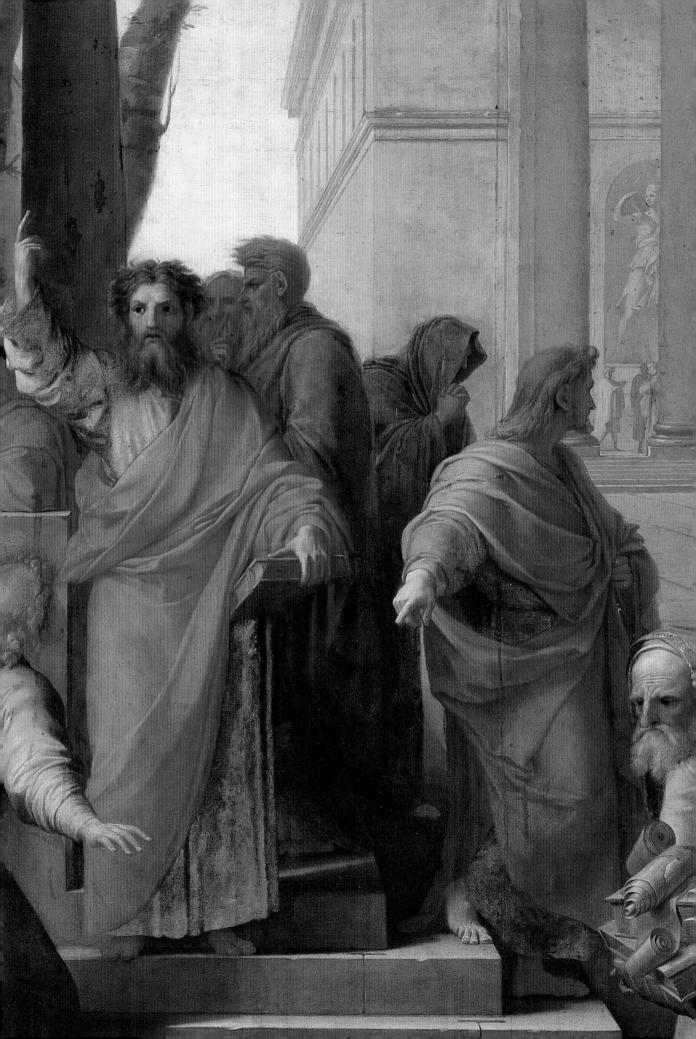

Chapter Ten

Institutional Appropriation

A small easel painting by Charles Le Brun, *Moses Striking the Rock* (fig. 87), was long mistaken for one of Poussin's paintings.[1] This is not entirely surprising given that Le Brun had studied with Poussin in Rome. Nevertheless, by the time he executed the canvas around 1648, years had elapsed since his training with the older artist. In the meantime Le Brun had learned to modify his style according to the terms of a commission. Therefore, his explicit reference to Poussin's painting of the same subject (fig. 88) was a conscious act of emulation. Indeed, Le Brun's contemporaries understood the merits of this decision. According to his seventeenth-century biographer, Le Brun painted at the height of the Fronde "in the beautiful taste and manner of Monsieur Poussin."[2]

The viewers no doubt perceived the nearly identical compositional structures of his picture and Poussin's. In both paintings Moses stands near a small precipice that secures the left-hand edge of the canvas while trees on the right serve as a counterbalance. Furthermore, Le Brun's picture explicitly echoes the figure groups in Poussin's *Gathering of the Manna* (see fig. 37). Indeed, Le Brun systematically created overt variations on the elements and structure of the two Poussins, seizing upon their characteristic composite arrangement of vignettes in the foreground. At the left side of his Moses picture, Le Brun echoed Poussin's representation of the men drawing water from the stream and drinking in the painting of the same subject. On the right, Le Brun adopted Poussin's triangular group of mother and two children for a similar grouping: a woman and suckling infant are complemented by a toddler and an old man. Le Brun also drew upon the charity group in the left foreground of Poussin's *Manna* (the younger painter more confidently placed an elderly man near the nursing breast, yet depicted him drinking from a vessel). Le Brun similarly appropriated the rhetorical pose of Moses from the *Manna*. As in Poussin's painting, Le Brun's composition is additive, stressing selection. By precipitating elements from two pictures, Le Brun not only avoided the charge of copying, but demonstrated how Poussin's authority might be transmitted.

Le Brun's small picture attests to the profound impact Poussin had upon painting practice in Paris during the 1640s. Soon after Poussin's departure from Paris, his art became identified as the apogee of French painting despite the fact that his easel pictures were produced on an intimate scale in his outpost in Rome. By the end of the decade, a number of artists were emulating his antique references and formal severity.[3] They were the first of several generations to be concerned with the problem of the transmission of Poussin's artistic practice. It is no surprise that they were also the founders of the Académie Royale de Peinture et de Sculpture who sought to renew state protection and sponsorship of the visual arts under the regency in 1648. Charles Le Brun was among the key players, along with Charles Errard, who had worked with Poussin on the Grande Galerie project.

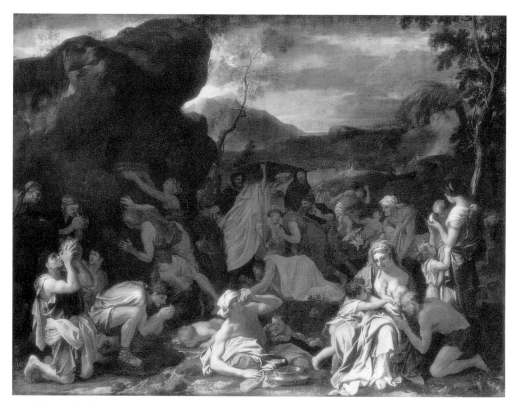

87. Charles Le Brun, *Moses Striking the Rock*, c. 1650, oil on canvas (Paris, Musée du Louvre, RF 1947-2), 1140 × 1530 mm.

Poussin's studio practice and its emulation therefore became associated with the most ambitious project to institutionalize French art.

How did the incorporation of the Académie by the regency in the first year of the Fronde tally with the uneasy relationship between Poussin and Mazarin's regime? Why would a young artist seeking support from the regency in the tumultuous year 1648 so explicitly emulate a painter identified with the previous political regime? In order to assess the extent to which Poussin's art was engaged in the cultural politics of the Fronde we must interrogate the seeming contradiction between Poussin's oppositional political symbolism and his centrality to the royal institution. The Académie's investment in the authority of an artist identified with groups antagonistic to the regency can be explained by dispensing with the assumption that the Académie was always a direct emanation of the will of the monarchy. It is easy to mistake the fledgling royal institution for an efficient instrument for the surveillance of cultural production by a centralized authority because of the subsequent successful bureaucratic consolidation of the institution during the reign of Louis XIV. The early Académie was formed, however, at a moment when even the most stable state institutions were succumbing to revolutionary forces of shifting personal loyalties and political positions.

The formation of the Académie was in part a consequence of the vacuum in royal support of the arts following Sublet de Noyers's retreat and subsequent death in 1645.[4] His death relieved Mazarin of the recalcitrant arts administrator's influence at court and he himself usurped the position of *surintendant des bâtiments* only a year after Sublet's death. For critics of the regime, who perceived Mazarin as an ineffectual patron of the arts, the Académie offered an institutional solution to the problem of cultural discontinuity and lack of protection. The Académie was formed as a response by artists to the concerted attacks upon their authority and privileges. After Sublet's death, the resulting lack of continuity in the administration of the arts was beneficial to the interests of the *maîtrise* or painting guild. The guild had contended with competition from artists protected by

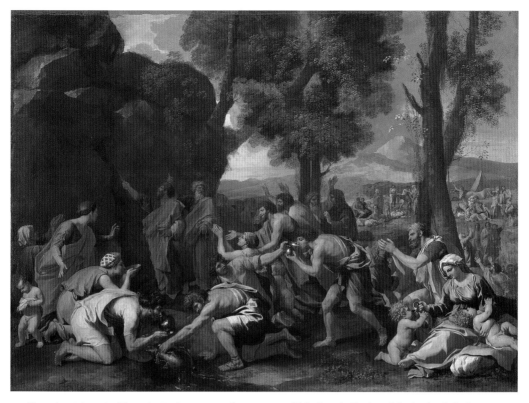

88. Poussin, *Moses Striking the Rock,* c. 1637, oil on canvas (Edinburgh, Duke of Sutherland Collection, on loan to the National Gallery of Scotland), 970 × 1330 mm.

the crown since the inception of privileged offices in the royal household. The ambitious cultural policies of Richelieu's administration were therefore accomplished at the guild's expense. Sublet's unprecedented increase in the numbers of the artists protected by the crown (the so-called *brevetaires*) and the extension of the role of their noncorporate system of art production had posed a threat to the interests and privileges of the older corporation. Moreover, his ambitions for the Louvre as a dominant artistic institution would have effectively diminished the guild's prestige. The Louvre housed not only a monumental decorative project and the royal mint but also the studios of artists supported by the royal administration. Even during his retreat, Sublet continued to protect artists, thereby asserting his own authority and angering both Mazarin and the traditional community of art practitioners.[5]

Early in 1646, shortly after Sublet's death, the guild saw its opportunity in the absence of an acting *surintendant* to make a legal appeal to the Parlement of Paris, which at that time was sympathetic to the corporate cause.[6] After confiscating the property of two *brevetaires* accused of violating corporate restrictions, the guild obtained an *arrêt* from the Parlement severely restricting the number of *brevetaires* and limiting their activities to work for the crown.[7] That is to say, this finite number of royal painters were to be prohibited from activity in the lucrative field of church commissions. This move was in part a response to the successful securing of commissions for religious paintings by the *brevetaires* in the late 1630s and 1640s. In fact, the proteges of the crown virtually monopolized the prominent and remunerative annual commission for the Cathedral of Notre-Dame in Paris. Beginning in 1630, a promising artist received a commission for a monumental painting depicting a scene from the Acts of the Apostles. The painting was called a *May* because it was displayed on the first of May outside the doors of the cathedral to a large crowd, before being permanently installed in the church. The *brevetaires'* control of one major annual venue of ambitious painting was an embarrassment to the power and prestige of the painters' guild.

Taking advantage of the unstable political climate and the withdrawal of active support of the *brevetaires* by the royal arts administration in 1646, the guild retaliated. The artisans insisted not only that the *brevetaires* be restricted to the royal buildings but also that they be excluded from regular market practices. The guild sought interdictions against shop signs, the display of pictures in boutiques, and the transport of work outside the studios in the Louvre. These restrictions were designed to inhibit access to other important clients. In contrast to the painting workshops of the Foire St-Germaine that supplied the steady demand for small devotional images or the engravers who purveyed religious and ephemeral products for a relatively stable bourgeois market, the *brevetaires* competed directly with the guild members for another important clientele: the *noblesse de robe* who commanded the ambitious and costly decorative projects for the townhouses of Paris, as well as altarpieces for family chapels. The competition was heightened by the severe restriction of ambitious state patronage under the regency. As I said earlier, Mazarin was apparently committed to foreign artists for the decoration of his own palace. Therefore, money in the *maison du roi* did not seem to be forthcoming, especially when the first minister assumed the office of *surintendant des bâtiments*.

Mazarin's cultural patronage was the subject of violent criticism, as I have shown. This is not to say that he did not obtain the services of any French artists: Charles Errard was one exception after the death of Sublet de Noyers. He picked up the odd job in the royal household,[8] but was in a tenuous and marginalized position. He worked under Torelli on the *Orféo* project, assisting in the production of stage sets and the architectural backdrop for a ball, where Mademoiselle de Montpensier was enthroned.[9] His talents seem also to have been relegated to other ornamental tasks, such as gilding the stucco for Romenelli's fresco projects. These paltry commissions were far from the cultural ambitions he had formerly expressed as a member of Sublet's circle and soon exercised as a key spokesperson for the Académie. In the midst of the Fronde, after the inception of the Académie, Roland Fréart continued to invoke Errard's name as a member of the cultural elite devastated by the absence of royal support of the arts. Errard drew the portrait of Sublet and supplied the drawings of columns for their shared architectural project published in exile (see figs. 44, 45, and 85).

The Incomplete Support of Vouet

This picture of the decline in the royal protection of the arts is of course one largely drawn by the critics of Mazarin. There were, in fact, some commissions to be obtained under the patronage of Anne of Austria. But even this support proved slight or fraught with financial uncertainty. For example, Simon Vouet's reputation and influence survived Poussin's brief visit to Paris. Vouet obtained a *brevet* to construct a monument to Louis XIII with a royal pavilion and triumphal arch. However, money was not forthcoming and the project was never realized.[10] He was able to execute painted decorations at Fontainebleau and the Palais Royal, but he had to litigate for several years in order to be paid.[11] Even as Vouet assumed the mantle of the most successful royal servant in the arts, he nevertheless experienced the disruption of his stipends.[12]

For those who had received direct support from Sublet de Noyers and were aligned with the artistic practice of Poussin, the paltry support of Vouet represented the drying up of the wellspring of royal patronage, and even the negligence of the artistic legacy of Sublet.[13] Thus, the well-known account of the professional and artistic opposition between

Vouet and Poussin exceeded personal rivalries and participated in the political skirmishes of the era of the Fronde. Poussin and his supporters would have been sensitive to any sign of Vouet's success during the regency at the expense of other artists more sympathetic to Poussin's project. Furthermore, Vouet's work for the regent tended to confirm a marked contrast or divide between the ambitions of Sublet de Noyers and the regency.[14] Vouet's return to artistic prominence after Poussin's departure and the retreat of Sublet marked a shift in the crown's priorities for state commissions as well as its conspicuous aversion to the stylistic example of Poussin. The decorations by Vouet for a vestibule in the palace at Fontainebleau and the bath of the Palais Royal answered a demand for private luxury in contrast to the official modes of address in the Grande Galerie. The pointed contrast between his rendering of mythological themes and Poussin's ambitious Herculean-Trajanic project would have been evident from the wide circulation of Vouet's work in the form of engravings (figs. 89a and b).[15]

The contrast between the cultural policies of the regency and the cultural ambitions of Richelieu's administration was further dramatized by the juxtaposition of the differing painting projects in the Palais Royal initiated by the respective regimes. In the minds of critics, the regent's decorative projects paled when compared to the artistic legacy of the late inhabitant of the former Palais Cardinal. By comparison with Richelieu's famous portrait gallery, the regent's commission for the bath at the newly re-named Palais Royal had negligible rhetorical and ethical value. Richelieu's gallery was often invoked by critics of the regency as an ideal form of patronage. The timely publication of *Les Portraits des hommes illustres françois* in 1650 (and reprinted in 1668; see fig. 60) was an ambitious engraving project that offered a pointed contrast with the engravings of the regent's decorative commissions.

Given the criticism of the regency's insularity, private luxury, and self-interest, the engravings after Vouet's decoration of the baths in the Palais were particularly damning. The juxtaposition of the queen's toilette and the gallery of significant men was a meaningful political opposition. Vouet's own contribution to Richelieu's portraits of worthy historical personages was contrasted with the kinds of demands made upon him by the regent. Following a familiar gendered structural opposition, the portrait of an exemplary Frenchman served as a foil to feminized ornamental tracery.

Reorganizing the Arts

Such was the status of state commissions when the Académie was conceived. The guild made its move against protected artists who

89a and b. Michel Dorigny after Simon Vouet, *Designs for the Decoration of the Palais Royal*, illustration in *Livre de diverses grotesques* (1647), plates 14 and 15 (Delaware, The Winterhur Library).

evaded the corporate body's attempts to monopolize artistic production. But the *breve-taires* made a well-known decisive countermove. An amateur named Charmois, repre-senting their interests, brought a proposal before the regent for a royal academy of painting. The royal council was presented with a complaint regarding the guild's litigious maneuvers to interfere with the privileges of the royal *brevetaires*. Strategically timed, the appeal was made only four days after the regent's authority had been challenged by Omer Talon's remonstrance to a *lit de justice* in the Parlement of Paris. The guild was perceived to be collaborating with the Parlement to intervene in the affairs of the *maison du roi*. Anne of Austria reacted violently to the attempted encroachment on royal power by these "vile and abject men."[16]

While accounts simplify this historical description into an opposition between the interests of the *brevetaires* and the crown on the one hand and the guild and Parlement on the other, it must be stressed that the *brevetaires* did not seek to entrench their extant privileges. Instead, the *brevetaires* effectively dissolved the basis for their own privileges and sought the protection of a newly created royal institution. Significantly, the forma-tion of the Académie was a reform entirely consistent with the current political climate. The founders participated in the political discourse of the *noblesse de robe* that attacked arbitrary power and a courtly system of favorites. Indeed, as *brevetaires* the artists were subject to the endemic criticism of favoritism. Contemporary observers noted that the practice instituted by Henry IV of lodging renowned artists had degenerated because "favor had more partisans than did merit."[17] The Italian scenographer Torelli was among those housed by the regency.[18] As a result of the usurpation of the noble residences by tal-entless favorites, a saying was coined: "All the good masters are not lodged in the gallery of the Louvre."[19] The rewards for merit in the arts, as in the court, were perverted into favoritism, the *piston* of cronies. The *brevet* appointments were understood to have degen-erated under the regency.

The Académie openly participated in these attacks against the *brevetaires*. One of the founding academicians, Henri Testelin, claimed that the regency's selection of the *breve-taires* was based on criteria other than the distinction of merit. In order to succeed, it sufficed to have "intimate access to some favorite or some minister, or merely to be on the good side of some functionary in the Office of Royal Buildings."[20] The founders of the Académie did not therefore seek the victory of the *brevetaires* over the guild; rather they attempted to obliterate both the "lowly and avaricious cabal" of the guild and the self-inter-ested "privileged multitude . . . under the shelter of their brevets of favor, or some lodging in the royal houses."[21] The Académie claimed to be the heir to a distinct third collectivity:

> The third [class] brought together a small number of superior men, true gentlemen of art in the beauty and the elevation of their genius, the wealth of talent, the nobility of their sentiments, and in their sincere love for the growth of beautiful knowledge and the glory of the French name. They were too jealous for the honor of their profession to desire it to depend on a vain title that no longer had anything flattering about it; they respected themselves too much to submit to the domination of men who, in the exercise of their art, would hardly have been deemed to be worthy to serve them . . . [The guild's] hatred and pride increased, and it dreamt of nothing but the doubling of its efforts to overpower these respectable and unique supporters of the fine arts, even more irritated by their merit than by their resistance.[22]

This statement is important because it demonstrates that the academicians were assert-ing their distance from the inherited system of *brevets*. They intended to address the abuses of royal authority by the crown. This new *noblesse* was distinguished by a superiority

derived from sentiments, love of knowledge, patriotic service to the *gloire du nom français*, and distance from flattering titles.

The Académie's attempt to align painting with the liberal arts is well known.[23] Indeed, it was a decisive move for the social aggrandizement of French artisans. But in describing the formation of the Académie, I am placing an emphasis on this link between art and humanist culture during the period of the Fronde. Testelin's account of the birth of the institution and his assessment of its actors resonate with the contemporary rhetoric and political culture of the *noblesse de robe*. His stress on a meritocracy and a disinterested nobility of spirit was consistent with their values. In the context of the reforms of the sovereign courts, the academicians were similarly responding to accusations of favoritism and private intrigue that were perceived as a threat to the fabric of social and political institutions. The transformation of the *brevetaire* from feudal subject who courted favor to institutional member defending abstract principles was a response to criticism leveled at the abuses of the older system of royal patronage. Far from courting absolutist culture, the fledgling academicians were declaring their allegiance to the political culture of the Fronde.

Conciliatory Moves

It may come as a surprise that the royal council supported the Académie's radical efforts to reform the arts in France, yet, this patronage was consistent with other timely strategies to forestall criticism. Indeed, the formation of the Académie can be best understood by examining a broad pattern of attempted conciliation during the early stages of the Fronde. In order to garner support, the regency had attempted to initiate reforms in the first months of 1648, including the nullification of the tax *intendants* and the resignation of the finance minister Particelli. A respected former president of the *Chambre des comptes*, Antoine Le Camus, was then assigned to a prominent position in the king's finances.[24] An important parallel reform simultaneously occurred in the administration of the arts. Mazarin stepped down from the *surintendant des bâtiments* position, which was then given to Etienne Le Camus, the brother of Antoine, himself a *maître des comptes* at Grenoble.[25] In a clear response to the ongoing criticism of his failure to protect the arts, Mazarin's letter of appointment for the new director of the arts emphasized an institutional support of art rather than the bequest of another favor.[26] Instead of relying upon the normative formula announcing the fidelity of the prospective royal agent, Mazarin offered a defense in advance of criticism: the new officeholder was knowledgeable in the arts, in particular architecture, and he was held accountable to the finances of the crown.[27] After only two years in Sublet's former office, Mazarin had retreated from the position and given it to a more politically viable candidate with better fiscal and artistic credentials.[28] The transfer of authority to Etienne Le Camus, like the appointment of his brother to administer royal finances, represented a tactical move on the part of the regency.

The regent's support of an institution closely aligned with the *noblesse de robe* and implicitly critical of Mazarin was similarly intended to forestall further criticism. The Académie was conceived at this moment when the regency was beginning to distance itself from Mazarin (or rather, Mazarin himself made one of the first in a series of strategic retreats, including resignation from the office of tutor for the dauphin).[29] In the official memoir of the Académie, the striking silence regarding the first minister was consistent with the willingness of the regency to create a distance between Mazarin and the

administration of the arts during this period. At that time, there did not seem to be any tension between the rehabilitated legacy of Sublet's administration and the attempts by the regency to maintain its authority. Hence, Poussin could serve a symbolic function for an institution founded by the regency. If Poussin and his art occupied a position that was critical of the cultural policies of the regency, the support of a French institution dedicated to Poussin's example functioned as an apology for the regime. The academicians' need to position themselves as disinterested was fulfilled by the symbolic appropriation of Poussin, the exile willing to sacrifice favor for loyalty. As we have seen, Poussin, like the *homme de bien* at court, was perceived as the victim of an infringement on the *bien public*. Similarly, the Académie was founded upon the rhetorical opposition of *courtiers* to the *noblesse de robe*. During the regency, the attachment of Poussin's symbolic authority to a royal institution committed to *utilité* "for the arts and for the public" countered claims that the government was rife with favoritism and was opposed to customary deliberative forms of political organization.[30] The Académie provided the crown with a reform in the arts that was an institutional solution based on *robe* discourse.

For the Académie in 1648 (as opposed to 1661), the language of the arts did not emanate directly from the king but was, instead, constituted by the participation of the *noblesse de robe* in all aspects of the institution. The newly appointed academicians were equipped with the skills that attracted the important clientele Poussin had fostered in Paris. They enlisted the support of the *noblesse de robe* through their study of ancient material culture. They also participated in the culture of the *noblesse de robe* by enunciating a discourse of political disinterestedness, disdaining favoritism, maintaining a distance from trade, and providing service to the *bien public* and nation. Rhetoric was supported by strategic actions. One would-be academician, despite his friendship with the director Charmois, was refused membership because acceptance was based on merit.[31] Bracing themselves for a counterattack from the guild, the Académie expanded the public exercises and drawing classes in order to garner support and assert their legitimacy. The open examination and judgment of works, the display of copies after exemplary artworks, and the study of the posed nude figure, suitable for significant narratives, insured the transmission of knowledge. This contribution to the progress of the arts in France foiled the surreptitious ploys of the intriguing artisans who kept trade secrets. Like the Parlement, the Académie was animated by its "love of the public good" and counterpoised its *utilité* and the pleasure of useful service to the interestedness of the guild.[32]

Other skills provided by allies among the *noblesse de robe* proved at least as valuable in the litigious conflict with the painter's guild. The Académie recognized the power of the Parlement, sought its support, obtained legal advise from its members, and employed due process in order to survive as an institution. With scant direct support from the crown, the former *brevetaires* had to become conversant in the legal intricacies of the *ancien régime*.[33] After a protracted legal battle, with lawyers drawing up briefs for each party before the Parlement, the guild was united with the Académie.[34] Rather than protecting the traditional artisans, this conciliation sealed the fate of the guild. The Académie had obtained the verification it sought from Parlement, thereby insuring its existence. What the royal council could not guarantee during the early stages of the Fronde, the Académie secured from Parlement at a subsequent critical juncture in the conflict. In June 1652, legal sanction was awarded to the institution when the king had retreated from Paris, Condé's troops virtually occupied the city, and Châteauneuf was acting first minister. One month later, the massacre at the Hôtel de Ville occurred, the king was declared a prisoner of Mazarin, Gaston d'Orléans assumed emergency powers, and, with the Parlement, controlled the municipal government in Paris. The Académie obtained its full legal status during the

absence of Louis XIV, securing its institutional authority far from the mythic protection of absolute power. The instrument for the continuity of French painting was born of strategic politics and endemic uncertainty. Art history entered a larger historical theater.

The Fronde Enters the Académie

The Académie's birth was imbedded in the circumstances and the political behavior of the Fronde. The legal maneuvers by the fledgling institution, based on *robe* political principles, were not only conjoined with academic practices but also the satiric print and the libelous pamphlet. In one instance, Poussin's colleague Charles Errard remonstrated against the appointment of the architect Mansard as a censor of prints during the Fronde.[35] Errard obtained the direct intercession of the ally of the Parlement, Châteauneuf, who was a powerful member of the royal council. Deploying the discourse of the *parlementaires*, Errard argued that Mansard had been awarded tyrannical power. Already suspected of self-interest in his property speculations, the architect was accused of putting a stranglehold on the arts. Errard's argument was also articulated in 1651 in a drawing (fig. 90) for a broadside entitled "Mansarade ou Portraict de l'architecte partisan," in which the caricatured Mansard conveys the arts out to the carrion-infested burial place for criminals.[36] An artist, probably an academician, lambasted the architect for his contribution to the dearth of the arts, a complaint that was also enunciated by a political pamphlet of the same title.[37] In the "war against the arts and sciences," Mansard had been declared "minister of avarice" and "mortal enemy" of the arts. The image of the "insolent architect" in the *Mansarade* was therefore based on the archetype provided by Mazarin. But, in the libelous pamphlet, Mansard was also the antithesis to Poussin: rather than conducting research or consulting the ancient masters of art in order to avoid ruinous mistakes, the architect only sought to serve his own ambition.[38] Even "the most knowledgeable painter of the kingdom" (read Poussin) would have to seek the permission of this "courtier architect" in order to have his drawings published.[39]

90. Anonymous, *Mansarade or Portrait of the Partisan Architect (Mansarade ou Portraict de l'architecte partisan)*, 1651, pen and black ink, gray wash (Rouen, Musée des Beaux-Arts, inv. 975-4-22), 212 × 285 mm. (Cartouche added later with modified title and incorrect date.)

91. Louis Testelin, *Return of the Bread of Gonesse (Le Retour de Gonesse)*, 1649, Pierre
noire, pen, and brown ink and gray was on paper (collection Musées de la Ville de
Poitiers et de la Société des Antiquaires de l'Ouest), 283 × 431 mm.

Members of the Académie directly felt the effects of Mansard's censorship. In addition
to the academician Bosse's attack on Mazarin in his print *David and Goliath*, at least one
other founding member produced popular prints in response to specific events of the
Fronde.[40] Louis Testelin, friend of Le Brun and brother of the Académie's memorialist,
in 1649 executed a drawing (fig. 91) for the engraving *Le Retour de Gonesse*, which inter-
preted resistance to the regent's blockade of Paris as a triumphal entry. The staple bread
from the region of Gonesse was transported in a resplendent bacchic procession. Instead
of mythological figures, or laurel-crowned warriors, peasants constituted the principal
agents of plenty. Engraved and sold in Paris, the print was consistent with the evocation
of peasantry in *parlementaire* speeches, contemporary correspondence, and the *mazari-
nades*. The people in the outskirts of Paris are the victims, heroes, and potentially violent
actors in the struggle with Mazarin's troops.[41] In Testelin's print, armed peasant revelers
bear the signs of bounty. Testelin was an academician caught up in the events of the Fronde
who sought support from a Parisian public willing to pay for representations of their vic-
tories over the royal armies. Popular disorder had its compensations.

Even the inner sanctum of the Académie was not immune from the pamphlet war of
the Fronde. A struggle for power occurred within the institution itself that mirrored (or
mimicked) the conflict in the larger political theater. In the first year, a rift developed
between the director Charmois and the twelve founding members or *anciens*. The acade-
micians perceived the growing power of Charmois to be a "menace."[42] A bloodless cabinet
coup was concocted by the assembly of artists to give Le Brun more authority. He would
be elected as a new officer who would distribute power between the director and the artists.
However, the implementation of such a plan posed a problem: how could the artists broach
the subject with the director without making enemies, without seeming self-interested, or
without repeating the kinds of divisive conflict occurring in the political situation? Le
Brun's tactical appeal to the deliberative assembly of artists participated in contemporary
strategies of political discourse and practice. An anonymous, secret document was deliv-
ered by a messenger at a meeting attended by both Charmois and the artists. Caught off
guard by the intrusive text, the painter Laurent de La Hyre became flustered and grabbed

the letter from the courier, throwing it into the fire. He mistook the text for a "satiric or injurious libel" distributed in the street in order to incite "trouble and disunion."[43] La Hyre had feared the intrusion of the more violent and burlesque aspects of current political discourse. But Le Brun knew in advance the contents of the envelope. Pulling it from the fire, he confidently read it before the assembly. He assured the company that it contained views that were "very sound, very wise, and very peaceful."[44] It contained an *avis* – a short rhetorical piece printed as a pamphlet, enunciating a decorous and legal discourse. The *avis* argued for a new office to be held by an academician. The company deliberated and then adopted the terms of the *avis*. Le Brun was elected.

Since the Académie claimed to have public exercises, its procedures reflected the quasi-legitimate forms of political address of certain pamphlets. In the spectacle of *frondeur* politics, the twin possibilities of anonymous political discourse were articulated: La Hyre had mistaken the piece for satire or libelous invective, printed by a self-interested faction, cast into the streets to kindle popular support and factional disunion. Against this slander, the phoenix-text resurrected by Le Brun was an *avis* whose argument and authority were based on its quasi-legal status. It was like the arm of the institutions of Parlement, their public voice, in the form of paraphrased edicts and remonstrances. Judicious judgment prevailed over the vagaries of opinion. This theatrical representation demonstrates that the Académie was not isolated from the political discourse of the Fronde. Le Brun was deploying the available *parlementaire* discourse and rhetorical strategies to advance his and his fellow artists' claims to authority (however provisional).

A reader still convinced that the Académie was closely aligned with absolute monarchy may still be troubled by my analysis, which can after all be summarily restated as follows: to all appearances the regency in 1648 was fostering an institution that promulgated a discourse that was soon associated with a *frondeur* position. Furthermore, the body of artists continued to seek and obtain support from members of those courts that posed a threat to the very existence of the regency and the first minister. However, in 1648, the full implications of this critical position had not yet been fully realized. I would underline that at this particular historical juncture of the formation of the Académie, a move to placate the critics of the regime and influence public opinion was entirely in keeping with the conciliatory strategies of the regency in early 1648. Because the regency did not sustain its patronage, however, there were inadvertent consequences. Once the artists were equipped by the crown with this public discourse and were subsequently left largely unprotected by a highly unstable regime, these tactical resources could be deployed for institutional preservation much in the order of the sovereign courts. No longer *brevetaires*, the painters bypassed the insecure support of the current regime and turned to other quarters. The institution sought out other institutions.

Robe *Patronage*

There was an effective distance between royal power and the Académie. Although the crown provided protection, it sacrificed a level of direct control and supervision of its artists: some operated outside the Louvre despite the interdiction of the guild, held public seances, trained and educated pupils, and conducted public lectures. They no longer solely communicated from the overdoors and encrustations of the royal household, but sought support, legal and financial, from a broader community among the members of the sovereign courts.

Indeed, like the Parlement, the Académie derived its authority from the monarch but survival depended upon the support of various patrons or advisors. Alliances were subject to the political winds of the Fronde. Although the academic body set itself up as a disinterested producer of knowledge and as a servant to the arts in France, it was nevertheless subject to historical contingencies. It is important to stress that the Académie was a royal institution conceived at the time that the power of the monarchy was being challenged. The early Académie belonged to *ancien régime* forms of clientage based on personal loyalties and individual appeals for support from officials. The modern state's centralized bureaucracy, associated with Colbert, had not yet supplanted clientage as a model for political relations.

Prominent officials and notables, such as Gaston d'Orléans, Châteauneuf, and Poussin's one-time client La Vrillière, were among the individuals from whom the academicians received advice and patronage.[45] Certainly, Le Brun's personal patron, Pierre Séguier, is the best-known of the Académie's major protectors. His reputation for fostering arts and letters in France through individual patronage is based in part on the profusion of dedications of works of literature to his name, often eulogizing his nobility in a lineage of *robe* merit.[46] Séguier's consonance with Colbert's image of the absolutist state, however, has been largely constructed by Le Brun's portrait of his patron later in the century, where he is famously depicted with a series of replicated pages circulating around the nucleus of his body mounted regally upon a horse.[47] He was not, however, so securely fastened to the helm of state during the Fronde: the chancellor, who had survived the transition of power after Richelieu's death, was disgraced on two occasions during the course of the civil unrest.

In contrast to Le Brun's painting of a model royal servant in the first year of Louis XIV's personal rule, a poem written by Tristan l'Hermite during the Fronde represented the protector of the Académie as the virtuous *robe* noble in disgrace. In Tristan's "Stances," dedicated "To the honor of Monseigneur the Chancellor" on the occasion of his fall from the government, the ex-official remained an exemplar.[48] Constantly murmuring his name, the twin monsters of Ignorance and Envy never cease their clamoring confusion in an attempt to obscure this star with their blackening slanders, even as he takes his place at the Temple of Glory. Adopted by Thetis, Séguier was dedicated to unimpeachable justice and was therefore blind to friends and family who stood before his tribune. His resistance to nepotism and untarnished reputation for disinterestedness made him a model of impartiality, a touchstone of *noblesse de robe* values.

During the Fronde, Séguier was not only perceived as the protector of the unknown innocent caught in judicial process, the odd orphan or afflicted widow, he was also heralded as a Maecenas for young Virgils.[49] Despite the demands of his official capacities, he loved the muses above all. Thus it was the arts and sciences that had to endure the direct consequences of Ignorance and Envy: "The fine minds regret his departure/ And his absence results in unfamiliar hardships for them."[50] It was the *sçavants* who suffered from the fall of this living apogee of *noblesse de robe* justice and protector of French culture. The themes of political and cultural negligence followed a now familiar pattern rehearsed by apologists of Sublet and Poussin: the regency was incapable of sustaining the devoted and disinterested servant of the crown in the face of an ignorant and envious court.

Tristan's poem suggests how extremely tenuous the position of the Académie was during its initial years. Even the most securely placed patrons were subject to the revolutions within the government. This did not mean however that Séguier was entirely divested of his influence. Rather than passively waiting out his disgrace and expecting to return to favor, Séguier turned to the princes in their bid to challenge the legitimacy of the regency.[51] After the debacle of the Fronde and the fall of the princes, he had to seek amnesty from

the crown. This lapse in Séguier's allegiance to the regency is suggestive for understanding the ways in which the academicians strategically positioned themselves during the political unrest. Personal protection as well as legalistic maneuvers overrode all possible claims to power emanating from the absolute authority of a patron-king.[52]

Because the regency failed to provide a consistent level of support to the Académie, one of the inadvertent consequences was that the protection of the academicians by members of the sovereign courts came to symbolize the sustenance of French *gloire* and cultural institutions by the *noblesse de robe*. If the Académie was understood to have inherited the gauntlet of Poussin's official artistic production, its lack of support by the regency served only to perpetuate the continuing legacy of Mazarin's incompetencies. Any appeal made by the founding academicians to the artistic authority of Poussin must also be understood in terms of the instability and uncertainty of cultural institutions and practices during the Fronde. Poussin's colleagues and followers in the Académie drew upon the same systems of support as Poussin: the culture and social practices of the *noblesse de robe*.

It is generally known that Poussin held a mythic position in the pantheon of French art, but it is still helpful to describe what symbolic attributes were ascribed to him at this early stage in the development of academic discourse and practice. Rather than a simple act of appropriation by a totalizing authority, the use of Poussin's art as a symbolic entity occurred at a fragile historical juncture.

Poussin Enters the Académie

Abraham Bosse was one of the first academicians to attempt to formulate a provisional system of theoretical knowledge.[53] Since he had trained in Lyon as an engraver, Bosse was somewhat peripheral to the ascendant profession of painting. However, he managed to carve a special niche for himself, taking on the pedagogical burden of instructing artists in one-point perspective. Like Errard, Bosse had been protected by Sublet and knew Poussin well enough to correspond with him. As I have shown, Bosse's *frondeur* sympathies and opposition to Mazarin were embodied in his 1651 signed engraving of David/Louis XIV displaying the head of Goliath/Mazarin (see fig. 52).

In the same years that the engraver was attacking the first minister, he dedicated a piece of artistic theory to the Académie. Bosse's *Sentimens sur la distinction des diverses manieres de peinture, dessein & graveure . . . (Sentiments on the Distinction of the Diverse Manners of Painting, Drawing and Engraving*, 1649) invoked Poussin as the *premier peintre* who symbolized the success and resources of royal support, however limited.[54] In Bosse's appeal to the monarch, he stated that in spite of "times that are very calamitous and extremely contrary to the arts" it would be possible for France to produce "many Raphaels" if the king would cast a favorable eye on the arts."[55] Even after the inception of the Académie, Bosse stressed the conditional mood. The importance of painting had not yet been recognized by the monarchy, but there was hope. Bosse suggested that a renaissance of the arts in France would be possible because the Nation had produced "persons so knowledgeable" like so many generative "shoots" despite war and political uncertainty. That is to say, France could hold up for emulation the nation's own Raphael, "the Rare N. Poussin." Bosse did not fail to mention that this painter was pointedly absent from his homeland. He was "at present in Rome" as there was a lack of support in France. In his preface, Bosse was one of many French artists who identified with Poussin's exile. His address to the monarch was a complaint and an appeal for support. According to Bosse, troubled times and state

affairs provided the monarch with no excuse. The late King Louis XIII had been able to be at war and yet support the arts. This is a pointed reference to the late king's minister of war Sublet, who mixed military dispatches with protection of the patrimony. Séguier and Richelieu too were active in both administration and artistic patronage. Bosse's tract was a thinly veiled criticism of the present regime.

Significantly, the *Sentimens* was dedicated to the Académie and spoke for its interests in 1649.[56] It therefore provides an invaluable document of academic discourse at a time when Le Brun was himself, as we have seen in the *Moses Striking the Rock*, making art "in the beautiful taste and manner of Monsieur Poussin."[57] Part of the burden of Bosse's treatise was to convince readers of Poussin's exemplary merits. Significantly, Bosse preferred the works that Poussin had made in the last decade, roughly from the time of his return from Rome to Paris.[58] Poussin's career was described as a progress culminating in the works of the late 1640s. Judged against his earlier paintings, his most recent work possessed a rigorous and systematic control of color, light, and shade. Furthermore, the authority of the French artist was the result of his firm dedication to "le bel Antique" and to Raphael.[59]

While Bosse sought comparisons between Poussin's art and the achievements of sixteenth-century Italian painting, he also employed a vocabulary that addressed the interests of the *noblesse de robe*. He stated that the works of Poussin followed only one rule:

> To speak with certainty of a thing, not to evaluate it by someone else's story, nor on the grounds that the story is by one or by another [i.e. by X or by Y] but [to speak] with knowledge of the cause. This is also, in my view, the sentiment of those who never affect manners . . . [60]

Bosse's criticism was derived from jurisprudence: direct speech is based on first-hand knowledge, not secondary "récits" from so and so. In the midst of the Fronde and a flood of gossip and hearsay opinions, Poussin's art was held up as model of certitude in the analysis of causes. For Bosse, an artist's arbitrary and transitory style was second-hand evidence. He differentiated Poussin from those artists who affected "manières." He had not changed his style again and again like so many others. Firm resolve was registered by an artistic production that shunned flagrant versatility and vagaries. Bosse was describing the formal redundancy of Poussin's most recent work and no doubt also had in mind a painting like the *Testament of Eudamidas*. He was searching for a way of describing the painting's formal difficulty, its directness of effect, in a way that a *robe* noble would have understood it. He grasped for metaphors from judicial rhetoric. Bosse's estimation of Poussin was mirrored by Tristan's eulogistic praise of the judiciousness of the magistrate Séguier: "He dedicates himself to nothing other than to see the truth/ He looks at the cause and not the person."[61] During a period of uncertainty, rampant hearsay, and rumor, Poussin's art offered direct proofs and revealed honest motives.

Transmission

In spite of artists' heroic struggle for survival, in spite of the disruption and uncertainty of Paris under siege and civil war, in spite of the absence of continuous support from the crown, major commissions were still to be had.[62] Not only did Poussin experience a full ledger of obligations to French clients at this time, so too did several of the academicians. At the very moment when the regency failed to support Poussin, Parisian elites fostered the arts by supporting painters who upheld the exiled Frenchman as an exemplary artist.

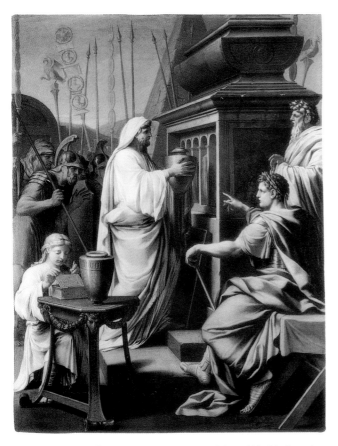

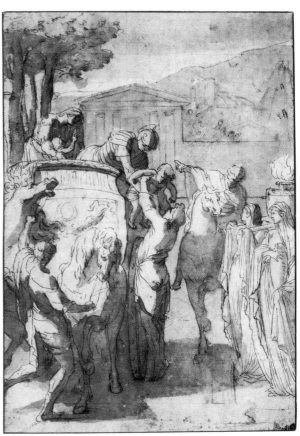

92. Eustache Le Sueur, *Caligula with the Ashes of his Mother*, 1647, oil on canvas (Hampton Court Palace, The Royal Collection), 1670 × 1430 mm.

93. Eustache Le Sueur, study for *Lucius Albinus, fleeing Rome with his Family, Yields his Chariot to the Vestal Virgins*, 1647, pen, brown ink, and brown wash on paper (New York, The Pierpont-Morgan Library), 266 × 189 mm.

One of the major French painters of the seventeenth century was also a key player in the Académie and was supported by the same kind of clientele as Poussin. During the period 1647–51, Eustache Le Sueur was a *maitre* turned *brevetaire*, then academician.[63] This shift from guildmember and Vouet's apprentice to official painter did not, however, insure direct rewards from the state. Le Sueur did not receive any royal commissions until 1653 (shortly before his premature death).[64] Besides a major mendicant commission (the famous St. Bruno Series) and a few works for churches, such as the *May* painting for Notre-Dame, Le Sueur's studio remained active primarily through a pattern of patronage that paralleled that of Poussin. In the first years of the Fronde, Le Sueur supplied easel paintings for important *officiers* and other members of an educated elite, including the *frondeur* president of Parlement Jacques Le Coigneux.[65]

A catalogue of themes Le Sueur depicted for this prominent clientele conforms to Poussin's output. Both painted the Holy Family and designed numerous scenes from the life of Moses.[66] Like Poussin, Le Sueur seized upon the less than exemplary materials of Roman history. In *Caligula with the Ashes of his Mother* (fig. 92), the pagan rituals in the hands of the infamous Roman emperor offered a sequel to the deathbed scene of Germanicus (see fig. 8).[67] Immediately after hypocritically delivering a funeral oration for Tiberius, replete with theatrical weeping, Caligula played to popular support again by gathering the previously exiled remains of his mother and his brother. The false piety and transparent hypocrisy of the hero's son provided a didactic foil to the religious and patriotic devotion witnessed in another work in the same collection (fig. 93). Fleeing a war-

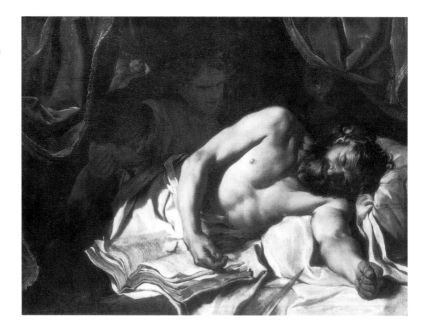

94. Charles Le Brun, *Death of Cato*, 1646, oil on canvas (Arras, Musée des Beaux-Arts), 960 × 1300 mm.

torn Rome, Lucius Albinus and his family came upon the Vestal Virgins on the roadside. Le Sueur depicted Lucius's gesture of giving up his chariot to the stranded women for the sake of the continuity of Roman religious practices. During the Fronde, Le Sueur represented narratives that offered either models for exemplary action or admonitory demonstrations against self-interest and avarice.[68]

Like Le Sueur, the founding member of the Académie Charles Le Brun also supplied prominent members of the *robe* nobility with didactic and patriotic themes consistent with their education and interests. His work for the Hôtel Lambert is one notable example, whereby a prominent member of the *Chambre des comptes* commissioned the artist to represent the labors of Hercules.[69] The paintings embodied the kind of highminded allegorical project befitting a *robin's* search for self-definition during the Fronde.[70] Le Brun's reputation was also based on his capacity to represent the more brutal aspects of ancient philosophy. Fresh from his visit to Rome, he executed the *Death of Cato* for a Lyonnais client (fig. 94).[71] In 1646, George de Scudéry's *Cabinet* included an actual or imagined picture of the *Death of Seneca* by Le Brun.[72] The philosopher's suicide complemented another painting of Diogenes castigating Alexander. In Le Brun's picture, stoical resolve as well as the cynic's recalcitrance matched Poussin's most severe productions.[73]

In addition to semi-public commissions for picture cabinets and galleries, Le Brun enjoyed the patronage of Pomponne II de Bellièvre in his capacity as president of the Parlement. Le Brun's lost *Agamemnon Sacrificing Iphigenia* hung in the magistrate's official living quarters attached to the Palais de Justice, along with Poussin's *Moses Striking the Rock* (see fig. 88).[74] There, Le Brun also executed an ambitious mythological and historical project. On the ceiling, Victory and Renown were joined by Juno, Iris, and Minerva. Four feigned bas-reliefs represented each of the ages of the world. Medals of Achilles, Lycurgus, Numa Pompilius, and other heroes of antiquity punctuated the decoration. Other cameos represented Glory and Magnificence, Justice, History, and Victory. These were accompanied by various genii, Virtue, Science, and the Arts represented by children. In all, the program echoed the Grande Galerie, and in addition to providing an allegory of the integration of jurisprudence and art would have been understood as a more successful example of sustained patronage.

Le Brun also contributed to the decoration of the deliberative chambers of the Parlement with themes of judgment from the Bible.[75] His representation of *Daniel*

95. Eustache Le Sueur, *Solomon and the Queen of Sheba*, 1650, oil on canvas (Birmingham, Trustees of the Barber Institute of Fine Arts, The University of Birmingham), 910 × 1140 mm.

Absolving Suzanna, commissioned by a *parlementaire* supporter of the Académie, hung in the same room as Sébastien Bourdon's *Christ and the Woman Taken in Adultery*. As a follower of Poussin, Bourdon undoubtedly turned to Poussin's contemporaneous rendition of the same theme of judgment and clemency. Far from antagonists, the Académie and Parlement were royal institutions with alliances and mutual interests during a period in which they had more in common with one another than with the regency.

Academicians including Le Brun contributed to official modes of display during the Fronde. The success of an artist such as Le Brun was not based solely on his direct training under Poussin or on the more abstract credentials of theoretical affiliation.[76] The art Le Brun displayed in official and semi-official spaces drew upon distinctive, recognizable feaures of Poussin's paintings. As shown earlier, his version of *Moses Striking the Rock* (see fig. 87) attests to an accomplished artist's willingness to imitate Poussin. Let me stress that this marked influence was not a function of a young artist bowing under an overpowering master. Le Brun, in fact, demonstrated stylistic versatility. Throughout his career, he selectively drew upon the stylistic and thematic resources of Poussin's painting. And it was precisely during the formation of the Académie in the midst of the Fronde that he most emphatically claimed his strongest affinity to Poussin.

In the case of Le Sueur, there were no pastiches after Poussin's works but he did adopt selective formal features of the French expatriate's painting. Significantly, the period of the Fronde, particularly around 1650, constituted what Alain Mérot calls "the apogee of Le Sueur's 'severe style.'"[77] During this time, Le Sueur's paintings of severe subjects drew upon the stylistic vocabulary of Poussin's work. In his evocations of antique actions and settings, monumental figures are strictly ordered by architectonic space. In at least one composition, *Solomon and the Queen of Sheba,* the figures rigidly conform to a plane parallel to the picture surface and stand in profile against a screen of arches and columns (fig. 95). Grand rhetorical gestures establish a profound sense of stasis in several other paintings too. While Le Brun declared his allegiance to Poussin through selective yet systematic replication, Le Sueur's affinity to Poussin was based on his sacrifice of certain talents, such as his consummate decorative patterning and delicate effects. In contrast to Le Sueur's finest Annunciations executed before and after the Fronde, his works at mid-century exhibit a more ponderous and weighted lexicon of anatomies and gestures.

To sum up, Poussin's style not only had a currency as a result of the avid collecting of his work, but also through its emulation by members of the Académie. Le Brun and Le Sueur were not isolated cases. By turning to Poussin's thematic and stylistic example, these painters in Paris addressed the demand for imagery appropriate to the culture and *cabinets* of the *noblesse de robe*. *Frondeur parlementaires*, such as the presidents Le Coigneaux and Bellièvre, patronized the followers of Poussin. Le Brun provided the requisite visual ground for official deliberation and remonstrance in the Parlement. His painting of *Agamemnon Sacrificing Iphigenia*, along with Poussin's *Moses Striking the Rock*, provided a backdrop for conversation no doubt directed to the dramatic events of the day in the reception chambers of president Bellièvre. Sociability of a particularly political nature took place under Poussin's painting and Le Brun's homage to the artist. When guests glanced up in the midst of a conversation they would have seen a painting of Moses legislating in the face of civil disorder or Agamemnon's acquiescence to religious law. Bellièvre may have punctuated an argument by referring to the theme of sacrifice or the image of the biblical exemplar.

Les Mays: *Ambition and Public Display during the Fronde*

The Académie had one other major source of artistic patronage and public display in mid-seventeenth-century Paris: as noted before, every first of May before the doors of Notre-Dame a major commissioned work of art was unveiled.[78] This annual donation to the cathedral by the goldsmiths' guild had evolved over the seventeenth century from a poetic offering to the regular patronage and public display of a monumental easel painting. The so-called *Mays* not only served the devotional purposes of the church but also addressed a throng of spectators at the annual ceremonial unveiling.[79]

The public exhibition of monumental painting helped to further the careers of artists and allowed them to develop a range of skills attractive to a clientele that demanded an impressive array of advanced techniques and narrative effects. Beginning in the period corresponding to Poussin's return to Rome and the disgrace of Sublet, several future academicians were selected annually to represent scenes from the Acts of the Apostles: Bourdon, Errard, Le Brun, Loir, and Testelin. These *brevetaires* cum academicians dominated this public field to such an extent that it effectively became an extension of the Académie. At the Académie's inception, during the Fronde, the annual presentation of paintings continued to offer a public discursive exercise and practice of display within a civic as well as ecclesiastical context. This institutional display of art was an early formative precursor to the Salons later held by the Académie.

The May paintings were a measure of the currency of the values attached to Poussin's stylistic project. Several paintings executed in the years immediately before and during the Fronde display their allegiance to his example. Rather than using the term imitation, which implies the paradigmatic copying of an artist's style by weaker spirits, the term appropriation more accurately conveys the use of the artists' borrowed procedures. Commissioned by a corporate institution entrenched in the civic politics of the Fronde, aligned with the Parlement of Paris in opposition to Mazarin, the paintings therefore served as examples of one kind of culture in contradistinction to the artistic patronage of the crown.

Sébastien Bourdon was an unabashed follower of Poussin. In his small easel pictures, he alternately emulated Poussin's bacchanals and his episodes in the life of Moses. His *Christ and the Children* characteristically attends to ancient costume in a well-appointed

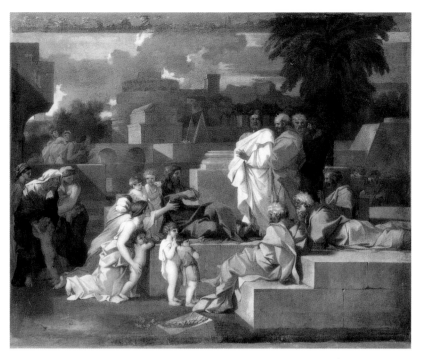

96. Sébastien Bourdon, *Christ and the Children*, 1650–55, oil on canvas (Paris, Musée du Louvre, inv. 2806), 5000 × 6100 mm.

antique landscape, recalling compositions by Poussin (fig. 96).[80] The rigid planar folds of fabric produce a complex pattern with a limited set of variables, comparable to the cloth on Eudamidas or the woman occluded by the column in Poussin's second sacrament of *Marriage* (see fig. 121). On a small scale, Bourdon competently amplified a single theme in Poussin's treatment of garments and produced a profuse, brittle geometry. Like Poussin, Bourdon's intense concentration of skills was well-suited to a small easel picture. The scale of the May paintings, however, challenged Bourdon as well as other followers of Poussin. In 1643, he executed his painting for Nôtre-Dame, the *Crucifixion of St. Peter*.[81] The high frequency of alternating directionality implied by the folds in the drapery in the small picture would have read as unnecessary surface busyness on a large scale. Poussin's style was not easily accommodated to the larger format. His heavy masses of figures, intense effort, and concentration of archeological resources were better suited to the modest cabinet picture, with its measured and intimate effects. The difficulty of translating Poussin's style to a large scale had already become apparent to contemporaries from the uneven results of the artist's own large compositions during his stay in Paris. There was, therefore, no technical advantage to drawing on Poussin's procedures. Several of the academicians had, after all, trained with Vouet who purveyed a range of expedient solutions for large-scale works. Yet Bourdon and others were willing to take the risk of adopting Poussin's pictorial language to the demands of ambitious, large paintings. This suggests that there were pressures encouraging such an appropriation.

In the year that the studio practice of painters outside the guild was being threatened, Le Brun executed his first *May* painting, *The Martyrdom of St. Andrew* (1647),[82] after which he founded the Académie Royale de Peinture et de Sculpture. With the inception of the Académie and in spite of the financial duress of the period of the Fronde, the *May* paintings continued to be a regular institution dominated by the academicians. Between 1649 and 1652, the paintings declared their indebtedness to Poussin's example in a public forum. In 1649, a year of siege and civil disorder, Eustache Le Sueur displayed his consummate performance, the *Saint Paul at Ephesus* (fig. 97).

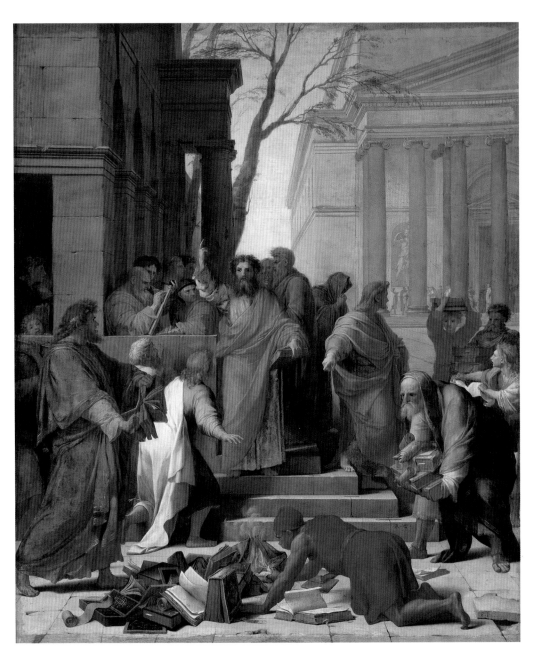

97 *(above).* Eustache Le Sueur, *Saint Paul at Ephesus,* 1649, oil on canvas (Paris, Musée du Louvre), 3940 × 3280 mm.

98 *(right).* Eustache Le Sueur, figure study for the *Saint Paul at Ephesus,* 1649, Pierre noir on paper (Paris, Cabinet des dessins, Musée du Louvre), 261 × 430 mm.

Eustache Le Sueur's May *Painting of 1649*

The ambition, monumentality, and public address of Le Sueur's *May* painting made hitherto unknown demands upon his skills. Apprenticed in Vouet's studio, Le Sueur had assisted in the execution of major decorative projects, but the *May* painting served as a demonstration of the new role he had assumed as a founder of the Académie.[83] The theme of the picture was resonant with the rhetorical demands put upon ambitious painting by the followers of Poussin. The apostle Paul preaches to the community of Ephesus. Through his command of speech and rhetorical gesture he persuades the assembly to renounce false teachings. The style of oratory is a powerful and plain affair: nothing detracts from the conviction of the rhetorician, no pretenses or flowery phrases.[84] The priests in their luxuriant robes hand over their books to the toiling servants who burn them (fig. 98).

Like the other *May* painters, Le Sueur was attempting to adapt distinctive features of Poussin's small easel pictures to the requirements of monumental painting. This problem-solving resulted in certain compromises. With the kind of training he had developed in Vouet's studio, he relied upon a broadness of touch and luminosity of hue to elicit pictorial interest. Yet, in order to lend authority to the rhetorical performance, the picture required significant placemarkers of a severe style. The rough texture of crude cloth on a socially subordinate figure provided a locus of unrefined directness of speech. Brevity and severity are also figuratively represented in the contrast between architectural forms.[85] The saint and his audience are visually aligned with a virile and austere architectural decorum. The archaic basilica, stripped of adornments, bespeaks the elimination of excess, the destruction of the accretions of false doctrines, those ornaments of thinking that are outside truth. In opposition to this humble basilica is the wondrous Temple of Ephesus. Le Sueur's attentiveness to archeological correctness is not for its own sake. He contrasts the virile Doric order on the side of orthodoxy to an elegant, effeminate Ionic temple dedicated to a goddess, on the side of heresy and over-refined paganism. The decalced evangelist is juxtaposed with the elegant cult statue of Diana in the temple wall, based on an ancient sculpture found in the French royal collections (see fig. 86).[86] Le Sueur made explicit the ways in which a criticism of seductive luxury and the countering of it with a severe alternative form entered a gendered typology.[87] The interests of the Parlement and its constitutive rhetorical culture was represented by an austere, masculine style. Yet, Le Sueur's ultimate success was based on a compromise: his delightful play of luminosity and soft tonal gradations entered the larger composition not merely to be deflected by the weight of rhetoric but also to sustain viewing on a grand scale.

Nicolas Loir and Louis Testelin: *The* May *Paintings of 1650 and 1652*

A year after Le Sueur's effort, Nicolas Loir executed the *St. Paul Blinding the False Prophet* (fig. 99).[88] Loir had recently returned to Paris after study and research in Rome, where he would have had direct contact with Italian painting and with Poussin.[89] He is best known to art historians as the creator of pastiches of Poussin's historical landscapes, like Bourdon with whom he trained. In the modestly scaled *Rebecca at the Well* (fig. 100), Loir wedded Poussin's famous chain of figures in his painting of the same theme with his formulaic distant view of an antique city by a body of water.[90] The preparatory drawings show that

99. Nicolas Loir, *St Paul Blinding the False Prophet and Converting the Proconsul Sergius*, 1650, oil on canvas (Paris, cathédrale de Notre-Dame), dimensions unknown.

100. Nicolas Loir, *Rebecca at the Well*, c. 1650, oil on canvas (Angers, Musée des Beaux Arts), dimensions unknown.

102. Louis Testelin, *St. Peter Reviving the Widow Tabitha*, 1652, oil on canvas (Arras, Musée des Beaux Arts), 3850 × 3000 mm.

Loir paid particular attention to the individual expressions of the witnesses to the false prophet struck blind by the apostle.[91] However, he was more successful in accomplishing the metamorphosis necessary to emulate Pousssin on a large scale. In the final painting, the movement and reactions of the principle figures and witnesses have been subdued. The narrative structure opposes the expressive figures which bracket the composition, recalling Poussin's *Judgment of Solomon* (see fig. 75). The two concentrated groups flanking the centralized emperor witness the tension between the contrasting religious leaders. In Loir's picture, the miracle results from the authority of the orator's speech and gesture, not from violence or intervention. In the center, the emperor, converted by the sight of the miracle, is depicted as a responsive figure who interprets the system of gestures. This authoritative viewer by proxy is, in turn, surrounded by compact isocephalic groups of attendant witnesses encompassed by a rigorous architectural structure, organized by a highly structured post and lintel system in the Ionic order. Loir's compression of figures within a shallow plane was a conspicuous declaration of affinity with Poussin's compositions of the late 1640s. He also appropriated distinctive features of Poussin's most recent work, the brutal symmetry and stiff figures of the *Judgment of Solomon*, thereby blurring the distinction between archaism and the limits of Loir's own competencies.

In 1652, the academician Louis Testelin executed and exhibited his *Saint Peter Reviving the Widow Tabitha*, perhaps the strongest direct appeal to Poussin's example in a *May* painting (fig. 101).[92] Like other founding members of the academy, including his good friend Charles Le Brun, Testelin was no stranger to the conflict of the Fronde. As I showed earlier, like Bosse Testelin produced and sold a *frondeur* print. Testelin's painting was commissioned at a time when support from the regency was negligible and the very survival of the regency was doubtful.

The treatment of the theme of the saint reviving the late Tabitha makes a direct appeal to a number of important compositions by Poussin through a process of reference and recombination. Tabitha's recumbent figure on the threshold between life and death recalls *The Death of Germanicus* (see fig. 8), the two sacraments of *Extreme Unction* (see figs. 70 and 71), and the *Testament of Eudamidas* (see fig. 79). Against the spare ground of the draped wall the range and amplitude of expressions are diminished. The reduction of the number of protagonists and the nearly brutal simplification of narrative anecdote demand comparison to Poussin's contemporary compositions.

Testelin had a better understanding of a painting such as *Eudamidas* than other followers. Rather than impressing upon the viewer a panoply of archeological referents, he used these materials with great economy. A fully constituted antique world is suggested by synecdoche. The colonnaded dome in the distance is seen in fragments through the pierced wall, enframed by the columns. The truncated posts reveal no capitals. The widow's tomb is severe. The bald effect of the unadorned architectural lines is relieved only momentarily by a few filigrees in the wall separating the mourning woman from the perceived miracle. In the *Testament of Eudamidas*, sensual properties of painting were relinquished in exchange for an intensity of formal relations on an intimate scale. The elements of Testelin's severe pictorial economy served as indices of Poussin's act of renunciation and violent substitution.

∗ ∗ ∗

The appropriation of Poussin's art was a complex phenomenon that occurred at the inception of the Académie Royale during the Fronde. Initially useful to ameliorate the critics of the cultural policies of the regency, the substantial support of official painters by those in opposition to the regime suggests that Poussin's example continued to serve the cultural politics of the *noblesse de robe*. By attempting to reestablish the cultural alliance between the crown and the royal officials, the regency gave the artists an authority exceeding that of *brevetaire* favorites or artisanal guild members.

Contrary to the subsequent identification of the Académie with the centralized management of political and artistic culture, the institution was established in order to undermine the image of the arbitrary authority of the regency. Extant histories tend to emphasize the role of the Académie as an arm of the state under Colbert. But at its foundation, it was intended to serve the state and the *bien public* like other royal institutions. To become another royal institution in the days of the Fronde meant that the Académie was subject to the same political behavior. The academicians supported themselves through a patchwork of personal and institutional patronage. As an assembly of royal servants dedicated to the principle of monarchy, it distanced itself from a regime whose right to power was disputed. Sometimes, the fledgling institution was a microcosm of the Fronde itself: declamation, deliberation, and stratagems were the order of the day.

Poussin's painting was ballast for the *noblesse de robe* during the uncertain conditions of the Fronde. His range of themes and the rhetorical power of his style embodied the tra-

ditional values of French humanism. By supplying members of the *noblesse de robe* with credentials based on these thematic and formal lexicons, the academicians insured their ability to obtain commissions as well as establish themselves as another meritorious elite in the service of the state. The early academicians were thereby rehearsing one of the ongoing paradoxes of the institutional formation of visual culture in France: institutional authority was largely derived from outside itself. Far from the machinations of Paris, Poussin's capacity to represent disinterestedness and bear the traditional cultural values of retreat offered a compelling example. Poussin's authority as an exile in Rome was recapitulated by generations of promising later students, Jacques-Louis David among them.

For the Académie in 1648, however, the capacity to maintain and reproduce institutional authority was tenuous. A transmittable style presented itself as a solution to this problem. However, the capacity of a regency to make claims to that authority potentially compromised the integrity of Poussin's pictorial language. The very way *manière* could be transmitted and copied posed a problem. Transmission made the symbolic function of style implicitly unstable. Emulation created its anxieties. Subject to appropriation and dispersion, art was vulnerable to compromise.[93]

Integrity and the capacity to sustain practice were problems Poussin had to face as a painter. I argued in the previous chapter that the *Testament of Eudamidas* thematized the particular terms of exchange between artist and recipient in order to secure signification. The painting accomplished this through the theme of legacy as well as a highly ordered application of paint. Poussin's painting rejected ostentation and unregulated *curiosité*, but it did so at the risk of stagnation. In order to sustain painting as a practice and yet articulate its suspicion of artifice, Poussin had to traverse other cultural terrains found in the sixteenth century. The landscape offered both a site of pictorial engagement and imagined retreat.

Chapter Eleven

Painting and Landscape

At the height of the Fronde, Michel Passart acquired a landscape painting by Nicolas Poussin (fig. 103).[1] The picture represents a scene of little historical or mythological consequence. On the outskirts of a town, a woman bathes her feet in a pool of water. An older woman sits nearby. A man's face peers out of the brush and spies upon the bather. Beyond the immediate group of figures, others recline. A soft light illuminates their leisure. Nearby, a shepherd leans over his staff as he looks after his sheep. As a rustic bathing scene with scattered and incidental figures, the canvas does not claim to depict a significant narrative. The voyeurism is not organized into myth. No satyr spies upon a nymph. Diana is not seen by Actaeon. Other erotic readings are withheld. The elderly figure chaperones rather than procures. A woman rubs her foot. The presentation of the everyday is declared and situated in a landscape where the staffage has the time and leisure to contemplate the play of light in the leaves seen against a crisp blue expansive sky with billowing white clouds.

The painting might strike some as an odd choice for my final chapter. The shift in rhetoric risks leading the reader astray from my tale of political engagement, disappointing some, confirming the doubts of others. How do I explain the existence of such a picture in the light of the historical events and pictorial interests that were shared by Poussin's clients in the critical year 1650? If I make the statement "In 1650, during a civil war, Nicolas Poussin painted a landscape with no apparent literary or historical referent," I am asking readers to relate two historical events of a different scope and magnitude, rebellion and landscape painting. Given my argument, how can I explain this apparent disjunction between the desire for a scene of rural repose and Passart's political commitments? Did the act of painting a landscape ultimately represent a disregard for politics?

The seeming lack of coordination between landscape painting and history is all the more dramatic against the background of the actual conditions of the countryside outside Paris. During the Fronde pamphlets drew upon the historical memory of the devastation of the previous century: "We still have not forgotten the furies of our recent civil war; our countrysides, covered by dead bodies, are not yet cleansed, our streams, our rivers, and our fountains are still reddened by French blood . . ."[2] Once again the countryside had been metamorphosed by civil war. Or rather, the representation of the landscape was once again central to the strategies of the pamphleteer. At times, political discourse was guilty of pathetic fallacy, imbuing nature with human qualities. The Seine drowned her children. The River Marne was a poor raped widow.[3] Hyperbole registered the intensity of feeling. Montparnasse was a Cossack mountain overrun by foreign mercenaries, eagles and vultures feeding on a French Prometheus.[4] Montmartre had become a second Mount Aetna "that ceaselessly vomits ash, fire, and flames." Warfare at the city's edge was not

103. Poussin, *Landscape with a Woman Washing Her Feet*, 1650, oil on canvas (Ottawa, National Gallery of Canada, Gift of H. S. Southam, Ottawa, 1944), 1165 × 1747 mm.

only measured in terms of material hardships within its walls but conflict had robbed the people of "a sacred theater":

> In the vicinity of this city, these beautiful places, which once served nature artfully, and were the admiration of all its spectators, are no longer seen. All these beautiful boroughs and all the rich ornaments of France are ruined. The situation and face of things have changed . . .[5]

In short, the view of the environs of Paris had been spoiled.

What does one do with the fact of a picture of a woman in rural repose against the testimony of a witness to the extinction of the countryside? The famous Jansenist Mère Angélique described the destruction of the French countryside by mercenary soldiers from her religious retreat at Port-Royal:

> It's horrible to see this poor country. Everything here has been pillaged. The soldiers quartered in the farms thrash the wheat and don't want to give any of the grain to the poor masters who beg them for some to mill. Nobody labors, because there are no longer any horses. Everything has been stolen.[6]

Mère Angélique's correspondence resembled the pamphlets that circulated in Paris during the Fronde. Both letter and *mazarinade* provided accounts of the threat of violence and the scenes of "families languishing from hunger, despair, and the tomb."

And so we might find it hard to reconcile Passart's picture of a woman washing her feet with Mère Angélique's words that traced the passage of the war through the months and seasons. In January, the winter landscape was desolate. The poor hid themselves in the woods in order to escape the marauding troops.[7] The spring brought no relief. The

104. Louis Le Nain, *Le Halte du Cavalier*, 1640s, oil on canvas (London, Victoria and Albert Museum), 546 × 673 mm.

nuns could not help the hungry peasants. By the end of summer, the sisters had entrenched themselves against another devastating winter. Port-Royal was a compound protecting the remaining animals; all the horses and asses were dead. The courtyard was full of chickens, turkeys, ducklings, and geese, inside and outside. One of the wine cellars housed forty cows. The church was used as a warehouse and silo. A dozen or so young girls had also sought refuge there.[8] But the woods were still filled with displaced persons. Prices had become inflated beyond comprehension and the suffering was inexpressible. Letters describing deserted villages, starvation, murder, and sexual violence continued to be written season after season for three years.[9] Mère Angélique was clearly describing a different landscape from the one presented to visitors in Passart's cabinet.

Another contemporary painting by one of the Le Nain brothers would not have seemed as remote from the terms of Mère Angélique's text (fig. 104).[10] The depiction of a group of prosperous peasants (sometimes including a tenant farmer hired by one of the Parisian bourgeoisie) may have been an attempt to commemorate through portraiture an economy and a culture ravished by demographic crisis and war. Clearly, Poussin's paintings neither addressed current social conditions nor attempted to recuperate that loss through ethnographic salvage. Nevertheless, I am not pointing out the great discrepancy between the actual condition of the land and the pictured landscape in order to underline some false consciousness or bad faith on Poussin's part. I am instead attempting to understand why the distance between the artist's intimate knowledge of his "pauvre France" and his landscape painting was meaningful. It is necessary to admit that such a tension existed between the representation of contemporary historical events and Poussin's landscapes in order to address his more radical avoidance of the task of representing history in a number of landscape paintings. An important group of Poussin's landscape paintings, several executed

105. Poussin, *Landscape with Orpheus and Eurydice,* 1648–50, oil on canvas (Paris, Musée du Louvre, inv. 7307), 1240 × 2000 mm.

106. Poussin, *Landscape with the Body of Phocion,* 1648, oil on canvas (Cardiff, National Museum of Wales, on loan from the Earl of Plymouth, Oakly Park, Shropshire), 1160 × 1781 mm.

during the period of the Fronde, were not derived from an identifiable literary or historical source. A woman washes her feet. Lightning strikes a tree and a branch falls upon some travelers in a cart (see fig. 117). Some landscape paintings were not even structured by a central narrative: people recline along a road or by a fountain (see figs. 110 and 111), a shepherd leans on his crook (see fig. 118).

There were, of course, important exceptions. A number of the artist's landscape paintings executed for his French clientele during the Fronde had an explicit theme. Some alluded to the recent history of France. Sheila McTighe has argued that the *Landscape with Orpheus and Eurydice* even approached the conditions of allegory (fig. 105).[11] Indeed, the civilizing Orpheus set against the burning city would have been pointed in its reference to the corrupt double in Torelli's opera. Other pictures, in keeping with the themes of Camillus and Eudamidas, used the landscape as a setting for significant individuals borrowed from the lexicon of Greco-Roman history and literature. Consider, for example, the case of a major pair of pictures painted in 1648 where ancient landscape provided the stage for recounting one of Plutarch's lives. Suffering disgrace and forced by the body politic to commit suicide, the general Phocion was refused a decorous burial and his remains were exiled from the territory of Athens (figs. 106 and 107). In one canvas, the solemn and rudimentary procession bears his body to the countryside away from Athens. In the other, his ashes are gathered and retained until they can be brought back to Athens after his reputation has been posthumously rehabilitated. In this pair of paintings the landscape was integral to telling the story. Far from depicting the clash of a disorderly crowd or the neglect of the corpse, the careful removal of the body represents a ritual that

107. Poussin, *Landscape with the Ashes of Phocion*, 1648, oil on canvas (Liverpool, Walker Art Gallery, The Trustees of the National Museums and Galleries on Merseyside), 1160 × 1785 mm.

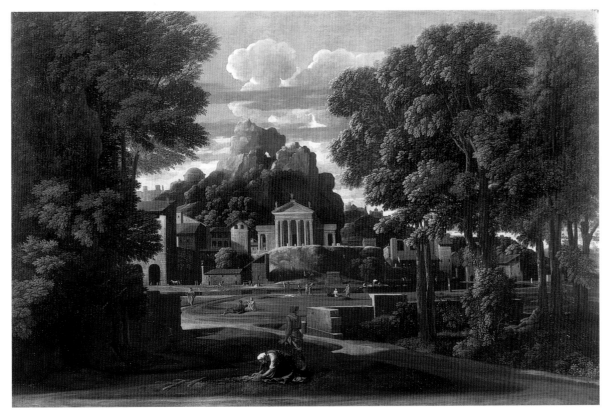

is compatible with the extramural burial of the Romans (witnessed by the tombs Poussin would have known along the via Appia Antica). Indeed, the burial outside the city was consistent with the practices of the early church that were being emulated by some in France during the Counter Reformation. In this way, the painting may be understood as a sequel to the Seven Sacraments and the *Testament of Eudamidas*, completing a cycle of unostentatious cultural responses to the passage from birth to death drawn from ancient sources and the archeology of the early Roman church.[12]

If Mère Angélique's landscape was filled with chickens, pigs, and ducks, the humanist's landscape was arguably replete with human cultural practices, so I would be hard pressed to speak of Poussin's landscapes as entirely devoid of history. In the eyes of Poussin's client, landscape was difficult to separate from historical narrative. One could even say that for the French humanist the landscape was saturated with the past. After all, artifacts were buried in this countryside. Scholars, such as Guillaume du Choul and the Bellièvres of Lyon, depended on the laborer toiling in the fields, who inadvertently unearthed the cache of medals, a lamp, or the Claudian tablet (see fig. 19).[13] Landscape also held in reserve the exposed architectural remnants of a Gallo-Roman past, witnessed in Poussin's drawing of an arch in the south of France (fig. 108). In the drawing, as in Montaigne's own encounter with antiquity along the same road to Rome, the landscape had the power to call forth social memory.[14] Poussin's arch was an irruption of the Roman past in the French countryside. In addition to the statuary collection, the epigraphic catalogue, and the antiquarian drawing, the land served as a repository, even an archive, for the humanist *noblesse de robe*. For Montaigne, in the account of his voyage to Rome, the landscape was the site where antiquity was brought into visibility from the quotidian: "a building, a fountain, a man, an ancient battlefield, the route taken by Caesar or Charlemagne."[15] The ruin was a commemorative site that complemented the historical text and institutional memory as sources of knowledge. As Montaigne traveled toward Rome, the traces of empire anticipated the Capitol of his imagination.

In fact, it is well known that several of Poussin's paintings trace the contours of a culture that understood the landscape as a repository of ancient material remains. The ruin-strewn landscape of a painting from the 1630s, *St. John at Patmos*, is the site of inscription (fig. 109). Millenary history is revealed through divine inspiration and a critical perspective gained on the ruins of empire. Poussin's reconstruction of the past was no doubt taken from his experience on a drawing expedition outside the city, encountering the remnants of antiquity pitched in the Roman campagna. His reputation for the compression of ancient history and the landscape is exemplified by his apocryphal response to a man searching for the best antiques in Rome: he reached down and gathered in his hands some soil filled with marble shards.

Yet even in pictures devoted to an explicit theme, such as the Phocion pictures, where the landscape served as a site of memory and recitation, there is a dispersal of attention to a number of incidents – mundane human activity, atmospheric conditions, and the effect of light on vegetation and soil. The seemingly accidental quality of the scene betrays an interest that far exceeds the demands of a didactic theme. Paintings such as *Landscape with a Storm* and *Landscape with a Calm* are declarative of their investigation of landscape with no explicit literary reference (see figs. 117 and 118).[16] Likewise, the pair entitled *Landscape with a Man Washing his Feet at a Fountain* and *Landscape with a Roman Road* signify not only a removal from contemporary events but even the refusal to illustrate a text and the withdrawal from historical narrative as an organizing principle (figs. 110 and 111). Rather, these pendants, like the series, stress their own internal dialogue. Atmospheric conditions are contrasted, for instance. A storm is understood by comparison with its

108. Poussin, *Drawing of an Arch in the South of France (View of Villeneuve-lès-Avignon)*, 1642, ink and brown wash on paper (Chantilly, Musée Condé), 219 × 277 mm.

109. Poussin, *Landscape with St. John on Patmos*, 1640, oil on canvas (The Art Institute of Chicago, A. A. Munger Collection, 1930.500), 1003 × 1364 mm.

110. Poussin, *Landscape with a Man Washing his Feet at a Fountain*, 1648, oil on canvas (London, National Gallery), 745 × 1000 mm.

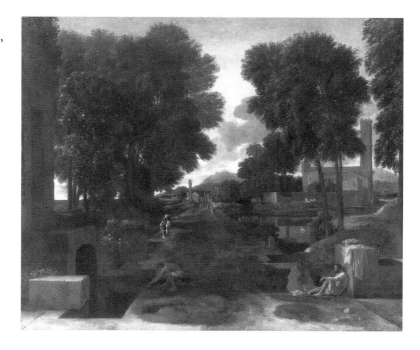

111. Poussin, *Landscape with a Roman Road*, 1648, oil on canvas (London, Dulwich, Alleyn's College of God's Gift), 780 × 990 mm.

counterpart, calm. Or, the comparison of a straight and a winding road points to the human gestures of those along the respective routes. The scattered human bodies do not make special claims to bear the burden of history painting yet their figures are not sufficiently extraneous to be discounted. They are not mere flicks of the brush.

Poussin's painting of a woman washing her feet, or picture of a man sitting by a roadside fountain, or a shepherd leaning against his staff, seem to resist being read as history paintings. Although verdant scenery at times provides a backdrop for history, it would be unwise to ignore the evidence in these paintings of Poussin's own assertion that narrative painting and landscape were distinct genres. Far from an anachronistic taxonomy, the distinction between landscape and history painting was one recognized by Passart. The following partial list of canvases in the inventory personally drawn up and signed by him after his wife's death provides an insight into the collector's interests as well as a working vocabulary:

Item in the salon a large landscape [*paisage*] by Rubens with gold frame . . . 600 livres

Item another landscape copy after Domenichino with gold frame . . . 200 livres

Item another landscape copy after Poussin with gold frame . . . 150 livres

Item two other landscapes of an unknown style with gold frame . . . 55 livres . . .

Item in the bedroom of M. Passart one landscape above the mantle and two other landscapes as overdoors . . . 10 livres

Item in the cabinet next to M. Passart's bedroom a landscape by Foucquiere . . . with gold frame . . . 80 livres . . .

Item in the *Grand cabinet* . . . a large painting [*peinture*] by Poussin representing the Continence of Scipio with gold frame . . . 2000 livres

Item a large landscape [*paisage*] by Poussin with gold frame . . . 1500 livres . . .

Item a painting by Dufresnoy representing a landscape with many figures . . . 150 livres

Item a landscape by Poussin with gold frame . . . 1500 livres . . .

Item a painting by Poussin representing a virgin in a landscape with gold frame . . . 2000 livres.

Item a painting by Poussin representing the Schoolmaster of Falerii . . . 1000 livres.[17]

From the antechamber of Passart's residence, through the sleeping quarters and its adjacent sitting room to the more formal picture gallery or *Grand cabinet*, the notary found a great number of landscape pictures. Landscapes by Poussin enjoyed pride of place among his history paintings. Their quantity and placement reveal a concerted interest on the part of the collector.[18] Nevertheless, the notary did not bother to offer a title or otherwise describe the landscape. When a landscape provides a setting for the Virgin it became a "peinture." Otherwise, the generic description was sufficient for the document. The painting we know as *Landscape with a Woman Washing her Feet* was a "paisage." At least in Passart's treatment of his own collection as property, *paisage* was differentiated from *peinture*. Landscape was understood in significant relation to the unmarked category "painting," which stood for narrative or history painting. By implication, a "landscape" was a picture that was categorically different from a *peinture* because it did not make any claims to represent a significant narrative. The notary's and owner's shared vocabulary points to an important difference between landscape and history painting, one that is borne out by other historical testimonies. I am not suggesting that landscape was "pure," free from history or outside the domain of the humanist culture described in this book. Rather, history was intelligible as a category because of its distance from the landscape as it was imagined by Poussin and his clientele.

Retreat

The contrast between history and landscape painting depended upon the familiar structural opposition between city and country. For Poussin, landscape signified detachment from the city and its histories but the requisite distance was visually and symbolically dependent upon an oblique view of the city (see figs. 105–7). Repose was always set in relief by removal from an architectonic order that was nevertheless still visible. Invariably, for Poussin's French clientele, the sustained visual engagement with the distant city was inflected by the practices of disgrace and retirement. By now the reader is familiar with the importance of retreat for Poussin and his French clientele. Sublet de Noyers's disgrace was specifically articulated as a withdrawal to the country. In a letter to the *parlementaire* Molé from his provincial retreat at Dangu he wrote: "Sir, permit the performance of one's

duties as well in the desert as in the mob and the tumult of cities." By calling the site of his retirement a "solitude" or a "wilderness," Sublet was rehearsing a well-known topos.[19] The experience of disgrace and the physical departure from the court was organized and performed according to pervasive traditional tropes.[20] *Robe* nobles modeled themselves after Montaigne, volunteering to flee the palace and "retir[e] to a private house to live without ambition."[21] When Guillaume du Vair left the court in the early seventeenth century, he ended his final harangue to the king with these words: "Having committed no other crime than being an *homme de bien*, I take leave of you."[22] Du Vair, who had served Henry IV in council as well as in the streets of Paris, who had written political theory and a consolation for civil war based in part on a theory of perception, retired to his country house.[23]

For viewers of Poussin's landscapes, there were ample models for an anti-courtly position in poems by a generation of writers who witnessed turbulent political fortunes in mid sixteenth-century France.[24] The refrain of the *robe* nobility's ambivalence toward the court was articulated in the figurative and actual flight from urbane society to the country. For the poet Philippe Desportes, retreat was the imaginative construction of one's own court in the midst of the "fields, forests and the woods/Far from the tumult and the popular noise."[25] Similarly, the verse of Nicolas Rapin claimed that living near a garden in a simple country house where "No costly Tapestry his walls prophan'd," was amply compensated by the promise of political autonomy.[26] His *Plaisirs du gentilhomme champêtre* (1575) eulogized a landed gentry distant from commerce and the court, tending to cattle and crop, whose house was built

> Without grand sumptuousness
> Only a few buildings.
> Beautiful entrance and beautiful exit
> With all the conveniences.[27]

Rapin was searching for a poetic language to articulate the theme of political retirement. His country gentleman resembles the same poet's rendition of Horace's fabled country rat who flees the alarming threat of the city. Despite the rat's attraction to the atmospheric effects of silk brocade in the grand seigneur's townhouse and the elaborate spread on the Turkish carpets of his urban host's table, he cannot settle. Instead, he flees back to his straw nest, nourished by the simple fare of nuts and fruit "without noise."[28]

As in the case of Montaigne, retirement was conceived by the *robe* nobility as productive leisure. Although one smug commentator wrote that Sublet des Noyers was going to the country "where there will be all the time in the world to plant cabbages," for Sublet, Charles Errard, and the Fréarts rural retirement was the site of conversations that led to a treatise on ancient architecture.[29] A *noblesse de robe*'s retreat to a country house provided the necessary *otium* for cultural production, which included the collection of paintings or the discussion of architecture.[30] As in the case of Descartes, who found his own "desert" in Holland, theoretical work occurred at a distance from institutional power.

When a Frenchman viewed one of Poussin's invocations of an ancient landscape, he would have associated landscape with retreat both because of events and poetry in recent historical memory and because of templates inherited from antiquity. The recent retreat of the Jansenists to Port-Royal not only rehearsed Christian asceticism but also followed the practices of ancient Romans.[31] Arnauld d'Andilly, who as I said earlier produced pamphlets against the regency, also wrote tracts on the cultivation of trees that imitated the exiled Cato's "On Agriculture."[32] Such interests were part of a larger social trend of cultivation of the land by urban elites.[33] The voices of other famous ancient exiles were uttered

by pamphleteers attacking the regime during the Fronde. According to the *mazarinade* entitled *Exiled Seneca*, although the "philosopher and physician of the State" was banished, he was "joyful to be delivered from the troubles of the world."[34] Here, removal was patterned upon a distinction between court and country.

The opposition between civic and rustic economies points to a particular form of citation. Rather than providing a key to "reading" specific works, that is, an iconography, the free circulation of citations from ancient literature offered a modality that helps describe the enterprise of landscape painting. The landscape inherited from antiquity provided the setting and situation for an imagined community in retreat.[35]

Eclogues

The category of landscape seems to resist citation, however. Indeed, the descriptiveness of Poussin's canvases attentive to the land appears largely unmotivated. In several landscapes, the artist depicted the apparent randomness of unworked stone and uncultivated vegetation. The accidents of nature were organized, however informally, by the social practices at the edge of the city. A shepherd tends his sheep along the shore. Bathers enjoy the deeper water. Figures recline. Poussin rehearsed the traditional contrast of persons and behaviors found at the border of the city with those within its walls. His reputation in the twentieth century has been largely dominated by one other representation of a rural community, his painting known as *Et in Arcadia Ego* (fig. 112). Any interpretation of the figures

112. Poussin, *Et in Arcadia ego*, c. 1638, oil on canvas (Paris, Musée du Louvre, inv. 734), 850 × 1210 mm.

contemplating the inscription on the tomb depends in part on the assumption that they occupy a space far from the city. Even as the tomb invokes history in the countryside, the legibility of the epigraphic remains is limited by the passage of time and is figuratively obscured by the shadow cast by the deciphering hand of the shepherd. A stress is placed on a situation marked by its difference from civil society.

A number of works painted around 1648–51 were similarly based upon such observed distinctions between urban and rural social practices. In *Landscape with a Calm,* a goatherd leans on his staff in the foreground (see fig. 118). In the near distance, a man plays the bagpipe, preceded by sheep, rams, and cattle (see fig. 102). The herder and the flock are subjected to the force of wind and rain in the pendant (see fig. 117). The figure of the goatherd and a grazing herd is again repeated in the middle ground of the *Landscape with Diogenes* against the reflecting pool of water (see figs. 119 and 120). Men from the town gather along the distant banks to bathe. The shepherd is never far from the traffic of city-dwellers as they temporarily seek repose.

The prospect of the retiree from political affairs was not the only template for viewing a landscape painting. Readers of Latin literature in sixteenth- and seventeenth-century France could not have viewed Poussin's representations of the countryside without the lens provided by pastoral poetry.[36] By assuming the shepherd's voice, humanist poets emulated the *Idylls* of Theocritus and Virgil's *Eclogues*, rehearsing a position of imagined autonomy and formal experimentation. By turning away from the trumpet and its epic voice, the pastoral poet assumed a diction, metrics, and range of metaphors appropriate for the conscious articulation of a lower decorum. Pastoral verse was one available form of the temporary renunciation of urbanity and cultural sophistication.

The contrast between *paisage* and *peinture* was therefore rehearsed in the generic distinction between, on one hand, the lowly themes and poetics of bucolic verse and, on the other, the historical import and grand effects of epic. But the eclogue was not understood as a complete renunciation of worldly affairs. For the poet, the banal details of bucolic life also became a prospect for political analysis. Having claimed distance from the pompous effects of encomiastic verse, the pastoral voice stood for truthfulness based on the authority of disinterestedness and the observation of nature. It permitted the poet to disavow at least imaginatively the contingencies of address to a social superior or the binding obligation of clientage. For the poet, the pastoral gesture renounced artifice. A seventeenth-century French speaker such as Poussin would have described this as the paradoxical claim for art *sans art*. The poet cast away falsifying diction and meter, brass and percussion, and made "rustic musings on a delicate reed." Lower decorum signified authenticity: "Truth again, and against poetry."[37]

When French speakers approached a painting peopled by shepherds, they brought with them a set of interpretive schema derived from pastoral literature. Just as the literary genre was, in Bahktin's sense, the already spoken, the landscape as a genre was the already seen. The painting, like the poem, derived its authority precisely from the fact that the pastoral mode already belonged to a situation. For seventeenth-century French viewers, that pastoral situation was conceived as the continuity between Virgilian pastoral and the use of bucolic imagery in the poetry of the previous century. The pastoral situation was not however a lotus land where social memory and frustrated desire were erased: as one of the first poetic genres adopted from antiquity during the French Renaissance, the eclogue was never an autonomous genre but one always closely associated with the politics of state.[38] On one level, it was understood to be allegorical. Virgil's fifth eclogue, the dialogic response to the death of the shepherd Daphnis, which was interpreted as an elegy for Julius Caesar, became the major precedent for an extensive tradition.[39] Ronsard's *Angelot* gave the Valois king a pastoral apotheosis:

> Shepherd Harry, instead of living on earth
> All full of fear, fraud, and war,
> You live high up there in the heavens.[40]

The pastoral elegy, which had a tremendous impact upon poetic responses to personal mourning in European literature (Milton's "Lycidas" is the benchmark in English), provided Poussin with a way of articulating the experience of political crisis and communal loss in the Phocion landscapes. If we attend to that patchwork of human activity in the pair of paintings with the eclogue in mind, a pattern of sociability familiar to the reader of pastoral verse falls into place. In the *Landscape with the Body of Phocion* (see fig. 106), the simple bier in the foreground contrasts with the pomp and fanfare of a procession in the distant, polluted city. The rudimentary ceremony is implicitly accompanied by the robed figures who, just beyond the shepherd, gather to sing and play the lyre (see fig. 115). Just beyond them, in the center of the canvas, is the garlanded relief decorating a monumental tomb. In the pendant (see fig. 107), a flutist resting in the meadow accompanies the gathering of ashes. Above the huddled woman who places the remains in the folds of her garment, a companion turns, responding to the sound of another solitary flute player lying in the shade of a birch (see fig. 113). Rather than reinscribe the political intrigue and popular disorder that led to Phocion's fall and officially imposed suicide, the painter offered a carefully structured elegiac response.[41] Like Ronsard's pastoral elegy, the ultimate tribute is the inversion of decorum. A tightly cadenced pictorial composition organizes the enumeration of simple motifs. A man strolls while reading a parchment. Another man reclines while his companion plays a wind instrument, oblivious of the women carrying water and washing laundry in the distance. The plight of exile and the disavowal of ostentatious ceremony were both central to the pastoral elegiac mode. Viewing the pair together, loss was articulated in tandem like the responsive songs of two shepherds.

The pastoral response to civil disorder and violence was not unprecedented. Again, Poussin's painting depended upon a depth of cultural and political practice. Throughout the sixteenth century, the French *églogue* enjoyed a special relationship to political culture precisely because of the devastating violence and demographic crises. After 1560, during the religious wars, there was an increase in poetry contrasting country and city life.[42] A dialogue of shepherds, such as Maurice Scève's "Saulsaye. Eglogue de la vie solitaire," debated the respective merits of city and country life. The country offered not only the pastoral conceit of a life *sans soucis* but also the requisite artlessness as a sign of freedom from external and internal servitude, tyranny, and ambition.[43]

As in Virgil's *Eclogues* and the *Georgics*, death and marching troops were never far from the idyll and the fruits of the harvest. Far from the bucolic world as cast by Boucher, the Virgilian world of shepherds offered French poets of the sixteenth century a position from which to speak of the horrors of civil war. In Claude Gauchet's "Eglogue," the dialogue of two herdsmen turns to the devastation of mercenaries:

> *Phlippot:* We see, even before our eyes,
> The raging soldier, furious, ravaging
> All that the poor peasant had gained
> With the sickle and the sweat of his poor family
> *Michaut:* I know it well. This Easter I had
> Six beautiful young sheep that I carefully tended
> Intending to sell and make money, so that I would be able to live
> Until the harvest; but they were taken from me. . . .
> They ravaged me entirely and senselessly
> Threatened still to burn my house.[44]

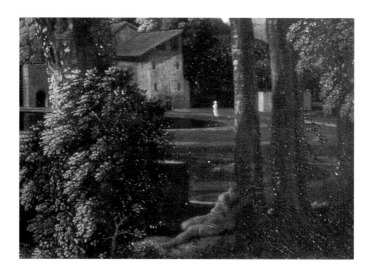

Phlippot responds with a description of the "raging wolves" who, quartered in his master's
house for eight days, ate ravenously, tortured, robbed, and raped.[45] In Gauchet's eclogue,
the desolation of the countryside was ultimately invoked by turning back to the Virgilian
source and lamenting the absence of shepherds:

> Too often you see herds without shepherds.
> Where are Belin, Phlippot and Bicheon
> Whose voices and flutes
> Have been heard so many times in the woods?[46] (fig. 113)

The capacity of Poussin's viewers to associate shepherds with a response to political
crisis was facilitated not only by the extensive production of eclogues during the civil war

114 *(left)*. Pierre Bertrand, *Two Peasants Discussing the War of Paris (Les Deux Paysans de Sainct Ouën et de
Mont-Morancy dans leur agréable Conférance touchant la guerre de Paris)*, 1649, engraving (Paris, Bibliothèque
Nationale).

115 *(right)*. Detail of fig. 106.

of the sixteenth century but also by the continuous deployment of pastoral imagery during the monarchical crises of the seventeenth century, from the death of Henry IV to the period of the Fronde. Some of the pastoral allegories "on current affairs" that served as thinly veiled political attacks on the regency of 1614 were merely reprinted in response to a repetition of circumstances in 1650.[47] The pastoral poetic tradition provided a readymade political discourse in numerous pamphlets during the Fronde. In one pastoral dialogue of "country frondeurs" the herdsmen spoke directly about contemporary events, condemning the "evil foreigner" Mazarin and eulogizing "Messieurs of Parlement," all the while mixing Roman history with metaphors from animal husbandry.[48] The political harangue in the guise of a eclogue began with a pastoral refrain adjusted to the politics of the day: "Let's stop here, dear village Frondeur, Our cattle would not be able to graze in a better pasture."[49] The seventeenth-century French reader overheard political commentary from a number of pastoral voices: a bucolic dialogue, the remonstrances of a shepherd,[50] and the plaint of a country poet.[51] The reference was far from being obscure or covert. Passart expected himself to be well prepared by an extensively read literature. Viewers were accustomed to the dialogic criticism of the city by country folk (fig. 114). For a few *sous*, Parisians bought pamphlets on the Pont-Neuf and overheard a conversation between two peasants. The pastoral genre placed a stress on an authoritative enunciative position in the most humble of circumstances. In a parallel gesture, Passart and his friends gathered around one of Poussin's landscape pictures, gazing at the shepherd, his flock, and a group of men reciting poetry (fig. 115).

Genre

The pastoral tradition helps us understand the differences between *paisage* and *peinture* as they were used in Passart's inventory. The French were in the process of developing the easel picture as an object with no small amount of cultural significance. Poussin's project depended upon an audience's capacities to distinguish between landscape and history painting and upon the understanding that literary language was organized into distinct hierarchies; just as eclogue differed from epic, so *paisage* and *peinture* were generically distinct. Therefore, exclusive attention to what these landscapes "meant" is inadequate to the task of understanding how they belonged to a particular culture. As in the genre of pastoral verse, part of the purpose of the landscape was to declare a distance from the tasks of history painting. The *Woman Washing her Feet* in Passart's collection is a case in point. Treating the painting in isolation, the reader might well ask whether or not this *paisage* hanging in the *robe* noble's cabinet signified a deliberate evasion of the political discourse of a group faced with civil war. Did the landscape mark a departure from the enlistment of history pictures by those resistant to the culture of the court? Indeed, there is a great distance between *Camillus* and the *Woman Washing her Feet*. However, I am arguing that landscapes did not renounce the project of history painting. In Poussin's production, as well as on the wall of Passart's cabinet, history and landscape were understood in relation. If landscape was a surrogate form of retreat, it required a meaningful juxtaposition to the genre of historical representation. The rituals of siege war were differentiated from the performance of rural repose. That difference suggests a conscious shift that asks for different kinds of attention on the part of the viewer.

While the *peinture* required skills attentive to compositions organized according to the human figure and a narrative, viewing the *paisage* demanded attention to a composition

in which human agency was subsumed by a modest appeal to a rural setting and quotidian activities. Instead of the consideration of the past event and its exemplary agents and negative object lessons, the seemingly insignificant gesture of bathing made the event available as an object of description in the present tense. This shift in viewing from history painting to a genre that was understood as hierarchically subordinate and not immediately attached to the demands of historical interpretation therefore entailed a modification of verb tense and social behavior.

Moving between painting genres had always been central to architectural programs. The demands put upon the viewer in Raphael's Stanze della Segnatura to interpret the continuity of pagan philosophy and Christian theology were different from the relaxed behaviors appropriate for the Villa Farnesina, with Raphael's programmatic display of the sexual foibles of the gods. Decorum as the inscription of social hierarchies in genre was a matter of place and situation. But in the picture cabinet, with its portable tableaux, the modification of the behavior of the viewer could be swift from frame to frame, offering significant oppositions and jarring dislocations of mood and import. A demand was put upon the unique object to assert its generic identity in certain recognizable, often self-reflexive, conventions of theme and handling. Again, self-reflexivity was not an inevitable condition for painting but a response to different historical pressures, political and economic.[52]

It is a truism that a landscape is a visit to the country by proxy. The genre privileges an awareness of the placement of the viewer and offers a fiction of retiring from civil obligations. This is not to suggest that the landscape viewer is posited in isolation. The genre is predicated on community. Based on a dialogic recitation, the pastoral gesture is highly phatic in that it thematizes the situation of the communicative act, proposing the terms of reception. Furthermore, landscape painting based on the tradition of the eclogue acknowledges the presence of a viewer who performs a particular role by setting aside certain behaviors. The viewer of Poussin's landscapes was asked to assume the protocols of pastoral poetry, to participate in and perform "rustic musings on a delicate reed." I wish to stress the role of the deictic structure of landscapes (*paisages*) for their reception rather than their strictly didactic function as history paintings (*peintures*). Whereas Louis Marin has argued in an important essay on *Et in Arcadia Ego* that "Classical" representation precludes Deixis, the "orientational traits of language, traits related to the time and situation where the utterance takes place," I argue that rather than a "historical" enunciative modality in which "events narrate themselves as if nobody were speaking," the pastoral genre grounded the landscape painting in a situation.[53] The viewer was in turn acknowledged and addressed as the appropriate recipient of a world prepared beforehand by the poet's utterance, always already in the present tense.

It is necessary to emphasize that the vicarious journey away from "history" is contingent upon a number of historical circumstances. For Passart, in 1650, the viewing of a landscape painting invited comparison to temporary exile. This was not only encouraged by contemporary associations of the landscape with political disgrace but also by the traditional articulation in verse of the relationship between the representation of land and political identities. This prior cultivation of the landscape by language points to the ways in which the association of *Woman Washing her Feet* with "pure" landscape is misleading. The distinction between *peinture* and *paisage* was not based on the evacuation of import. History and politics were not entirely forgotten as landscape offered the promise of nature. As an imagined situation that derived its significance from its prior inhabitants, it was marked by the traces of previous linguistic and social performances. Writers had already been there and they had left their own traces in order to claim that site as their own.

Ekphrasis

When the antiquarian and historian Symphorien Champier wrote in Latin to a friend from on top of a hill overlooking Lyon in the early sixteenth century, the landscape below was an unavoidably crowded place.[54] That is, crowded with objects commemorating the ancient Roman colony. After all, for the writer of a catalogue of Gallo-Roman inscriptions, the hillside was the site of the *jardin des antiques* belonging to his friend Claude de Bellièvre.[55] So, given Champier's learning and the inescapable self-consciousness he experienced writing a letter in the language of Virgil, we would be hard pressed to call Champier's view innocent. For him as for Montaigne, the landscape was a palimpsest. He tells his correspondent that the summit on which he and a group of male friends were gathered commemorated a compression of time and cultures; formerly a Forum of Venus, it was later dedicated to the Virgin Mary. Its present incarnation, as a site of masculine social practice, renders its feminine nomenclature ironic. Champier consciously asserts that far from the society of women, letters replace their company and concomitant pleasures.[56] The humanist cannot avoid organizing his leisure into an academy. Conversation turns to a series of topics: religion, death, the regulation of passion, and the improvement of the mind. One participant is compared to Socrates, another to Apollo. After the reading and recitation of poetry, the discussion of literature and gossip, the group turns to the performance of music: they play the lute and the flute. Some then turn to boxing, running, and other games. At dusk, the company pauses and looks around at the landscape.

Clearly, as a figure in a landscape that might have been part of a painting by Poussin, Champier would have had a difficult time sorting out his own present experience from his habitual citation of someone else's historical culture. Yet, as we read the letter by a man accustomed to literary references and the collection of ancient artifacts, there is an unexpected turn when he attempts to describe the landscape to a learned friend:

> When evening comes, we look at the tranquil water of the flowing Saône, the surface barely broken by the breath of a soft breeze. We make out the houses in the city below us. We hear the noise of workshops and machinery and we retrace with our eyes the fire that the shooting stars leave in the azure skies. The echo of the valley responds to this confused murmuring and carries it back up to us. There is no more magnificent spectacle than the one we enjoy from our vantage point on the summit of the mountain. The verdant countryside that stretches out far around us, the burgeoning vineyards, the groves covered with every variety of flower, the willows with green leaves, the tilled and sown fields, the luxuriant harvest, the clusters of trees that are seen here and there. All of this forms a ravishing painting.[57]

Surprisingly, Champier's description is hardly inflected by the commemoration of antiquity. His description of the valley below effectively denies his view of the city as the former Lugdunum, the Roman colony that became Lyon. No tablets, columns, or other ruined fragments erupt from the surface of words and things. Instead, his communication in Latin is telling us something about the practices of the *noblesse de robe* not found in the archival organization of historical materials. The French humanist, when faced with the challenge of representing the landscape, turned to a specific set of tools in order to accomplish that task. These techniques were different from those used when history was the object of description. The description of the land is set apart from registers and harangues, transcriptions and inventories. The fragmentary traces of Gallo-Latin speech receded from immediate consideration. The author selectively turned his attention away from the more explicit sites of historical memory, the epigraphic evidence on which so much of the group's identity had depended.

Champier did not choose to evoke the commerce on the river or the land routes between Paris and Italy – no bustle of boats or transport of wares, credit slips, raw silk, velour, ledgers, and locally produced books. These elements were available to the neo-Latinist wishing to evoke the local commercial world. In Champier's verse, industry appears instead in the juxtaposition of factories to shooting stars. It is a late summer evening. Labor is not visible except as barely perceptible traces: the ambient sound of distant machinery and the regular patterns of cultured grapevines and shafts of wheat contrasting with the verdant foliage of the willow along the meandering tributaries.[58] *How* nature became bountiful does not warrant a line.

Instead, Champier invites the reader to abandon imaginatively the obligations of civil society. And yet, surprisingly, the humanist does not explicitly draw upon the frame provided by the eclogue. He avoids the motifs or staffage that would explicitly draw a comparison of his verse with that of Virgil – no swains sit in the shade of a tree. It is the seemingly pure act of describing the features of the valley that mapped out the pleasures of a shared interest. Metaphors and personification are kept to a minimum. Comparison does not disrupt the sight of the immediate object. Although variety is preferred to similarity, the contrasts between things are introduced gently and provide evidence of barely perceptible shifts of attention. The text is a performance of observation of a particular kind. The valley murmurs. It is not entirely choate. Champier looks beyond the surface of things, yielding to his desire for tenuous visual certainties.

The author's repetitive utterance of the first person plural evokes a group of men on a hill, far away from commericial ledgers and political affairs, attentive to a countryside that was seen as a ravishing painting. The writer shares with a distant friend the sociability of a group that constituted its identity through its leisurely activities on that hillside as much as by the social practices in the city below. Champier's text offers a clue not only to a specific social response to landscape but also to the associated practices of representation. He did not rely solely on placing himself on the summit but also announced his position through his use of language. This conscious gesture of temporarily turning away from the traces of human events is analogous to Poussin's own drawing practice outside the walls of Rome (fig. 116). Actual architectural sites are rarely recognizable in his drawings of the Roman campagna because the compositions were typically limited to a few natural formations. In drawings such as these, the artist's attention was directed to the foliage more often than the ruin. No people or relics betray human agency. A variety of marks on paper register different textures, patterns of growth, and inferred traces of natural incidents promoting change. In these drawings, Poussin turned his back on the analysis of bas-reliefs and other artifacts found in so many other studies. And as in some of his landscape paintings, his drawings claim to register direct observation. In *Landscape with a Man Washing his Feet at a Fountain* and *Landscape with a Roman Road* (see figs. 110 and 111), the contrast between a winding path and a planned road provided the opportunity to observe the various gestures of figures dispersed in the land: women are burdened by vessels and infants, men collect water to bathe or drink, a man and woman gather near the base of some unspecified edifice.[59] These activities do not coalesce into a larger narrative. The site does not warrant commemoration. As much as the comparison of the pendants invites a learned explanation, the figures seem to resist falling into semantic order. Instead, the paintings draw our attention to these sites of apparently mundane activity. The painting declares the absence of disciplinary significance.

Landscape with a Woman Washing her Feet does not locate its object in a particular space or time. Even in other paintings that refer to specific histories, the particulars of daily life structure that experience. The rural gesture of the woman washing her feet is echoed by the action in the pendant to the *Landscape with the Body of Phocion* (see fig. 107). A woman

116. Poussin, *Forest Landscape* (verso of *Studies of Two Circular Panels and Four Rectangular Panels Depicting Episodes from the Life and Labors of Hercules for the Grande Galerie of the Louvre,* fig. 5), c. 1640, pen and brown ink on paper (Bayonne, Musée Bonnat), 186 × 303 mm.

enacts ritual devotion in the collection of the ashes. Yet there are numerous other figures, performing similar simple gestures, indifferent or oblivious to the history at hand. The viewer is asked to attend to a number of discrete narrative incidents realized in diminutive passages of paint. These paintings encourage the kind of enumerative description found in Champier's verse rather than a coordinating narrative structure (as in the *Gathering of the Manna*). The compositions stress a measured set of formal relations. Minute events are often dissociated from one another. The passing of a dead body in the foreground does not disturb the leisure and labor of others placed within graduated, successive planes in depth. Sometimes, a violent incident, such as the attack of a snake, hardly causes a ripple on the surface of things (see fig. 105). Eurydice enters the underworld; a bent naked bathing man exposes his buttocks, inviting catcalls from passengers on a passing boat pulled by slaves. I believe such banal juxtapositions were not intended to be ironic or even pathetic but that centrality as a measure of semantic or hierarchic significance was being challenged. There is a great leveling. Ultimately, Poussin provides a vehicle for dispersed attention within a structured compositional order.

How do we account for the fact that the greatest expanses of the canvases are largely devoted to incidents unrelated to the narrative in the foreground? How do we explain the apparent retreat from historical narrative? Champier's epistle gives us some tools to address these questions. His conscious shift from historical writing to the description of the land, from persons to things, entailed a modification of style as well as genre that may help us to understand further the relationship between Poussin's projects of narrative and landscape painting.

Landscape as it was understood and practiced by Poussin was never pure painting (as much as such a promise of formal autonomy might be desirable and as much as Poussin's landscape enterprise makes such an invitation). Poussin and his audience drew upon traditions that valued a selective withdrawal from utility and the demands of historical representation. Pastoral poetry was one such tradition but landscape painting itself was another. When Champier wrote his description of the valley below, he gave himself permission to displace historical discourse by situating his utterance as an act of ekphrasis before a landscape painting ("All of this forms a ravishing painting."). The act of describ-

117. Poussin, *Landscape with a Storm*, 1650–51, oil on canvas (Rouen, Musée des Beaux-Arts), 990 × 1320 mm.

ing the view of the land as a landscape painting was understood as a form of retreat. Such a removal from affairs in order to view imaginatively a landscape painting became pointed in a political crisis. In fact poets who had faced the civil war of the previous century collapsed land and landscape painting in order to articulate their response to exile. Du Bartas looked to the land as something already mediated by a painting. Far from the court, he looked out upon his ancestral land from his "republic" ("My dear Bartas, my Louvre") like a painter who, having selected a varied landscape (*paysage*), has put nature into the work of art. Imagining himself a painter, the poet puts aside the brush, forgets his labors, and fixes his eyes on the finished canvas:

> He looks . . .
> A sheep that always, silent, seems to bleat.
> Presently he contemplates the trees in a grove
> Now the hollowness of a wild grotto
> Now a little track, now a cleared path,
> Now a cloud-kissing pine, now a fallen oak.[60]

Ekphrasis was imaginatively performed far from the life at court as if in front of a landscape painting, and the object of that ekphrasis was not an intricately wrought rare material: natural motifs viewed on the canvas were uttered and qualified by artisanal metaphors applied to a lowly material: "Here two shepherds along the enameled river/ Race for the prize, a hutch."[61] Narrative is reduced to basic elements: herds step slowly, gathering as shadows traverse the plain. We hear the sound of coursing water and witness smoke drifting from the city in the distance (see figs. 105 and 118). In the poem, as in Poussin's *paisage*, the motif is not dissociated from its purported source, direct observa-

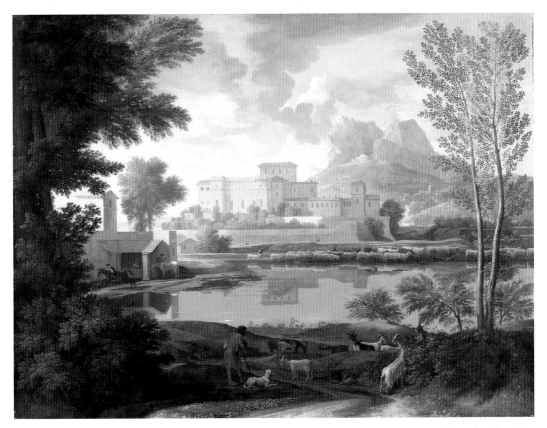

118. Poussin, *Landscape with a Calm (Un Tem[p]s calme et serein)*, 1650–51, oil on canvas (Los Angeles, The J. Paul Getty Museum), 970 × 1315 mm.

tion. For the poet, the landscape painting's persuasive visual testimony provides evidence that this is not a fanciful or artificial pastoral. The repetitiously intoned "now" insists upon the present tense and presence. The motif is not a symbol to be evacuated by its reference to some "other" reading. "Smoke is war" is subsumed by "smoke is smoke." The statement "storm is conflict" plays a subordinate role to "storm is storm." Truth resides in the utterance of the pale and wet shepherd. The poem withdraws from allegory. It is anti-historical as the past is displaced by the invocation of synchrony. *Paisage* not *peinture*. Description asserts that meaning is not deferred to be "read" otherwise or elsewhere. "For a moment, art so vividly expresses nature,/ That the painter is lost in his own painting." The descriptive poem demanded that the reader accept the fiction of looking at a painted landscape and rhetorically abandon the obligations of direct service to the state. By so doing the poem renounced the brief of other *robe* noble linguistic performances, panegyric verse or the historical reference. Even the eclogue, which was also subject to utility in allegorical elegy or royal panegyric, is kept at a distance. Shepherd is shepherd. Truth again, not art.

For viewers of Poussin's landscape pictures, the epistle by Champier and the poem by Du Bartas were rehearsals for a studied leisure, *otium*, before a painting. The practice of ekphrasis, which historically had been largely disparaged in artistic discourse by an attention to composition (*historia*), was always held in reserve, here as a mode of retreat.[62] The attendant tools belonged to a set of behaviors understood in contradistinction to historical representation. In temporary retirement, Champier described the sheen of water unbroken by the wind. Poussin painted the reflective pool on the outskirts of an imagined ancient city (see figs. 102 and 118). The painting was premised on direct observation, not hearsay but an assertion of the present tense. Yet it also derived its authority from the

linguistic performances that had already occurred there. The repeated utterance of the present tense implies the past.

The mundane details in Poussin's paintings repeat the poetic performances of the previous century when poets turned to the description of a landscape as a form of consolation. Far away from the political divisions of civic life and the violence of civil war, in the midst of dairy cows and apples, Nicolas Rapin declared that he was more likely to be roused out of sleep by "the bray of a donkey, the song of a cock or a female duck" than the bellicose trumpet or drum.[63] The lesson drawn from seemingly insignificant events and objects resulted in a highly conscious refusal to chronicle persons of great import. Banality paradoxically made the landscape a semantically charged place.[64] The description of incidental motifs and actions belonging to the countryside and the use of a humble style, in which "a naked and unmixed simplicity is most sought after," signified disinterestedness, integrity, and recalcitrance during a period of civil disturbance. Rustic rhetorical effects were stressed in order to articulate a culture in retreat.[65]

After meandering through these sixteenth-century poetic landscapes, we can infer that a similar form of *otium* was rehearsed in front of Poussin's landscapes. In paintings of 1648–51, the *Phocion* landscapes, *Diogenes, Orpheus, A Woman Washing her Feet,* and *Storm* and *Calm,* the *Man at a Fountain,* and the *Roman Road,* we are invited to contemplate through the lens of this indigenous poetic tradition the incidental, even the extraneous, as a sign of exemplary detachment. Claude Gauchet's *Plaisir des champs* (1604), for example, provides a gloss for Poussin's painted storm and calm (figs. 117 and 118):[66]

> The shepherd was soaked to the skin.
> Frightened by the havoc, the laborer beheld
> The misfortune that had come to pass and, growing pale, he told him
> The water carried downstream the perishing flock.[67]

When the sun appears again, we are invited to witness the calm. The swollen Marne floods the plain. Rye and wheat have been beaten by hail. Many branches are broken and splintered, many sound trees battered, and many flowers spoilt. Yet now all is tranquil in the fields.[68]

In Poussin's landscapes, the various views structure the repeated motifs of minute figures engaged in humble tasks. Collectively, some figures pursue their leisure. Groups gather by the water to bathe, others play a flute or a lyre. An archer aims his bow at a distant target (see fig. 107). In these pictures we also witness laboring bodies: the washing of laundry, the collection and carrying of water, the pulling of an ox, the ferrying of a barge, and the herding of sheep, goats, and cows. Hardship is evident, but also gestures of the renunciation of civil strife and, at times, an oblique view upon disorder and history – a woman gathers the ashes of a disgraced political leader.

Otium before a landscape picture was performed in Passart's townhouse, near the bustle of the Seine, a short walk from his administrative duties and the sites of civil unrest around Châtelet and the Hôtel de Ville. His bedchamber and the adjoining salon were decorated with landscapes, thereby invoking rest. But, as I have stated before, the landscapes by Poussin, such as the *Woman Washing her Feet* and the *Landscape with Diana and Orion,* were juxtaposed with the *Camillus* and *Scipio* paintings in the most prestigious and public *Grand cabinet.* A conscious contrast in genre, between *peinture* and *paisage,* registered a range of behaviors from political commentary to contemplative repose within a few steps of one another. The viewer was asked by Poussin and Passart to take seriously a genre that in other hands was considered a specialized production or a decorative accouterment to a drawing room. Poussin seized upon a genre that conventionally had lesser monetary value and turned back to skills achieved in his early days in Rome (see fig. 9).

In Passart's cabinet in 1650, the protocols of reception were adjusted according to the respective demands of historical narrative and the adjacent interests in description. One demanded exegetical skills culled from reading ancient history. The other encouraged the performance of ekphrasis patterned after poetic traditions, both ancient and in recent historical memory. The history of Camillus was an example that achieved its full significance by comparison to other persons and situations. In a landscape with dispersed figures, attention was meant to linger on the immediate mimetic referent, not a further meaning. The landscape paintings thereby resisted being made equivalent to the history picture. Instead, the generic shift from *histoire* to *paysage* made the claim that the latter genre was ostensibly set apart from discursive requirements.

This is not to say, however, that these landscapes were pure paintings. I would argue that the depth of citational practices (from the eclogue to the descriptive poem) prevented them from being read as such. Indeed, by declaring its affinity with the country rat, distant from the noise of the city, landscape entered into a pastoral allegory (or better, fable). Landscape painting's capacity to invoke the vital pastoral poetry of the sixteenth-century *robe* nobility once again underlined Poussin and his clientele's identification with that culture, however belatedly. To describe the effects of light on water was to emulate the poets of the previous century who refused temporarily a language that was subject to service and utility. This I believe helps explain the differences between Poussin's representation of landscape and that found in Mère Angélique's correspondence. In contrast to Angélique's immediate engagement in daily politics, the painter's characteristic remoteness again signified disinterest and the conservation of shared values. Landscape as a displacement of history painting thereby provided opportunities imaginatively to retreat from the culture of the city. The ground was cleared.

Such a clearing away, as I have argued, reveals the very dependency of the genre of landscape upon history painting. Without the resistance of history, the landscape would have been inchoate. Without its structural counterpoint, it would have lost its intelligibility for viewers such as Michel Passart. In easel painting, such generic distinctions were significant and necessary. By contrast, the painting *in situ* was inflected by the rules of architectural decorum, the rank of the owner, and the ritual protocols of the space. Without these semantic moorings, easel painting had to signify its own situation and address. This meant that an even greater burden was placed on the object not only to assert the difference between Livy or Tacitus and Virgil's eclogues, for example, but also to thematize materially the terms of its own reception. Easel paintings became increasingly dependent upon their internal structure and handling to register the terms of their address (one can say that even the handling of the paint is deictic).[69] Poussin not only depended upon the imagined dialogues of shepherds found in pastoral poetry and his audience's habits of artless ekphrasis to situate the reception of his landscape paintings, he relied upon his painting to be thematically self-referential about his performance of painting.

Paint without Art

Poussin sought to thematize the relationship between *peinture* and *paisage* in one of his most monumental landscapes painted during the Fronde, the *Landscape with Diogenes* (fig. 119).[70] In the foreground, a stream swells. A young man at the water's edge, using his hand as a cup, offers an object lesson to a philosopher in the landscape. The Cynic Diogenes had renounced all material possessions save a bowl. The gesture of a youth bending down

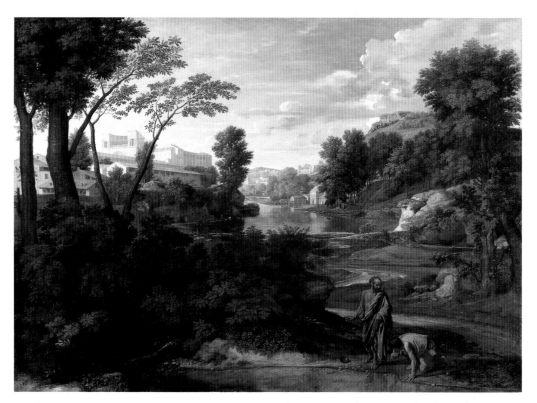

119. Poussin, *Landscape with Diogenes,* 1648, oil on canvas (Paris, Musée du Louvre), 1600 × 2210 mm.

to drink with his hand results in the sacrifice of the old man's last cultural implement. "Having seen someone drink with their hand, he threw down his glass, like a useless thing."[71] The famous apothegm, attributed to Diogenes, reminds us of Poussin's own response to the question of where to locate antiquity: some shards of marble in the ground under his feet. The narrative asks us to imagine the complete withdrawal from affairs and even the rejection of culture itself. The secular gesture of removing oneself from the affairs of the world in the *Landscape with Diogenes* resounded with customary French political behavior. Lumague, who received the painting in the turbulent year of 1648, would have seen in the recalcitrant philosopher a prototype for his own experience as a confidante of Richelieu and close friend of Passart.[72] The significance of the painting was inflected by the collector's own retirement from financial and political affairs.[73]

In the rudimentary narrative, the elimination of the useless thing, the "inutile," defines utility. Like the enunciation itself, the superfluous is cast off from the core of necessity. This is the pastoral performance, the thing itself. As attention moves from epic battles to the death of a herdsman, the poet of the *Aeneid* exchanges his poetic tools for those of the *Eclogues.* Trumpets are put down for pipes. The casting away of even the simplest of tools signified the imaginative desire for a culture uncorrupted by the city (a city conspicuously modeled after the imperially inspired architecture of the Cortile di Belvedere). The longing for technological anachronism is similar to the gesture made by Montaigne in his essay on vanity where he cited Virgil's second eclogue: "Why do you not do something useful, like making baskets of wickerwork or pliant reeds?"[74] The handmade rustic object becomes a measure of utility and truth. In *Landscape with Diogenes,* the movement of the hand and the discarded crude implement remind us of the rude pipe played by the shepherd or the country rat scurrying away from the noise of the city.

The reader may well have expected me to turn at last to the painting of Diogenes. After all, the highly selfconscious theme of renunciation recalls the *Testament of Eudamidas.* A

lesson is gained by relinquishing property and the material deficit is considered an asset. Furthermore, the landscape matches our expectations for Poussin: the view provides a setting for a theme from humanist culture, a robed exemplary figure, even a philosopher. Like the Phocion paintings, the picture with Diogenes continues to bear the epithet "heroic landscape." Indeed, the painting behaves in some ways like a history picture, and yet the narrative we encounter is rudimentary, even impoverished. We depend upon a single anonymous body stooped over a pool of water to convey the story and a single erect figure to witness that crude gesture and respond. Finally, we depend upon an insignificant still life to register that response – ceramic in the silt. Casting aside the bowl was not only a lesson for Diogenes but also a *mise en abyme* for the act of painting. Poussin rehearsed the anti-cultural gesture articulated from within culture. Tossing the bowl resembles the actions of the poet who enunciates the voice of the shepherd in a language that renounces artifice. Drinking with the hand provides a figure for the artist who puts aside the tools for the grand epic *machine* and paints a landscape. Yet, when faced with the fact of the landscape, what tools are left for the painter? How could an artist represent a significant enunciation of a lower decorum, archaism, or renounced skills? What lesson could the artist derive from a poet who situates himself before a landscape painting in order to sustain the fiction of disinterested description?

Diogenes stands along the water's edge: the traces of a small brush loaded with white. Near the bank, there is a bowl, scattered pebbles, and a rock. Poussin's confident handling of the simple earthenware, his glazed white impasto repeating the effects of light reflected from the crude ceramic glaze, paradoxically betrays an interest in a discarded object imbedded in a large canvas. This attention to particulars invites a close examination of the surface of the canvas. In the right middle ground, summarily blocked in patches of red, ocher, and dark blue signify a group of reclining men. Beyond them, nude men bathe while other men stroll. Human activities and minute objects invite a dispersed attention to an assembly of details and implied gestures.

Handling of paint is determined locally. Movement is suggested by shifts in tone: in the trees, the shimmering leaves evoke a breeze. In the left middle ground, a rough patch of green bridges the near and far bank, collapsing depth. Two strokes signify as many legs. Another stroke, an upper arm and elbow, is conjoined with a diagonal line. This is a shepherd leaning on his staff while guarding his flock. The sun illuminates the top of a sheep. The bottom of the animal is in shadow (fig. 120). By contrasting the dark gray hue of a single stroke with the lighter tone of a parallel stroke above it, the painter suggests the volume of the sheep. Poussin's coordination of tonal variation and facticity registered relative illumination. A sheep is only two strokes, one above the other. The process is repeated – a flock.

120. Detail of fig. 119.

A paintbrush of the same density and size as the one used to paint the sheep, loaded with iridescent green pigment of the same viscosity as the painted fleece, is moved in the same direction with the same inferred velocity and duration – a silty, scrubby bank. The thin stretch of shoreline extends to the right-hand side of the canvas and picks up some of the yellow impasto on the eroded tall bank exposed to the sun

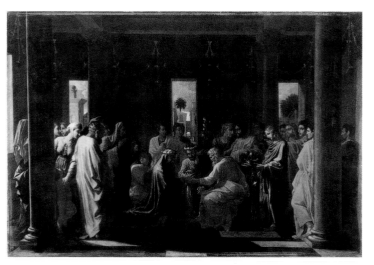

122. Poussin, *Sacrament of Marriage*, 1647–48, oil on canvas (Edinburgh, Duke of Sutherland Collection, on loan to The National Gallery of Scotland), 1170 × 1780 mm.

(Courbet would have been attentive to that passage). Despite the shift in hue, tone, and reflectivity at the point of contact of fleece-like stroke and bank-like stroke, the passage between coterminus strokes reads as a brief interruption of the movement of the brush. This part of the canvas displays a great economy of effort. While the repeated gesture results in the radical reduction of the variety of facture, it nevertheless draws attention to that handling of the brush. It is a case of truth and practice, not art, again.

The brush's capacity to represent the behavior of light on the top of sheep and shoreline is dependent upon Poussin's treatment of the buildings as experimental controls. The ways in which the light illuminates the uniform architectural surface offer to the viewer the means to predict the responses of the light to a number of surfaces, according to their relative position and properties. The directed attention to tightly bound surfaces in the architecture on the left contrasts with the reflection of light on the high exposed bank on the right, which displays the yellow impasto. This is the problem posed by Poussin in his representation of the *Sacrament of Marriage* in the same year (fig. 121). The graduated tonal variation on the left-hand column suggesting shadow, and therefore the volume of a cylinder, is compared to the study of fabric in the adjacent standing figure, removed from any expressivity or narrative incident. Control and experiment reveals not so much differences in texture as the relative tensile strengths of marble and linen. In the *Landscape with Diogenes*, the registration of the differential tactile properties of fleece and sand are similarly made negligible. The substances, if not made equivalent, are in any case made commensurate. Differences in particular tex-

121. Detail of fig. 122.

123. Detail of fig. 118.

tures are made subordinate to general structural similarities. Single brushstrokes are inextricable from the objects they signify, the sheep and the sandy bank. The painter's great economy of movement repeats the gesture of Diogenes. And yet, a large composition devoted to different depicted materials and conditions permitted an uneven attention to handling over the surface of the canvas.

The local handling of paint is an important move. Whereas I have described the evenness of Poussin's ordered application of paint in his contemporaneous figurative compositions and the ways in which it marked in some ways an impasse in his studio practice, the landscape provided other opportunities for painting. The greater frequency of variation in response to different objects encourages ekphrasis. Contrasts are invited through the enumeration of motifs and an uneven suggestion of relative mass and texture. Differences in the relative complexity of bathing man, philosopher, reclining man, youth, palatial architecture, and distant buildings do not entirely correspond to the representation of relative distance and the corresponding degeneration of visual acuity. Although the handling is far from improvised, it is variable. Nevertheless, the structure of the depicted object was always ordered by the well-rehearsed gesture of the brush. Poussin achieved variety while abstaining from luxuriance.

A similar pictorial strategy is evident in other landscape paintings, which also encourage sustained close attention, description, and the imaginative recapitulation of painting by drawing inferences from painterly effects. In *Landscape with a Calm*, parallel brushstrokes read as an inverted series of bands (see figs. 102 and 123). The sheep and cattle are mirrored in the water. A patch of brown as opposed to white marks a cow or bull rather than the successive passages of ewes and rams. Beneath their individual reflections, there is a band of red and then a band of green, signifying, respectively, the exposed clay resulting from erosion that is inhospitable to growth and the adjacent verdant layer of pasture on the fertile topsoil. Two strokes of contrasting tones convey the shared preoccupations of painter and descriptive poet, yielding, in turn, another opportunity for ekphrasis. Below this reflection is the inverted double of a walled city. Architecture mixes with moss at the water's edge. But the reflection is not symmetrical. The painter observes the occluded image on a reflective surface, limited by the angle of vision. He chose to minimize the

reflection of cloud and imposing precipices, enhancing the blue and thereby making the surface of the water more uniform, surrounding the partial view of towers and fenestrated walls (a lesson in optics is directed to specific compositional ends).[75] Here the surface resembles the relatively monochrome and evenly treated draperies in the contemporary figurative compositions. Poussin made only a few brief dragging gestures of the white-loaded brush to demarcate surface tension. The doubling reflection in the water binds the surface of the canvas by compressing depth and repeating forms in a system of inversions. The reflection of bodies in a mirror or water is of course a system used by different artists to different ends, from Velazquez to Manet and Monet. Reflections provide an internally coherent referential system where reflective stroke is a modification of a corresponding represented object.

For Poussin, the reflection provided another means of controlling the most immediate terms of comparison. As I have suggested, the series and the pair of paintings secured the systematic reception of his easel picture by insisting upon an internal referential system, thereby providing the situation for interpreting the work. The doubling of pictorial gestures similarly attempted to control the direct comparison of one brushstroke to an adjacent one rather than to some external referent in nature or someone else's painting. The ordered series of paired identities is contingent, however, on the undisturbed surface tension of the water, which permits the relatively distinct boundaries between reflected objects. Reflection ultimately represents the tenuous condition of calm. The sluggish gait of a wading ox disrupts the sheen of water only momentarily – again, the brief tread of a white loaded brush. Beyond the cattle, the smoke billows and trails off into a windless sky. Champier made the same observation as he looked down upon Lyon. The verse of du Bartas described the same effects of smoke as seen in a painting. Poussin left the trace of a brush and repeated the gesture as a reflection (see fig. 102).

The discrete forms of distant animals, extended patches of soil, and the blanched stone-faced surfaces of Mediterranean architecture provide painting with opportunities to display simplified brushstrokes. By contrast, foliage offers a potential structure for variety of touch. A multiplicity of strokes can be built upon a set of organic models moving from a few, large generalized forms to more numerous, smaller structures with increasing particularity: trunk, branch, twig, and leaves. The greater amplitude of extension exhibited by foliage provides the landscape painter with a pictorial opportunity for the active display of dispersed painterly incident. At the same time, it permits the representation of the effects of the retina's limited capacities to accommodate a discrepancy in the intensity of light.[76] Poussin directed these potentialities and perceptual observations to specific pictorial ends. In his *Landscape with a Calm*, the tower attached to the stable at left reveals an attention to a discrepancy between the sun-drenched wall and the dark foliage screen in the foreground. The shadow on the building itself mediates between the intensity of illumination in the direct sunlight and the relative absence of light in the foliage (a similar effect is exhibited in the branch against the sky in the *Woman Washing her Feet* and in the *Landscape with a Storm*, both on the left side of the canvas). By stressing the loss of visual acuity within the relatively shadowed mass seen against direct light, the perception of particularities is reduced and, by extension, facture is simplified. The method is deployed in *Diogenes* as well. The trunks and branches form an unnuanced screen with the illuminated Cortile di Belvedere in the distance. The blanched architecture asserts itself while the dark branches recede, thereby compressing depth and effectively reducing the differentiation of materials.

Poussin's landscapes betray an interest in minutiae, in terms of depicted persons and actions, as well as in modest pictorial effects. For instance, the lesson of Diogenes is taken

from the body of a single figure, the young man crouched in a landscape, not a series of complex groups (paid by the figure). The famous overall compositional structure associated with Poussin's landscapes is built upon a system of small spatial compressions and the limited discrimination between the substance of objects. In his landscape paintings Poussin rehearsed different pictorial strategies from those of his contemporary figurative paintings, such as the compression of depth, rigid figures, and archaic composition found in his *Moses Trampling on Pharaoh's Crown* (see fig. 68). By contrast, the integrity of the surface of the landscapes is produced by the interpenetration of homologous brushstrokes depicting different objects. The result is a restrained system of visual puns between objects in disparate positions relative to the viewer. In *Landscape with a Calm*, the shimmering leaves in the foreground on the right of the tree are confused with the pattern of sheep reflected in water to the left (see fig. 118). A system of feathery strokes represents bushes on the far bank. The structure of the strokes representing chaparral reflected in the water is further dispersed. Lacking distinctness, the reflected low scrub becomes confused with the ascendant foliage of trees on the near bank. Confusions between objects reflected in water make up a pattern in Poussin's landscapes. Despite the overall impression of atmospheric transparency and visual clarity in his mature landscape compositions, a pattern of local incidents of visual uncertainty produces the necessary surface tension for simplified planar relations. The limits of vision undercut difference. Nature is made into a choate form. Poussin's hallmark, broadly structured landscape compositions are based on the artist's focused attention to the complexities of painterly incident (not the supplanting of facture by design).

Indeed, the painter of *Eudamidas* found ways of sustaining his painting through observation and discipline. Retreat from his own technical conception of history painting offered the possibility of sustained practice and visual pleasure, albeit of a particular order. Instead of encountering the impacted wall of figures of his *peintures* of the late 1640s, Poussin's audience found in his *paisages* the promise of a distant view with a brush that turned to diverse objects with different degrees of attention. In addition to being encouraged to describe the depicted objects, there was an invitation to attend to the variety of the painter's touch. And yet "variety," if it signifies a generous handling of paint and surprising perceptual incidents, might still be inadequate for describing the overall pictorial effect of Poussin's landscapes. As we have seen, through this extended description of surface effects, the "landscape" encouraged a drift from "history," but only in exchange for a disciplined practice.

In the *Diogenes*, Poussin's viewer would have found a large dull patch of brush and trees dominating the left side of the canvas (fig. 124). For the painter, it served of course as a repoussoir device binding the composition and serving as a ballast for pictorial structure. The edge of the mass of shrubbery provides a break in the screen to a crisp view beyond. The leaves in shadow lack distinctness, thereby drawing attention to the clarity of the objects and events in depth. Yet, despite an apparent lack of declarative pictorial interest, the brush and trees in the left foreground dominate the composition. The human figures seem displaced by the weight of the dense growth. Furthermore, the foliage is not constituted by cursory passages blocked in to suggest a whole. Despite the apparent lack of distinctness, Poussin attended to individual features, a network of discrete leaves. If this were a mere repoussoir we would not have any business attending to these particularities. But Poussin seems to have placed an inordinate emphasis on this expansive area of the canvas on the left, attracting our attention. Yet, aside from a few yellow leaves in the shadows attached to a fallen branch, and a spectacular passage of stones and stream near the bottom edge, in the great expanse of canvas the artist has left us with neither a rich

variety of nuanced forms nor even a surprising textural incident called into relief by the relentless pattern. Despite an attention to this area out of proportion to its narrative function, no declarative performance of paint encourages a prolonged viewing. It is unlike the virtuosity found in *Landscape with a Storm* (see fig. 117), where the depiction of the erratic light and wind of the tempest accounts for the ever-changing directionality of the facture in that tempest; the inferred brutal movement and rhythm of brushstrokes threatens to break from the regular patterns of organic growth. By contrast, on the left-hand side of *Diogenes*, the foliage is made up of redundant marks, plodding enumerations of the same stroke. The brushstrokes bespeak a willingness to treat this area of the canvas with a different degree of attention. Importantly, the handling reveals a structured procedure in and for itself rather than the pursuit of description or indexical signs of movement.

Poussin's treatment of this portion of the surface of the canvas is analogous to the action of Diogenes. The renunciation of artifice was represented through the invocation of the structure of nature. In one area, the broad stroke signifies sheep or bank. In the expansive foliage, each brushstroke is equivalent to a leaf. The genre of landscape itself provided a means of articulating distance from artifice while sustaining the act of painting. The rigors of Poussin's narrative paintings, the sacrifice of facture for compositional structure, threatened an impasse in his production. The figurative compositions became increasingly

redundant at the same time that the representation of a landscape permitted a greater variety of facture, compositional complexity, and the enumeration of narrative incident. Yet, even in those patches of systematically repeated brushstrokes, as in the left-hand side of *Landscape with Diogenes*, the plenitude of those discrete marks is disciplined in order to emphasize above all a sustained practice. As in the simple decorum of the eclogue, the economical treatment of pictorial surface thematized a significant opposition to luxuriant effects. The building up of pigments and the facile impasto of his earliest works is absent. Yet, unlike Poussin's mature *peintures*, the *paisages* were not premised on renunciation. The staging of restricted means in the landscape redefined the terms of the pleasure of painting.[77] As Champier responded to the view of the echoing valley below by attending to quotidian incident, so too did Poussin register with his brush the interaction of bodies and light. Poussin's clients were drawn to that distant view and abandoned themselves to a loss of visual acuity. They also attended to the marks on the surface of a canvas. The painting invited ekphrasis attentive not only to depicted things but also to the traces of the brush. This was viewing and *otium*, not gratuitous leisure.

Scholars who treat the painting as a tableau vivant, unmediated by either genre or the movement of a hand with brush on a surface, can argue that it refuses the poles of emission and address (deixis). Louis Marin has pointed out that the social encounter by proxy of viewer and depicted figure would thereby be denied. However, the pastoral genre established the terms for an imagined sociability. I would also argue that the handling of paint in and of itself addressed a viewer, registering and inviting behaviors that constituted a social relation. The intensive attention to the rather crude implements of easel pictures – a bundle of hair on a stick and some suspended pigment on canvas – far exceeded their material significance. As a result of the brushstroke's apparent impoverishment through the constraints of an intensive discipline, the easel picture became the site of a politics.

* * *

Distance does not mean disengagement from politics or history, as I have argued. When Poussin was attempting to address the desires of his audience in France, he found in the Roman campagna both the ruins of an empire and the effects of light and shade. He negotiated the eruption of antiquity in the quotidian and those features of the landscape that exist in an eternal present. In my description of Poussin's own practice and the traces that remain, I find myself slipping between the past and the present tense. At times, in my writing, description of history and description of material presence compete with one another, each with their respective claims for preeminent authority.

A sheet of drawings by Poussin offers an archeology of a practice that depended and depends upon these competing claims. On one side of a single sheet, there is a study for the labors of Hercules (see fig. 5). As a drawing for the Grande Galerie, it exemplifies the discipline of the history painter. The example clearly belongs to the argument in Chapter Two. It is a diagram to be worked up as studies for assistants. Hercules wrestles with Cacus in mortal combat. Hercules overcomes Lacin. The mythological and antiquarian project ultimately addresses the relationship between king and royal subject. The monarch is dependent on the political ballast of panegyric. Yet at the same time the provisional marks indicate that the drawing is addressed to the artist himself. The images are supplemented by notations and numbers keyed to the compendium that served as a reference. The sheet was clearly in the service of state-patronized history painting. Its cultural repertory was designed to address his clientele in Paris. Drawing and ultimately painting were grounded in the politics of the *noblesse de robe*.

Turn the sheet over and the picture belongs to this final chapter. On this side there is a study of a landscape (see fig. 116). The ink drawing is not the basis for any known composition. The provisional marks of the quill seem to be limited to a study rather than leading directly to a painting. The compressed growth and implied circuitous path permit little room for an imagined narrative let alone a view that would serve to highlight some architectural feature. The direct applicability of the drawing to some ultimate project is also greatly diminished by the limited expenditure of materials and labor. Even though some of the drawing is restrained to provisional notations in brown ink that in other works on paper would have been further developed with wash, he never returned to the drawing with a brush. So the study appears to have been made entirely in the Roman campagna, foreclosing its address to a patron.

It is impossible to know the circumstances of these two drawings made on both sides of a single sheet. If we treat them as archeological traces of Poussin's practice, these two strata are temporally reversible. The artist might have grabbed the landscape study from the table in his cluttered studio and turned it over to make a sketch for the Grande Galerie project. Or he might have taken that sketch for the design of the Louvre with him on an outing to the Roman campagna. But we can also imagine the two events as complementary activities. Research was conducted in the studio as well as in the countryside.

Poussin may have never intended to return to the landscape sketch with a brush in hand. He brought limited tools with him to the countryside. The simple graphic implement applied to the paper echoes the bowl cast aside by Diogenes. The artist himself may ultimately be the hermit or the philosopher out in the countryside, using the meanest of materials, removed from institutional ambitions and state power. However, retreat was a social practice that accrued a symbolic power that far exceeded its actual material resources.

I began this chapter by stressing rhetorically the disparity between Mère Angélique's and Poussin's representation of the countryside. Her vision of cruelty and disorder may still seem incommensurate with Poussin's oblique view onto death and political disgrace. It is important to maintain that sense of difference. Yet they both share the cultivation of an art predicated on the divestment of ambition and material power. When Mère Angélique attempted to influence monarchs she turned to the crudest of resources: a letter including a list of animals, a prospect onto the woods, and a recipe for soup. Sustained detachment from the tools of state also made the relatively insignificant materials of the painter count for much. Poussin exploited the particular conditions of an easel picture. The history of relatively insignificant events, such as commissioning or even talking about pictures, assumed an importance that competed with other historical events. Indeed, Poussin's history is ultimately the traces of the modest movements of his hand. But such seemingly inconsequential actions, sustained as a shared practice measured against social transformation, mediated the relations between men and constituted them as a political group.

Notes

Preface

1 Anthony Blunt, "The Heroic and the Ideal Landscapes of Nicolas Poussin," *Journal of the Warburg and Courtauld Institutes* 7 (1944), pp. 154–68.

2 Denis Mahon, *Studies in Seicento Art and Theory*, London, Warburg Institute, 1947.

3 See Stefan Germer and Christian Michel's introduction to the collection of essays "La Naissance de la théorie de l'art en France 1640–1720," *Revue d'esthétique* 31/32 (1997), pp. 7–16. I am indebted to the examples of Michael Baxandall and Thomas Crow.

4 See e.g. *Poussin et Rome: Actes du colloque à l'Académie à Rome et à la Bibliotheca Hertziana 16–18 novembre 1994*, ed. Olivier Bonfait et al, Paris, s10, 1996.

5 Sheila McTighe, *Nicolas Poussin's Landscape Allegories*, Cambridge and New York, Cambridge University Press, 1996.

6 Elizabeth Cropper and Charles Dempsey, *Nicolas Poussin: Friendship and the Love of Painting*, Princeton University Press, 1996, and Oskar Bätschmann, *Nicolas Poussin: Dialectics of Painting*, trans. Marko Daniel, London, Reaktion Books, 1990 [Eng. trans. of *Dialecktik der Malerei von Nicolas Poussin*, Zürich, 1982].

7 Richard Beresford, "Séraphin de Mauroy: un commanditaire dévôt," in *Nicolas Poussin (1594–1665), Actes du colloque*, Musée du Louvre, 1994, ed. Alain Mérot, Paris, La documentation française, 1996, II, pp. 719–45; Jacques Thuillier and Claude Mignot, "Collectionneur et peintre au XVIIᵉ: Pointel et Poussin," *Revue de l'art* 39 (1978), pp. 39–58. Antoine Schnapper and Marcel-Jean Massat, "Un amateur de Poussin: Michel Passart (1611/12–1692)," *Bulletin de la société de l'histoire de l'art français* (1994), pp. 99–109.

8 See, for example, Cropper and Dempsey, 1996, and Marc Fumaroli, "Muta Eloquentia: la représentation de l'éloquence dans l'oeuvre de Nicolas Poussin," *Bulletin de la société de l'histoire de l'art français* (1984), pp. 29–48.

9 Elizabeth Cropper, *The Ideal of Painting: Pietro Testa's Düsseldorf Notebook*, Princeton University Press, 1984, p. 160.

10 McTighe, 1996, p. 51.

11 Cropper, 1984, p. 158.

12 Richard Verdi, "Poussin and the Tricks of Fortune," *Burlington Magazine* 24 (1982), pp. 681–85. See McTighe, 1996, and Bätschmann, 1990.

13 "Vous serez tout estonnez un de ces jours quand vous verrez les loix enversées, le gouvernement changé, tout mis en confusion, ceux qui gouverneront avec dessein de se perdre eux & leur pais, & qu'il ne sera pas permis aux gens de bien d'ouvrir la bouche & donner un bon & salutaire conseil. Souvenez-vous lorsque vous estes hommes, & que voues estes François." Guillaume du Vair, *Traité de la Constance et Consolation ès calamitez publiques*, Paris, 1595, p. 109. All translations mine unless otherwise noted (original French orthography retained where possible).

14 See Denis Mahon, "A Plea for Poussin as a Painter," in *Walter Friedlaender zum 90. Geburtstag*, Berlin, 1965, pp. 113–42, and Neil MacGregor, "Plaidoyer pour Poussin peintre" in Paris, 1994, *Nicolas Poussin 1594–1665*, exh. cat., ed. Pierre Rosenberg and Louis-Antoine Prat, Paris, Réunion des musées nationaux, 1994, pp. 118–20.

Chapter One: French Humanism

1 Montaigne, "De la vanité," *Essais*, III, ch. 9; *The Complete Essays*, trans. M. A. Screech, London, Penguin, 1991, p. 1127.

2 Théophraste Renaudot, *Gazette*, December 22, 1640, cited by Howard M. Solomon, *Public Welfare, Science and Propaganda in Seventeenth Century France: The Innovations of Théophraste Renaudot*, Princeton University Press, 1972, p. 138.

3 For an excellent study of the Louvre project and Henry IV's patronage in Paris, see Hilary Ballon, *The Paris of Henri IV: Architecture and Urbanism*, Cambridge, Mass. and London, MIT Press, 1991.

4 See Corrado Vivanti, "Henry IV, the Gallic Hercules," *Journal of the Warburg and Courtauld Institutes* 30 (1967), pp. 192–93.

5 See Orest Ranum, *Les Créatures de Richelieu: Secrétaires d'etat et surintendants des finances, 1635–1642*, trans. S. Guenée, Paris, Pedone, 1966, pp. 146–48. C. Michaud, "François Sublet de Noyers, Surintendant des bâtiments de France," *Revue Historique* 242 (1969), p. 327 f. Henri Chardon, *Amateurs d'art et collectionneurs manceaux du XVIIᵉ siècle: Les frères de Chantelou*, Le Mans, Monnoyer, 1867. Antoine Jules Dumesnil, *Histoire des plus célèbres amateurs français et de leurs relations avec les artistes*, 3 vols., Paris, J. Renouard, 1853, I, p. 467.

6 A prolific writer of letters and dispatches, Sublet involved himself in the most minute of details, often intervening personally in the execution of tasks. Vincennes, Archives de la Guerre, AI, 69.

7 See Michaud, 1969, pp. 353–54. Comte de Labord, "Les Travaux éxécutés au château de Fontainebleau sous le règne de Louis XIII," *Revue Universelle des Arts* (1856), t. iv. Paris, Archives Nationales O1/2127 fol. 280 [1639].

8 See Ballon, 1991.

9 See Michaud, 1969, p. 348. Paris, Bibliothèque Nationale fonds français 18504, fol. 64 et copie fol. 82. Archives Nationales, Minutier Centrale, étude XLIII, 32, 37 f. Sublet's argument for coinage with the image of the king anticipates that described by Louis Marin during the reign of Louis XIV: *Portrait of the King*, trans. M. M. Houle, Minneapolis, University of Minnesota Press, 1988, pp. 121–37.

10 See Roland Mousnier, ed., *Richelieu et la culture: actes du colloque international en Sorbonne*, Paris, Editions du Centre national de la recherche scientifique, 1987.

11 See Joseph Forte, "Deconstruction and Reconstruction in Poussin's Decoration of the Grande Galerie of the Louvre," in *Artistic Strategy and the Rhetoric of Power: Political Uses of Art from Antiquity to the Present*, ed. David Castriota, Carbondale and Edwardsville, Southern Illinois University Press, 1986, pp. 57–66.

12 Present knowledge of the decoration is based on an engraving of the Salon of 1699, the snuffbox in fig. 3, some drawings attributed to Poussin and his assistants, and contemporary verbal descriptions by Sauval, Bellori, and Félibien; Sauval, *Histoire et recherches des antiquités de la ville de Paris*, 3 vols., Paris, 1724, II, pp. 43–44; Bellori, 1672, p. 68, discusses the casts; Félibien describes the drawings in the Hercules cycle: *Entretiens sur les vies . . .* , 4 vols., Trevoux, 1725, IV, p. 33. Otto Grautauff, *Nicolas Poussin, sein Werk und sein Leben*, 2 vols., Munich, 1914, I, pp. 175 f., and Walter Friedlaender, *Nicolas Poussin: Die Entwicklung seiner Kunst*, Munich, 1914, pp. 71 ff. Anthony Blunt, "Poussin Studies VI: Poussin's decoration of the Long Gallery in the Louvre," *Burlington Magazine* 93 (1951), pp. 369–76, and 94 (1952), p. 31. Walter Friedlaender and Anthony Blunt, *The Drawings of Nicolas Poussin*, vol. 4 (1963), pp. 11 ff. Doris Wild, "Nicolas Poussin et la décoration de la Grande Galerie du Louvre," *Revue du Louvre* 16 (1966), pp. 77–84. H. W. van Helsdingen, "Notes on Two Sheets of Sketches by Nicolas Poussin for the Long Gallery of the Louvre," *Simiolus* 5:3/4 (1971), pp. 172–84. Natalie and Arnold Henderson, "Nouvelles recherches sur la décoration de Poussin pour la Grande Galerie," *Revue du Louvre* 4 (1977), pp. 225–34. Joseph Forte, "Political Ideology and Artistic Theory in Poussin's Decoration of the Grande Galerie of the Louvre," Ph.D diss., Columbia University, 1982, and Forte, 1986. Pierre Rosenberg and Louis-Antoine Prat, *Nicolas Poussin 1594–1665: Catalogue raisonné des dessins*, Milan, Leonardo, 1994.

13 See Blunt, 1951, p. 373. Sauval, 1724, II, p. 43. Ballon, 1991, pp. 50–52, 212–19.

14 See Forte, 1986, pp. 58–61.

15 See Ballon, 1991, p. 52.

16 See ibid., p. 50.

17 See Blunt, 1951, p. 375.

18 See Roland Fréart, sieur de Chambray's *Parallèle de l'architecture antique et de la moderne*, Paris, Edme Martin, 1650, regarding the acquisition of reliefs. According to Forte, the relief tondi from the Arch of Constantine are also believed to have originated from a Trajanic monument. The reliefs may have

been intended to occupy the crown of the vault, the tondi bracketing the entire scheme. See Forte, 1986, p. 58.

19 See Jacques Thuillier, *Poussin Before Rome, 1594–1624*, trans. Christopher Allen, London, Richard L. Feigen & Co., 1995.

20 Ibid., p. 63. Of several compositions depicting the same theme, Thuillier has tentatively authenticated a fragment and a canvas in New York private collections.

21 Ibid., pp. 30–33.

22 See Jane Costello, "Poussin's Drawings for Marino and the New Classicism: I – Ovid's Metamorphoses," *Journal of the Warburg and Courtauld Institutes* 18 (1955), pp. 296–317. Robert B. Simon, "Poussin, Marino, and the Interpretation of Mythology," *Art Bulletin* 60 (1978), pp. 56–68.

23 The structure resembles the type found in Agostino Carracci's *Lascivie*: a sleeping nymph is exposed to the sight of the bestial and onanistic satyr. The motif of the voyeuristic interloper at the window is also found in Marcantonio Raimondi's *Modi*. See Paula Findlen, "Humanism, Politics, and Pornography in Renaissance Italy," in *The Invention of Pornography: Obscenity and the Origins of Modernity, 1500–1800*, ed. Lynn Hunt, New York, Zone Books, 1993, pp. 49–108, and Diane DeGrazia Bohlin, *Prints and Related Drawings by the Carracci Family: A Catalogue Raisonné*. Washington, D.C., National Gallery of Art, 1979.

24 Félibien claims Poussin did some "petits ouvrages" for the Luxembourg under the direction of Nicolas Duchesne, 1690, II, pp. 174–75, 573, cited by Thuillier, 1995, p. 43. For a lost painting for Notre-Dame de Paris see ibid., pp. 100–103.

25 Even though the attribution of the Fort Worth *Venus and Adonis* has been debated, it nevertheless offers evidence that his erotic works (or copies after them) continued to be in demand well into the 1640s. See Ann Sutherland-Harris, review of Konrad Oberhuber, *Art Bulletin* 72 (March 1990), p. 151, and D. S. Pepper, "Poussin's Venus and Adonis: An Autograph Work Restored," *Burlington Magazine* 127 (1985), pp. 370, 372–74.

26 The first version in the Jerusalem Museum was received in 1633–34 by Charles I, duc de Créquy, maréchal de France and ambassador to Rome, presumably for Richelieu. The second version (Vienna, Kunsthistorisches Museum) was given to a diplomat, Prince Eggenberg, probably as a gift to the new Hapsburg Emperor Ferdinand III in 1638–39. Ludwig Pastor, *The History of the Popes*, 40 vols., Liechtenstein, 1968–69, XXVIII, pp. 355–58.

27 These early works in Rome will be discussed in my book in progress *Self-Promotion and the Margins: Representing Subordinates in Seventeenth-Century Rome*.

28 Henri Sauval, *Histoire et recherches des antiquités de la ville de Paris* [1650s], 3 vols., Paris, 1724, II, pp. 166–68. Jacques Thuillier, *Vouet*, Paris, Réunion des musées nationaux, 1990, pp. 244–46. The smaller paintings and emblems were executed by Juste d'Egmont and Charles Poerson.

29 See e.g. one version of this topos: "Poussin realized his destiny lay not with grand decorations." Christopher Wright, *Poussin, Paintings: A Catalogue Raisonné*, London, Jupiter, 1984, p. 81.

30 Anthony Blunt, *Nicolas Poussin*, Washington, D.C., Pantheon, 1967, p. 173.

31 See Antoine Jules Dumesnil, "Le Comandeur Cassiano Del Pozzo," in *Histoire des plus célèbres amateurs italiens et de leurs relations avec les artistes*, Paris, J. Renouard, 1853, 1, pp. 403–543. Francis Haskell, *Patrons and Painters: A Study in the Relations between Italian Art and Society in the Age of the Baroque*, rev. ed., New Haven and London, Yale University Press, 1980, pp. 44–46, 98–117. Francis Haskell et al, *Il Museo Cartaceo di Cassiano dal Pozzo: Cassiano naturalista*, n.p., Rome, Olivetti, 1989. Ian Jenkins et al, *Cassiano dal Pozzo's Paper Museum volume I*, Rome, Olivetti, 1992. Jennifer Montagu et al, *Cassiano dal Pozzo's Paper Museum volume II*, Rome, Olivetti, 1992. Cropper and Dempsey, 1996, pp. 109–74. Donatella L. Sparti, "Carlo Antonio dal Pozzo (1606–1689): An Unknown Collector," *Journal of the History of Collections* 2:1 (1990), pp. 7–19. Elizabeth Cropper, "Vincenzo Giustiniani's 'Galleria': The Pygmalion Effect" in Montagu, 1992, pp. 124–25.

32 See Francis Haskell and Nicholas Penny, *Taste and the Antique: The Lure of Classical Sculpture, 1500–1900*, New Haven and London, Yale University Press, 1981, p. 32. See e.g. Poussin's discussion regarding a cast of the Farnese Hercules, *Correspondance de Nicolas Poussin* [hereafter, *Correspondance*], ed. Ch. Jouanny, Paris, J. Schemit, 1911, pp. 306, 349.

33 See *Correspondance*, p. 34.

34 The complete relief cycle was first published in 1579. Over 130 plates of the whole frieze were engraved by Girolamo Muziano as an illustration for Alonso Chacon's commentaries on the Dacian Wars, *Historia*, Rome, 1576. For Poussin's source for the Roman strong-arming a prisoner in the *Destruction of the Temple of Jerusalem*, see Rosenberg and Prat 1994, no. 198; see also nos. 194–97. This motif can also be seen from the ground, thereby making the drawing recognizable to the viewer.

35 Beatrizet's engravings in Lafréry's *Speculum Romane magnificentiae* (Rome, 1575) was a source book for both artists and antiquarians. Beatrizet's engraving after a famous relief found in the Forum (now in the Capitoline Museum) was the basis for Poussin's graphic investigation of sacrificial instruments. See Anthony Blunt, *The Drawings of Nicolas Poussin*, New Haven and London, Yale University Press, 1979, p. 134, figure 153. Friedlaender and Blunt, 1939–74, v, pp. 43–44, no. 352. Anthony Blunt, "Les cérémonies religieuses antiques," *Revue des Arts* 10 (1960), p. 62. For Beatrizet, see Rosenberg and Prat, 1994, no. 184. Bosio's *Roma Soutteranea*, printed under the patronage of the Barberini, was yet another source for Poussin's investigation of early Christian archeology that served to mediate the antiquarian concerns of Poussin and client: see ibid., 1994, nos. 242–44. For Bosio's Christian archeology see my "Pitiful Relics: Caravaggio's *Martyrdom of St Matthew*" *Representations* 77 (winter 2002).

36 Poussin's habitual textual borrowing is well known. See Anthony Blunt, "Poussin's Notes on Painting" *Journal of the Warburg and Courtauld Institutes* 1 (1937–38), pp. 344–51; Bätschmann, 1990, pp. 219–47; and Thomas Puttfarken, "Poussin's Thoughts on Painting," in *Commemorating Poussin: Reception and Interpretation of the Artist*, ed. Katie Scott and Genevieve Warwick, Cambridge University Press, 1999, pp. 58–59.

37 Cropper and Dempsey, 1996, p. 74.

38 See Marc Fumaroli, "The Republic of Letters," *Diogenes* 143 (fall 1988), p. 135.

39 For Gentileschi's self-portrait see Mary D. Garrard, *Artemisia Gentileschi: The Image of the Female Hero in Italian Baroque Art*, Princeton University Press, 1989, pp. 84–88.

40 François Perrier, *Icones et segmenta nobilium signorum et statuarum . . .* , Rome 1638. See Jacques Thirion, "Perrier et la diffusion des modèles antiques," *Revue du Louvre* (1971), p. 147f. Walter Vitzhum, "L'Album Perrier du Louvre," *L'Oeil* (May 1965), pp. 20–24.

41 The references to the hippopotami on the rear of the base for the *Nile* was thereby available to Poussin's audience when he painted the animals in conjunction with the river god. See Chapter Four above, n. 3. On the hippopotamus in Poussin's work see McTighe, 1996, pp. 120–21.

42 François Perrier, *Icones et segmenta illustrium e marmore tabularum . . .* , Rome, 1645, the *Tabularum*, contains 52 plates after reliefs.

43 It is clear that Poussin used one of the series of engravings as a visual source for a local monument that he could have drawn first hand. Poussin's *Marcus Aurelius* (Chantilly) is almost identical to an engraving in Perrier's *Icones* (1638) but in reverse. This suggests that he either relied on Perrier's original drawing or an offset; see Blunt, 1979, p. 130.

44 See Forte, 1986, p. 61.

45 For Perrier's decoration of the gallery in the Hôtel de la Vrillière, see Paris, Archives Nationales, Minutier Centrale, étude VII/35 [marché], and Sabine Cotté, "Un exemple du 'goût italien': la galerie de l'hôtel de la Vrillière à Paris," in *Seicento: le siècle de Caravage dans les collections françaises*, Réunion des musées nationaux, 1988, p. 43.

46 Guillaume du Choul, *Discours de la religion des anciens Romains; escript par noble seigneur du Choul et illustre d'un grand nombre de medailles, & de plusieurs belles figures retirées des marbres antiques . . .* , Lyon, G. Rouille, 1556 (reprint, New York, Garland, 1976). Latin and Italian editions were published in Lyon in 1569. Friedlaender and Blunt, 1939–74, v, nos. 354–57. Blunt, 1960, p. 58. Alain Mérot, *Nicolas Poussin*, New York, Abbeville, 1990 (Fr. ed. Paris, Hazan, 1990), p. 92.

47 See Francis Haskell, "The Early Numismatists," in *History and its Images: Art and the Interpretation of the Past*, New Haven and London, Yale University Press, 1993, p. 16 and fig. 4. The first edition of Guillaume du Choul's *Discours de la religion* (Lyon, 1556) was dedicated to the dauphin; *Discours sur la castramentation et discipline militaire des Romains* (Lyon, 1557) was dedicated to Henry II; *Des Bains et antiques exercitation grecques et romaines* was also dedicated to the king.

48 For the relationship between du Choul and other Lyonnais antiquarians see Mathieu Varille, *Les Antiquaires Lyonnais de la Renaissance*, Lyon, Audin, 1924.

49 See Charles Dempsey, "Poussin and Egypt," *Art Bulletin* 45 (1963), pp. 109–19, and Blunt, 1960.

50 Elizabeth Cropper, *The Ideal of Painting: Pietro Testa's Düsseldorf Notebook*, Princeton University Press, 1984, pp. 158, 160. Cropper discusses the questions of authority implicit in the epistemology of Roman classicism. See p. xv above.

51 "Petit benestrier portatif, comme celuy qui se port par noz eglises encore aujourdhuy." Du Choul, 1556, p. 267.

52 The engraved "Lucerne de Bronze antique" found in Lyon in 1525 resembles the lamp in Poussin's painting. Ibid., p. 151.

53 There is evidence, for example, of the interest and study of Egyptian religious practices in Nîmes that predated the Roman occupation. The ancient worship of the god Serapis was known to the seventeenth-century Nîmois; the god is represented in Poussin's *Rest on the Flight to Egypt* (Hermitage). See Dempsey, 1963. We might consider the importance of the study of the early church in contact with "provincials" as a model for Gallican theory.

54 See Jerry H. Bentley, *Politics and Culture in Renaissance Naples*, Princeton University Press, 1987, p. ix.

55 Engravings by Lazare de Baïf after François de Dieuterville in *De Re Navali*, Paris, 1536. R. Chevalier, "Dessins du 16ème siècle de la colonne Trajane dans une collection parisienne, contribution à l'histoire des formes et des idées," *Bulletin de la Société nationale des antiquaires de France* (1977), p. 130f.

56 See Haskell and Penny, 1981, p. 6.

57 See ibid., p. 32; Bellori, 1976, pp. 443–44.

58 See van Helsdingen, 1971, p. 172–84. The first Fr. ed. was published in 1599.

59 See Vivanti, 1967, p. 183.

60 R. Trousson, "Ronsard et la légende d'Hercule," *Bibliothèque d'humanisme et renaissance* 24 (1962), pp. 77–88, and Marc René Jung, *Hercules dans la littérature française du 16e siècle*, Geneva, Droz, 1966.

61 For the mental gifts of Hercules see Servius in the commentary of the *Aeneid*. Vivanti, 1967, p. 184. See Erwin Panofsky, *Hercules am Scheidewege und andere antike Bildstoffe in der neueren Kunst*, Leipzig and Berlin, B. G. Teubner, 1930.

62 See Vivanti, 1967, p.185. For the early use of the myth by Henry II see Frances A. Yates, "Poètes et artistes . . . ," in *Les Fêtes de la renaissance*, ed. Jean Jacquot, Paris, CNRS, 1956, p. 69.

63 For Hercules as progenitor of Gaul see Jean Seznec, *La Survivance des dieux antiques*, 1940, p. 28f. For the accrued allegorical meanings of "charme par le discours," see Jules-César Soulenger, *Triomphe sur les victoires du Roy*, Paris, 1601.

64 See Vivanti, 1967, pp. 183–84.

65 See ibid., p. 164.

66 Paris, Bibliothèque Nationale, Cabinet des Estampes, Series Qb1, Histoire de France. Vivanti, 1967, pl. 18g–h. The suppression of disorder was also represented by the victory of Hercules over a female centaur; ibid., pl. 18g.

67 Pliny's *Panegyric to Trajan* was translated by Jean de la Mesnardière and published in Paris in 1633, reprinted in 1642. See Françoise Bardon, *Le Portrait mythologique à la cour de France sous Henri IV et Louis XIII: mythologie et politique*, Paris, Picard, 1974. For a persuasive argument that the Trajanic iconography was a "conscious act of affiliation between the emperor and the king of France, Louis XIII," see Forte, 1986, p. 58. On the panegyrics celebrating the triumphal entries of Louis XIII into Lyon in 1623 and Paris in 1629, see Forte, 1982, p. 85.

68 For the codification of the ritual and imagery of triumphs in the sixteenth century see Loren Partridge and Randolph Starn, "Triumphalism and the Sala Regia in the Vatican," in *All the World's a Stage: Art and Pageantry in the Renaissance and Baroque. Triumphal Celebrations and the Rituals of Statecraft*, ed. Barbara Wollesen-Wisch and Susan Scott, University Park, Pennsylvania State University, VI, pt. I, 1990, pp. 22–23. The first fully articulated reference to a Roman triumph in a French

entrance ceremony was in 1550. Lawrence M. Bryant, *The King and the City in the Parisian Royal Entry Ceremony: Politics, Ritual, and Art in the Renaissance*, Geneva, Droz, 1986, p. 66.

69 See Roy Strong, *Art and Power: Renaissance Festivals, 1450–1650*, Berkeley, University of California Press, 1984, p. 47. Margaret M. McGowan, "Form and Theme in Henri II's Entry into Rouen," *Renaissance Drama*, n.s. I (1968), pp. 199–252. Steven Mullaney, "Strange Things, Gross Terms, Curious Customs: The Rehearsal of Cultures in the Late Renaissance," *Representations* 3 (1983), pp. 40–67, and David Richards, *Masks of Difference: Cultural Representations in Literature, Anthropology and Art*, Cambridge University Press, 1994, pp. 37–39.

70 Pierre Matthieu, *Discours de la ioyeuse et triomphante entrée de très-haut, très-puissant et très magnanime Prince Henry IIII de ce nom, très-Chrestien Roy de France & de Navarre, faicte en sa ville de Rouën, capitale de la province & duché de Normandie, le Mercredy seizième iour d'Octobre MVIXCVI. Avec l'ordre & sompteueuses magnificences d'icelle, & les portraictz & figures de tous les spectacles & autres choses y representez*. Rouen, Chez Raphael du Petit val, 1599 (repr. *Entrée à Rouen du roi Henri IV en 1596*, Rouen, 1887). In the "Sonnet au Lecteur," the analogy appears again: historian as painter and painter as historian.

71 Despite the fact that Henry IV's early identification with the Gallic Hercules subsequently gave way to the imperial imagery of Augustus, the latter figure still maintained the virtues of clemency, valor, and justice. Ballon, 1991, p. 231.

72 Matthieu, 1887, pp. 34–35.

73 In the Lyon *entrée* of 1595, Victory was represented chained to the twin columns of the kingdoms of France and Navarre. Restricted to the two geographical entities, imperial ambitions were meant to be limited to internal unity. Vivanti, 1967, p. 188.

74 Pierre Matthieu, "Description des honneurs, pompes et triomphes dressez à l'entrée du Roy en sa ville de Lyon," in *Les deux plus grandes, plus célèbres et mémorables resjouissances de la ville de Lyons*, Lyon, T. Ancelin, 1598, pp. 22 f., cited by Vivanti, 1967, p. 190.

75 Antoine Loisel, *La Guyenne de M. Ant. Loisel: qui sont huict remonstrances faicts en la chambre de justice de Guyenne sur le subject des edicts de pacification*, Paris, chez Abel l'Angelier, 1605, p. 321. On Loisel, see Chapter Four n. 23, below.

76 "Il avoit vaincu, & gaigné par sa prudence, temperance, & clemence, non seulement les coeurs des habitans de la ville, mais des subjects de toutes autres villes qui auront parler d'une si grande & magnanime bonté & douceur." Ibid., p. 330.

77 Matthieu, 1887, pp. 34–35.

78 Ibid., p. 51.

79 The obelisk was supported by a pedestal with "tables": two sides were inscribed with verses linking Hercules to Henry, another in gilded letters simply designated "Hercules Gallicus" and another was left blank, signifying the future achievements of the king. Ibid., p. 52.

80 "Ce magnifique ouvrage vray hieroglyfique de ses vertues." Ibid.

81 The notion of perspective as a position in relation to historical sites has implications for the theorization of systematic perspectival representatation; see Catherine Soussloff, *The Absolute Artist: The Historiography of a Concept*, Minneapolis, University of Minnesota Press, 1997.

82 Matthieu, *L'Entrée de très grand et victorieux prince Henri IIII* [September 1595] Lyon, 1598, "aux Lecteurs," n.p.

83 On the print culture of sixteenth-century Lyon see Natalie Zenon Davis, "Printing and the People," *Society and Culture in Early Modern France*, Stanford University Press, 1975, pp. 189–226.

84 See Chapter Four below.

85 According to Matthieu, the first proposal by Bellièvre was "de Remprunter les inventions des anciens, pour leur en desrober l'honneur, ny celles des modernes, pour les se rendres propres. L'Histoire luy donne la forme du Triomphe des anciens, comme de Titus Tatius [etc] Cesar & les autres Empereurs, on l'on void luire la grandeur & la magnificence des Romains, & l'heureuse recompense des merites." Matthieu, 1598, p. 3. Bellièvre cited Livy's *Decade*, I, 1 and Ovid's *Metamorphoses*, 14.

86 Matthieu, *Entrée de . . . Marie de Médicis . . .* , Rouen, J. Osmont, 1601, p. 17.

87 For Nicolas II de Langes see Varille, 1924, pp. 26–30.

88 Ibid., p. 15.

89 See Katie Scott's introduction to *Commemorating Poussin*, 1999, pp. 1–52.

90 On the archival basis of institutional authority see Alanson Lloyd Moote, *The Revolt of the Judges: The Parlement of Paris and the Fronde, 1643–1652*, Princeton University Press, 1972, p. 8.

91 Anthony Giddens describes this body of knowledge as "authoritative resources" in contradistinction to power derived from coercive force and material accumulation ("allocative resources"). Anthony Giddens, *A Contemporary Critique of Historical Materialism, vol. 1. Power, Property, and the State*, Berkeley and Los Angeles, University of California Press, 1981, p. 5.

92 The memory palace is also a relevant metaphor. Marie Montembault, *L'Album Canini du Louvre et la collection d'antiques de Richelieu*, Paris, Réunion des musées nationaux, 1988.

93 "Et puis la valeur de Cesar & d'Alexandre estoit une valeur esquisée de la plus violente ambition qui jamais saisit une ame, l'un pour ruiner sa patrie, l'autre pour s'attribuer en terre des honneurs tous divins. Et celle du Roy n'a voulu rencontrer autre sugget que la grandeur de la France, la deffence de ses subjects, la conservation des loix fondamentales de cest Estat. Et à ce la Dieu, le Dieu vivant, pas le Jupiter d'Alexandre, ny le Mars de Cesar, mais le grand monarque des Rois, le Dieu des batailles l'a appellé miraculeusement, l'a conduit eslevé . . ." Pierre Matthieu, *L'Entrée de tresgrand, treschrestien tresmagnanime et victorieux prince Henri III roy de France et de Navarre en sa bonne ville de Lyon le III septembre l'an* M.D.XCV, Lyon, 1595, n.p.

94 Plutarch described his principle of selecting bad leaders whose misconduct is made conspicuous by their extreme power in his introduction to his life of Demetrius. Plutarch, *Age of Alexander*, in *Plutarch's Lives*, trans. Arthur H. Clough, 3 vols., London and New York, Everyman's Library, 1910, III, pp. 227–28.

95 The significance of the Tacitian theme in the *Death of Germanicus* will be explored in my work in progress *Self-Promotion and the Margins*.

96 For an account of the change of the critical fortune of Tacitus in the the sixteenth century, see J. H. M. Salmon, "Cicero and Tacitus, *Renaissance and Revolt: Essays in the Intellectual and Social History of Early Modern France*,

Cambridge and New York, Cambridge University Press, 1987, pp. 27–53.

97 See Marc Fumaroli, "Rhetoric, Politics, and Society: From Italian Ciceronianism to French Classicism," in *Renaissance Eloquence: Studies in the Theory and Practice of Renaissance Rhetoric*, ed. James J. Murphy, Berkeley, University of California Press, 1983, pp. 253–73.

98 See Salmon, 1987, p. 43.

99 Arnaldo Momigliano, "The First Political Commentary on Tacitus," *Essays in Ancient and Modern Historiography*, Oxford University Press, 1977, pp. 222–24. La Boétie similarly praised Tacitus for his description of the corruption of Nero as part of Huguenot propaganda. La Boétie, *Discours de la servitude volontaire* (1574), ed. Paul Bonnefon, Paris, 1922, p. 83.

100 Jean Bodin, *Les Six Livres de la République*, 2 vols., Geneva, 1577, V, p. 392.

101 For a discussion of the term *amasser* in collecting practices of the seventeenth century see Louis A. Olivier, "'Curieux,' Amateurs, and Connoisseurs: Laymen and the Fine Arts in the Ancien Regime," Ph.D. diss., Johns Hopkins University, Baltimore, 1976.

Chapter Two: Object Lessons

1 See George Huppert, *Public Schools in Renaissance France*, Urbana and Chicago, University of Illinois Press, 1984, and George Huppert, *Les bourgeois gentilshommes: An Essay on the Definition of Elites in Renaissance France*, University of Chicago Press, 1977. Rogier Chartier et al, *L'Education en France du XVIe au XVIIIe siècle*, Paris, Société d'edition d'enseignement supérieur, 1976. There was a parallel phenomenon in Han Dynasty China: see Martin Powers, *Art and Political Expression in Early China*, New Haven and London, Yale University Press, 1991.

2 On the contractual demand for "un stille parisien" see Huppert, 1984, pp. 49–51.

3 See e.g. Nicolas Claude Fabri de Peiresc, *Lettres de Peiresc*, ed. Philippe Tamizey de Larroque, 2 vols., Paris, Imprimerie Nationale, 1888–98.

4 See Huppert, 1984, pp. 53–54.

5 On the transformation of the system at the end of the sixteenth century see George Huppert, "Ruined Schools: The End of the Renaissance System of Education in France," in *Humanism in Crisis: The Decline of the French Renaissance*, ed. Philippe Desan, Ann Arbor, University of Michigan Press, 1991. On the perpetuation of independent teachers and municipal *collèges* in a number of cities, despite the greater authority given to the Jesuits, see Huppert, 1984, p. xii.

6 Augustin Sicard discussed the reform of education in sixteenth-century France in *Les Etudes classiques avant la révolution*, Paris, Perrin, 1887, p. 7.

7 For a bibliography of pedagogical texts see France, Musée Pédagogique, *Répertoire des ouvrages pédagogiques du XVIe siècle: Bibliothèques de Paris et des départements*, Paris, Imprimerie Nationale, 1866.

8 Charles Perrault, *Mémoires de ma vie*, ed. Paul Bonnefon, Macula, 1993, p. III (Paris, H. Laurens, 1909, p. 21).

9 See Catherine E. Holmès, *L'Eloquence judiciaire de 1620 à 1660: reflet des problèmes sociaux, religieux et politiques de l'époque*, Paris, A. G. Nizet, 1967, p. 37. Thomas Puttfarken describes this

pattern of textual appropriation in terms of the "scholastic traditions of pre-Cartesian France" in "Poussin's Thoughts on Painting," in *Commemorating Poussin: Reception and Interpretation of the Artist*, ed. Katie Scott and Genevieve Warwick, Cambridge University Press, 1999, p. 59.

10 See, for example, Montaigne's "Du repentir" (*Essais*, III, 2) where he borrows freely from Amyot's translation of Plutarch's *Apophtegmes des Rois et Capitaines* in a reference to the Athenian general Phocion.

11 As early as 1598, youth had participated in the royal entries. For example, the youth of Rheims in a panegyric hailed Henry IV as the Gallic Hercules. Vivanti, 1967, p. 189.

12 See Charles Ledré, "Théâtre et 'exercices publics' dans les collèges lyonnais du xve au xviiie siècle," *Bulletin de la société de Lyon* 16 (1940–44), pp. 1–29, 17 (1945–49), p. 7, rep. no. 3. Students also put on plays commemorating French history. "Philippe Auguste à la journée de Bouvines" was also performed in 1622 for the entrance of Louis XIII. Ledré, 1940–44, p. 6.

13 See Louis Desgraves, *Répertoire des programmes des pièces de théâtre jouées dans les collèges en France (1601–1700)*, Geneva, Droz; Paris, Champion, 1986.

14 Annecy, Collège des Barnabites in 1621. Ibid., 1986, p. 19.

15 Lille, Collège des Jésuites, September 13, 1650. Ibid., p. 69.

16 Charles and Claude Perrault, *Les murs de Troye, ou l'origine du Burlesque*. The second book was found in manuscript form at the Bibliothèque de l'Arsenal and was published by Paul Bonnefon in the *Revue d'histoire littéraire de la France* 7 (1900), pp. 449–72. See Marc Soriano, "Burlesque et langage populaire de 1647 à 1653: Sur deux poèmes de jeunesse des frères Perrault," *Annales, économies, sociétés, civilizations* 24 (1969), pp. 949–75.

17 "Il a imaginé le burlesque pour avoir bâti les murs de Troye avec Neptune, et que c'est dans les atteliers des maçons et toutes sortes d'ouvriers qu'il appris toutes les expressions triviales qui entrent dans la composition du burlesque." Charles Perrault, *Mémoires de ma vie*, Paris, Macula, 1993, p. 114 n. 8.

18 Statutes of 1578, cited in Huppert, 1984, p. 85 n. 31. See Léon Ménard, *Histoire civile, ecclésiastique et littéraire de la ville de Nismes*, 7 vols., Nîmes, 1750–63, iv, p. 41.

19 This is in disagreement with Georges Snyders who asserted that the classroom was "un univers fondamentalement différent du monde quotidien," in *La Pédagogie en France aux xviie et xviii siècles*, Paris, Presses Universitaires de France, 1965.

20 The art historian Corrado Vivanti describes the historical imagination and practices of the royal officials during the reign of Henry IV who served as models for subsequent generations of educated elites: "We can see the fruits of humanist teaching in this culture 'engaged' in civil life and trained to a polemical search into the past for the pristine purity of an institution and a 'truth' by then obscured or corrupted . . . Those who wished to restore those institutions by political action sought support for their programme in historical research." Vivanti, "Henry IV, the Gallic Hercules," *Journal of the Warburg and Courtauld Institutes* 30 (1967), p. 181. On the importance of education for the constitution of *habitus* see Pierre Bourdieu, *Outline of a Theory of Practice*, Cambridge University Press, 1977.

21 As Vivanti states, 1967, p. 181, ancient historiography was not "academic habit or spiritual refuge," nor was rhetoric a "literary epiphenomenon."

22 See e.g. the collection at the Collège de la Trinité. Léopold Nièpce, *Archéologie lyonnaise*, 3 vols., Lyon, Henri George, 1881–85, ii: *Les chambres de merveilles ou cabinets d'antiquités de Lyon depuis la Renaissance jusqu'en 1789*.

23 According to Fumaroli, rhetoric "served as the tangible framework for a socialized mode of learning and knowing." Marc Fumaroli, "The Republic of Letters," *Diogenes* 143 (fall 1988), p. 135. See also Marc Fumaroli, *L'Age de l'éloquence: Rhétorique et "res literaria," de la Renaissance au seuil de l'époque classique*, Geneva, Droz, 1980.

24 See Mathieu Varille, *Les Antiquaires Lyonnais de la Renaissance*, Lyon, Audin, 1924, pp. 29–30.

25 See *Correspondance*, pp. 136–37 [April 7, 1642]. Sauval, *Histoire et recherches des antiquités de la ville de Paris*, 3 vols., Paris, 1724, ii, p. 207. M. Michon, "Communication du 26 Février 1913," in *Mémoires de la Société nationale des antiquaires de France* (1913), p. 121.

26 Vincennes, Archives de la Guerre, A1, 69, fols. 544, 550 [June 28–29, 1642]. The engraver was Louis Bertrand. See Michaud, 1969, p. 343.

27 Vincennes, Archives de la Guerre, A1, 71, fol. 268bis.

28 See Arnaldo Momigliano, "Ancient History and the Antiquarian," *Journal of the Warburg and Courtauld Institutes* 13 (1950), pp. 285–315.

29 On the crisis in historiography see Julian H. Franklin, *Jean Bodin and the Sixteenth-Century Revolution in the Methodology of Law and History*, New York, Columbia University Press, 1963, p. 92 n. 4. On the inheritance and transformation of ancient epistemologies see Anthony Grafton, *New Worlds, Ancient Texts: The Power of Tradition and the Shock of Discovery*, Cambridge, Mass., Harvard University Press, 1992.

30 Cornelia Agrippa, cited by Franklin, 1963, p. 92.

31 "In the period after 1492 the discovery that there existed an entire continent of which the Ancients had been wholly ignorant effectively excluded the possibility that any ancient emperor could have been literally a world ruler." Anthony Pagden, *Lords of all the World: Ideologies of Empire in Spain, Britain and France, c. 1500–c. 1800*, New Haven and London, Yale University Press, 1995, p. 38.

32 Louis Hennepin, cited by Grafton, 1992, dust jacket.

33 See Franklin, 1963, pp. 59–79.

34 See ibid., p. 135; François Baudouin, *De Institutione historiae universae et ejus cum jurisprudentia conjunctione prolegomenon*, Halle, 1726, pp. 31–33, 122.

35 See Elizabeth Cropper and Charles Dempsey, *Nicolas Poussin: Friendship and the Love of Painting*, Princeton University Press, 1996.

36 Pierre Sala was a humanist poet and one of the earliest collectors of inscriptions. Symphorien Champier (1472–1539) published a compendium of the antiquities of Lyon entitled *Trophoeum Gallorum*, which included nineteen inscriptions copied in different quarters of Lyon. Varille, 1924, pp. 6–18. The most famous epigraphic study of the late seventeenth century is Jacob Spon's *Recherches des antiquités et curiosités de la ville de Lyon*, Lyon, 1673. See Antoine Molliere, *Une famille medicale lyonnaise au xviie siècle: Charles et Jacob Spon*, Lyon, A. Rey, 1905. For Spon's list of collectors, including examples of Poussin's work, see M.-F. Pérez and J. Guillemain, "Curieux et collec-

tioneurs à Lyon d'après le texte de Spon (1673)," in *Jacob Spon: Un humaniste lyonnais du XVIIe siècle* (Université Lumière Lyon 2, VI, Lyon, 1993), ed. Roland Etienne, Paris, Boccard, 1993, pp. 39–50.

37 Varille, 1924, pp. 19–20.

38 Tacitus, *The Annals of Imperial Rome*, trans. Michael Grant, London, Penguin, 1989, p. 243.

39 Ibid.

40 Ibid. This is a central theme of the *Rape of the Sabines*.

41 The tablet included the fact that the Emperor's uncle Tiberius had already introduced into the Senate an elite of provincial foreigners and that Lyon and neighboring Vienne, in particular, had contributed many good senators.

42 Bellièvre's manuscript includes a translation of the Claudian tablet. Claude I de Bellièvre, *Lugdunum priscum, par le président Claude Bellièvre*, ed. J.-B. Monfalcon et al, Lyon, Dumoulin et Ronet, 1846. The text was first published anonymously in Guillaume Paradin de Cuyseaux's *Mémoires de l'histoire de Lyon* (1573).

43 See Varille, 1924, p. 21. See also J. J. Grisard, *Odyssée de la Table de Claude*, Lyon, 1896.

44 On the *consulat* as the traditional form of civic government in Lyon, see my "Nicolas Poussin, his French Clientele, and the Social Construction of Style," Ph.D. diss., University of Michigan, Ann Arbor, 1994, p. 60.

45 Samuel Chappuzeau, *Lyon dans son lustre*, Lyon, 1656, p. 13. On the building project of the *hôtel de ville* during the 1650s, including the sculptural programs, see P. Dominique de Colonia, s.j., *Histoire littéraire de la ville de Lyon*, 2 vols., Lyon, 1728–30, II, p. 68.

46 For a description of the facade see Marius Audain, *La Maison de ville de Lyon*, Lyon, 1655, p. 27, and Lyon, Archives municipales (série BB). André Steyert, *Nouvelle histoire de Lyon et des provinces de Lyonnais, Forez, Beaujolais, Franc-Lyonnais et Dombes*, 3 vols., Lyon, Bernoux et Cumin, 1895–99, I, p. 251f.

47 For Thomas Blanchet's work on the Hôtel de Ville begun in 1655 see Lucie Galactéros-de Boissier, *Thomas Blanchet (1614–1689)*, Paris, Arthéna, 1991.

48 G. Barbier, *Recueil des privilèges*, Lyon, 1649.

49 For example, the *garde de la ville*, who held the keys to the city, oversaw arms, and had jurisdiction over roads, was the same as the Roman *aediles*.

50 On the notion of exteriority and discontinuity as characteristics of the rhetorical example see John D. Lyons, *Exemplum: The Rhetoric of Example in Early Modern France and Italy*, Princeton University Press, 1989, pp. 28–32.

51 Jean Poldo d'Albenas, *Discours historial de l'antique et illustre cité de Nîmes, en la Gaule Narbonnoise, avec les portraits des plus antiques et insignes bastimens dudit lieu, reduitz à leur vraye mesure et proportion, ensemble de l'antique et moderne ville*, Lyon, Guillaume Rouille, 1560, ch. XVI, pp. 73–80.

52 Ibid., p. 75.

53 On the insertion of the Maison Carrée into public discourse well into the latter half of the seventeenth century, see Deyron's *Des antiquités de la ville de Nismes*, Nîmes, Par Jean Plasses, 1663 (1656), which was dedicated to the consuls of the city. *Extrait des registres des deliberations consulaires de la ville de*

Nismes [1656, October 7]. In addition to arguing that the decorum of the building was too humble for a temple dedicated to the wife of an Emperor, Deyron used a Gallo-Roman building in Vienne as comparative formal evidence; pp. 48–49. He also made an explicit parallel between the rights of the Roman colony and the town in the Royaume of France. See my dissertation.

54 See Sharon Kettering, *Judicial Politics and Urban Revolt in Seventeenth-Century France: The Parlement of Aix, 1629–1659*, Princeton University Press, 1978.

55 See Léon Ménard, "Dissertations historiques et critiques sur les antiquités de la ville de Nismes," *Histoire civile, ecclésiastique, et littéraire de la ville de Nismes*, 1763, VII, p. 39.

56 For a discussion of the contractual notion of triumphalism as well as the inadvertent effects of praise see Loren Partridge and Randolf Starn, "Triumphalism and the Sala Regia in the Vatican," in *All the World's A Stage: Art and Pageantry in the Renaissance and Baroque. Triumphal Celebrations and the Rituals of Statecraft*, ed. Barbara Wollesen-Wisch and Susan Scott Munshower, University Park, Pennsylvania State University, VI, pt. 1, 1990, pp. 22–81. According to these authors, p. 24, the representation of a series of structural oppositions in the triumph is inherently unstable. The monotony of the formulaic triumph "should not obscure the cultural dynamic of tension and conflict which they always addressed, i.e. war opposed to peace, defeat opposed to victory, domination opposed to liberation, pillage opposed to propriety, and so on in endless permutations." The work of triumphal ritual and imagery was to regulate a set of oppositions that could exceed attempts to control meaning.

57 George Huppert speaks even more strongly about the inherently subversive ideas that were transmitted by the humanist tradition. Huppert, 1991, p. 65.

58 Much has been written on the limits of absolutism. See Roger Mettam, *Power and Faction in Louis XIV's France*, Oxford, Basil Blackwell, 1988. William Beik's work is useful as a general theoretical model for the productive study of the uneven realization of absolutism: "social conflicts are more fundamental than social solidarity in explaining the functioning of a given society." William Beik, *Absolutism and Society in Seventeenth-Century France: State Power and Provincial Aristocracy in Languedoc*, Cambridge University Press, 1985, p. 10. More recently, see William Beik, *Urban Protest in Seventeenth-Century France: The Culture of Retribution*, Cambridge University Press, 1997. Perry Anderson, *Lineages of the Absolutist State*, London, Verso, 1974.

59 As Beik suggests, 1985, p. 12, the problem with this formulation is that the "repression model rules out any notion of interaction between the state and the various classes in society, making it impossible to detect common interests or class alliances." For a model of negotiation between local and central institutions as it pertains to visual culture and urban planning see Hilary Ballon, *The Paris of Henri IV: Architecture and Urbanism*, Cambridge, Mass. and London, MIT Press, 1991.

60 Customary forms of provincial administration, such as the Toulousain Estates, were never really independent, neither were they really "taken over." Beik, 1985, pp. 38–39, and see p. 66f.

61 For Flavius Josephus, see Chapter Four below.

Chapter Three: Emergent Clients

1 "[Passart] veut passer pour homme/ Aussi sçavant qu'on en ait vu dans Rome." Anonymous, *Le Banquet des curieux* [1676–77], ed. Paul Lacroix, *Revue Universelle des Arts* 4 (1856), pp. 47f., extract in Jacques Thuillier, "Pour un 'Corpus pussinianum'," in *Actes du colloque Nicolas Poussin* (1958), ed. André Chastel, Paris, CNRS, 1960, II (hereafter *Actes*, 1960), p. 170. There was also a *Response au Banquet des curieux* bound with the text in the Bibliothèque de l'Arsenel, n.p., n.d., in-12. See Bernard Teyssèdre, *Roger de Piles et les débats sur le coloris au siècle de Louis XIV*, Paris, La Bibliothèque des arts, 1957, pp. 220–25.

2 See e.g. Frederick Hammond, *Music and Spectacle in Baroque Rome: Barberini Patronage under Urban VIII*, New Haven and London, Yale University Press, 1994, pp. 103–13.

3 *Correspondance*, p. 132 n. 2. Anthony Blunt, *Nicolas Poussin*, Washington, D.C., 1967, p. 208.

4 See Jean Orcibal, *Port-Royal entre le miracle et l'obéissance: Flavie Passart et Angélique de Saint-Jean Arnauld d'Andilly*, Paris, Desclee De Brouwer, 1957, p. 14. A genealogy in Paris, Bibliothèque Nationale, Département des Manuscrits (hereafter BN MSS), lists Passart as a "Marchand bourgeois de Paris" who died in 1569. Dossiers Bleus 512.

5 Michel Passart the elder was a colonel in control of one the sixteen bourgeois militia responsible to the *hôtel de ville* loyal to Henry of Navarre. Orcibal, 1957, p. 14. He was described as a "partisan dévoué du Roi Henri IV, qui contribua à la réduction de Paris." Comte Henri Coustant d'Yanville, *Chambre des comptes de Paris: Essais historiques et chronologiques, privilèges et attributions nobiliaires et armorial*, Paris, 1866–75, p. 891.

6 Pierre de l'Estoile, *Journal de l'Estoile pour le règne de Henri IV*, I (1589–1600), ed. Louis-Raymond Lefèvre, Paris, Gallimard, 1948, pp. 235–6 [April 4, 1593].

7 He was exiled on December 28, 1593. "Ce jour, le Roy, fasché de ce que Passart et Marchant avoient esté chassés de Paris, dit que c'estoient de vrais manans, qui avoient fait les sots et avoient babillé: qui estoit tout ce qu'ils sçavent faire. Dont il estoit bien marri; car il avoit plus affaire de ses bons serviteurs à Paris qu'il n'avoit jamais eu." Ibid., p. 344 [December 31, 1593].

8 On Henry's entry see David Buisseret, *Henry IV*, London, George Allen & Unwin, 1984, p. 53; Estoile, 1948, p. 385, and Paul Robiquet, *Histoire municipale de Paris*, 3 vols., Paris, 1880–1904, III, p. 181. Jacques Passart, du Vair et al benefited from a quick recovery of their privileges by Henry IV's reinstatement of the sovereign courts on March 28, 1594, six days after his entry.

9 For a more thorough genealogical account of Michel Passart's extended family, see my dissertation pp. 88–89, 143–44 nn. 8–19.

10 BN MSS, Dossiers Bleus 512. Claude was married to Anne Drouart. He died on May 10, 1605.

11 Michel had two brothers, Jean and Alexandre. Jean entered the church as a *chanoine de St Augustine*. Alexandre also became a member of the *Chambre des comptes*. According to the same genealogical document, he was a lieutenant in charge of artillery in 1649 "sans alliance." Michel had one sister Monique who married Etienne de Maugenat sgr de Courcette, maître des comptes in Dijon. Ibid.

12 Perhaps this was supplemented with some intensive instruction at home. Rogier Chartier et al, *L'Education en France du XVIe au XVIIIe siècle*, Paris, Société d'edition d'enseignement supérieur, 1976, p. 173.

13 The inventory of Michel Passart's property was made upon the death of his wife Marie Le Conte (d. November 1683). Paris, Archives Nationales, Minutier Centrale (AN, MC), étude CXV, 244 [February 26, 1684]. Independently discovered by me, the inventory has been generously annotated and published by Antoine Schnapper and Marcel-Jean Massat, "Un amateur de Poussin: Michel Passart (1611/12–1692)", *Bulletin de la société de l'histoire de l'art français* (1994), pp. 99–109.

14 AN, MC, étude CXV, 244 [February 26, 1684].

15 "Reçu en l'office du conseiller du Roy et l'auditeur en la Chambre," Paris, Archives Nationales (hereafter AN) P/2680 [February 6, 1637]: *Copie officielle du plumatif de la Chambre des Comptes*. See A. de Boislisle, *La Chambre des comptes: Pièces justificatives pour servir à l'histoire des premières présidents (1506–1771)*, Paris, 1873. Coustant, 1866–75, p. 891. The date for the picture is based on Félibien, *Entretiens*, 1725, IV, p. 25. A "*Maitre d'école de faleries*" is listed in the inventory and valued at 1000#. AN, MC, étude CXV, 244 [February 26, 1684].

16 George Huppert's quintessential "gentry," the historian Etienne Pasquier, was a president of the *Chambre des comptes*. George Huppert, *Les bourgeois gentilshommes: An Essay on the Definition of Elites in Renaissance France*, University of Chicago Press, 1977. The useful term "political nobility" has been used as an alternative to *noblesse de robe*. Robert Descimon, "The Birth of the Nobility of the Robe: Dignity versus Privilege in the Parlement of Paris, 1500–1700," trans. Orest Ranum, in *Changing Identities in Early Modern France*, ed. Michael Wolfe, Durham, N.C. and London, Duke University Press, 1996, pp. 95–123. I use the term *robe* and *robin* for convenience to designate the social class and political group whose identity was being constructed in the precinct of visual culture.

17 A document of 1587 states that a "bourgeois merchant" named Passart was a member of an "Honorable famille françois." Paris, BN MSS, fr. 26288 (1537) (sic) [June 22, 1587].

18 As in the majority of cases, Michel did not inherit the title. Passart was received in place of Nicolas Le Clerc de Lesseville who had received his post from his brother Antoine Le Clerc de Lesseville on August 8, 1631. AN P/2638 (IV, 592). For the obligation of the *clercs* to fill vacant *maitre* positions see Coustant, 1866–75, p. 213. Although the lower office did not initially confer nobility, Passart did not have to wait for a vacancy among the *maitres* to receive the prestige and privileges of noble status. A royal edict of January 1645 conferred nobility to officers including *auditeurs*. Ibid., p. 365.

19 Passart purchased the office for 169,500 livres in March 1650 (1684 inventory, papiers, item 6). He was received on April 6. On the 11th, the Chambre acted upon his payment for the office. AN P/2685 [Copie officielle du plumatif de la Chambre des comptes]. See also AN P2635. 1650. E.540. Coustant, 1866–75, pp. 544, 891.

20 Alexandre Passart purchased the office from his brother for 61,000 livres on April 8, 1650 (AN, MC, étude LVII, 66, 356). Alexandre was received as an *auditeur* on June 3, 1650. AN P2638. IV, 650. Born on July 26, 1666, Michel's son Claude was received

on January 18, 1692. AN 2635. 1692. E.676. He replaced his father before Michel's death on July 3, 1692. Coustant, 1866–75, p. 544. It was unusual for the son to assume the father's office; there were only two patrilineal successions in the years 1514 to 1742.

21 AN P/2638 (IV, 121).

22 BN MSS, Dossiers Bleus 512. On Passart's daughter Anne see Gédéon Tallemant des Réaux, *Historiettes* (1657), Paris, Pléiade, 1960–62, pp. 163–71.

23 Even before the death of his father, Michel Passart could afford a house for 30,000 livres. AN, MC, étude CXV, 244 [February 26, 1684].

24 See Huppert, 1977, p. 40. There were also certain fiscal advantages to maintaining a bourgeois title. See Descimon, 1996, p. 98.

25 Before Michel was received as an *auditeur*, he was proceeded by the reception of eight *auditeurs* and six *maîtres* in offices newly created by an edict of December 1635. AN P/2636.

26 Despite these efforts, Richelieu was responsible for creating one *président*, 16 *maîtres*, 14 *correcteurs*, 20 *auditeurs*, and a host of lesser offices in the *Chambre des comptes* in the years 1635–40. Julian Dent, *Crisis in Finance: Crown, Financiers and Society in Seventeenth Century France*, Newton Abbot (Devon), David & Charles, 1973, p. 100. The *Cour des monnaies* was also threatened by the mushrooming of offices. See my dissertation, p. 146 n. 38, and Jacques Bouclier, *La Cour des monnaies de Paris à la fin de l'ancien régime*, Paris, 1924, p. 23.

27 Michel was received in the eighth *Office de Maître*, a title created in 1483. AN P/2638 (IV).

28 On the important fiscal and deliberative role of the auditors see Boislisle, 1873, p. lxxi.

29 Passart was in charge of the *bourse commune*. AN P/2685, p. 108 [July 1, 1651]. He was later assigned the shared responsibility for *les comptes au semestre de juillet*. P/2686 [January 2, 1652]. On these duties as a sign of seniority and competence, see Boislisle, 1873, p. xxx.

30 On the practice of *remonstrances* as part of the duties of the *Chambre des comptes* see Boislisle, 1873, pp. xxv–xxvi.

31 "La résistance respecteuse dont nous usons quelquefois dans les affaires publiques, ne doit pas être interprétée comme une marque de désobéissance, mais plutôt comme un effet nécessaire de la fonction de nos charges, de l'intention de ceux qui ont établi les parlemens, que les lois publiques de l'Etat autorisent, que le consentement des rois vos prédécesseurs ont introduit et souffert longues années, sous la bonne foi desquels Vostre Majesté règne sur nous heureusement." Omer Talon, *Mémoires*, ed. Louis-Gabriel Michaud et J.-F. Michaud, Paris, 1839, p. 260.

32 In the midst of the Fronde, *robe* theorists enlisted the authority of Henry IV to support the remonstrative rights of the Parlement. Mathieu de Morgues cited Henry IV's response to President du Harlay's remonstrance in his own pamphlet: "A Dieu ne plaise, que je me serve iamais de cette authorité souveraine, qui détruit souvant en la voulant establir, & à laquelle je sçay que les peuples donnent un mauvais Nom." *La très-humble et véritable Remonstrance de nosseigneurs du Parlement pour l'esloignement du Cardinal Mazarin*, p. 14. (no. 3808 in Celestin Moreau, *Bibliographie des mazarinades*, 3 vols., Paris, J. Renouard, 1850–51, and no. 12347 in the Bibliothèque Mazarine, hereafter Moreau 3808 [BMI2347]).

33 "Députations pour faire remonstrances au Roy sur l'edict de création de plusieurs offices en la chambre du mois de decembre dernier," AN P/2602 Extraits du Plumatif, 1636, p. 96.

34 AN P/2602, 1636, p. 97.

35 See A. Lloyd Moote, *The Revolt of the Judges: The Parlement of Paris and the Fronde, 1643–52*, Princeton University Press, 1972, p. 370: "Proclaiming belief in royal absolutism and yet using every legal power at their command, the parlementaires steered reforms past the administration while avoiding the self-defeating label of rebels. The parlementary Fronde was not entirely legal, but it certainly was legalistic."

36 This differs from the version by Valerius Maximus, in which the entire Senate of Falerii is guilty of an attempt to ransom the patrician youth.

37 For a convincing argument that relates the theme of Camillus to the epideictic rhetoric of blame urged by the Roman rhetorician Mascardi, see Genevieve Warwick, "Nicolas Poussin and the Arts of History," in *Commemorating Poussin: Reception and Interpretation of the Artist*, ed. Katie Scott and Genevieve Warwick, Cambridge University Press, 1999, p. 141.

38 Livy, *The Early History of Rome*, trans. A. de Sélincourt, Penguin, London, 1960, p. 372 (V, 28). I have followed this translation except where I replace "nature" for "common humanity" in conformity with the Latin text's "*natura*." This has a direct bearing upon the interpretation of the behavior of the schoolmaster as an act against nature. This use of the word "nature" is found in B. O. Foster's translation of Livy in the Loeb Classical Library edition, III, Cambridge, Mass., Harvard University Press, 1924 (V, 27), pp. 92–95.

39 Roscioli was cupbearer for Urban VIII and a musical patron for the Barberini court. Sandro Corradini, "La Quadreria di Giancarlo Roscioli," *Antologia di Belle Arti* (December 1979), pp. 192–96. Liliana Barroero, "Nuove acquisizioni per la cronologia di Poussin," *Bolletino d'Arte* 6 (1979), pp. 69–74. Hammond, 1994, p. 103. Nicoletta Guidobaldi, "Giovanni Maria Roscioli: Un esempio di mecenatismo musicale alla corte di Urbano VIII," *Esercizi: Arte, musica, spettacolo* 6 (1983), pp. 62–70. The painting is listed in Passart's inventory. Schnapper and Massat, 1994, pp. 104–105, 107.

40 "Ce qui nous fait espérer de pouvoir rétablir en nos jours est le langage ancien de nos ancêtres, qu'une mauvaise et infâme adulation a mis hors d'usage; car au lieu que parlant à nos souverains nous usons de termes de grandeur et de majesté, ils usoient du mot de clémence et de débonnaireté. Le premier est du nom d'empire, d'autorité, de commandement absolu, qui nous représente un prince à cheval, le bâton à la main, au milieu de ses armées, la victoire marchant devant lui; l'autre est un terme d'amour, de bienveillance et d'humanité, bienséant à une tige issue de la race de saint Louis, au petit-fils de Henri-le-Grand, lequel eut cet éloge dans sa pompe funèbre d'être surnommé *incomparable en magnanimité et clémence*." Talon, 1839, p. 260.

41 Montaigne, *Essais*, I, 5.

42 Timothy Hampton cites Montaigne's famous passage from "Du jeune Caton" in his discussion of the antique exemplum: "Rampant au limon de la terre, je ne laisse pas de remerquer, jusques dans les nues, la hauteur inimitable d'aucunes âmes heroïques." Hampton, *Writing from History: The Rhetoric of*

Exemplarity in Renaissance Literature, Ithaca, N.Y., Cornell University Press, 1990, p. 134.

43　Montaigne discusses siege warfare in the essay which refers to Camillus (*Essais*, 1, 5) as well as in the following essay entitled "L'Heure des parlements dangereuses" (ibid., 6). Both draw on contemporary sieges such as that of 1569. The latter discusses the hazards of negotiating with a siege army and permitting entrance into the town.

44　"Le passage et l'insolence des gens de guerre, ont été les fruits d'une mauvaise plante, qui ont désolé le plat pays, incommodé les bonnes villes, et réduite le royaume dans une extrémité de langueur qui menaçoit la ruine de l'Etat." Talon, 1839, p. 297 [October 24, 1648].

45　See Chapter Eleven below, pp. 214–15 and nn. 6–9.

46　Livy, 1960, pp. 354–55 (v, 11). "Camillus at Capena plundered on a great scale and left untouched nothing that fire or sword could destroy." Ibid., p. 358 (v, 15).

47　For the conquest of Veii see ibid., p. 365 (v, 21).

48　Ibid., pp. 372–73 (v, 28).

49　Even before the conquest of Falerii, when spoils were obtained from one of the town's abandoned encampments, Camillus turned anything of value over to the *quaestors*: "This the troops violently resented, but discipline was good and they could not but admire the strict honesty of their commander however much they might disapprove of it." Ibid., p. 371 (v, 27).

50　Giovanni Botero, *The Reason of State* [*Della ragione di stato*, Venice, 1589], trans. and ed. P. J. and D. P. Waley, Routledge & Kegan Paul, London, 1956, Book 1, 8, pp. 12–13. William Farr Church, *Richelieu and Reason of State*, Princeton University Press, 1972, pp. 62–64.

51　For a discussion of Poussin's Camillus as an orator see Marc Fumaroli, "Muta Eloquentia: La représentation de l'éloquence dans l'oeuvre de Nicolas Poussin," *Bulletin de la société de l'histoire de l'art français* (1982), pp. 29–48.

52　"On remarque la satisfaction que vraisemblablement doivent avoir des écoliers à se venger enfin sur les épaules de celui qui ne les a jamais épargnés de férules et du fouet, que tant de fois ils en ont reçus. Les uns y admirent l'union des couleurs, les autres le choix des draperies; mais tous, les airs de tête, la variété des passions bien remuées, & la composition entière de cette grande histoire." Sauval, 1724, ii, p. 230. *Actes*, 1960, p. 150. Shortly before the French Revolution, another guidebook also emphasized the topos of torment: "On voit dans le cinquième tableau le Maître d'école qui ayant voulu livrer à Camille des enfans des principaux de la ville des Falèsques, est abandonées à la discrétion de ses écoliers, qui le fouettèrent de toutes leurs forces." Thiéry, *Guide des amateurs et des étrangers voyageurs à Paris*, 2 vols., Paris, 1787, 1, p. 308. Both authors are responding to the second version of the painting executed for La Vrillière.

53　On the *collège* de Laön see Henri Sauval, *Histoires et recherches des antiquités de la ville de Paris* [1650s], 3 vols., Paris, 1724, ii, p. 374. The *collège* was socially permeable. There were several poor students with scholarships in philosophy, theology, law, and medicine. Jean Aimar Piganiol de la Force, *Description historique de la ville de Paris et de ses environs*, 10 vols., Paris, 1765, v, p. 167. Poussin painted temporary decorations in celebration

of the canonization of St. Francis Xavier. André Félibien, *Entretiens sur les vies et sur les ouvrages des plus excellens peintres anciens et modernes: avec la vie des architectes*, Paris, 1690, ii, pp. 572–73, cited in Jacques Thuillier, *Poussin Before Rome, 1594–1624*, trans. Christopher Allen, London, Richard L. Feigen & Co., 1995, p. 36.

54　"J'y fait toutes mes études, ainsi que tous mes frères, sans que pas un de nous y ait jamais eu le fouet." Charles Perrault, *Mémoires de ma vie*, ed. Paul Bonnefon, Paris, Macula, 1993, p. 109 (H. Laurens, 1909).

55　Mikhail Bahktin, *Rabelais and His World*, trans. H. Iswolsky, Bloomington, Indiana University Press, 1984.

56　See David Freedberg, "Cassiano on the Jewish Races," in *Cassiano Dal Pozzo's Paper Museum volume ii*, ed. Jennifer Montagu et al, Rome, Olivetti, 1992, p. 55.

57　J. J. Bouchard, "Le Carneval à Rome" in *Journal*, ed. E. Kancheff, Turin, 1976, 1, p. 143. For the print culture of carnival inversions see Sara F. Matthews Grieco, "Pedagogical Prints: Moralizing Broadsheets and Wayward Women in Counter Reformation Italy," in *Picturing Women in Renaissance and Baroque Italy*, ed. Geraldine A. Johnson and Sara F. Matthews Grieco, Cambridge University Press, 1997, pp. 61–87.

58　In Théodore de Godefroy's *Grand cérémonial de France* (Paris, 1619, republished as *Le Cérémonial françois* by his son Denis in 1649), the heated *lits de justice* of 1648 (January 15 and July 31, pp. 647–50 and 1046) are represented by the precise description of the spatial and procedural disposition of the social order.

59　For "la procession Macabre" see Hélène Duccini, *Concini: Grandeur et misère du favori de Marie de Médicis*, Paris, Albin Michel, 1991, pp. 322–36. For the justification for Concini's execution see Pierre Matthieu, *La Conjuration de Conchine, ou l'Histoire des mouvements derniers*, Paris, Michel Thevenin, 1619, p. 272. See Chapter Six, n. 58 below.

60　The stress here is on a representation of the "popular" as constituted by an elite. Bahktin's notion of the Carnivalesque resorts to a nostalgia for a precapitalist primordial ethos, rather than a selfconscious appropriation of customary forms of parody. Bahktin, 1984.

61　This figure appears drawing a chariot with a female carnal partner, subject to the humiliations of cupid, in a painting by Agostino Carracci, the *Punishment of Love* (Vienna, Kunsthistorisches Museum). It is an adaptation of a plate in the *Hypnerotomachia Poliphili* of F. Colonna, Venice, 1499.

62　Diane DeGrazia Bohlin, *Prints and Related Drawings by the Carracci Family: A Catalogue Raisonné*, Washington, D.C., National Galllery of Art, 1979.

63　For the political symbolism of sodomitical rape see Richard C. Trexler, *Sex and Conquest: Gendered Violence, Political Order, and the European Conquest of the Americas*, Ithaca, N.J., Cornell University Press, 1995.

64　See Jeffrey Merrick, "The Cardinal and the Queen: Sexual and Political Disorders in the Mazarinades," *French Historical Studies* 18:3 (spring 1994), pp. 667–99, and David Teasley, "The Charge of Sodomy as a Political Weapon in Early Modern France: The Case of Henry III in Catholic League Polemics, 1585–89," *The Maryland Historian* 18 (spring/summer 1987), pp. 17–30.

65 Indeed, the homosocial relation to the satyr is not mediated by an attendant female, as in Poussin's later *Inspiration of the Poet* (Louvre). See my forthcoming article based on a paper "Evivva il coltello: Marsyas and the Castrato" delivered at the College Art Association Annual Conference, New York, 1997.

66 For the paintings in la Vrillière's gallery see Christel Haffner, "La Vrillière, collectionneur et mécène," in *Seicento: le siècle de Caravage dans les collections françaises*, Paris, Réunion des musées nationaux, 1988, pp. 29–38, 305–7. For the Hôtel de la Vrillière see Sabine Cotté, "Un exemple du 'goût italien': la galerie de l'hôtel de la Vrillière à Paris," in ibid., pp. 39–46.

67 For example see the abuse of the royal tax collector Fiquepau in Lyon, Archives Communales de Lyon, série CC 333 [January 26, 1639] and my dissertation p. 149 n. 85. For the recalcitrant character of the *Consulat* see W. Gregory Monahan, "Lyon in the Crisis of 1709: Royal Absolutism, Administrative Innovation, and Regional Politics," *French Historical Studies* 16:4 (fall 1990), pp. 833–48. For numerous examples of resistance to the crown and its agents see Beik, 1997.

68 On the revolt in Poussin's birthplace, the *présidial d'Andely*, see Madeleine Foisil, *La révolte des nu-pieds et les révoltes normandes de 1639*, Paris, Presses universitaires de France, 1970, p. 298.

69 See Orest Ranum, *The Fronde: A French Revolution 1648–1652*, New York and London, Norton, 1993, p. 45.

70 Ibid., p. 13.

71 This traditional punishment is called *hanoter*. François de Verthamont, *Diaire ou journal du voyage du Chancelier Séguier en Normandie après la sédition des nu-pieds, 1639–1640*, Rouen, E. Frère, 1842 (Geneva, Slatkine-Megariotis Reprints, 1975), p. 316.

72 Ibid., p. 166.

73 Royal agents, such as the *intendants*, were not strictly outsiders, they were "socially indistinguishable from those who resisted" because they had the same background as *robe* nobility. William Beik, *Absolutism and Society in Seventeeth-Century France: State Power and Provincial Aristocracy in Languedoc*, Cambridge University Press, 1985, p. 15. "Their speeches were crammed with classical and biblical references, rhetorical flourishes and philosophical distinctions," ibid., p. 51. From the perspective of the central government, the intendants served "as intermediaries between local and national ties." Richard Bonney, *Political Change in France under Richelieu and Mazarin, 1624–1661*, Oxford and New York, Oxford University Press, 1978. See Beik, 1985, p. 98f. There was a shift under Colbert from personal to bureaucratic relationships. Beik, 1985, p. 113.

74 "L'art de gaigner par l'Amour, l'obeissance, & le respect des Peuples. C'est la chaisne qui lie leur coeur, qui attache leur volonté, qui attire leur service: il n'en est point, qui soit plus forte, & plus agréable: on ne sent nullement son poids, & on prend plaisir à la porter." Guillaume Le Pelletier, *L'Oraison funèbre sur le tréspas de son Altesse [le] duc de Longueville [le 23 mai 1663]*, Caen, 1663, p. 26.

75 "Ce n'estoit pas le faste, & l'orgueil, l'empire et la terreur; c'estoit sa douceur extraordinaire, sa bonté non-pareille, une espèce d'affabilité, qui luy estoit propre, & qui ravissoit tous les coeurs." Ibid.

76 This ideology corresponds to the original conception of the Grande Galerie as a series of "portraits" of various towns in France. See Chapter One above, n. 13.

77 The negotiation between clients is documented in another case. Chantelou had sought to obtain permission from Cassiano dal Pozzo to have copies made of the Sacraments before Poussin agreed to make a variation on the series. *Correspondance*, p. 245 [January 1644].

78 See Domna C. Stanton, "Classicism (Re)constructed: Notes on the Mythology of Literary History," in *Continuum: Problems in French Literature from the Late Renaissance to the Early Enlightenment, vol. 1: Rethinking Classicism*, ed. David Lee Rubin, New York, AMS Press, 1989, pp. 1–30.

Chapter Four: Antique Moses

1 Richard Beresford has documented the collecting practices of one of the officials in Sublet de Noyers's administration, Séraphim de Mauroy, providing a vivid description of the specific devotional requirements of a particular French Catholic who was also an aspiring member of the *noblesse de robe*. Beresford, "Séraphin de Mauroy: un commanditaire dévôt," in *Nicolas Poussin (1594–1665), Actes du colloque*, Musée du Louvre, 1994, ed. Alain Mérot, Paris, La documentation française, 1996, II, pp. 719–45. Beresford underlines the significance of Mauroy's membership in the Compagnie du Saint Sacrament in order to account for what he describes as the "taste of a dévôt." I thank Mr. Beresford for generously sharing his manuscript.

Some statistical evidence offers a picture of the importance of religious subjects for the Parisian bourgeoisie. In a study by Roland Mousnier of inventories of marriage records of *honorable hommes* and *marchands* in the years 1634–36, there appeared to be 72% religious against 28% profane "tableaux." The statistical segregation of the sacred and profane, however, can be misleading, as in the case of the secular connotations of Moses. Roland Mousnier in *La Stratification sociale à Paris aux XVIIe et XVIIIe siècles*, Paris, Pedone, 1975, p. 98. For a study of the engravings possessed by a similar social order see Georges Wildenstein, "Le Goût pour la peinture dans le cercle de la bourgeoisie parisienne, autour de 1700," *Gazette des Beaux-Arts* 48 (September 1956), pp. 113–94.

2 See Charles Dempsey, "Poussin and Egypt," *Art Bulletin* 45 (1963), pp. 154–68.

3 *Exposition of Moses* (Dresden and Oxford) and *Finding of Moses* (three versions).

4 Pierre Charron, *De la sagesse*, Paris, 1595, Book 1, ch. 48, cited by Anthony Blunt, "The Heroic and the Ideal Landscapes of Nicolas Poussin," *Journal of the Warburg and Courtauld Institutes* 7 (1944), p. 159.

5 The first version (now in Jerusalem) was given to Charles I, Duc de Créquy, Maréchal de France and ambassador to Rome in 1633–34. The second version (1638, Vienna, Kunsthistorisches Museum, Gemäldegalerie) was given to a diplomat, Prince Eggenberg, probably as a gift to the new Hapsburg Emperor Ferdinand III in 1638–39. Ludwig Pastor, *The History of the Popes: From the Close of the Middle Ages Drawn from the Secret Archives of the Vatican and Other Original Sources*, 40 vols., Liechtenstein, Kraus Reprint, 1968–69, XXVIII, pp. 355–58. Denis Mahon, "Gli

esordi di Nicolas Poussin pittore: Lavori dei suoi primi anni a Roma," in *Nicolas Poussin: I primi anni romani*, exh. cat., Rome, Electa, 1998, pp. 13–33.

6 The evidence was recognized by contemporaries. "Quoiqu'il n'ait pas entièrement suivi le texte de l'Ecriture Sainte, on ne peut pas dire qu'il se soit éloigné de la verité de l'histoire . . . il a voulu suivre celle de Josèphe." André Félibien, *Entretiens sur les vies* . . . , 4 vols., Trevoux, 1725, IV, p. 142.

7 The theme is represented in two canvases (Louvre and a British private collection). The first painting (*Woburn Abbey*) was executed for a French patron, Pointel; the repetition (*Louvre*) was commissioned by a Roman patron.

8 In *Moses Striking the Rock*, the water flows from a fissure in the rock that is described by Josephus, *Les Oeuvres de Flave Joséphe*, Paris, 1597, 2 tom. in 1 fol. [Bibliothèque Mazarine H2076–2077], p. 74. For the subject that is the basis for Poussin's painting *Crossing the Red Sea*, Josephus describes the Egyptian armor that is collected from the shore as so much driftwood, ibid., p. 69. Poussin took this opportunity to depict the pell-mell pile of antique implements found in his drawings of the trophies inscribed at the base of the Trajan's Column. See my dissertation, p. 134. In the *Judgment of Solomon*, Poussin deviated from the biblical account. The painting depicts the accusatory mother holding a dead child. However, this is consistent with Josephus who states that a mother, whose child had died, accused another mother of having stolen her baby and of having replaced it with the corpse. The distraught woman therefore holds the dead child. Another detail in studies for the painting that does not correspond to the biblical account can be explained by reference to Josephus. Two of the preparatory drawings depict a soldier grabbing the foot of the dead infant, prepared to sever the body in half. This, in fact, conforms to Josephus's account: rather than parceling out the living child, both children are to be divided and each half joined in order to form two whole children, albeit dead ones.

9 There were seven editions of the translated works of Josephus by 1646. The most popular translation until Arnauld d'Andilly (1668) was by Gilbert Génébrard, Archbishop of Aix in 1578. On the various tributes to Josephus in France, see Richard A. Sayce, *The French Biblical Epic in the Seventeenth Century*, Oxford, Clarendon Press, 1955, p. 28. In addition to Montaigne, other early use of Josephus includes Thierry Pitremand's *Judith* (1578).

10 In a series of extraordinary actions, driven by passion, *fierté*, even *ardeur et manie*, Montaigne cites at length Josephus's version of the speech of a Jewish martyr executed by the tyrant Antiochus. Montaigne, *Essais*, II, 2. According to Tacitus, Antiochus IV Epiphanes of Syria (176–164 BCE) tried to "get rid of their primitive cult and hellenize" the Jews. Tacitus, *The Histories*, trans. Kenneth Wellesley, London, Penguin, 1991, p. 276.

11 See the sonnet preceeding the 1558 edition of *Antiquités judaiques*.

12 See e.g. Tacitus, *The Annals of Imperial Rome*, trans. Michael Grant, London, Penguin, 1989, XV, p. 44.

13 In particular, Josephus defended himself in his *Response by Joseph to that which Appion had written against his History of the Jews concerning the antiquity of their race*.

14 Following Machiavelli, Tommaso Campanella had included Moses among the gallery of illustrative men in his utopian fantasy, *La città del sole: dialogo poetico. The City of the Sun: a poetical dialogue*, trans. David J. Donno, Berkeley, University of California Press, 1981, p. 81.

15 See Catherine E. Holmès, *L'Eloquence judiciare de 1620 à 1660: reflet des problèmes sociaux, religieux et politiques de l'époque*, Paris, A. G. Nizet, 1967.

16 See Julian H. Franklin, *Jean Bodin and the Sixteenth-Century Revolution in the Methodology of Law and History*, New York, Columbia University Press, 1963, p. 91. For Bodin and Tacitus, see Chapter One above.

17 "Joseph fait voir combien cet admirable Legislateur a surpassé tous les autres, & que nulles loix n'ont jamais esté si saintes ny si religieusement observées que celles qu'il a établies." Robert Arnauld d'Andilly, trans., *Histoire des Juifs par Flavius Josephus et Histoire de la guerre des Juifs contre les Romains*, 5 vols., Paris, 1668, II, vi.

18 See George Huppert, *Les bourgeois gentilshommes: An Essay on the Definition of Elites in Renaissance France*, University of Chicago Press, 1977, p. 90.

19 See Sayce, 1955, p. 28.

20 Josephus, 1597, p. 440.

21 "Je dis donc que ceux qui par leur amour pour le bien public ont étably des lois pour le règlement des moeurs sont beaucoup plus estimables que ceux qui vivent sans ordre & sans discipline. Le devoir d'un Legislateur consiste à n'ordonner rien qui ne soit si juste que l'usage en soit utile à ceux qui le pratiquent: Et le devoir des peuples consiste à ne s'en départir jamais ny dans leur bonne ny dans leur mauvaise fortune . . . Nostre Legislateur précede en antiquité Lucurgne, Solon, Zaleueus de Locres." Ibid.

22 Fragment of a letter to Stella, *Correspondance*, p. 5.

23 This statement was made by Antoine I Loisel, the famous lawyer and jurist of the sixteenth century (related to an owner of a painting by Poussin). "De l'Amnestie" in *La Guyenne de M. Ant. Loisel: qui sont huict remonstrances faictes en la chambre de justice de Guyenne sur le suject des édicts de pacification*, Paris, chez Abel l'Angelier, 1605, p. 74.

24 According to Josephus, the father of Moses secretly raised the child for three months then released him to the river. Josephus, 1597, II, p. 58.

25 For references to the parallel between Richelieu and Moses, see William Farr Church, *Richelieu and Reason of State*, Princeton University Press, 1972, pp. 156, 220, et passim. Richelieu commissioned the *Moses and the Burning Bush* for the Grand Cabinet of the Palais Cardinal (Anthony Blunt, *Nicolas Poussin: A Critical Catalogue*, London, Phaidon, 1966, cat. no. 18). The painting for Richelieu had priority over the *Eucharist* and the painting of *St. François Xavier*. Later, it shared the same space with Poussin's *Time saving Truth from the Attacks of Envy and Discord* (Blunt, 1996, cat. no. 122). Both canvases were finished in November 1641.

26 "Ou Moyse estant un personnage de tresbonne grace à le voir, & ayant la parole propre à persuader une multitude, commença à appaiser leur courroux, en les exhortant de ne se souvenir tellement des difficultés présentes, qu'ils en oubli assent les biens-faits passez: & que la peine qu'ils enduroient alors, ne leur

chassast de la pensée, les graces & grandsbiens qu'ils avoient receus de Dieu . . . Le secours n'est pas pourtant tardif, s'il ne vient tout soudain, & avant qu'on ait passé par quelque difficulté. Ainsi, les addoucit-il, & retint la furie qu'ils avoient de le lapider." Josephus, 1597, p. 72.

27 "Qu'il pardonnast ce que la necessité avoit fait faire à ce peuple, attender que le naturel de tous hommes est d'estre chagrins & prompts à se plaindre lorsqu'il leur advient quelque malavanture." Ibid.

28 In contrast, Pietro da Cortona's pupil Romanelli, who was patronized by Mazarin, depicted a moment of unambivalent thanksgiving in the painting in the Louvre.

29 For a discussion of Charles le Brun's *conférence* of November 5, 1667, see Elizabeth Cropper and Charles Dempsey, *Nicolas Poussin: Friendship and the Love of Painting*, Princeton University Press, 1996, p. 33.

30 Tacitus, *Histories*, p. 272.

31 *Correspondance*, pp. 4–5.

32 Félibien, 1725, IV, viii, p. 24.

33 Ibid., II, pp. 327, 356. Paris, BN MSS 5481 (936), 22270, 26276, n.a. 9679.tl. Gilliers's position in Parisian society can be gauged by his inclusion, along with his wife Marie, in Nanteuil's series of engraved portraits of notables. Charles Petitjean and C. Wickert, *Catalogue de l'oeuvre gravé de Robert Nanteuil*, 2 vols., Paris, L. Delteil et M. Le Garrec, 1925, I, p. 199. Nanteuil's portrait of Gilliers (c. 1651–52) was unique in that it was drawn and engraved by the artist himself, rather than an assistant. He also dedicated the engraving to Gilliers: "par son très humble serviteur Nanteuil qui la desseigné et gravé sur le naturel." It can be presumed that Gilliers had offered Nanteuil some protection or patronage that had incurred this expression of an obligation. This notion of indebtedness is linked to the epistolary form of address as well as the literary dedication. On dedications to friends in the literature of the sixteenth century, see E. F. Rice, "The Patrons of French Humanism, 1450–1520," in *Renaissance Studies in Honor of Hans Baron*, ed. Anthony Molho and John A. Tedeschi, Dekalb, Northern Illinois University Press, 1971, pp. 687–702.

In addition to owning several properties, Gilliers lived in a house on the fashionable Ile-St. Louis, designed and constructed by Le Vau. M. Dumolin, *Etudes de topographie parisienne*, Paris, 1929–31, III, pp. 152–53, 155; Constance Tooth, "The Paris houses of Louis Le Vau," unpublished diss., University of London, 1961, pp. 62–66, and Tooth, "The Early Private Houses of Louis Le Vau," *Burlington Magazine* 109 (1967), p. 510. Gilliers was not, however, a prominent merchant or an extremely rich financier. In addition to possessing a *seigneurie*, which gave him the title of *écuyer*, his claim to noble status was soundly based on his official capacities and his marriage to the daughter of a prominent member of the *robe* nobility, Marie Jolly. For her death see François-Nicolas Baudot Dubuisson-Aubenay, *Journal des guerres civiles de Dubuisson-Aubenay, 1648–1652*, ed. G. Saige, 2 vols., Paris, Champion, 1883–85, I, p. 344 [December 1650]. Melchior published a "lettre d'invitation à ses obsèques qui eurent lieu le 3 décembre 1650 à l'église St Louis en l'Isle." Paris, BN MS, pièces originales, 1326, fol. 110. Her posthumous portrait by Daret has the following verse inscription: "La vertu qui sous ce Visage voulut parestre dans ces lieux/ a repris la route des Cieux il ne reste plus que l'image." Petitjean and Wickert, 1925, p. 199.

34 By 1632 (at the age of 43), Gilliers was a *Conseiller du roi en ses conseils d'Etat et privé*. In that year, he published his family tree, in which he traced his lineage to the town of Romans (south of Lyon near Valence). True to the *officier* class, Gilliers aggrandized his forebears by identifying them with each successive reigning monarch. BN MS, pièces originales, 1326, fol. 140. He later held the royal office of *maître d'hôtel ordinaire* (the same position enjoyed by Chantelou).

35 As early as 1632 Gilliers was also *intendant et procureur général* of Charles I, Sire de Créquy, Maréchal de France. Paris, AN, MC étude II, 140 [Transport, June 7] and étude XII, 73 (December 12, 1641) Bail – m[aître] d'hotel du Roi. For Créquy's inventory and Gillier's role in the acquisition of paintings see Jean-Claude Boyer and Isabelle Volf, "Rome à Paris: les tableaux du maréchal de Créquy (1638)," *Revue de l'art* 79 (1988), pp. 22–41. Honor Levi, "L'Inventaire après décès du cardinal Richelieu," *Archives de l'art français* 27 (1983), p. 62. For the Créquy clan see my dissertation, p. 151 n. 109.

36 See Boyer and Volf, 1988, p. 24. Several years before Gillier's death, Poussin's *Moses Striking the Rock* passed into the hands of a "M. de l'Isle Sourdière," of whom little is known. Poussin's letters refer to a "Mr. de Lisle" and "Monsieur de Lysle la Sourdière," a friend of Chantelou who also desired paintings by Poussin. As a favor to Chantelou, Poussin may have executed a painting to complement the *Moses Striking the Rock*. *Correspondance*, pp. 318, 371, 376, 385, 386. For the numerous inconclusive references to his identity in the literature and archives see my dissertation, pp. 128, 152–53 n. 117–20. If we assume the last year of possession by "Lisle Jourdain" or "M. de la Soudière" as 1650, then the next person listed by Félibien may have possessed it from then until 1657, the year of his death.

37 See Chapter One above. Pomponne II de Bellièvre's great-greatgrandfather was Barthélemy II, *secrétaire du Cardinal de Bourbon et intendant de sa maison*. Barthélemy was married to Françoise Fournier and his greatgrandfather was Claude I, *dit le jeune* (March 1487–1557). His wife was Louise Faye. Pomponne II's grandfather Pomponne (1529–1607) was Intendant de Finances de Lyon (June 1594). He was largely responsible for the administration of the city of Lyon under Henry IV after the League. Paris, BN MS FR 15912 fols. 265–70, "Discours de M. de Bellievre sur la reduction de la ville de Lyon en l'obéissant du roi." He became Chancelier in 1599 and negotiated the marriage of the king with Marie de' Medici. He participated in the 1600 *entrée* of Marie and retired in 1605. He inherited antique gold medals from Nicolas de Langes, his cousin. See Arthur Kleinclausz, *Histoire de Lyon*, 3 vols., Lyon, 1948–52, II, p. 5. Raymond F. Kierstead, *Pomponne de Bellièvre: A Study of the King's Men in the Age of Henry IV*, Evanston, Ill., Northwestern University Press, 1968. Paris, BN MS fr. 16519 fol. 37: mélanges of translations after Latin poetry. Pomponne II's grandmother was Marie Prunier (d. 1610) whose funeral was a grand affair in Paris (l'Estoile, X, p. 171).

38 In addition to being related to the prominent Bullion clan, Pomponne II's maternal grandfather, Nicolas Brulart de Sillery, was Chancellor of France.

39 Appointed *conseiller* in the Parlement in 1629, he later joined the royal household in 1631 as a *maître des requêtes ordinaire de l'hôtel du roi*. In 1635, he was *conseiller d'état ordinaire* in Rome. He was ambassador to England in 1637–40. Bellièvre returned to France and assumed a post in Louis XIII's *conseil privé* in 1640.

40 In November 1642, Bellièvre's father named him his successor to the office of President of the Parlement of Paris. During his tenure as a president, his diplomatic duties did not cease. He returned to England as ambassador and later became ambassador to Holland (1650–51). After his initial office of *président mortier*, he then held the highest position of *premier président*. He was active in Parlement throughout his tenure of office until his death in 1657. Upon his death, a *harangue* was given in his honor in Parlement on December 13, 1651. Dubuisson-Aubenay, 1883–85, I, p. 140, and AN XIb. 1721.

41 Colonia, *Histoire littéraire de la ville de Lyon*, 2 vols., Lyon, 1728–30, I, p. 777.

42 For a discussion of Bellièvre's testament see my description of the relationship between Bellièvre and Châteauneuf in Chapter Five below. Because Félibien offers only a surname, a monsieur "Dreux," it follows that the "Dreux" under consideration would have been the most prominent member of the clan, Guillaume de Dreux who was the *avocat général* in the *Chambre des comptes* mentioned in several contemporary memoirs, e.g. Omer Talon, *Mémoires*, ed. Louis-Gabriel Michaud et J.-F. Michaud, 1839, p. 315. The Dreux family had been in the *Chambre des comptes* for over four generations. Jean Dreux, *procureur général* (1585) and Simon Dreux, *avocat général* (1607). Guillaume and his father, Gilles, were both *avocats généraux* as well as *conseillers de Ville*. Passart would have known them in both institutions. Gilles, before dying on July 20, 1649, had resigned and given his office to his son. Paris, *Registres de l'Hôtel de Ville de Paris*, III, p. 461.

Fromont de Veine was at the *Chambre des comptes* on April 27, 1650 and is therefore linked to both Passart and Dreux. M. Molé, *Mémoires*, ed. A. Champollion-Figeac, 4 vols., Paris, 1855–57, IV, p. 80 [April 27, 1650], pp. 312–13n. For Froment's active involvement in the civic administration as a *conseiller de ville*, see *Registre de l'Hôtel de Ville de Paris*, I, pp. 2, 42, 66; II, p. 253; III, pp. 448, 461. In the Minutier Centrale, I know of one record for Guillaume de Dreux, where he is a witness to a marriage, as a friend of the bride: Henry Le Blanc and Marie, widow of Jacques Brou (AN MC étude LIII/9). For Dreux's participation in municipal politics see *Registres de l'Hôtel de Ville de Paris*, I, p. 311. Dreux was also exiled by the regent during the early phase of the Fronde on May 30, 1648 with Michel Passart's relative Jacques Passart (Dubuisson-Aubenay, 1883–85, I, p. 23). The link between Passart and Dreux is also substantiated by the fact that they are both listed among the devotees of Poussin who attended the fictional *Banquet des Curieux* that debated the relative merits of the painter. Dreux is named Lisimante. See Chapter Three, n. 1 above. After Dreux, the painting belonged in the collection of Jean Baptiste Colbert, Marquis de Seignelay, son of the minister Colbert.

43 The Bellièvre's house *nostra aedes lugduni* and its *jardin des antiques* remained in the family until 1658. Mathieu Varille, *Les Antiquaires Lyonnais de la Renaissance*, Lyon, Audin, 1924, p. 25.

Chapter Five: The Fronde

1 See Thomas Puttfarken, "Poussin's Thoughts on Painting," in *Commemorating Poussin: Reception and Interpretation of the Artist*, ed. Katie Scott and Genevieve Warwick, Cambridge University Press, 1999, pp. 58–59.

2 Elizabeth Cropper and Charles Dempsey, *Nicolas Poussin: Friendship and the Love of Painting*, Princeton University Press, 1996, p. 182. See also Oskar Bätschmann, *Nicolas Poussin: Dialectics of Painting*, trans. Marko Daniel, London, Reaktion, 1990, p. 51. Sheila McTighe, *Nicolas Poussin's Landscape Allegories*, Cambridge and New York, Cambridge University Press, 1996.

3 *Correspondance*, pp. 402 [June 20, 1649], 405 [September 19, 1649], 407 [October 8, 1649].

4 In Rome, the artist had visits from at least two French clients, Sérizier and Pointel. Jacques Thuillier and Claude Mignot, "Collectionneur et peintre au XVIIe: Pointel et Poussin," *Revue de l'art* 39 (1978), pp. 39–58.

5 Cropper and Dempsey, 1996, p. 131.

6 See Marc Fumaroli, "The Republic of Letters," *Diogenes* 143 (fall 1988), pp. 129–52.

7 See e.g. Guy Patin, *Lettres de Gui Patin, 1630–1672*, Paris, H. Champion, 1907.

8 Sheila McTighe has drawn attention to Poussin's familiarity with contemporaneous politics in his letters. McTighe, 1996, p. 51.

9 The first published collection of Poussin's letters contains a useful appendix that correlates epistolary and historical events, giving due emphasis to the Fronde. *Collection de lettres de Nicolas Poussin*, ed. Antoine-Chrysostome Quatremère de Quincy, Paris, Didot, 1824.

10 Poussin's discussion of the troubles in France included reflections on the provinces. In two letters, as part of an exchange of international news, he discussed the potential threat of papal and Spanish forces in France. *Correspondance*, pp. 402 [June 20, 1649] and 404 [August 22, 1649]. In the latter letter, Poussin informs his correspondent that he had also heard that "tout va en Ruine" and "les affaires de bordeaux ne sont pas accommodées." Indeed, the Treaty of Rueil did not prevent revolts in the provinces.

11 See Alanson Lloyd Moote, *The Revolt of the Judges: The Parlement of Paris and the Fronde, 1643–1652*, Princeton University Press, 1972. Orest Ranum's *The Fronde: A French Revolution, 1648–1652*, New York and London, Norton, 1993, is an excellent introductory essay. Hubert Carrier is the foremost scholar on the political pamphlets of the Fronde.

12 E.g. Nicolas Arnoul, a *commissaire général* at Toulon, refused to serve Mazarin and entered the service of Sublet. Arnoul was forced into retirement when Sublet was disgraced. Sharon Kettering, *Patrons, Brokers, and Clients in Seventeenth-Century France*, Oxford and New York, Oxford University Press, 1986, p. 200.

13 See Henri Chardon, *Amateurs d'art et collectionneurs manceaux du XVIIe siècle: Les frères de Chantelou*, Le Mans, Monnoyer, 1867, pp. 55, 65.

14 "Celuycy est seulement pour Vous donner avis que le Roy ayant accordé à M de Noyers la permission de se retirer qu'il luy avoit instamment demandé" [Mazarin to Le Tellier, April 11,

1643, Bibliothèque Mazarine MS. no. 1719, t.I, fol. 34 recto]. Jules Mazarin, *Lettres du cardinal Mazarin pendant son ministère*, ed. A. Chéruel, 9 vols., Paris, Imprimerie Nationale, 1872–1906. See Chardon, 1867, p. 55.

15 See e.g. Goulas who depicted Sublet as a *bon jesuit* and *confessor du Roy*. Nicolas Goulas, *Mémoires*, ed. Charles Constant, 3 vols., Paris, Renouard, 1879–82, I, p. 430. Guy Patin reported that the disgrace of Sublet was an order from the king by the mouth of Mazarin. Patin, 1907, p. 283.

16 *Mémoires de Mademoiselle de Montpensier*, ed. A. Chéruel, 4 vols., Paris, R. Charpentier, 1858–68, I, pp. 59–60. P. René Rapin, *Mémoires de P. René Rapin (1644–69)*, Paris, 1865, pp. 41–42.

17 Poussin stated his intent to return to France in order to forestall those who coveted his house in the Tuileries. However, because his "cher Maistre" was absent from the court, there was little reason to return at that moment. *Correspondance*, p. 219 [October 5, 1643].

18 In one letter Poussin refers to "les misères et disgraces"; in another he prays for Sublet's return to court with the commencement of the regency (ibid, p. 200). However, Poussin experiences more fear than joy at the prospect of his own return to court. Hence, his identification with a position of retreat, which he relates to *repos* and tranquility (ibid, p. 201). There are rumors of the "retour de Monseigneur" (ibid, pp. 211 and 214). Poussin continued his cartoons for the Grande Galerie (September 23, 1643).

19 Ibid, p. 248 [February 25, 1644]. The *intendant* Jacquelin had been in the administration of the royal buildings since the 1630s. He was certainly an adversary of Sublet who attempted to diminish the powers of the *surintendant des bâtiments*. Archives des Affaires Etrangères, France, 831 fol. 229 [September 12, 1638], cited by Orest Ranum, *Les Créatures de Richelieu: Secrétaires d'état et surintendants des finances, 1635–1642*, trans. S. Guenée, Paris, Pedone, 1966, pp. 146–47 n. 3.

20 *Correspondance*, p. 238 [January 7, 1644].

21 Ibid, p. 254 [March 8, 1644]. In the same letter Poussin writes: "bientost Dieu aydans les afferes de Monseigneur," linking Sublet's efforts to those of Chantelou.

22 A *brevet* for Samson Lepage dated November 8, 1644 has been known for some time as it was extracted by Jal (*Dict.* 997) and published in the *Correspondance*, p. 298 n. 1. Jouanny cites AN E 9299 (sic?). Jacques Thuillier, *Actes du colloque Nicolas Poussin* (1958), ed. André Chastel, Paris, CNRS, 1960, II (hereafter *Actes*, 1960), pp. 71–72, reprints Jal's citation and mentions that E. Magne found *brevets* concerning this affair in AN O1 1047 fol. 3.

23 *Correspondance*, pp. 298–99 [November 25, 1644].

24 For the text of the unpublished *brevet* (AN O1 1049, pp. 105–6) in its entirety, see my dissertation, p. 245, n. 243. According to records in the Minutier Centrale (AN), Samson occupied the property by December 13, 1648 (but no earlier than February 17, 1645).

25 *Correspondance*, p. 299 [November 26, 1644].

26 Ibid, p. 308 [June 18, 1645].

27 For the connotations of the word *patrie* see the introduction by Orest Ranum in *National Consciousness, History, and Political Culture in Early Modern Europe*, ed. Orest Ranum, Baltimore, Johns Hopkins University Press, 1975.

28 *Correspondance*, p. 227 [November 5, 1643].

29 Ibid, p. 249 [February 22, 1644].

30 Jacques Thuillier, Barbara Brejon de Lavergnée, Denis Lavalle, *Vouet*, exh. cat., Paris, Réunion des musées nationaux, 1990, p. 132.

31 Moote, 1972, is largely responsible for the modern emphasis on the legitimate institutional aspects of the Fronde. For readers of English, his effort to lend the Fronde a high-mindedness that it had previously been largely denied has resulted in a tendency to underplay the role of the princes and aristocracy. One of the consequences of this compensation for the discourses of comedy and femininity that pervaded earlier scholarship is to ignore the roles of the nobility and women in particular.

32 The newly formed Chambre de St. Louis met from June 30 to July 29, 1648. Roger Mettam, *Power and Faction in Louis XIV's France*, Oxford, Basil Blackwell, 1988, pp. 141–42.

33 Ibid., pp. 142.

34 Mazarin made a sacrificial offering of the *surintendant des finances* Particelli d'Emery (July 9), and eliminated the *intendants* three days later. Moote, 1972, p. 156.

35 *Correspondance*, p. 386 [August 2, 1648].

36 The opposition of *vertu* to the *malignité du siècle* is identical with the phrasing of a dedication by François Derand to the *parlementaire* Malo. Derand's treatise on architecture, published in the same year, may have been known to Poussin, or there may have been a common reference. For Derand and his relation to the Fronde see below. The contrast of the *homme de bien* and a corrupt century is a leitmotif of the literature of the royal officials with whom Poussin identified. See Noémi Hepp, "Peut-on être homme de bien à la cour?" in *La Cour au miroir des mémorialistes, 1530–1682*, ed. Noémi Hepp, Paris, Klincksieck, 1991.

37 See n. 32 above and Quatremère de Quincy, 1824, p. 375; *Correspondance*, p. 386 n. 1.

38 I disagree with McTighe's emphasis on Poussin's alienation from both the hereditary nobility and the "lowest spectrum of the populace." McTighe, 1996, pp. 29–30.

39 *Correspondance*, pp. 394–95 [January 17, 1649]. The letter was written twelve days after the second flight of the court.

40 Ibid, p. 396 [February 7, 1649].

41 Charles Dempsey, "Poussin's Ecstasy of Saint Paul: Charles Le Brun's 'over-interpretation'," in *Commemorating Poussin: Reception and Interpretation of the Artist*, ed. Katie Scott and Genevieve Warwick, Cambridge University Press, 1999, p. 121.

42 *Correspondance*, p. 397 [May 2, 1649]. Poussin had heard stories of the siege from Pointel.

43 Ibid, pp. 397–98 [May 2, 1649].

44 Ibid, pp. 398–99 [May 24, 1649].

45 Jouanny, the editor of the letters, was surprised by this statement because he incorrectly interpreted Poussin's antagonism to the treaty as a demonstration of his unexpected support for Mazarin and a call for further military punishment of the *frondeurs*; *Ibid*, p. 398 n. 1. The Treaty was signed on March 12, 1649.

46 Sheila McTighe concurs with this reading but places rhetorical emphasis on Poussin's aversion to the "random violence of the populace." McTighe, 1996, p. 30.

47 These are among the professions listed by the author of *Les contents et mécontents sur le sujet du temps*, Paris, 1649. Moreau 782 [BM10761]. The riot occurred on March 13, 1649. For bibliographic references to *Mazarinades*, see Chapter Six, nn. 2 and 3 below.

48 *Correspondance*, p. 399 [May 24, 1649]. Quatremère de Quincy, 1824, p. 376.

49 According to Quatremère de Quincy, "Généralement ses lettres donnent lieu de penser que, si son correspondant et lui n'étoient pas tout-à-fait opposés à la Cour, ils avoient du moins, comme presque toute la France, une telle aversion pour le Ministre, qu'ils étoient portés à s'intéresser à ses ennemies." Quatremère goes on to include the Cyclops image as a reference to Mazarin. Quatremère de Quincy, 1824, p. 376.

50 *Correspondance*, p. 405 [September 19, 1649].

51 In a seminal article, Anthony Blunt cited Poussin's comments regarding the "stupidity and inconstancy of the people" out of context and with tenuous grammatical justification for emphasis on the definite article in "le peuple" (see, e.g. fig. 43). This translation lent support to his view that Poussin's paintings expressed the anti-popular sentiments of the "bourgeoisie"; Blunt, "The Heroic and the Ideal Landscapes of Nicolas Poussin," *Journal of the Warburg and Courtauld Institutes* 7 (1944), p. 160. My quotation marks round "bourgeoisie" are intended to underline Blunt's use of the term as an ahistorical group with a coherent ideology. The editor Jouanny's reading is closer to the public response to contemporary events in 1649: "Poussin fait sans doute allusion à l'accueil enthousiaste que les Parisiens firent, non seulement au roi, mais encore à Mazarin." *Correspondance*, p. 406 n.

52 A treaty negotiated under a weakened monarchy during a regency government would have obtained more concessions. When the king reached his majority, the possibility of scrapping the queen regent and her favorite would have been impossible. Poussin's cryptic reference in a letter to good news and the fulfillment of Chantelou's predictions probably refers to Mazarin's imminent fall. *Correspondance*, p. 410 [October 18, 1649]. Quatremère de Quincy, 1824, p. 377.

53 Older brother of the author Charles and the architect Claude. See Chapter Two, n. 16.

54 Poussin's responses to the receipt of news in spring and summer 1650 are vague and inconclusive. *Correspondance*, pp. 414 [May 8, 1650] and 417 [July 3, 1650].

55 Ibid, p. 422 [April 24, 1651]. Poussin was responding to a letter written by Chantelou in Le Mans during the first months of 1651. Jouanny notes: "Allusion à l'exil de Mazarin." Mazarin fled the city on February 6–7. Ibid, p. 422 n. 1.

56 Ibid, p. 426 [November 10, 1652]. Chantelou annotates the letter: "il croioit que la guerre civile eust amorti ma curiosité."

57 Quatremère de Quincy, 1824, pp. 377–78. On the threat posed by the interception of letters, see *Le Caquet ou Entretien de l'accouchée, contenant les pernicieuses entreprises de Mazarin découvertes*, Paris, 1651, Moreau 630 [BM12608], p. 5.

58 *Correspondance*, p. 404 [August 22, 1649]. He had not yet heard about the cessation of conflict with the return of the court to Paris.

59 Ibid, p. 408 [October 8, 1649].

60 See Kettering, 1986.

61 The damaged canvas is in the collection of the Wadsworth Atheneum, Hartford, Conn.

62 Regarding the letters of 1644–46 with references to de Thou, see my dissertation, pp. 233–34 n. 103. According to Bonnafée, de Thou augmented the collection of books, medals, and portraits inherited from his father. See Duc de Saint-Simon, *Mémoires complets*, ed. A. Chéruel, 13 vols., Paris, Hachette, 1856–82, VI, p. 136. His learned interests also included astronomy. He had an observatory to which he invited others to observe an eclipse. François-Nicolas Baudot Dubuisson-Aubenay, *Journal des guerres civiles de Dubuisson-Aubenay, 1648–1652*, ed. G. Saige, 2 vols., Paris, Champion, 1883–85, II, p. 199.

63 The rioting and burning of the Hôtel de Ville on July 4, 1652 created a state of emergency that forced the popular *parlementaire* Broussel into the position of head of the municipal government. De Thou assisted Gaston d'Orléans with the ceremony to confirm the election of Broussel to *Echevin* (July 6, 1652). Because the authority of confirmation was traditionally held by the king, Gaston's daughter, Mlle. de Montpensier, described the ceremony as a piece of theater because her father acted as king and de Thou played the role of his secretary of state. Montpensier, 1891, II, 127–28. Paris, *Registres de l'Hôtel de Ville de Paris*, III, p. 81. De Thou was later granted an amnesty. He became an ambassador to Holland in 1657.

64 As one of the *présidents de mortier* in the Parlement of Paris, Bellièvre delivered several remonstrances during the Fronde, e.g. on December 13, 1651. Dubuisson-Aubenay, 1883–85, II, p. 140; AN X1b. 1721.

65 BN MS FR 16519, fol. 87.

66 Ibid.

67 Ibid., fol. 78.

68 June, 1650. Dubuisson-Aubenay, 1883–85, I, p. 270. For the "intrigue" with Chevreuse, see Jean Loret, *Muze historique . . .*, 4 vols., Paris, P. Jannet, 1857–78, I, p. 49. Bellièvre is recorded at Berny on another occasion during the Fronde, December 29, 1651. Dubuisson-Aubenay, 1883–85, II, p. 145.

69 Although the provenance of *Coriolanus*, as well as a painting entitled *Solitude* (Belgrade) is not conclusive, if Châteauneuf did not own these paintings, they would have been in the possession of a branch of his family through marriage, the Loisels. The *Solitude* and *Coriolanus* were in the household of Charles de l'Aubespine, who was a descendent of Châteauneuf and Elisabeth Loisel, whose father was Antoine III. See Anthony Blunt, *Nicolas Poussin: A Critical Catalogue*, London, Phaidon, 1966, p. 69.

70 He held many titles and benefices, e.g. C*hevalier*, Marquis de Châteauneuf-sur-Cher, *commandeur chevalier des ordres du roi*, *conseiller d'Etat*, Abbé de Marsan, de Préaux & de Noirlac, and Governor of Tourraine. He began a long political career as a *conseiller* in Parlement under Henry IV (1603). During the same reign, he became *ambassadeur extraordinaire* in Holland (1609). During the unstable period of the regency of Marie de' Medici, he became an important negotiator for the return of the princes in 1617.

71 Châteauneuf was loyal to the crown during the regency of Marie de' Medici and was rewarded for his services with

several important posts culminating in heading the royal council, receiving the Seals directly from the king in 1630. On the educational reforms proposed by Anthoine Mathé de Laval's *Desseins de professions nobles et publiques* (1605) see James J. Supple, "The Failure of Humanist Education: David de Fleurance-Rivault, Anthoine Mathé de Laval, and Nicolas Faret," in *Humanism in Crisis: The Decline of the French Renaissance*, ed. Philippe Desan, Ann Arbor, University of Michigan Press, 1991, p. 35–53. On the *gentilshommes* in the *collège* see Rogier Chartier et al, *L'Education en France du XVIe au XVIIIe siècle*, Paris, Société d'edition d'enseignement supérieur, 1976, pp. 179–81.

72 Châteauneuf became the *chancelier des Ordres du roi* in 1620. Again he served as a diplomat, this time in England and Venice (1629–30). After receiving the Seals in 1630, he survived the Day of the Dupes in that year but was later suspected by Richelieu of having too much power. He gave up the Seals on February 25, 1633.

73 Châteauneuf sought the restoration of his position as keeper of seals. This cabal included the Duc de Beaufort as well as the Bishop of Beauvais, who sought the cardinal's hat. Victor Cousin, *Madame de Chevreuse: Nouvelles études sur les femmes illustres et la société du XVIIe siècle*, 2 ed., Paris, Didier, 1876, pp. 485, 493. *Journal des Savants*, 1854, pp. 537, 612; 1855, p. 33; 1856, p. 111. For Mazarin's spy report on the intrigues of Sublet's circle in October 1643, see Cousin, *Madame d'Hautefort: Nouvelles études . . .* , 5 ed., Paris, Didier, 1886, pp. 136f and 468–70.

74 Châteauneuf's exile was due to his association with Gaston d'Orléans in the early phases of the Fronde. His return was negotiated in October, 1648 by a group of *parlementaires*. Pierre Goubert, *Mazarin*, Paris, Fayard, 1990, p. 259. He first became the *garde des sceaux* for one provisional royal council in 1650, taking the seals from Le Brun's patron Séguier when he was disgraced. Châteauneuf held this position from March 1, 1650 until April 3, 1651. He gave up the seals to Président Molé on April 4, 1651 in one of his temporary disgraces. Mlle. de Montpensier, *Mémoires*, Paris, Librairie Fontaine, 1985, 1, p. 157. When the Regent's council was reconstituted he became First Minister. He was head of the royal council from September 8, 1651 to January 28, 1652. According to Roger Mettam, this position was a concession to the Gondi party. Mettam, 1988, p. 151. Mettam characterizes Châteauneuf as no friend to Condé, Mazarin, and the Parlement. Châteauneuf's positions and alliances were generally in line with Broussel, the great *parlementaire* hero, as well as his friend Bellièvre. Châteauneuf's commitment to the Parlementary Fronde was expressed by Matthieu de Morgues. Châteauneuf commissioned at least two pamphlets from Morgues: one tract was written against the apologists for the princes, in May 1650: *Bons Avis sur plusieurs mauvais avis*, Moreau 594 [BMI0688]. Hubert Carrier, *La Presse de la Fronde, 1648–1653, I: Les Mazarinades, II: Les Hommes du livre*, Geneva, Droz, 1989–92, II, pp. 10, 47–48, 184, and 355. In July 1651, Morgues published *Discours désintéressé sur ce qui s'est passé de plus considérable depuis la liberté de messieurs les Princes*, Moreau 1118 [BMI2820], cf. Carrier, I, p. 176 n. 537; 1992, II, p. 10. Châteauneuf also probably permitted Morgues (also in line with Broussel) to edit the parlementary remonstrance concerning the return of Mazarin (March 1652): *La très-humble et véritable*

Remonstrance de nos seigneurs du Parlement pour l'esloignement du Cardinal Mazarin, Moreau 3808 [BMI2347], cf. Carrier, 1992, II, p. 338 n. 212. For Morgues, see Richard Bailey, "Les Pamphlets de Mathieu de Morgues (1582–1670), Bibliographie des ouvrages disponibles dans les bibliothèques parisiennes et certaines bibliothèques des Etats-Unis," *Revue française d'histoire du livre* 18 (1978), pp. 3–48; see also Jeffrey K. Sawyer, *Printed Poison: Pamphlet Propaganda, Faction Politics, and the Public Sphere in Early Seventeenth-Century France*, Berkeley, University of California Press, 1990.

75 Bellièvre, in turn, gave full executory powers to Châteauneuf's *intendant des maisons* René Mignon. AN MC Et XVI 404 (October 3, 1653).

76 Antoine III Loisel's (1611–January 4, 1652) family was from Beauvais. His grandfather Antoine I (1536–1617) received a fief in 1597. His father Antoine II (d. 1610) had a brother Guy who was a *conseiller au parlement* as well as a canon of Paris. His aunt's son was the memorialist of the Fronde Claude Joly, also a canon. Claude became Antoine III's tutor after his father's premature death.

77 The cardinal had put property into the hands of the banker Cantarini in order to evade confiscation. BN MS Fr 6881 Le Tellier, Papiers d'Etat, fol. 24 "Mémoire de la vaiselle d'argent pierreries & perles du Cardinal Mazarin par luy mises en maines du sieur Cantarini banquier." On the confiscations and sales see fols. 26 and 29.

78 BN MS Fr 6888 fol. 67f. The trial took place on March 16, 1651.

79 Jean Perrault (older brother of Charles) was the owner of a copy of the set of Poussin's second version of the Seven Sacraments. Germain Brice, *Description de la ville de Paris et de tout ce qu'elle contient de plus remarquable*, 9th ed., Paris, 1752, repr. Geneva, Droz, 1971, II, p. 301; *Actes*, 1960, p. 189. This is likely to have been arranged through Chantelou, who was also at one time a secretary attached to the house of Condé. See Chardon, 1867, and *Correspondance*, pp. 310–11 [July 3, 1645].

80 On Dreux, see Chapter Four, n. 42 above.

81 Jean Mercier probably originated from a Lyonnais family who made a living from silk. Lyon, Archives Municipales, état civile, Mercier. The *trésoriers* were office-holders who represented the traditional link between the crown and local authorities for the collection of taxes. They were under the jurisdiction of the *Chambre des comptes* and their nomination to office was subject to the chamber's approval. The office of *trésorier* was sometimes purchased by a local family in order to keep Parisian interests outside the affairs of a provincial city. Julian Dent, *Crisis in Finance: Crown, Financiers and Society in Seventeenth Century France*, Newton Abbot (Devon), David & Charles, 1973, pp. 141–42. This may account for the fact that Mercier purchased the office in 1635 but did not actually execute the duties of that office until some twenty years later (around the same time that he acquired Poussin's painting). Mercier probably sided with the reforming efforts of the Parlement of Paris. Several *trésoriers* were arrested by the regency because of their association with the reform efforts of the sovereign courts and their resistance to the tax farmers. On June 5, 1648, seven *trésoriers-généraux de France* were imprisoned in the Bastille for writing a circular letter to all the *Bureaux de France* inviting their colleagues to join

the sovereign courts. Dubuisson-Aubenay, 1883–85, II, p. 25; I, p. 36.

82 On the participation of Dreux, Passart, and Fromont de Veine see Chapter Four, n. 42 above.

83 For the harangues made by the *premier président* of the *Chambre des comptes* see e.g. *Harangue faite à m. le duc d'Orléans, par M. Nicolaï*, Paris, 1649, Moreau, 1576. For Talon's harangues see Chapter Three, n. 31.

84 Guillaume de Dreux, who later owned *Moses Striking the Rock*, was exiled on May 30, 1648 with Jacques Passart, Michel's *parlementaire* cousin, for their *frondeur* activities. Dubuisson-Aubenay, 1883–85, I, p. 23. Mentioned by Talon, 1839, p. 315.

85 Poussin's client Melchior Gilliers negotiated for the release of the president of the *Chambre des comptes* and his rehabilitation in Parisian society, Jean Perrault. Dubuisson-Aubenay, 1883–85, II, p. 123. According to Rapin, Perrault was "devoué à la maison de Condé, dont il était intendant." Rapin, 1865, p. 157 n. 1. He was arrested on January 18, 1650. See Comte Henri Coustant d'Yanville, *Chambre des comptes de Paris: Essais historiques et chronologiques, privilèges et attributions nobiliaires et armorial*, Paris, 1866–75, p. 204. The *Chambre des comptes* responded with a series of remonstrances: "Remonstration sur la detention de M. le président Perrault," AN P.2602, 265, and "Harangue faict au roy & à la reyne par monsieur le Président L'Archer sur la detention de m. le président Perrault," January 26, 1650, AN P. 2602, 266. Perrault's attachment to the Grand Condé as his secretary (a post held by Chantelou at one time) and the resulting incarceration of the president of the *Chambre* with Condé in the Château de Vincennes, helped to unify the *robe* and princely factions.

86 BN MSS nouv. acq. Fr. 10829, Mascranny, fol. 165.

87 AN P2685, p. 128.

88 Ibid.

89 The political power invested in the ledger is demonstrated in a comic sense by the Chamber's resistance to the regent when they were ordered to move to Poitiers along with displaced docile *parlementaires*, puppets of the exiled court. They excused themselves because they could not perform their duties without their desks and their books. Ibid., and Dubuisson-Aubenay, 1883–85, II, p. 277 [August 22, 1652].

90 Claude de Beaune, *Traicté de la chambre des comptes de Paris*, Paris, M. Bobin, 1647. BN Lf27.2. Earlier descriptions of the chamber include Etienne Pasquier's *Recherches de la France* (II, 5) and Jean Lescuyer's "Instruction générale des finances" in *Nouveau style de la Chancellerie*, Paris, 1622.

91 By specifying the traditional composition and number of offices, the author provided a customary argument for the retention of a fixed number and thereby hoped to forestall any augmentation by the monarch. Beaune also stressed "les procez sur les oppositions formées aux Lettres subjectes à verification." Beaune, 1647, p. 25.

92 "Demand: Pourquoy la Chambre est-elle establie? Réponse: Pour voir, ouyr, examiner, clorre et arrester les comptes de toutes les finances du Roy, les juger & terminer. Elle cognoist des bastards, des aubayns, des admortissements, alienations, verifications d'apanages & contracts de mariage des Enfans de France." Ibid., pp. 152–53.

93 One of the types of *lettres patentes* that the Chamber had to verify was the *Lettre de Declaration de naturalité*. Ibid., p. 15.

94 "Demande: Que signifie le mot Aubain? Réponse: Il signifie estranger, qui est homme nay hors du Royaume, & en latin Albinum, quasi alibi natum. D: Combien y a il sortes d'hommes en France? R: De deux sortes . . . les vrais naturels François nez dans le Royaume . . . Et l'autre sorte est des Aubains, c'est à dire estrangers." Ibid., p. 295. The text goes on to define two types of *aubains*: those who follow the laws of their native foreign country and those who are naturalized by the king. Ibid., p. 296.

95 The *aubains naturalisés* had certain rights, such as protection from prohibitive taxation. See e.g. the "taxes et impositions extraordinaires" imposed on foreigners in Lyon that resulted in the exodus of the majority of foreign residents. Lyon, Archives Communales, série CC 333: impots et comptabilité, Lyon 1639–98 [January 26, 1639]. For instance, Poussin's client Marc Antoine II Lumague obtained naturalization in 1626. Madeleine F. Pérez, "Le Mécenat de la famille Lumague (branche française) au XVIIe siècle," in *La France et l'Italie au temps de Mazarin*, ed. Jean Serroy, Press universitaires de Grenoble, 1986, p. 161. See also Françoise Bayard, *Le monde des financiers au XVIIe siècle*, Paris, Flammarion, 1988, p. 365. On September 3, 1640, Lumague was granted "permission de faire résidence en France nonobstant sa résidence hors du Royaume." AN, Lettres patentes de Louis XIV, p. 151.

96 Beaune, 1647, p. 309.

97 For the earlier *Lettre de naturalité* for Mazarin: "Nat. et pouvoir de tenir bénéfices au dit Mazarin abbé de Saint Arsau, référendaire en Cour de Rome, 7 Juin 1639" see AN, Lettres patentes de Louis XIV, p. 151.

98 See Marc de Vulson de la Colombière, *Raisons d'Estat contre le ministère étranger*, 1649. Mazarin's apologist Naudé argued that a foreigner could be a superior minister because as an outsider he would be disinterested. Gabriel Naudé, *Jugement de tout ce qui a esté imprimé contre le Cardinal Mazarin depuis le 6 janvier jusqu'à la déclaration du 1er avril 1649* [known as *Mascurat*], Paris, 1650, pp. 208, 350f.

99 "On repute chose odieuse de donner office ny Benefice à un estranger." Beaune, 1647, p. 309.

100 Pasquier, *Recherches de la France*, II, 5, cited by Arthur M. Boislisle, *Chambre des comptes de Paris: Pièces justificatives pour servir l'histoire des premiers présidents (1506–1791)*, Nogent-le-Rotrou, A. Gouverneur, 1873, p. xxv.

101 "Passard, maître des comptes" is listed under Maistre Robert Hamonin, *quartinier*, in a document in the Bibliothèque de Ste-Geneviève, Paris. Cited in *Registres de l'Hôtel de Ville de Paris*, p. 453.

102 Robert Angot, *Les Nouveaux satires et exercises gaillards de ce temps*, Rouen, 1637 [*Les nouveaux satires et exercises gaillards d'Angot l'Eperonnière: texte original*, ed. *Prosper Blanchemain*, Paris, Lemerre, 1877], p. 100, cited by George Huppert, *Les bourgeois gentilshommes: An Essay on the Definition of Elites in Renaissance France*, University of Chicago Press, 1977, p. 191 n. 25.

103 See Robert Darnton, "A Pamphleteer on the Run," *The Literary Underground of the Old Regime*, Cambridge, Mass., Harvard University Press, 1982, pp. 71–121.

104 See Hepp, 1991.

105 *Correspondance*, pp. 310–11 [July 3, 1645]. Jacques Stella may have been making a bid for Condé's patronage as well when Stella painted the Prince's portrait. Chardon, 1867, pp. 88–90.

106 See Rapin, 1865, p. 157 n. 1.

107 Born in Rouen in the year of Poussin's birth, Saint-Amant accompanied Créquy to Rome in 1633–34, where he probably met Poussin. For the *frondeur* poetry see Chapter Seven below.

108 Fromont de Veine owned at least four paintings including the *Death of Sapphira* and Passart's *Testament of Eudamidas*. Bonnafée, *Dictionnaire des amateurs français au XVIIe siècle*, Paris, A. Quantin, 1884, p. 116. Félibien stated that Fromont owned the *Death of Sapphira* and "une vierge dans un païsage accompagnée de cinq figures." Félibien, 1725, IV, p. 152. Before 1700, Pesne engraved the *Death of Sapphira* and the *Testament of Eudamidas*, inscribing both with the alternative spelling of Fromont's name ("Fremont de Vence)." The painting was not in Passart's collection in 1683 according to his inventory. The painting is therefore likely to have entered Fromont's collection during Passart's lifetime. The paintings were a *Sainte Vierge dans un paysage* or *Holy Family with a Bath Tub*. According to the inscription on the Pesne engraving, the painting was in his collection but may have entered it via Créquy. Blunt, 1966, p. 40. Fromont also owned several "très finis & très-beaux" preparatory drawings for the Hercules cycle of the Grande Galerie. Félibien, 1725, IV, viii, p. 33.

109 As a *secrétaire des commandements* for the prince Gaston d'Orléans, Fromont played an important role in a fully articulated court ready to assume power when the regency collapsed. Gaston, supported by Parlement, declared the king a prisoner of Mazarin (July 20, 1652) and was given emergency powers as "lieutenant général de l'Etat pendant la captivité." Carrier, 1989, p. 262f. Moreau 1044 [BMI3123], 1154, 806 [BMI2699], 786 [BMI2687]. When Gaston retreated, Fromont assisted in setting up the court elsewhere at Menen. Goulas, 1879–82, II, p. 167. Dubuisson-Aubenay, 1883–85, I, pp. 206, 246; II, p. 240 (January 1650 and April 16, 1651).

110 The famous memorialist of the Fronde, Goulas, was also a *secrétaire des commandements* for Gaston. Mathieu de Morgues had written pamphlets against Richelieu while Gaston was in exile (see Châteauneuf). The Jansenist Robert Arnauld d'Andilly similarly had training in the affairs of state as *intendant général* for Gaston in the 1620s. Hubert Carrier, "Port-Royal et la Fronde: deux mazarinades inconnues d'Arnauld d'Andilly," *Revue d'histoire littéraire de la France* (January-February 1975), pp. 3–29.

111 Fromont was an important and reliable negotiator among factions and institutions – the Hôtel de Ville, Cardinal Retz, and Presidents Molé and Bellièvre in Parlement. Fromont acted as a liaison between Gaston and the municipal government of Paris, giving and receiving letters between the Palais d'Orléans and the Hôtel de Ville. *Registres de l'Hôtel de la Ville de Paris* refers to Fromont on two dates, December 15, 1649 and February 5, 1651. Fromont also acted as a diplomat with one factional leader during the Fronde. One memoir of the Fronde tells the story of how Cardinal Retz, Paul Gondi, hid in his house and feigned illness in order to evade possible attacks from the men of the prince who was "maître de l'esprit de m. d'Orleans."

Fromont paid him a visit to allay his fears. Valentin Conrart, *Mémoires de Valentin Conrart, premier secrétaire perpétuel de l'Académie française* (Paris, 1826), Geneva, Slatkine Reprints, 1971, p. 96 [June 18, 1652]. He was also an intermediary between Parlement and Gaston. In one instance, Fromont urged President Molé to postpone a remonstrance because it might have caused popular unrest in the king's absence. Mathieu Molé, *Mémoires*, ed. A. Champollion-Figeac, 4 vols., Paris, 1855–57, IV, pp. 312–13n and p. 80 [April 27, 1650]. Fromont also participated in negotiations with another collector of Poussin's work, the President Bellièvre. BN MS Fr 16519, fol. 78. This unpublished document is the only evidence of a direct liason between Bellièvre and Fromont. Gaston defected to the Condé-*frondeur* alliance days before the first exile of Mazarin, February 6–7, 1651. Mettam, 1988, p. 149; Carrier, 1992, p. 240. The alliance fell apart by April. Condé entered Paris on April 11, 1652. Gaston renewed a temporary alliance with Condé with the return of Mazarin to France on January 24, 1652. This was the burial of the Parlementary Fronde. Carrier, 1992, p. 252. See Moreau 424, 1527, 2366, and 2509. Orléans was exiled from Paris the day after the *Entrée* of Louis XIV, October 22, 1652. See my dissertation, pp. 189–90, 238 n. 170.

112 *Correspondance*, pp. 206, 207, 362, 369, 388, 427 [April 4, 1643 – February 16, 1653]. There is an engraved portrait of Renard by Sylvestre. There has been some confusion in the literature between Louis Renard and his father Pierre. The land in the Tuileries was ceded to Pierre Renard by Louis XIII in 1630 and 1633. Henri Sauval, *Histoire et recherches des antiquités de la ville de Paris*, 3 vols., Paris, 1724, II, p. 60. Poussin was probably Louis's neighbor in 1641 and may have known his father who died sometime before 1643. Bonnafée is therefore correct in saying Pierre died. Louis Renard (January 1643) received a *brevet* for his father's charges and lodgings ("en survivance de Pierre Renard dit St Malo son pere les charges de son arquebuzier ordinaire & garde du Cabinet de ses armes & le logement dans le jardin des Tuilleries." AN O1.1049, p. 72. Signed Loménie (Brienne).

113 The *brevet* of March 20, 1641 gave Poussin "la maison et le jardin qui est au milieu de son jardin des Tuileries, où avait demeuré le feu sieur Menou, pour y loger et en jouir sa vie durant, comme avait fait ledit sieur Menou." See Antoine Jules Dumesnil, "Le Commandeur Cassiano del Pozzo" in *Histoire des plus célèbres amateurs italiens et de leurs relations avec les artistes*, 3 vols., Paris, J. Renouard, 1853, I p. 513. For Poussin's house, see *Correspondance*, p. 40. Not all the other artist *brevetaires* were housed in the Louvre: another artist, Poussin's friend and assistant LeMaire, also lived in the Tuileries.

114 Chardon, 1867, p. 70. *Correspondance*, p. 427 [February 16, 1653].

115 Dumesnil, 1853, I, p. 511.

116 See "instructions from Mazarin to Johart," BN MS. Fr. Baluze Coll. Item 31 [April 1651].

117 Sieur de Croissy-Foucquet and Nicolas II Camus de Pontcarré (d. 1660) were among the established parlementary habitués. Conrart, 1826, p. 162 [July 1652]. For Croissy see ibid., p. 579, and Carrier, 1992, p. 138. For his arrest and examination by Bellièvre see Loret, 1857–78, I, p. 354 and BN MS. Fr. 18431. See my dissertation, p. 239 n. 177.

118 Conrart, 1826, p. 163. Conrart called it an "espèce de conseil."

119 *Correspondance*, p. 206 [August 4, 1643].

120 See Loret, 1857–78, I, p. 129 [June 25, 1651]. For the *beau monde chez Renard*, see Sauval, 1724, II, p. 286.

121 See Dubuisson-Aubenay, 1883–85, II, p. 234 [June 9, 1652]. Orest Ranum, "Courtesy, Absolutism, and the Rise of the French State, 1630–1660," *Journal of Modern History* 52 (1980), pp. 426–30.

122 The event, which took place on June 18, 1649, was celebrated in at least seven *mazarinades*, the poet Blot's "triolet," as well as the memoirs of Retz and Motteville. Christian Jouhaud, *Mazarinades: la Fronde des mots*, Paris, Aubier, 1985, pp. 109–12.

123 "Pourtant fixation à 95130# 2s 6d le remboursement du Sr Reynard du jardin et terrein qu'il a au dela du thuilleries." Paris, AN, Lettres patentes de Louis XIV (March 11, 1651). Registered August 3, 1660.

124 Roland Fréart is primarily known for his later theoretical work often associated with doctrinaire French "classicism," the *Idée de la perfection de la peinture* (1662). See Donald Posner, "Concerning the 'Mechanical' Parts of Painting and the Artistic Culture of Seventeenth-Century France," *Art Bulletin* 75:4 (December 1993), pp. 583–98, and Thomas Crow, "The Critique of Enlightenment in Eighteenth-Century Art," *Art Criticism* 3:3 (1987), pp. 17–31.

125 Roland's translation of da Vinci's treatise was dedicated to Poussin. He discussed the *Parallèle* in his letters. He gave the books as gifts to Cassiano dal Pozzo.

126 *Baptism of Christ* (1648), Swiss private collection, formerly Wildenstein. There is an engraving by Pesne. A series of letters dating 1643–48 document the importance of their relationship.

127 *Correspondance*, p. 393 [December 19, 1648].

128 In addition, as in the case of his fellow *maître* Gilliers, the office did not preclude attachment to Condé, who had protected Chantelou during the first years of disgrace. During the early part of the regency, he had been a secretary for the Duc d'Enghien before the latter had inherited the title of Condé.

129 Poussin expected Chantelou to have been caught in Paris during the siege, suggesting that Poussin did not entertain the idea that he would have followed the court in exile. At a later stage of the Fronde, Poussin posted a letter either to Paris or Le Mans, also suggesting that Chantelou may have chosen to withdraw from both the court and Paris. Ibid., p. 425 [November 10, 1652].

130 The elder Jean was *grand prévôt du Maine*. The oldest son, Jean (1604–74), had been a *commis* of Sublet de Noyers, serving from Le Mans. He had served as a *commissaire provincial* for Champagne, Alsace, and Lorraine. Jean's brother Roland also served under Sublet as a *commis* and was entrusted with some duties in Piedmont. Ibid, p. 27 n.

131 See Roland Mousnier, "Recherches sur les syndicats d'officiers pendant la Fronde: Trésoriers-généraux de France et élus dans la révolution," *XVIIe siècle* 42–43 (1959), pp. 76–117. Poussin wrote to Jean in Paris on a number of occasions in the mid-forties, but then he seems to have remained in Le Mans during the Fronde. Chardon provides details of Jean Fréart's place in his community. His seven children were born between

1634 and 1649 in the parish of Saint-Nicolas. Their godparents were also members of the Election among the "premières familles de robe du Maine." Chardon, 1867, p. 93.

132 Le Mans, *Registres de l'Hôtel de la Ville du Mans*, p. 83.

133 François Dornic, *Louis Berryer, agent de Mazarin et de Colbert*, University of Caen, 1968, p. 176.

134 The following April 16. Ibid.

135 Roland and Jean Fréart were nominated at the suggestion of the Baron des Essarts, Sénéchal du Maine. *Registres de l'Hôtel de ville du Mans*, p. 84 [April 2 and 5, 1649]. Chardon, 1867, pp. 98–99. As one of the *élus*, Jean verified 5,000 livres for defenses, a breach of institutional boundaries that insulted the municipal leaders, the *échevins*. Le Mans, *Registres*, p. 84.

136 Blunt, 1944, p. 160 n. 4. Madeleine F. Pérez and J. Guillemain, "Curieux et collectioneurs à Lyon d'après le texte de Spon (1673)," in *Jacob Spon: Un humaniste lyonnais du XVIIe siècle* (Université Lumière Lyon 2, VI, Lyon, 1993), ed. Roland Etienne, Paris, Boccard, 1993, pp. 39–50.

137 According to Passeri, the artist's association with Lyon had begun as early as the 1610s when he might have spent as many as two years there. See Jacques Thuillier, *Poussin Before Rome, 1594–1624*, trans. Christopher Allen, London, Richard L. Feigen & Co., 1995, pp. 32–33. Poussin's friend and fellow artist Jacques Stella who trained in Rome, moved to Paris, and became a *brevetaire* housed in the Louvre, was also from Lyon. See Gilles Chomer, "Jacques Stella: 'pictor lugdunensis'," *Revue de l'art* (1980), pp. 85–89. The engraver Abraham Bosse trained in Lyon and took up residence in Paris.

138 See Thuillier and Mignot, 1978. Pointel later acted as an agent on behalf of Créquy's grandson, Charles III.

139 The notarial records for the Sérizier family are found in Paris, Archives Nationales, Minutier Centrale, étude LXXXV. For the inventory after the death of Jean Pointel, see Thuillier and Mignot, 1978, p. 39. See my dissertation, p. 241 n. 202.

140 See *Correspondance*, pp. 32, 48, 49, 76, 301. Pérez, 1986. Marc Antoine Lumague (also Lumagne or Lumaga) served Richelieu and is noted in his correspondence. For a discussion of the version of *Diogenes* associated with Lumague, see Chapter Eleven below.

141 Lumague offered Poussin a good rate of exchange "for the love of Passart." *Correspondance*, p. 76 [June 16, 1641]. See n. 155 and Chapter Eleven, n. 1 below.

142 Sylvio Reynon originally owned the *Christ Healing the Blind* (1650, Louvre) and a *Finding of Moses* (1651) that ended up in the Duc de Richelieu's collection before 1665. Sylvio and Bernadin Reynon are recorded as prominent suppliers of silk to the court of Louis XIV. Paris, AN, *Comtes des bâtiments*, 1665–1675 (possibly one ceases to be recorded in 1669 or 1670). For records, including donations, that attest to Sylvio's involvement in the community of Lyon, see e.g. Lyon, Archives Communales, B2 Actes de soumission, and my dissertation, p. 241 n. 202. On the circulation of Poussin's paintings in Lyon see Pérez and Guillemain, 1993, and Madeleine F. Pérez, "La collection de tableaux de Louis Bay Seigneur de Curis (1631?–1719) d'après son inventaire après décès," *Gazette des Beaux-Arts* 95 (May–June 1980), pp. 183–86 and n. 138.

143 In Thomas Blanchet's contemporary ceiling painting at the Hôtel de Ville in Lyon, the twin allegories of Credit

and Commerce unproblematically occupied the same field as Nobility. Lucie Galactéros-de Boissier, *Thomas Blanchet (1614–1689)*, Paris, Arthéna, 1991. The Consulat pressed the crown to preserve these definitions in order to retain the prestige of the city's important families ("l'aristocracie des affaires") and maintain the privileges of tax exemption. Richard Gascon, *Grand Commerce et vie urbaine au XVIIe siècle: Lyon et ses marchands (environs de 1520–environs de 1580)*, 2 vols., Paris, La Haye, Mouton, 1971, I, p. 369f.

144 The political behavior of Poussin's merchant clients Pointel and Sérizier was inflected no doubt by their complicated positions and personal histories split between two cities. Although documented as "bourgeois de Paris" they may have retained some of the rights and privileges of the bourgeois Lyonnais. On the notion of the merchants in Lyon as "l'aristocracie des affaires" see Gascon, 1971, p. 369f. In Lyon, banking and commerce were not incompatible with local definitions of nobility. Lyon's civic government fought to retain certain local privileges regarding the definition of nobility, as the crown sought to restrict that definition in order to enlarge the tax rolls. As in other cities of southern France, there was a relative fluidity between *marchandise* and *noblesse*. While Lyon had never regained the financial wealth and power of the sixteenth century, banking and the silk trade continued to carry social prestige. Poussin's Lyonnais clients enjoyed local rights and privileges that more fully integrated them with the office-holders. As with other provincial elites, resistance to the regency during the Fronde was a response to the threat to those privileges and prerogatives.

145 See Blunt, 1944. For a discussion of these paintings, see Chapter Eleven below.

146 For a discussion of Mazarin's threat to cloth merchants as well as Poussin's and Pointel's shared economic interests see McTighe, 1996, p. 73. See Moote, 1972, pp. 94–95.

147 *Le Caquet ou Entretien de l'accouchée*, 1651, Moreau 630 [BM 12608], pp. 7–10.

148 *Lettre d'un religieux envoyée à monseigneur le Prince de Condé, à Saint-Germaine-en-Laye, contenant la vérité de la vie et moeurs du Cardinal Mazarin, avec exhortation au dit seigneur prince d'abandonner son parti*, Paris, chez Rolin de la Haye, 1649, Moreau 1895 [BM 11180], Moreau, 1853, I, pp. 92–109. The *Lettre* was praised by both Patin and Naudé. See Hubert Carrier, "Mécénat et politique: l'action de Mazarin jugée par les pamphlétaires de la Fronde," in *L'Age d'or du mécénat (1598–1661): actes du colloque international CNRS (mars 1983) – Le mécénat en Europe, et particulièrement en France avant Colbert*, ed. Roland Mousnier and Jean Mesnard, Paris, Centre national de la recherche scientifique, 1985.

149 "Et cet esprit mercenaire et de trafic luy est tellement naturel, qu' à présent qu'il est Cardinal, gorgé de biens, et suffoqué presque de toutes les richesses de l'Estat, il ne sçauroit se retenir d'enuser." *Lettre d'un religieux*, 1649, p. 6, Moreau, 1853, I, p. 97.

150 "Par cet Avare, mais infâme commerce, oste la vie à cinquante familles de Paris, qui la gaignoient légitement sur les choses qu'elles fournissoient à la cour, chacune selon sa condition." Ibid., p. 98.

151 The view that Mazarin was guilty of *curiosité* is expressed by a *parfumeuse* in *Le Caquet ou Entretien de l'accouchée*, 1651, p. 19.

152 According to Anthony Blunt, Sérizier "belonged to the class of person in whom the scorn and fear of the people was most deeply ingrained." Blunt, 1944, p. 160. As evidence, Blunt cited two writers of the late sixteenth century: Guillaume du Vair and Pierre Charron. Blunt elides the differences between the two authors and by his own admission downplays du Vair's criticism of princes. The *officier* is positioned between the monarch and the subjects. Written during the siege of Paris, du Vair's essay contrasts with Charron's 1595 piece, which is a much stronger apology for monarchical absolutism. Note also that du Vair stresses the infinite number of those banished from Rome, a criticism of imperial power.

153 "It is an almost recurrent theme in the confused story of the Fronde that whenever the people get out of hand – often stirred by the Prince's party – the bourgeoisie takes fright and comes to terms with any party that can repress the popular sedition." Ibid., p. 160. For the claim that Poussin similarly "wanted nothing to do with the whole disturbance," see Bätschmann, 1990, p. 110. See Michael Kitson's essay on the issue of Blunt's early Marxist scholarship. Michael Kitson, "Anthony Blunt's *Nicolas Poussin* in Context", in *Commemorating Poussin: Reception and Interpretation of the Artist*, ed. Katie Scott and Genevieve Warwick, Cambridge University Press, 1999, pp. 211–30.

154 For Blunt, Poussin's formal order is a reflection of this antagonism to popular disorder on two counts: 1) the "clarity of disposition" has the rhetorical connotation of an undisputed semantic field. This is dialetically opposed to rumor or communication obstructed by noise. 2) Blunt appeals to Cartesian rationality to structure this ideology of order. Popular forms of political practice are constrained by a consistently measured and ordered space. For example, the imbedded procession is ordered and constrained in the *Phocion* burial painting by the pictorial structure. See Chapter Eleven below.

155 For example, Sérizier and Pointel had business connections that helped assist the transport of antique busts and copies intended for Chantelou. They were also knowledgeable of the employment of *lettres de change*. Pointel's knowledge of exchange rates was deployed in Rome on behalf of Chantelou and Poussin. See Chapter Eleven, n. 1 below.

156 See Moote, 1972, p. 94. Kossman's *Fronde* (1954) is an articulate defense of the "thèse royale." For a repudiation of this thesis see Jean-Louis Bourgeon, "L'île de la Cité pendant la Fronde," *Paris et Ile de France* (1963), pp. 23–143.

157 Persistent efforts by Particelli d'Emery to tax the six guilds made relations between the wealthiest merchants of Paris and the regent very uncertain by 1648. Moote, 1972, p. 95. E. H. Kossmann, *La Fronde*, Leiden, Universitaire Pers Leiden, 1954, pp. 88–94. Many "bons & petits bourgeois" sided with the rebels. Moote, 1972, p. 204.

158 On the tensions between tactics and interests see my dissertation, p. 243 n. 227.

159 Wealthy Parisians were capable of being violently anti-Mazarinist. For example, bourgeoisie from the rue de Grenelle and rue Saint Honoré actually broke up pro-Mazarin demonstrations. Moote, 1972, p. 341.

160 See ibid., p. 152.

161 Silversmiths, members of the six guilds, organized mass opposition to Séguier when he tried to get past their shops. Ibid., p. 153.

162 In at least one case, a mob that entreated Gaston to expel troops from the city was constituted by "bourgeois de toute condition." "Papiers de Mascranny," BN MSS nouv. acq. Fr. 10829, fol. 191. Although there is a degree of uncertainty as to the extent of bourgeois participation in the days of the barricades, even the most cautious historians will not perpetuate the stereotype of the complete renunciation of disorder. Bourgeon presents the strongest of arguments for mixed class participation in the unrest. Goubert's more cautious account nevertheless admits to the evidence of the complicity of militia colonels and *officiers.* Pierre Goubert, *Mazarin*, Paris, Fayard, 1990, pp. 254–55. It is important to stress that collective demonstrations and the threat of mob violence remained strategic weapons used by various factions and involved different social strata. After all, the Parlement had used the power of the mob to force the release of Broussel and fellow judges. Moote, 1972, p. 153.

163 There is a rich literature on collecting and collections. See e.g., Donatella L. Sparti, *Le collezione dal Pozzo: Storia di una famiglia e del suo museo nella Roma seicentesca*, Modena, F. C. Panini, 1992; Victor I. Stoichita, *The Self-Aware Image: An Insight into Early Modern Meta-Painting*, trans. Anne-Marie Glasheen, Cambridge University Press, 1997. My emphasis is on the artist's conscious response to these conditions.

164 For the critical fortune of Poussin's exile see Katie Scott's discussion of his tomb in Rome in "Introduction", *Commemorating Poussin*, pp. 5–10.

165 I take issue with the notion of Poussin's "anti-politics." McTighe, 1996, p. 71.

166 *Journal d'Olivier d'Ormesson*, ed. A. Chéruel, Paris, 1860–61, p. 23, cited and trans. Richard Bonney, *Society and Government in France under Richelieu and Mazarin, 1624–61*, New York, St. Martin's Press, 1988, p. 48.

167 Mademoiselle called the house "commode" with a door onto the Tuileries. Montpensier, 1891, II, p. 194 [1652].

168 In the margins of official correspondence to the then ambassador to England, Sublet thanks Bellièvre for books and other news. BN MS FR 15915, fol. 113 [April 27, 1638].

169 "Pour jouïr du repos & de la tranquillité que l'on trouve rarement à la Cour." Antoine Fauvelet du Toc, *Histoire des Secretaires d'Estat contenant l'origine, le progrés, et l'établissement de leurs charges, avec les éloges, les armes, blasons, & genealogies de tous ceux qui les ont possedées jusqu'à present*, Paris, C. de Sercy, 1668, pp. 294–95. "Il les exerça tout l'honneur possible, & la réputation juste & veritable du plus fidelle, du plus laborieux, & du plus desinteressé Ministre de son Siècle." Ibid., p. 294. See Hepp, 1991, and Chapter Ten below.

170 Even within Poussin's circle, there was room for criticism of Richelieu. When the Cardinal died and France was in mourning, Bourdelot did not hesitate to inform Cassiano del Pozzo that Paris was rampant with poets dancing on Richelieu's grave. The spontaneous outpouring of satiric epitaphs, rondeaux, sonnets, etc., much of which was written by scholars who had to put up with the tomb housed in the Sorbonne, amused this friend of Pozzo and Poussin's circle. Giacomo Lumbroso, ed., "Notizie sulla vita di Cassiano dal Pozzo," in *Miscellanea di Storia Italiana* 15 (1874), pp. 336–67.

171 Sublet resisted Mazarin's attempts to have Le Tellier replace himself as secretary of state by refusing to sell his office. See Chardon, 1867, p. 59. He finally gave up his secretary of state position, and the income, to Le Tellier on November 7, 1643. Sublet nevertheless retained a position in court. Le Tellier was an *intendant de justice de l'armée d'Italie*, a creature of Mazarin, who exercised the offices of secretary of state even though he had not secured the title from Sublet. Mazarin's protégé performed the duties of the position while Sublet continued to hold the office.

172 Mazarin stated in his *carnets* that Beaufort and the bishop of Beauvais sought the return of Sublet: according to Mazarin, "M di Noyers demanda di venir a servire nella carcia . . . Il primo presidente ne parla." Sublet demanded to fulfill his charge and was supported by Président Matthieu Molé. Sublet therefore had Parlementary support. *Carnets de Mazarin*, August 1643, 3e *carnet*, p. 75.

173 Madames Hauteville and Chevreuse retreated to their estates, Beaufort was incarcerated at the Château de Vincennes, and Châteauneuf was exiled again.

174 "Je confesse . . . qu'en cette pensée tout me paroist si caduc & si inquiet dans les grandeurs, que je trouve la retraite des disgraciez (pourueu qu'ils soient gens de bien) infiniment préferable à leur Faveur. Si le mérite & les services considerables pouvoient establir & affermir pour toujours un homme à la cour, & être un rempart contre l'envie & la jalousie, qui sont les ennemies immortelles, & les pestes de la vertu, lesquelles régnent malheureusement en ce lieu-là." Roland Fréart, *Parallèle de l'architecture antique et de la moderne: avec un recueil des dix principaux auteurs qui ont ecrit des cinq ordres* (Paris, Edme Martin, 1650), Geneva, Minkoff, 1973, n.p.

175 Daret: "[Il] se retira de la Cour en 1643 fuyant les attaintes de l'Envie."

176 "Que depuis le premier jour qu'il fut appellé aux affaires après la mort de deffunct Cardinal de Richelieu autheur de sa grandeur, il fit chasser du conseil le sieur des Noyers Secrétaire d'Estat, dont le deffunct Cardinal s'estoit servy avec beaucoup de satisfaction aux plus grandes affaires de l'Estat." *Le Caquet ou Entretien de l'accouchée*, 1651, p. 35.

177 Ibid.

178 The queen seems to have been sympathetic to Sublet and influenced by those favorable to him. Mazarin had to persuade her otherwise, and did not cease to spy and exert pressure.

179 In order for Sublet to retain the office of *surintendant*, Président Matthieu Molé of the Parlement of Paris negotiated with Mazarin in the months after Sublet's disgrace. In a letter to Molé dated September 19, 1643 from his "solitude" in Dangu, Sublet acknowledged Molé's support in maintaining his position as *surintendant des bâtiments*. See n. 187 below.

180 Poussin's acquaintance Bourdelot wrote to Cassiano del Pozzo from Paris on April 18, 1643. Cited in *Correspondance*, p. 197 n. 4.

181 "Parmy les affaires de la guerre dont il avoit l'administration fit régner les arts de la paix en France par les beaux ouvrages de Peinture, Graveure, Architecture, et d'Imprimerie quil y entretenoit."

182 Alexandre Francini was paid for construction of a canal bank. AN O1/2128 [April 2, 1644]. Another *brevet* was signed by Sublet on June 13–14, 1644 on behalf of the gardener Le Febre.

AN 01/2128. See Albert Mousset, *Les Francines: créateurs des eaux de Versailles, intendants des eaux et fontaines de France de 1623 à 1784*, Paris, E. Champion, 1930.

183 Mazarin's surveillance and continued attempts to check Sublet's power and to humiliate him are recorded in the cardinal's *carnets*. Mazarin continued to oppose Sublet's retention of the *intendant* office. Sublet's return to favor bothered him; he was a threat to his position and represented the potential power of the Importants even in exile (see 3e *carnet*, p. 6: "Bove procura il ritorno di M di Noyers e tutti gli Importanti.") As we have seen, Mazarin believed that Sublet was supported by Matthieu Molé and therefore received the support of the Parlement of Paris. Finally, the 4e *carnet* indicated Mazarin's surveillance of Sublet. He pressed for Sublet's resignation and insisted that the queen replace the secretary of state with Le Tellier (6e *carnet*, p 35). Chéruel, 1872–1906, p. 454 n. Mazarin wrote a letter to his brother talking about Sublet purportedly begging at his door. Ibid., p. 505.

184 On Bourdelot's letters see Lumbroso, 1874, p. 129f.

185 For example, Sublet commissioned a "grande colonne de graive destinée pour l'oratoire que sa majesté a commandé estre faie joignant son cabinet du chasteau dud. Fontainebleau," AN 01.2128 [May 25, 1643].

186 *Correspondance*, p. 197 [June 9, 1643].

187 The passage reads: "Quant à ce qui est de mes charges des bâtiments et de Fontainbleau, dont il vous a aussi plu me mander que vous avez parlé à Son Éminence, je vous prie, Monsieur, de l'assurer que je tiendrai à grand honneur d'y servir la Reine et que je ne m'y appliquerai pas avec moins de soins et de plaisir, que s'il y alloit des plus grandes affaires d'État, ayant toujours été persuadé que c'est la volonté du maître qui donne le prix et la valeur aux emplois. Trois lignes de la Reine me feront prendre la truelle et aller avec joie exécuter ses nobles desseins touchant la sépulture du feu Roi et la continuation des bâtiments du Louvre, m'assurant que Son Éminence, qui aime et cognoît les belles choses, nous fera donner volontiers et l'autorité et les moyens pour devancer tout ce qui a été fait de plus beau jusques ici. C'est maintenant à vous, Monsieur, à conduire à sa perfection la pensée que l'amour que vous avez pour nous vous a donnée, assurant à cet effet Son Éminence qu'elle ne sera jamais trompée dans la parole que vous lui donnerez de l'obéissance et de la recognoissance de votre, etc. De Dangu, ce 19 septembre 1643." BN MSS Collection Colbert, II, p. 395, Molé, III, 1855–57, p. 94. Sublet acknowledges Molé's assurances to Mazarin of the respect Sublet has for the Cardinal: "j'ai conservé dans ma solitude les mêmes sentiments d'honneur et de respect que j'ai toujours eus pour lui" despite "le zèle indiscret de mes amis et les impertinences de tant de gens qui parlent sans ordre et sans aveu." Ibid., p. 93. Sublet diplomatically distanced himself from the fallen Importants. See my dissertation, p. 212.

188 In addition to references to the project in the correspondence, the presence of the drawings in Roman collections suggests that Poussin continued to make them when he returned.

189 By October 5, 1643, Rémy Vuibert asked Poussin to send two medals to be painted above the windows between the terms. *Correspondance*, p. 216. On Vuibert's participation, see Anthony Blunt, "Poussin Studies VI: Poussin's Decoration of the Long Gallery in the Louvre," *Burlington Magazine* 93 (December 1951), p. 375.

190 Sublet was officially recognized for his effective renovation of Fontainebleau: "Sa Majesté a trouvé le palais de Fontainbleau presque tout renouvelé; il surpasse de beaucoup son ancienne splendour par ses nouveaux édifices et ornements, qui sont dus aux soins qu'en a pris le sieur de Noyers, surintendant général des bâtiments de France." *Gazette*, p. 664, cited by Molé, 1855–57, p. 31 n.

191 There were over a dozen *brevets* signed by Sublet des Noyers at Dangu following his disgrace. AN 01.2128. They pertain to the royal buildings at Fontainebleau, St.-Germain-en-Laye, the Palais Royale, Monceaux, and the Tuileries. He identified himself as "Sr Desnoyers surIntendant et ordonannateur de ses Batimens" and "Capitaine Concierge et sur-Intendant des Batimens de son Château de fontainebleau."

192 François Derand, *L'architecture des voutes, ou, l'art des traits, et coupe des voutes: Traicté tres-util, voire necessaire a tous architectes, maistres massons, Appareilleurs, Tailleurs de pierre, et generalement a tous ceux qui se meslent de l'architecture, mesme militaire.* par le R. P. François Derand de la compagnie de Iesus. Chez Sebastien Cramoisy, Imp. ord. du Roy, rue Sainct Jacques aux Cicognes, Paris, MDCXLIII (1643). See Bosse's dedications as well.

193 "J'entreprens, Monseigneur, sous l'abry de vostre auctorité, & sous l'un de vos employs dans l'Estat, ce travail." Ibid.

194 Derand's privilege was granted May 5, 1643.

195 The dedication reads "A Monseigneur De Noyers, Baron de Dangu, conseiller du roy en ses conseils, secretaire d'estat, et des commandements de sa Majeste, sur-intendant, et ordonnateur General des Bastimens, Arts, & Manufactures de France."

196 After Sublet's death, the first official act signed for the *surintendance des bâtiments* was by Louis Phélypeaux de La Vrillière, the owner of Poussin's *Camillus*. AN 01/2128 [December 31, 1645]. The following August, a *brevet* was signed by Mazarin. AN 01/2128 p. 10bis–11, August 6, 1646. On Septembre 26, 1647, a *brevet* was registered in the name of "sieur de Compiegne Nicolas Dupont Pere et reconnoitre en toutes occasions les bons et agreables services qui lui rend" as "Concierge de la Volliere de Fontainebleau." The *brevet* was specifically designed to recognize "toutes sortes d'oiseaux autant rares et curioux qu'il s'en poura trouver." The *brevet* was signed by Louis Guenegaud, Ratabon, and "Cardinal Mazarin capne Gouverneur, Concierge et sur-Intendant des Batimens dud Château de fontainbleau." C. Michaud, "Francois Sublet de Noyers, Surintendant des bâtiments de France," *Revue historique* 242 (1969), p. 327f.

197 "Avec connoissance, & qui les cultive, qui mesprise son propre interest pour conserver celuy de l'Estat & du public." Fréart, *Parallèle*, "epistre," n.p.

198 "C'est dans M. de Chambray qu'il faut voir l'esprit de la Fronde artistique." Chardon, 1867, p. 96.

199 In a letter, Poussin acknowledged that Fréart de Chambray's book was a veritable portrait of Sublet. *Correspondance*, 418–19 [August 29, 1650].

200 "Le plus grand Ministre, le plus désintéressé, le plus laborieux, le plus effectif, d'une probité si extraordinaire et si éprouvée." Fréart, "epistre," n.p.

201 See examples of *mazarinades* accusing him of selling off royal domaines.

202 One must be careful not to use this term (*patrimonie*) lightly because it suggests a notion of culture presupposing a nationalist discourse. It cannot be suggested that this conception of patrimony is one attached to a national spirit or genius. But I have suggested in Chapter One that there was a patriotic culture, and a configuration of local heritages, circulating throughout the provinces and Paris, with a shared repertory of tools acquired through a shared education. For a discussion of the notion of *patrie*, see Ranum, 1975. Sublet appealed to Poussin's love of *patrie* in order to have him return to France. *Correspondance*, p. 33.

203 While performing his duties in Nîmes, Sublet received the gift of a Roman high-relief of an eagle. He responded by commissioning a portfolio of portraits of Nîmois antiquities. He also ordered the architect Le Mercier to survey antique architecture in order to restore it. He had the arenas and the Maison Carrée in mind. Michaud, 1969, p. 327f. See Vincennes, Archives de la Guerre, A1, 69.

204 See *Actes*, 1960, pp. 87–90. In this text, Fréart also discusses the "fascheuses revolutions" that smothered the productions that had been conceived by Sublet.

205 See Poussin's discussion of the increase in France's *gloire*, when he thought that Sublet de Noyers had returned to the court. *Correspondance*, p. 227 [November 5, 1643].

206 Indeed, retreats are integral to the history of the *noblesse de robe* in addition to the important tradition of noble exile in aristocratic culture in France. E.g., Pomponne II Bellièvre's maternal grandfather Nicolas Brulart was the *garde des sceaux* under Henry IV, who retired to his country home after the king's death until the coup against Concini. Similarly, Châteauneuf, also *garde des sceaux*, was exiled by Richelieu until the Cardinal's death. In his testament, Châteauneuf gave his *maison des champs* to Bellièvre. On the notion of retreat as it related to *otium* see Fumaroli, 1988, and Chapter Eleven below.

207 "Monsieur, permettez que l'on vous rende les devoirs aussi bien dans le désert que dans la foule et le tumulte des villes. Je n'ai pas pu différer davantage sans vous prier de me faire part de ce qui s'est passé entre vous et M. le Grand Maître, au dernier voyage qu'il a fait à Paris, si le Dieu de paix a régné à l'entrevue que je suppose s'être faite, parce qu'elle m'avoit été promise, et si cette ancienne chaleur s'est rallumée. Je le souhaite comme la vie; que si cela n'est pointe, où est l'Évangile, qui veut que nous nous pardonnions septuaginta et septies? Je sais bien que vous êtes tous deux meilleurs théologiens que moi; mais je suis dans la solitude où le *fascinum negotiorum* me permet de voir quelquefois plus clair dans la discussion des passions, qu'il ne fait à ceux qu'il possède. Je conserverai toujours ma liberté avec vous, parce que j'ai l'honneur de cognoître votre coeur, et je crois que vous cognoissez celui, Monsieur, de votre, etc. De Dangu, ce 10 août 1643. Molé, 1855–57, pp. 295–96 [Colbert, II, p. 379]. See also Chapter Eleven below.

208 For a discussion of the occurrence of structural change at the points of relatively diminished power, see Marshall David Sahlins, *Historical Metaphors and Mythical Realities: Structure in the Early History of the Sandwich Islands Kingdom*, Ann Arbor, University of Michigan Press, 1981. William H. Sewell, Jr. uses the term "transposition" to describe the application of various cultural resources from relatively autonomous practices to areas subject to greater coercion. Sewell, "A Theory of Structure, Duality, Agency, and Transformation," *American Journal of Sociology* 98: 1 (July 1992), pp. 1–29.

209 See Fumaroli, 1988, p. 149.

210 See Fréart, *Parallèle*, n.p. *Actes*, 1960, p. 86.

Chapter Six: Mazarinades

1 Gabriel Naudé, *Jugement de tout ce qui a esté imprimé contre le Cardinal Mazarin depuis le 6 janvier jusqu'à la déclaration du 1er avril 1649* [Paris, 1650], generally called the *Mascurat* after one of the speakers. This bit of "crisis management" was clearly Naudé's idea. In the correspondence between the librarian and his patron, Naudé constantly urged Mazarin to consider seriously the importance of propaganda, to counter opposition, and to hire French writers. Unlike Richelieu, Mazarin was an outsider who was slow to recognize the importance of the press in French politics and the danger of disgruntled writers. On Richelieu's cultural tactics see Roland Mousnier, ed., *Richelieu et la culture: actes du colloque international en Sorbonne*, Paris, Centre national de la recherche scientifique, 1987.

2 From Voltaire to Michelet, the *mazarinades* had been generally treated as factional invective or pulp literature. Voltaire, *Le Siècle de Louis XIV*, Paris, Hachette, 1906, pp. 46, 57–58, 62. Serious consideration of the *mazarinades* began with the seminal work of the nineteenth-century historian Celestin Moreau, who catalogued the collections of the Bibliothèque Mazarine and other Parisian libraries (*Bibliographie des Mazarinades*, Paris, J. Renouard, 1850–51, 3 vols. and addenda). Moreau also published an anthology of *mazarinades*: Moreau, ed., *Choix de mazarinades*, 2 vols., Paris, J. Renouard, 1853. More recently, important scholarship has attended to the *mazarinades* in order to fill in the gaps of the historical record. In addition to this necessary historical reconstruction of the events of the Fronde, a more complete picture of the importance of public opinion and debate has emerged. For the most thorough account of the historiography of the Fronde and the *mazarinades* see Hubert Carrier, *La Presse de la Fronde, 1648–1653: Les Mazarinades*, I: *La conquête de l'opinion*, II: *Les Hommes du livre*, Geneva, Droz, 1989–92. See also Christian Jouhaud, *Mazarinades: la Fronde des mots*, Paris, Aubier, 1985. For a discussion of the sexual politics of the *mazarinades* see Jeffrey Merrick, "The Cardinal and the Queen: Sexual and Political Disorders in the Mazarinades," *French Historical Studies* 18:3 (spring 1994), pp. 667–99.

3 For example, lawyers made their reputations in the popular collections of *plaidoyers*. See Catherine E. Holmès, *L'Eloquence judiciare de 1620 à 1660: reflet des problèmes sociaux, religieux et politiques de l'époque*, Paris, A. G. Nizet, 1967.

4 Moreau lists over 77 *harangues* in his catalogue. Talon's *harangues* survive in several versions including those in his own *Mémoires*, ed. Louis-Gabriel Michaud et J. F. Michaud, Paris, 1839. A letter to Charles Spon bears testimony to the impact of Talon's rhetoric: "Monsieur Talon, avocat générale, harangua devant la Reine, à ce qu'on dit, divinement, et contenta si fort les gens de bien, qu'on ne parle ici que de ce qu'il a dit." Guy Patin, *Lettres de Gui Patin, 1630–1672*, 3 vols., ed. J.-H. Reveillé-Parise, Paris, Champion, 1907, I, p. 556.

5 All citations for *mazarinades* will first present the title and then the catalogue number assigned by Celestin Moreau (e.g. Moreau 292), and, when available, the shelf number at the Bibliothèque Mazarine in brackets (e.g. [BMI4529]). Unless specified otherwise, the authors are anonymous and the works are published in Paris. Moreau catalogues some 192 *arrêts* that were published as brochures (Moreau 149–341). This includes legislation enacted by *parlements* outside Paris. Among them is the injunction against foreign participation in the conseils d'Etat (*Arrêt de la cour de parlement, portant qu'aucuns cardinaux étrangers, naturalisés, même françois, ne seront reçus dans les conseils d'Estat du roi, et que les qualités de Notre cher et bien amé, attribuées au cardinal Mazarin, seront retranchées de la déclaration de Sa Majesté. Du lundi 20 février 1651*, Paris, Jean Guignard, 1651, Moreau 292 [BMI4529]) and the *arrêt* concerning the sale of Mazarin's household (Moreau 246). Other official publications included letters to provincial *parlements* and other royal officers, such as *Lettre de la cour de Parlement de Paris envoyée à la cour de Parlement de Normandie*, Rouen, 1649, Moreau 1934 [BMI5170bis], *Lettre de la cour de Parlement de Paris envoyée aux parlements du Royaume, du 18 janvier 1649*, Paris, 1649, Moreau 1936 [BMI1217], and *Lettre de la cour de Parlement de Paris, envoyée aux Baillifs, sénéchaux, maires, échevins et autres officiers de ce royaume, du 18 janvier 1649*, Paris, 1649, Moreau 1935 [BMI1216]. *Harangues* provided another category of official publication that was appropriated by the clandestine literature.

6 The experienced propagandist Mathieu de Morgues, who had served Marie de' Medici and went into exile as a pamphleteer for Gaston Duc d'Orléans against Richelieu, emerged in the mid-century as an important writer who bridged various factions. In addition to writing several independent pieces for the influential Garde des Sceaux Châteauneuf, de Morgues was also commissioned by Châteauneuf, with the approval of the *parlementaire* Broussel, to edit the Parlement's *remonstrance* exiling Mazarin from France.

7 Théodore de Godefroy's *Grand cérémonial de France* (1619) was republished by his son at the time of the Fronde as *Le Cérémonial françois* (1649). In this revised edition, the accounts of the heated *lits de justice* of January 15 and July 31, 1648 that pitted Parlement against regent describe with cool precision the spatial and procedural enactment of political authority; pp. 647–50, 1046. *La résistance respectueuse* was a mixture of tradition-bound deference and the assertion of rights and privileges.

8 "Ses préambules estoient tousjours farcis de Latin." *Commerce des nouvelles rétabli, ou le Courrier arrêté par la Gazette*, Paris, 1649, Moreau 718 [BMI4859], pp. 12–13. The pamphleteer is referring to the *Courrier françois*, Moreau 830. See Carrier, 1992, II, p. 212.

9 *Le Virgile Mazarin, ou l'après-soupée des messieurs de S. – Germain*, Paris, Mathurin Henault, 1649, Moreau 4031 [BMI4089]. The Latin play has a French prose dedication to "la pauvre ville de Paris." The players are listed as Gaston, Anne, Condé, Cardinal, and "Le Génie de la ville de Paris." For an example of Latin marginalia see *Ariadne mistérieuse et mistique de madame la princesse*, 1651, Moreau 147 [BMI2477].

10 See e.g. Poussin's letter to Jean Fréart, *Correspondance* p. 393 [December 19, 1648]. See Elizabeth Cropper and Charles Dempsey, *Nicolas Poussin: Friendship and the Love of Painting*, Princeton University Press, 1996, passim.

11 See e.g. *Ovide parlant à Tieste (sic) luy monstrant l'ordre qu'il doit tenir pour gouverner un Estat, & le rendre victorieux malgré ses ennemis . . .* , Paris, 1652, Moreau 2637 [BMI1715], p. 11. In the first of six sections entitled "Que la Coustume doit estre observée, sans que l'on y puisse mettre empeschement," the author of the *mazarinade* borrrowed liberally from Montaigne's essay on habit (I, 23, 1595 edition).

12 *Le Héraclite courtisan*, Paris, 1649, Moreau 1621 [BMI3042]; *Le Héraclite françois parlant I. au roi de l'état de son royaume. 2. sur les justes entreprises de S.A.R. et de mm les Princes*, Paris, 1652, Moreau 1622 [BMI3043]; *Le Caton françois disant les vérités . . .* , sl. 16 mai 1652, Moreau 655 [BMI0711]; *Senèque exilé*, Paris, 1652, Moreau 3639 [BMI3934]; *Senèque mourant*, Paris, 1652, Moreau 3640 [BMI3935].

13 *Plainte du Palais Royal sur l'absence du roy avec un dialogue du grand Hercule de bronze et des douze statues d'albâtre qui sont à l'entour de l'étang du jardin, faicte par un poëte de la cour, H.C.*, Paris, David Beauplet, 1649, Moreau 2783 [BMI1771].

14 *Démocrite et Héraclite, riante et pleurant sur le temps qui court, dialogue satyrique*, Paris, 1649, Moreau 999 [BMI0802].

15 E.g. *Triolets d'Apollon et des neuf Muses*, Paris, François Noël, 1650, Moreau 3848 [BMI0321] and *Rencontre inopinée de Mars et de Vénus dans le cours de la reine, arrrivée nouvellement en France*, 1649, Moreau 3348 [BMI3655].

16 *Le Hercule triomphant, ou les Heureux succès de Sa Majesté en son voyage de Normandie*, Paris, Veuve François Targa, 1650, Moreau 1626 [BMI3046]. See Jean Valdor, *Les Triomphes de Louis le Juste*, Paris, 1649.

17 "Prince en sagesse un vray Caton,/ En valeur un autre Alexandre." Paul Scarron, "La Mazarinade" [February 1649–January 1651], in *Poésies diverses de Scarron; textes originaux.* ed. M. Cauchie, 2 vols., Paris, Didier, 1947–61, II, pp. 17–18, ll. 291–92. Broussel was also compared to Cato. See e.g. the broadsheet of sonnets by Du Pelletier (October 15, 1648). See fig. 43.

18 *Lettre du chevalier Georges de Paris à monseigneur le Prince de Condé*, Paris, Nicolas Boisset, 1649, Moreau 2099 [BMI3800], p. 16. Reprinted in Moreau, 1853, I, pp. 149–72.

19 *Archipraesulis, in Joanne, Francisco, Paulo Gondoeo, propter impugnatum Mazarinum, germanus character. Oratio panegyrica*, Paris, Mathurinus Henault, 1649, signed Mathieu Du Bos, Moreau 146 [BMI0636], passim.

20 *Seconde lettre du sieur du Pelletier, à monseigneur le duc de Beaufort*, Paris, Nicolas de la Vigne, 1649 (March 6, 1649), Moreau 3616 [BMI3911], p. 6. The author uses these exemplars with some irony when eulogizing the "prince des Halles." While the youth of Socrates was "une source de débauches" and the old age of Solomon was made up of vices and idolatries, the author expected more from the Duc de Beaufort.

21 *Couronne de gloire de nos généraux les Césars françois*, Paris, Claude Morlot, 1649, Moreau 808 [BMI0772].

22 *L'Ombre du grand César à m. le prince de Condé pour l'animer à la destruction du Mazarin et la protection de Paris*, Paris, 1652, Moreau 2594 [BMI3154].

23 *Lettre d'un religieux, envoyé à monseigneur le Prince de Condé, à Saint-Germain-en-l'Aye, contenant la vérité de la vie et moeurs du Cardinal Mazarin, avec exhortation audit seigneur prince d'abandonner son parti*, Paris, Chez Rolin de la Haye, 1649,

Moreau 1895 [BMII180], p. 9, Moreau, 1853, I, p. 105. This is the *mazarinade* that received the highest praise from Patin: "Le Mazarin est sanglé là-dedans, tout du long, et très vilainement, comme il le mérite; il me semble que c'est la meilleure pièce de tout ce qui s'est fait." Patin, 1907, I, p. 641 [to Spon, January 25, 1649]. In a pornographic libel not praised by Patin, the same call to "c'est Auguste Senat" was made: *La custode du lit de la Reine qui dit tout*, 1649, Moreau 856 [BMI0084]. "Cet illustre sénat auquel j'ai dédié *l'Union des bons françois*, en forme de panégyrique, qui fera voir à toute la France qu'elle est appuyé d'une main suprême et auxiliare plus puissante que celle d'Hercule, etc." *Manifestation de l'antechrist en la personne de Mazarin et de ses adhérents, avec des figures authéntiques de l'Ecriture sainte, où est vu à découvert l'impiété et le blasphême des mauvais chrétiens de ce temps...*, 1649, Moreau 2350 [BMII543]. Cited by Moreau, 1850, II, p. 235. Another *mazarinade* entitled *Les Merveilles de la Fronde du grand Hercules* [sic] *de Paris*, Anvers, 1649, Moreau 2458 [BMII621], also referred to the Parlement as Hercules.

24 "La véritable image du Senat Romain souz les Empereurs: C'est le vray lieu du throsne de nos Roys, & le véritable conseil de Paris, de toute la France, & des nations mesmes estrangères qui s'y sont soumises. L'on n'y travaille que pour la gloire & par honneur: ces saints Aréopages taschent par leurs peines & par leurs veilles, à nous donner le repos, & les plaisirs d'une douce vie: ils suënt pour le bien du public, ils s'exposent courageusement à l'inimitié des meschans, & ont quelquefois à combattre contre les plus puissans." *Lettre du chevalier Georges*, pp. 15–16, Moreau, 1853, I, pp. 168–69. See Naudé's praise in the *Mascurat*, II, pp. 199, 208–61.

25 *Lettre du chevalier Georges*, p. 16, Moreau, 1853, I, p. 169.

26 *Le Cacus italien renversé par l'Hercule François en prose et en vers burlesque, par le sieur D.L.G.*, Paris, 1652, Moreau 616 [BMI0694].

27 *La Chûte de Phaëton par un vieux Gaulois, revêtu et interprété de nouveau, présentée au roi par un Parisien*, Paris, 1651, Moreau 699 [BMI2640].

28 "Nous pouvons cacher sous la peau de la brebis et évitons les sanglantes mains du Ciclope enragé et furieux." *Correspondance*, p. 399 [May 24, 1649]. "La Sicile partie du Mazarin estoit celle de polyphème le signe de la tyrannie." *Le Triomphe du faquinisme* [sic] *cardinal Mazarin, décrit avec les ornemens & la pompe qu'on voyoit dans les Triomphes de l'ancienne Reyne* [sic]. *Hymne* (n.p., 1652), Moreau 3883 [BMI2361], p. 6. This notion of allegory as a popular strategy is consistent with Sheila McTighe's evidence. However, I wish to claim that this allegorical strategy need not be understood as a specifically libertine behavior. See McTighe, *Nicolas Poussin's Landscape Allegories*, Cambridge and New York, Cambridge University Press, 1996, p. 66.

Mazarin was also represented in more complex mythological political allegories: *Mars captif mis en liberté par Thémis, et le Typhon de la France banni par la même déesse, ou la Délivrance de m. le Prince de Condé par l'entremise du Parlement, et l'éloignement du Cardinal Mazarin ordonné par l'arrêt de cet auguste corps*, Paris, 1651, Moreau 2416 [BMII580]. Thémis is Parlement, Mars is Condé, and Typhon is Mazarin.

29 "Tout Prince n'est qu'une homme, & tout homme est muable. Neron fut vertueux; Neron fut détestable." *Salomon*

instruisant le Roy, Paris, Augustin Courbé, 1651, Moreau 3574 [BMI4966], p. 17.

30 See e.g. *Les Regrets du Cardinal Mazarin sur le lèvement du siège de Cambray avec la description des arcs de triomphe qu'il prétendoit faire ériger lorsqu'il feroit sa première entrée dans cette place*, Paris, 1649, Moreau 3085 [BMI2III], p. 4.

31 *Le Triomphe du faqinissme*, p. 3.

32 Ibid., p. 4.

33 Ibid.

34 "On y voit l'escolier, et les troupes claustrales,/ Nosseigneurs les laquais/ Les Dames de baquets,/ Et tous les Habitans du Royaume des Hales." Ibid.

35 Ibid., p. 5.

36 "Ses hautes enterprises/ et fait mille tableaux/ de ses faits les plus beaux/ et des plans des citez qu'il voudroit avoir prises." Ibid.

37 "Le Triomphe de Vénus Paphienne & celuy de Cupidon Gomorréen y devoient aussi estre représentés, avec toutes les friponneries, inventions & finesses dont se servent ceux qui révérent ces deux Divinitez & qui mettent en pratique l'amour naturel & son contraire." *Les Regrets du Cardinal Mazarin*, p. 5.

38 *Le Triomphe du faqinissme*, p. 5.

39 Ibid., p. 6.

40 "Il est temps spectateurs que la pompe finisse,/ Tournez l'oeil & le coeur devers ce sacrifice." Ibid., p. 8. There are several references to triumphs in the literature of the Fronde: see e.g. Moreau 686, 1211, 1626, and 1638.

41 For a discussion of practice theory, see Marshall David Sahlins, *Historical Metaphors and Mythical Realities: Structure in the Early History of the Sandwich Islands Kingdom*, Ann Arbor, University of Michigan Press, 1981. As Sahlins put it, "there is a change of value in action." See William H. Sewell, Jr., "A Theory of Structure, Duality, Agency, and Transformation," *American Journal of Sociology* 98:1 (July 1992) pp. 1–29.

42 This positive comparison of the Roman general and statesman to Mazarin is acknowledged by Scarron in his "Le Mazarinade"; he points out ironically that it is sheer coincidence that Jules César was the namesake of Jules Mazarin (ll. 5–6).

43 *Disgrâce de Mazarin, avec ses préparatifs à une honteuse fuite*, LDCF, Paris, 1652, Moreau 1155 [BMI0113]. The tract demanded that Brutus kill Caesar (read Mazarin).

44 "Vous supportez César et sa fortune." *Le Mercure de la Cour*, 1652, Moreau 2452 [BMII618], cited by Moreau, 1850–51, II, p. 267.

45 *Les Curieuses recherches faites sur la vie de Jules César, pour montrer les conformités de Mazarin avec les vices de ce Romain, dont il porte une partie du nom, lequel en est le symbole*, 1652, Moreau 855 [BMI2711], p. 4.

46 Ibid., p. 7. The influence of the *intendants* in the affairs of state at the expense of the sovereign courts was also compared to the Tribune's infringement of the power of the Senate. Ibid., p. 8.

47 *La Véritable response faite par les dames du Parlement de Paris à la letre* [sic] *qui leur a esté escrite par les dames du Parlement de Bordeaux, pour les remercier de la paix, suivant l'extraict tiré de leur Registres, contenant un agréable récit de ce qui s'est passé à Bordeaux durant que la cour y a demeuré*, 1650, signed la dame Du Tillet, Paris, August 28, 1650, Moreau 3961 [BMI2383], pp. 6–7.

48 Achilles III Harlay's painting was originally commissioned by Pointel. See Chapter Seven below.

49 Achilles II de Harlay, *Les Oeuvres de C. Tacite, traduites de latin en françois par M. Achilles de Harlay*, Paris, Vve J. Camusat et P. le Petit, 1644, "préface," n.p.

50 Tacitus, *The Annals of Imperial Rome*, trans. Michael Grant, London, Penguin, 1989, p. 388.

51 For the displacement of Ciceronian rhetoric by the historical style of Tacitus in late sixteenth-century French humanism see Nannerl O. Keohane, *Philosophy and the State in France: The Renaissance to the Enlightenment*, Princeton University Press, 1980. See J. H. M. Salmon, *Renaissance and Revolt: Essays in the Intellectual and Social History of Early Modern France*, Cambridge and New York, Cambridge University Press, 1987.

52 Suetonius also provided historical evidence but Tacitus is more frequently found in the literature. See e.g. *L'Esprit du feu roy Louis XIII à son fils Louis XIV, luy monstrant que la mauvaise conduite de Mazarin, est la cause des troubles de l'Estat, et luy donnant les moyens infaillibles de les appaiser, par son retour en sa bonne Ville de Paris*, Paris, 1652, Moreau 1287 [BMI0914]. The author refers to Tacitus's description of Tiberius as "le Prince le plus rusé qui jamais eut l'honneur de s'asseoir sur le trosne des Césars" who had for a long time "des inclinations & des tendresses particulières pour Aelius Seianus" (p. 26). The author also implicates Sejanus in the poisoning of Germanicus (pp. 28–29).

53 Tacitus, 1989, p. 167. Noémi Hepp, "Peut-on être homme de bien à la cour?" in *La Cour au miroir des mémorialistes, 1530–1682*, ed. Noémi Hepp, Paris, Klincksieck, 1991, p. 169.

54 *Chronologie des reynes malheureuses par l'insolence de leurs favoris, dédiée à la reyne régente pour luy servir d'exemple et de miroir*, Paris, Claude Morlot, 1649, Moreau 698 [BMI1997]. Among the queens are included "Hecuba, mother of Priam, Olympias, mother of Alexander, Agrippina, mother of Caligula, Joanna of Castile, mother of the Emperor Charles V, and Anne Boleyn, mother of Elizabeth." Another author advised Anne of Austria that if she was not warned by the fate of Nero's mother Agrippina, she should consider the more recent example of the exile of Maria de' Medici by her own son. *Dernière et très-importante Remonstrance à la Reine et au seigneur Jules Mazarin, pour haster son départ de la France*, Paris, 1652, Moreau 1020 [BMI2781], p. 9. The same author also admonished the Queen Regent not to emulate Caligula (p. 10).

55 *Métamorphose de Mazarin en la figure du Dragon Notre-Dame, en vers burlesque*, Paris, 1652, Moreau 2463 [BMI1625]. Mazarin is compared to Nero burning Rome. *Examen de l'écrit dressé par Molé, Servien et Zondedei [sic] sous le titre de "Edit du roi portant amnestie de tout ce qui s'est passé à l'occasion des présents mouvements, à la charge de se remettre, dans trois jours, dans l'obéissance du roi*," Paris, 1652, Moreau 1314 [BMI2912] and Moreau 1618.

56 Among those *mazarinades* discussed below, the following were repetitions of the earlier period. *Les Apparitions épouvantables [sic] de l'esprit du marquis d'Ancre, venu par ambassade à Jules Mazarin. Le marquis d'Ancre en reproches avec Mazarin*, n.p., 1649, Moreau 144 [BMI2476], p. 4; *Avis salutaire, donné à Mazarin pour sagement vivre à l'avenir*, Paris, Arnould Colttinet, 1648, Moreau 536 [BMI1996]. Imitation of 1614 piece "Avis salutaire, donné à Cardinal de Sourdis pour sagement vivre à l'avenir"; *Le Bon françois à m. le Prince*, Paris, Gilles de Halline, 1652, Moreau 587 [BMI2587]. Imitation of a 1614 piece written in response to a *libelle* "le Vieux gaulois à messieurs les princes"; *Diogène françois ou l'homme d'Estat à la France soupirante*, Paris, Jacques Poncet, 1652, Moreau 1097 [BMI0107], was a reprint of a 1615 pamphlet. *Les Lunettes à toutes âges [sic], pour faire voir clair aux ennemis de l'Etat*, Paris, Veuve Jean Remy, 1649, Moreau 2335, was an imitation of a piece entitled: "Les Lunettes à touts âges, pour faire voir clair à ceux qui ont la vue troublé (1615)."

57 See Hélène Duccini, "L'État sur la place: Pamphlets et libelles dans la première moitié du XVIIe siècle," in *L'État baroque: Regards sur la pensée politique de la France du premier XVIIe siècle*, ed. Henry Méchoulan, Paris, J. Vrin, 1985, pp. 289–300, and *Concini: Grandeur et misère du favori de Marie de Médicis*, Paris, Albin Michel, 1991. Jeffrey K. Sawyer, *Printed Poison: Pamphlet Propaganda, Faction Politics, and the Public Sphere in Early Seventeenth-Century France*, Berkeley, University of California Press, 1990.

58 Pierre Matthieu, *La Conjuration de Conchine ou l'histoire des mouvemens derniers*, Paris, Michel Thevenin, 1619, p. 269. Matthieu's *Aelius Sejanus, histoire romaine recueillie de divers autheurs*, Paris, R. Estienne, 1617, was published in several editions in Paris, Lyon, and Rouen from 1617 to 1642.

59 *Association de Messieurs le princes pour le bien public*, Paris, BN, nouv. ac. fr. 7797, fol. 88, n.p.

60 "Les étrangers et leur fauteurs se sont impatronisés et mis en possession absolu le gouvernement du royaume qu'ils occupent injustement et exercent avec une extrême tyrannie et oppression." Ibid., n.p.

61 "Le feu et le fer furent employés pour couper la racine du mal si contagieux, que le salut de tout le royaume en estois menacé; une punition aussi soudaine comme la foudre [de Jupiter] tomba sur la tête d'un seul pour la correction et pour l'exemple de plusieurs." The speech was made by Père Lingendes. Cited by Duccini, 1991, p. 397.

62 "Ce conquérent dès sa naissance/ Comme lui [Hercule] donna des combats;/ Et les Dragons qu'il mit à bas/ Furent les jeux de son enfance." Pierre Corneille, *Les Triomphes de Louis Le Juste*, 1649, n.p.

63 See François-Nicolas Baudot Dubuisson-Aubenay, *Journal des guerres civiles de Dubuisson-Aubenay, 1648–1652*, ed. G. Saige, 2 vols., Paris, 1883–85, I, p. 25.

64 For example, the interdiction was cited by the nobility in their remonstrances delivered at an assembly at Troyes in 1649. Y. Durand, ed., "Cahier des remonstrances de la noblesse du baillage de Troyes," in *Deux Cahiers de la Noblesse pour les États Généraux de 1649–1651*, ed. R. Mousnier., J.-P. Labatut, Y. Durand, Paris, Presses universitaires françaises, 1965, p. 142.

65 *Ombre du maréchal d'Ancre, apparue au cardinal Mazarin en la ville de Sédan, touchant la résolution qu'il doit prendre sur les troubles qu'il a suscités en France, pour la sêureté de sa personne*, 1651, Moreau 2595 [BMI1698], pp. 3–4. See also *Satyre contre Mazarin*, Paris, 1651, Moreau 3587 [BMI0282], p. 7.

66 *Parallèle des plus pernicieux et abominable tyrans que la nature réprouvée ait jamais su créer en forme d'hommes, ou Véritable parangon des moeurs, humeurs, conditions et maximes de Jules*

Mazarin avec celles d'Oelius Séjanus, l'un et l'autre généralement reçus de tout l'univers pour les plus illustres Coryphées de tout la doctrine machiavélique, dédié à monseigneur le Prince, Paris, 1652, two parts, Moreau 2680 [bmi3183], i, p. 4.

67 *L'Ambitieux, ou le Portrait d'OElius Séjanus en la personne du cardinal Mazarin*, Paris, Pierre du Pont, 1649, Moreau 73 [bmi2443], pp. 3–4.

68 In order to have free rein of the state, Sejanus encouraged Tiberius to become a recluse at his villa. Mazarin similarly sequestered the young king. Ibid., p. 7. See e.g. the *Parallèle des plus pernicieux* (i, pp. 18, 30) and *Les Regrets du Cardinal Mazarin* (p. 9) which also take up this theme.

69 *L'Ambitieux*, p. 5. In *Parallèle des plus pernicieux*, there is a series of direct parallels between Sejanus and Mazarin, Germanicus and Condé. Mazarin's threats on the life of Condé arose from jealousy over the prince's victories in the low countries just as Sejanus sought the death of Germanicus because of his triumphs in Germany (ii, pp. 10–13). The death of Germanicus parallels the incarceration of Condé at Vincennes (ii, pp. 14–15).

70 *L'Ambitieux*, p. 5.

71 "Cruel tyran, Séjanus, nostre ennemy commun . . . qui ayme la confusion et le desordre." *Le Sésanus romain au roy, ou l'abbrégé des crimes du proscript Mazarin*, Paris, 1652, Moreau 3667 [bmi3945]. Imitation of "Sésanus françois" (1615), pp. 6, 10.

72 "A tous les gens d'esprit es Reyne/ Et pourtant, d'un Roy, pedagogue! . . ./ Bougre à chèvres, bougre à garçons,/ Bougre de toutes les façons." Paul Scarron, "La Mazarinade" (l. 373), cited by Moreau, 1853, ii, p. 252.

73 See Pauline M. Smith, *The Anti-Courtier Trend in Sixteenth Century French Literature*, Geneva, Droz, 1966, p. 202 n. 2.

74 "Si c'est un Courtisan Français,/ Il veut sçavoir combien de fois/ Il a fait le peché de Rome,/ Je voulois dire de Sodome:/ Mais si c'est un Italien,/ Il ne luy demandera rien." *L'Enfer burlesque ou le sixième livre de l'Eneïde travestie et dédiée à mademoiselle de Chevreuse, le tout acommodé à l'Histoire du Temps* (Anvers) Paris, 1649, Moreau 1216 [bmi0473], p. 23.

75 See e.g. "Cet homme, sans naissance, sans conduite, sans vertu, & principalement sans foy" conducted the education of the king at "un aage qui doit recevoit et retenir les impressions." *La très-humble et véritable Remonstrance de nos seigneurs du Parlement pour l'esloignement du Cardinal Mazarin*, Paris, Jacob Chevalier, 1652, Moreau 3808 [bmi2347], p. 9.

76 "Des inclinations & des tendresses particulieres pour Aelius Seianus." *L'Esprit du feu roy Louis XIII*, p. 26.

77 "La passion, Sire, ne me faict point parler, je n'ay aucun interest en ses affaires, mais la vérité guide mes paroles, jamais Catelina Marius ny Silla, dont l'histoire Romaine [de Tacite] fait mention, ne furent si pernicieux à l'Empire que ce nouvel Sésanus l'est à la France, le Trionvirat ne fit jamais tant de mal que ce Sésanus faict." *Le Sésanus romain*, p. 23–24.

78 "Le Parlement, cet auguste senat de la Justice des Roys, cest cour des Pairs, le ferme coullonne de vostre Couronne est menassée de mort, de prison perpetuelle ou d'exile, si elle continue en ses très-humbles remonstrances." Ibid., p. 4.

79 Ibid., p. 3.

80 Livy, *The Early History of Rome*, trans. A. de Sélincourt, London, Penguin, 1960 (*History*, ii, 40), p. 150, and Plutarch, *Makers of Rome*, trans. Ian Scott-Kilvert, London, Penguin, 1965 (*Lives*, xii, 34), pp. 46–50.

81 "La composition . . . donne à Poussin une nouvelle occasion d'étudier les attitudes des femmes qui supplient le héros, mais aussi de traiter d'un thème politique (lié aux guerres de la Fronde?) dont l'artiste exploite la signification à des fins morales et exemplaires." Pierre Rosenberg, *Nicolas Poussin, 1594–1665*, Rome, Villa Medici, November 1977–January 1978, Rome, Edizioni dell'Elefante, 1977, pp. 218–20. "On peut y reconnaître en effet un écho de la Fronde des princes (1650–52)." Alain Mérot, *Poussin*, Paris, Hazan, 1990, p. 143.

82 Based on stylistic evidence after cleaning, the painting has been dated to c. 1651 in Rosenberg, 1978.

83 *Correspondance*, p. 397 [May 2, 1649].

84 The siege of Bordeaux was treated as an infamous collaboration of foreign mercenaries, the foreign first minister Mazarin, and fellow Frenchmen. Jouhaud, 1985, passim. We have seen the brothers Fréart actively engaged in the fortification and defense of Le Mans against the troops loyal to Mazarin. The siege of Cambrai (June 24–July 3, 1649) was a failed attempt by Mazarin to garner support; the threat to peace was attributed to the minister's ambitions. See Carrier, 1989, i, p. 230; Nicolas Goulas, *Mémoires*, ed. Charles Constant, 3 vols., Paris, Renouard, 1879–82, iii, p. 85; *Triolets de Paris*, 1649, Moreau 3854 [bmi0327] and *Triolets sur Cambrai*, 1649, Moreau 3865 [bmi0340]. The siege of Anger mobilized Gaston and galvanized Paris, resulting in some twenty *mazarinades*. Carrier, 1989, i, p. 253. The siege of Etampes (May–June, 1652) also resulted in twenty *mazarinades*. Ibid., p. 262.

85 Livy, 1971, p. 145. For Plutarch, the wheat deal was characteristic of the Roman's singularly steadfast position. Plutarch, 1965, p. 30.

86 Poussin's choice therefore seems to temper the severe disregard of *le peuple* attributed to him in Blunt's account of the Phocion landscapes. Anthony Blunt, "The Heroic and the Ideal Landscapes of Nicolas Poussin," *Journal of the Warburg and Courtauld Institutes* 7 (1944), pp. 154–68.

87 Livy and Dionysius of Halicarnassus name the mother Veturia and the wife Volumnia. Plutarch chose Volumnia for the mother and Vergilia as the wife, suggesting different sources for this account.

88 Livy, 1971, p. 150.

89 Ibid.

90 Mazarin was refused an honorable entrance by the magistrates of the city of Sedan when the cardinal moved his troops through in 1651. *Nouveau caquet, ou Entretien de l'accouchée sur le départ du Cardinal Mazarin de la ville de Dinan jusqu'à son arrivée à Saint-Germain, première journée*, Paris, 1652, Moreau 2533 [bmi0517], pp. 7–10. An actual or fictive *harangue* of December 25, 1651, was cited in its entirety.

91 *Le Triomphe des armes parisiennes et le retour de l'abondance à Paris*, Paris, Claude Morlot, 1649, Moreau 3881 [bmi4002], p. 6. The pamphlet begins "Les audacieux Mazarinistes ayans inhumainement conjuré la ruine de Paris, ne se sont contentés pour en venir à bout de l'encloire de tous costez pour l'affamer, & d'avoir laisse mille marques de leur fueur & de leur rage à

Sainct Denis, à Surene, à sainct Cloud, à Meudon, à Clamar, à Charenton, & en tous les autres lieux que leur barbarie a occupez" (p. 3).

92 *Relation dernière et véritable de tout ce qui s'est passé en l'attaque & combat de la ville d'Estampes entre l'armée du Roy & celle de Mrs les Princes, vers S. Lazare & le lien appellé le Corps Saints, depuis le 29 may jusques au 1 juin 1652*, Paris, Jacob Chevalier, 1652, p. 7. Not published by Moreau [BMI2117]. The city sent deputies of Parlement to entreat the king to put an end to the misery by exiling Mazarin.

93 *Le Caquet ou Entretien de l'accouchée, contenant les pernicieuses entreprises de Mazarin découvertes*, Paris, 1651, p. 11, Moreau 630 [BMI2608]. The letter from Bordeaux is dated August 29, 1650.

94 For Châteauneuf see Chapter Five, n. 70 above. The other proposed owner, Antoine Loisel, was an active member of the Parlement's opposition to the regime. He was directly involved in the trial and ostracism of Mazarin. He made the initial inventories of Mazarin's possessions and investigated the allegations against Mazarin in his dealings with Cantarini. As in the hypothetical case of Châteauneuf, the picture may have complemented the client's active participation in the political arena wherein parallels to Roman history constituted the terms of discourse. For Loisel see Chapters Five above and Seven below.

95 See Mademoiselle de Montpensier, *Mémoires de Mademoiselle de Montpensier*, ed. A. Chéruel, 4 vols., Paris, 1848–68, R. Charpentier, II, p. 120.

96 Ibid., pp. 127–28.

97 For references to Mademoiselle as a warrior see Carrier, 1989, I, p. 256. At least ten libels immediately celebrated her entrance into Orleans. See e.g. *Les Généreux sentiments de Mademoiselle, exprimés à m. le duc d'Orléans, son père, Paris, 1652*, Moreau 1489 [BMI2982] and the print devoted to her in BN Est. Qb1, 1652 (see fig. 56). The Amazonian imagery was used to represent the Duchess of Chevreuse as well: *Amazone françoise au secours des Parisiens, ou l'Approche des troupes de Mme la duchesse de Chevreuse*, Paris, Jean Hénault, 1649, Moreau 63 [BMI2441].

98 " . . . La gloire des armes a rendu autresfois signalées plusieurs de mon sexe; des filles ont jetté les fondemens d'un puissant Empire, & au milieu des plus forts & plus vaillans hommes de la terre. Les Amazones ont regné plus de deux cents ans; nous ne sommes plus dans ce temps auquel la vertu ne paroissoit qu'estant Armée, bien qu'il se trouve des Heroïnes, néantmoins leur générosité paroist toute dans la force de l'esprit & non pas dans celle du corps. Les Poëtes ont feint que Jupiter avoit donné ses foudres à sa fille Themis, aussi n'estoient ils jamais lancez que contre les géans, contre les tyrans & contre les testes criminelles. Je puis dire Monseigneur, que depuis que vostre Altesse Royale, ayant recogneu les vices du Cardinal Mazarin, a voulu chastier son insolence & abbatre son orgueil, je me suis laissée emporter à un semblable désir de contribuer à sa defaite de mes deniers, pour lever des troupes pour le combatre, tandis que vous avez entre vos mains la plus grande partie des forces de l'Estat." *Les Généreux sentiments de Mademoiselle*, pp. 6–7.

99 See *La Véritable relation de ce qui s'est passé entre les habitans de la ville d'Angers & les troupes du cardinal Mazarin*, p. 8.

100 See *Le Caquet ou Entretien de l'accouchée*, p. 13.

101 "La liberté de nostre patrie." *Lettre des dames du Parlement de Bordeaux aux dames du Parlement de Paris, contenant les remerciments de leur entreprise pour la paix, avec un récit véritable de tout ce qui s'etoit passé au dedans et au dehors la ville de Bordeaux pendant le Siège, écrite pendant la trève*, Bordeaux, 1650, Moreau 2071 [BMI1337], p. 4.

102 "On ne nous a pas seulement descrit la beauté de vos charmans visages, mais encore vostre valeur, vostre générosité, & la grandeur de vostre courage. Tantost on vous a représentées occupées à travailler avec vos belles mains à vos fortifications; tantost à repousser vos ennemis du pied de vos murailles; & tantost à animer vos maris au combat." *La Véritable response faite par les dames du Parlement de Paris*, 1650, Moreau 3961, p. 4.

103 See Francois Berthod, *Mémoires (1652–1653)*, Paris, Didier, 1854, p. 580. The "woman of the people" was also exploited as a figure of popular disorder in pamphlets. The cries of women in the street of Paris were repeated in print, sometimes anxiously to ridicule the specter of collective power as a grotesque monstrosity. *Le caquet des marchandes poissonières et harangères des halles sur la maladie du duc de Beaufort, soupçonné de Poison, et leur voyage au palais de ce Prince*, Paris, 1649, Moreau 629 [BMI2607]. When the women march out of Les Halles the author states: " . . . qu'on ne fait pas le jour du mardy gras à voir les masques. La grotesque façon dont elles sont vétuës, donnerent à rire, & quelques uns les voyent ainsi melangées." *Le caquet des marchandes*, p. 8.

104 On Dame Anne, see Carrier, 1989, I, p. 119–22. She is represented in at least one contemporary print as an elderly woman. "La magnifique nopce de Jeane," BN, Cabinet des Estampes, Qb 1. 1650.

105 *Entretien politique de Jaquelon et de Catau sur le retour du roi*, 1649, Moreau 1243 [BMI0892]. Carrier, 1989, I, p. 231. There is also the example of a prostitute addressing the Prince de Condé: *Lettre de la petite Nichon du Marais, à Monsieur le prince de Condé à Saint Germain*, 1649 (signed January 26), Moreau 1940 [BMI0176].

106 See Domna C. Stanton, "Recuperating Women and the Man Behind the Screen," in *Sexuality and Gender in Early Modern Europe: Institutions, Texts, Images*, ed. J. G. Turner, Cambridge University Press, 1993, pp. 247–65.

107 There is at least one known author of *mazarinades* who used her own name, Charlotte Henault. See Carrier, 1989–92, I, p. 304, and II, p. 21. *Admirables sentiments d'une fille villageoise envoyée à monsieur le Prince de Condé touchant le partie qu'il doit prendre*, Paris, Jean Hénault, 1648, Moreau 47 [BMI2435], signed Ch. H. Naudé mentions the work in the *Mascurat*, p. 8. Moreau attributed other works to her: Moreau 1486 [BMI2980], 596 [BMI0686], 1269 [BMI2868], and 2657 [BMI1725].

108 Letters supposedly intercepted between Mademoiselle and Gaston, Madame la duchesse d'Orléans and her brother, or Condé and his mother, were useful tools in political argument. See e.g. *Les Généreux sentiments de Mademoiselle, exprimés à m. le duc d'Orléans*, 1652, *Lettre de madame la duchesse d'Orléans envoyée au duc Charles son frère sur le sujet de son infâme Trahison*, Paris, Chez Jean du Prat, 1652, Moreau 1949 [BMI3427]. *Remonstrance faite par madame la princesse douairière de Condé au prince de Condé son fils, en faveur de la ville de Paris*, Paris, Michel Met-

tayer, 1649, Moreau 3330 [BMI3644]. See also, *Lettre de madame la princesse douairière de Condé présentée à la reine régente*, 1650 [dated Chantilly, May 16, 1650], Moreau 1954 [BMII240]. During Condé's imprisonment, the women in retreat at Chantilly actively read and probably wrote *mazarinades*. Pierre Lenet, *Mémoires*, ed. J.-P. Michaud and J.-J. Poujalat, 3rd series, Paris, 1850, II, p. 230. For a letter from a woman of Les Halles, see *Lettre d'une bourgeoise de la paroisse Saint Eustache présentée à Mademoiselle suppliant Son Altesse de vouloir agir pour la paix du Royaume*, Paris, Chez Guillaume Sassier, 1649, Moreau 1899 [BMII183], signed SDN (Suzanne de Nervèse). See Carrier, 1989, I, p. 239.

109 "Alors qu'on se plaignoit à ce Cardinal des voleries, sacrilèges, impietez & outrages que les soldats de son armée faisoient, il ne respondoit autre chose, sinon que c'estoient les effets de la guerre, sans confesser que luy seul estoit la cause des desordres & de la guerre." *Nouveau caquet*, p. 19.

110 It is significant that in the first *Caquet ou Entretien de l'accouchée*, the women represent the interests of a particular class. The commercial interests of Paris and their correspondents in outlying cities are voiced by the women: the woman in bed is the wife of "un Parfumeur de Cour dans Paris." She is joined by "La femme d'un Banquier en Cour de Rome sa cousine, Une marchande de Soye sa soeur, Une marchande Lingere sa commere, Une autre Parfumeuse parente de son mary, Une Espiciere sa voisine, La femme d'un Esleu sa compagne ordinaire, Une marchande Merciere, Et une marchande Pelletiere." *Caquet ou Entretien de l'accouchée*, p. 4. The *Nouveau caquet*, probably written by the same hand, numbers among the company, the wives of *robins* as well as merchants: a wife of a *secretaire du Roy*, a wife of a *maitre facteur des marchands estrangers & françois*, a wife of an *avocat du Conseil*, the wife of a *concierge de la maison d'un grand*, the wife of a *procureur de la Cour*, and a wife of a *marchand de Marée*. *Nouveau caquet*, pp. 3–4.

111 *Lettre de madame la princesse douairière de Condé*, p. 5

112 Ibid., p. 25.

113 Madeleine de Scudéry, *Les Femmes illustres ou les Harangues héroïques de M. de Scudéry avec les véritables portraits de ces héroïnes tirez des médailles antiques* (Paris, A. de Sommaville et A. Courbé, 1642), repr., Paris, côté-femmes éditions, 1991.

114 "Entre mille belles qualitez que les Anciens ont remarquées en votre sexe, ils ont toujours dit que vous possédiez l'éloquence sans art, sans travail et sans peine." Ibid., p. 28.

115 "L'artifice plus délicat consiste à faire croire qu'il n'y en a point." Ibid., p. 29.

116 "Je méprisais également les prières et les menaces du tyran, ses offres et ses demandes furent également rejetées. L'amour ni la crainte n'eurent point de place en mon âme, la mort ne me fit point d'effroi, et bien loin de l'appréhender, je le dérirais plus d'une fois." Ibid., p. 124.

117 Louise Abbé, Catherine Des Roches, and Madeleine Des Roches were among the important participants in the humanist culture of the sixteenth century. See my "*La Femme à la Puce et la Puce à l'Oreille*: Catherine Des Roches and the Poetics of Sexual Resistance in Sixteenth-Century French Poetry," in *The Journal of Medieval and Early Modern Studies* (spring 2002).

118 The women of Bordeaux in *Lettre des dames du Parlement de Bordeaux* called Mazarin "ce mauvais Pilote, qui merite moins que toute autre de tenir le Timon de l'Estat qu'il a rendu si miserable," thereby combining biblical and antique references (p. 4). In another passage, the crown's soldiers gather in an amphitheatre built by Emperor Galien, inviting the comparison to the lions and tigers of the imperial Romans: "il anima ses soldats qu'imitant ces animaux cruels" (p. 7). There is also a reference to the twin pillars of Mars and Diana (p. 11).

119 *La Véritable response faite par les dames du Parlement de Paris*, pp. 6–8.

120 *Remonstrance faite par madame la princesse douairière de Condé*, p. 6.

121 *La Véritable response faite par les dames du Parlement de Paris*, p. 13.

122 "Il jetta sa veuë sur les Arcs triomphaux de ses sourcils, sur les fenetres de christal de ses yeux, & sur cette sacrée porte du palais, qui est la bouche, d'où sortent contre les Tyrans les Oracles de sa justice." *Lettre des dames du parlement de Bordeaux*, p. 5.

123 Ibid., p. 7.

124 See Merrick, 1994.

125 "Qui eust creu, Monsieur, qu'après tant de protestations d'amour, de services, & de fidélité, vous en eussiez eu si peu pour les François & pour moy? Comment assiéger une ville où est la petite Nichon, la vouloir prendre de force? Hélas vous sçavez, que je ne vous ay jamais refusé l'entrée; je n'ay point fortifié la Place contre vos approches. Et si vous eussiez eu des munitions pour faire seulement une descharge, vous eussiez peu braquer vostre canon sur une eminence proche de la contrescarpe du fossé." *Lettre de la petite Nichon*, p. 5.

126 "Ce ne sont plus les paroles ny la voix, ce ne sont plus les simples accens de la France désolée qui frappent les oreilles de vostre Majesté. Ce sont les larmes, ses misères & son sang qui se présentent à ses yeux, & qui se sont unis pour combattre cette austère résolution, d'affliger la ville de Paris par le sac, & les désordres d'un Siège . . . C'est la plus belle du Royaume . . . qui se vient rendre aux pieds de vostre Majesté, afin d'implorer la protection de vostre main . . . Ce sont les Cloistres & les Vierges . . . qui solicitent la pitié." L. G[ibault], *Trésor des harangues, remonstrances, et oraisons funèbres de ce temps, redigées par ordre cronologique par Me L.G[ibaut] avocat au Parlement*, Paris, Michel Bobin, 1654, p. 126.

Chapter Seven: Frondeurs

1 "Qui ne sçait ce que coustent à la France les comédiens chanteurs, qu'il a fait venir d'Italie, parmy lesquels estoit une infâme qu'il avoit desbauchée à Rome, & par l'entremise de laquelle, il s'estoit insinué dans les bonnes graces du Cardinal Antonio? Tout cela durant la guerre, dans le temps qu'on mettoit le peuple à la presse pour contribuer à la subsistance des armées, & le sang des pauvres estoit employé à faire rire le Cardinal Mazarin, à la satisfaction de ses convoitises." *Lettre d'un religieux . . .*, Moreau 1895 [BMIII80], pp. 6–7 Moreau, 1853, I, p. 99. See Chapter Six, n. 23 above.

2 Hubert Carrier, "Mécénat et politique: l'action de Mazarin jugée par les pamphlétaires de la Fronde," in *L'Age d'or*

du mécénat (1598–1661): actes du colloque international CNRS (mars 1983) – Le mécénat en Europe, et particulièrement en France avant Colbert, Paris, Centre national de la recherche scientifique, 1985, p. 254. See e.g. *Dialogue entre le roy de Bronze et la Samaritaine sur les affaires du temps present*, Paris, Arnould Cottinet, 1649, Moreau 1090 [BM14628].

3 "Dans ces extraordinaires despenses de ces Comédies Italiennes qu'il a fait faire au Palais Royal, qu'il y a eu quelque chose d'approchant de l'extravagance de Séjanus." *Parallèle des plus pernicieux*, Moreau 2680 [BM13183], I, p. 33.

4 The poet Jean-François Sarrazin was put in the Bastille as a result of his criticism of the opera. Sarrazin had delivered *la Pompe funèbre* for Voiture, who was also intimate with Chantelou. Gédéon Tallemant des Réaux, *Historiettes*, 3e edition, Paris, Garnier, VII, p. 89. Guy Patin, *Lettres de Gui Patin, 1630–1672*, 3 vols., ed. J.-H. Reveillé-Parise, Geneva, Slatkine, 1972, II, p. 313 [June 14, 1650]. Carrier, 1985, pp. 253–54, and *La Presse de la Fronde*, Geneva, Droz, 1989, I, pp. 137–38. See Henri Prunières, *L'Opéra Italien en France avant Lulli*, Paris, Champion, 1913, pp. 86–150. Sheila McTighe discusses *Orfeo* and its critical reception in relation to the Orpheus myth in Poussin's painting at the Louvre (see fig. 105). McTighe, "The Hieroglyphic Landscape: 'Libertinage' and the Late Allegories of Nicolas Poussin," Ph.D. diss., Yale University, 1987, p. 303f., and *Nicolas Poussin's Landscape Allegories*, Cambridge and New York, Cambridge University Press, 1996, pp. 71–78. For examples of the criticism in *mazarinades* see *Orphée grotesque avec le Bal rustique*, vers burlesques, première partie, Paris, 1649, Moreau 2634 [BM10522] and *L'Ariadne mystérieuse et mystique de Mme la princesse*, 1651, Moreau 147 [BM12477]. See Carrier, 1985, pp. 253–57.

5 On the difficulty of understanding the Italian libretto see Olivier Ormesson, *Journal d'Olivier Lefevre d'Ormesson*, ed. A. Chéruel, 2 vols., Paris, 1860–61, I, p. 178, cited by Prunières, 1913, p. 110. There were three performances leading up to Mardi Gras. After Easter, there were eight performances. Prunières, 1913, pp. 110–11, 129–35.

6 Arnauld d'Andilly decried the construction of a theatre "pour donner place aux immenses machines de cette ennuyeuse Comédie, qui cousta cinq cens mille francs au Roy de l'argent du peuple." *La Vérité toute nue, ou Avis sincère et désintéressé sur les véritables causes des maux de l'Etat, et les moyens d'y apporter le remède*, Paris, 1652, Moreau 4007 [BM14081], p. 4. Guy Joly spoke in his memoirs of the "dépense excessive et superflue" that upset the "compagnies souveraines."

7 "Que ceux qui ayment parfaitement la Vertu, se doivent détacher entièrement des plaisirs de ce monde, et n'attendre leur récompense que du Ciel." Anon., *Orphée, Tragicomédie en musique*, Paris, 1647, BN cote Yf. 946. Libretto not published, ms. Vatican, Codex Barberini 3808. Cited by McTighe, 1996, p. 76.

8 As Sheila McTighe has perceptively noted, "considering the popular view that Mazarin was enriching himself at the expense of the state, this pious statement in such an expensive diversion must have been perceived with more than a little irony." Ibid.

9 After concerted efforts to introduce Italian opera to Paris, Mazarin successfully produced *La Finta pazza* in 1645. Torelli was given permission to publish the libretto with five engravings and a frontispiece engraved by N. Cochin (see fig. 59). *Feste Theatrali per la finta pazza drama del Sigr. Giulio Strozzi. Rappresantate nel piccolo Borbone in Parigi quest anno MDCXLV. Et da Giacomo Torelli da Fano Inventore*, n.d. The illustration is for Act I: 1–2. Per Tjurström, *Giacomo Torelli and Baroque Stage Design*, Stockholm, Almquist & Wiksell, 1961, pp. 134–43. The ballet was published separately. For Mazarin's early dedication of resources to opera in Paris see Neal Zaslaw, "The First Opera in Paris," in *Jean-Baptiste Lully and the Music of the French Baroque: Essays in Honor of James R. Anthony*, ed. John H. Heyer, Cambridge University Press, 1989, pp. 19–23.

10 *Les Regrets du Cardinal Mazarin sur le lèvement du siège de Cambray* (1649), pp. 5–6, 10–11.

11 See Margaret Murata, *Operas for the Papal Court, 1631–1668*, Ann Arbor, University of Michigan Press, 1981, and Frederick Hammond, *Music and Spectacle in Baroque Rome: Barberini Patronage under Urban VIII*, New Haven and London, Yale University Press, 1994.

12 See Terence Ford, "Andrea Sacchi's 'Apollo crowning the singer Marc Antonio Pasqualini,'" *Early Music* 12 (February 1984), pp. 79–84, and my forthcoming article based on a paper, "*Evviva il coltello*: Marsyas and the Castrato," delivered at the College Art Association Annual Conference, 1997.

13 The Comte de Bury, son of the Marquis de Rostain, came to blows with Pasqualini. Prunières, 1913, p. 89. Regarding the "moeurs" of Antonio Barberini see Nicolas Goulas, *Mémoires*, ed. Constant, Paris, Renouard, 1879–82, II, p. 118.

14 Jeffrey Merrick, "The Cardinal and the Queen: Sexual and Political Disorders in the Mazarinades," *French Historical Studies* 18:3 (spring 1994), pp. 667–99.

15 Cyrano de Bergerac: "Pour en faire rire quelques-uns, cependant qu'il en faisoit pleurer une infinité, il a tiré de l'Italie des farceurs, de qui les postures n'estoient gueres plus honnestes que celles de l'Aretin, qui faisoient profession ouverte d'introduire les Images de toutes les voluptez scandaleuses par les yeux et par les oreilles, et qui pour estre entendus avec moins de peine et avec plus d'authorité, enseignoient à faire des maquerelages de tout Sexe en plein Theatre, et ce qui n'est pas moins étrange, dans une maison Royale." *Le Gazetier désintéressé*, Paris, Jean Brunet, 1649, Moreau 1466, repr. in Cyrano de Bergerac, *Oeuvres complètes*, ed. Jacques Prévot, Paris, Belin, 1977, p. 324. See Carrier, 1985, p. 255.

16 See Prunières, 1913, p. 92.

17 "All'armi, mio core,/ E contro il rigore/ D'avara beltà/ Tue forze prepara." Ibid., p. 117.

18 Ibid.

19 Ibid., p. 108.

20 Moreau 638 [BM12613], p. 6. See Carrier, 1989, I, p. 304.

21 "L'intendant de quelques plaisirs qui ne sont pas fort honnestes à dire." *Parallèle des plus pernicieux*, I, p. 6. The same charge was echoed in one of the most heralded *mazarinades*: "Il s'y signala par ses débauches, & fut l'intendant des plaisirs deshonnestes de la Cour Romaine." *Lettre du chevalier Georges*, p. 6, Moreau, 1853, I, p. 154; see Goulas, II, p. 118. Unlike Sejanus, who came from a noble family, Mazarin was the son of a "pauvre chapelier, natif de Sicile." The *mazarinades* remind us repeatedly that Mazarin came from low condition in Sicily, whose people were reduced to servitude. Because sexual relations between men were somewhat tolerated among the French nobility, the severe

abhorrence of Mazarin's sodomy was contingent on the accusation of lowly and foreign birth. For the political symbolism of sodomitical rape see Richard C. Trexler, *Sex and Conquest: Gendered Violence, Political Order, and the European Conquest of the Americas*, Ithaca, Cornell University Press, 1995.

22 Cyrano: "Cependant cét amour abominable qui ne cherche que les enfans, & qui n'en sçauroit estre jamais le père, a esté une des premieres occupations de sa vie; il a connu ce vice, lors qu'il pouvoit à peine nommer, & s'y est abandonné dans un âge, qui est dans tous les autres, l'âge d'innocence. Dans ce commerce pour qui les loix n'ont pu trouver de moindre punition que celle du feu, il fit depuis l'épreuve de ce Tirésias de la fable, pour mettre toutes les abominations en usage; & dans cét estat dont l'idée seule fait trembler, il fut long temps le mary de ceux là mesme dont il avoit esté la femme. Cette horrible galanterie l'approcha de plusieurs personnes pour estre & l'object & le ministre de leurs voluptés enragées; de leur galand & de leur maistresse, il devint en suite leur maquereau, & s'efforça par toutes ses brigues de leur procurer ce qu'il ne pouvoit plus leur vendre. Il fut assez heureux dans cette negotiation scandaleuse; il tira d'abord quelque fruict de cette Ambassade." *Le Gazettier désintéressé*, p. 5, *Oeuvres complètes*, 1977, p. 321. In the same *mazarinade*, Mazarin is both Medea and a harpie (p. 23). See Randy Conner, "Les Molles et les chausses: Mapping the Isle of Hermaphrodites in Premodern France," in *Queerly Phrased: Language, Gender, and Sexuality*, ed. Anna Livia and Kira Hall, New York and Oxford, Oxford University Press, 1997, pp. 127–46.

23 Montaigne, *The Complete Essays*, London, Penguin, 1991, III, 9, p. 1087.

24 "Si vous n'estes Italiens,/ Vous ne verrez point l'Orphée." *L'Enfer burlesque ou le Sixième livre de l'Eenïde traverstie, et dédiée à mlle. de Chevreuse, le tout accommodé à l'histoire du temps* (Anvers), Paris, 1649, Moreau 1216 [BMI0473], p. 6.

25 For an important discussion of the failures of Mazarin's literary patronage, to which I am indebted, see Carrier, 1985. See also Carrier, 1989, I, pp. 149–52. Carrier gives a fair picture of the political suicide entailed by the creation of a force of disenfranchised writers when there was a demand for libels.

26 Dubuisson-Aubenay, *Journal des guerres civiles de Dubuisson-Aubenay, 1648–1652*, ed. G. Saige, Paris, 1883, I, p. 6 [after January 21, 1648]. See Tjurström, 1961, p. 134f.

27 See Hepp, 1991.

28 See Carrier, 1985, and 1991, I, p. 149–52.

29 Scarron had dedicated his *Typhon* (1644) to Mazarin. He did not receive any patronage until a pension of a mere 500 écus was received from Anne of Austria in 1648. Paul Scarron, "La Mazarinade" in *Poësie diverses de Scarron*, ed. M. Cauchie, 2 vols., Paris, Didier, 1947–61, II, pp. 17–18. See also his *Triolets de la cour* (1649). See Carrier, 1985, p. 251.

30 "Bougre grand, & petit volume,/ Bougre Sodomisant l'Estat,/ Et bougre du plus haut Karat." Scarrron, "La Mazarinade," p. 7.

31 "Les pauvres Courtisans des Muses/ Sont aujourd'huy traittez de Buzes/ Qu'autrefois defunct Richelieu,/ Qu'ils on traitté de demy-Dieu." Scarron, "Epitre chagrine," n.p., 1652, Moreau 1268 [BMI5116], n.p.

32 Ibid.

33 *Moise sauvé* (1653), extract in *Actes du colloque Nicolas Poussin* (1958), ed. André Chastel, Paris, CNRS, 1960, II, p. 97. Hereafter *Actes*, 1960. Saint-Amant was protected by Gondi, Cardinal Retz, for whom he wrote *mazarinade* poetry, the *Nobles triolets* (1649). See Chapter Five, n. 107 above.

34 Mazarin received the charge of "surintendant au gouvernement et de la conduitte de la personne du roy" on March 15, 1646. BN MS Fr. 4222. no. 13, fol. 40.

35 Arnauld d'Andilly: *Avis d'Etat à la reine, sur le gouvernement de sa régence*, 1649, Moreau 498 [BMI0666]. For the attribution of this pamphlet and *La Vérité toute nue, ou Avis sincère et désintéressé sur les véritables causes des maux de l'Etat, et les moyens d'y apporter le remède*, Paris, 1652, Moreau 4007 [BMI4081], see Hubert Carrier, "Port Royal et la Fronde: deux mazarinades inconnues d'Arnauld d'Andilly," *Revue d'histoire littéraire de la France* 75:1 (January–February 1975), pp. 3–29.

36 According to Tallemant des Réaux. See Antoine Adam, *Histoire de la littérature française au XVIIe siècle*, 5 vols., Paris, Domat, 1948–56, II, p. 468.

37 Three *mazarinades* have been attributed to Marc de Vulson, Sieur de La Colombiere: the highly successful *Raisons d'Estat contre le ministre étranger*, n.p., 1649, Moreau 2783 [BMI1771], Moreau, 1853, I, pp. 56–65, *Le Mouchard ou Espion de Mazarin*, Paris, Claude Boudeville, 1649, Moreau 2510 [BMI1652], and *La Parabole du temps présent*, Paris, 1649, Moreau 2673 [BMI1729]. See Carrier, 1985, p. 251. Carrier, 1989–92, I, p. 6, 426, II, p. 37. Naudé, *Mascurat*, p. 208.

38 See André Félibien, *Entretiens sur les vies et sur les ouvrages des plus excellens peintres anciens et modernes: avec La vie des architectes*, 4 vols., Trevoux, SAS, 1725, IV, p. 146. For the identification of "Mr du Fresne" as the owner of Poussin's *Bacchanal in Front of a Temple* see Anthony Blunt, *Nicolas Poussin: A Critical Catalogue*, London, Phaidon, 1966, p. 100. Naudé earned about 200 francs a year, little more than a common laborer. Jack A. Clarke, *Gabriel Naudé 1600–1653*, Hamden, Conn., Archon Books, 1970, p. 83.

39 Patin, 1907, I, p. 579–80 [March 22, 1648]. Jean de Silhon, who produced many press releases for Mazarin, similarly went to Sweden. He wrote *Eclaircissement de quelques difficultés touchant l'administration du cardinal Mazarin, première partie, par le sieur de Silhon*, Paris, Imprimerie Royale, 1650, Moreau 1181 [BMI2016]. See Carrier, 1985, p. 252; Carrier, 1989, I, p. 152; Carrier, 1992, II, p. 193 n. 38.

40 As Patin wrote to his correspondent Spon in 1648: "Le bon seigneur ne fait bien à personne: au moins je ne voy personne qui se loue de sa libéralité: il prend beaucoup et ne donne rien, et estouffe les espérences de profiter de tous ceux qui s'estoient mis près de luy." Patin, 1907, I, p. 597, cited by Carrier, 1985, p. 251.

41 "Neuf pauvres filles désolées/ Tristes, pasles, eschevelées." *Le Déspit des muses contre Mazarin, en vers burlesques*, 1649, Moreau 1004 [BMI0805], p. 3.

42 See n. 52 below.

43 For Mazarin's neglect of *gens de lettres* see various *mazarinades*. *La requête des auteurs, présentée au Parlement à l'encontre de Mazarin*, 1649, Moreau 3484 [BMI3699], p. 5, cited by Carrier, 1985, p. 248. *Lettre du sieur Pepoli, comte bolognois, écrite au Cardinal Mazarin, [touchant] sa retraite hors du royaume de France,*

n.p., 1649, signed Marco-Flaminio Pepoli, Moreau 2205 [BMI4800], p. 7. Naudé, *Mascurat*, p. 15. *Lettre véritable envoyée à Mazarin par le révérend père, innocent calterone, Sicilien, général des RRPP capucins de France & de Flandre*, n.p., 1649, signed J. Ch., Moreau 2260 [BMI1479], p. 5.

44　Several *mazarinades* drew parallels between Richelieu and Mazarin, with greater or lesser criticism of the late cardinal. See *Discours d'un philosophe mécontent, envoyé à madame la fortune, sur le malheur des savants de ce siècle*, 1649, Moreau 1110 [BMI2815], p. 5. *Le Déspit des muses contre mazarin* is more generous to Richelieu than most: "Tousiours le nom de Richelieu/ Sera comme celuy d'un Dieu" (p. 5). While the *sçavans* were obligated to the *volonté* and *sçavoit* of Richelieu, the nine desolate Muses, finding neither Caesar nor Mecenas in Mazarin, rank him among the beasts: "Mais toy, gros lourdaut, grosse beste/ Tu n'as point de cervelle en teste/ Sous son chapeau de Cardinal/ Tu n'es rien qu'un gros animal" (p. 6).

45　"Le Cardinal de Richelieu fascha les françois en ce qu'il fit de magnifique Palais, & d'autres despenses, qui leur paroissoient superfluës, de l'argent qui provenoit de la sueur du sang du peuples, & Mazarin loin de le faire passer de mesme aux mains des ouvriers les plus experts qui se trouvent en chaque art à Paris, & parmy la France, a fait transporter plusieurs millions en Italie, qu'il a revestuë ainsi des despoüilles de nostre Royaume sans vostre aveu, ny celuy d'aucun de Trois Estats." *Esprit du feu roy Louis XIII*, pp. 21–22. See Chapter Six, n. 52, above.

46　"Le Cardinal de Richelieu fut parfaitement liberal sur tout aux honnestes gens, & aux sçavantes personnes, à qui la fortune s'estoit monstrée avare en naissant, & le Mazarin à tousjours paru le plus traistre & le plus ingrat de tous les hommes, sans avoir honoré le mérite d'aucune faveur, ny reconnoissance." Ibid., p. 23.

47　See *Discours d'un philosophe mécontent*, p. 5.

48　*Le Déspit des muses*, p. 8.

49　See n. 52 below.

50　*Correspondance*, p. 306 [May 28, 1645].

51　For an account of these events see Gabriel Jules Cosnac, *Les Richesses du Palais Mazarin*, Paris, Renouard, 1885.

52　The chronology is as follows: Mazarin fled from Paris with the royal family on January 5, 1649. The inventory and seizure date from January 13 and January 25. Another act of confiscation dates from February 16, 1649. It was revealed, however, during the trial of 1649 that Mazarin had already stored numerous precious objects with the banker Cantarini as early as August 12, 1648. Claude Dulong, "Mazarin et les frères Cenami," *Bibliothèque de l'Ecole des Chartes* 144 (July–December 1986), p. 312. Antoine Loisel, possibly the owner of two paintings by Poussin, conducted the enquiry, made an inventory, and prepared the case against Mazarin (BN MS fr 6881, fol. 26 et passim). The second flight took place on February 6, 1651. Mazarin rolled up and stored several canvases in the Palais Royale in April 1651 (BN MS Baluze 182, fol. 29). The sale of the furniture took place on December 29, 1651. Naudé obtained a temporary restraining order for the sale of the books, on the grounds that it was a public library. Soon thereafter, the library also fell to the auctioneers. Intellectuals such as Patin mourned the loss of the library (but not the dispersed collection). A *lettre de cachet* was issued to suspend the sale of the books. On July 24, 1652, the

Hôtel de Ville decided to sell the statues and remaining furniture. On August 25, another *lettre de cachet* was issued to stop the sale of furnishings. Mazarin returned definitively on February 3, 1653. The inventory of his collection made by Colbert (published in London, 1861) was undertaken on September 12, 1653. See Cosnac, 1885.

Recent scholars have attempted to describe and reconstitute Mazarin's collection prior to its confiscation. Dulong, 1986, gives an account of the agents who sought to protect the cardinal's property. Michel Patrick describes its formation by agents in Rome. Anne Le Pas de Sécheval describes Mazarin's acquistion of an important Roman collection. Michel Patrick, "Rome et la formation des collections du Cardinal Mazarin," *Histoire de l'Art* 21/22 (May 1993), pp. 5–16. Anne Le Pas de Sécheval, "Aux Origines de la collection Mazarin: l'acquisition de la collection romaine du duc Sannesio (1642–1644)," *Journal of the History of Collections* 5:1 (1993), pp. 13–21.

53　Ironically, one of the collectors of a painting by Poussin may have suffered from such a search. According to Patin, there was a search for loot at the house of the water pump at La Samaritaine near the Pont-Neuf on January 29, 1649. Patin, 1907, p. 244. For John Evelyn's visit to the collection in the same house where he saw one of Poussin's paintings see *Actes*, 1960, p. 85.

54　See Durand, 1965, p. 146.

55　*Seconde partie du Mercure de la cour*, Paris, 1652, Moreau 2452 [BMI1618], p. 6.

56　See *Le Grand miroir des financiers, tiré du cabinet des curiosités du défunt Cardinal de Richelieu*, Paris, 1652, Moreau 1511 [BMI3321].

57　The *arrêts*, like many key parlementary acts, were published as brochures for public inspection. The seizure of Mazarin's property and assets took place on January 13: *Arrêt de la cour de parlement, pourtant que tous les biens meubles ou immeubles et revenus des bénéfices du cardinal Marzarin seront saisis, et commissaires, séquestres et gardiens commis à iceux. Du 13 janvier 1649*. Paris, par les imprimeurs et librairies ordinaires du roy, 1649, Moreau 224 [BMI4434]. It was followed by another edict calling for the opening of locked doors, securing and inventorying the property: *Arrêt de la cour de parlement pourtant qu'ouverture sera faite de toutes les Chambres de la maison du Cardinal Mazarin, & description sommaire de tout ce qui se trouvera dans laditte maison*. January 13, 1649, not catalogued by Moreau [BMI4439], and January 25, 1649, Moreau 233 [BMI4445]. Signed Du Tillet. One month later, the decision was made to sell the cardinal's property, except the library. Naudé had appealed to the magistrates to keep this collection intact because it was available to the public. *Arrêt de la cour de Parlement, pourtant que tous les meubles, étans* [sic] *en la maison du cardinal Mazarin, seront vendus. Du 16ème février 1649*. Paris, par les imprimeurs et librairies ordinaires du roy, avec privilège de sa majesté, Paris, 1649, Moreau 246 [BMI4459]. See also *Arrêt de la cour de Parlement donné en faveur des créanciers du Cardinal Mazarin, portant la vente de ses meubles . . .* , Paris, 1651, Moreau 300 [BMI4540]. Tubeuf received 600,000 livres.

58　The Parlement's inventory has not been found. However, Antoine Schnapper directed me to an obscure article said to be an extract of the inventory of 1649: "Extrait de l'inventaire et du procès-verbal de vente du mobilier du Cardinal Mazarin, dressés

en 1649, en vertu d'un arrêt du Parlement portant confiscation; par M. le baron Coquebert de Montbret, membre résident," in *Mémoires de la société royale des antiquaires de France* VII, 1826, pp. 343–50.

59 "Item, donne & legue audit Manchini & à ses deux soeurs, pour se loger en commun, la Galanterie, appellée autrement (il palazzo di Venere) où sont toutes ses plus riches peintures & sculptures, laquelle consiste en un beau & grand jardin, appellé le giardino d'amore . . . Sur le portail dudit Palais est une statuë de Venus en triomphe avec son Cupidon. A la droite, est la gallerie des postures de l'Aretein [sic]. A la gauche, est le ravissement des Sabines. A la premiere sont, les amours de Venus & de Cypris, avec le jugement de Paris. A la seconde, l'Histoire de la belle Helene. A la premiere chambre, les amours de Marc-Antoine & Cleopatre. A la seconde, Messaline & tous les ribauts. A costé de la première est le cabinet des nuditz, tant d'hommes que de femmes, de garçons que de filles, des plus grands Peintres de l'Europe." *Seconde partie du Mercure de la cour, ou les Conférences secrètes du Cardinal Mazarin . . .* , Paris, 1652, Moreau 2452 [BMI1618], pp. 7–8.

60 *L'Inventaire des merveilles du monde rencontrées dans le palais du Cardinal Mazarin*, Paris, Robin de la Haye, 1649 [January 26, 1649], Moreau 1729 [BM13104], published by Celestin Moreau, *Choix de mazarinades*, Paris, Renouard, 1853, I, pp. 143–48. For a discussion of this pamphlet see my essay "Painting for the French: Poussin, the Fronde and the Politics of Difficulty," in *Commemorating Poussin: Reception and Interpretation of the Artist*, ed. Katie Scott and Genevieve Warwick, Cambridge University Press, 1999.

61 "La variété de ses couleurs rend les regardans variables dans sa considération; et l'agréable confusion de ses richesses confonds leurs regards et leurs esprits." *L'Inventaire des merveilles*, p. 4, Moreau, 1853, I, p. 144.

62 See Jacqueline Lichtenstein, *The Eloquence of Color: Rhetoric and Painting in the French Classical Age*, trans. Emily McVarish, Berkeley, University of California Press, 1993 (Eng. trans. of *La couleur éloquente: rhétorique et peinture à l'âge classique*, Paris, Flammarion, 1989).

63 "Si belle et si luisante qu'on diroit que ce soit une glace noire, dont la pureté reçoit nos regards facilement, les conduit partout, et innocentement descouvre ses secrets." *L'Inventaire des merveilles*, p. 4, Moreau, 1853, I, pp. 143–48.

64 This is a recurrent motif in the *mazarinades*. See e.g. *Le Caquet ou Entretien de l'accouchée*, p. 20.

65 *L'Inventaire des merveilles*, p. 6, Moreau, 1853, I, p. 146.

66 A *parfumeuse* who supplies the incense for the censors of the church contrasts this function to that of the perfumes in Mazarin's palace that annoint the bodies of slaves. *Le Caquet ou Entretien de l'accouchée*, p. 19.

67 "Ils seduisent leurs spectateurs/ par le brillant de leur license/ Ils ont comme en nostre despense/ Mis le désordre dans nos sens." *Justes reproches de la France à m. le Prince de Condé*, Paris, 1649, Moreau 1788, p. 5.

68 "Le désir de voir ces beautez a fait mespriser aux hommes ce qu'ils avoient de plus cher, et les a poussés à commettre leur vie à l'inconstance de la mer et du hazard. La curiosité leur a donné des mespris pour leur pays et de l'amour pour les Barbares." *L'Inventaire des merveilles*, p. 3, Moreau, 1853, I, p. 143.

69 The criticism of *curiosité* served the general xenophobic discourse in the *mazarinades*. For example, one pamphlet constructs this opposition between France and other nations: "Je prie Dieu et les Patrons de cette ville qui ont chassé les Huns & les autres nations barbares de ses murailles, qu'ils vous touchent le Coeur, & qu'ils vous fassent desister de vostre entreprise par un sage conseil." *Lettre du chevalier Georges*, p. 17, Moreau, 1853, I, p. 171.

70 For the distinction between *curieux* and the positive associations of *amateur* and *connaisseur*, see Louis Olivier, "'Curieux,' Amateurs and Connoisseurs: Laymen and the Fine Arts in the Ancien Régime," Ph.D. diss., Johns Hopkins University, Baltimore, 1976. See Donald Posner, "Concerning the 'Mechanical' Parts of Painting and the Artistic Culture of Seventeenth-Century France," *Art Bulletin* 75:4 (December 1993), pp. 583–98.

71 La Bruyère, "La curiosité n'est pas un goût pour ce qui est bon ou ce qui est beau, mais pour ce qui est rare, unique, pour ce qu'on a et ce que les autres n'ont point." Cited by Olivier, 1976, p. 25.

72 "Il était curieux sans toutefois se connaître parfaitement aux belles choses." Henri Auguste de Loménie, Comte de Brienne, *Mémoires contenant les évènements remarquables des règnes de Louis XIII et de Louis XIV, jusqu'à la mort du Cardinal Mazarin (1615–1661)*, Paris, Didier, 1854, II, p. 21. Note how Poussin's letter inflects *curiosité* with "belles choses."

73 Tacitus called any arguments in favor of luxury "euphemistic admissions of debauchery." Tacitus, 1989, p. 93.

74 "César fut le plus curieux du monde . . . César aima singulierement les bijous & les pierreries, & tous les riches ameublemens . . . Mazarin pour satisfaire à cette passion qui le presse avec une avidité beaucoup plus grande, s'est fait une trésor merveilleux." *Les Curieuses recherches*, pp. 11–12. See Chapter Six, n. 45, above. For Caesar's pomp, luxury, and the marvels of imperial conquest, see e.g. *La Véritable response*, pp. 6–7.

75 "Il prostituë l'innocence par le luxe de sa vie, et en prophane la candeur et la maiesté par les tourbes et les malices de sa conduite. Jamais homme ne fut plus attaché que luy aux objets des sens, ny plus ensevely dans les plaisirs & dans la volupté." *Lettre d'un religieux*, p. 6.

76 François Blanchard and Tristan l'Hermite (Jean-Baptiste l'Hermite de Soliers), *Les Eloges de tous les premiers présidents du parlement de Paris*, 2 vols., Paris, 1645, II, p. 81.

77 "L'estude estoit son exercise ordinaire & ses plus grands délices; aussi cherissoit-il uniquement ceux de cette profession: & jamais le désir de faire amas de richesses n'entra dans son Esprit se contentant seulement d'assembler quelques peintures excellentes & particulièrement de bons livres pour se divertir à ses plaisirs innocens lors qu'il avoit quelque loisir." Blanchard, and Tristan l'Hermite, II, p. 81. After Verdun's illustrious career was checked by illness and age, "il se retira dans sa maison des champs qu'il avoit prés de Paris." Blanchard, I, p. 82. See Chapter Eleven below.

78 Tristan l'Hermite, "Tableaux que l'on regarde avec étonnement/ Où de sçavans Pinceaux marquent leur excellence." *Les vers héroiques du sieur Tristan l'Hermite*, Paris, 1648 [printed January 20, 1648], reprinted in *Actes*, 1960, p. 81. In "Epitre chagrine" (1652), Scarron writes affectionately of the poet's lack of support: "Notre Amy Tristan Gentilhomme/ Autant qu'un

Dictateur de Rome,/ Qui fait des Vers si noblement;/ Et dont le tour est si charmant,/ Attend encore que la Fortune/ Contre luy n'ait plus de rancune." See also Chapter Eleven below.

79 Vulson's scholarly tome *Vrai théâtre d'honneur* (1645) is similar to the rehearsals of sixteenth-century humanist values in the work of Arnauld and Gomberville. Vulson's research on Greek and Roman customs was used to admonish the abuses of contemporary French mores. This appeal to Mazarin in the language of the educated *robe* may have been offered to the first minister as the means by which he could redress his faults. Vulson's failure to secure patronage prompted his authorship of at least three *mazarinades*. In *Raisons d'Estat contre le ministère étranger* (1649), his research skills were applied to the argument for the prohibition of foreigners from public office: "Je vous ay justifié par les loix & par les exemples comme les estrangers ont esté bannis du maniement des affaires publiques" (p. 5). Moreau, 1853, I, p. 63. Part of his argument resembles the anxieties of subsequent disenfranchised and disgruntled nationalists: "C'est une chose honteuse à un peuple, qui ne manque pas de personnes capables du Ministre, de se voir soumis à un Estranger" (p. 7, Moreau, 1853, I, pp. 64–65).

80 "Les Estrangers introduisent les moeurs & les vices de leurs pays." Ibid., p. 1, Moreau, 1853, I, p. 57.

81 "Les différences des moeurs & du langage met la discorde entre les coeurs." "Un Estranger ne conduit l'Estat avec la mesme passion qui se trouve dans un sujet naturel." "Un prince, dit Tacite, instruit aux coustumes estrangères plustost qu'en celles de son Royaume, sera non seulement suspect au peuple, mais il passera toujours pour fascheux; & ce peu bien faissant." Ibid., p. 6–7, Moreau, 1853, I, p. 64. See my dissertation, pp. 311–12.

82 Marc de Vulson, Sieur de la Colombière, *Les portraits des hommes illustres françois qui sont peints dans la Galerie du Palais Cardinal de Richelieu*, Paris, 1650. A smaller and less costly edition was published in 1668 and dedicated to Séguier.

83 Gabriel Naudé, "Mazarin fait recherche de tous les plus beaux tableaux qui se puissent trouver qu'on dit estre pour mettre dans les galeries du Louvre." BN fr 17387, fol. 30 [July 8, 1647].

84 Between 80 and 100 scholars worked there regularly in 1648. Clarke, 1970, p. 83.

85 Naudé, *Mascurat*, 1649, pp. 565–66.

86 Raphael's cartoons were displayed in Paris in the 1640s. See Crow, 1985, p. 83.

87 Passart's inventory includes a copy after Domenichino and works attributed to Annibale Carracci. See Antoine Schnapper and Marcel-Jean Massat, "Un amateur de Poussin: Michel Passart (1611/12–1692)," *Bulletin de la société de l'histoire de l'art français* (1994), p. 106.

88 Félibien states that the *Orion* landscape was in Passart's collection. On the issue of the presence of the landscape in Passart's collection in 1684 see Schnapper and Massat, 1994, p. 104.

89 Lucian, *Lucian*, trans. A. M. Harmon, Cambridge, Mass., Harvard University Press, 1913, p. 176. For a discussion of Lucian's "Hall", see Elizabeth Cropper, *The Ideal of Painting: Pietro Testa's Düsseldorf Notebook*, Princeton University Press, 1984, pp. 169–72, and "'La più bella antichità che sappiate

desiderare': History and Style in Giovan Pietro Bellori's *Lives*," in *Kunst und Kunsttheorie, 1400–1900*, ed. Peter Ganz et al, Wiesbaden, Wolfenbütteler Forschungen 48, 1991, p. 169. E. H. Gombrich was the first modern commentator to point out this source in "The Subject of Poussin's *Orion*," *Burlington Magazine* 84 (1944), pp. 37–41. For important recent contributions to the literature on this painting see Sheila McTighe, 1996, p. 40, and Richard Verdi, "Poussin's Giants: From Romanticism to Surrealism", in *Commemorating Poussin*, 1999, pp. 190–210.

90 See Charles Dempsey, "'Et Nos Cedamus Amori': Observations on the Farnese Gallery," *Art Bulletin* 50:4 (December 1968), pp. 363–74.

91 Lucian, 1913, pp. 182–83, who attributes the tale to Herodotus.

92 Ibid., p. 183.

93 For the importance of Lucian, see Cropper, 1984, pp. 169–72, and 1991, p. 169.

Chapter Eight: Reception, Style, and Drawing

1 Orest Ranum, "Courtesy, Absolutism, and the Rise of the French State, 1630–1660," *Journal of Modern History* 52 (1980), pp. 426–30.

2 "Au Lecteur qui ne m'a jamais veu", in Paul Scarron, *Relation véritable de tout ce qui s'est passé en l'autre Monde, au combat des Parques, sur la mort de Voiture*, Paris, T. Quinet, 1648, n.p. The poet Voiture, who died in 1648, was a close friend of Chantelou. See *Correspondance*, p. 383 [June 22, 1648]. "Mes dents autrefois perles carrées, sont de couleur de bois, & seront bien tost de couleur d'ardoise. J'en ay perdu une & demie du costé gauche, & deux & demie du costé droit, & deux un peu égrignées." Scarron, 1648, n.p. For a discussion of Mademoiselle de Montpensier's *Divers Portraits* see Erica Harth, *Ideology and Culture in Seventeenth-Century France*, Ithaca and London, Cornell University Press, 1983, pp. 102–15.

3 Poussin to Chantelou, *Correspondance*, p. 350 [February 4, 1647]. Poussin wrote that he had received "un livre ridicule des frénésies de Monsieur Scarron," probably Scarron's recently published *Suite des oeuvres burlesques* (1646).

4 See Jacques Thuillier, *Nicolas Poussin*, Paris, Fayard, 1988, pp. 104–5.

5 While Pierre Rosenberg has disattributed the drawing, Jacques Thuillier, Elizabeth Cropper, and Charles Dempsey are among those who continue to accept the attribution.

6 "Monsieur le Poussin les introduisit ingenieusement & avec beaucoup d'adresse & de consideration, pour se conformer à la demande que l'on luy fit d'un dessein, non pas le plus magnifique ny le plus superbe qu'il peust composer, mais d'un ornement dont l'execution fust prompte, & d'une dépense moderée, eu esgard au temps, & à l'humeur impatiente de nostre nation." Roland Fréart, sieur de Chambray, *Parallèle de l'architecture antique et de la moderne: avec un recueil des dix principaux avteurs qui ont ecrit des cinq ordres: scavoir, Palladio et Scamozzi, Serlio et Vignola, D. Barbaro et Cataneo* (Paris, Edme Martin, 1650), Geneva, Minkoff, 1973, n.p., extract by Jacques Thuillier, "Pour un 'corpus pussinianum'," in *Actes du colloque Nicolas Poussin* (1958), ed. André Chastel, Paris, CNRS, 1960, II, pp. 86–87, hereafter *Actes*, 1960.

7 "Honneur des François en sa profession, & le Raphaël de nostre siècle." Fréart, *Parallèle de l'architecture*, "epistre," n.p. "Le restaurateur de la peinture, et l'ornement de son siècle." Fréart, *Traité de la peinture de Leonard de Vinci donne au public et traduit d'Italien en François par RFSDC* (Paris, 1651), in *Actes*, 1960, p. 88.

8 Charles Perrault, *Les Hommes illustres qui ont paru en France pendant ce siècle: avec les portraits au naturel*, Paris, 1696–1700, I, p. 90. For a discussion of this text see my contribution, "Painting for the French: Poussin, the Fronde, and the Politics of Difficulty," to *Commemorating Poussin: Reception and Interpretation of the Artist*, ed. Katie Scott and Genevieve Warwick, Cambridge University Press, 1999.

9 "Comme il y a peu de personnes capables de juger de la perfection des choses, il ne leur étoit mal aisé de faire croire aux ignorans que ces ouvrages considerables par leur simplicité, n'étoient pas comparables à une infinité d'autres que le vulgaire estime par la quantité & la richesse des ornemens." André Félibien, *Entretiens sur les vies* . . . , 4 vols., Trevoux, 1725, IV, p. 38.

10 Poussin's letter to Sublet is quoted and paraphrased by ibid., pp. 40–49, and cited by Jouanny, *Correspondance*, pp. 139–47. Poussin's decisions for the Grande Galerie interfered with the plans of the architect Mercier, who also continued to be protected by Sublet de Noyers. Hence Poussin had to account for his actions. *Correspondance*, p. 142. On Mercier's protection see C. Michaud, "Francois Sublet de Noyers, Surintendant des bâtiments de France," *Revue historique* 242 (1969), p. 327. See Vincennes, Archives de la Guerre, A1, 69.

11 Poussin argued that there are "deux manières de voir les objets." *Correspondance*, p. 143.

12 "Il croyoit avoir très-bien servir le Roy, en faisant un ouvrage plus recherché, plus agréable, plus beau, mieux entendu, mieux distribué, plus varié, en moins de temps, et avec beaucoup moins de dépense que celuy qui avoit esté commencé." *Correspondance*, p. 146.

13 Poussin began with a discussion of the difficulty of judging the capacity of persons in the arts and sciences: it is the same difficulty as judging "leurs mauvaises inclinations dans les moeurs." *Correspondance*, p. 140. He proceeded to complain "que toute l'étude et l'industrie des gens sçavans ne peut obliger le reste des hommes à avoir une croyance entière en ce qu'ils disent." *Correspondance*, p. 14. Despite meritorious devotion to art and science, artists such as Domenichino and Annibale Carracci were faced with "les brigues de leurs envieux qui joûirent pendant leur vie d'une réputation et d'un honneur qu'ils ne méritoient point." *Correspondance*, p. 141. Already Poussin identified himself with the ill fortunes of two painters who valued study and work. Their demise was not a tragic fall from the heights of intense psychological experience, rather they fell victim to those envious of their merit and dedication to studio practices.

14 Ibid., p. 145.

15 See Michael Baxandall, *Painting and Experience in Fifteenth-Century Italy*, Oxford University Press, 1988. Similar cultural behaviors have been observed in Han China: see Martin Powers, *Art and Political Expression in Early China*, New Haven and London, Yale University Press, 1991, and "The Dialectic of Classicism in Early Imperial China," *Art Journal* (spring 1988), pp. 20–25.

16 *Correspondance*, p. 147.

17 Ibid.

18 "C'est un malheureux pays que la cour, on y veut estre bon à quelque chose, et pour y estre en considération il faut avoir l'argrément du maistre qui peut faire le bien et le mal, rendre de bons et de mauvais offices, mais a toujours les rieurs de son costé; et tel qui le déteste en son âme n'a pour luy que des paroles de joie." Nicolas Goulas, *Mémoires*, ed. Charles Constant, 3 vols., Paris, Renouard, 1879–82, I, p. 26. See Noémi Hepp, "Peut-on être homme de bien à la cour? Le débat sous Louis XIII," in *La Cour au miroir des mémoralistes, 1530–1682*, ed. Noémi Hepp, Paris, Klincksieck, 1991, p. 163.

19 Poussin's apology functioned like the epistles to the patron in sixteenth- and seventeenth-century literature: authenticity of the historical text depended upon a contract on the part of the reader and writer that the text should not flatter. E. F. Rice, "The Patrons of French Humanism, 1450–1520," in *Renaissance Studies in Honor of Hans Baron*, ed. Anthony Molho and John A. Tedeschi, Dekalb, Northern Illinois University Press, 1971. Orest Ranum, *Artisans of Glory: Writers and Historical Thought in Seventeenth-Century France*, Chapel Hill, University of North Carolina Press, 1980.

20 "Une lettre à Monseigneur peu artificieuse véritablement mais plaine de franchise et de vérité." *Correspondance*, p. 148 [April 24, 1642].

21 "Je vous suplie comme mon bon protecteur, si par adventure Mor la trouvoit mal asaisonnée de l'adoucir un peu du mil [miel] distillans de vostre persuation." *Correspondance*, p. 148. He used this sense of *doux/franchise* in his discussion of the so-called modes. It is the courtier-artists who attempt to flatter with their sweet brushes. See also his use of the terms *douce* and *grace* in his discussion of the architectural drawings for the Dangu chapel. *Correspondance*, pp. 179–82.

22 See e.g. ibid., p. 289 [October 30, 1644].

23 "Si vous m'en mandé sans flatter vostre sentiment vous m'obligerés beaucoup." Ibid., p. 290 [November 6, 1644]. "Je vous ay suplié de m'en escrire vostre sentiment à la réale sans flatterie." Ibid., p. 297 [November 25, 1644].

24 Ibid., p. 274 [June 20, 1644].

25 Ibid., p. 393 [December 19, 1648].

26 "Je ne vous l'ay dédié qu'à la Mode de Michel de Montagne non pour bon, mais tel que je l'ay peu fere." Ibid. For a discussion of this reference to Montaigne's "Des livres," *Essais* II, 10, see Elizabeth Cropper and Charles Dempsey, *Nicolas Poussin: Friendship and the Love of Painting*, Princeton University Press, 1996, p. 183.

27 For the importance of the rhetoric of Erasmus (in the *De copia* and *Ciceronianus*) for the *noblesse de robe* see Marc Fumaroli, "Rhetoric, Politics, and Society: From Italian Ciceronianism to French Classicism," in *Renaissance Eloquence: Studies in the Theory and Practice of Renaissance Rhetoric*, ed. James J. Murphy, Berkeley, University of California Press, 1983, pp. 253–73.

28 Although Fumaroli traces the development of a compromise style in the prevailing theories of rhetoric by the 1640s, the so-called Atticism that prevailed in the reign of Louis XIV, he points out the revival of deliberative rhetoric during the Fronde. Ibid., p. 271.

29 Harlay's remonstrance continued to be efficacious for the *frondeurs* loyal to the Parlement: see Morgue's *La très humble et véritable remonstrance de nosseigneurs du Parlement pour l'éloignement du Cardinal Mazarin*, Paris, Jacob Chevalier, 1652, p. 14, Moreau 3808 [BM12347].

30 Achilles III de Harlay, President of the Parlement of Paris, owned Poussin's *Judgment of Solomon* (Louvre) by 1685.

31 "Son ouvrage ressemble à ces tableaux dans lesquels on recognoist les traits hardis de la main des grands peintres; & quoy qu'ils soient un peu rudes, leur rudesse a pourtant sa beauté; Si bien que malaysément les pourroit-on adoucir sans leur oster leur grace & leur naïveté. Tous ceux qui lisent cet Autheur avec attention y remarquent je ne sçay quelle obscurité, qui néantmoins leur produit de belles lumières, tout ainsi que les ombres les plus brunes d'un protraict luy donnent bien souvent un jour plus vif & plus esclattant." Achilles II de Harlay, *Les Oeuvres de C. Corneille Tacite, traduites en françois par M. Achilles de Harlay*, Paris, Vve. J. Camusat et P. le Petit, 1644, n.p.

32 See Morris W. Croll, *Style, Rhetoric, and Rhythm*, ed. J. Max Patrick, Princeton University Press, 1966, p. 23. Dominique Bonhours, *La manière de bien penser dans les ouvrages d'esprit*, Amsterdam, 1688.

33 "A toutes ces recherches je ne me suis estudié d'apporter autre ornement que la verité d'une narration simple, nuë, & sans fard." Tristan l'Hermite and François Blanchard, *Les présidents au mortier du parlement de Paris*, Paris, 1645, "preface" n.p. [second page]. Dedicated to Séguier and signed F. Blanchard. The frontispiece depicting an enthroned blind Justice surrounded by shackled slaves was based on a drawing by Poussin's friend and colleague Stella. There are several pages devoted to members of the Bellièvre family.

34 On the ambivalence toward seductive ornament see Jacqueline Lichtenstein, *The Eloquence of Color: Rhetoric and Painting in the French Classical Age,* trans. Emily McVarish, Berkeley, University of California Press, 1993 (*La Couleur éloquente: Rhétorique et peinture à l'âge classique*, Paris, Flammarion, 1989).

35 "Pour l'ordonnance & la hardiesse des coups de Pinceau." François Tristan l'Hermite, *Vers heroiques du Sieur Tristan l'Hermite*, Paris, 1648, n.p.

36 *Le Grand Miroir des financiers, tiré du cabinet des curiosités du défunt cardinal de Richelieu*, Paris, 1652, Moreau 1511 [BM13321].

37 "Il faudroit, s'il y avoit moyen, ne leur parler que par des signes abbregez, & par des expressions générales & pareilles à celles qui sont propres des purs Esprits. Il faudroit au moins, qu'il y eust par tout, comme en la Chine, une langue particulièrement destinée à traitter avec eux: Et encore cette Langue à mon sens, devroit estre aussi comte que celle de l'ancienne Sparte, où il se faisoit des Harangues de deux mots, & des Lettres d'une syllabe." Ibid., "au lecteur," n.p.

38 For a very different understanding of the function and value of a transparent language such as hieroglyphs see Sheila McTighe, *Nicolas Poussin's Landscape Allegories*, Cambridge and New York, Cambridge University Press, 1996, p. 134.

39 The whole passage reads: "Les sages advouent que ces gens-là rangent mieux leurs paroles, qu'ils ne reglent leurs pensées, lorsqu'ils s'imaginent, que tout ce qui agréera aux curieux, sera bien receu par les serieux. Ce qui est plus fascheux est, que les autheurs de ces ouvrages cherchent plûtost la reputation de polis escrivains, que de bons citoyens. . . . Nous pouvons dire aussi à ces Messieurs, que leurs plumes paroissent legeres, lorsqu'elles volent en fort peu de temps d'une extremité à l'autre, & ne s'arrestent point dans le milieu, où est la vertù." Mathieu de Morgues, *Bon Avis sur plusieurs mauvais advis*, 1650, Moreau 594 [BM10688], p. 3. See Hubert Carrier, *La Presse de la Fronde*, Geneva, Droz, 1992, II, p. 10 n. 26. Commissioned by Châteauneuf.

40 "Elles s'exercent maintenant, non seulement à les blanchir, mais à les farder." Morgues, *Bon Avis*, p. 4. See Lichtenstein, 1989.

41 See Chapter Five above.

42 Preliminary sketches for some twenty of the panels are extant. Anthony Blunt, *The Drawings of Nicolas Poussin*, New Haven and London, Yale University Press, 1979, p. 152. In the *Labors of Hercules* (Bayonne, Musée Bonnat), each of the panels is assigned a number from 55 to 60. This suggests that a sequence of at least 60 had been planned.

43 Félibien was discussing the series of the labours of Hercules when he wrote: "Vous en pouvez voir plusieurs desseins de la main de Poussin, très-fini & très-beaux, qui sont chez Monsieur de Fromont de Veine." Félibien, *Entretiens sur les vies . . .*, 1725, Trevoux, IV, p. 33. For Fromont as the owner of the *Death of Sapphira* and the *Testament of Eudamidas* after Passart, see Chapter Five above.

44 The volumes were available at Chez Guerineau, according to Berthod, *La Ville de Paris en vers burlesque*, Paris, 1652 (privilege granted August 5, 1650). Cited in *Actes*, 1960, p. 94.

45 The proposals were submitted by Le Vau and Adam to Sublet de Noyers. *Correspondance*, p. 179–82 [September 21, 1642].

46 "Je direi librement mon oppinion." Ibid., p. 180 [September 21, 1642].

47 On authoritative resources (concentrated material or coercive resources) see Anthony Giddens, *A Contemporary Critique of Historical Materialism, vol. 1. Power, Property, and the State*, Berkeley and Los Angeles, University of California Press, 1981.

48 See Marshall David Sahlins, *Historical Metaphors and Mythical Realities*, Ann Arbor, University of Michigan Press, 1981. For a more extended discussion of the implications of this notion of shifting enunciative positions in genre see my unpublished MS "Shifting Structures: Constraint and Agency in the Drawings of Nicolas Poussin," presented at the College Art Association Conference, San Antonio, 1995.

49 *Correspondance*, p. 317 [August 20, 1645].

50 Blunt calls a drawing for the *Triumph of Pan* "a sort of pastiche of an ancient bas-relief." Blunt, 1979, p. 104, fig. 119.

51 Jacques Thuillier, *L'Opera completa di Poussin*, Rome, 1974, pp. 103–4 n. 149.

52 Another presentation drawing depicting Scipio is known from the letters. It is probably the same drawing now in Windsor Castle, Royal Library. Pen and brown wash, 331 × 465 mm. Walter Friedlaender and Anthony Blunt, *The Drawings of Nicolas Poussin: Catalogue Raisonné*, 5 vols., London, Warburg Institute, 1939–74, II, p. 14, A32, pl. 122; Blunt, 1979, F

fig. 135. There is also a drawing that was a gift for Cardinal Francesco Barberini depicting *Scipio and the Pirates*.

53 *Sacrifice of an Ox* (Bayonne, Musée Bonnat), black chalk and bistre wash on paper, 142 × 211 mm. Friedlaender and Blunt, v, pp. 27, 243 no. 297. Blunt, 1979, Fig. 146.

54 *Correspondance*, p. 13 [April 1639].

55 "Je ne prends pas garde à si peu de chose . . . tous seront riches selon leur subiet." Ibid., p. 328 [January 21, 1646].

56 "Toutte mon estude et toutte les forces de mon talent." Ibid., p. 260 [April 8, 1644].

57 For a sequential viewing of tableaux protected by curtains see Laurent de la Hyre's engraving for the frontispiece of Marie Cureau de la Chambre's *Les Caractères des passions* (Paris, 1640), in which he represented a wise old man cueing his audience's attention with a pointer, lecturing upon the unveiled emblems in a vaulted picture gallery. Pierre Rosenberg and Jacques Thuillier, *Laurent de la Hyre, 1606–1656: l'homme et l'oeuvre*, Geneva, Skira, 1988, no. 171, p. 220.

58 For Poussin's discussion of the *Extreme Unction*, see *Correspondance*, p. 266 [April 25, 1644].

59 See Friedlaender and Blunt, I, p. 49, pl. 67.

60 Executed for Sylvio Reynon. See Chapter Five above.

61 *Christ and the Woman Taken in Adultery* was executed for Le Nôtre. Félibien, 1725, IV, p. 63. *The Death of Sapphira* was executed for Fromont de Veine. Ibid., p. 152.

62 For a discussion of "personal style" as a relevant but distinct problem in Bellori studies, see Elizabeth Cropper, "'La più bella antichità che sappiate desiderare.' History and Style in Giovan Pietro Bellori's *Lives*," in *Kunst und Kunsttheorie, 1400–1900*, ed. Peter Ganz et al, Wiesbaden, Wolfenbütteler Forschungen 48, 1991, pp. 145–73.

63 On the series in Poussin's work, see Matthias Bruhn, *Die bieden Fassungen der "Sieben Sakramente" von Nicolas Poussin*, Magisterarbeit, University of Hamburg, 1992.

64 See Bellori and Félibien.

65 In one preparatory drawing, the archaic effect is even more explicit: Paris, Ecole des Beaux-Arts, pen and brown wash over black chalk on paper, 248 × 384 mm. See Friedlaender and Blunt, I, pp. 15–16, no. 32, pl. 20. Blunt, 1979, fig. 71.

66 The archaic composition of the *Solomon* compositions can be compared to a contemporaneous drawing by Poussin of the Holy Family, *The Madonna Enthroned* (Stockholm, National Museum), pen and brown wash, 157 × 190 mm. See Friedlaender and Blunt I, p. 27, no. 52, pl. 32. Blunt comments that "the hieratic frontal pose is consciously archaic." Blunt, 1979, p. 74, fig. 85.

67 Executed for Pucques. See Thuillier, 1974, no. 165, and Blunt, 1966, no. 153 (lost). See also *Rebecca at the Well* (Louvre) executed for Pointel.

68 See Alain Mérot, *Nicolas Poussin*, Paris, Hazan, 1990, p. 143.

69 See e.g. Christopher Wright on *Christ Healing the Blind* (Louvre): "Poussin had obviously not managed to work out of his system the achievement of the second set of Sacraments when he painted this picture." Wright, *Poussin: Paintings. A Catalogue Raisonné*, London, Jupiter, 1984, p. 218. On the *Death of Sapphira* he writes, "It is as if Poussin could not get off his mind the obsessions which occurred while he was painting the series" (p. 225).

70 The fortune of Poussin's early paintings, evident from the circulation of prints after these works, dramatically sets in relief the changes in his mature work. Rather than religious or classical history subjects, the prints perpetuated his reputation for mythological themes. With one exception (Rémy Vuibert's 1643 engraving after the Munich *Entombment of Christ*), engravings after his religious paintings were only executed from 1650 with *The Plague of Ashdod* (Louvre). Wildenstein, 1955, no. 23. For this conclusion based on Wildenstein see my dissertation, pp. 364–65 and 373 n. 85.

71 According to Cropper and Dempsey, the drawing of the atelier "provides a unique point of departure for determining how the painter approached the study of chiaroscuro and color in accordance with what he had learned from studying the manuscripts of Zaccolini." Cropper and Dempsey, 1996, p. 150. Their stress is on Poussin's relationship to an "observational tradition" (p. 152). See Donatella L. Sparti, *Le collezione dal Pozzo: Storia di una famiglia e del suo museo nella Roma seicentesca*, Modena, F. C. Panini, 1992.

Chapter Nine: Interventions

1 *Correspondance*, p. 76 [June 16, 1641].

2 Bellori, *Le vite de' pittori, scultori e architetti moderni*, ed. Evelina Borea, Torino, Einaudi, 1976, pp. 471–72. The absence of the *Testament* from the inventory and the engraving of the painting in Fromont de Veine's collection during Passart's lifetime suggest that the painting was acquired by Fromont directly from Passart. See Antoine Schnapper and Marcel-Jean Massat, "Un amateur de Poussin: Michel Passart (1611/12–1692)," *Bulletin de la société de l'histoire de l'art français* (1994), p. 103. I further speculate that this transaction had the same significance as the provenance of the *Moses Striking the Rock* (Edinburgh). The theme of friendship enacted by an exchange would have made this particular painting especially meaningful. Richard Verdi dates the painting 1645–50. Rosenberg and Prat date it around 1643 based on the style of the drawing.

3 For Poussin's use of Lucian see pp. 134–35 and p. 279 n. 93 above.

4 Montaigne, "De l'amitié," *Essais*, I, ch. 28.

5 For Poussin's (most recently uncovered) testament in which Pointel is the executor, see Anthony Blunt, "A Newly Discovered Will of Nicolas Poussin," *Burlington Magazine* 124 (November 1982), pp. 703–4. The other two published testaments are in *Correspondance*, pp. 193–95 [April 30, 1643] and pp. 466–78 [September 21, 1665].

6 For the relation between sixteenth-century testamentary practices and Montaigne's written legacy see Natalie Zenon Davis, "A Renaissance Text to the Historian's Eye: The Gifts of Montaigne," *Journal of Medieval and Renaissance Studies* (Duke) 15 (1985), pp. 47–56.

7 The formula was "gisant au lict malade." Pierre Chaunu et al, *La Mort à Paris: 16e, 17e, 18e siècles*, Paris, Fayard, 1978, p. 298.

8 See Catherine E. Holmès, *L'Eloquence judiciare de 1620 à 1660: reflet des problèmes sociaux, religieux et politiques de l'époque*, Paris, A. G. Nizet, 1967.

9 *La verité toute nue . . .* (1652), Moreau 4007 [BM14,081], pp. 2–3. Hubert Carrier, "Port-Royal et la Fronde: deux mazarinades

inconnues d'Arnauld d'Andilly," *Revue d'histoire littéraire de la France* 75:1 (January–February 1975), pp. 3–29.

10 *Le Testament solemnel du Cardinal par luy fait au temps des barricades et trouvé depuis la sortie de Paris en son Cabinet, datté du 29 août 1648. avec l'advertissement de la vente de ses biens etc. suivant l'Arrêt de la cour du mois précédent*, Paris, François Musnier, 1649, Moreau 3766 [BMI3890].

11 Ibid., p. 8.

12 Ibid.

13 See Chaunu, 1978, p. 297.

14 *Le Testament solemnel*, p. 5.

15 Ibid., p. 11.

16 Recent historians have argued over the ways in which quantitative studies of testaments ought to be interpreted. Chaunu, 1978. Michel Vovelle, *Mourir autrefois: attitudes collectives devant la mort aux XVIIe et XVIIIe siècles*, Paris, Gallimard, 1974, and *Piété baroque et déchristianisation en Provence au XVIIIe siècle*, Paris, Editions du Seuil, 1978. Philippe Ariès, *The Hour of Our Death*, trans. Helen Weaver, New York, Knopf, 1981.

17 Chaunu, 1978, p. 359.

18 For Châteauneuf's testament see Chapter Five, n. 75 above. Pierre Chaunu selected Lambert's testament as one of the "beaux testaments." "Quant aux cérémonies et pompes funèbres d'iceluy (pour ce que) il doibt estre réduict en bref en pourriture et cendre suyvant sa nature et origine considérant néantmoins qu'il a esté le domicile et habitacle de mon âme." Chaunu, 1978, p. 516.

19 "Premièrement je recommande mon âme à dieu implorant sa miséricorde infinie pour le pardon de mes crimes." AN MC CXV 244. Passart's own testament was deposited on July 4, 1692. The first section is signed and dated April 6, 1690. There are two addenda signed by Passart on April 10, 1690 and October 18, 1691. See Chapter Three above, n. 13.

20 AN MC CXV 244, November 15, 1683. See Schnapper and Massat, 1994, p. 106.

21 He requested 300 low masses, 450 at St.-Germain, 50 at St.-Nicolas, 100 at Pons-Augustins du grand couvent and 100 elsewhere.

22 Only 4% were holographic testaments in the first half of the seventeenth century in Paris. Chaunu, 1978, p. 379.

23 For the "situational self-reflexivity" of certain literary texts see Ross Chambers, *Story and Situation: Narrative Seduction and the Power of Fiction*, Minneapolis, University of Minnesota Press, 1984, pp. 24–26.

24 First published by Pierre Rosenberg in *La Mort de Germanicus*, Paris, 1973, p. 25, no. 43. For the leonine motif derived from an engraving of an altar in the Giustiniani collection, see the drawing in the Musée Bonnat. Anthony Blunt, *The Drawings of Nicolas Poussin*, New Haven and London, Yale University Press, 1979, fig. 132.

25 The author of a readerly or "classical text" is described as a public scribe in Roland Barthes, *S/Z*, trans. R. Miller, New York, Hill and Wang, 1972. See Chambers, 1984, pp. 23–24.

26 Discussing irony and allegory as key tropes of discursive authority Ross Chambers writes: "Each produces the authority of a given piece of discourse as dependent on reading (There can be no allegory and no irony except 'as read'), and so they manifest 'authority' as a consequence of *authorization*, and there-

fore as a product of mediation. In both irony and allegory, the text is dependent on its 'other' (on reading) for an authority that derives from something 'other' than *what it says*." Chambers, *Room for Maneuver: Reading (the) Oppositional (in) Narrative*, University of Chicago Press, 1991, p. 238.

27 In the prepatory drawing, Poussin emphasizes the version told by Flavius Josephus. See Chapter Four above.

28 Elizabeth Cropper and Charles Dempsey, *Nicolas Poussin: Friendship and the Love of Painting*, Princeton University Press, 1996, p. 156.

29 See Michel Serres, *The Parasite*, trans. Lawrence R. Schehr, Baltimore and London, Johns Hopkins University Press, 1982. In one further example, the uncertainty of the interpretation of visual signs creates a crisis. In the *Landscape with Pyramus and Thisbe* (Frankfurt), the ill-fated pair of lovers are destroyed by their misreading of signs in the landscape. The lover finds the bloodied garment of the beloved one and reads it as a signifier of death. The abandoned cloth spoiled by the traces of the lion's other mauled victim is false evidence imbedded in a landscape fraught with the noise of storm and the confusion of night. Misreading results in tragedy.

30 Claude de Beaune, *Le Vray et parfait instructif de la théorique et pratique générale des notaires de Paris*, 2nd ed., Paris, P. Rocolet, 1646, p. 68.

31 Widows enjoyed more power than married women because they were invested with the role of being head of the family, the responsibility for the patrimony, and the education of the children. Chaunu, 1978, pp. 369–70.

32 Ibid., p. 369.

33 For example, Loisel's daughter Elisabeth sought a legal injunction against the sale of community property, including paintings by Poussin, by her husband. The paintings may have been part of her inheritance and, therefore, her legal action was an attempt to forestall any further loss of her property.

34 See Eve Kosofsky Sedgwick, *Between Men: English Literature and Male Homosocial Desire*, New York, Columbia University Press, 1985, and Carla Freccero, "Cannibalism, Homophobia, Women: Montaigne's 'Des Cannibales' and 'De l'amitié'," in *Women, "Race," and Writing in the Early Modern Period*, ed. Margo Hendricks and Patricia Parker, London and New York, Routledge, 1994, p. 80.

35 For the literature on the discussion of the figure in the Louvre *Self-Portrait*, see Cropper and Dempsey, 1996, pp. 117–215. I thank Page Du Bois and Richard Meyers for an exchange of ideas regarding this aspect of the painting in conversation.

36 The *Massacre of the Innocents* (Chantilly) concerns a similar legibility of internal states on the body of a woman as she witnesses the murder of her own child.

37 There are a group of paintings that have imbedded texts, most notably the *Et in Arcadia Ego* paintings and the *Christ and the Woman Taken in Adultery* (Louvre). Erwin Panofsky's elegant essay develops the problem of exegesis in the former works. In the Louvre's depiction of the shepherd readers, the problem of legibility is visually represented by the interference of the shadow cast by the reader. Panofsky, "Et in Arcadia ego: Poussin and the Elegiac Tradition" in *Meaning in the Visual Arts*, Garden City, Doubleday, 1955, pp. 295–320.

38 See Norman Bryson, *Word and Image: French Painting and the Ancien Régime*, Cambridge and New York, Cambridge University Press, 1981, pp. 27 and 61. For the most important work on Le Brun, see Jennifer Montagu, *The Expression of the Passions: The Origin and Influence of Charles Le Brun's "Conférence sur l'expression générale et particulière,"* New Haven and London, Yale University Press, 1994.

39 The subsequent inclusion of the *Testament of Eudamidas* in Fromont de Veine's collection offers a further and more explicit renunciation of women as a thematic sign of radical severity. One can imagine the painting of *Eudamidas* hanging together with Fromont de Veine's other acquisition, the *Death of Sapphira*. In the latter painting, the lying, avaricious woman is struck dead by the declamatory apostle. Stark justice and expedient execution are represented in a severe pictorial structure.

40 *Correspondance*, pp. 121–22 [March 20, 1642]. See Elizabeth Cropper, "On Beautiful Women, Parmigianino, 'Petrarchismo,' and the Vernacular Style," *Art Bulletin* 58 (1976), pp. 374–94.

41 This opposition was taken up in eighteenth-century perceptual psychology, using the term "attention." On "attention" in the perceptual psychology of Locke and Condillac see Michael Baxandall, *Shadows and Enlightenment*, New Haven and London, Yale University Press, 1995, pp. 18 and 177–78 n. 38.

42 In a famous letter (*Correspondance*, p. 143), Poussin attempted to theorize a science of perception in the same terms. See e.g. Svetlana Alpers, *The Art of Describing: Dutch Art in the Seventeenth Century*, University of Chicago Press, 1983, pp. 48–49.

43 Poussin's viewer can be likened to a seventeenth-century *flâneur* who classifies the neglected marble. For the low decorum of the Maison Carrée see Chapter Two above.

44 "Si vous considérés se ne sont pas des choses que l'on puise faire en siflans comme vos peintres de paris qui en se jouant font des tableaux en vintequatre heures." *Correspondance*, p. 317 [August 20, 1645].

45 Ibid., p. 122 [March 20, 1642].

46 "On a creu que les Spectateurs auroient beaucoup plus de plaisir d'estre surpris par les machines & par les diverses décorations & changemens de Scène dont cette pièce est enrichie, que de les sçavoir avant que de les avoir veuës." Anonymous, *Orphée, Tragicomédie en musique*, Paris, Cramoisy, 1647, n.p., Paris, Bibliothèque Nationale, Yf 946. See Sheila McTighe, *Nicolas Poussin's Landscape Allegories*, Cambridge and New York, Cambridge University Press, 1996, pp. 75 and 191 n. 47.

47 See Roland Fréart, sieur de Chambray, *Parallèle de l'architecture antique et de la moderne* (Paris, Edme Martin, 1650), Geneva, Minkoff, 1973, p. 4.

48 Fréart begins: "Je vais donc finir par cette rare façon de parler, qui n'a besoin ny d'oreilles, ny de langue, & qui est la plus divine invention que les hommes ayent iamais rencontré. Au reste on verra dans mon profil de la colonne Traiane, avec quelle diligence & exactitude tout y est conforme à l'original, iusqu'aux moindres ornemens, afin qu'on iuge par là du soin que i'ay apporté aux autres choses de plus grande considération." Here is the passage quoted in the text: "Si le lecteur est intelligent, & qu'il ait veu avec attention, & avec des yeux de maistre, ce riche & incomparable chef-d'oeuvre que ie décris, la satisfaction qu'il recevra de l'estude exact que i'en ay fait, & que ie luy donne,

se rendra proportionné à sa suffisance: car les yeux ne voyent en ces matières, qu'autant que l'entendement leur éclaire, & les beautez excellentes ne s'y monstrent pas d'abord, ny à tout le monde; elles veulent estre curieusement observées, & découvertes avec industrie: Il y en a mesme de plusieurs espèces, que chacun va remarquant selon la portée de son esprit, & conformément à son génie; les uns y cherchent la grace, & la gentillesse des ornemens, les autres considérant la noblesse de l'ouvrage, & la nouveauté de l'invention; les plus connoissans ayant égard principalement à la proportion, & à la régularité du tout avec ses parties, à la iudicieuse composition, à la grandeur & à la solidité du dessein, & à telles beautez essentielles, qui ne sont visibles qu'aux yeux des plus sçavans architectes . . . il est plus de sots que d'habiles gens." Ibid., pp. 89–90. *A Parallel of the Ancient Architecture with the Modern . . .* , trans. John Evelyn, 4th edition, London, 1733, pp. 95–96.

49 Fréart, *Parallel*, 1733, p. 95.

50 See Giovanni Previtali's introduction to Bellori, 1976.

51 "In Previtali's view, Bellori's very act of writing about art was the work of an erudite grown old in a culture increasingly given over to the experiences of sensation, to novelty, and to opinion." Elizabeth Cropper, "'La piu bella antichità che sappiate desiderare': History and Style in Gian Pietro Bellori's *Lives*," in *Kunst und Kunsttheorie, 1400–1900*, ed. Peter Ganz et al, Wiesbaden, Wolfenbütteler Forschungen 48, 1991, p. 164.

52 Félibien, 1725, IV, p. 129. Félibien's description of the *Manna* in his eighth *entretien* is based on the second Conférence of the Académie, held in 1667. See Claire Pace, *Félibien's Life of Poussin*, London, A. Zwemmer, 1981, pp. 92–96. Louis Marin described the "admiration révérentielle" of the figure who functions as a frame of reference for the viewer. Marin, "Le Cadre de la représentation et quelques-unes de ses figures," *Les Cahiers du Musée national d'art moderne* 124 (1982), p. 70.

53 On Poussin and neo-Stoicism see Blunt, *Nicolas Poussin*, Washington, D.C., Pantheon, 1967, pp. 157–76, Walter Friedlaender, *Nicolas Poussin: A New Approach*, New York, H. N. Abrams, 1966, and Richard Verdi, "Poussin and the Tricks of Fortune," *Burlington Magazine* 124 (1982), pp. 681–85. I have stated elsewhere that "the category is highly problematical because its association with a position of withdrawal tends to reify the image of an isolated artist." Olson, "Painting for the French: Poussin, the Fronde, and the Politics of Difficulty," in *Commemorating Poussin: Reception and Interpretation of the Artist*, ed. Katie Scott and Genevieve Warwick, Cambridge University Press, 1999, p. 183 n. 24.

54 Guillaume du Vair, *Traité de la Constance et Consolation ès calamitez publiques*, Paris, 1595. Pierre Charron, *De la sagesse* [Bordeaux, 1601] in *Toutes les Oeuvres de Pierre Charron* (Paris, 1635), repr. Geneva, Droz, 1970. See also *Les Oeuvres de Messire Guillaume Du Vair*, Paris, Cramoisy, 1641.

55 Charron acknowledged his debt in the "avertissement" before his discussion of the passions and affections. Charron, 1635, p. xviii.

56 Verdi, 1982, p. 681. Anthony Blunt's use of these writers in association with Poussin is worthy of analysis. In Blunt's early work, he put an emphasis on the writers' utility for the anti-popular philosophy of a bourgeois clientele. Blunt, "The Heroic

and the Ideal Landscapes of Nicolas Poussin," *Journal of the Warburg and Courtauld Institutes* 7 (1944), pp. 154–68. Later, stoical withdrawal from political affairs was read into these authors in order to match the image of the retired *peintre-philosophe* in his own "little corner" who feared the danger of popular revolt. Blunt, 1967, pp. 170–71. Indeed, du Vair took up the stoical notion of exile but ultimately called for active engagement in political affairs. See Gerhard Oestreich, *Neostoicism and the Early Modern State*, ed. Brigitta Oestreich and H. G. Koenigsberger, trans. D. McLintock, Cambridge and New York, Cambridge University Press, 1982. Sheila McTighe identified these authors who had enjoyed an extensive reading public with the more restricted group of the "libertines." Her claim that a passage from Charron had by the middle of the seventeenth century become "identified with the clandestine doctrine of the libertins" risks taking the writer out of his important position in public discourse. McTighe, 1996, p. 20.

57 *Correspondance*, p. 384 [June 22, 1648].

58 "En l'homme, la plus haute & souveraine puissance de l'âme, qui est l'entendement, estant posée au plus haut lieu, comme en un thrône, pour conduire & gouverner toute la vie & toute ses actions, a disposé & ordonné sous soy une puissance que nous appellons Estimative, pour cognoistre & juger par rapport des sens la qualité & condition de choses . . . de mouvoir nos affections pour l'exécution de ses jugemens." Du Vair, 1595, p. 12.

59 "Ainsi en l'homme l'entendement est le soverain, qui a sous soy une puissance estimative & imaginative comme un magistrat, pour cognoistre et juger par le rapport des sens de toutes choses qui se présenteront, & mouvoir nos affections pour l'exécution de ses jugemens." Pierre Charron, 1635, pp. 66–67. Note that Charron describes a monarchical state with a magistrate directly under the king.

60 "Les sens, vrayes sentinelles de l'âme, disposez au dehors pour observer tout ce qui se présente, sont comme une cire molle, sur laquelle s'imprime, non la vraye & intérieure nature, mais seulement la face & forme extérieure des choses. Ils en rapportent les images en l'âme, avec un tesmoignage & recommandation de faveur & quasi avec un préjugé de leur qualité, selon qu'ils les trouvent plaisantes & agréables à leur particulier, & non utiles & nécessaires au bien universel de l'homme: & outre, introduisent encore avec les images des choses, l'indiscret jugement que le vulgaire en fait. De tout cela se forme en nostre âme ceste inconsiderée Opinion . . . qui est certainement une dangereuse guide, & téméraire maistresse." Du Vair, 1595, pp. 13–14.

61 Charron, 1635, pp. 66–67.

62 "Sçavants qui examinent et jugent des choses à la manière des Géometres, c'est à dire à la rigueur, par la pure démonstration, et par l'Analyse de leur principes, sans donner aucune entrée à l'Opinion, ou à la Faveur, qui sont les pestes de la Verité." Roland Fréart, *Idée de la perfection de la peinture . . .* , Le Mans, 1662, p. 122.

63 Michael Baxandall, *Painting and Experience in Fifteenth-Century Italy*, 2nd edition, Oxford University Press, 1988.

64 "Pour que la statue soit nue les beaux discours doivent s'envoler." Albert Camus, *La Chute*. I would like to thank Bérénice Jacobs for drawing my attention to this passage.

65 See Merleau-Ponty and Meyer Schapiro in *Cézanne in Perspective*, ed. Judith Wechsler, Englewood Cliffs, N.J., Prentice Hall, 1975, pp. 120–24, 133–41.

66 "Le P(ère): Nostre Apelle François, d'un Peinceau plus sçavant/ Chasse de ses Tableaux ce monstre décevant." Hilaire Pader, *La Peinture parlante*, Toulouse, 1653. Excerpted by Jacques Thuillier in *Actes du colloque Nicolas Poussin*, ed. André Chastel, Paris, CNRS, 1960, II, p. 98.

67 Using Norman Bryson's terms, there was no opposition between the figural and the discursive. Bryson, 1981, p. 27.

68 See e.g. Donald Posner, "Concerning the 'Mechanical' Parts of Painting and the Artistic Culture of Seventeenth-Century France," *Art Bulletin* 75:4 (December 1993), pp. 583–98.

69 For "static" or "la parasite" see Serres, 1982.

70 Clement Greenberg, "Avant-Garde and Kitsch," in *The Collected Essays and Criticism*, ed. J. O'Brian, 4 vols., University of Chicago Press, 1986–93, I, pp. 16–17. My emphasis.

Chapter Ten: Institutional Appropriation

1 For Le Brun's "formule poussinesque" see Versailles, Musée national de Versailles et des Trianons, *Charles le Brun 1619–1690, peintre et dessinateur*, Paris, Ministères d'état/ Affaires culturelles, 1963, no. 14.

2 Ibid., p. xlix.

3 See Gilles Chomer and Sylvain Laveissière, *Autour de Poussin*, Paris, Réunion des musées nationaux, 1994.

4 See [Henri Testelin], *Mémoires pour servir à l'histoire de l'Académie Royale de Peinture et de Sculpture depuis 1648 jusqu'en 1664*, ed. Anatole de Montaiglon, 2 vols., Paris, P. Jannet, 1853. A slightly different version of the memoirs of the portraitist and secretary of the Académie was edited by P. Lacroix: "Relation de ce que s'est passé en l'établissement de l'Académie royale de peinture et de sculpture," *Revue universelle des arts*, 1856. Antoine Schnapper, "The Debut of the Royal Academy of Painting and Sculpture," in *The French Academy: Classicism and Its Antagonists*, ed. June Hargrove, London and Cranbury, Delaware University Press, 1990. Thomas Crow, *Painters and Public Life in Eighteenth-Century France*, New Haven and London, Yale University Press, 1985.

5 Mazarin actually appointed more administrators, increasing the number of venal offices. Three offices of *conseiller intendant généraux des bâtiments* were created in May 1645. Paris, AN 01/1045.7.

6 In addition to the traditional ties between the judicial and corporate institutions, the Parlement was sympathetic to the Guild because the inflation of the number of *brevetaires* was symptomatic of the proliferation of offices in the 1640s. Moreover, the issuance of *brevets* constituted one of the privileges of the *maison du roi* and was, therefore, outside the jurisdiction of the Parlement. Thus, a ruling in favor of the guild extended the powers of the Parlement. The *vu* delivered by the Parlement in August, 1647 was an assertion of the Parlement's power to verify offices and scrutinize financial policies.

7 Testelin, 1853, I, pp. 18–19. Testelin describes the guild members as a litigious cabal that abused the due process of the Parlement for its own ends. Ibid., p. 21.

8 Errard's position was apparently maintained through the protection of Ratabon, an *intendant des batiments* who survived the disgrace of Sublet de Noyers. Georges Guillet de Saint-Georges, "Notice sur Charles Errard" in *Mémoires inédits sur la vie et les ouvrages des membres de l'Académie Royale de peinture et sculpture*, ed. L. Dussieux et al, Paris, J. B. Dumoulin, 1854, p. 93.

9 See Henri Prunières, *L'Opéra Italien en France avant Lulli*, Paris, Champion, 1913, p. 105.

10 Vouet's painting of the widow Artemisia planning her husband's tomb may have been a bid for securing the commission. Jacques Thuillier, Barbara Bréjon de Lavergnée, Denis Lavalle, *Vouet*, exh. cat., Galeries nationales du Grand Palais, Paris, November 6, 1990–February 11, 1991, Paris, Réunion des musées nationaux, 1990, cat. 58, p. 326.

11 He prepared the royal apartments and oratory for the conversion of the Palais Cardinal into the Palais Royal. Vouet turned to president Tubeuf of the *Chambre des comptes* for an intervention on his behalf. Thuillier et al, 1990, p. 138.

12 In 1643 he only received a fraction of his payment, in 1644 he received nothing, in the following year he received only a small portion of the fees due to him. He was finally given only three-quarters of the contractual payment. Ibid., p. 135.

13 Aside from using the services of Vouet (and in one painting Perrier, and possibly La Hyre), Anne of Austria retained only three lesser painters in the Maison de la Reine. François Desmurget (1649–52), a horse-painter named Laurent Dufaye (1649–52), and a portrait painter, Vincent Roynard (1642–56). Emmanuel Bénézit, *Dictionnaire critique et documentaire des peintres, sculpteurs, dessinateurs et graveurs*, rev. ed., 10 vols., Paris, Grund, 1976, VII, p. 405. A painter named Nocret was also active in the queen's entourage in 1649.

14 Vouet's commission for the decoration of the vestibule of the gallery of Diana at Fontainebleau may have also been interpreted as a slight to Sublet, whose reputation had been based in part on his direct control over renovations at Fontainebleau. See C. Michaud, "François Sublet de Noyers, Surintendant des bâtiments de France," *Revue historique* 242 (1969), pp. 353–54.

15 Beginning in 1644, the engraver Michel Dorigny published six compositions for the vestibule at Fontainebleau and fifteen for the bath at the Palais Royal. Thuillier et al, 1990, p. 72.

16 Charles Le Brun showed the *requête* to Séguier in advance to get his support and protection. The Council met at the Palais Royal on January 20, 1648. The king, Anne of Austria, Gaston d'Orléans, prince Condé, chancellor Séguier, and some ministers were present. Charmois read the *requête* which gave a resumé of the trials the arts had undergone up to and including "celui qui pendoit actuellement au Parlement, rapporta cette étonnante requête présentée par les jurés le 7 février 1646, et mit dans tout son jour l'attentat que ces hommes vils et abjects avoient osé former contre la puissance royale même, en poursuivant au Parlement la limitation des peintres et sculpteurs du roi et de la reine régente." Testelin, 1853, I, pp. 29–30.

17 "La faveur a eu plus de partisans que le mérite." Henri Sauval, *Histoire et recherches des antiquités de la ville de Paris* (1650s), 3 vols., Paris, 1724, II, p. 41.

18 Torelli was apparently living in the Louvre in 1649. L. Hautecoeur, *L'Histoire du Louvre et des Tuileries*, Paris, G. Van Oest, 1927, p. 200.

19 "Que tous les bon maîtres ne logent pas à la galerie du Louvre." Cited by *AAE* I, "Brevets de logements."

20 Testelin, 1853, I, p. 11.

21 Ibid.

22 "La troisième réunissoit en soi un nombre peu considérable d'hommes supérieurs, véritables gens d'art par la beauté et l'élévation de leur génie, la richesse de leurs talents, la noblesse de leurs sentiments, et par leur amour sincère pour l'accroissement des belles connoissances et la gloire du nom françois. Ils étoient trop jaloux de l'honneur de leur profession pour vouloir qu'il dépendît d'un vain titre qui désormais n'avoit plus rien de flatteur; ils se respectoient trop eux-mêmes pour se soumettre à la domination de gens que, dans l'exercice de leur art, ils auroient à peine estimés dignes de les servir. Le parti qu'ils prirent fut de se retirer sous la sauvegarde des lieux privilégiés et dans d'autres asyles pareils, impénétrables à la jurande. Sa haine et son orgueil en accrurent, et elle ne songea plus qu'à redoubler ses efforts pour accabler ces respectables et uniques soutiens des beaux arts, plus irritée encore de leur mérite que de leur résistance." Ibid., p. 12.

23 See n. 4 above.

24 See Julian Dent, *Crisis in Finance: Crown, Financiers and Society in Seventeenth Century France*, Newton Abbot (Devon), David & Charles, 1973, pp. 96, 202–3.

25 See Bernard Barbiche, "Henri IV et la surintendance des bâtiments," *Bulletin monumental* 142 (1984), p. 38 n. 109.

26 See René Crozet, *La vie artistique en France au xviie siècle: les artistes et la société*, Paris, Presses universitaires de France, 1954, p. 73. Le Camus was appointed in April, 1648. His first recorded act as *surintendant* was on October 25, 1648, a *brevet* in favor of Louis de la Lande, *jardinier*. Paris, AN 01/1046, nos. 1–46.

27 The letter of appointment stressed the legitimate succession of the office from Sublet to Mazarin and then to Le Camus. Among Camus's qualifications, it stated that "Il a une particulière connaissance de l'architecture . . . il a toujours rendu preuve d'une singulaire probité et suffisance au fait de nos finances." AN 01/10, fol. 1 [signed April 5, 1648]. For a more conventional example, see the *brevet* which addresses the "loyauté, diligence et fidélité" of the gardener (and client of Poussin) André Le Notre and his father Jean. AN 01/1046 nos. 1–46 [January 26, 1637].

28 Mazarin held the office from May 10, 1646 until April 1648.

29 Mazarin's position as "surintendant de la conduitte & gourvernement du Roy & de Monsieur son frère" (*Gazette*, p. 168 [March 9, 1646]) was subject to much criticism. In *La mazarinade*, Scarron ridiculed the cardinal's appointment to the office: "A tous les gens d'esprit es Reyne/ Et pourtant, d'un Roy, pedagogue!" (l. 373). The Lyonnais nobleman Villeneuf replaced Mazarin as tutor.

30 "Rien enfin ne fut omis ou négligé de ce qui pouvoit contribuer à raffermir cet établissement et le rendre d'une utilité aussi transcendante que solide et pour les arts et pour le public." Testelin, 1853, I, pp. 42–43. The first public exercises of the Académie were held on February 1, 1648 only days after the Académie was inaugurated, followed by the first examination and judgment of works. Ibid., pp. 37, 41.

31 Ibid., p. 83.

32 Utility was linked with pleasure in parlementary discourse: "l'Excellence est remplie de grâce, l'utilité de plaisir, & la beauté d'agréement." *Trésors des harangues, remonstrances, et oraisons funèbres de ce temps, redigées par ordre cronologique par Me L.G[ibaut] avocat au Parlement*, Paris, Michel Bobin, 1654; "au lecteur," n.p.

33 Chancellor Séguier interceded on behalf of the Académie seeking the support of "magistrats supérieurs." Testelin, 1853, 1, p. 45. He also took the artists through the necessary procedures and protocols for verifying the *lettres patentes* in Parlement. Documents were put in order and the artist deputies were coached. Ibid., p. 46. A *conseiller* of the *grande chambre* of the Parlement also intervened on their behalf. Ibid., p. 89. The artists also sought support from Meliand, *procureur général* of the Parlement, an amateur and friend of a number of artists. Ibid., p. 46.

34 Hervé, a *conseiller* in the Parlement, acted as an impartial magistrate to draw up a contract joining the guild and the Académie. An *arrêt de la cour* verified the joint body on June 7, 1652.

35 Errard's complaint was addressed to Châteauneuf. Testelin, 1853, 1, pp. 81–82. Mansard was therefore directly responsible for the approval of prints and, as in book publication, the obligatory signatory *privilège du Roi*.

36 For the drawing, see Jean-Claude Boyer et al, *Dessins français du XVIIe siècle dans les collections publiques françaises*, Paris, Réunion des musées nationaux, 1993, pp. 186–87. The print is in the BN Estampes Qb1. 3,639 [May 1651]. The cartouche must postdate the drawing that was the basis for the "placard" of 1651.

37 Anonymous, "La mansarade, ou portrait de l'architecte partisan. Fidel avertissement à ceux qui font bastir, pour se garantir de ses grivellées et de ses ruines" [Paris, May 1, 1651], published in *Archives de l'art français*, ed. Montaiglon (1862), pp. 242–60.

38 Ibid., pp. 247–48.

39 Ibid., p. 257.

40 In addition to the print of *la Gonesse*, Testelin executed at least two other drawings for engravings. Testelin depicted the effects of rumor on the populace in a representation of a looting party looking for sequestered treasures rumored to be hidden in fish. In a more serious allegorical print, he celebrated the lifting of the blockade and the return of support for the arts. Boyer, 1993, pp. 182–84.

41 See Mère Angélique, 1, p. 139 [June 26, 1652] and Chapter Eleven below.

42 Although the artists were helped by Charmois, a *conseiller d'état*, they effectively checked his power in the organization of the Académie. Perhaps this distance was created because of his position as secretary of Maréchal de Schomberg, a supporter of Mazarin. Schomberg was unpopular among *parlementaires* and bourgeois because of his quartering of troops in Paris in the name of the queen regent. Testelin, 1853, 1, p. 63f.

43 "Une libelle satyrique ou injurieux hasardé par le syndic naguère destitué dans la rue de semer le trouble et la désunion." Ibid., p. 67.

44 "Il assura la compagnie qu'elle ne contenoit que des avis et très solides, et très sages, et très pacifiques." Ibid.

45 In a painting by Juste d'Egmont, Gaston d'Orléans was also portrayed as an author of the Académie. Ibid., p. 59.

46 See Yannick Nexon, "Les dédicaces au chancelier Séguier," *XVIIe siècle* 167 (April–June 1990), pp. 203–19. For example, in the epistolary dedication of Tristan l'Hermite and Blanchard's collaborative history of the presidents of Parlement, Séguier was lauded for virtues derived from his parlementary forebears. Séguier's clear judgment, wisdom, and forceful thinking coupled with grave eloquence are at the height of their powers in close proximity to the young King. Poussin's friend Jacques Stella designed the frontispiece depicting Justice. Tristan l'Hermite, Jean-Baptiste l'Hermite de soliers and François Blanchard, *Les Eloges de tous les premiers présidents du Parlement de Paris*, 2 vols., Paris, 1645.

47 See Norman Bryson, *Word and Image: French Painting of the Ancien Regime*, Cambridge and New York, Cambridge University Press, 1981, pp. 56–57.

48 Tristan l'Hermite, *Stances*, n.p., n.d., 4p in-4. Paris, BN Ye 1341. Identified by Hubert Carrier, *La Presse de la Fronde, 1648–1653: Les Mazarinades*, II: *Les Hommes du livre*, Geneva, Droz, 1992, p. 78 n. 422.

49 See e.g. the eulogy for Séguier in Scarron's "Epistre chagrine": "Ha! j'en enrage quand j'y pense,/ Peu de Richelieux aujourd'huy,/ Sauf SEGUIER, qui fait comme luy." n.p.

50 "Aussi les beaux Esprits regrettent son départ,/ Et pour eux son absence [a] des rigueurs estranges."

51 For instance, Mazarin was informed in a letter that Séguier met in council with Gaston d'Orléans on March 6, 1652. *Affaires étr. Fr.* vol. 881, fol. 419 r, cited by Carrier, *La Presse de la Fronde, 1648–1653: Les Mazarinades*, I: "La conquête de l'opinion," Geneva, Droz, 1989, p. 254 n. 251.

52 The Académie asserted its political distance from the agents at Châtelet who reported directly to Mazarin. Carrier, 1992, p. 336 fn. 190 [June 17, 1649]. Thuillier et al, 1990, p. 143.

53 See André Blum, *Abraham Bosse et la société française au dix-septième siècle*, Paris, A. Morance, 1924, and Duplessis, *Catalogue*, Paris, 1859. Abraham Bosse, *Sentimens sur la distinction des diverses manières de peinture, dessein & graueure, & des originaux d'auec leurs copies. Ensemble du choix des sujets, & des chemins pour arriver facilement & promptement . . .* Paris, Chez l'autheur, 1649. Extract by Jacques Thuillier, "Pour un 'corpus pussinianum'," in *Actes du colloque Nicolas Poussin* (1958), ed. André Chastel, Paris, Centre national de la recherche scientifique, 1960, II, p. 83. Hereafter, *Actes*, 1960.

54 *Actes*, 1960, pp. 82–84.

55 Ibid., p. 83.

56 See Donald Posner, "Concerning the 'Mechanical' Parts of Painting and the Artistic Culture of Seventeenth-Century France," *Art Bulletin* 75:4 (December 1993), pp. 583–98.

57 Versailles, 1963, p. xlix.

58 See *Actes*, 1960, p. 84.

59 Bosse is repeating Fréart's comparison of Poussin to Raphael, which was part of the artistic discourse of Sublet's administration and the basis for promoting a patriotic culture. Sublet wanted Poussin to paint a Madonna to compete with the fame of Raphael. Chantelou had commissioned a painting from Poussin to serve as a pendant to a painting then attributed to Raphael. *Correspondance*, p. 128 [April 4, 1642]. Raphael

had a central position in the pedagogical practice of the Académie. Le Brun presented his copies after Raphael for the edification of amateur and practitioner. The engraver Daret also translated and published Vasari's biography of Raphael at this time. There were also a number of copies after Raphael in Passart's collection.

60 "Qui est en un mot le moyen de parler avec certitude d'une chose, afin de ne l'estimer point par le récit d'autruy, ny à cause qu'elle est d'un tel, ou d'un tel, mais avec connaissance de cause. Aussi voilà à mon avis le sentiment de ceux qui n'affectent point de manières à l'exclusion des autres que celle qui peut résister à de telles Epreuves." Bosse, *Sentimens,* [p. 36], cited in *Actes,* 1960, p. 83.

61 "Il ne s'attachoit plus qu'à voir la Verité;/ Il regardoit la Cause & non pas la Personne." Tristan l'Hermite, *Stances,* n.p.

62 In the case of Le Brun, for example, his financial security in January 1651 is attested by his purchase of a house in the faubourg Saint-Victor for 7,000 livres, a considerable sum, immediately before the exhibition of the *May* painting.

63 See Alain Mérot, *Eustache Le Sueur, 1616–1655,* Paris, Arthéna, 1987, pp. 114, 127. An unpublished document still refers to him as "maître-peintre" one month after the *vernissage* of *St. Paul.* The notary is the same used by Pointel. Paris, AN MC, étude LXXXV 153 [June 2, 1649].

64 Mérot, 1987, p. 34.

65 For indispensable archival research on Le Sueur and his clientele see ibid., esp. pp. 31–39. Mérot draws attention to the importance of the *parlementaires* among Le Sueur's clients during the troubles of the Fronde. Ibid., pp. 33–34. Le Sueur's association with the *noblesse de robe* is also attested by his patronage by the author Marin Le Roy, sieur de Gomberville. Ibid., pp. 28–29, 220–21 no. 68. For Le Coigneux, see ibid., nos. 86–94.

66 See ibid., nos. 108–9.

67 Painted for Claude de Guénégaud, *trésorier de l'Epargne,* in 1647. Ibid., nos. 77–78. Guénégaud was affiliated with Pomponne II de Bellièvre. He is listed in the testament of Marie de Bullion, wife of Bellièvre. Paris, AN MC. See also Dent, 1973, pp. 80–81 and n. 28. Mérot, 1987, nos. 3 and 78 (D 199). See Suetonius, *Lives of the Twelve Caesars,* VI, 15.

68 The one exception to narrative painting was an allegory, *Ministre Parfait* (1653), in the same collection ("M. Planson, les halles") as the spectacular patriotic sacrifice of *Marcus Curtius Plunging with his Horse.* Mérot, 1987, nos. 163–64. In another painting, for a *parlementaire,* Le Sueur represented a narrative from Herodotus: burning with avarice, Darius attempts to rob the tomb of Nitocris. Ibid., pp. 235–36, no. 82.

69 See ibid., pp. 257–80. In 1646, Nicolas Lambert, seigneur de Thorigny (d. May 1692), established himself as a *maître,* the same office as Passart. He later became president. With the mansion and fortune inherited from his late *financier* brother, Lambert employed Le Sueur, Le Brun, François Perrier, and others. See my dissertation, p. 430 n. 75. For Perrier at the Hôtel Lambert see Jacques Thuillier, "Les dernières années de François Perrier (1646–1649)," *Revue de l'art* 99 (1993), pp. 9–28.

70 Le Brun's other known clients during this period included M. de Nouveau, *surintendant des postes et relais,* who had been Le Sueur's client as well. Versailles, 1963, [August 3, 1650]. Mérot, 1987, p. 33.

71 See Gilles Chomer, "Charles Le Brun avant 1646: Contribution aux problèmes de sa formation et de ses oeuvres de jeunesse," *Bulletin de la société de l'histoire de l'art français* (Séance du 8 janvier 1977).

72 Georges de Scudéry, *Le Cabinet de Mr de Scudéry, Gouverneur de Nostre Dame de la Garde,* Paris, 1646, p. 212.

73 Recounted by Cicero, Valerius Maximus, and Seneca, the anecdote of Diogenes in his barrel is rarely found in later compendia because it takes liberties with the glory of Alexander, using him to comment on the vanities of liberality. Cicero, *Tusc. Disp.,* V, 32. Valerius Maximus, IV, iii, ext. 4. Seneca, *De Ben.,* V, iv, 4, and V, vi, 1.

74 Le Brun also executed a lost portrait of Bellièvre that was later in the collection of his nephew Harlay, who owned at least one painting by Poussin. Versailles, 1963.

75 See Guillet de Saint-Georges in Testelin, 1853, I, pp. 14, 93.

76 Versailles, 1963, n. 6.

77 Mérot, 1987, p. 281.

78 For the May paintings see Emile Bellier de la Chavignerie, "Les Mays de Notre-Dame," *Gazette des Beaux-Arts* 16 (May 1864), pp. 457–69. P.-M. Auzas, "La tradition du May et les grandes heures de Notre-Dame de Paris," *Pro Arte* 6 (1947), pp. 473–76, "Les 'Grands Mays' de Notre-Dame de Paris," *Bulletin de la société de l'histoire de l'art français* (1949), pp. 40–44, and "Précisions nouvelles sur les Mays de Notre-Dame de Paris," *Bulletin de la société de l'histoire de l'art français* (1953), pp. 40–44.

79 At least one May painting, Louis Testelin's second May painting *Flagellation of Sts Paul and Silas* (1655), had a published *livret* that anticipated the descriptions of paintings in the Salons, thereby underscoring the public function of the work. "L'Explication du tableau posé le 1er mai 1655 devant Notre-Dame," Paris, BN, slnd. in-4, 4 p.

80 In 1644, the commission went to another founding member, the elder Michel Corneille (Orléans, 1601 – Paris 1644?), *Saint Paul et saint Barnabé.* In 1646, the commission went to the future academician Louis Boullogne the elder (1609 – Paris, June 13, 1674) for the *Miracles of Saint Paul at Ephesus* (Louvre). See Comte de Caix de Saint-Aymour, *Une famille d'artistes et de financiers aux XVIIe et XVIIIe siècles: les Boullogne: catalogue raisonné de 588 oeuvres,* Paris, H. Laurens, 1919, and my dissertation, pp. 412–13.

81 Formerly Louvre, no. 42, now in Notre-Dame de Paris.

82 See Anthony Blunt, "The Early Work of Charles Lebrun," *Burlington Magazine* 85 (1944), pp. 165–73. The painting was lauded by the poet Charles de Beys, *Oeuvres poétiques,* Paris, Toussaint Quinet, 1651. See Versailles, 1963, no. 16.

83 See Mérot, 1987, p. 115 [January 24].

84 The formal reference to Raphael's *School of Athens* shows a use of the available resources of monumental figure painting recognized in the streets of Paris. Raphael's ambitious monumental draftsmanship in the *Acts of the Apostles* was known to the community of Paris because the famous cartoons had been exhibited as part of Tubeuf's decoration for the *fête-dieu* in 1645. See Crow, 1984, p. 83.

85 I am indebted to Professor Nathan Whitman for his salient interpretation of this painting.

86 See Francis Haskell and Nicholas Penny, *Taste and the Antique: The Lure of Classical Sculpture, 1500–1900,* New Haven and London, Yale University Press, 1981, pp. 196–98.

87 The figure of feminine seduction and resistance to it is of course a longstanding sexual discourse. See Jacqueline Lichtenstein, *The Eloquence of Color: Rhetoric and Painting in the French Classical Age*, trans. Emily McVarish, Berkeley, University of California Press, 1993.

88 See Guillaume Janneau, *La Peinture française au XVIIe siècle*, Geneva, the author, 1965, p. 244. Michel Hilaire, Jean Aubert, Patrick Ramade, *Grand Siècle: Peintures françaises du XVIIe siècle dans les collections publiques françaises*, Paris and Montreal, Réunion des musées nationaux/Musée des Beaux-Arts de Montréal, 1993, p. 312.

89 See Hilaire et al, 1993, p. 312.

90 Pierre Rosenberg discusses the painting's sources: it is derived from Raphael's *Blinding of Elymas* from the *Acts of the Apostles* tapestry cycle as well as Poussin's *Camillus and the Schoolmaster* and the *Institution of the Eucharist* (Louvre). See ibid., p. 375. Other works resembling Poussin's paintings include the *Moses Saved from the Water* and the *Eleazer and Rebecca at the Well*, both at Nantes, Musée des Beaux-Arts. Ibid., no. 106.

91 One figure, derived from Raphael's *Fire in the Borgo*, reacts violently to the blinded man. Paris, private collection, 456 × 372 mm. In another sketch, the figure is substituted by a centurion closely resembling the soldier witnesses in Poussin's *Camillus* compositions. Oil sketch on canvas, 1055 × 900 mm, Paris, Musée Carnavalet, P2173, 1981. *Les acquisitions de la ville de Paris pour le Musée Carnavalet, 1977–1983*, Paris, Musée Carnavalet, February 22 / April 17, 1983, no. 12.

92 Louis Testelin l'aîné (Paris, 1615 – Paris, August 19, 1655). Engraved by Abraham Bosse. In the preceding year, Le Brun unveiled his second painting for Notre-Dame: *The Martyrdom of St. Stephen*. Versailles, 1963, no. 16. For Le Brun's homage to the elder painter, see *Portrait du peintre Louis Testelin*. Ibid., no. 11.

93 It must be granted that the regent seems to have made some attempts at producing a mode of painting consistent with the values of politically engaged royal and *robe* patronage. Indeed, examples of some of the art commissioned for the royal house seem to have been conceived for their propagandistic value in the face of criticism. An *Allegory of Prudence* (Montpellier, Musée Fabre) is the surviving example from a probable series of allegories supporting the virtues of the regent. Thuillier et al, 1990, p. 340 n. 62. There was also a representation of *Curtius Dentatus Refusing Presents* that in its topos of renunciation of rewards or bribes exploits a Roman subject of magnanimity befitting a monarch. Vouet's *Artemisia having the Mausoleum Constructed* (Stockholm, National Museum) may have been included in this project. Ibid., pp. 326–27, no. 58. The reference to the Queen Regent as the dutiful widow would not have been missed. Indeed, Vouet must have conceived of it in relation to his own projected monument to Louis XIII as further testimony of the regent's devotion to pious works.

Chapter Eleven: Painting and Landscape

1 Félibien identifies the picture in Passart's collection. For the question of the identification of these landscapes, see Antoine Schnapper and Marcel-Jean Massat, "Un amateur de Poussin: Michel Passart (1611/12 – 1692)," *Bulletin de la société de l'histoire de l'art français*, (1994), p. 104.

2 "Nous n'avons encor oublié nos dernières fureurs civiles, nos campagnes ne sont point encores desgraissées de corps morts qu'elles ont couverts, nos rivières, nos fleuves & nos fontaines rouissent encores du sang des François, & voulez vous Sire, que pour un tyran & ses adhèrans qui ruinent vostre Estat nou perissions tous?" *Séanus Romain au Roy, ou l'abbregé de crimes du proscript Mazarin*, Paris 1652 (imitation of *Sejanus François* of 1615), Moreau 3667 [BM13945], pp. 17–18.

3 *La Métamorphose de la France envoyée à une dame de la campagne*, Paris, Claude Marette, 1649, signed VSB and dated February 21, 1649, Moreau 2462 [BM11624], p. 2.

4 Ibid.

5 "Dans le voisinage de cette ville l'on y voit plus rien de ces beaux lieux, on l'ait se servant adroitement de la nature, se faisoit admirer de tous ses spectateurs. Tous ces beaux bourgs sont ruynés, & tous ces riches ornements de la France, ont changé de face & de situation . . ." Ibid., p. 1.

6 "C'est une chose horrible que ce pauvre pays: tout y est pillé; les gens de guerre se mettant dans les fermes sont battre le bled, & n'en veullent pas donner un grain aux pauvres maîtres, qui leur en demandent par aumône pour mettre au moulin. On ne laboure plus, car il n'y a plus de chevaux, & tout est volé." Mère Angélique, Arnauld d'Andilly, *Mémoires pour servir à l'histoire de Port-Royal, et à la vie de la Reverende Mère Marie Angélique de Sainte Magdeleine Arnauld réformatrice de ce monastère*, 3 vols., Utrecht, 1742, I, pp. 402–3 [January 1649].

7 Ibid., p. 404 [January 1649].

8 Ibid., p. 416 [April 1649].

9 See e.g. her letters to the Queen of Poland written in June and July 1652, II, pp. 139, 157.

10 See Neil MacGregor, "The Le Nain Brothers and Changes in French Rural Life," *Art History* II (1979), p. 401.

11 Sheila McTighe, *Nicolas Poussin's Landscape Allegories*, Cambridge and New York, Cambridge University Press, 1996, pp. 53–78.

12 See my "Poussin's *Phocion Landscapes*: Painting in the Tradition of Visual and Verbal Responses to Death," M.A. thesis, University of California, Berkeley, 1984.

13 Du Choul, *Discours de la religion des anciens romains . . .*, Lyon, De l'imprimerie de Guillaume Rouille, 1556, p. 120.

14 Montaigne, "Est-ce par nature ou par erreur de fantasie que la veüe des places, que nous sçavons avoir esté hantées et habitées par personnes desquelles la memoire est en recommendation, nous esmeut aucunement plus qu'ouïr le recit de leurs faicts ou lire leurs escrits? 'Tanta vis admonitionis inest in locis. Et id quidem in hac urbe infinitum: quacunque enim ingredimur in aliquam historiam vestigium ponimus.' ['Such is the power of places to call up the memories. And in this city this is infinite; for wherever we walk we set our foot on history.']," "De la vanité," *Essais*, III, 9, ed. Maurice Rat, Paris, Garnier, 1962, II, p. 441.

15 "De l'institution des enfants," *Essais*, I, 26. See Irma S. Majer, "Montaigne's Cure: Stones and Roman Ruins," in *Michel de Montaigne: Modern Critical Views*, ed. Harold Bloom, New York, Chelsea House, 1987, pp. 117–33.

16 Denise Allen and David Jaffé, "Poussin's *A Calm* and *A Storm*," *Apollo* (June 1998), pp. 28–34.

17 Paris, Archives Nationales, Minutier Centrale, étude CXV, 244 [February 26, 1684], p. 10f.

18　While landscapes still fetched a smaller sum than multiple figure compositions, Poussin's landscapes were valued far more than those of the same genre by other painters. And when the interest in figures was combined with the depiction of landscape, the painting commanded a dear price.

19　Mathieu Molé, *Mémoires*, ed. A. Champollion-Figeac, 4 vols., III, Paris, 1855–57, p. 93.

20　In an argument that was important for the formulation of this chapter, George Huppert considers the analysis by Lucien Goldmann of the famous retreat at Port-Royal: "Jansenism was to be one form – spectacular because it coalesced itself into a movement and persecuted because it expressed itself in theological positions – of a general retreat from society which was advocated in the gentry's best-loved books as early as the 1570s." George Huppert, *Les bourgeois gentilshommes: An Essay on the Definition of Elites in Renaissance France*, University of Chicago Press, 1977, p. 162. See Lucien Goldmann, *Le dieu caché: étude sur la vision tragique dans les Pensées de Pascal et dans le théâtre de Racine*, Paris, Gallimard, 1955.

21　The phrase is from a letter by Antoine Lemaistre to his father in 1637. Cited by Huppert, 1977, p. 228 n. 46. The famous self-imposed retirement of the 29-year-old Lemaistre in the late 1630s was a key event in the foundation of Port-Royal. Nicolas Fontaine, *Mémoires pour servir à l'histoire de Port-Royal*, 2 vols., Cologne, 1738, I, p. 36.

22　"[Moi, qui] n'ay point d'autre Crime que d'estre Homme de Bien, je prens congé de vous." *L'adieu de m. du Vair sur son départ de la cour ensemble l'arangue faicte au roy*, n.p., n.d., Paris, Bibliothèque Nationale, Lb36.906, p. 4.

23　Du Vair's *bastide*, the Provençal name for a house in the country, was on the road between Aix and Aygalades. It was called *Florida*, a French colonial reference intended to stress his remoteness from Paris. See Jean-Jacques Bouchard, *Les Confessions de Jean-Jacques Bouchard, parisien, suivies de son voyage de Paris à Rome*, Paris, 1881, pp. 80–83, and Louis Wolff, *La vie des parlementaires provençaux au XVIe siècle*, Marseille, 1924.

24　"La cour est un théâtre, où nul n'est remarqué/ Ce qu'il est, mais chacun s'y moque, étant moqué:/ Où Fortune, jouant, de nos états se joue,/ Qu'elle tourne, et renverse, et change avec sa roue." The inconstant court is a world turned upside down: "L'esprit bon s'y fait lourd, la femme s'y diffame./ La fille y perd sa honte, la veuve y acquiert blâme,/ Les savants s'y font sots, les hardis éperdus." De la Taille, "Le courtisan retiré," in Maurice Allem[and], [pseud.] ed., *Anthologie poétique française: XVIe siècle*, 2 vols., Paris, Garnier-Flammarion, 1965, II, p. 228.

25　"O bien heureux qui peut passer sa vie/ Entre les siens franc de haine et d'envie,/ Parmi les champs, les forêts et les bois,/ Loin du tumulte et du bruit populaire,/Et qui ne vend sa liberté pour plaire/ Aux passions des princes et des rois! . . . En vivant content de sa fortune,/ Il est sa cour, sa faveur et son roi." Ibid., pp. 265–66. An imagery of nymphs is consistent with the retreats of the nobles described by Thomas Crow, *Painters and Public Life in Eighteenth-Century France*, New Haven and London, Yale University Press, 1985. See also Desportes, "Chanson": "Dans les palais enflés de vaine pompe,/ L'ambition, la faveur qui nous trompe,/ Et les soucis logent communément; / Dedans nos champs se retirent les fées,/ Reines des bois à tresses décoiffées,/ Les jeux, l'amour et le contentement." In Allemand, 1965, p. 267.

26　"Near Paris, where the rapid Sein do's glide,/ In a Suburban Villa did reside/ A Single man; his Garden was his Wife;/ And his delight a solitary life./ Few acres were the limits of his land;/ No costly Tapestry his walls prophan'd:/ And yet he was as satisfied as those,/ On whom too partial fortune oft bestows/ Her greatest favours, since tis not excess,/ But moderation causes happiness." Réné Rapin, *Of Gardens. Four Books. First Written in Latin Verse by Renatus Rapinus. And now made English by J.E.*, London, Thomas Collins and John Ford, 1673, pp. 50–51. In these books of Latin verse, the author responded to a mid-sixteenth-century preoccupation with the ancient agronomic literature, which included Cato's *De re rusticus* (Lyon, 1549) as well as anthologies, such as *Auctores de re rustica. Columella, Palladius, M. Cato, M. Varro*, Lyon, 1541. See Martine Gorrichon, *Le Travaux et les jours à Rome et dans l'ancienne France: Les agronomes latins inspirateurs d'Olivier de Serres*, Tours, 1976.

27　"Heureux celui qui, loin d'affaires/ Comme les gens du temps passé/ Avecques ses boeufs ordinaires/ Laboure le champ que ses pères/ En propre lui on délaissé . . ./ De qui la maison est bâtie/ Sans grande somptuosité,/ De peu de logis assortie,/ Belle entrée et belle sortie/ Avec toute commodité." Rapin, *Les Plaisirs du gentilhomme champêtre* (1575), in Allemand, 1965, pp. 180–81. There were some forty editions between 1575 and 1700. The edition of 1581 was dedicated to Achilles de Harlay.

28　"Je m'en retourne à ma première vie,/ Dans mon pailler où le noix et le fruit/ Me nourriron sûrement et sans bruit." Nicolas Rapin, "Le rat de ville et le rat des champs" (fragment of the translation of Horace's Satire VI, Book II) in ibid., pp. 176–78.

29　"M. de Noyers . . . a chargé de se retirer de sa cour (en laquelle il se fourroit trop avant pour tâcher d'y être employé) et d'en aller en sa maison des champs, où il y a tout loisir de planter des choux." Guy Patin, *Lettres de Gui Patin, 1630–1672*, 3 vols., ed. J.-H. Reveillé-Parise (1846), Geneva, Slatkine, 1972, I, pp. 339–40 [October 21, 1644].

30　For President Nicolas de Verdun's retirement to his *maison de champs* and his collection of paintings see Chapter Seven above, p. 132 and nn. 76–77. Châteauneuf's possible ownership of the Belgrade *Solitude* may have been inflected by his repeated retirements to his country estate. For Châteauneuf's retirement to Mont-Rouge at the behest of Condé, see [Morgues], *Le Secret de la retraite de monseigneur le Prince contenant une fidèle & courte déduction de toutes les intrigues qu'on a joué* [sic] *dans l'Estat depuis son eslargissement jusqu'à l'arrest de proscription donné contre le Cardinal Mazarin*, 1652, Moreau 3628, p. 6.

31　Hermits were also a major figure in the *mazarinades* that bridged ancient and Christian models of retreat to a desert. Some of these critics in the wilderness, e.g., voiced the arguments of Tacitus. *Les Veritez de l'hermite de l'isle d'oleron presentées au Roy à Poictiers*, Paris, 1652, Moreau 4008 [BMI2398], p. 10. Others were known to bemoan the degeneration of France since the time of the ancients. See e.g. *Révélation d'un bon Hermite sur la prochaine Paix générale & déliverance de Paris*, Paris, Claude Boudeville, 1649, Moreau 3539 [BMI1923]. The hermit also provided a foil to Mazarin's luxury: "Il a bâti lui-même de boue les murailles de sa maison; foible défense contre le vent et la pluie. Son lit est composé de feuilles d'arbre; une pierre lui sert de chevet," *Lettre de l'hermite . . .* Moreau 1932 [BMI1214], n.p.

32 Robert Arnauld d'Andilly, *La manière de cultiver les arbres fruitiers*, Paris, A. Vitre, 1653.

33 See MacGregor, 1979, p. 401.

34 "Ce Philosophe Medecin d'Estat vous présente, il est banny, mais il est joyeux d'estre délivré de l'embaras du monde, & s'il n'avoit de l'armour pour ses compatriotes, & du souvenir pour la Ville qui l'a élevé, il ne voudroit pas faire esclatter." *Le Senèque exilé*, 1652, Moreau 3639 [BM13934], pp. 9–10.

35 Citation, as I have been treating it, was not an act of pedantry. Nor did it always depend upon an object as its significant referent. Instead, the manner of enunciation pointed to the speaker's identification with a shared practice. The citation of a style or behavior was a means of belonging, of constructing a sociability whether actual or imaginary. Citation was the performance of that which was already articulated by those who came before. For the poet or painter, citation was a means of averting isolation and loneliness and finding communion with the living and the dead. Yet, because of that revealed desire, citation betrays the experience of loss, belatedness, and nostalgia.

36 Virgil's *Eclogues* first appeared in French translation in 1529. *Les Oeuvres de Virgille translatées de latin en francoys*, trans. Nicolas Couteau, Paris, 1529. Alice Hulubei, *L'Eglogue en France au XVIe siècle: Epoque des Valois (1515–1589)*, Paris, Droz, 1938.

37 Raymond Williams, "Pastoral and Counter-Pastoral," *The Country and the City*, in Oxford and New York, Oxford University Press, 1973, p. 13.

38 See Hulubei, 1938.

39 See Renato Poggioli, *The Oaten Flute: Essays on Pastoral Poetry and the Pastoral Ideal*, Cambridge, Mass., Harvard University Press, 1975.

40 "Berger Henriot, en lieu de vivre en terre/ Toute pleine de peur, de fraudes & de guerre,/ Tu vis la haut au Ciel." Thomas Harrison, *The Pastoral Elegy: An Anthology*, Austin, University of Texas, 1939, p. 155. Marot's lament for Louis of Savoy (1531) is another major example.

41 In Fénélon's *Dialogue des morts*, the painting of the body is called "les funerailles de Phocion" in order to acknowledge the presence of an honorable convoy. For a discussion of this stress on the fulfillment of the burial rites, see my M.A. thesis.

42 See Pauline M. Smith, *The Anti-Courtier Trend in Sixteenth Century French Literature*, Geneva, Droz, 1966, p. 160ff. Hulubei, 1938, chs. 14–15.

43 "Humble, et sans art, ny despence ecsessive/ Pour son tropeau, et soy rendre contents/ D'estre couverts aux injures du temps." Maurice Scève, "Saulsaye. Eglogue de la vie solitaire," in *Oeuvres Complètes*, ed. Pascal Quignard, Mercure de France, 1974, pp. 379–405. See Verdun-L. Saulnier, *Maurice Scève (ca. 1500–1560)*, Geneva/Paris, Slatkine, 1981.

44 "Phlippot: 'D'autre part nous voyons, même devant nos yeux,/ Le soldat arragé, ravageant, furieux,/ Tout ce qu'à la sueur de sa pauvre famille/ Le pauvre paysan gagne avec sa faucille.' Michaut: 'Je puis bien le savoir. A ces Pâcques, j'avais/ Six beaux jeunes agneaux que soigneux je gardais/ Pour vendre et faire argent, duquel je pourrais vivre/ Attendant les moissons; mais j'en suis bien délivré./ Encores n'est-ce tout; à la maudite gent/ Au partir, malgré nous, il faut bailler argent./ S'en allant l'autre jour ils prirent ma Paquette;/ Ils me ravirent tout et vides de raison, Me ménaçaient encor de brûler

ma maison.'" Gauchet, "Eclogue," in Allemand, 1965, II, pp. 344–45.

45 "Encores n'est-ce tout (O quelle cruauté!)/ Et les pieds et les mains ils lui ont garotté,/ Et à force de coups au bonhomme ont fait dire/ Où était son trésor, puis après ce martyre,/ (O mon Dieu quelle horreur!) mes cheveux hérissés/ Pour l'exécrable fait à mon chef sont dressés!/ Sa fille qu'il avait à Perrin fiancée/ Tour à tour les méchants devant lui l'ont forcée." Ibid., p. 345.

46 "Aussi tu ne vois plus en ce pauvre quartier/ Tu ne vois plus d'autels à ce Dieu forestier,/ Ce Dieu aux pieds de bouc; aussi par les prairies/ Plus souvent sans pasteur tu vois les bergeries./ Où est Belin, Phlippot, et Bicheon, que les bois/ Ont entendu chanter et flûter tant de fois?/ Ce Dieu aux pieds de bouc." Ibid., p. 347.

47 For example, one pamphlet of 1614 criticized the elder Condé's attempts to encroach upon the power of the regent Marie de' Medici. The shepherd Damon attempted to woo the shepherdess by promising the devotion of a warrior: "Mes matins pleins de furie/ Feront la guerre pour vous." Sylvie, seeing through his machinations, responds: "Mais toute la bergerie/ Croid que vos chiens sont des loups." In the reprint of 1650, Anne replaced Marie as Sylvie and Condé was replaced by his son. *Dialogue du berger Damon et de la bergère Sylvie sur les affaires du temps*, Paris, Nicolas Bessin, 1650, Moreau 1086 [BM10840], p. 4. Sylvie also appeared in a pamphlet written during the Fronde. *Lettre à Mademoiselle de V. estant à la campagne, en suite de la Guerre des Tabourets*, Paris, 1649, Moreau 1811 [BM11125], which has the following lines: "Voila trop aymable Silvie, . . ./ Attendant que votre retraite/ Rende ma joye plus parfaite." (p. 16). The allegorical possibilities of the eclogue were exploited in a pamphlet during the Fronde by a writer close to the circles that owned pictures by Poussin. Vulson de la Colombière told the pastoral fable of a wolf masquerading as a shepherd's "foreign" dog in his *Parabole du temps présent*, Paris, 1649, Moreau 2673 [BM11729], pp. 3–4. See Hubert Carrier, "Mécénat et politique: l'action de Mazarin jugée par les pamphlétaires de la Fronde," in *L'Age d'or du Mécénat (1598–1661)*, 1985, p. 251.

48 *Frondeurs champêtres, églogue allégorique sur les affaires du temps*, 1651, Moreau 1453 [BM1453].

49 "Colin: Arrestons nous icy, cher Frondeur de village,/ Nos boeufs ne sçauroient paistre en meilleur pasturage." Ibid., p. 1.

50 *Remonstrance du berger de la grande montagne faite à la reine régente à Compiègne pour le retour de Leurs Majestés à Paris*, Paris, 1649, Moreau 3314 [BM11808].

51 "Plus malheureux qu'un baston à la main/ Que Méligène qui parut plus qu'humaine/ Qui fut contraint avecque sa science/ Demandier pour chercher sa substance/ Ses Citoyens n'ayants pris aucun soin/ De l'assister à son plus grand besoin./ Je vais courir une mesme fortune,/ Un mesme mal à présent m'importune . . . D'avoir trop leu & trop escrit de vers/ Du plus grand roy qui fut dans l'Univers." *Plainte du poëte champêtre à la cour des aydes*, n.p., n.d. [1649], Moreau 2795 [BM11770].

52 See my book in progress *Caravaggio's Pitiful Relics: Painting History after Iconoclasm*. The portable tableau under market conditions rehearsed other strategies of self-reflexivity. For Caravaggio, these formal characteristics were important for his monumental altarpieces.

53 I am attempting to theorize both pictorial utterance and address in terms other than the orientational traits supplied by the gestures of depicted sociability. The situation for the utterance might be found in terms of genre, as I am suggesting here. Attempting to describe the temporality of the pictorial utterance is implicitly pursued in the following discussion of the dissonance of the "presentness" of the landscape and the inferences of past actions drawn from the observance of pictorial effects. What Marin describes as "classical representation" may in fact be useful as a critique of the easel picture as long as the historical peculiarity of those conditions that contributed to the manufacture and reception of such an object are recognized. Louis Marin, "Towards a Theory of Reading in the Visual Arts: Poussin's *The Arcadian Shepherds*," in *The Reader in the Text: Essays on Audience and Interpretation*, ed. S. R. Suleiman and I. Crossman, Princeton University Press, 1980, pp. 293–324.

54 Symphorien Champier (1472–1539) was cofounder of the Collège de Trinité, politician and physician. The Latin letter of 1506 to Humbert Fournier, First President of the Parlement of Bourgogne, was published in Symphorian Champier, *Liber de Quadruplicii Vita* (Lyon, 1507). It was translated into French by P. Menestrier, *Bibliothèque curieuse et instructive*, Trévoux, Ganeau, 1704, II, pp. 120–26 and cited by Mathieu Varille, *Les Antiquaires Lyonnais de la Renaissance*, Lyon, Audin, 1924, pp. 14–15.

55 See Chapter Two.

56 For the group as it was constituted in 1536, see P. de Colonia, *Histoire littéraire de la ville de Lyon*, II, p. 466f. Louise L'abé and other women are noticeably omitted.

57 "Quand vient le soir, nous regardons couler au-dessous de nous les eaux tranquilles de la Saône à peine ridées par le souffle d'une molle brise; nous distinguons les maisons de la ville, nous entendons le bruit des ateliers et des machines, et nous suivons de l'oeil la trace de feu que les étoiles filantes laissent dans l'azur des cieux. L'écho des vallons répond à ce murmure confus et l'apporte jusqu'à nous; mais il n'est pas de plus magnifique spectacle que celui dont nous jouissons de notre observatoire placé au sommet de la montagne: la campagne verdoyante qui s'étend au loin autour de nous, les vignobles bourgeonnants, les bosquets couverts de fleurs de toute espèce, les saules au feuillage verdâtre, les prairies, les terres ensemencées, les moissons luxuriantes, les bouquets d'arbres qu'on aperçoit çà et là, tout cela forme un tableau ravissant." Varille, 1924, p. 15.

58 True to a speaker from an urban society, where nobility was compatible with commerce and not dependent upon the possession of country estates, attention to the feudal organization of land is underdescribed. Lyon depended upon its commercial economic base to import sufficient foodstuffs. For the concept of nobility in Lyon see W. Gregory Monahan, "Lyon in the Crisis of 1709: Royal Absolutism, Administrative Innovation, and Regional Politics," *French Historical Studies* 16 : 4 (fall 1990), pp. 833–48.

59 See Anthony Blunt, *Nicolas Poussin: A Critical Catalogue*, London, Phaidon, 1966, pp. 146–47. See Elizabeth Cropper and Charles Dempsey, *Nicolas Poussin: Friendship and the Love of Painting*, Princeton University Press, 1996, p. 284.

60 "Le Peintre qui, tirant un divers paysage/ A mis en oeuvre l'art, la nature, et l'usage/ Et qui d'un las pinceau sur si docte pourtrait/ A, pour s'eterniser, donné le dernier traict:/ Oublie ses travaux, et d'aise en son courage,/ Et tient tousjours ses yeux collez sur son ouvrage./ Il regarde tantost par un pré sauteler/ Un agneau, qui tousjours, muet, semble besler./ Il contemple tantost les arbres d'un bocage,/ Ore le ventre creux d'une grotte sauvage,/ Ore un petit sentier, ore un chemin batir,/ Ore un pin baise-nue, ore un chesne abatu." Guillaume de Saluste du Bartas, "Le Septième Jour," *La Semaine* (1581), ed. Yvonne Bellenger, Paris, Société des textes français modernes, 1992, pp. 303–44. As in Rapin's poem, the humble and isolated country house becomes a self-sufficient state, wherein the poet is its ruler served by trustworthy hired hands. "Que si ses garde-robes/ Ne sont toujours comblés de magnifiques robes/ De velours à fond d'or, et si les faibles aix/ De son coffre peu sûr ne ployent sous le faix/ Des avares lingots . . ./ Car mon vers chante l'heure du bien aisé rustique,/ Dont l'honnête maison semble une république . . ./ Mon cher Bartas mon Louvre et mon cour mes valets." Du Bartas, "Le Troisième Jour," *La Semaine*, in Allemand, 1965, p. 243. The motif of the self as republic was repeated in a letter by Estienne Pasquier, *Lettres*, Paris, 1619, II, p. 403, cited by Huppert, 1977, p. 163.

61 Du Bartas, 1992, p. 304.

62 For Alberti's privileging of composition see Michael Baxandall, *Giotto and the Orators: Humanist Observers of Painting in Italy and the Discovery of Pictorial Composition, 1350–1450*, Oxford University Press, 1971. For a discussion of ekphrasis as an alternative mode of art criticism see my "Pitiful Relics: Caravaggio's *Martyrdom of St Matthew*," *Representations* 77 (winter 2002).

63 "Qui en un temps bien pacifique/ Ne veoit plus fort que luy cheux soy:/ Mais sans querelle domestique/ Sur sa petite République/ Commande comme un petit Roy.// Qui n'oyt plus sonner la diane/ D'une trompette ou d'un tabour:/ Mais plustost au braire d'un asne/ Au chant d'un coq ou d'une cane/ S'esveille dès le poinct du jour." Rapin, *Les Plaisirs*, in Allemand, 1965, p. 181. "Quelquefois le long d'un rivage/ Il vois conduire son troupeau,/ Voit ses vaches au pâturage/ L'une bonne pour le laitage,/ L'autre meilleure à porter veau. . . ./ Vivez contents, ô gentils hommes,/ Avec la paix et la santé,/ Estimant vos fruits et vos pommes/ Plus que ne fait ses grosses sommes/ L'usurier de peur tourmenté./ Vivez donc aux champs, gentilshommes/ Vivez sains et joyeux cent ans,/ Francs du malheur des autres hommes,/ Et des factions où nous sommes/ En un si misérable temps." Ibid., pp. 182–84.

64 Landscape allowed Poussin to depict certain realistic effects without resorting to low-life genre. The importance of this will be pursued in my book in progress *Self-Promotion and the Margins: Representing Subordinates in 17th-Century Rome (1600–1656)*.

65 In Rapin's preface to his work on the cultivation of plants he writes: "Natural ingenuity is such, as will hardly admit of that more elegant dress which I have put on; Considering also the humility of that style, in which a naked and unmixed simplicity is most sought after." Rapin, 1673, preface.

66 Claude Gauchet's poem eventually became a primer on land management. In the argument between the respective pro-

ponents of country and city life, the Hunter delivers a "Discours des facultez & moyens que doit avoir un gentilhomme champestre." Gauchet is teaching the reader how to become "un homme de repos." The country rat educates the city rat. *Le Plaisir des champs, divisée en quatre livres selon les quatre saisons de l'année*, Paris, A. L'Angelier, 1604, pp. 75.

67 "Et le berger trempé jusques à la chemise,/ Effraye du degast, le laboureur advise/ Du mechef advenu, & luy dict, palissant,/ Comme l'eau porte aval le troupeau perrissant." Ibid., p. 39.

68 Ibid., p. 40.

69 See Ross Chambers, *Story and Situation: Narrative Seduction and the Power of Fiction*, Minneapolis, University of Minnesota Press, 1984.

70 S. Kimura, "Autour de N. Poussin – Notes iconographiques sur le thème de Diogène jetant son écuelle," *Bulletin de la société franco-japonaise d'art et d'archéologie* 3 (December 1983), pp. 39–53, and "Études sur Diogène jetant son écuelle de Nicolas Poussin," *Mediterraneus* 5 (1982), pp. 51–56. The Louvre painting is traditionally dated 1648. I respectfully acknowledge Denis Mahon's thesis that the Diogenes painting for Lumague is in Madrid and that the Louvre painting dates from later. If this is so, the Louvre work was painted in the wake of the Fronde. I do not have to insist that the painting and the civil war were contemporaneous. In fact, it is entirely consistent with my argument that the production of landscapes documented during the course of the Fronde would continue beyond that historical crisis. This inflects the position of retreat enunciated by the paintings.

71 "Ayant veu quelqu'un boire dans sa main, il jetta son verre, comme une chose inutile." *Les Apoptegmes ou Bons mots des Anciens*, trans. Nicolas Perrot, Paris, 1694, p. 200.

72 The subject suited the foreign-born Frenchman's assimilation in the metropolitan society of Lyon and his familiarity with the vocabulary of the *collège*. The native of Grison (in what is now the Italian Alps) and inhabitant of Lyon was a naturalized Frenchman who in these last years sought to take up residence in Milan. There he gave much of his wealth to a church and later died. Madeleine F. Pérez, "Le Mécénat de la famille Lumague (branche française) au XVIIe siècle," in *La France et l'Italie au temps de Mazarin*, Presse universitaire de Grenoble, 1986, p. 161.

73 The recalcitrant position of Diogenes was known from contemporary paintings (such as one by Le Brun) depicting the encounter of the philosopher and Alexander. Refusing the gifts of the powerful ruler, Diogenes rebuked the emperor from his barrel, because magnanimity was only another face of vanity.

74 "Quin tu aliquid saltem potius Quorum indiget usus,/ Viminibus mollique paras dextere junco?" *Eclogues*, II, ll. 71–72, cited in "Sur la vanité" (English trans., p. 1077).

75 See Allen and Jaffé, 1998. Papers delivered by Denise Allen, Pauline Maguire, and Janis Bell at the symposium "Perspectives on Poussin," J. Paul Getty Museum, Los Angeles, 1998, discussed the role of optical theory in Poussin's landscapes.

76 Claude Lorrain pursued this observation of the effects of the loss of visual acuity toward specific ends. A screen of leaves with greater illumination coming from behind (relative to the light falling on the surfaces nearer the observer) stresses the representation of the active permeation of light through foliage. The scintillating effect of indistinct edges and translucent planes underscores the more ephemeral interaction of bodies and light.

77 It is difficult to associate the word "irony" with Poussin. Irony is usually associated with the playful dissociation of painterly signifier/signified in Manet's work. But here, as in Chapter Nine, I am dwelling on the authority of that which is "other" than "*what it says*" (to use Ross Chambers's words). Painting relies upon the "unsaid" as the appreciation of formal difficulty or the "said" otherwise perceived as impoverishment of the "painterly."

Bibliography

For a useful list of Poussin's works and a chronological bibliography see Blunt, 1966. Other catalogue raisonnées exist, principally Thuillier, 1974 and more recently those found in the exhibition catalogues, Paris, 1994; London, 1994; and Rome, 1998. For a thorough recent bibliography see Paris, 1994. For an anthology of Poussin's critical fortune see the contribution of Jacques Thuillier in the still indispensable *Actes du colloque Nicolas Poussin*, 1960. For a convenient list of clients and the works they collected see Mérot, 1990. For the *mazarinades*, see Moreau, 1850–51, and Carrier, 1989–92. All pamphlets cited have complete bibliographic references in the endnotes.

Manuscripts

Lyon, Archives Communales, série CC 333, impots et comptabilité.

—, Archives Municipales, état civile.

Paris, Archives Nationales, AN E/676; 01/10, 1045.7, 1046; 1049, 2128; P/2602, 2635, 2636, 2638, 2680, 2685, 2686; U/336, 497.

—, Archives Nationales, Minutier Centrale, étude II, 061-215 [1605–1660]; étude VII, 35; étude XLIII, 32; étude LVII, 66; étude CXV, 244 [February 26, 1684].

—, Bibliothèque Nationale, Cabinet des Manuscrits, Collection Baluze 182, fol. 29; Collection Colbert, II, 395; MS fr. 26288 [June 22, 1587]; fr. 4222, no. 13, fol. 40 [March 15, 1646]; MS fr. 6881, MS fr. 6888, 15915, 16519.

Vincennes, Archives de la Guerre, A1, 69, fol. 544, fil. 550 [June 28–29, 1642]; A1, 71, fol. 268bis.

Publications

Abraham, Claude Kurt, *Tristan L'Hermite*, Boston, Twayne, 1980.

Actes du colloque Nicolas Poussin (1958), ed. André Chastel, 2 vols., Paris, Centre national de la recherche scientifique, 1960.

Adam, Antoine, *Histoire de la littérature française au XVIIe siècle*, 5 vols., Paris, Domat, 1948–56.

Agnew and Sons, Thos., *Master Paintings: Recent Acquisitions*, June 14–July 28, 1989, London, 1989.

Allem[and], Maurice, [pseud.] ed., *Anthologie poétique française: XVIe siècle*, 2 vols., Paris, Garnier-Flammarion, II, 1965.

Allen, Denise and David Jaffé, "Poussin's A Calm and A Storm," *Apollo* (June 1998), pp. 28–34.

Alpers, Svetlana, *The Art of Describing: Dutch Art in the Seventeenth Century*, University of Chicago Press, 1983.

Anderson, Perry, *Lineages of the Absolutist State*, London, Verso, 1974.

Angeloni, Francesco, *L'historia augusta da Giulio Cesare a Costantino, il Magno / illustrata con la verita dell'antiche medaglie da Francesco Angeloni. Seconda impressione / con l'emendationi postume del medesimo autore, e col supplimento de'Rouesci, che mancauano nelle loro tauole, tratti dal tesoro delle medaglie della Regina Christina Augusta e descritti da Gio. Pietro Bellori*, Rome, 1685.

Angot, Robert, sieur de l'Eperonnière, *Les Nouveaux satires et exercises gaillards de ce temps* (Rouen, 1637), repr. "avec notices et notes par Prosper Blanchemain," Paris, Lemerre, 1877.

Archives Nationales (France), *Nouveaux hommages rendus à la Chambre de France: Chambre des comptes de Paris, série P, XVIIe-XVIIIe siècles: inventaire analytique,* ed. Jean-Pierre Babelon, Albert Mirot, Jeanne Vielliard, 2 vols., Paris, Archives Nationales, 1988–89.

Archives Nationales (France), *Répertoire numérique des archives de la Chambre des comptes de Paris: série P*, ed. Alexandré Bruel, Paris, Kraus Reprint, 1977.

Ariès, Philippe, *The Hour of Our Death*, trans. Helen Weaver, New York, Knopf, 1981.

Arnauld Andilly, Angélique de Saint Jean, *Mémoires pour servir à l'histoire de Port-Royal, et à la vie de la Reverende Mère Marie Angélique de Sainte Magdeleine Arnauld reformatrice de ce Monastère*, 3 vols., Utrecht, 1742.

Arnauld d'Andilly, Robert, *La manière de cultiver les arbres fruitiers*, Paris, A. Vitre, 1653.

—, trans., *Histoire des Juifs par Flavius Josephus et Histoire de la guerre des Juifs contre les Romains*, 5 vols., Paris, 1668 (*Histoire ancienne des Juifs & la Guerre des Juifs contre les Romains, 66–70 ap. J.-C., Autobiographie*, Paris, Editions Lidis, 1968).

Auzas, P.-M., "La tradition du May et les grandes heures de Notre-Dame de Paris," *Pro Arte* 6 (1947), pp. 473–76.

—, "Les 'Grands Mays' de Notre-Dame de Paris," *Bulletin de la société de l'histoire de l'art français* (1949), pp. 40–44.

Bahktin, Mikhail, *Rabelais and His World,* trans. H. Iswolsky, Bloomington, Indiana University Press, 1984.

Bailey, Richard, "Writers against the Cardinal: A Study of the Pamphlets which Attacked the Person and Policies of Cardinal Richelieu during the decade 1630–1640," Ph.D. diss., University of Michigan, Ann Arbor, 1973.

—, "Les Pamphlets de Mathieu de Morgues (1582–1670), Bibliographie des ouvrages disponibles dans les bibliothèques parisiennes et certaines bibliothèques des Etats-Unis," *Revue française d'histoire du livre* 18 (1978), pp. 3–48.

—, "Pamphlets des associés polémistes de Mathieu de Morgues: Marie de Médicis, Gaston d'Orléans et Jacques Chanteloube. Une bibliographie des fonds des bibliothèques de Paris et des Etats-Unis," *Revue française d'histoire du livre* 27 (1980), pp. 229–70.

—, "Les recueils de Mathieu de Morgues: une bibliographie des collections dans les bibliothèques de Paris," *Revue française d'histoire du livre* 33 (1981), pp. 553–92.

Ballon, Hilary, *The Paris of Henri IV: Architecture and Urbanism*, Cambridge, Mass. and London, MIT Press, 1991.

Bar, Francis, *Le genre burlesque en France au XVIIe siècle: étude de style*, Paris, d'Artrey, 1960.

Barbiche, Bernard, "Henri IV et la surintendance des bâtiments," *Bulletin monumental* 142 (1984), pp. 19–39.

Barbier, G., *Recueil des privilèges*, Lyon, 1649.

Bardon, Françoise, *Le portrait mythologique à la cour de France sous Henri IV et Louis XIII: mythologie et politique*, Paris, Picard, 1974.

Barroero, Liliana, "Nuove acquisizioni per la cronologia di Poussin," *Bolletino d'arte* 6 (1979), pp. 69–74.

Barthes, Roland, *S/Z* (Paris, 1970) trans. R. Miller, New York, Hill and Wang, 1972.

Bätschmann, Oskar, *Nicolas Poussin: Dialectics of Painting*, trans. Marko Daniel, London, Reaktion, 1990 [trans. of *Dialecktik der Malerei von Nicolas Poussin*, Zürich, 1982].

Baxandall, Michael, *Giotto and the Orators: Humanist Observers of Painting in Italy and the Discovery of Pictorial Composition, 1350–1450*, Oxford University Press, 1971.

—, *Painting and Experience in Fifteenth-Century Italy,* 2nd ed., Oxford University Press, 1988.

Bayard, Françoise, *Le monde des financiers au XVIIe siècle*, preface by Pierre Goubert, Paris, Flammarion, 1988.

Beaune, Claude de, *Le Vray et parfait instructif de la théorique et pratique générale des notaires de Paris*, Paris, 1646.

—, *Traicté de la chambre des comptes de Paris*, Paris, M. Bobin, 1647.

Beaurepaire, Charles De Robillard de, *Recherches sur les établissements d'instruction publique et la population dans l'ancien diocèse de Rouen*, Caen, Hardel, 1863.

Beik, William, *Absolutism and Society in Seventeeth-Century France: State Power and Provincial Aristocracy in Languedoc*, Cambridge University Press, 1985.

—, *Urban Protest in Seventeenth-Century France: The Culture of Retribution*, Cambridge University Press, 1997.

Bellier de la Chavignerie, Emile, "Les Mays de Notre-Dame," *Gazette des Beaux-Arts* 16 (May 1864), pp. 457–69.

Bellièvre, Claude I de, *Lugdunum priscum, par le président Claude Bellièvre*, ed. J.-B. Monfalcon et al, Lyon, Dumoulin et Ronet, 1846.

Bellori, Giovanni Pietro, *Le vite de' pittori, scultori e architetti moderni*, ed. Evelina Borea, intro. Giovanni Previtali, Turin, Einaudi, 1976.

Bénézit, Emmanuel, *Dictionnaire critique et documentaire des peintres, sculpteurs, dessinateurs et graveurs*, rev. ed., 10 vols., Paris, Grund, 1976.

Bentley, Jerry H., *Politics and Culture in Renaissance Naples*, Princeton University Press, 1987.

Beresford, Richard, "Séraphin de Mauroy: un commanditaire dévôt," in Alain Mérot, ed., *Nicolas Poussin (1594–1665), Actes du colloque*, Musée du Louvre, 1994, Paris, La documentation française, 1996, II, pp. 719–45.

Bergin, Joseph, *Cardinal Richelieu: Power and the Pursuit of Wealth*, New Haven and London, Yale University Press, 1985.

Berthod, François, *Mémoires (1652–1653)*, Paris, Didier, 1854.

Blum, André, *Abraham Bosse et la société française au dix-septième siècle*, Paris, A. Morance, 1924.

—, *L'oeuvre gravé d'Abraham Bosse*, Paris, A. Morance, 1924.

Blunt, Anthony, "The Early Work of Charles Lebrun," *Burlington Magazine* 85 (1944), pp. 165–73.

—, "The Heroic and the Ideal Landscapes of Nicolas Poussin," *Journal of the Warburg and Courtauld Institutes* 7 (1944), pp. 154–68.

—, "Poussin Studies VI: Poussin's decoration of the Long Gallery in the Louvre," *Burlington Magazine* 93 (December 1951), pp. 369–76, and 94 (1952), p. 31f.

—, "The Précieux and French Art," in *Fritz Saxl: A Volume of Memorial Essays from his Friends in England*, ed. D. J. Gordon, London, T. Nelson, 1957, pp. 326–38.

—, "Poussin et les cérémonies religieuses antiques," in *Revue des Arts* 10 (1960), p. 58.

—, *Nicolas Poussin: A Critical Catalogue*, London, Phaidon, 1966.

—, *Nicolas Poussin*, Washington, D.C., Pantheon, 1967.

—, *The Drawings of Nicolas Poussin*, New Haven and London, Yale University Press, 1979.

—, "A Newly Discovered Will of Nicolas Poussin," *Burlington Magazine* 124 (November 1982), pp. 703–4.

Bohlin, Diane DeGrazia, *Prints and Related Drawings by the Carracci Family: A Catalogue Raisonné.* Washington, D.C., National Gallery of Art, 1979.

Boisclair, Marie Nicole, *Gaspard Dughet, sa vie et son oeuvre: 1615–1675*, Paris, Arthéna, 1986.

Boislisle, Arthur M., *Chambre des comptes de Paris: Pièces justificatives pour servir l'histoire des premiers présidents (1506–1791)*, Nogent-le-Rotrou, A. Gouverneur, 1873.

Bonnaffé, Edmond, *Les collectionneurs de l'ancienne Rome: notes d'un amateur*, Paris, A. Aubry, 1867.

—, *Les collectionneurs de l'ancienne France: notes d'un amateur*, Paris, A. Aubry, 1873.

—, *Dictionnaire des amateurs français au XVIIe siècle*, Paris, A. Quantin, 1884.

Bonney, Richard, *Political Change in France under Richelieu and Mazarin, 1624–1661*, Oxford and New York, Oxford University Press, 1978.

—, *The King's Debts: Finance and Politics in France 1589–1661*, Oxford and New York, Oxford University Press, 1981.

—, *Society and Government in France under Richelieu and Mazarin, 1624–61*, New York, St. Martin's Press, 1988.

—, *The Limits of Absolutism in Ancien Regime France*, Aldershot (Hants.) and Brookfield (Vt.), Variorum, 1995.

Bosse, Abraham, *Sentimens svr la distinction des diverses manieres de peinture, dessein & graueure, & des originaux d'auec leurs copies. Ensemble du choix des sujets, & des chemins pour arriuer facilement & promptement . . .* Paris, Chez

l'autheur, 1649 (New York, Broude International Editions, 1981).

Botero, Giovanni, *The Reason of State* [*Della ragione di stato*, Venice, 1589], trans. and ed. P. J. and D. P. Waley, London, Routledge & Kegan Paul, 1956.

Bouchard, Jean-Jacques, *Les Confessions de Jean-Jacques Bouchard, parisien, suivies de son voyage de Paris à Rome*, Paris, 1881.

Bourdieu, Pierre, *Outline of a Theory of Practice*, Cambridge University Press, 1977.

Bourgeon, Jean-Louis, "L'île de la Cité pendant la Fronde," *Paris et Ile de France* (1963), pp. 23–143.

Boyer, Jean-Claude and Isabelle Volf, "Rome à Paris: les tableaux du maréchal de Créquy (1638)," *Revue de l'art* 79 (1988), pp. 22–41.

— et al, *Dessins français du XVIIe siècle dans les collections publiques françaises*, Paris, Réunion des musées nationaux, 1993.

Brice, Germain, *Description de la ville de Paris et de tout ce qu'elle contient de plus remarquable*, 9th ed., Paris, 1752, repr. Geneva, Droz, 1971.

Brienne, Henri Auguste de Loménie, Comte de, *Mémoires contenant les événements remarquables des règnes de Louis XIII et de Louis XIV, jusqu'à la mort du Cardinal Mazarin (1615–1661)*, Paris, Didier, 1854.

Bruhn, Matthias, *Die Bieden Fassungen der "Sieben Sakramente" von Nicolas Poussin*, Magisterarbeit, University of Hamburg, 1992.

Bryant, Lawrence M., *The King and the City in the Parisian Royal Entry Ceremony: Politics, Ritual, and Art in the Renaissance*, Geneva, Droz, 1986.

Bryson, Norman, *Word and Image: French Painting of the Ancien Regime*, Cambridge and New York, Cambridge University Press, 1981.

Buisseret, David, *Henry IV*, London, George Allen & Unwin, 1984.

Bussy, Roger de Rabutin, Comte de, *Correspondance avec le père René Rapin*, ed. C. Rouben, Paris, A. G. Nizet, 1983.

Caix de Saint-Aymour, Comte de, *Une famille d'artistes et de financiers aux XVIIe et XVIIIe siècles: les Boullogne: catalogue raisonné de 588 oeuvres*, Paris, H. Laurens, 1919.

Campanella, Tommaso, *La città del sole: dialogo poetico. The City of the Sun: a poetical dialogue*, trans. David J. Donno, Berkeley, University of California Press, 1981.

Carrier, Hubert, "Port-Royal et la Fronde: deux mazarinades inconnues d'Arnauld d'Andilly," *Revue d'histoire littéraire de la France* 75:1 (January-February 1975), pp. 3–29.

—, "Mécénat et politique: l'action de Mazarin jugée par les pamphlétaires de la Fronde," in *L'Age d'or du mécénat (1598–1661): actes du colloque international CNRS (mars 1983) – Le mécénat en Europe, et particulièrement en France avant Colbert*, Paris, Centre national de la recherche scientifique, 1985.

—, *La Presse de la Fronde, 1648–1653: Les Mazarinades*, I: "La conquête de l'opinion," II: *Les Hommes du livre*, Geneva, Droz, 1989–92.

—, ed., *La Fronde: contestation démocratique et misère paysanne: 52 mazarinades*, Paris, EDHIS, 1982.

Cato, Marcus Porcius, *Avctores de re rvstica, Colvmella, Palladivs, M. Cato, M. Varro*, Lvgdvni, Apvd Sebast. Gryphivm, 1541.

Chacun, *Historia*, Rome, 1576.

Chambers, Ross, *Story and Situation: Narrative Seduction and the Power of Fiction*, Minneapolis, University of Minnesota Press, 1984.

—, *Room for Maneuver: Reading (the) Oppositional (in) Narrative*, University of Chicago Press, 1991.

Champier, Symphorien, *Cy commence ung petit livre de lantiquité, origine et noblesse, de la trés antique cité de Lyon*, Lyon, 1529.

—, *Liber de Quadruplici Vita* (1507), in *Bibliothèque curieuse et instructive*, trans. and ed. P. Menestrier, Trévoux, Ganeau, 1704, II, pp. 120–26.

Chappuzeau, Samuel, *Le cercle des femmes et l'académie des femmes*, ed. Joan Crow, University of Exeter Press, 1983.

Chardon, Henri, *Amateurs d'art et collectionneurs manceaux du XVIIe siècle: Les frères de Chantelou*, Le Mans, Monnoyer, 1867.

—, *Scarron inconnu, et les types des personnages du Roman comique*, Paris, Champion, 1903–4.

Charron, Pierre, *De la sagesse* [Bordeaux, 1601], in *Toutes les Oeuvres de Pierre Charron* (Paris, 1635), repr. Genera, Droz, 1970.

Chartier, Rogier, et al, *L'Education en France du XVIe au XVIIIe siècle*, Paris, Société d'edition d'enseignement supérieur, 1976.

Chaunu, Pierre (with the collaboration of Amick Pardaillié-Galabrun et al), *La Mort à Paris: 16e, 17e, 18e siècles*, Paris, Fayard, 1978.

Chennevières-Pointel, Charles Philippe de, *Recherches sur la vie et les ouvrages de quelques peintres provinciaux de l'ancienne France*, Paris, Dumoulin, 1847–62.

Chéruel, Pierre A., *Dictionnaire historique des institutions, moeurs et coutumes de la France*, Paris, L. Hachette, 1855.

—, *Histoire de France pendant la minorité de Louis XIV*, 4 vols., Paris, Hachette, 1879–80.

—, *Histoire de France sous le ministère de Mazarin (1651–1661)*, 3 vols., Paris, Hachette, 1882.

Chevalier-Wilson, Katherine, "Women on Top at Fontainebleau," *Oxford Art Journal* 16:1 (1993), pp. 34–48.

Chevallier, R. "Dessins du 16ème siècle de la colonne Trajane dans une collection parisienne, contribution à l'histoire des formes et des idées," *Bulletin de la société nationale des antiquaires de France* (1977), p. 130f.

Chomer, Gilles, "Charles Le Brun avant 1646: Contribution aux problèmes de sa formation et de ses oeuvres de jeunesse," *Bulletin de la société de l'histoire de l'art français* (Séance du 8 janvier 1977).

—and Sylvain Laveissière, *Autour de Poussin*, Paris, Réunion des musées nationaux, 1994.

Church, William Farr, *Constitutional Thought in Sixteenth-Century France: A Study in the Evolution of Ideas*, Cambridge, Mass., Harvard University Press, 1941.

—, *Richelieu and Reason of State*, Princeton University Press, 1972.

—, ed., *The Impact of Absolutism in France: National Experience under Richelieu, Mazarin, and Louis XIV*, New York, Wiley, 1969.

Clarke, Jack A., *Gabriel Naudé*, Hamden (Conn.), Archon Books, 1970.

Colantuono, Anthony, *Guido Reni's Abduction of Helen: The Politics and Rhetoric of Painting in Seventeenth-Century Europe*, Cambridge University Press, 1997.

Colonia, P. Dominique de, *Antiquitez profanes et sacrées de la ville de Lyon*, Lyon, 1701.

—, *Histoire littéraire de la ville de Lyon*, 2 vols., Lyon, 1728–30.

Commemorating Poussin: Reception and Interpretation of the Artist, ed. Katie Scott and Genevieve Warwick, Cambridge University Press, 1999.

Conner, Randy, "Les Molles et les chausses: Mapping the Isle of Hermaphrodites in Premodern France," in *Queerly Phrased: Language, Gender, and Sexuality*, ed. Anna Livia and Kira Hall, New York and Oxford, Oxford University Press, 1997, pp. 127–46.

Conrart, Valentin, *Mémoires de Valentin Conrart, premier secrétaire perpétuel de l'Academie française*, Geneva, Slatkine, 1971.

Corradini, Sandro, "La Quadreria di Giancarlo Roscioli," *Antologia di belle arti* (December 1979), pp. 192–96.

Cosnac, Gabriel Jules, *Les Richesses du Palais Mazarin*, Paris, Renouard, 1885.

Costello, Jane, "The Twelve Pictures 'ordered by Velasquez' and the Trial of Valguarnera," *Journal of the Warburg and Courtauld Institutes* 13 (1950), pp. 237–84.

—, "Poussin's Drawings for Marino and the New Classicism: I – Ovid's Metamorphoses," *Journal of the Warburg and Courtauld Institutes* 18 (1955), pp. 296–317.

—, *Nicolas Poussin, The Martrydom of Saint Erasmus: Le martyre de saint Érasme*, Ottawa, National Gallery of Canada, 1975.

Cotté, Sabine, "Un exemple du 'goût italien': la galerie de l'hôtel de la Vrillière à Paris" in *Seicento: le siècle de Caravage dans les collections françaises*, Paris, Réunion des musées nationaux, 1988, p. 43.

Courbis, Eugene, *Municipalité lyonnaise sous l'ancien régime*, Lyon, Waltener, 1900.

Cousin, M., *Journal des Savants*, August 1854, p. 460.

Crelly, William R., *The Painting of Simon Vouet*, New Haven, Yale University Press, 1962.

Croll, Morris W., *Style, Rhetoric, and Rhythm*, ed. J. Max Patrick, Princeton University Press, 1966.

Cropper, Elizabeth, "On Beautiful Women, Parmigianino, 'Petrarchismo,' and the Vernacular Style," *Art Bulletin* 58 (1976), pp. 374–94.

—, *The Ideal of Painting: Pietro Testa's Düsseldorf Notebook*, Princeton University Press, 1984.

—, "'La più bella antichità che sappiate desiderare': History and Style in Giovan Pietro Bellori's *Lives*," in *Kunst und Kunsttheorie, 1400–1900*, ed. Peter Ganz et al, Wiesbaden, Wolfenbütteler Forschungen 48, 1991, pp. 145–73.

—, "Vincenzo Giustiniani's 'Galleria': The Pygmalion Effect," in *Cassiano Dal Pozzo's Paper Musem volume II*, Rome, Olivetti, 1992, pp. 124–25.

—and Charles Dempsey, *Nicolas Poussin: Friendship and the Love of Painting*, Princeton University Press, 1996.

Crow, Thomas, *Painters and Public Life in Eighteenth-Century France*, New Haven and London, Yale University Press, 1985.

—, "The Critique of Enlightenment in Eighteenth-Century Art," *Art Criticism* 3:3 (1987), pp. 17–31.

Crozet, René, *La vie artistique en France au xviie siècle: Les Artistes et la Société*, Paris, Presses universitaires de France, 1954.

Cuenin-Lieber, Mariette, "L'expérience de la disgrâce sous Louis XIII et sous la Régence," in *La Cour au miroir des mémo-rialistes, 1530–1682*, ed. Noémi Hepp, Klincksieck, Paris, 1991, p. 111–22.

Cyrano de Bergerac, Savien de, *Oeuvres complètes*, ed. Jacques Prévot, Paris, Belin, 1977.

Darnton, Robert, *The Literary Underground of the Old Regime*, Cambridge, Mass., Harvard University Press, 1982.

Davis, Natalie Zenon, *Society and Culture in Early Modern France*, Stanford University Press, 1975.

—, "A Renaissance Text to the Historian's Eye: The Gifts of Montaigne," *Journal of Medieval and Renaissance Studies* (Duke) 15 (1985), pp. 47–56.

Dempsey, Charles, "Poussin and Egypt," *Art Bulletin* 45 (1963), pp. 154–68.

—, "'Et Nos Cadamus Amori': Observations on the Farnese Gallery," *Art Bulletin* 50:4 (December 1968), pp. 363–74.

Dent, Julian, *Crisis in Finance: Crown, Financiers and Society in Seventeenth Century France*, Newton Abbot (Devon), David & Charles, 1973.

Derand, François, *L'architecture des voutes, ou, l'art des traits, et coupe des voutes: traicte tres-util, voire necessaire a tous architectes . . .*, Paris, S. Cramoisy, 1643.

Descimon, Robert, "The Birth of the Nobility of the Robe: Dignity versus Privilege in the Parlement of Paris, 1500–1700," trans. Orest Ranum, in *Changing Identities in Early Modern France*, ed. Michael Wolfe, Durham, N.C., and London, Duke University Press, 1996, pp. 95–123.

Desgraves, Louis, *Répertoire des programmes des pièces de théâtre jouées dans les collèges en France (1601–1700)*, Geneva, Droz; Paris, Champion, 1986.

Desmarets de Saint Sorlin, Jean, *Oevvres poetiqves dv sievr Des Marets*, Paris, Chez Henry le Gras, 1641.

Dessert, Daniel, "Pouvoir et finance au xviie siècle: La fortune de Mazarin," *Revue d'histoire moderne et contemporaine* 23 (1976), pp. 161–81.

—, *Argent, pouvoir et société au Grand Siècle*, Paris, Fayard, 1984.

Deyron, Jacques, *Des antiquités de la ville de Nismes, par le Sr. Deyron*, Nîmes, Jean Plasses, 1663.

Dornic, François, *Louis Berryer, agent de Mazarin et de Colbert*, University of Caen, 1968.

Du Choul, Guillaume, *Discours sur la castramentation et discipline militaire des Romains. Des bains et antiques exercitations grecques et romaines. De la religion des anciens Romains*, Lyons, G. Rouillius, 1555.

—, *Discours de la religion des anciens Romains; escript par noble seigneur Guillaume du Choul . . . et illustré d'vn grand nombre de medailles, & de plusieurs belles figures retirées des marbres antiques* (Lyon, G. Rouille, 1556), repr. New York, Garland, 1976.

Du Vair, Guillaume, *Adieu de m. du Vair sur son départ de la cour ensemble l'arangue faicte au roy*, n.p., n.d., Paris, Bibliothèque Nationale, Lb36.906.

—, *Traité de la Constance et Consolation ès calamitez publiques*, Paris, 1595.

Dubuisson-Aubenay, François-Nicolas Baudot, *Journal des guerres civiles de Dubuisson-Aubenay, 1648–1652*, ed. G. Saige, 2 vols., Paris, Champion, 1883–85.

Duccini, Hélène, "L'État sur la place: Pamphlets et libelles dans la première moitié du xviie siècle," in *L'État baroque: Regards*

sur la pensée politique de la France du premier XVIIe siècle, ed. Henry Méchoulan, Paris, J. Vrin, 1985, pp. 289–300.

—, *Concini: Grandeur et misère du favori de Marie de Médicis*, Paris, Albin Michel, 1991.

Dulong, Claude, "Mazarin et les frères Cenami," *Bibliothèque de l'Ecole des Chartes* 144 (July–December 1986).

Dumesnil, Antoine Jules, *Histoire des plus célèbres amateurs français [italiens, vol. 1] et de leurs relations avec les artistes*, Paris, J. Renouard, 3 vols., 1853–58.

Durand, Y., ed., "Cahier des remonstrances de la noblesse du baillage de Troyes," in *Deux Cahiers de la Noblesse pour les États Généraux de 1649–1651*, ed. R. Mousnier., J.-P. Labatut, Y. Durand, Paris, Presses universitaires de France, 1965.

Dussieux, L. and E. Soulie, *Mémoires inédits sur la vie et les ouvrages des membres de l'Academie royale de peinture et de sculpture, publiées d'après les manuscrits conservés à l'Ecole impériale des beaux-arts*, Paris, J. B. Dumoulin, 1854.

Ellery Schalk, *From Valor to Pedigree: Ideas of Nobility in France in the Sixteenth and Seventeenth Centuries*, Princeton University Press, 1986.

Eloges et discovrs svr la triomphante reception dv Roy [Lovis [XIII] en sa ville de Paris, après la réduction de la Rochelle: accompagnez des figures, tant des arcs de triomphe, que des autres préparatifs, Paris, P. Rocolet, 1629.

Fauvelet du Toc, Antoine, *Histoire des Secrétaires d'Estat contenant l'origine, le progrès, et l'établissement de leurs charges, avec les éloges, les armes, blasons, & généalogies de tous ceux qui les ont possédées jusqu'à présent*, Paris, C. de Sercy, 1668.

Félibien, André, *Entretiens sur les vies et sur les ouvrages des plus excellens peintres anciens et modernes: avec La vie des architectes / par Monsieur Félibien. Nouvelle édition, revue, corrigée & augmentée des conférences de l'Academie royale de peinture & de sculpture; de l'idée du peintre parfait, des traitez de la miniature, des desseins, des estampes, de la connoissance des tableaux, & du gout des nations; de la description des maisons de campagne de Pline, & de celle des Invalides*, 4 vols., Trévoux, SAS, 1725.

Findlen, Paula, "Humanism, Politics, and Pornography in Renaissance Italy," in *The Invention of Pornography: Obscenity and the Origins of Modernity, 1500–1800*, ed. Lynn Hunt, New York, Zone Books, 1993, pp. 49–108.

Fléchier, Esprit, Bishop of Nîmes, *Mémoires de Fléchier sur les Grands-jours d'Auvergne en 1665*, ed. P. A. Chéruel, 2nd ed., Paris, Hachette, 1856.

Foisil, Madeleine, *La révolte des nu-pieds et les révoltes normandes de 1639*, Paris, Presses universitaires de France, 1970.

—, "Parentèles et fidélités autour de Longueville, gouverneur de Normandie pendant la Fronde," in *Hommage a Roland Mousnier: clientèles et fidélités en Europe à l'époque moderne*, ed. Yves Durand, Paris, Presses universitaires de France, 1981.

Ford, Terence, "Andréa Sacchi's 'Apollo Crowning the Singer Marc Antonio Pasqualini'," *Early Music* 12 (February 1984), pp. 79–84.

Forte, Joseph, "Political Ideology and Artistic Theory in Poussin's Decoration of the Grande Galerie of the Louvre," Ph.D. diss., Columbia University, New York, 1982.

—, "Deconstruction and Reconstruction in Poussin's Decoration of the Grande Galerie of the Louvre," in *Artistic Strategy and the Rhetoric of Power: Political Uses of Art from Antiquity to the Present*, ed. David Castriota, Carbondale and Edwardsville, Southern Illinois University Press, 1986, pp. 57–66, 192–95.

Fournival, Simon, *Recueil général des titres concernant les fonctions, rangs, dignitez séances et privilèges des charges des présidens trésoriers de France, Généraux des finances, & grands voyers des généralitez du Royaume*, Paris, A. Chouqueux, 1655.

Fourrier, Charles, *L'enseignement français de l'Antiquité à la Révolution: précis d'histoire des institutions scolaires par les textes juridiques*, Paris, Institut pédagogique national, 1964.

France, Musée Pédagogique, *Répertoire des ouvrages pédagogiques du XVIe siècle: Bibliothèques de Paris et des départements*, Paris, Imprimerie nationale, 1866.

—, Bibliothèque Nationale, *Mazarin: homme d'état et collectionneur, 1602–1661*, exh. cat., Paris, Bibliothèque Nationale, 1961.

Franklin, Julian H., *Jean Bodin and the Sixteenth-Century Revolution in the Methodology of Law and History*, New York, Columbia University Press, 1963.

Fréart, Roland, sieur de Chambray, *Parallèle de l'architecture antique et de la moderne: avec un recueil des dix principaux autheurs qui ont ecrit des cinq ordres: scavoir, Palladio et Scamozzi, Serlio et Vignola, D. Barbaro et Cataneo* (Paris, Edme Martin, 1650), Geneva, Minkoff, 1973.

—, *Traité de la peinture de Leonard de Vinci donne au public et traduit d'Italien en François par RFSDC*, Paris, 1651.

—, *Idée de la perfection de la peinture . . .*, Le Mans, 1662.

Freccero, Carla, "Cannibalism, Homophobia, Women: Montaigne's 'Des Cannibales' and 'De l'amitié'," in *Women, "Race," and Writing in the Early Modern Period*, ed. Margo Hendricks and Patricia Parker, London and New York, Routledge, 1994.

Friedlaender, Walter, *Nicolas Poussin: A New Approach*, New York, N. H. Abrams, 1966.

—and Anthony Blunt, *The Drawings of Nicolas Poussin: Catalogue Raisonné*, 5 vols., London, Warburg Institute, 1939–74 [IV (1963) in collaboration with John Sherman and Richard Hughes-Hallet].

Fumaroli, Marc, *L'Age de l'éloquence: Rhétorique et "res literaria," de la Renaissance au seuil de l'époque classique*, Geneva, Droz, 1980.

—, "Rhetoric, Politics, and Society: From Italian Ciceronianism to French Classicism," in *Renaissance Eloquence: Studies in the Theory and Practice of Renaissance Rhetoric*, ed. James J. Murphy, Berkeley, University of California Press, 1983, pp. 253–73.

—, "Muta Eloquentia: la représentation de l'éloquence dans l'oeuvre de Nicolas Poussin," *Bulletin de la société de l'histoire de l'art français* (1984), pp. 29–48.

—, "The Republic of Letters," *Diogenes* 143 (fall 1988), pp. 129–52.

—, *L'inspiration du poète de Poussin*, Paris, Réunion des musées nationaux, 1989.

G[ibault], L., *Trésors des harangues, remonstrances, et oraisons funèbres de ce temps, redigées par ordre cronologique par Me L.G[ibaut] avocat au Parlement*, Paris, Michel Bobin, 1654.

Galacteros-de Boissier, Lucie, *Thomas Blanchet (1614–1689)*, Paris, Arthéna, 1991.

Garden, Maurice, *Lyon et les Lyonnais au XVIIIe siècle*, Paris, Belles Lettres, 1970.

Gareau, Michel and Lydia Beauvais, *Charles Le Brun: First Painter to King Louis XIV*, New York, Abrams, 1992.

Garrard, Mary D., *Artemisia Gentileschi: The Image of the Female Hero in Italian Baroque Art*, Princeton University Press, 1989.

Gascon, Richard, *Grand Commerce et vie urbaine au XVIIe siècle: Lyon et ses marchands (environs de 1520 – environs de 1580)*, 2 vols., Paris, La Haye, Mouton, 1971.

Gauchet, Claude, *Le Plaisir des champs divisé en quatre livres selon les quatre saisons de l'année . . .* , Paris, A. L'Angelier, 1604.

Giddens, Anthony, *A Contemporary Critique of Historical Materialism, vol. 1. Power, Property, and the State*, Berkeley and Los Angeles, University of California Press, 1981.

Gigli, Giacinto, *Diario romano (1608–1670)*, ed. G. Ricciotti, Rome, 1958.

Godefroy, Théodore, *Grand cérémonial de France, ou Description des cérémonies, rangs, [et] séances observées aux couronnemens, entrées, [et] enterremens des roys [et] roynes de France, [et] autres actes et assemblées*, Paris, A. Pacard, 1619; as *Le Cérémonial français*, Paris, 1649.

Gofflot, L. V., *Le théâtre au collège du moyen âge à nos jours*, Paris, H. Champion, 1907.

Goldmann, Lucien, *Le dieu caché: étude sur la vision tragique dans les Pensées de Pascal et dans le théâtre de Racine*, Paris, Gallimard, 1955.

Gomberville, Marin Le Roy, sieur de, *La doctrine des moeurs, tirée de la philosophie des stoïques, représentée en cent tableaux et expliquée en cent discours pour l'instruction de la ieunesse*, Paris, L. Sevestre, 1646.

Gombrich, E. H., "The Subject of Poussin's *Orion*," *Burlington Magazine* 84 (1944), pp. 37–41.

Gorrichon, Martine, *Le Travaux et les jours à Rome et dans l'ancienne France: Les agronomes latins inspirateurs d'Olivier de Serres*, Tours, 1976.

Goubert, Pierre, *Mazarin*, Paris, Fayard, 1990.

Goulas, Nicolas, *Mémoires*, ed. Charles Constant, 3 vols., Paris, Renouard, 1879–82.

Gramsci, Antonio, *An Antonio Gramsci Reader: Selected Writings, 1916–1935*, ed. David Forgacs, New York, Schocken, 1988.

Grand-Mesnil, Marie Nöelle, *Mazarin, la Fronde et la presse, 1647–1649*, Paris, A. Colin, 1967.

Grautauff, Otto, *Nicolas Poussin, sein Werk and sein Leben*, 2 vols., Munich, 1914.

Greenberg, Clement, "Avant-Garde and Kitsch, " in *The Collected Essays and Criticism*, ed. J. O'Brian, University of Chicago Press, 1986–93.

Grigsby, Darcy Grimaldo, "Rumor, Contagion, and Colonization in Gros's *Plague-Stricken of Jaffa* (1804)," *Representations* 51 (summer 1995), pp. 1–61.

Guidobaldi, Nicoletta, "Giovanni Maria Roscioli: Un esempio di mecenatismo musicale alla corte di Urbano VIII," *Esercizi: Arte, musica, spettacolo* 6 (1983), pp. 62–70.

Guillet de Saint-Georges, Georges, "Notice sur Charles Errard" in *Mémoires inédits sur la vie et les ouvrages des membres de l'Acadèmie Royale de peinture et sculpture*, ed. L. Dussieux et al, Paris, J. B. Dumoulin, 1854.

Gutton, Jean Pierre, *La société et les pauvres: l'exemple de la généralité de Lyon, 1534–1789*, Paris, Belles Lettres, 1971.

Guyaz, Marc, *Histoire des institutions municipales de Lyon avant 1789*, Lyon, 1884.

Hadas-Lebel, Mireille, *Jérusalem contre Rome*, Paris, Cerf, 1990.

—, *Flavius Josèphe* (Paris, Arthème Fayard, 1989), *Flavius Josephus: Eyewitness to Rome's First-Century Conquest of Judea*, trans. Richard Miller, New York, Macmillan, 1993.

Haffner, Christel, "La Vrillière, collectionneur et mécène," in *Seicento: le siècle de Caravage dans les collections françaises*, Paris, Réunion des musées nationaux, 1988, pp. 29–38, 305–7.

Hammond, Frederick, *Music and Spectacle in Baroque Rome: Barberini Patronage under Urban VIII*, New Haven and London, Yale University Press, 1994.

Hampton, Timothy, *Writing from History: The Rhetoric of Exemplarity in Renaissance Literature*, Ithaca, N.Y., Cornell University Press, 1990.

Harlay, Achilles II de, *Les Oeuvres de C. Corneille Tacite, traduites de latin en français par m. Achilles de Harlay*, Paris, Vve. J. Camusat et P. le Petit, 1644.

Harth, Erica, *Ideology and Culture in Seventeenth-Century France*, Ithaca and London, Cornell University Press, 1983.

Haskell, Francis, *Patrons and Painters: A Study in the Relations between Italian Art and Society in the Age of the Baroque*, rev. ed., New Haven and London, Yale University Press, 1980.

—, "The Early Numismatists," in *History and its Images: Art and the Interpretation of the Past*, New Haven and London, Yale University Press, 1993, pp. 13–25.

—and Nicholas Penny, *Taste and the Antique: The Lure of Classical Sculpture, 1500–1900*, New Haven and London, Yale University Press, 1981.

—et al, *Il Museo Cartaceo di Cassiano dal Pozzo: Cassiano naturalista*, n.p., Rome, Olivetti, 1989.

Hautecoeur, L., *L'Histoire du Louvre et des Tuileries*, Paris, G. Van Oest, 1927.

Helsdingen, H. W. van, "Notes on Two Sheets of Sketches by Nicolas Poussin for the Long Gallery of the Louvre," *Simiolus* 5:3/4 (1971), pp. 172–84.

Henderson, Natalie and Arnold, "Nouvelles recherches sur la décoration de Poussin pour la Grande Galerie," *Revue du Louvre* 24 (1977), pp. 225–34.

Hepp, Noémi, "Peut-on être homme de bien à la cour?" in *La Cour au miroir des mémorialistes, 1530–1682*, ed. Noémi Hepp, Paris, Klincksieck, 1991.

Hilaire, Michel, Jean Aubert, Patrick Ramade, *Grand Siècle: Peintures françaises du XVIIe siècle dans les collections publiques françaises*, Paris and Montreal, Réunion des musées nationaux/Musée des Beaux-Arts de Montréal, 1993.

Holmès, Catherine E., *L'Eloquence judiciare de 1620 à 1660: reflet des problèmes sociaux, religieux et politiques de l'époque*, Paris, A. G. Nizet, 1967.

Hulubei, Alice, *L'Eglogue en France au XVIe siècle: Epoque des Valois (1515–1589)*, Paris, Droz, 1938.

Huppert, George, *The Idea of Perfect History: Historical Erudition and Historical Philosophy in Renaissance France*, Urbana, University of Illinois Press, 1970.

—, *Les bourgeois gentilshommes: An Essay on the Definition of Elites in Renaissance France*, University of Chicago Press, 1977.

—, *Public Schools in Renaissance France*, Urbana and Chicago, University of Illinois Press, 1984.

Jacquot, Jean, ed., *Les fêtes de la Renaissance*, Paris, Centre national de la recherche scientifique, 1956.

Jaffé, David, "The Barberini Circle: Some Exchanges between Peiresc, Rubens, and their Contemporaries," *Journal of the History of Collections* 2:2 (1989), pp. 119–47.

Janneau, Guillaume, *La Peinture française au XVIIe siècle*, Geneva, the author, 1965.

Jassemin, Henri, *La Chambre des comptes de Paris au XVe siècle, précédé d'une étude sur ses origines*, Paris, A. Picard, 1933.

Jenkins, Ian et al, *Cassiano dal Pozzo's Paper Museum volume I*, Rome, Olivetti, 1992.

Johnson, W. R., *Momentary Monsters: Lucan and his Heroes*, Ithaca, N.Y., Cornell University Press, 1987.

Joly, Guy, *Mémoires*, 2 vols., Geneva, 1777.

Josephus, Flavius, *Les Oeuvres de Flave Joséphe*, Paris, 1597. Bibliothèque Mazarine H2076–2077, 2 tomes in 1 fol.

Jouhaud, Christian, *Mazarinades: la Fronde des mots*, Paris, Aubier, 1985.

Jung, Marc René, *Hercules dans la littérature française du 16e siècle: De l'Hercule courtois à l'Hercule baroque*, Geneva, Droz, 1966.

Keohane, Nannerl O., *Philosophy and the State in France: The Renaissance to the Enlightenment*, Princeton University Press, 1980.

Kervandjian, Melina V., "Achilles in Drag: The Suspension of Identities in Crisis in the Work of Nicolas Poussin," M.A. thesis, Southern Methodist University, Dallas, Tex., 1995.

Kerviler, René Pocard du Cosquer de, *Le chancelier Pierre Séguier, second protecteur de l'Académie française. Etudes sur sa vie privée, politique et littéraire*, 2nd ed., Paris, Didier, 1875.

—, *Valentin Conrart, premier secretaire perpétuel de l'Académie française. Sa vie et sa correspondance. Etude biographique et littéraire, suivie de lettres et de mémoires inédits*, Paris, Didier, 1881.

Kettering, Sharon, *Judicial Politics and Urban Revolt in Seventeenth-Century France: The Parlement of Aix, 1629–1659*, Princeton University Press, 1978.

—, *Patrons, Brokers, and Clients in Seventeenth-Century France*, Oxford and New York, Oxford University Press, 1986.

Kierstead, Raymond F., *Pomponne de Bellièvre: A Study of the King's Men in the Age of Henry IV*, Evanston, Ill., Northwestern University Press, 1968.

Kimura, S., "Etudes sur Diogène jetant son écuelle de Nicolas Poussin," *Mediterraneus* 5 (1982), pp. 51–56.

—, "Autour de N. Poussin – Notes iconographiques sur le thème de Diogène jetant son écuelle," *Bulletin de la société franco-japonaise d'art et d'archéologie* 3 (December 1983), pp. 39–53.

—, "La source écrite du Miracle de saint François-Xavier de Poussin," *La Revue du Louvre et des Musées de France* 5–6 (1988), pp. 394–98.

Kitson, Michael, "The Relationship between Claude and Poussin in Landscape," *Zeitschrift für Kunstgeschichte* 24 (1961), pp. 142–62.

Kleinclausz, Arthur, *Histoire de Lyon*, 3 vols., Lyon, 1948–52.

Kossmann, E. H., *La Fronde*, Leiden, Universitaires Pers Leiden, 1954.

Kraus, Andréas, "Amt und Stellung des Kardinal Nepoten zur Zeit Urbans VIII (1623)," *Römische Quartalschrift für Christliche Altertumskunde und Kirchengeschichte* 53 (1958), pp. 239–43.

—, "Der Kardinal-Nepote Francesco Barberini und das Staatssekretariat Urbans VIII," *Römische Quartalschrift für Christliche Altertumskunde und Kirchengeschichte* 64 (1969), pp. 191–208.

Krueger, Derek, "The Bawdy and Society: The Shamelessness of Diogenes in Roman Imperial Culture," in *The Cynics: The Cynic Movement in Antiquity and its Legacy*, ed. R. Bracht Branham and Marie-Odile Goulet-Cazé, Berkeley, University of California Press, 1996, pp. 222–39.

La Fontaine, Jean de, *Fables choisies, livres I à VI* (1668), ed. Hubert Carrier, Paris, Hachette, 1975.

La Mothe Le Vayer, François de, *Petits traitez en forme de lettres escrites à diverses personnes studieuses*, Paris, A. Courbé, 1648.

Labatut, Jean-Pierre, *Noblesse, pouvoir et société en France au XVIIe siècle: recueil d'articles et de travaux*, intro. Roland Mousnier, Madeleine Foisil, Yves-Marie Berce, Limoges, Faculté des lettres et des sciences humaines, 1987.

Lagny, Jean, *Le poète Saint-Amant, 1594–1661: essai sur sa vie et ses oeuvres*, Paris, A. G. Nizet, 1964.

Lanham, Richard A., *The Motives of Eloquence: Literary Rhetoric in the Renaissance*, New Haven, Yale University Press, 1976.

Laurain-Portemer, Madeleine, "Absolutisme et népotisme: la surintendance de l'état ecclésiastique," *Bibliothèque de l'Ecole des Chartes* 131 (July–December 1973), p. 516.

—, *Études mazarines*, Paris, Boccard, 1981.

Lavin, Marilyn Aronberg, *Biblioteca apostolica vaticana: Seventeenth-Century Barberini Documents and Inventories of Art*, New York University Press, 1975.

Le Pas de Sécheval, Anne, "Aux origines de la collection Mazarin: l'acquisition de la collection romaine du duc Sannesio (1642–1644)," *Journal of the History of Collections* 5:1 (1993), pp. 13–21.

Ledré, Charles, "Théâtre et 'exercises publics' dans les collèges lyonnais du XVe au XVIIIe siècle," *Bulletin de la société de Lyon* 16 (1940–44), pp. 1–29, 17 (1945–49), p. 7, rep. no. 3.

Léon, Antoine, *Histoire de l'enseignement en France*, Paris, Presses universitaires de France, 1967.

Lequenne, Fernand, *Olivier de Serres: Agronome et Soldat de Dieu*, Paris, Berger-Levrault, 1983.

L'Estoile, Pierre de, *Journal de l'Estoile pour le règne de Henri IV, I, 1589–1600*, ed. Louis-Raymond Lefèvre, Paris, Gallimard, 1948.

Levi, Honor, "L'Inventaire après décès du cardinal Richelieu," *Archives de l'art français* (1983), p. 62.

Lichtenstein, Jacqueline, *The Eloquence of Color: Rhetoric and Painting in the French Classical Age*, trans. Emily McVarish, Berkeley, University of California Press, 1993 (*La couleur éloquente: rhétorique et peinture à l'âge classique*, Paris, Flammarion, 1989).

Livy, *The Early History of Rome*, trans. A. de Sélincourt, London, Penguin, 1960.

Loire, Stéphane, ed., *Simon Vouet: actes du colloque international, Galeries nationales du Grand Palais, 5–6–7 février 1991*, Paris, Documentation française, 1992.

Loisel, Antoine I, *La Guyenne de M. Ant. Loisel: qui sont huict remonstrances faicts en la chambre de justice de Guyenne sur le subject des édicts de pacification. Plus une autre remonstrance sur la reduction de la ville . . .*, Paris, Abel l'Angelier, 1605.

—, *Divers opuscules, tirez des mémoires de M. Antoine Loisel advocat en parlement*, Paris, I. Guillemot et I. Guignard, 1652.

London, 1994. *Nicolas Poussin*, ed. Richard Verdi, London, Academy of Fine Arts, 1994.

Loret, Jean, *Muze historique ou recueil des lettres en vers contenant les nouvelles du temps, écrites à Son Altesse Mademoiselle de Longueville, depuis duchesse de Nemours (1650–1665)*, 4 vols., Paris, P. Jannet, 1857–78.

Lucian, *Lucian*, trans. A. M. Harmon, Cambridge, Mass., Harvard University Press, 1913.

Lumbruso, Giacomo, ed., "Notizie sulla vita di Cassiano dal Pozzo," in *Miscellanea di Storia Italiana* 15 (1874), pp. 131–388.

Lyons, John D., *Exemplum: The Rhetoric of Example in Early Modern France and Italy*, Princeton University Press, 1989.

MacGregor, Neil, "The Le Nain Brothers and Changes in French Rural Life," *Art History* 11 (1979), p. 401.

Magendie, Maurice, *La politesse mondaine et les théories de l'honnêteté, en France au xviie siècle, de 1600 à 1660*, Paris, F. Alcan, 1925.

—, *Le roman français au XVIIe siècle, de l'Astrée au Grand Cyrus*, Paris, E. Droz, 1932.

Magne, Emile, *Scarron et son milieu*, Paris, Emile-Paul frères, 1924.

Mahon, Denis, *Studies in Seicento Art and Theory*, London, Warburg Institute, 1947.

—, *Poussiniana: Afterthoughts Arising from the Exhibition*, London, A. Zwemmer, 1962.

—, "Gli esordi di Nicolas Poussin pittore: lavori dei suoi primi anni a Roma," in *Nicolas Poussin: I primi anni romani*, exh. cat., Rome, Electa, 1998, pp. 13–33.

— and Hugh Brigstocke, "Il noviziato di Poussin: Una proposta di sir Denis Mahon ed un'appendice di Hugh Brigstocke," *Quadri & Sculturi* (November 1998), pp. 22–35.

Majer, Irma S., "Montaigne's Cure: Stones and Roman Ruins," in *Michel de Montaigne: Modern Critical Views*, ed. Harold Bloom, New York, Chelsea House, 1987, pp. 117–33.

Marigny, Jacques Carpentier de, *Les triolets du temps, suivant les visions d'un petit fils du grand Nostradamus* [S.l., s.n., 1649].

Marin, Louis, "Le cadre de la représentation et quelques-unes de ses figures," *Cahiers du Musée National d'Art Moderne* 24 (1988), pp. 63–81.

—, "Towards a Theory of Reading in the Visual Arts: Poussin's *The Arcadian Shepherds*," in *The Reader in the Text: Essays on Audience and Interpretation*, ed. S. R. Suleiman and I. Crossman, Princeton University Press, 1980, pp. 293–324.

Martin, Henri Jean, *Livre, pouvoirs et société à Paris au 17e siècle (1598–1701)*, Geneva, Droz, 1969.

—, "Culture écrite et culture orale, culture savante et culture populaire dans la France d'Ancien Régime," *Journal des savants* (July–December, 1975), pp. 225–82.

Mascardi, Agostino, *Dell'arte istorica*, ed. Adolfo Bartoli, Modena, Mucchi, 1994.

Matthews Grieco, Sara F., "Pedagogical Prints: Moralizing Broadsheets and Wayward Women in Counter Reformation Italy," in *Picturing Women in Renaissance and Baroque Italy*, ed. Geraldine A. Johnson and Sara F. Matthews Grieco, Cambridge University Press, 1997, pp. 61–87.

Matthieu, Pierre, "Description des honneurs, pompes et triomphes dressez à l'entrée du Roy en sa ville de Lyon," in *Les deux plus grandes, plus célèbres et mémorables resjouissances de la ville de Lyons*, Lyon, T. Ancelin, 1598.

—, *L'Entrée de très grand et victorieux prince Henry IIII, en sa bonne ville de Lyon, le IIII sept 1595*, Lyon, 1598.

—, *Discours de la ioyeuse et triomphante entrée de très-haut, très-puissant et très magnanime Prince Henry IIII de ce nom, très-Chrestien Roy de France & de Navarre, faicte en sa ville de Rouën, capitale de la province & duché de Normandie, le Mercredy seizième iour d'Octobre MVIXCVI. Avec l'ordre & somptueuses magnificences d'icelle, & les portraictz & figures de tous les spectacles & autres choses y representez*, Rouen, Raphael du Petit val, 1599 (repr. *Entrée à Rouen du roi Henri IV en 1596*, ed. Charles De Robillard de Beaurepaire, Rouen, Espérance Cagniard, 1887).

—, *L'Entrée de . . . Marie de Médicis en la ville de Lyon, avec l'histoire de l'origine et progrez de l'illustrissime maison de médecis*, Rouen, J. Osmont, 1601.

—, *La Conjuration de Conchine ou l'histoire des mouvemens derniers*, Paris, Michel Thevenin, 1618.

Mauss, Marcel, *The Gift: Forms and Functions of Exchange in Archaic Societies*, trans. Ian Cunnison, Glencoe, Free Press, 1954 (New York: Norton, 1967).

Mazarin, Jules, *Le testament du defunct cardinal Jul. Mazarini, duc de Nivernois, &c. premier ministre du roy de France*, Cologne, Imprimé jouxte la Copie, 1663.

—, *Inventaire de tous les meubles du Cardinal Mazarin. Dressé en 1653, et publié d'après l'original, conservé dans les archives de Condé*, ed. Duc d'Aumale, London, Whittingham & Wilkins, 1861 (Geneva, Minkoff, 1973).

—, *Lettres du cardinal Mazarin pendant son ministère*, ed. A. Chéruel, 9 vols., Paris, Imprimerie Nationale, 1872–1906.

McGowan, Margaret M., "Form and Theme in Henri II's Entry into Rouen," *Renaissance Drama*, n.s. 1 (1968), pp. 199–252.

McTighe, Sheila, "The Hieroglyphic Landscape: 'Libertinage' and the Late Allegories of Nicolas Poussin," Ph.D. diss., Yale University, 1987.

—, *Nicolas Poussin's Landscape Allegories*, Cambridge and New York, Cambridge University Press, 1996.

Ménard, Leon, *Histoire des antiquités de la ville de Nismes et de ses environs*, 7 vols., Nimes, 1750–63.

Menestrier, Claude-François, *Les divers caractères, des ouvrages historiques. Avec le plan d'une nouvelle histoire de la ville de Lyon. Le jugement de tous les autheurs qui en ont écrit, & les dissertations sur sa fondation, & son nom*, Lyon, J. Bapt. & Nicolas de Ville, 1694.

Mérot, Alain, *Eustache Le Sueur, 1616–1655*, Paris, Arthéna, 1987.

—, *Poussin*, Paris, Hazan, 1990 (*Nicolas Poussin*, trans. Fabia Claris, New York, Abbeville, 1990).

—, *French Painting in the Seventeenth Century*, trans. Caroline Beamish, New Haven and London, Yale University Press, 1995.

—, ed., *Nicolas Poussin (1594–1665): Actes du colloque*, Musée du Louvre, 1994, 2 vols., Paris, La documentation française, 1996.

— et al, *La Condition sociale de l'artiste: XVIe–XXe siècles: actes du colloque du Groupe des chercheurs en Histoire moderne et contemporaine du CNRS, 12 octobre 1985*, ed. Jérome de La Gorce and Françoise Levaillant, Saint-Etienne, Université de Saint-Etienne, Centre interdisciplinaire d'études et de recherches sur l'expression contemporaine, 1987.

Merrick, Jeffrey. "The Cardinal and the Queen: Sexual and Political Disorders in the Mazarinades," *French Historical Studies* 18:3 (spring 1994), pp. 667–99.

Merrinan, Michael, "Literal/Literary/'lexie': History, Text, and Authority in Napoleonic Painting," *Word and Image* 7:3 (July–September 1991), p. 177.

Methivier, Hubert, *La Fronde*, Paris, Presses universitaires de France, 1984.

Mettam, Roger, *Power and Faction in Louis XIV's France*, Oxford, Basil Blackwell, 1988.

Michaud, C., "François Sublet de Noyers, Surintendant des bâtiments de France," *Revue historique* 242 (1969), p. 327f.

Michon, M. "Communication du 26 Fevrier 1913" in *Mémoires de la société nationale des antiquaires de France* (1913), p. 121.

Molé, Mathieu, *Mémoires*, ed. A. Champollion-Figeac, 4 vols., Paris, J. Renouard, 1855–57.

Momigliano, Arnaldo, "Ancient History and the Antiquarian," *Journal of the Warburg and Courtauld Institutes* 13 (1950), pp. 285–315.

Monahan, W. Gregory, "Lyon in the Crisis of 1709: Royal Absolutism, Administrative Innovation, and Regional Politics," *French Historical Studies* 16:4 (fall 1990), pp. 833–48.

Montagu, Jennifer, *The Expression of the Passions: The Origin and Influence of Charles Le Brun's "Conférence sur l'expression générale et particulière,"* New Haven and London, Yale University Press, 1994.

— et al, *Cassiano dal Pozzo's Paper Museum volume II*, Rome, Olivetti, 1992.

Montaigne, Michel de, *The Complete Essays*, trans. M. A. Screech, London, Penguin, 1991.

—, *Essais*, ed. Maurice Rat, 2 vols., Paris, Garnier, 1962.

Montpensier, Mademoiselle de, *Mémoires de Mademoiselle de Montpensier*, ed. A. Chéruel, 4 vols., Paris, R. Charpentier, 1858–68.

Moote, Alanson Lloyd, *The Revolt of the Judges: The Parlement of Paris and the Fronde, 1643–1652*, Princeton University Press, 1972.

—, *Louis XIII: The Just*, Berkeley, University of California Press, 1989.

Moreau, Celestin, *Bibliographie des mazarinades*, 3 vols., Paris, J. Renouard, 1850–51.

—, *Choix de mazarinades*, 2 vols., Paris, J. Renouard, 1853.

Motteville, Françoise Bertaut de, *Mémoires (1615–1666)*, Paris, Didier, 1854.

Mousnier, Roland, *La Stratification sociale à Paris aux XVIIe et XVIIIe siècles*, Paris, Pedone, 1975.

—, ed., *Richelieu et la culture: actes du colloque international en Sorbonne*, Paris, Centre national de la recherche scientifique, 1987.

Mousset, Albert, *Les Francines: créateurs des eaux de Versailles, intendants des eaux et fontaines de France de 1623 à 1784*, Paris, E. Champion, 1930.

Mouton, Léo, *Le quai Malaquais*, Paris, 1920.

Mullaney, Steven, "Strange Things, Gross Terms, Curious Customs: The Rehearsal of Cultures in the Late Renaissance," *Representations* 3 (1983), pp. 40–67.

Müntz, E. and Em. Molinier, "Le château de Fontainebleau au XVIIe siècle d'après des documents inédits," *Mémoires de la société de l'histoire de Paris et de l'Ile-de-France* 12 (1885), pp. 255–358.

Murata, Margaret, *Operas for the Papal Court, 1631–1668*, Ann Arbor, University of Michigan Press, 1981.

Murphy, James J., *Renaissance Eloquence: Studies in the Theory and Practice of Renaissance Rhetoric*, Berkeley, University of California Press, 1983.

Naudé, Gabriel, *Jugement de tout ce qui a esté imprimé contre le cardinal Mazarin, depuis le 6 janvier, jusques à la déclaration du 1er avril 1649* [known as *Mascurat*], Paris, 1650.

—, *Considérations politiques sur la Fronde: la correspondance entre Gabriel Naudé et le cardinal Mazarin*, ed. Kathryn Willis Wolfe and Phillip J. Wolfe, Paris and Seattle, Papers on French Seventeenth Century Literature, 1991.

Nemours, Marie d'Orléans, Duchesse de, *Mémoires de Marie d'Orléans, duchesse de Nemours. Suivis de Lettres inédites de Marguerite de Lorraine, duchesse d'Orléans*, ed. Micheline Cuenin, Paris, Mercure de France, 1990.

Neuschel, Kristen Brooke, *Word of Honor: Interpreting Noble Culture in Sixteenth-Century France*, Ithaca, N.Y., Cornell University Press, 1989.

Nexon, Yannick, "Les dédicaces au chancelier Séguier," *XVIIe siècle* 167 (April–June 1990), pp. 203–19.

Nièpce, Léopold, *Archéologie lyonnaise*, 3 vols., Lyon, Henri George, 1881–85, II: *Les chambres de merveilles ou cabinets d'antiquités de Lyon depuis la Renaissance jusqu'en 1789*.

Nussdorfer, Laurie, *Civic Politics in the Rome of Urban VIII*, Princeton University Press, 1992.

Oberhuber, Konrad, *Poussin. The Early Years in Rome: The Origins of French Classicism*, New York, Hudson Hills Press, 1988.

Oestreich, Gerhard, *Neostoicism and the Early Modern State*, ed. Brigitta Oestreich and H. G. Koenigsberger, trans. David McLintock, Cambridge and New York, Cambridge University Press, 1982.

Olivier, Louis, "'Curieux,' Amateurs, and Connoisseurs: Laymen and the Fine Arts in the Ancien Régime," Ph.D. diss., Johns Hopkins University, Baltimore, 1976.

Olson, Todd P., "Nicolas Poussin, his French Clientele, and the Social Construction of Style," Ph.D. diss., University of Michigan, Ann Arbor, 1994.

—, "Painting for the French: Poussin, the Fronde and the Politics of Difficulty," in *Commemorating Poussin: Reception and Interpretation of the Artist*, ed. Katie Scott and Genevieve Warwick, Cambridge University Press, 1999.

—, "Pitiful Relics: Caravaggio's Martyrdom of St Matthew," *Representations* 77 (winter 2002).

Orcibal, Jean, *Port-Royal entre le miracle et l'obéissance: Flavie Passart et Angélique de Saint-Jean Arnauld d'Andilly*, Paris, Desclee De Brouwer, 1957.

Ormesson, Olivier Lefevre d', *Journal d'Olivier Lefevre d'Ormesson et extraits des Mémoires d'André Lefevre d'Ormesson*, ed. A. Chéruel, 2 vols., Paris, Impr. impériale, 1860–61.

—, *De l'administration de Louis XIV, 1661–1672*, ed. A. Chéruel, Geneva, Slatkine-Megariotis, 1974.

Pace, Claire, *Félibien's Life of Poussin*, London, A. Zwemmer, 1981.

Pader, Hilaire, *La peinture parlante dediée à Messieurs les peintres de l'Academie royale de Paris suivi du Songe énigmatique sur la*

peinture universelle, Toulouse, Arnaud Colomiez, 1653 (Geneva, Minkoff, 1973).

Pagden, Anthony, *Lords of all the World: Ideologies of Empire in Spain, Britain and France c.1500 – c.1800*, New Haven and London, Yale University Press, 1995.

Panofsky, Erwin, *Hercules am Scheidewege und andere antike Bildstoffe in der neueren Kunst*, Leipzig and Berlin, B. G. Teubner, 1930.

—, "Et in Arcadia ego: Poussin and the Elegiac Tradition," in *Meaning in the Visual Arts*, Garden City, N.Y., Doubleday, 1955, pp. 295–320.

Panofsky-Soergel, G., "Zur Geschichte des Palazzo Mattei di Giove," *Römisches Jahrbuch für Kunstgeschichte* 11 (1967–68), p. 109.

Paradin de Cuyseaux, Guillaume, *Histoire de nostre tems. Faite en Latin par maistre Guillaume Paradin, & par lui mise en François. Despuis par lui mesme revue & augmentée*, Lyon, J. Tournes et G. Gazeau, 1552 (Paris, I. Caueiller, 1555).

—, trans. *Histoire de Procopie de Caesaree, de la guerre des Gothz faicte en Italie, contre l'Empereur Iustinian le Grand . . . Traduit par Guillaume Paradin*, Lyon, Benoist Rigaud, 1578.

—, *Mémoires de l'Histoire de Lyon* (1573), Roanne, Horvath, 1973.

—, *Le journal de Guillaume Paradin, ou, La vie en Beaujolais au temps de la Renaissance (vers 1510–1589)*, ed. Mathieu Meras, Geneva, Droz, 1986.

Parias, Louis-Henri, ed., *Histoire générale de l'enseignement et de l'education en France*, Paris, Nouvelle Librairie de France, 1981.

Paris, 1988, *Seicento: le siècle de Caravage dans les collections françaises*, Galeries nationales du Grand Palais, Paris, October 11, 1988 – January 2, 1989, and Palazzo Reale, Milan, March–April 1989, Paris, Réunion des musées nationaux, 1988.

—, 1990, *Seicento: la peinture italienne du XVIIe siècle et la France*, Paris, La documentation française, 1990.

—, 1993, *Dessins français du XVIIe siècle: dans les collections publiques françaises*, exh. cat., Musée du Louvre, 28 January – 26 April 1993, Paris, Réunion des musées nationaux, 1993.

—, 1994, *Nicolas Poussin 1594–1665*, ex. cat., ed. Pierre Rosenberg and Louis-Antoine Prat, Paris, Réunion des musées nationaux, 1994.

Paris, Hôtel de Ville, *Registres de l'Hôtel de Ville de Paris pendant la Fronde*, ed. Advien Jean Victor Le Roux de Lincy and Douët-D'Arcq, 3 vols., Paris, Renouard, 1847–48.

Parker, David, *The Making of French Absolutism*, London, E. Arnold, 1983.

Parsons, Jotham, "The Political Vision of Antoine Loisel," *Sixteenth Century Journal* 27 (summer 1996), pp. 453–76.

Partridge, Loren and Randolf Starn, "Triumphalism and the Sala Regia in the Vatican," in *All the World's A Stage: Art and Pageantry in the Renaissance and Baroque. Triumphal Celebrations and the Rituals of Statecraft*, ed. Barbara Wollesen-Wisch, University Park, Papers in Art History from The Pennsylvania State University, VI, pt. 1, 1990, pp. 22–81.

Pasquier, Nicolas, *Lettres*, Paris, 1623.

Pasquier, Etienne, *Lettres*, Paris, 1619.

—, *Ecrits politiques*, ed. D. Thickett, Geneva, Droz, 1966.

—, *Oeuvres complètes*, Geneva, Slatkine, 1971.

Pastor, Ludwig, *The History of the Popes: From the Close of the Middle Ages Drawn from the Secret Archives of the Vatican and Other Original Sources*, 40 vols., Liechtenstein, Kraus Reprint, 1968–69.

Patin, Guy, *Lettres de Gui Patin, 1630–1672*, Paris, H. Champion, 1907.

Patrick, Michel, "Rome et la formation des collections du cardinal Mazarin," *Histoire de l'art* 21/22 (May 1993), pp. 5–16.

Peiresc, Nicolas Claude Fabri de, *Lettres de Peiresc*, ed. Philippe Tamizey de Larroque, 2 vols., Paris, Imprimerie nationale, 1888–98.

Pelletier, Guillaume Le, *L'Oraison funèbre sur le tréspas de son Altesse [le] duc de Longueville [le 23 mai 1663]*, Caen, 1663.

Pérez, Madeleine F., "La collection de tableaux de Louis Bay Seigneur de Curis (1631?–1719) d'après son inventaire après décès," *Gazette des Beaux-Arts* 95 (May-June 1980), pp. 183–86.

—, "Le Mécénat de la famille Lumague (branche française) au XVIIe siècle," in *La France et l'Italie au temps de Mazarin*, ed. Jean Serroy, Presses universitaires de Grenoble, 1986, pp. 153–65.

— and J. Guillemain, "Curieux et collectioneurs à Lyon d'après le texte de Spon (1673)," *Jacob Spon: Un humaniste lyonnais du XVIIe siècle* (Université Lumière Lyon 2, VI, Lyon, 1993), ed. Roland Etienne, Paris, Boccard, 1993, pp. 39–50.

Perrault, Charles, *Les Hommes illustres qui ont paru en France pendant ce siècle: avec les portraits au naturel*, 2 vols., Paris, 1696.

—, *Mémoires de ma vie*, Paris, Macula, 1993.

Perrier, François, *Icones et segmenta nobilium signorum et statuarum . . .* , Rome, 1638.

—, *Icones et segmenta illustrium e marmore tabularum . . .* , Rome, 1645.

Petitjean, Charles and and C. Wickert, *Catalogue de l'oeuvre gravé de Robert Nanteuil*, 2 vols., Paris, L. Delteil et M. Le Garrec, 1925.

Picart, Yves, *La vie et l'oeuvre de Simon Vouet*, Paris, Cahiers de Paris, 1958.

Piganiol de la Force, Jean Aimar, *Description historique de la ville de Paris et de ses environs*, Paris, 1765.

Pintard, René, *Le Libertinage érudit dans la première moitié du XVIIe siècle*, Paris, Boivin, 1943.

Plutarch, *Makers of Rome*, trans. Ian Scott-Kilvert, London, Penguin, 1965.

Poggioli, Renato, *The Oaten Flute: Essays on Pastoral Poetry and the Pastoral Ideal*, Cambridge, Mass., Harvard University Press, 1975.

Poldo d'Albenas, Jean, *Discours historial de l'antique et illustre cité de Nimes, en la Gaule Narbonnoise, avec les portraits des plus antiques et insignes bastiments dudit lieu, reduitz à leur vraye mesure et proportion, ensemble de l'antique et moderne ville*, Lyon, Guillaume Rouille, 1560.

Pomian, Krzysztof, *Collectionneurs, amateurs et curieux: Paris, Venise, XVIe–XVIIe siècle*, Paris, Gallimard, 1987 (*Collectors and Curiosities: Paris and Venice 1500–1800*, trans. Elizabeth Wiles-Portier, Cambridge, Polity Press, Cambridge, Mass., Basil Blackwell, 1990).

Portail, Nicolas Johannes, sieur Du, *L'histoire du temps, ou Le véritable récit de ce qui s'est passé dans le Parlement de Paris, depuis le mois d'aoust 1647. iusques au mois de novembre 1648. Augmentée de la seconde partie qui vient iusques à la paix*, 1649.

Posner, Donald, "Concerning the 'Mechanical' Parts of Painting and the Artistic Culture of Seventeenth-Century France," *Art Bulletin* 75 : 4 (December 1993), pp. 583–98.

Poussin, Nicolas, *Correspondance de Nicolas Poussin*, ed. Ch. Jouanny, Paris, J. Schemit, 1911.

Powers, Martin, "The Dialectic of Classicism in Early Imperial China," *Art Journal* (spring 1988), pp. 20–25.

Price, Jonathan J., *Jerusalem Under Siege: The Collapse of the Jewish State 66–70 C.E.*, Leiden, Brill, 1992.

Prunières, Henri, *L'Opéra Italien en France avant Lulli*, Paris, Champion, 1913.

Puttfarken, Thomas, "Poussin's Thoughts on Painting," in *Commemorating Poussin: Reception and Interpretation of the Artist*, ed. Katie Scott and Genevieve Warwick, Cambridge University Press, 1999, pp. 53–75.

Quatremère de Quincy, Antoine-Chrysostome, ed., *Collection de lettres de Nicolas Poussin*, Paris, Didot, 1824.

Ranum, Orest, *Les Créatures de Richelieu: Secrétaires d'etat et surintendants des finances, 1635–1642*, trans. S. Guenée, Paris, Pedone, 1966.

—, "Courtesy, Absolutism, and the Rise of the French State, 1630–1660," *Journal of Modern History* 52 (1980), pp. 426–30.

—, *The Fronde: A French Revolution, 1648–1652*, New York and London, Norton, 1993.

—, ed. *National Consciousness, History and Political Culture in Early Modern Europe*, Baltimore, Johns Hopkins University Press, 1975.

Rapin, René, *Of Gardens. Four Books. First written in Latin verse by Renatus Rapinus. And now made English by J.E.*, London, Thomas Collins and John Ford, 1673.

—, *Mémoires de P. René Rapin (1644–69)*, Paris, 1865.

Retz, Jean François Paul de Gondi de, *Mémoires*, ed. Simone Bertière, 2 vols., Paris, Garnier, 1987.

Reynaud, Françoise, "Recherches sur la population de l'île Saint-Louis en 1652," mémoire de maîtrise, University of Paris IV – Sorbonne, 1976.

Rice, E. F., "The Patrons of French Humanism, 1450–1520," in *Renaissance Studies in Honor of Hans Baron*, ed. Anthony Molho and John A. Tedeschi, Dekalb, Northern Illinois University Press, 1971.

Richards, David, *Masks of Difference: Cultural Representations in Literature, Anthropology and Art*, Cambridge University Press, 1994.

Rome, 1998, *Nicolas Poussin: I primi anni romani*, exh. cat., Palazzo delle Esposizioni, Rome, Electa, 1998, pp. 13–33.

Rosenberg, Pierre, "La Mort de Germanicus de Poussin," *La Revue du Louvre et des Musées de France* 2 (1973), pp. 137–40.

—, *Nicolas Poussin, 1594–1665*, Rome, Villa Medici, November 1977 – January 1978, Rome, Edizioni dell'Elefante, 1977.

— and Denis Lavalle, *La Peinture d'inspiration religieuse à Rouen au temps de Pierre Corneille (1606–1684)*, exh. cat., Rouen, Eglise Saint-Ouen, 1984.

— and Louis-Antoine Prat, *Nicolas Poussin 1594–1665: Catalogue raisonné des dessins*, 2 vols., Milan, Leonardo, 1994.

— and Jacques Thuillier, *Laurent de la Hyre, 1606–1656: l'homme et l'oeuvre*, Geneva, Skira, 1988.

Sahlins, Marshall David, *Historical Metaphors and Mythical Realities: Structure in the Early History of the Sandwich Islands Kingdom*, Ann Arbor, University of Michigan Press, 1981.

Saint-Amant, Marc Antoine Gerard, sieur de, *Moyse sauvé, idyle héroique du sieur de Saint Amant. A la serenissime reine de Pologne, et de Suède*, Paris, Augustin Courbe, 1653.

Saint-Simon, Louis de Rouvroy, Duc de, *Mémoires complets et authentiques du duc de Saint-Simon sur le siècle de Louis XIV et la régence*, ed. A. Chéruel, 13 vols., Paris, Hachette, 1856–82.

Salmon, J. H. M., *Renaissance and Revolt: Essays in the Intellectual and Social History of Early Modern France*, Cambridge and New York, Cambridge University Press, 1987.

Sauval, Henri, *Histoire et recherches des antiquités de la ville de Paris* (1650s), 3 vols., Paris, 1724.

Sawyer, Jeffrey K., *Printed Poison: Pamphlet Propaganda, Faction Politics, and the Public Sphere in Early Seventeenth-Century France*, Berkeley, University of California Press, 1990.

Sayce, Richard A., *The French Biblical Epic in the Seventeenth Century*, Oxford, Clarendon Press, 1955.

Scarron, Paul, *Poèsies diverses de Scarron; textes originaux*, ed. M. Cauchie, 2 vols., Paris, Didier, 1947–61.

—, *Le Virgile travesti*, ed. J. Serroy, Paris, Garnier, 1988.

Scève, Maurice, "Saulsaye: Eglogue de la vie solitaire," in *Oeuvres complètes*, ed. Pascal Quignard, Mercure de France, 1974, pp. 379–405.

Schnapper, Antoine and Marcel-Jean Massat, "Un amateur de Poussin: Michel Passart (1611/12 – 1692)," *Bulletin de la société de l'histoire de l'art français* (1994), pp. 99–109.

Scholl, Dorothée, *Moyse sauvé: poetique et originalité de l'idylle héroïque de Saint-Amant*, Paris and Seattle, Papers on French Seventeenth Century Literature, 1995.

Scudéry, Georges de, *Le Cabinet de Mr de Scudéry, Gouverneur de Nostre Dame de la Garde*, Paris, 1646.

Scudéry, Madeleine de, *Les Femmes illustres ou les Harangues héroïques de M. de Scudéry avec les véritables portraits de ces héroïnes tirez des médailles antiques*, repr. Paris, côté-femmes éditions, 1991.

Sedgwick, Eve Kosofsky, *Between Men: English Literature and Male Homosocial Desire*, New York, Columbia University Press, 1985.

Séguier, Pierre, *Lettres et mémoires adressés au chancelier Seguier (1633–1649)*, ed. Roland Mousnier, 2 vols., Paris, Presses universitaires de France, 1964.

Serres, Michel, *The Parasite*, trans. Lawrence R. Schehr, Baltimore and London, Johns Hopkins University Press, 1982.

Sewell, Jr., William H., "A Theory of Structure, Duality, Agency, and Transformation," *American Journal of Sociology* 98 : 1 (July 1992), pp. 1–29.

Sicard, Augustin, *Les Etudes classiques avant la révolution*, Paris, Perrin, 1887.

Simon, Robert B., "Poussin, Marino, and the Interpretation of Mythology," *Art Bulletin* 60 (1978), pp. 56–68.

Smith, Pauline M., *The Anti-Courtier Trend in Sixteenth Century French Literature*, Geneva, Droz, 1966.

Snyders, Georges, *La pédagogie en France aux XVIIe et XVIIIe siècles*, Paris, Presses universitaires de France, 1965.

Solomon, Howard M., *Public Welfare, Science and Propaganda in Seventeenth Century France: The Innovations of Théophraste Renaudot*, Princeton University Press, 1972.

Soriano, Marc, "Burlesque et langage populaire de 1647 à 1653: Sur deux poèmes de jeunesse des frères Perrault," *Annales, économies, sociétés, civilizations* 24 (1969), pp. 949–75.

—, *Le Dossier Perrault*, Paris, Hachette, 1972.

Soussloff, Catherine, *The Absolute Artist: The Historiography of a Concept*, Minneapolis, University of Minnesota Press, 1997.

Sparti, Donatella L., "Carlo Antonio dal Pozzo (1606–1689): An Unknown Collector," *Journal of the History of Collections* 2:1 (1990), pp. 7–19.

—, *Le Collezione dal Pozzo: Storia di una famiglia & del suo museo nella Roma seicentesca*, Modena, F. C. Panini, 1992.

Spini, Giorgio, "Historiography: The Art of History in the Italian Counter-Reformation," in *The Late Italian Renaissance 1525–1630*, ed. Eric Cochrane, New York, Harper, 1970, p. 130.

Spon, Jacob, *Recherches des antiquités et curiosités de la ville de Lyon*, Lyon, 1673.

—, *Jacob Spon: un humaniste lyonnais du XVIIème siècle*, ed. Roland Etienne, Paris, Boccard, 1993.

Standring, Timothy J. "Some Pictures by Poussin in the Dal Pozzo collection: Three New Inventories," *Burlington Magazine* (August 1988), pp. 608–26.

Stanton, Domna C., *The Aristocrat as Art: A Study of the Honnête homme and the Dandy in Seventeenth- and Nineteenth-Century French Literature*, New York, Colombia University Press, 1980.

—, "The Fiction of Préciosité and the Fear of Women," in *Feminist Readings: French Texts/American Contexts*, *Yale French Studies* 62 (1981), pp. 107–34.

—, "Recuperating Women and the Man Behind the Screen," in *Sexuality and Gender in Early Modern Europe: Institutions, Texts, Images*, ed. J. G. Turner, Cambridge University Press, 1993, pp. 247–65.

Steinberg, Leo, "Women of Algiers," in *Other Criteria: Confrontations with Twentieth-Century Art*, Oxford, 1972, pp. 174–92.

Steyert, André, *Nouvelle histoire de Lyon et des provinces de Lyonnais, Forez, Beaujolais, Franc-Lyonnais et Dombes*, 3 vols., Lyon, Bernoux et Cumin, 1895–99.

Stoichita, Victor I., *The Self-Aware Image: An Insight into Early Modern Meta-Painting*, trans. Ann-Marie Glasheen, Cambridge University Press, 1997.

Strong, Roy, *Art and Power: Renaissance Festivals 1450–1650*, Berkeley, University of California Press, 1984.

Supple, James J., "Nobilium culpa iacent literae": Guillaume Budé and the Education of the French Noblesse d'Epée," in *Acta conventus neo-latini Sanctandréani*, ed. Ian D. McFarlane, Binghamton, New York, Medieval and Renaissance Texts and Studies, 1986, pp. 207–22.

—, "The Failure of Humanist Education: David de Fleurance-Rivault, Anthoine Mathé de Laval, and Nicolas Faret," in *Humanism in Crisis: The Decline of the French Renaissance*, ed. Philippe Desan, Ann Arbor, University of Michigan Press, 1991, pp. 35–53.

Sutherland Harris, Ann, Review of Konrad Oberhuber, *Poussin:*

The Early Years in Rome: The Origins of French Classicism, exh. cat., New York, Hudson Hills Press, 1988, *Art Bulletin* 72 (March 1990), pp. 144–55.

—, " A propos de Nicolas Poussin paysagiste," *La Revue du Louvre et des Musées de France* 2 (April 1994), pp. 36–40.

Tacitus, *The Annals of Imperial Rome*, trans. Michael Grant, London, Penguin, 1989.

—, *The Histories*, trans. Kenneth Wellesley, London, Penguin, 1991.

Tallemant des Réaux, Gédéon, *Historiettes* (1657), ed. Antoine Adam, 2 vols., Paris, Pléiade, 1960–62.

Talon, Omer, *Mémoires*, ed. Louis-Gabriel Michaud et J.-F. Michaud, Paris, 1839.

Teasley, David, "The Charge of Sodomy as a Political Weapon in Early Modern France: The Case of Henry III in Catholic League Polemics, 1585–89," *The Maryland Historian* 18 (spring/summer 1987), pp. 17–30.

Testelin, Henri, *Mémoires pour servir à l'histoire de l'Académie Royale de Peinture et de Sculpture depuis 1648 jusqu'en 1664*, ed. Anatole de Montaiglon, 2 vols., Paris, P. Jannet, 1853.

Teyssèdre, Bernard, *Roger de Piles et les débats sur le coloris au siècle de Louis XIV*, Paris, La Bibliothèque des arts, 1957.

Thirion, Jacques, "Pierre et la diffusion des modèles antiques" Revue de Louvre (1971), pp. 147f.

Thuillier, Jacques, *L'Opera completa di Poussin*, Rome, 1974.

—, "Le Paysage dans la peinture français du XVIIe siècle," *Cahiers de l'association internationale des études françaises* 29 (1977), pp. 45–64.

—, *Nicolas Poussin*, Paris, Fayard, 1988.

—, "Les dernières années de François Perrier (1646–1649)," *Revue de l'art* 99 (1993), pp. 9–28.

—, *Nicolas Poussin*, Paris, Flammarion, 1994.

—, *Poussin Before Rome, 1594–1624*, trans. Christopher Allen, London, Richard L. Feigen, 1995.

— and Claude Mignot, "Collectionneur et peintre au XVIIe: Pointel et Poussin," *Revue de l'art* 39 (1978), pp. 39–58.

—, Barbara Bréjon de Lavergnée, Denis Lavalle, *Vouet*, exh. cat., Galeries nationales du Grand Palais, Paris, November 6, 1990 – February 11, 1991, Paris, Réunion des musées nationaux, 1990.

Tilly, Charles, *The Contentious French*, Cambridge, Belknap Press, 1986.

Tooth, Constance, "The Paris Houses of Louis Le Vau," unpublished diss., University of London, 1961.

Tristan l'Hermite (Jean-Baptiste l'Hermite de Soliers) and François Blanchard, *Les Eloges de tous les premiers présidents du parlement de Paris*, and *Les présidents du mortier de parlement de Paris*, 2 vols., Paris, 1645.

—, *Les vers heroiques*, ed. Catherine M. Grise, Geneva, Droz, 1967 (*Vers heroiques du Sieur Tristan l'Hermite*, J.-B. Loyson and N. Portier, 1648, n.p.).

Trousson, R., "Ronsard et la légende d'Hercule," *Bibliothèque d'humanisme et renaissance* 24 (1962) pp. 77–88.

Turner, James Grantham, *Sexuality and Gender in Early Modern Europe: Institutions, Texts, Images*, Cambridge University Press, 1993.

Valdor, Jean, *Les Triomphes de Louis le Juste*, Paris, 1649.

Varille, Mathieu, *Les Antiquaires Lyonnais de la Renaissance*, Lyon, Audin, 1924.

Verdi, Richard, "Poussin and the Tricks of Fortune," *Burlington Magazine* 124 (1982), pp. 681–85.

Versailles, Musée national de Versailles et des Trianons, *Charles Le Brun, 1619–1690, peintre et dessinateur*, Paris, Ministère d'Etat/Affaires culturelles, 1963.

Verthamont, François de, *Diaire ou journal du voyage du Chancelier Séguier en Normandie après la sédition des nu-pieds, 1639–1640*, Rouen, E. Frère, 1842 (Geneva, Slatkine-Megariotis, 1975).

Vitzhum, Walter, "L'Album Perrier du Louvre," *L'Oeil* (May 1965), pp. 20–24.

Vivanti, Corrado, "Henry IV, the Gallic Hercules," *Journal of the Warburg and Countauld Institutes* 30 (1967), pp. 192–93.

Voltaire, *Le Siècle de Louis XIV*, Paris, Hachette, 1906.

Vovelle, Michel, *Mourir autrefois: attitudes collectives devant la mort aux XVIIe et XVIIIe siècles*, Paris, Gallimard, 1974.

—, *Piété baroque et déchristianisation en Provence au XVIIe siècle*, Paris, Editions du Seuil, 1978.

Vulson, Marc de, Sieur de la Colombière, *Les portraits des hommes illustres françois qui sont peints dans la Galerie du Palais Cardinal de Richelieu*, Paris, 1650.

Wickelgren, Florence Louise, *La Mothe le Vayer; sa vie et son oeuvre*, Paris, E. Droz, 1934.

Wild, Doris, "Nicolas Poussin et la décoration de la Grande Galerie du Louvre," *Revue du Louvre* 2 (1966), pp. 77–84.

Wildenstein, Georges, "Le Goût pour la peinture dans le cercle de la bourgeoisie parisienne, autour de 1700," *Gazette des Beaux-Arts* 48 (September 1956), pp. 113–94.

—, "Les graveurs de Poussin au XVIIe siècle" *Gazette des Beaux-Arts* 2 (1955 [1958]), pp. 73–371 and *Gazette des Beaux-Arts* (1962), pp. 39–202.

Williams, Raymond, *The Country and the City*, New York, Oxford University Press, 1973.

Wolff, Louis, *La vie des parlementaires au XVIe siècle*, Marseille, 1924.

Wright, Christopher, *Poussin: Paintings. A Catalogue Raisonné*, London, Jupiter, 1984.

Zaslaw, Neal, "The First Opera in Paris," in *Jean-Baptiste Lully and the Music of the French Baroque: Essays in Honor of James R. Anthony*, ed. John H. Heyer, Cambridge University Press, 1989, pp. 19–23.

Zeller, B. *Richelieu et les ministres de Louis XIII de 1621 à 1624*, Paris, 1880.

Zerner, Henri, "Classicism as Power," *Art Journal* (spring 1988), pp. 35–6.

Zolotov, Youri and Natalia Serebriannaïa, *Nicolas Poussin. Musée de l'Ermitage. Musée des Beaux-Arts Pouchkine*, Paris, Cercle d'Art, 1990.

Zolotov, Youri, *Nicolas Poussin*, Musée de l'Ermitage, Musée des Beaux-Arts Pouchkine, Paris, Cercle d'Art, 1990.

Photograph Credits

Index